Charlton Heston

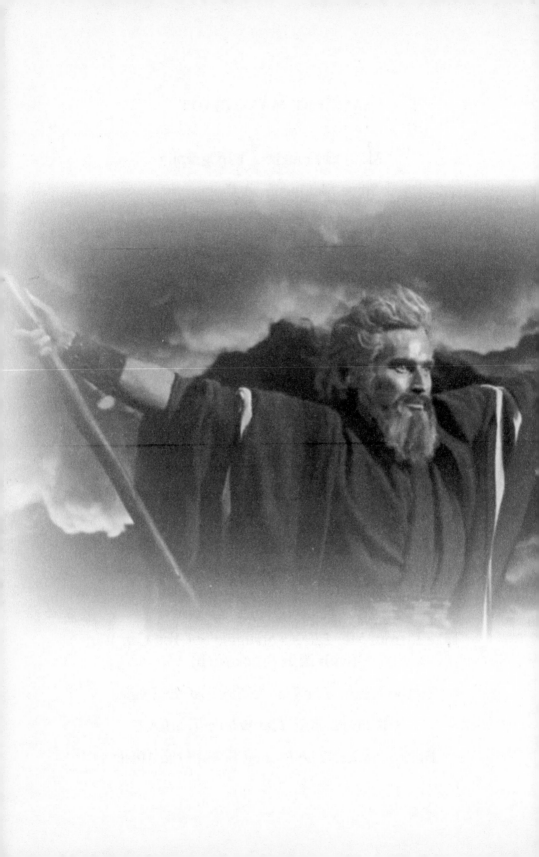

Charlton Heston

Hollywood's Last Icon

Marc Eliot

An Imprint of HarperCollinsPublishers

The author would like to thank Agamemnon Films, Lydia C. Heston, Fraser Heston, Holly Heston Rochell, and the Heston Family Trust for their generous contribution of certain materials used in this biography. All excerpts from written materials provided by licensors are © 2017 by Agamemnon Films, and all photos used, except where noted, are courtesy of the Heston Family. Those taken by Lydia Heston, as noted, are © 2016 by Lydia C. Heston.

HarperCollins books may be purchased for educational, business, or sales promotional use. For information please e-mail the Special Markets Department at SPsales@harpercollins.com.

FIRST HARPERLUXE EDITION

ISBN: 978-0-06-264445-9

HarperLuxe™ is a trademark of HarperCollins Publishers.

Library of Congress Cataloging-in-Publication Data is available upon request.

17 18 19 20 21 ID/LSC 10 9 8 7 6 5 4 3 2 1

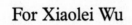

For Xiaolei Wu

Charlton Heston is an axiom. By himself alone he constitutes a tragedy, and his presence in any film whatsoever suffices to create beauty. The contained violence expressed by the somber phosphorescence of his eyes, his eagle's profile, the haughty arch of his eyebrows, his prominent cheekbones, and the bitter and hard curve of his mouth, the fabulous power of his torso; this is what he possesses and what not even the worst director can degrade.

—MICHAEL MOURLET,
Cahiers du Cinéma, May 1960

From start to finish, Heston was a grand, ornery anachronism, the sinewy symbol of a time when Hollywood took itself seriously, when heroes came from history books, not comic books. Epics like *Ben-Hur* or *El Cid* simply couldn't be made today, in part because popular culture has changed as much as political fashion. But mainly because there's no one remotely like Charlton Heston to infuse the form with his stature, fire and guts.

—RICHARD CORLISS,
Time magazine, April 10, 2008

*If you were to ask me the old question about who is
the real Charlton Heston, I wouldn't be able to answer
you . . . I simply like pretending to be other people. Let
the Freudians make of that what they want . . .*

 —CHARLTON HESTON,
 quoted in Pete Hamill, "Heston:
 Larger Than Life," *Sunday Evening
 Post,* July 3, 1965

*I was staying at the Marriott, with Jesus and John
 Wayne
I was waiting for a chariot, they were waiting for a
 train . . .
I was staying at the Westin, I was playing to a draw
When in walked Charlton Heston with the Tablets of
 the Law . . .*

 —WARREN ZEVON,
 "My Ride's Here," 2002

Contents

Book Two: HOLLYWOOD'S LAST ICON

Prologue

B y the age of thirty-seven, Charlton Heston was an Oscar-winning Hollywood superstar. After appearing on Broadway and in dozens of live television dramas in New York City, his career crested on the tidal wave of the iconic roles he played in three of Hollywood's highest-grossing live-action features of the '50s. In the next forty-five years he appeared in more than one hundred films and was instrumental in resurrecting the largely dormant science fiction, western, and disaster film genres. He was also the longest-running president of the always-roiling Screen Actors Guild, from the mid-'60s through the early '70s, and was crucial in keeping the American Film Institute in existence by fighting the government to maintain a reasonable amount of federal funding for the National Endowment

for the Arts, the AFI's chief source of income. He was also an accomplished stage actor. Besides Broadway, he appeared in London's West End, in Los Angeles and Chicago's biggest theaters, and even directed on Beijing's main stage. He was also a member of the Greatest Generation and saw combat in the Pacific during World War II. And he lived an exemplary life as a family man, married to the same woman for sixty-four years, with whom he raised two children.

Yet, for all that, the first and, in many instances, the only thing that comes to people's minds when the name Charlton Heston is mentioned is his relatively late in life membership in the National Rifle Association and the infamous moment in 2000 when the seventy-six-year-old actor raised a long rifle over his head and declared, with dramatic emphasis, that the only way it would ever be taken away was *"From my cold dead hands!"* In the instant-impact, media-dominated world we live in, where a single sentence gets repeated over and over again until it can overshadow the accomplishments of an entire career, and often derail it, Heston's moment of enthusiastic NRA campaigning did just that (one thinks of Howard Dean, who suffered a similar fate when one overly enthusiastic scream fueled a media reaction that destroyed a lifetime in political service and his frontrunning presidential aspirations).

As will become clear, there was so much more to Heston's life than a single exclamation. The NRA episode does not, by any stretch of the imagination, define who Charlton Heston was, all that he had accomplished in his extraordinary life, what made him tick as an artist and drove him as a man.

Heston became a superstar after portraying Moses in Cecil B. DeMille's *The Ten Commandments* (1956) at a time when screen acting in America was in the midst of an extended infatuation with Method acting and its new wave of young movie stars, exemplified by Montgomery Clift, Marlon Brando, James Dean, Eva Marie Saint, Shelley Winters, and others. They were the individual standouts amid the last wave of cookie-cutter studio contract players: the Rock Hudsons, the Tab Hunters, the Joi Lansings, the Jayne Mansfields, to name a few. Heston was neither old school nor new Method; he brought something different to the screen—a stoic American Cold War fundamentalism he didn't learn in acting schools, or even from looking death in the eye during World War II. All of it was rooted in and flowed directly from the emotional remnants of his early, traumatic upbringing. He had his own personal version of the Method.

Heston was raised in the backwoods of Lower Mich-

igan, where his happiest days were spent hunting, fishing, chopping wood, and swimming with his dad, and happiest nights alone by the fireplace, losing himself in the literary worlds of Mark Twain's *Tom Sawyer*, Howard Pyle's *The Merry Adventures of Robin Hood*, and Jack London's *The Call of the Wild*. It was a time and place of childhood joy that was suddenly taken away from him when his parents divorced and his mother remarried and eventually settled in the urban environs of Chicago. The little boy lost everything: his dog, his beloved woods, his real dad, even his name.

For the rest of his life, Heston sought to reclaim that lost world through the creative universe of acting, in characters and films that resonated with him and that would define him as a figure of strength, stature, leadership, and ideals. There was Moses, who was taken as a baby from his parents and for the rest of his life tried to find and reunite with his true heritage; Judah Ben-Hur, who rose from Hebrew slavery and, once freed, searched for his former home and his missing mother and sister; Will Penny, who late in life desired to marry and become a husband to the woman he loved and a father to her boy before giving up and going his own way; Michelangelo, who was determined to please the father-figure pope by giving up his own creative urges

to sculpt and instead painting the Sistine Chapel for him; Captain Garth, who fought in the Pacific during World War II to preserve America's freedom and way of life at the Battle of Midway.

Heston's desire to reclaim the perfect world of his childhood also expressed itself politically. As his fame grew, the onetime activist Democrat, who, in 1960, had supported John F. Kennedy's successful bid to become president and in 1963 marched alongside Martin Luther King Jr. at the great March on Washington, began to turn away from the liberal Left in favor of a more conservative interpretation of the Constitution, especially the Second Amendment. Eventually, he became an enthusiastic supporter of the NRA, a commitment that many in liberal-dominated Hollywood considered outrageous.

Most Tinseltown scandals don't last, whether it's who slept with whom, who's getting divorced, whose dress top fell off at which function, etc. ad nauseum. Hollywood loves these bits because they do nothing so much as promote this actor or his, or her, next film. The one big no-no is politics, unless you're on the so-called ride side of the equation. During the industry-wrecking blacklist years of the '50s, not one of Hollywood's conservative stars—the Bing Crosbys, the Bob Hopes, the Gary Coopers—suffered for their "patriotic" po-

sitions. Some, like Ronald Reagan, used that time as a springboard to post-film political careers of varying degrees of significance. When an actor takes a position that is unpopular, he may not only lose his audience, but also the money people who finance his movies. He becomes a risk, and in an industry that purports to be an art form—the essential ingredient of which is taking risks—the last thing the financiers want. They like to play it safe, with films that look alike, sound alike, and earn alike, with no visible politics to get in the way of popcorn sales.

Most noncommittal (as in nonpolitical) actors will happily compromise their own beliefs and espouse middle-of-the-road views in the pursuit of widespread popularity and, with it, the promise of fame and fortune. Most, but not all. Heston did not worry about these things as much as he did his right to free expression, and if his views cost him parts in films, bigger paychecks, or his place in the pantheon, so be it, he was willing to pay that price. By the '90s, when he became president of the NRA, he had already made his name in movies, won his Oscar, raised his children, and banked a sizable sum. He cared more about being a voice for freedom and a defender of the Second Amendment than having the approving roar of the crowd or hearing the ongoing jingle of the cash register.

The more he became involved with the NRA, the more the demand for his films faded (as did those of the post-Reagan crop of liberal actors that had once dominated the industry). He replaced that loss in a different kind of arena where he could act out his best character, "Charlton Heston," a version as singular and recognizable as Hal Holbrook's celebrated Mark Twain, a combination of Ronald Reagan (another Illinoisan from the sticks) and Davy Crockett, for those audiences eager to see him perform it.

But there was more to it than just adulation. Defending the Second Amendment was the best way he found to keep himself connected to his dreams of childhood—that life he lived in the woods, hunting and fishing with his dad. Up to the end of his days, until Alzheimer's blurred the deep focus of his longing, erased the memories of his past and took away his visions of the future, Heston's life journey propelled him inevitably forward, while he sought to somehow find a way to go back, to revive and release the lost child within.

Here is the story of Charlton Heston.

Charlton Heston

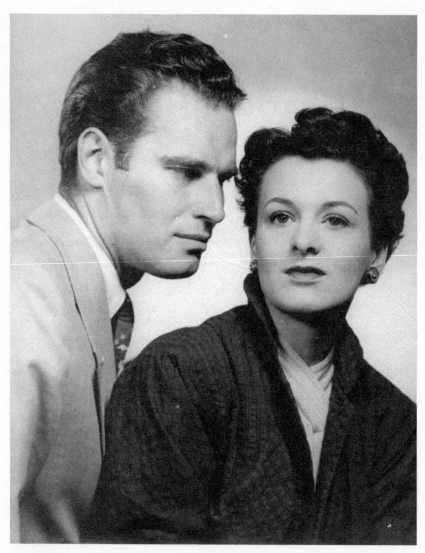

Charlton and Lydia Heston in New York City, 1948. (Courtesy of the Heston Family)

BOOK ONE

From St. Helen
to Mt. Sinai

Charlton Heston, age seven, in the North Woods of Michigan.
(Courtesy of the Heston Family)

Chapter One

It's 1923 and Hollywood, like the rest of the country, is thriving. Americans are roaring through the twenties, making lots of money, drinking bootleg booze, dancing the Charleston, and packing themselves into movie theaters to see the latest picture shows. Demand for new films is so great the studios can't crank them out fast enough. An undeveloped orange grove at the turn of the century, Hollywood is now the prime locale for the hot new industry of motion pictures. Houses are being speed-built to accommodate the explosion of studio personnel needed to help meet the public's insatiable demand for "movies."

At the height of this construction frenzy, a couple of opportunistic real estate developers hang a sign near the top of the hills surrounding the valley to advertise their

new housing development. It has fifty-foot-high white letters that spell out HOLLYWOODLAND. It is meant to stay there only for one year, or until all the units are sold, whichever happens first, but it never comes down. Shortened to HOLLYWOOD in 1949, it becomes a hovering symbol of the industry of dreams, and to this day watches over Tinseltown like the giant statue of Jesus over Rio de Janeiro.

With revelry running rampant, Hollywood has fallen under increasing scrutiny by the federal government, which is concerned about its excessive displays of cultural decadence. In response, on December 4, Cecil B. DeMille, one of the industry founders, premieres his spectacular silent epic *The Ten Commandments* at, appropriately enough, Grauman's Egyptian Theatre on Hollywood Boulevard. It is immediately recognized as a moral testament to both ancient times and the present. Shot in rare two-strip Technicolor, and with its breathtaking sequence of the parting of the Red Sea, the film receives rave reviews and packs every theater it plays. Even the government approves.

Two months earlier, two thousand miles east and light-years away from the manufactured glamour and crunchy glitz of Tinseltown, in a rural, woody section of Evanston, Illinois, John Charles Carter is delivered into the world. Thirty-three years later, in 1956, at an-

other moral crossroads in America, he will play Moses in DeMille's even more spectacular remake of his biblical masterpiece.

By then, John Charles Carter will be known to the world as Charlton Heston.

His parents kept a small getaway shack in the woods that John Charles' father, Russell Whitford Carter, had built for them by hand. Russell, who had learned construction from his father, John Carter, a poor Yorkshire County coal mine pit boy in the United Kingdom who came to America in search of freedom and fortune, and landed a job as a lumberjack with the Stevens Logging company of Roscommon, Michigan, a town named after the county in Ireland. Eventually, having sufficiently depleted the forests of Roscommon, the company moved its outfit farther south. Carter, who had saved every penny he earned, managed to convince the county of Roscommon to sell him half the newly denatured forests for a modest sum, in return for his guarantee to produce taxable revenue from it.

John's mother, Lilla Charlton, was born in Chicago, descended from the Scot-English Clan Fraser of Inverness, a lineage traceable to William the Conqueror and whose ancestors came down to America from Canada and settled in Illinois. "She came from a very

interesting family," according to Holly Heston Rochell, Charlton Heston's daughter. "It was run by a strict, Victorian-style matriarch, my grandmother, Lilla's mother—'Ladybird,' as she was sometimes called by other kids in the neighborhood, or 'Josie,' or 'Uncle Jo,' which referred to Joseph Stalin, that ought to give you an idea of the kind of person she was.

"Lilla, a dark-haired, blue-eyed beauty, eventually ran off with the first guy who came along who got [her] out of her restrictive Victorian household. That was Russell. My dad, Charlton Heston, was their firstborn. He arrived on October 23, 1923. She always called him that, Charlton, not John or John Charles . . . the only one who ever did it, and the only one he would ever let do it. Or sometimes Tigger. Later on my mom called Dad Charlie, and she was the only one who could do *that.* Everyone else, all his life, called him Chuck."

Lilla had met the handsome, charming Russell Carter during one of her Chicago-based family's frequent excursions to the St. Helen woods of Michigan, a favorite vacation spot of theirs. The couple was engaged while he was still in boot camp at the Great Lakes Naval Training Center, not very far away, just north of Chicago, where he was stationed. "I believe she loved him," Holly said, "but she also had a mission, to get out of that house and have some freedom."

Russell and his new bride lived in a small cabin in the St. Helen woods, near to where he felt he could earn a living. Although Lilla would always describe it as much more comfortable than it really was, she had a difficult time coping. Holly: "This was a woman from a sophisticated, urban, well-heeled life who was used to going to the opera, to the Chicago Art Institute, and now found herself living in Podunk, Nowhere, in what was really just another cage, only worse. Instead of the gilded one she had tried to flee, she was stuck in a shack in this outback, feeling culturally stifled among the unfriendly, suspicious, uneducated locals she considered heathens. Russell loved it there, and I don't think he had any idea how Lilla really felt."

From a very early age young John shared his father's love of the woods, and believed it to be the center of the universe. During the week, while his father worked, he liked to go and sit by himself along the edge of the lake, to daydream, while breathing the pine-sweet air. "I lived a very solitary life in the woods because there was no one around my age. So I did even more of what all kids do, which is play pretend games [with myself]."

On weekends, Russell would take the boy and the family dog hunting in the woods. Russell taught him everything about guns—how to load and unload them, sight, aim, shoot, and, after, thoroughly clean them. In

the winter when it snowed, the two would push through the slush to chop down trees for firewood. The freshly cut splits smelled wet and sweet, and covered the boy's fingers with splinters and sticky pinesap. No matter. He proudly carried as much firewood as he could to the house and loved to shove them through the front door of the central stove. In the summer, Russell taught his boy how to fish, everything from baiting a hook to cleaning a catch. All they caught was taken back and cooked by Lilla as dinner for the family.

When John Charles was five, two things happened that upset his world: the first was when his mother gave birth to a girl she named Lilla Ann, after herself. Baby Lilla's arrival ended John's special status as the family's only child. The second was his enrollment in school, a one-room house with no plumbing, and a class of twelve students over eight grades. School expanded his world and, for the first time, let him interact with other children his own age. That fall he won the part of Santa Claus in the school's annual Christmas play. He had one line of dialogue: "Merry Christmas!" As he later told one reporter, "That was the real beginning." Other than that, he did not blend in easily. During classes, he had a tendency to daydream. "I liked to draw cowboys in my geography book . . . I had almost no playmates."

At home after school every day, he liked to listen

to Enrico Caruso records on the family's windup phonograph, and as he learned to read, books became his preferred vehicle of escape. He discovered the classics most boys do, his favorite Ernest Thompson Seton's *Lives of the Hunted.* He liked to act out all the parts of the animals by himself in the living room while his mother prepared dinner. On days when there was no school, he would take his dog Lobo with him deep into the woods, where he would continue to act out the stories from his books. "I pictured myself like Tom Sawyer—hunting and fishing, trapping, canoeing, and all that stuff."

As the boy got older, other reading material had a different effect on him. In those days every house in rural America had a Sears, Roebuck & Co. catalog, and in his memoirs Charlton recalled the hormonal charge he got from browsing through the phone book–size, fully illustrated one his parents kept: "My first pubescent juices stirred while staring transfixed at the underwear models. (They were in the first part of the catalogue, just after housedresses.)"

Russell found full-time daywork in St. Helen, operating a sawmill in one of the lumberyards, and a second job on weekends helping to build an earth dam. Sometimes, when he had to work, instead of hunting or fishing he would take the boy along with him to the dam

to watch it being made. What better show for John's fanciful mind?

And then, when he was ten years old, everything changed again. According to Holly, "After my grandmother gave birth to a third child, a baby boy she named Alan, she had reached her breaking point. I think she knew early on she had married the wrong guy and one day said, 'That's it,' packed a bag with their few belongings, took her three children with her to the station, and boarded a train bound for Columbus, Georgia, where her sister May lived. Lilla wanted her children to be raised the way she had been." Lilla's sister had married a radiologist and lived in a marble-floored southern mansion.

It soon became clear to John that this wasn't just a visit and that they were never going home. And where was his dad? One day not long after they were settled in, Lilla sat John down and calmly explained that she was no longer married to his father and that he wouldn't be around anymore. In his memoir, Heston says that he didn't really understand what it all meant, but the thought of not seeing his dad again sent him into a crying jag that lasted two full days, during which he kept begging his mother to tell him where his dad was, but all she kept repeating was he wouldn't be seeing him anymore. "It was an extremely traumatic experi-

ence," Heston said years later, and suggested, as many children of divorced parents do, that it was somehow his fault his father had gone. "It colored my whole adolescence . . . for years it seemed an awful thing to me. I felt a deep sense of personal guilt." And still later, he admitted it wasn't just his father he missed, but the world they shared together: "I missed my dad greatly, and the woods I knew best . . ."

Lilla wasted no time enrolling John in a Columbus middle school, but the boy found it hard to adjust to southern children, who were so different to him from his classmates back home. He made only one new friend, an African American boy named Josh whose family lived and worked in Aunt May's house. Holly: "Lilla had basically dumped Russell, but before she left him, she had become pregnant with Alan, her third child, except Russell was not the father. Chet Heston [Chester Lucien Heston] was, and he became her second husband. They'd first met while Heston was working for Russell. My grandmother saw Chet as her ticket out of St. Helen. She was a die-hard Chicagoan, and that's where she wanted to live and raise her kids, in a more urban and cultured environment."

One day, again without any advance warning, Lilla packed the children's belongings and returned with them to St. Helen. John brightened up and thought ev-

erything was going to be all right again, until he real-
ized it wouldn't. There was a new, tall man with his
mother while his own dad was nowhere to be found.
John had seen this man before, whenever his dad had
taken him to work at the dam.

Shortly after they returned to St. Helen, Lilla mar-
ried Chester, who then put the family's belongings into
a trailer hooked to the back of his car and drove them
all south to Alliance, Ohio, where he was from and
where he intended to live with his new family.

To Lilla, it was a big step in the right direction.

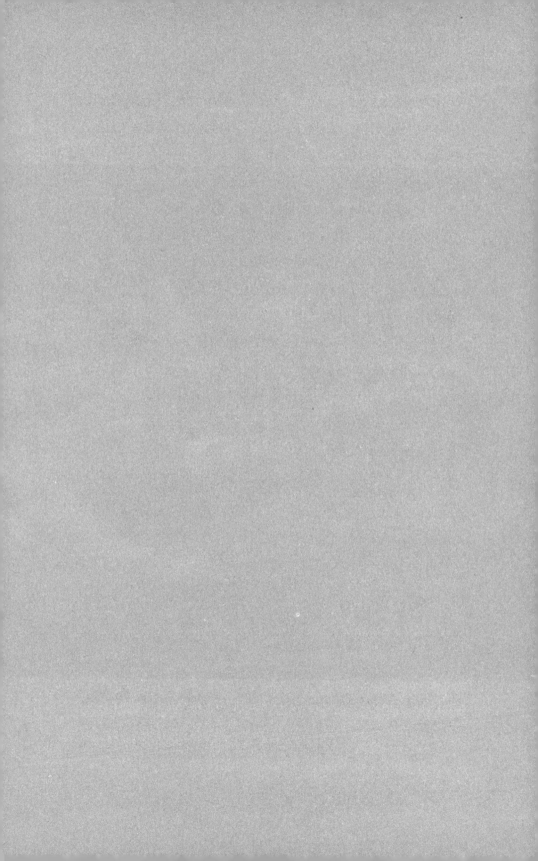

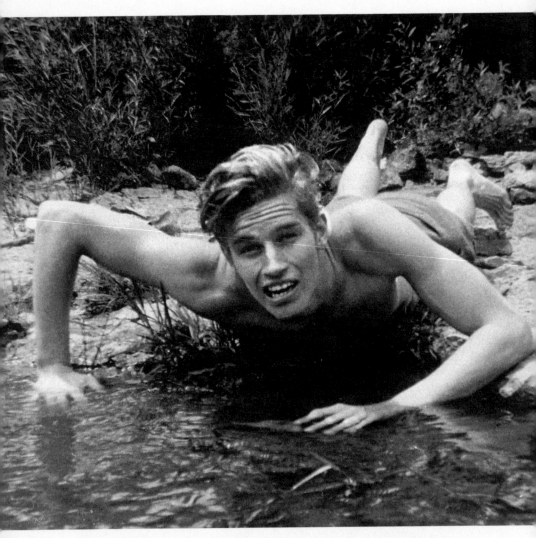

Charlton Heston filming Peer Gynt. (Courtesy of the Heston Family)

Chapter Two

It was the height of the Depression, and Chester had difficulty finding steady work in Alliance. After only a few weeks, he packed up the family and headed for Wisconsin to start another new life with them. When the "plenty of jobs" he'd heard about there proved to be just rumors, he moved the family yet again, this time at Lilla's urging, to Wilmette, North Chicago, where Chester rented a house and found a job near Lake Michigan as a welder in a defense plant. Soon enough, he had saved enough money for a down payment on a house of their own at 325 Maple Avenue, in one of Wilmette's better neighborhoods.

The move had its advantages for John. For the first time, he had a space of his own, the third floor of the house, really the attic that Chester had turned into

a bedroom for him. That part was great, but he still missed the woods of St. Helen, Lobo, and, most of all, his real dad. Chester tried to do the right thing, but it was just as difficult for him as it was for young John. According to Holly, "Even though my dad deeply respected his stepfather, there was really very little warmth, no nurturing, no tenderness from Chester."

Then, as if to erase everything that reminded her son of Russell, Lilla told him his name was no longer John Charles Carter; from now on he was Charlton Heston. The boy was confused but said nothing. Holly: "Dad took the new name not because he loved Chet, but because he was embarrassed and ashamed he was from a divorced family, although he was too young to understand what had happened or why."

Holly continued: "He also no longer had a middle name . . . Early on, when his friends at school would ask him why, he would shrug his shoulders and say he wasn't given one. He did give himself one later on when he was at university—Lance—that he used for a while before abandoning it and being just Charlton Heston."*

* For the rest of her long life, Lilla tried to deny the emotional struggle of the early Michigan years of Heston's life. In 1985, after he published his memoir, she called Heston's memories of those days "nonsense." From an article in *People* magazine: "Charlton says his favorite childhood memory is 'hunting rab-

Chet continued to do well, and in 1934, at Lilla's urging, he moved the family to Chicago. That fall, Heston started classes at Wilmette's New Trier East High School, one of the best schools in the nation according to *Life* magazine. It proved another difficult transition for him. Years later he recalled, "When I first [moved to Chicago,] I remember being actually scared to death of the automobile traffic and the noise and everything else that goes with a big city. New Trier was a social kind of school . . . kids are the most conventional people in the world. It is more important than anything else for them to conform, and I was a kind of the oddball. I was driven into being independent. The fact that, until sixteen, I was small for my age, made it worse because I was also the most awkward guy in school."

There were continued difficulties for him with his new name. "When I first went to high school, the teacher read the roll and said, 'Charlotte Heston?' and I sank in my seat and she said, 'Charlotte Heston?' and I sank further, and she said, 'Where is the little Heston girl.' God! It was dreadful." Taking their cue from the teacher, the bigger boys took to calling him Charlotte

bits.' Mom says, 'He never hunted a rabbit in his life!' . . . As to his memory of himself as a 'shy little country boy,' she points out, 'We lived in Wilmette [an affluent Chicago suburb].' " (Lilla Heston, *People*, August 19, 1985.)

and taunted him in the schoolyard. To make everything worse, he suffered a severe outbreak of acne. Then he turned sixteen and went from being the shortest and smallest among them to the tallest and biggest. He grew eight inches in a single year and his skin cleared up. They stopped calling him Charlotte.

"I can't emphasize enough how important New Trier turned out to be for me," Heston said later. "Given my lonely circumstances, being a hick kid from a lonely part of the woods, who didn't know how to dance, who didn't know how to drive, didn't have any money, had never played team sports before because there were never enough kids around to form a team. The only thing I felt equipped for were the rifle team and the chess club . . ." Gradually, Heston found a way to make friends with the other boys. He was now big enough to play softball after school in the well-cared-for neighborhood field, and everyone wanted him on their team.

The other thing about New Trier that was new and exciting for him was its co-ed policy, something relatively new to American high schools. He'd never seen so many pretty girls except in those Sears catalogs, and these were much better. He could smell their hair when he sat behind them in class, and he marveled at how their skin glowed, but he didn't dare speak to

any of them. Later on he said, "I was homely and self-conscious. My hair hung in my eyes. In high school, I never dated."

And it was at New Trier that he first discovered the academic world of drama. One of Heston's classmates, a boy named Warren Mackenzie, was trying out for the freshman play and invited him to tag along. Chuck said okay, but he had no idea why Warren would want to be in a play, until he saw that all the prettiest girls from his class were on the stage of the school auditorium, and he got it. Or got something. He had always loved playing pretend in the woods by himself, but here all the kids were playing it together, and now he wanted to be included. He tried out for the play and won a role. As Heston recalled in his memoir, this was the moment when "I began my life." Call it the craziest of second comings.

Acting with his schoolmates was something new and exciting for him, a type of social interaction he had never before experienced, and he couldn't get enough. He tried out for every new play, acted out individual scenes in front of his English class, and, because of his deep voice, read parts in plays over the New Trier radio system. He was cast in one school production of *Death Takes a Holiday*, a romantic drama based on the Italian play *La Morte in Vacanza* by Alberto Casella, opposite

what Heston later described as the prettiest girl he had ever seen. During the performance, he was supposed to pick her up and carry her across the stage, but he tripped over himself, dropped her, and then fell on top of her. Everyone laughed—he did too—but he would have preferred acting the hero rather than playing the fool.

As he began to feel more socially at ease, he allowed himself gradually to get closer to Chet, who was receptive to his stepson's overtures. Whenever he asked, Chet always found time to help him with his chemistry homework, Heston's most difficult subject at school. Lilla hoped their growing relationship would help erase the pain of Russell's absence, that still lingered.

One afternoon after school, while he was playing softball, a car pulled up to the side of the field. The driver's side window rolled down and Heston immediately recognized his father's familiar warm grin. He dropped his mitt and ran over. They talked for a few minutes, until his father stuck his hand out and patted the boy on his shoulder, rolled the window up, and drove away. Heston watched the car until it turned a corner and disappeared. The familiar waves of longing and shame washed back over him. He left the field, ran home, and locked himself in his room, staying there until the bad feelings passed.

In his senior year, Heston dropped his other extra-curricular activities and devoted all his free time to acting in school plays. At six feet, three inches, with his body filled out and his handsome face, perfect nose, hero's jaw, and head full of wavy, thick brown hair, he got all the leading roles, not just in school but at the local community theater as well. In the spring he was offered the lead in the big senior production, *The American Play*, a popular prewar anti-Nazi piece that had recently been on Broadway.*

One day, during rehearsals, he received an anonymous note praising his acting and, along with it, a ten-dollar bill. He didn't know for certain who had sent it, but suspected, and rightly so as he later found out, it was from the mother of the female lead. It was meant to pay for him to take her daughter out. The girl was very pretty and had a crush on him but, like Heston, she was shy and socially inexperienced. He read the note and wanted to ask her out, but he had never been on a date before, and couldn't get up the nerve. He wound up using the money to take a couple of buddies out for burgers and shakes.

Opening night went well, and afterward, while still

* Not to be confused with the Suzan-Lori Parks play *The America Play.*

in costume sitting in his small dressing room, a large, intense-looking young man came by and said he wanted to see him. The fellow introduced himself as David Bradley, congratulated Heston on his performance, explained that he was an independent filmmaker and wanted Heston to star in his next production, an adaptation of Henrik Ibsen's *Peer Gynt,* in the title role of the foolish, immature young man who seeks his fortune traveling the world. What he didn't tell Heston was that he had found the high school production amateurish and difficult to sit through, but thought this actor's good looks and strong physique would translate well to the screen.

The twenty-one-year-old Bradley had begun making amateur films at the age of ten and, when he was old enough, trained at the Todd School for Boys at Woodstock, Illinois, the same institution that the young Orson Welles had attended, after which Bradley made a number of self-financed silent 16 mm movies, fanciful adaptations of *Treasure Island* and *Oliver Twist,* the latter partially funded by Northwestern University's School of Speech. Bradley had gone to see *The American Play* when he'd heard the actor in the lead was talented, good-looking, and, as he found out that night, willing to work for no pay. Bradley had begun production of *Peer Gynt* with a Northwestern student

in the title role, but he quit after landing a paying job in a summer stock company. When Heston agreed to do it, Bradley later said, "I found I had discovered a natural. Heston was not only the rabbit pulled hastily from the hat, but he had a natural presence and instinctive acting ability."

Heston, meanwhile, had never heard of *Peer Gynt*, or Ibsen for that matter, but was eager to be in the movie. He agreed to do it if he could film on weekends, his only days off from a summer job at the local steel mill Chet had helped him get. He told Bradley he needed to save as much money as he could for his college expenses, as he was starting Northwestern in the fall. The Winnetka Community Theater, where he had done several shows, had awarded him a full drama scholarship to the School of Speech at the university's drama department.

It may not have been his work at the community theater that was the real reason for his scholarship. It is likely the family contributed more than a little to the community theater to help get Heston into its plays and indirectly funded the scholarship to ensure Heston would attend Northwestern. Holly: "Northwestern was part of the family tradition. Lennox Barrett Clarke, my father's father-in-law, graduated from there Phi Beta Kappa in 1918."

No, Bradley said, no steel mill. Heston had to make a full commitment to the film, or he couldn't be in it. It may have been a bluff on Bradley's part, as he was by this time desperate to finish his film, but Heston agreed.

Peer Gynt took the entire summer to shoot. As Heston later remembered, "My performance as Peer has only physical virtues. David somehow perceived what other [future] directors also found: my face is useful for the camera. [Otherwise] I had no concept for performing the part. I'm not sure David did either." To fill out the film, Bradley cut in stock footage of Norway, a few stock shots of Arabs crossing the desert, and a sailing ship caught in a storm he concocted out of miniatures. He made his own title cards for the dialogue, and in one brief fantasy sequence tinted the negative alternately green, blue, and red. Whenever he showed it, he played a tinny-sounding recording of composer Edvard Grieg's *Peer Gynt* as the sound track. Heston did surprisingly well considering this was the first time he had ever appeared on film.

The production wrapped early in the fall of 1941, just before Heston was about to begin his freshman year at Northwestern. Although he tried, Bradley was unable to secure any distribution for his opus, and reluctantly put it aside to move on to his next project.

In his first semester, according to Holly, Heston had his own unique style of dress. Holly: "He wore tight green corduroys and Elizabethan silk tops that his mother made for him, drapey shirts, with strings instead of buttons, ascots, and he wore three-inch copper bands on each wrist. On one side were his initials, CLH (the *L* for Lance), and on the other the name of his imaginary girlfriend."

He decided to try out for the football team. He was big and strong enough and believed he might even make first string, until one scrimmage when his nose was broken during play action. It swelled up and twisted and left a permanent bump with a slight hook. He dropped football after that, and the only extracurricular activity he went out for was acting in the university's plays.

His deep, resonant voice also helped land him some bits on a local Chicago radio station, mostly daytime soap operas and an occasional appearance on the popular serial *Terry and the Pirates*. The gigs helped make up the extra money he had lost giving up his job to make *Peer Gynt*.

During this first year, in addition to his regular academic load, Heston took classes in Theater, set building, lighting design, stage makeup application, and speech. He enjoyed most of them, but couldn't make

heads or tails of the Stanislavski-influenced Funda-
mentals of Theater Practice B-40 acting class. It made
no sense to him to look within to find his characters;
they had a life of their own, and his job, he believed,
was to approximate that life by acting it out, not by
connecting it to his, in some kind of weird collabora-
tion of spirits and personalities. He said about it years
later, "Method acting is like masturbating. It's a lot of
fun, but you don't accomplish much."

His primary acting teacher was Alvina Krause, an
assistant professor of "voice and interpretation," who
would go on to have a distinguished acting career in
repertory theater. She urged Heston to improve his
elocution and enunciation by unlocking his jaw, some-
thing that made sense to him. He had a tendency to talk
through clenched teeth (something he never entirely
got rid of). Heston later said, "I consider myself lucky
to have had a drama coach like Alvina Krause . . . and
I know all of my other classmates, including [future
stars] Patricia Neal and Ralph Meeker, felt the same."

Just for fun, when he wasn't playing sports or study-
ing, he would often take out a pad and sketch—whatever
the subject matter was, it didn't matter. "He just loved
sketching," Holly said. "He also got into watercolors.
He was quite good with both. Part of his scholarship
deal at Northwestern was that he had to make silk

screen posters for the speech department's productions, which he enjoyed doing. He was also a talented draftsman. He could do anything with his hands." In his limited spare time he still loved to read, a self-described "print freak" who would stare at the ingredients on cereal boxes if nothing else was available.

One afternoon, Heston noticed the pretty young co-ed sitting directly in front of him in his Fundamentals of Theater Practice class, a ravishing nineteen-year-old student with a tumbling mane of black Irish hair that bounced when she tossed her head back. She was an anthropology major taking the class as part of her minor requirements in theater.

He decided right then he wanted to marry her, even though he had no idea how to go about making that happen. Or even what her name was.

Charlton Heston at Northwestern, 1941. (Courtesy of the Heston Family)

Chapter Three

Lydia Clarke's mother, Lydia Lenore Schaper, was a direct descendant of Margaret Huntington, a British immigrant who had landed in the New World a new widow, after a long and difficult journey across the Atlantic Ocean. Her husband died within hours of their arrival in Boston in 1633. With five children to raise, she managed to eke out a living until she remarried and then thrived. A century later, one of her many grandchildren, Samuel Huntington, was a signer of the Declaration of Independence. And nearly a century after that, several Huntingtons fought and died fighting on the side of the North in the Civil War. Lydia Lenore Schaper, the daughter of Dr. Charles Schaper, was an activist for the suffragettes and a gifted teacher of the German language, who had to give up her career

when she married her husband, Lennox Barrett Clarke
of Wisconsin, because of the Wisconsin teacher-tenure
law of 1923 that made it illegal for female teachers to
be married (when the law was later rescinded, her hus-
band discouraged her from resuming her career).

L. B. Clarke, of Irish descent, was a graduate of
Northwestern and a Greek and Latin scholar.* He
survived eighteen months on the front lines of France
during World War I as part of the American Expe-
ditionary Force and, upon his discharge, became the
youngest principal of the high school in Two Rivers,
Wisconsin, where he met and married Lydia Schaper.
They had a beautiful daughter they also named Lydia,
who, while still in her teens, decided she wanted to
have a career as an anthropologist.

When Lydia turned her head to the side that day
in class and her dark curls shimmied, Heston couldn't
resist putting his fingers through them. Lydia remem-
bered, "I had, at that time, long black hair, and a lot of
it. One day in class all of a sudden I felt my head swing
back, and I realized the student sitting behind me was

* The family history lists "Clark" as the ancestral name, until
1817, when the e was added. Lennox Barrett Clarke always in-
sisted the name "Clarke" was English, "Clark" Irish. (Lydia
Clarke Heston, *Jack Heston, from 1067: A Family History* [Bal-
timore, MD: Gateway Press, 1996].)

pulling my hair. He claims he was merely caressing it."
No luck. He then tried doing a wolf howl for her in the
hallway just as she walked by, something he was sure
would do the trick.

It didn't.

She had noticed him all right, but decided he wasn't
at all her type. This hick was, in her words, "the tall-
est, skinniest man I ever saw in my life."

He nodded hello to her whenever they passed each
other on campus and was hoping to find a way to for-
mally introduce himself, but it wouldn't have mattered;
romance was the last thing on her mind. This was the
'40s; a woman either got married and raised a family or
remained single and pursued a career. She was attend-
ing Northwestern to prepare herself for a professional
life, not to find a husband. She never forgot that her
mother's ambitions had been curtailed by marriage and
motherhood, and she was determined not to go down
that same path. But even if she did, it never would have
been with Heston: "I thought he was arrogant and con-
ceited and supremely self-confident" was how she later
described Heston.

They soon found themselves auditioning for the
same plays. Each was cast in a separate one-acter on a
multiple-act bill, and at the daily rehearsals they con-
stantly and politely kept running into each other. Ac-

cording to Heston, it was Lydia who made the first real move when she asked him how she should read the weird entrance line she had in her script: "Minnie, my frog is dead!" He took the opening to ask this "breathtakingly beautiful, enchantingly intelligent, real *girl*" to go with him for coffee so they could talk it over.

Lydia didn't remember it quite that way: "We were insufferably rude to each other during play rehearsals and argued constantly," until one day, quite unexpectedly to him, she turned and said, sweetly, "I wonder if I could ask your advice, Mr. Heston." On the way to the coffee shop, Lydia later remembered, she had to tilt her head all the way back to look into his eyes. That was the first time she saw anything about him she actually liked. "We had a very stimulating conversation and that was it," she said. "I was insanely in love with him."

"That was my first date," Heston later recalled. "My first date with anybody. I was a pretty weird kid then. But I obviously found the right girl the first time out. And I had the brains to recognize that, even at 17."

Lydia quickly picked up on his moodiness and sensitivity and her calming effect on him, and also the fact that he was always broke. "One day he played the lead in a class play and was severely panned by student critics. After class I felt sorry for him and told him I thought he had done rather well. He scowled and said something

about not trying to kid him. 'I was just trying to be nice,' I said, 'but if that's the way you feel . . .' 'Come on,' he said, 'I'll buy you a cup of coffee.' When it came time to pay for the coffee he had to borrow the 20 cents from me."

He soon realized he would need money if he was going to seriously pursue Lydia, so he took any work he could get, including a stint as an elevator operator. "It was the best job outside of acting that I ever had, because you can get a little sleep. I used to rehearse in the lobby. I was on duty from midnight until eight in the morning, you see, and all the people who lived in the apartments were so old that they went to bed very early, so I was left pretty much to myself."

In what spare time he had, whenever Lydia—"Kitten" to him now—was also free, or made herself so, he loved to get together with her and talk about anything and everything, from reminiscing about the beloved woods of his childhood to his literary and dramatic hero, William Shakespeare. If anything attracted Lydia to him, besides his rough-edged good looks, it was the intelligent way he spoke and the words he used. They were his best assets, she decided.

Heston proposed marriage not long after they started dating, and her answer was a firm no. She insisted she wanted no part of marriage, not to him, not to any-

body, and maybe, she added, he should look to one of the many cute and very available co-eds on campus. Undeterred, Heston continued proposing, convinced that one day she would say yes.

As the first semester came to an end, their insular academic world was turned upside down, along with everyone else's, when, in December 1941, the Japanese attacked Pearl Harbor. That infamous early Sunday afternoon (midwestern time), Heston was at his dorm desk working on a paper about *Macbeth* when the shocking news came crackling over his radio. He was jolted out of his chair and, red-faced with rage, decided he *had* to enlist in the military and help defend his country. The next day he joined the Army Air Corps Reserves, hoping to move through basic training quickly and be sent on to active duty.

It didn't exactly happen that way. Two and a half years passed before he received the call-up, during which time he continued his studies at Northwestern. He and Lydia continued to see each other, and as she gradually grew more comfortable around him, she sometimes let him hold her hand as they walked, but that was it. She would go no further, leaving Heston wondering how she really felt about him. Then shortly before he was finally scheduled to leave for basic train-

ing, he found out she was going on a date with another young man who had just enlisted in the navy. It was too much for him. He burst in on them during their dinner at a local restaurant, grabbed Lydia by the hand and pulled her out the door. She didn't resist; the other fellow didn't really matter to her anyway and she liked the drama of the moment.

Then, in the winter of 1944, Heston was gone.

He was assigned to basic training in the piney woods just outside of Greensboro, North Carolina, where, despite the rigorous wartime regimen, he found time to write to Lydia every night before he went to bed (proposing in every letter). When he received his orders to ship out, he wrote Lydia for what he believed would be the last time, telling her he was about to be assigned to an active-duty unit and promising he would come back in one piece. Two days later, after breakfast he found a telegram that had been placed atop his neatly made bunk. Telegrams were never good news and his first thought was something must have happened to his mother. He ripped it open, read it, and broke into a smile that was a combination of relief and joy: "HAVE DECIDED TO ACCEPT YOUR PROPOSAL. LYDIA."

He arranged for her to come to Greensboro by train and managed a last-minute two-day pass. He reserved a room at a bed-and-breakfast in town and bought a

twelve-dollar wedding ring from a local jeweler. He met her at the station in his uniform, and when she stepped out of the car put his hands under her arms and lifted her off her feet. He held her that way as he kissed her and spun in a circle until they both were so dizzy they almost fell down.

They were married on St. Patrick's Day, March 17, 1944, he in his dress uniform, she in a lavender suit she had bought for fifty dollars, with matching high heels and a white hat covered with artificial flowers. On the way to the Grace Methodist Protestant Church, which Lydia later described as "a beautiful white church with a flowering cherry tree in bloom," the skies opened and she and Heston held hands and ran to avoid arriving drenched. Only then did she take her hat off, and Heston waited to see if the rain had ruined it. Then he broke into a grin and said, "If only they'd been real flowers, it might have done them some good."

Two ladies from the church served as witnesses. After, the minister wouldn't let Heston pay, he said, because soldiers were giving enough defending the country. The next day, the eighteenth, Heston shipped out, to Scott Field in Illinois, assigned to further training at radio school, and Lydia returned to Northwestern to complete her studies.

At Scott Field, Heston proved adept at learning

Morse code—memorizing patterns was easy for him when he broke down the dots and dashes like the lines of a play to learn their rhythms. Then it was on to aerial gunnery classes, where he was trained how to handle a .50-caliber machine gun, something that he was also able to pick up without much difficulty, having been around guns since he was a little boy. His next stop was Sheppard Field, in Texas, and after that Selfridge Field, in Michigan. By the time he arrived at Selfridge, he had reached the rank of staff sergeant, which made it easier for him to get a three-day pass to see Lydia.

As Heston sweetly notes in his memoir, they spent the first day of this brief reunion "conjugating." That night he took her to see Paul Robeson in *Othello* at the Cass Theatre in nearby Cass City. As he ran his fingers down the phone book looking for the street address, he noticed a listing for "Carter, Russell W." He turned to Lydia, pointed to the listing, and told her he believed this might be his real father, whom he hadn't seen since that day nearly four years ago at the high school softball field. Lydia urged him to call and find out and, if it was him, to meet with him. According to Holly, "He was hesitant because he didn't want to open old wounds. The painful memories of what had happened were still there, and he knew his mother would be unhappy if he reunited with his father, but he decided since he

was over eighteen he should make that choice for himself. His longing for a connection to his real father was stronger than his not wanting to disappoint Lilla."

He dialed the number. When a man's voice answered, Heston asked if he was the Russell Carter from St. Helen. The voice said yes, and Heston said, simply, "This is Charlton."

After a pause, Russell said hello. They talked for a few minutes, and when Heston gave his father his address, he said he'd be right over. "It was the beginning of reestablishing their relationship that this time could not be interfered with by my grandmother," Holly said. "She never wanted them to have a relationship. She wanted [Charlton] to learn about art and music, not how to skin rabbits."

Russell arrived at the hotel twenty minutes later with his second wife, Velda, and his six-year-old towheaded daughter, Kay, the half sister who until then Heston didn't know he had. The meeting was warm, and he couldn't help but notice how much older and less fit his father looked. When Russell suggested they come and stay at his house for the duration of their stay, Heston and Lydia said yes.

The weekend passed quickly, and when it was over Russell took them both to the station, where Lydia boarded a train back to Northwestern. Heston looked

tall and handsome in his uniform as she watched him slowly shrink into the distance. She put her head in her hands. "It was hard to have him go off and become a soldier. It was very painful for me."

Heston returned to Selfridge Field, but he wouldn't be there for long. The next day, he received a new assignment. He was being sent to the Aleutian Islands in Alaska, where, it was widely rumored the Japanese were planning another murderous sneak attack.

Sergeant Heston in the Aleutian Islands during World War II.
(Courtesy of the Heston Family)

Chapter Four

In 1942, the Japanese had invaded the islands of Kiska and Attu in the Rat and Near group of the Aleutians off the western coast of Alaska. It took the Allies more than two years to drive them out. The American commanders knew the Japanese were planning a new offensive and had sufficient air power ready to defend against it.

Heston was assigned to the Seventy-Seventh Bombardment Squadron of the Eleventh Air Force, stationed on an island in the Aleutian chain, where he was trained as a radio gunner and, for the next two years, flew several B-25 combat missions over the Kuril Islands of northern Japan. His assignment was to man one of the waist guns that radiomen like him usually handled as the second gunner. The extreme weather

they had to fly through, with no visibility and limited radar, was as dangerous as enemy aircraft. Radiomen were the only connections pilots had to their landing strips, and their primary role was to help guide the planes safely down.

In whatever spare time he had, which was not much, Heston plotted a world map and had it sent through the proper channels to Lydia. He was not able to tell her exactly where he was, but he had left a secret code with her before they'd separated. He told her to read his letters that quoted Shakespeare, and then look up the quote to find the act and the scene it was from. Those numbers would be the coordinates of where he was on the map.

Late in 1944 word filtered through the base the coming all-out invasion of Japan would surely cost at least a half million American GI lives. Heston was sure he was going to be part of that grand assault. The army would be sending every available soldier it had to Tokyo. A grim silence engulfed the base as the men waited, on edge. One day, not long after, an army plane returning from a mission got caught in a crosswind and crashed onto the island. As Heston and others ran to help get the pilots out of their cockpits, he slipped on a patch of ice and was run over by an ambulance. He was taken along with the pilots to the base medical center.

When he had recovered enough to travel, he was sent to Elmendorf Field in nearby Anchorage, Alaska. Still in a wheelchair, he was assigned to the base control tower, convinced that if he was well enough to handle this, he should be considered well enough to be part of the invasion despite his injury.

And then, without warning, in August 1945 the United States dropped two atomic bombs on Japan, one at Hiroshima and one at Nagasaki, and the war in the Pacific was over. There wasn't an American soldier anywhere who didn't celebrate the decision to use nuclear weapons on the enemy, including Heston, who believed the bombs saved the lives of those half million GIs, including his own. "If we had to go through that invasion, I'm not sure I'd be standing here today," he said later.

A few weeks after the Japanese officially surrendered, a still-limping Heston was transferred to Great Falls, Montana, where he was given a formal discharge. In March 1946, the twenty-three-year-old veteran was once more a civilian. He wasted no time heading back to Evanston and to Lydia, who greeted him at the train station with open arms, tears of happiness streaming down her face.

Lydia had graduated that June and started modeling while looking for acting work. Heston moved into her

small, rented Chicago apartment that she'd held on to. (She had lived in one of the dormitories until her wedding, then had to move out because of the university's policy that married women whose husbands weren't with them were "bad influences" on single, unattached students.) It was the first time the couple actually shared a living space. Heston was getting twenty dollars a week veteran pay that he would receive for a year, part of what was then known as the "52–20" deal. Combined with her modeling fees, it was barely enough for them to get by.

As soon as he settled in, he received a call from, of all people, the filmmaker David Bradley, who had somehow managed to track him down. Bradley had scraped together $5,000 to make a new sound movie version of *Macbeth*, he told Heston, and wanted him to design the costumes for the film. Heston excitedly asked if he could also play Macbeth, but Bradley said no, he was going to play the part himself. Heston took the job.

After completing work on the film, Heston suggested to Lydia that they move to New York City and try to find acting work on Broadway, and she eagerly said yes. As they began to make their plans to leave, Heston heard about a new Chicago play and tried out for it. British director Harry Wagstaff Gribble was looking to mount a biracial Broadway production of *Romeo*

and Juliet. Gribble had had some success a year earlier with an all-black production of *Anna Lucasta* that had begun in Chicago before moving to Broadway. Emboldened by that success, he decided to try *Romeo and Juliet,* using black Capulets and white Montagues, and opening it in Chicago prior to moving it to New York. He cast the actress Hilda Simms as Juliet and began to audition local actors to fill out the rest of the parts.

Heston tried for and got the part of Mercutio, a small but important role in the play. Neither a Montague nor a Capulet, Mercutio is a friend of Romeo's and the play's voice of reason, and gets killed off in a sword fight with Juliet's hotheaded cousin Tybalt (played by an as-yet-unknown Brock Peters). Mercutio has one good scene before he dies. Heston was thrilled; it meant he would be going to New York as a Broadway actor. The show began rehearsals and all went smoothly until Gribble suddenly lost his funding and the production collapsed.*

Heston and Lydia resumed their plans to move to New York City. Lydia went to stay with her parents while he boarded a train for New York to find them a place to live.

* The word was that Broadway did not want a biracial production of *Romeo and Juliet,* and the show's investors were pressured to pull out by New York's powerful all-white clan of theater owners.

Charlton Heston performing in Macbeth *live on the CBS network's* Studio One, *October 21, 1951.* (Courtesy of the Heston Family)

Chapter Five

To Charlton Heston, New York City meant Manhattan, and Manhattan meant Broadway. When he arrived at Grand Central Terminal with his suitcase in hand, he went to a phone book and called an army buddy, a Jewish fellow living with his family in Brooklyn. They offered to put Heston up while he searched for an apartment. He later recalled that this was his first exposure to the ethnic richness of kosher food, something he'd never even heard of before.

He quickly discovered how scarce apartments were in postwar Manhattan, due mostly to all the returning GIs. While continuing his search he ran into another army pal who said he had a friend, Edgar Pitske, who owned a couple of Hell's Kitchen cold-water tenements he rented only to veterans. Heston met with Pitske, who

agreed to rent him a third-floor walk-up—a two-room, single-tap cold-water railroad—in a nineteenth-century tenement at 433 West Forty-Fifth Street, for thirty dollars a month. The Hell's Kitchen neighborhood was where a lot of young actors, musicians, and dancers who worked the Broadway theater circuit lived.*

The air in the third-floor hallway had a musty, closed-in staleness to it. The rickety stairs crackled under his weight whenever he ran up and down them, and the door to the railroad apartment opened directly into what passed for a kitchen. All the rooms were the same size—thirteen by ten feet—one behind the other in a row, with no partitions, just small ceiling archways. There was no heat, no air conditioning, and one tiny bathroom that Pitske had added to bring the apartments up to postwar code. As Heston later recalled, "The flat had just two little windows and if I went up on the roof I could see daylight."

He took the subway back to Brooklyn to get his things, brought them to the new apartment, and then went to Western Union and sent Lydia a wire to come

* Pitske initially tried to charge Heston forty dollars, but Heston appealed to the rent control board, who didn't allow it. "I still have a rent receipt he signed 'reduced rent accepted under protest,'" Heston said later. (Charlton Heston, interview by Michael Viner, *Interview,* June 1976.)

join him in their new palace. It was like a forest, he told her. After she arrived he explained what he meant—it was a forest filled with all types of wildlife: roaches, mosquitoes, mice. *But they were in New York! What could be better?*

One of the first things Lydia did after she arrived was to pawn her wedding dress. She got ten dollars for it, enough to buy some linoleum for the tilted, bare wooden kitchen floor and a used carpet for the front room. Heston bought a desk from the Salvation Army for $2.50.★ The first few days they slept on the floor while Heston finished building a bed frame and a couple of bookcases from discarded boards he found in the street. He gave Lydia a fifteen-dollar-a-week budget to buy food, mostly canned goods, lots of peaches, his favorite, and they shared a five-dollar-a-week budget for carfares (when they couldn't walk it) and clothing (to be bought used and only when absolutely necessary), and if they had anything left over, they could eat out once or twice a week, mostly at the Gaiety Bar at Forty-Sixth and Eighth, where a hot meal cost fifty cents, or at a cheap Chinese restaurant on their block where food

★ For the rest of his life, Heston donated to the Salvation Army in return, he said, for all the help the organization had given him during his years as a struggling actor.

was served family style for a dollar. Bars and grills all over the city one night a week when hot dogs boiled in huge vats were given away with drinks, while piano players pounded out show tunes and singers sang and dancers danced, with each other or alone, the bar floor their stage. As Heston later recalled, "That was when you could be both broke and happy in New York City."

They scoured the daily trade papers to find out where auditions were being held. If there was nothing on any given day, they made the familiar actors' rounds of agents and producers to drop off their pictures and résumés. "I was a very difficult actor to cast by the time I got to New York," Heston later recalled. "I was six foot three, broken nose, bass voice, and going up for juvenile roles. I'm not going to get those parts."

When it became clear that his twenty dollars a week and her small savings were not going to be enough to make ends meet, Heston began looking for nonacting jobs with enough flexibility to allow him to go to auditions and callbacks. One day he saw an ad in the paper for men with "perfect physiques." He answered it and landed his first job in Manhattan, posing as a nude model for the Art Students League of New York on West Fifty-Seventh Street, for $1.25 an hour. He later recalled one of the special hazards of the job: "I did get an erection once, but I wasn't thinking about sex

or Shakespeare at the time. I think it was because the studio was warmer than usual . . . it got pretty crowded inside that jock strap, but I never moved a muscle and in the end it gave up." Lydia had sewn a little gray velour jock strap for him to wear, so he wouldn't catch cold, she said.

Lydia also found work as a "figure model" at the art institute as well as catalog work, mostly girdles, slips, garter belts, and stockings.

That September, during his morning perusal of the trades, Heston saw an ad for actors, specifically veterans (proof needed), to try out for a place in the Theater Incorporated repertory company. He answered it and was told to report to the Booth Theater on West Forty-Fifth Street, where he sat patiently in an outer room while the other veterans there before him went in and auditioned. When it was finally his turn, he did Mercutio's famous "Queen Mab" monologue.

He was one of the few asked to stay; the rest were dismissed with the usual "Thank you. We'll call if we need you." The casting director was Robert Fryer, a friendly, diminutive fellow, who then asked Heston to read for the male lead in the company's upcoming production of *The Changeling*, a Jacobean tragedy written by Thomas Middleton and William Rowley. Fryer liked what he saw and gave Heston a tentative yes, but

before the production happened Theater Incorporated suspended operations due to a lack of "investor interest"; they had run out of money. Heston returned to nude modeling, disappointed at this latest dead end, and back to pounding on doors, hoping for some kind of break. "No one who hasn't been an actor can know how ego-shattering it is. I went up for stage shows, radio, TV, anything. In ordinary work, you are just turned down, impersonally. But in theatrical work, you are told you are too big or too short, your eyes aren't the right color, or your voice is terrible. The rejection is a rejection of you as an individual."

The fall cross-faded into winter and the city turned biting cold, the streets filled with relentless snow, and the days dark by late afternoon. By Christmas the Hestons were cold, hungry, and nearly broke, barely clinging to the last bit of their Broadway dream. Heston had somehow managed to save a few extra pennies and gave them to Lydia so she could buy a green woolen hat to keep her head warm as his Christmas present. Lydia gave him a couple of used books on painting.

They continued to make the rounds, slagging through the wet slush of the city's sidewalks, until one day early in the new year when it looked like he might have actually caught a real break. Forrest Wood was an associate

of the Thomas Wolfe Memorial Theatre in Asheville, North Carolina, and he had come to Manhattan to find a director for the spring season. He talked to several producers and casting directors, one of whom gave him Heston's picture and résumé. Wood put it in his pile and, after going through all his other potentials without finding anyone willing to take the job—most actors wanted to stay in New York City and land something on Broadway—he called Heston.

When he found out the job included room and board, he agreed to take it if Wood would hire Lydia as well. Wood went back to the theater and met with the board of directors. They agreed to hire both Hestons for a combined salary of $100 a week, one shared room, and three meals a day. Heston found a friend to take over the apartment, then he and Lydia packed their bags and caught a Greyhound bound for Asheville.

Regional theater in postwar America was not the star-studded extravaganza it has since become. The Thomas Wolfe Memorial Theatre, a two-hour drive out of Charlotte, was a place where beginning actors and actresses could practice their craft in front of audiences whose level of expectation was far less than those on Broadway. For the Hestons, the benefits were many. It gave them a chance to act in plays together, something they hadn't done since their days at Northwestern; it

afforded him an opportunity to learn how to direct live theater; and it provided room and lodging in the relative comfort of the warmer North Carolina winter.

The theater itself wasn't much—part of the local church's community center—and the talent pool was made up of local volunteers. Heston was put in charge of everything, from picking what plays to perform to casting and directing. He dove into his assignment with great enthusiasm; in addition to his other chores he designed the sets, costumes, and posters that hung in storefront windows nearby and in Charlotte for every show.

To open the season, Heston chose Elliott Nugent and James Thurber's *The Male Animal,* a play he'd acted in at Northwestern, and to close it he went with Russel Crouse and Howard Lindsay's *State of the Union,* a hit on Broadway the previous season. He gave Lydia a featured role in *Male Animal* and the female lead in *State of the Union.*

Both shows sold out and the board of directors asked the Hestons to consider extending their stay through the summer with a decent salary bump, bigger budgets to produce better-looking shows, a local radio show, and the use of a car. They accepted the offer, and Heston mounted productions of the stock standard *Kind Lady,* a play about a wealthy woman trapped in

her house by evil dastards, with Lydia in a prominent role, and Tennessee Williams's *The Glass Menagerie,* in which he cast himself as Tom. As he later remembered, "We went there to do one play, earn a little money, and return to New York, and it was a pleasant thing, after having been thrown out of countless offices and having doors slammed in my face, to go somewhere and find that an opinion was respected and you could work!"

So they worked, but by the end of August they had had enough of regional theater and turned down another contract extension that would have kept them in North Carolina through the fall. The morning after *Menagerie*'s run ended, they made their good-byes and Forrest Wood drove them to the Greyhound terminal, where they boarded a bus for the eighteen-hour ride back to New York City.

When they stepped out of the depot, tired and stiff, they were hit with the city's unique smell of warm summer garbage that trailed them all the way to Forty-Fifth Street, where Heston carried their bags up the three flights to their freshly vacated and sweltering apartment.

They quickly found themselves back in the same old routine of actors going nowhere fast, and at one point, broke and hungry, they thought about returning to Asheville, when Heston received a tip from a friend

that the famed Broadway producer and director Guthrie McClintic was casting a new production of Shakespeare's *Antony and Cleopatra* as a starring vehicle for his wife, Katharine Cornell, at the time the first lady of the American theater.

Early the next morning, Heston hoofed it to McClintic's luxe Radio City headquarters, only to find it already crowded with actors waiting for a chance to try out for what was sure to be the hit of the fall '47 Broadway season. "The offices [were] jammed by people who probably had genuine appointments, and maybe had actually met Miss Cornell or worked with her, or at least [had worked before] on Broadway. None of these applied to me. The girl inside the office came out and ushered in someone who actually had an appointment, and I slipped into that empty seat. They worked through eight or nine people until I was the only one there, and she said, 'I don't think we have your name?' I said, 'Charlton Heston, Maynard Morris of MCA sent me up.' I'd never been inside MCA and never met Maynard Morris. She said, 'Well, we're a little ahead, I guess we can see you.'"

The bluff worked and Heston found himself face-to-face with McClintic, who looked exhausted and by now was just going through the paces. After he quickly ran down Heston's well-padded litany of experiences,

McClintic sighed and in a flat voice asked him to do a cold reading. An assistant handed him the closing monologue of Octavius Caesar and he read it, then paused and waited for a response. Without showing any emotion, or looking up, McClintic told him to come back the next morning.

He kept Lydia up that whole night talking over what his chances were and why he would and then wouldn't get the part. Back at the Radio City offices by eight A.M., he was ushered into McClintic's office, who sat him down and informed him he was Proculeius in the play, a small but important part. Heston was elated. He had been discovered! His acting abilities had been deemed worthy! The truth was less laudatory than practical. McClintic cast him because of his height; Katharine Cornell liked to act with tall actors.

Heston's pragmatic welcome to Broadway came with a sixty-five-dollar-a-week salary and, just as important, a coveted Actors' Equity card, entrée to union-member-only auditions that would take him out of the cattle-car open calls.

The big production opened November 26, 1947, with a cast that included, besides Cornell, Godfrey Tearle, Eli Wallach, Maureen Stapleton, Bruce Gordon, and Charlton Heston. It received strong reviews and enjoyed a healthy, sold-out six-month run and a few extra

weeks on the road. There were one or two minor mishaps along the way for the rookie, including the night he almost stabbed Cornell to death onstage with his prop sword, something he was summoned to her dressing room about after. Calling him "Chuck," she lifted her robe high up on one side and showed him her bruised thigh. She then asked him if he could move his sword to his other hip so he wouldn't keep on stabbing her. Of course, he said, apologizing and quickly leaving, grateful he wasn't fired.

When the play's run ended that spring, Heston and Lydia booked a season of summer stock at Mt. Gretna, Pennsylvania, a repertory company that rehearsed a new show during the day and performed the current one at night, a total of ten plays in eleven weeks. He and Lydia played the leads together in three: George S. Kaufman and Moss Hart's farcical *You Can't Take It with You;* Patrick Hamilton's melodramatic *Angel Street,* which the film *Gaslight* was based on; and Henry and Phoebe Ephron's romantic comedy *John Loves Mary.* They were reliable crowd-pleasers that shared a crucial stock component: they could be performed on a single set. When the season ended, Labor Day weekend, the Hestons returned once more to New York City, creatively stimulated, and with a few dollars in the bank, ready once more to take on the world.

That fall, Lydia managed to find a real agent, Maynard Morris of the MCA Talent Agency—the same Maynard Morris whose name Heston had used to fake his way into the audition with McClintic. Morris immediately put Lydia up for the role of Lady Anne in a new off-Broadway production of *Richard III,* and she got it. Lydia then asked Morris if he would consider seeing her husband, and he said he was happy to oblige his new money-earning client. He met with Heston, signed him, and quickly placed his newest client as an understudy for the lead in a new Broadway play that no one seems to remember. (The show opened with a thud, and the run lasted exactly one week. Heston never played the role.)

Morris then helped him land a small role in Rouben Mamoulian's production of Joseph Hayes's *Leaf and Bough.* It opened January 21, 1949, notable because it provided Heston his first professional mention. John Chapman, the drama critic for the *New York Daily News,* hated the show but liked him and gave him one line in the review: "Charlton Heston holds your interest as the repulsive and despicable Brother."

Leaf and Bough closed after three performances.

The next month Morris got him into something called *Cock-a-Doodle Doo,* wearing only a jock strap

(the same one Lydia had made for him when he was a nude model). The *New York Times* called the play "gibberish." Heston was thankful not to be mentioned this time in the newspaper's bloodletting review.

And then he hit a wall. Unable to find another Broadway job, Heston agreed to return to Evanston to film another Shakespearean "epic" for David Bradley, a ninety-minute sound version of *Julius Caesar.* He went by himself because Bradley couldn't afford to pay travel and lodging for Lydia. The film was made quickly and on a shoestring. Bradley shot Heston doing Antony's famous "Friends, Romans, countrymen" speech on the steps of Chicago's Field Museum.

With filming completed, Heston returned to New York and an out-of-work Lydia. Things once more looked bleak for the young couple, when a new phenomenon came along that was about to revolutionize the world of entertainment. It was something like radio, only better, or worse. It had live pictures, sort of, that appeared on ten-inch black-and-white screens that jerked around as if suffering from some sort of nervous condition, with weird horizontal lines that sometimes turned into disturbing zzzzs, tinny sound, and a lot of cornball content.

They called it television.

In 1948, the nascent TV industry that had begun in the late 1930s was rebooted, helped immeasurably by the introduction of a show that starred a has-been burlesque comic who walked on the sides of his feet, made funny faces and strange noises, and regularly had pies thrown in his face by cohorts. Milton Berle was television's first prime-time star. The popularity of his weekly Tuesday night variety show helped sell millions of TV sets and made watching TV a regular family living room ritual.

In the late '40s, most network television was broadcast live out of New York City because that's where the largest pool of talent lived.* Manhattan was already the capital of live theater in America; many radio programs originated there, "serious" writers all wanted to live in the city, and actors who as yet had no marquee value and were willing to work for next to nothing to appear on the new small-screen medium were plentiful. Television was the answered prayer for all those out-of-work thespians making ends meet by tending bars, waiting

* New York–based TV was broadcast live regionally along the East Coast and kinescoped for later prime-time broadcast in the rest of the country.

on tables, selling shoes at Macy's, or posing nude at art schools.

Robert Fryer, the producer who had attempted and failed to mount *The Changeling* in Chicago, was now working for CBS's new live drama division. When he decided to air a production of *Julius Caesar* as part of the spring 1949 schedule for the network's popular *Studio One* dramatic series, he would see only actors with professional experience doing Shakespeare. Fryer knew that Heston had done *Antony and Cleopatra* for McClintic and called him in to try out. Heston auditioned; he didn't get Caesar or Antony, but landed one of the lesser roles, a bit that paid all of fifteen dollars, before taxes.

Heston happily reported for work the first day of rehearsals, and he was amazed at how small the studio set was that was meant to suggest all of Rome, with three bulky cameras squeezed in just beyond the line of sight. Frank Schaffner, the resident executive producer/director for CBS-TV, was directing the show, and during rehearsals he mentioned to Worthington "Tony" Miner, his line producer, that he thought "the kid," meaning Heston, had some real talent and maybe should be bumped up to a bigger role.

It didn't happen, but a week later, Schaffner cast him in a featured part in the *Studio One* production of *Jane*

Eyre, and then *Battleship Bismarck.* By now, Schaffner had a pool of actors he liked to use as they all felt their way through the new medium together. They included Jack Lemmon, George C. Scott, Steve McQueen, Walter Matthau, James Dean, Anne Bancroft, Joanne Woodward, Rod Steiger, and Charlton Heston.

As he later recalled, "The whole new medium was invented by a group of unemployed twenty-five-year-olds, of which I was one . . . [W]e got to make up [the medium] as we went along. In the space of fifteen months as a freelance actor I got to play in *Taming of the Shrew, Wuthering Heights, Of Human Bondage,* and [many of us] already had something of a following." It was a great time of learning for Heston the student of television, and terrific exposure for Heston the actor of the small screen. "The stretching capacities were fantastic . . . I'm not pretending that my roles in *Macbeth* and *Taming of the Shrew* were marvelous productions, but at least the material for live TV theater was more valuable than sitcoms [of the day]. It taught me my trade and made me a better actor."

Eventually, one of his TV performances caught the eye of a Los Angeles–based independent producer named Hal Wallis, on the make for new talent. Wallis had seen Heston's Heathcliff in the *Studio One* production of *Wuthering Heights* and wanted to sign him to

a film contract. Only one thing stood in the way of a deal: Charlton Heston. He considered himself a New York actor and had already turned down a contract from Jack Warner to study film acting at his studio as a way to break into the movies. Heston was sure he wanted nothing to do with Hollywood.

Charlton Heston making his movie debut in William Dieterle's noirish Dark City *(1950), produced by Hal B. Wallis.* (Courtesy of Rebel Road Archives)

Chapter Six

During the '30s and '40s, producer Harold Brent "Hal" Wallis made a series of hugely popular films at Warner Bros., beginning with Mervyn LeRoy's 1931 classic gangster picture, *Little Caesar,* which made a star out of Edward G. Robinson and set the standard for the genre. Along the way Wallis discovered and was instrumental in promoting the careers of, among others, Errol Flynn, Bette Davis, James Cagney, and Humphrey Bogart, the latter perhaps most memorably as "Rick" in Michael Curtiz's 1942 classic, the multiple-Oscar-winning *Casablanca.* The night the film won Best Picture, an award that goes to the film's producer, Wallis rose from his seat and started walking to the podium, but he was beaten there by Jack Warner, who

accepted both the statuette and the accolades. The next day Wallis resigned from the studio.

He formed a new independent production company and signed a long-term deal with Paramount Pictures. In return for funding his films, Paramount retained exclusive rights to distribute them (utilizing Universal Studios' widespread network). Wallis was eager to sign fresh faces under exclusive contract, and unlike most Hollywood producers who saw TV as the competition, he was excited by television, believing it was the best breeding ground for new big-screen talent. He had seen Heston's Heathcliff and was impressed enough to want to sign him for a new film project. Wallis had acquired the rights to Larry Marcus's novel, *No Escape*, intending to turn it into a movie, and liked Heston for the featured role of a young card hustler.

He quickly found out it wasn't going to be that easy to get him, because Heston insisted he had no interest in movies, but Wallis stayed at it and went to Maynard Morris who convinced the reluctant young actor to at least go out to Hollywood to talk things over. After speaking with Morris, Heston agreed to consider signing a contract with Wallis if it allowed him to continue to act on the New York stage and in live TV. Morris assured him Wallis didn't care about any of that. Morris

then connected Heston with a West Coast MCA agent to negotiate the deal. The agent's name was Herman Citron. Citron was told by Wallis that he wanted Heston to sign a nonexclusive five-picture commitment, with no set time limit to fulfill it. (Wallis was thinking like a producer; if *No Escape* was a hit, he would have a rising star signed for four more movies. If it bombed, he could cut Heston loose and send him back to the New York he loved so much.) The deal was set and Wallis arranged for Heston to fly out to L.A. He had to make the trip alone because Lydia, via Morris, had just landed a job in the original Broadway production of Sidney Kingsley's *Detective Story*, replacing Meg Mundy in the role of Mary McCloud.

Walter Seltzer, a quiet accounting type, was the publicity director for Hal Wallis Productions. Here Seltzer describes his first meeting with Heston: "We signed a young actor out of New York called Charlton Heston. I was assigned by Wallis to go and meet him at the airport when his plane landed in Los Angeles." Seltzer had brought along a wallet-size publicity photograph to make sure he greeted the right person coming off the plane. He held the photo in his palm, and when he recognized the actor he quietly slipped it into his jacket pocket, smiled, went over and extended his hand. "I

remember he was wearing a very tired blue suit, which I guessed was his only suit at the time, and the pants were a little thin. I was a bit hesitant to invite him to come to lunch with me at [the exclusive Hollywood restaurant] Romanoff's, but I did . . ."

Wallis was already there at his favorite table, sipping a drink and waiting for them, and he stood and waved as soon as Seltzer and Heston came through the front door. At the next table, Heston immediately noticed, was Spencer Tracy, one of his idols, devouring a bowl of fresh strawberries smothered in whipped cream. Heston had to pinch himself to make sure he wasn't dreaming. "How do you like everything so far?" Seltzer asked him. Heston took a deep breath, smiled, and said, "This must be heaven."

Later, Heston's son, Fraser, recalled, "He still wouldn't admit to himself that movies were going to be his future. This was meant as a short-term one-film thing, after which he would return to his real life in New York. It was, however, the start of a beautiful life-long friendship between Seltzer and my dad." Heston told one Hollywood reporter, during an interview set up by Wallis's people, that he was a New York actor and meant to stay one, and as if to prove it, he said he intended to keep his apartment in Hell's Kitchen:

"After all, I haven't made a fortune yet . . . and where else is there a place fixed up the way we want it where we could live for $30 a month?"

Despite all that Wallis had done for Heston, he thought his new actor still seemed a bit distracted. He was right, he was—mostly because he was constantly thinking of Lydia and how he didn't like being three thousand miles away from her. Nothing meant more to him than that, and because of it he hadn't yet signed the contract with Wallis. Only after a long phone call to Lydia one night, when she came home from the Broadhurst Theatre, where *Detective Story* was playing, in which she urged him to, did Heston finally put pen to paper, set to star in *No Escape,* by then renamed *Dark City.*

Wallis wasted no time cranking up his star-making machinery. The first official mention of Charlton Heston in Hollywood appeared within days in Paramount's in-house newspaper:

Charlton Heston, new discovery from Broadway and television . . . is making his debut in Hal Wallis' "Dark City." Heston was notified recently that he and his wife, Lydia Clarke, have been named "Most promising theater personalities of the year"

by "Theatre World Magazine" . . . the first time in the history of the awards that the magazine has chosen a married couple in the same year.

The industry bigs read the article with great interest, none more than Jack Warner, who had tried and failed before Wallis to sign Heston. He was already furious at Wallis for leaving the studio, and was now so enraged at MCA for repping the deal that he unilaterally banned all its agents from ever again doing business with Warner Bros.*

Wallis then assigned veteran William Dieterle to direct the film, whose cast included some well-known film names: Lizabeth Scott, Viveca Lindfors, Dean Jagger, Don DeFore, Ed Begley, Mike Mazurki, Harry Morgan, and Jack Webb. Heston was the newcomer among them. Filming began April 5, 1950, at Paramount Studios and on location at the Griffith Observatory, Union Station, an amusement pier in Santa Monica, the Wilshire Plaza Hotel, the Valley Vista Motel, and in and around North Hollywood, Las Vegas, and Chicago.

The film is a noir crime caper, similar in type and look to earlier independently produced films of Wal-

* The ban lasted two days.

lis's that introduced his newest protégés Burt Lancaster (Robert Siodmak's *The Killers* [1946], distributed by Paramount) and Kirk Douglas (Lewis Milestone's *The Strange Love of Martha Ivers* [1946], distributed by Universal). Both pictures were box-office hits and made stars out of their relatively unknown male leads, and Wallis hoped lightning would strike a third time with Heston.

In *Dark City*, Heston plays Danny Haley, a World War II veteran who has difficulty readjusting to civilian life after his discharge and becomes a hustler, one of a team of sleazy card-game sharks who takes a mark (DeFore) for $5,000. The mark then commits suicide, and his brother, Sidney (Mazurki), sets out to avenge his death by killing the crooked gamblers, one by one. "I had never heard of *film noir*," Heston recalled years later. "When in doubt I reverted to my 'brooding look,' which I thought matched the mood of the movie."

As soon as filming was completed, Heston flew back to New York City, in time to catch the closing night of *Detective Story*. The next day, to celebrate his good fortune and Lydia's, he used some of his *Dark City* money to buy a brand-new cream-colored Packard convertible that he kept parked on the street in front of their building. Word quickly spread among the neigh-

bors that it belonged to that "movie star guy." Nobody ever touched it.

With both out of work for the first time in months, and with a little money still in the bank, the Hestons decided to take their first real summer vacation together and drove the Packard out to the white sandy beaches of Fire Island. They stayed there until October, returning to the city only to attend a sneak preview of *Dark City.* It received positive marks from the audience and Wallis was delighted, believing he had a hit film on his hands and a new star in his pocket. He scheduled a fourteen-city, twenty-three-day publicity blitz for Heston to promote the film, and his performance in it.★

The film officially opened on October 17, 1950, at Manhattan's Paramount Theatre. The next day the *New York Times*'s film critic Bosley Crowther panned the film but praised Heston's debut:

A new star named Charlton Heston—a tall, tweedy, rough-hewn sort of chap who looks like a triple-threat halfback on a midwestern college football team—is given an unfortunate send-off on the

★ The accompanying Paramount press release for the film also described Heston as six foot two (an inch shorter than he was) and 205 pounds, with gray-blue eyes and blondish hair, shoe size 12, hat size 7½.

low and lurid level of crime in Hal Wallis' thriller, "Dark City," which came to the Paramount yesterday. Apparently Mr. Heston, who has worked for the stage and video [television], has something more than appearance to recommend him to dramatic roles. He has a quiet but assertive magnetism, a youthful dignity and a plainly potential sense of timing that is the good actor's *sine qua non*. But in this "clutching hand" chiller, he is called upon to play nothing more complex or demanding than a crooked gambler marked for doom.

Crowther's review didn't help sell tickets, and Paramount moved the picture to a smaller theater in the city, near the Brooklyn Navy Yard, where it quickly sunk into the ocean.

Nonetheless, that December, in her "Hedda Hopper Picks Film Stars of 1951," the Hollywood gossip columnist marked the following actors and actresses for stardom in the coming year: Arthur Kennedy, Lloyd Bridges, Judy Holliday, Jan Sterling, David Wayne, Barry Sullivan, Gary Merrill, Jeff Chandler, Mala Powers, Micheline Presle, Faith Domergue, Howard Keel, Frank Lovejoy, "Anthony" Curtis, "Deborah" Reynolds, and . . . Charlton Heston: "A huge, talented fellow, [he] caused considerable commotion when he

came here to make his first picture, *Dark City,* last summer. Two producers fought over him . . . Charlton, in addition to being a very good actor, also has a great personality."

The film eventually earned back its cost but failed to generate any profits. Later on, Heston recalled this about the production: "I [know I] learned to deal cards one-handed . . . I also remember a lovely, soft scene with Viveca Lindfors, shot in the Planetarium at Griffith Observatory in L.A. . . . Dieterle was a good director and I gave him a good performance, if no more than that . . ." With the passage of time, however, Heston grew less kind about his first film outing: "I don't think *Dark City* is a good film . . . it's like *The Movie of the Week,* strictly a television movie . . . after you've done six or seven films, you can survive a mediocre one. But when a mediocre one is your first film, it's a little dicey."

When the film flopped, without bothering to tell Heston, Wallis sold his contract to Paramount. He then signed the up-and-coming nightclub comedy duo Dean Martin and Jerry Lewis to a multiple-film deal. He made a series of light comedies with them that made Martin and Lewis superstars and Wallis superrich. Still later, Wallis produced nine Elvis Presley movies, all box-office megahits, before returning to more se-rious filmmaking with such hits as *Becket* (1964) and

True Grit (1969), which won John Wayne his only Best Actor Oscar.

Meanwhile, believing his Hollywood career was over, Heston returned to doing live TV drama in New York City.

After a few weeks in Manhattan, the Hestons decided to take a break from everything and go back to Fire Island for a long weekend with Jolly and Kathryn West, a couple Lydia had connected with one day when Jolly was walking past the Broadhurst and saw Lydia's name on the marquee and her picture in the lobby. He recognized her from high school. He left a note, she called, and they renewed their friendship. Heston, who never made friends easily, quickly grew close to Jolly, who was, at the time, attending medical school in the city and a newlywed, which took care of any potential threat his reappearance might have caused. The Wests and the Hestons remained close for the rest of their lives.

Two months later, after trying, without much success, to find new stage or TV work, Heston received a call from veteran film director William Wyler, who had signed on with Paramount to direct the film version of *Detective Story*. Wyler asked Heston to read for it at the urging of Paramount head Barney Balaban, who wanted to get some mileage out of his new acquisi-

tion. This could have been a touchy subject between Heston and Lydia, who, despite appearing in the show on Broadway was not even asked to audition for the movie, but it wasn't, because the Hestons saw themselves as a team; what was good for one was good for the other. Lydia encouraged her husband to go back to Hollywood and give the movies one more try. He agreed to do it.

He flew out to Los Angeles a day or two later, and when he landed, he picked up the convertible Paramount had reserved for him and drove himself to the Beverly Hills Hotel, where his studio-reserved room was waiting. There he was greeted by a representative who told him to relax, eat well, and get some sun at the pool until the director was ready to see him. Days passed before he heard from Wyler, and when he finally did, it wasn't good news. The director had finally gotten around to screening *Dark City* and hadn't been impressed, either with the film or with Heston's performance. He told him he wasn't ready, "But one day you will be. Unless I miss my guess you are one of those actors who will mature slowly toward greatness. Then I will want you."

The next morning, listening to the radio as he packed his bags, Heston heard gossip columnist Louella Parsons announce that Wyler had cast Kirk Douglas to

play the lead in *Detective Story.* Thoroughly deflated, he checked out of the hotel and had his car brought around so he could drive to the airport and get out of L.A. as fast as he could. Once he was on Sunset, he decided to cruise east, to Paramount, to say good-bye to some of the friends he'd made during *Dark City.* When he got there, he turned left toward the arched Bronson Gate. Just as he passed through he happened to glance over to his right and saw, standing there not fifteen feet away, Cecil B. DeMille, the great man himself, on the steps of the building that bore his name. Heston waved and smiled at the director as if they were old friends.

As it happened, at that moment DeMille was casting his new film, *The Greatest Show on Earth,* and searching for an idealized version of himself to play the role of the general manager of a circus troupe. He had already seen dozens of actors but hadn't yet found one he thought was exactly right for the part until he saw Heston wave and smile. DeMille looked at his secretary, standing with him, and asked her who that was. She said it was Charlton Heston, the contract player who'd been in *Dark City,* a film he hadn't liked.

"Um, I liked the way he waved just now," DeMille said. "We'd better have a talk with him about the circus manager . . ."

Cecil Blount DeMille was one of the founders of Par-

amount Studios. He had, in his long and storied Hollywood career, gone through a series of career ups and downs. At the time he was on an upturn due to his 1949 film, *Samson and Delilah*, which he both produced and directed. The film was a signature biblical epic based on the Book of Judges, with a thrilling and extravagant climax during which Samson single-handedly pulls down the pillars of the Temple of Dagon, the power center of the Philistines, killing everyone, including himself. He sacrifices his own life to punish his enemies and atone for his straying from his Hebrew beliefs. The film proved extremely popular with audiences, giving them something they couldn't see on the new medium of TV: color, grandeur, sensuality—Hedy Lamarr's Delilah for the men, Victor Mature's Samson for the women—and, of course, that thunderous climax. From a then enormous production budget of $3 million, *Samson and Delilah* returned an astonishing $26 million, making it the top-grossing film of the year, along the way earning several Academy Awards.*

* *Samson and Delilah* won for Best Art Direction, Color (art directors Hans Dreier and Walter H. Tyler and set decorators Sam Comer and Ray Moyer), and Best Costume Design, Color (Edith Head, Dorothy Jeakins, Elois Jenssen, Gile Steele, and Gwen Wakeling). It was also nominated for Best Cinematography, Color (George Barnes); Best Music Score of a Dramatic or

When the heads of the studio asked DeMille what he was going to do next, he said he wanted to make a movie about the circus. He had gotten the idea after producer/director David O. Selznick abandoned a similar project after being unable to make a deal with John Ringling North, the owner of Ringling Bros. and Barnum & Bailey Circus. Selznick then put the film in turnaround. When DeMille expressed interest in the project, Paramount stepped in and quickly came to terms with North, agreeing to a ten-year circus support contract for $25,000 a year, plus $75,000 in advance against 10 percent of the film's gross after it earned back twice its negative cost. DeMille began traveling the country with the Ringling Bros. circus, watching the show every night from the audience and during the day, trying to learn circus life from the inside out. When he felt he had gathered enough material, he developed a screenplay with a team of writers that included Fredric M. Frank, Theodore St. John, Frank Cavett, and Barré Lyndon (British screenwriter Alfred Edgar).

DeMille began casting the film and found it difficult to find the right actor to play Brad Braden, the tough, smart, hard-hitting DeMille-like general man-

Comedy Picture (Victor Young); and Best Special Effects (Cecil B. DeMille Productions).

ager of the film's big top. He had originally wanted
Kirk Douglas for Braden, but Douglas turned down
the offer when DeMille wouldn't meet his asking price
of $150,000. DeMille then saw dozens of other actors
and didn't think any was right, when Paramount began
pushing Heston on him. DeMille screened *Dark City*
and didn't like it, thinking Heston came off too sinister,
until he saw Heston that day at the studio, smiling and
waving.

The wave had caught DeMille off guard. When his
secretary said it was Heston he was surprised and
decided to take another look at *Dark City*. The studio,
meanwhile, sent word to Heston to return to the hotel
and await further instructions.

DeMille also screened David Bradley's *Julius Caesar;*
he still didn't like the noir and he hated the Shake-
speare, but wanted to talk to Heston nonetheless. That
talk led to several more. According to Heston: "He
would never say, 'I'm considering you for the part' or
'I'm told that you might be good in this, and possibly
it may work out.' He certainly would never have you
read for a part. He would merely *talk* about it, which
left you at a loss for a response. You couldn't say, 'Well,
I think I could do that' because the question had never
come up. I never did figure out the proper tone to strike
there. Through half a dozen interviews for the circus

picture . . . all I could say was, 'Certainly is interesting. Sounds like it would make a fine film.' "

Finally, at the urging of Henry Wilcoxon, DeMille's longtime production associate and a key member of his creative team, DeMille finally cast Heston as Brad Braden.

The next day, at the director's office at Paramount, with a smiling Citron standing on one side and a delighted DeMille on the other, twenty-seven-year-old Heston leaned over and signed a contract to be one of the stars of "the circus picture," whose filming would turn out to be as much a circus off-camera as it was on.

Charlton Heston and a clown-faced James Stewart, in a still from The Greatest Show on Earth. *(Courtesy of Rebel Road Archives)*

Chapter Seven

Throughout his five-decade, seventy-plus feature film career, Cecil B. DeMille rarely made a feature set exclusively in the present time. The only thing about *The Greatest Show on Earth* that hinted at anything historical was the New Testament–style title, à la *The Greatest Story Ever Told*. Otherwise, this film was a new bar of soap.

After his tour with Ringling Bros. and Barnum & Bailey, and an all-too-brief rest, DeMille directed his writing team to work up a script, emphasizing that while the story was set in a circus, it was not a circus film they were writing but one about democracy, or, more accurately, DeMille-style democracy; a picture that extolled the virtues of hard work and good product, and a show-must-go-on track—the show standing

in for America—with plenty of romance and drama and, of course, a bang-'em-up climax. "The first of you gentlemen that mentions the words 'circus' or 'big top' is fired. I don't want that at all. Tell me a story about people, a very basic story, which could be dropped in a fish cannery, a studio . . . or a circus. First I want the plumbing in the house and a strong foundation. Don't write me a lot of beautiful trimmings. Don't start putting curtains up before the windows are built." Later on, Ben Hecht, who had no love for DeMille, came aboard to work on the script for a hefty fee, as did the novelist-turned-screenwriter Stephen Longstreet, who had most recently helped touch up the screenplay for director Alfred E. Green's phenomenally successful *The Jolson Story* (1946, Columbia Pictures). That was the kind of screenplay DeMille was after, one that grabbed the audience from the opening shot and never let go.

With the shooting script completed and Heston signed, DeMille set about casting the rest of the film. He had originally wanted Paulette Goddard to play the female aerialist, but old grudges between them caused her to turn it down. The director went instead with the always effusive Betty Hutton, after her successful portrayal of Annie Oakley in George Sidney's popular 1950 film adaptation of the Irving Berlin Broadway

musical *Annie Get Your Gun* (having stepped in for the unstable Judy Garland at the last minute). Gloria Grahame, who had made a career playing the pretty but troubled girl, was given the role of the pretty but troubled "elephant girl." He also cast the beautiful but fading Dorothy Lamour in one of the film's many female supporting roles as a featured circus performer. For the male aerialist, "The Great Sebastian," Wilcoxon suggested another Hal Wallis discovery, former acrobat Burt Lancaster, but DeMille said no. The politically conservative DeMille, aware of Lancaster's liberal leftist leanings and pro-union activities, did not want to use him: "Look, Harry," DeMille angrily told Wilcoxon, "I'm well aware that Paul Robeson [the African American actor/singer/civil rights activist who was blacklisted in 1950, during the House Un-American Activities Committee investigation of possible communist infiltration in the film industry] is your friend and I try to be tolerant, but I've had just about enough on this subject. I don't want to hear any more from you about this Lancaster fella. Do I make myself clear?" Not that it really mattered. Lancaster had already backed away from Wilcoxon's overtures, claiming, sarcastically, that he was afraid of heights. A few years later Lancaster produced and starred in his own circus movie, Carol Reed's *Trapeze* (1956). Instead, DeMille cast Cornel

Wilde. The big coup was getting Jimmy Stewart to play "Buttons," the fugitive disguised as a clown, for the bargain rate of $50,000. Stewart's career had not as yet fully recovered the Oscar-worthy momentum it had gained prior to his wartime service, and it would take a series of increasingly brutal westerns directed by Anthony Mann and three suspense pictures by Hitchcock to put him back on top.* He was grateful for the work and DeMille made it easy for him; because the role called for his character to always be in makeup, he didn't have to go on location. Ted Mapes doubled for him on the road, with Stewart shooting all his scenes at the studio.

Heston, meanwhile, hoped *The Greatest Show on Earth* would be the big break he was waiting for, and he put a positive and appreciative spin on his inclusion in the ensemble cast. "I've been particularly fortunate

* Stewart won a Best Actor Academy Award for his work in George Cukor's *The Philadelphia Story* (1940), made three less successful films, then entered the U.S. Army Air Corps. He saw action and was seriously wounded during sorties over Germany. His first film after returning to Hollywood was Frank Capra's commercially disastrous *It's a Wonderful Life* (1946) that all but ended the director's career and nearly ended Stewart's. He took what amounted to a pay cut to be in *The Greatest Show on Earth*. Stewart actually asked DeMille if he could be in it because he believed that everyone loved the circus and the film would be a huge hit—good for DeMille and good for him.

in my role in the DeMille circus picture. You know you can have long roles in shows at times and they just don't get you anywhere. Other sharper, shorter parts may stand out and leave you with nothing but the exercise.

"Here I am in this picture with big stars like Jimmy Stewart, Betty Hutton and Dorothy Lamour and, of course, no one is going to take a back seat. But the picture has a theme, one driving idea—getting the circus to the next town the next day for the next performance in spite of all obstacles—and luckily for me that theme is tied directly to my role. I'm the manager who has this problem on his hands 24 hours every day."

Early into filming, DeMille decided he wanted Braden to wear a hat, so he had Heston try on dozens of them, all colors and sizes from the costume department, until he settled on a brown one that he felt fit his actor perfectly, boasting of swagger and authority. Heston added a pipe to bring gravitas to his role. Building a character from the outside in was a method of acting Heston understood.*

Filming began February 5, 1951, on location in Sarasota, Florida, for a scheduled eight-week convoy with

* The fedora, leather jacket, and revolver Heston used in the film became the models for Harrison Ford's Indiana Jones in George Lucas's script for *Raiders of the Lost Ark* (1981).

the real Ringling Bros. on its winter southern railway route, followed by a return to Hollywood for some pick-ups (additional filming) at Paramount, and then back out on the road for one more brief stint along the circus's Washington, D.C., to Philadelphia run. DeMille and cinematographer George Barnes filmed everything they could, from how the circus set up in a new town, to putting on its spectacle, to how it broke down afterward and rolled out, with DeMille using many of the circus performers and employees as extras.

The film itself is set up like a three-ring circus, with several plotlines unfolding at the same time, their stories and character development overlapping. Braden's begins when he has to tell his girlfriend, Holly (Betty Hutton), she is being replaced in the center ring by the world-renowned "Great Sebastian" (Wilde) to attract bigger audiences to keep the circus afloat. However, Sebastian comes with his own set of problems; he is an unrepentant womanizer, something that, predictably, causes problems. Soon enough, a love triangle develops between Braden, Sebastian, and Holly, even as the latter two continue to compete for the coveted center ring. There is yet another story line involving an embezzler, and finally, the "Buttons" plot, the fugitive who was a doctor and performed a mercy killing on his terminally ill wife.

Heston's first big scene during filming was one where he had to drive up in his Jeep, jump out, and dress down Betty Hutton. Easy enough, he thought, until his jitters caused him to drive up, get out, and trip over a ring post. DeMille was amused at Heston's enthusiasm, less so with his awareness, and encouraged him to try it again. He nailed it on the second take and from that point sailed through his part like a seasoned veteran, later on noting how easy it was to work with the famed director known by many in the business for his notorious short fuse: "I didn't find him a tyrant. He wanted what he wanted when he wanted it, and he was determined to get a shot made the way he wanted it, and he would stay with it until he did. He was demanding. He might have been a martinet in his early days but that had mellowed a bit . . ."

DeMille's gentle manner with the still-raw Heston did not extend to the rest of the cast. He quickly grew weary of Wilde and his real fear of heights, something the actor had failed to mention when the director cast him in the part of the high-wire aerialist.

Heston had asked for and gotten permission from DeMille to bring Lydia along for the location shoots, so she wouldn't have to spend the winter alone in their unheated Hell's Kitchen apartment. The director wound up using her as an extra in one scene, a moment

that marks her screen debut.* As filming dragged on, Heston promised Lydia that when the picture was over he would return to New York with her and find them a much better place to live. He still considered himself primarily a stage actor, the film a detour on his road to stage success.

They spent all of his off-screen time together, including every Sunday, as DeMille believed the seventh day was for rest, prayer, and meditation. After a few weeks, more out of boredom than anything else, Lydia borrowed a crew member's still photo camera and began taking pictures of the filming. One day, while she was clicking away, Count Rasponi came over to her and in an even tone said, "You are going to have to take the publicity photos [of Heston], Lydia." He also said he would see to it she was kept on the payroll. "I told him I was terribly unmechanical," Lydia said later, "but he said 'You have to do it anyway.' So I corralled the still camera man on the set and followed him around eight hours a day for three months, using a second-hand Speed Graphic—and if you learn how to use one of those, you can learn anything."

* She was billed as Lydia Clarke and listed in the credits as a "circus person." Lydia used Clarke as her professional name and Heston everywhere else.

The long weeks of the shoot pressed on, until it was time for DeMille to film the big train wreck that was the explosive climax of the film—the money sequence for which the film would be remembered. Despite the visuals that create an illusion of location continuity, the sequence was all done at Paramount. The studio gave DeMille two square blocks of the back lot which he filled with six full-size circus train cars, built to exactly match the real ones that had been destroyed during earlier filming of parts of the scene in Florida.

Heston knew he was in for an ordeal when DeMille changed a sequence that began with Braden in a train car that had flipped. As the smoke from the wreckage cleared, an overhead camera on a boom was to sweep across it to discover Braden pinned under several heavy timbers. The way the scene was originally written, a black panther was to have gotten loose and threaten the trapped Braden, the next shot being a close-up of Braden's face, hot and sweaty and in extreme pain. DeMille ordered a "prop animal" (a real panther trained to "act") to be made to jump through the damaged bars of its cage directly onto Heston, and because the action was going to be filmed in medium shot, a double for Heston couldn't be used. When the panther appeared reluctant to move, one of the animal wranglers suggested shoving a stick up its rear, some-

thing Heston pleaded with him not to do. Instead, the trainer used a blast of compressed air. Heston: "I shut my eyes and waited. I played dead because even a panther knows that a dead man is awfully uninteresting. As he came out he put a paw on my face—it covered my whole face, but it didn't hurt me because his claws were retractable like an airplane's wheels. After that, everybody stood around and wondered if the shot was all right. DeMille then had me unscrewed for lunch and I walked into the Paramount commissary covered with makeup blood, and everybody [who saw me] got sick."

The final part of the sequence, shot that same afternoon, involved an elephant being brought in to free Braden by lifting off the beams that had pinned him to the ground. "They brought in an elephant which was supposed to rescue me by breaking everything loose with his trunk. But they needed to have several rehearsals for the camera on this shot, and the elephant didn't quite understand. They led him up to my timbers and told him to put his trunk around one of them—sort of just trying it on for size—but not to disturb anything. This upset the elephant considerably. He didn't understand why he should begin a job of destruction and not complete it. The elephant was getting upset, and I was getting even more upset

down there underneath his feet. When DeMille finally decided that we were ready to shoot the scene, the elephant had been so conditioned to not do anything that he simply leaned against the side of the wrecked railroad car and wrecked it. And there was I, still screwed down. Finally, they gave the elephant a shot of compressed air from that hose and he wrathfully tore up all the timbers. I crawled out, dodging tusks, trunks and four-foot feet. DeMille had cameras going through all of it . . ."

As soon as DeMille shouted cut, Heston stood up and ran into Lydia's arms, to reassure her he was all right. Lydia hugged him warmly, happy and relieved. She had watched the filming, and when the panther pawed her husband's face she feared the worst, even as she kept photographing it all. To her, and to DeMille, Heston's resilience was impressive, a product of great acting or great apprehension. Either way, it looked terrific on-screen.

Charlton Heston with Eleanor Parker in Byron Haskin's The Naked Jungle *(1954).* (Courtesy of Rebel Road Archives)

Chapter Eight

DeMille wrapped *The Greatest Show on Earth* in March 1951, and the next day Heston and Lydia flew back to New York, their first order of business to search for a new and better place to live, one that had, among other amenities, heat. It wasn't easy; Manhattan was still in the grip of its housing shortage, mostly due to wartime rent controls that had caused a serious lack of new housing being built. A common practice of those looking to find an apartment at the time was to either read the obituaries to see who died and then rush to the location before it was rented to someone else, or to bribe superintendents to find out which spaces were about to come on the market and get to the top of the waiting list.

Five years after they had first moved to Hell's Kitchen, they found an apartment they liked in Tudor City on the much tonier East Side. They got it because Heston had heard about an upcoming vacancy from another actor while they were both checking the audition board at the Equity offices in midtown. He and Lydia went over to see it and were impressed by the twenty-eighth-floor penthouse with a wraparound terrace—one side looked directly onto the United Nations and the East River, the other side had a view of downtown Manhattan—twenty-foot ceilings, and, most important to Lydia, a wood-burning fireplace that ensured they would never be cold again in New York City. Even though the rent was a colossal $480 a month, they took it.

As soon as they settled in, Paramount assigned Heston to star in director George Marshall's *The Savage,* to be shot on location in the Dakota Hills and in Florida. The film, about the war between the U.S. Cavalry and the Sioux nation, is sympathetic to the ways of and the injustice done to Native Americans ("Indians" in the Hollywood parlance of the day). The film begins when a wagon train crossing Sioux territory is attacked by the Crow, the only survivor a young boy who is spared and taken with them. They call him "Warbonnet." By the time he grows into manhood, his

loyalties are divided between the Sioux nation and his white heritage. (At the time the idea of Native Americans being wholly formed characters with a real native culture seemed not just out of step, but a little bizarre. Thirty-eight years later Kevin Costner would make a film with a similar theme, *Dances with Wolves,* that would win an Oscar for Best Picture.)

Heston's character got away from him somewhere during what turned out to be another difficult location shoot disrupted by what seemed like an endless series of Florida rainstorms (Heston later remarked that *The Savage* was the first film "to be shot in glorious water color") and required extensive cutting to make the backgrounds match.

The hours and the continual traveling between locations left Heston exhausted, and it shows in his performance. Milburn Stone, a character actor whose face was only vaguely familiar and his name unknown until four years later when he took the role of "Doc" on TV's long-running series *Gunsmoke,* played Corporal Martin, a relatively small part in the film. After watching Heston struggle through one particularly difficult scene, "Milly," as he was called by friends, went over to Heston and said, in a friendly slap-on-the-back fashion intended to be a good-natured acting tip, "Don't you ever smile?"

It was a question he would hear repeatedly from directors, costars, and critics for the rest of his career.

Back in New York and looking to catch up on some much-needed rest and quality time with Lydia, he wasn't home very long when she was offered a part in Jerry Hopper's film *The Atomic City,* an H-bomb thriller from Paramount in which agents kidnap a Los Alamos–based scientist's son and demand the formula for the bomb as ransom (Gene Barry played the scientist, Lydia his wife, Lee Aaker his son). The film was penned by Sydney Boehm, who, a year earlier, had written the screenplay to the sleeper sci-fi adventure *When Worlds Collide,* whose box-office success had caught Paramount by surprise, after which it commissioned *The Atomic City* as a quickie follow-up. *The Atomic City* was not strictly sci-fi, but its end-of-the-world paranoia was the essential ingredient of films of that genre. The studio was also hoping to cash in on the real-life Rosenberg spy saga that was being played out in the headlines as the basis for its fictional plot.

While Lydia was in Hollywood, Heston remained in New York to do a live, nationally televised *Studio One* presentation of *Macbeth,* directed by Franklin Schaffner. From her dressing room, Lydia watched the kinescoped broadcast on the evening October 21,

1951, three hours later than when it went out live on the East Coast, a same-day first for the CBS television network.* She later told Heston she cried when she saw his head impaled on a spear at the end of the play (it was a lifelike mold of Heston's head). She then decided she never wanted to be that far away from him again. He was happy to hear it. With *The Greatest Show on Earth* and *The Savage* still not released, Heston figured his film career in Hollywood might be over before it officially began. When Lydia finished filming and returned to New York, they decided Manhattan would be where they made their home. Only then did they begin to seriously furnish the Tudor. Heston built a seven-foot bed for them so he could sleep at night without his feet hanging over the edge.

Everything changed for them when *The Greatest Show on Earth* finally opened on January 10, 1952, premiering at New York's Radio City Music Hall, only days after DeMille had finally completed the slow and meticulous postproduction by adding his florid narration over the opening montage:

* In Los Angeles, the series was called *Studio One in Hollywood,* even though virtually every episode, including this sixty-minute version of *Macbeth,* was done in New York.

We bring you the circus—that Pied Piper whose magic tunes lead children of all ages into a tinseled and spun-candied world of reckless beauty and mounting laughter; whirling thrills; of rhythm, excitement and grace; of daring, enflaring and dance; of high-stepping horses and high-flying stars . . . a fierce, primitive fighting force that smashes relentlessly forward against impossible odds: That is the circus—and this is the story of the biggest of the Big Tops—and of the men and women who fight to make it—The Greatest Show On Earth!

The film was an immediate smash. Audiences of all ages loved it, and by the end of the year it had grossed $15.79 million ($144 million in 2016 dollars) and continues to generate income to this day in various new-format rereleases and on cable TV, despite its overblown script and Stewart's nonsensical clown, who even sleeps in his makeup. Not surprisingly, critics had sniffed and generally considered the film far from the greatest show on Earth. The *New York Herald Tribune*'s film reviewer wrote that "the train wreck looks as luridly contrived as rubber octopuses, falling temples, and all the other divertissements of [DeMille's] past epics," and that was one of the kinder reviews. Pauline Kael, then a freelance critic before joining the *New Yorker*, wrote that

the film was "a huge, mawkish, trite circus movie . . . awesomely melodramatic. A cornball enterprise," while Bosley Crowther, the lead critic for the *New York Times*, thought it was a documentary about the circus: "The captivation of this picture is in the brilliance with which it portrays the circus and all its movement, not as a mere performing thing but, as Mr. DeMille says in the narration, as a restless, mobile giant . . . the impact of a top documentary film."

None of it mattered to audiences; kids couldn't get enough of it and neither could the parents who took them to it. The film not only salvaged Heston's film career; it gave him a jolt of face-and-name popularity that resulted in his being listed number twenty-three that year on the Quigley Poll of film exhibitors, an annual survey of movie theater owners that ranks the most popular movie stars in America according to the amount of money their films made.* Thanks to

* Quigley's top twenty-five movie stars of 1953 were: 1) Gary Cooper, 2) Dean Martin & Jerry Lewis, 3) John Wayne, 4) Alan Ladd, 5) Bing Crosby, 6) Marilyn Monroe, 7) James Stewart, 8) Bob Hope, 9) Susan Hayward, 10) Randolph Scott, 11) Doris Day, 12) Esther Williams, 13) Marjorie Main & Percy Kilbride, 14) Gregory Peck, 15) Ava Gardner, 16) Clark Gable, 17) Burt Lancaster, 18) Jeff Chandler, 19) Jane Wyman, 20) Abbott & Costello, 21) Stewart Granger, 22) Jane Russell, 23) Charlton Heston, 24) Humphrey Bogart, 25) Rita Hayworth. Heston appeared on the Quigley list four other times: in 1960 at sixteen;

DeMille, Heston had gone from zero to sixty and by the end of the year was a no-doubt-about-it movie star. His reaction to all the laudatory attention he was now receiving was typically self-deprecating; he (rightfully) gave most of the credit for his muscular, authoritative performance to the director: "If you can't make a career out of a DeMille film, you'll never make it in this business."

He was inundated by requests for interviews and to be the subject of magazine pieces. Not all of them were complimentary. The *Los Angeles Times* published a typically smirky profile by Hedda Hopper (if she aimed her pen at you, whether the ink smeared or not, it meant you counted) that recapped Heston's salad days to *The Greatest Show on Earth,* and noted good-humoredly (to a degree), among other gemlets about Hollywood's newest overnight sensation, "Money and better eating have meant that Heston has to watch his weight, which is about 200 lbs . . ."

Heston knew he was no longer a skinny college kid or a hungry soldier, but it was still jarring to see his weight noted with such chortling glee in an article that was syndicated all over the country. He decided

in 1961 at eighteen; in 1962 at twelve; and 1963, the last time he appeared on the list, at twenty-three.

he wasn't getting enough exercise and took up tennis, making it part of his daily regimen. From then on, until he was no longer physically able to do so in his later years, he tried, whenever possible, to play at least two hours every day, no matter where he was or what he was working on. "My waistline is my living," he told everyone who asked why he had become so devoted to the sport. And he knew he would also have to try to change his eating habits, especially his lifelong addiction to peanut butter. When he was a kid he could eat jarsful of it and never gain an ounce. As an adult he still slathered crunchy Skippy on his breakfast toast every morning, ate it with mayonnaise on bread at lunch or as a late-night snack, straight out of the glass container.

His swift glory-ride balloon somewhat deflated that July when *The Savage* opened to little notice and negligible box office, even though Paramount had positioned it as its big summer western. Paramount then called upon Heston to promote the film in the hopes of pumping up receipts, and he expressed an unexpected sense of outrage in his interviews. Working on the film had awakened him to something he had never thought about before, the injustice done to Native Americans during the great expansion west, and rather than talking about how happy he was to be in *The Savage* and complimenting everyone and everything connected

to it, he praised what he saw as the importance of its subject, how it focused on a sore point in the country's history that Hollywood, with rare exception, ever acknowledged: "I think [*The Savage*] is more than just another western . . . Now that I've worked with the Sioux [as advisers on the film], I think there should be a movie made about the modern-day Sioux, and people should talk about them. Maybe somebody should get up on their hind legs and scream about them . . . here are people really worth waving a flag for . . . I think it's strange that while nearly everybody knows about the needs of the Greeks, the Israelis, the DP's and the other war orphans, and most people are trying to help them, almost nobody in this country knows anything about the Sioux or the spot they're in. Maybe it's because they're too proud to ask for help . . ."

Paramount execs were less than thrilled with what they considered Heston's overly outspoken comments and, despite the success of *The Greatest Show on Earth*, which was still playing to packed houses, quietly sold his contract back to Hal Wallis (who made a profit on the return option). If Heston was aware of the negative reaction to his remarks at the studio, he never showed it and didn't give any indication that he cared at all what execs thought or did with his contract. This was how he would be for the rest of his career, an

interviewer's dream and a PR department's nightmare. He believed in saying whatever he wanted, whenever he wanted, and to anybody he wanted, with no concern for the consequences that might result. This was his right as an American citizen, a right he had put his life on the line during the war to preserve, and he wasn't going to let anyone, least of all a studio, take it away from him.

Wallis had jumped at the chance to get Heston back and, as soon as the ink was dry, made a deal with Twentieth Century-Fox for a new three-picture deal with Heston as the star. The first was *Ruby Gentry*, costarring Karl Malden and beautiful Jennifer Jones, independent producer David O. Selznick's second wife. Before production began, Selznick invited Heston to lunch to introduce himself. He was not affiliated with Fox and had no connection to the film other than being married to Jones. It was not a pleasant meeting. In no uncertain terms Selznick warned Heston to stay away from her. Not to worry, Heston said. He was very much in love with his own wife. And, he thought to himself, far more secure.

Ruby Gentry was directed by King Vidor, who, like DeMille, had been making movies since the silent era. The film was a redneck love triangle set in the humid

swamplands of North Carolina. It was made quickly to open in time for Christmas Day 1952. Armond White reviewed the film for the *New York Times* and said, in part: "Jennifer Jones, as a Ruby Gentry who is often more physical than delicate, gives stature to the delineation. A spirited and passionate creature, she generates voltage in tight-fitting jeans or evening gowns as the girl who could learn to hate as easily as she loves. Charlton Heston, as Boake [Tackman], is a convincingly muscular and indomitable gent, whose attempts to better his lot destroy him . . . 'Ruby Gentry' is purveying pure, old-fashioned passion, corny and uncut, and she doesn't care who knows it."

That was the extent of it, a studio-concocted star turn for Jones and another muscular, one-dimensional, unsmiling role for Heston. In the film she plays a girl from the other side of the tracks in love with the well-to-do Heston, but marries an older man (Karl Malden) who accidentally dies in a boating accident, after which she is branded as a murderer. The story is a bit of a knockoff of George Stevens's *A Place in the Sun,* the movie sensation of the previous year, the main difference between them being that Jones was no Elizabeth Taylor and Heston no Montgomery Clift; where the star-crossed lovers in Stevens's film sizzled on-screen, Jones and Heston gave off no sparks between them.

Their love scenes did, however, make Selznick squirm in his seat when he saw them.

According to Heston, "It was a pretty steamy story for the '50s . . . [even if] the sex was implied, rather than acted out on camera. There was one exception, when we did get pretty physical. King Vidor asked Jennifer to slap me on the cheek. She did. It was no good. 'A bit harder, please,' Vidor instructed. 'It's okay,' I said, 'just let go. I'll live.' Jennifer took a deep breath, swung her arm back and dealt me this terrific blow to the jaw. For a moment, I had difficulty staying on my feet. That hurt! I thought. Though not as much as Jennifer's hand. She had broken it."

Despite lukewarm reviews, *Ruby Gentry* was a major hit at the box office; from a $535,000 budget it earned $1.75 million in its initial domestic run, making it the highest-grossing Hollywood movie of the preceding twenty years. Wallis was thrilled and Fox immediately put Heston into another film.

When the Academy Awards nominations for 1952 were announced, *The Greatest Show on Earth* was nominated for five, including Best Director and Best Picture, although Heston's performance as DeMille's on-screen surrogate was overlooked. The film itself was considered a long shot to win Best Picture. *Vari-*

ety, usually the savviest and most informed trade paper (Hollywood's "bible" of record), predicted that Stanley Kramer's *High Noon* "was a cinch to win." Even DeMille thought his picture didn't stand a chance: "I thought *High Noon* or [John Ford's] *The Quiet Man* would get it," he told friends after the ceremonies.

The awards show took place on March 19, 1953—the first time it was broadcast live on television—and had dual hosts: a tuxedoed Bob Hope, Hollywood's favorite wisecracker, ran the show in Hollywood from the stage of the Pantages Theatre, while silent film star Conrad Nagel did the honors from NBC International Theatre in midtown Manhattan. *The Greatest Show on Earth* won two upset awards—Best Picture (DeMille) and Best Story (Fredric M. Frank, Theodore St. John, and Frank Cavett)—and immediately added to the film's already hefty box office. Everyone had agreed with *Variety* that *High Noon* could not be beaten for Best Picture, especially by DeMille's circus opera (he knew in advance he was going to receive the prestigious Irving G. Thalberg Memorial Award for lifetime achievement that night, a more than adequate consolation prize). Best Director went not to Fred Zinnemann, the favorite for *High Noon,* but to John Ford for his John Wayne–Maureen O'Hara set-in-Ireland love story. Ford was unable to attend (or didn't want to; he didn't

like to lose) and his pal Wayne accepted the award for him.* A few statuettes later, veteran character actor Edmund Gwenn handed out the Oscar for Best Supporting Actress to a genuinely surprised Gloria Grahame, not for *The Greatest Show on Earth* (for which she wasn't nominated), but for her performance in *The Bad and the Beautiful*. Always an audience favorite, as she rushed up to accept her trophy, all bubbly, Gwenn said into the microphone, "She's beautiful!"† Grahame, who had a habit of stuffing cotton along her gum line to straighten out and thicken her upper lip, had not removed it and came across sounding as if she had had one too many. Best Actor went to the still enormously popular Gary Cooper, and the audience roared its approval. Once again, Wayne was called upon to do the honors. Stepping up to the mike while the applause continued, he said, "I'm glad to see you're giving this award to a man who has conducted himself throughout his years in this business in a manner that we can all be proud of him. And now, I'm going to go back and

* The other nominees for Best Director were DeMille, John Huston for *Moulin Rouge*, and Joseph L. Mankiewicz for *Five Fingers*.

† Grahame won out over Jean Hagen in *Singin' in the Rain*, Colette Marchand in *Moulin Rouge*, Terry Moore in *Come Back, Little Sheba*, and Thelma Ritter in *With a Song in My Heart*.

find my business manager, agent, producer, and three name writers and find out why I didn't get *High Noon* instead of Cooper."

When *The Greatest Show on Earth* won Best Picture, an obviously surprised DeMille was caught by the TV camera in a close-up that showed him looking as if he had just been shot.* The audience too was stunned. DeMille bounded up to the stage to accept the award, abandoning his typical bombast for a few words of tasteful modesty, if peppered with a bit of exaggeration, thanking "the thousands of stars, electricians, circus people and others" who made the moment possible.

High Noon had been the hands-down favorite, but the contentious politics of the notorious, Washington-driven Hollywood blacklist probably cost it its Oscar. The film was written by Carl Foreman (who was not even nominated) and produced by Foreman and Stanley Kramer. The two had had a falling out after Kramer thought the film too dangerously left-leaning in the poisoned and paranoid atmosphere and had Foreman's name removed as the other producer of the film (he retained screenwriting credit because of the rules of the Writers Guild). By the time *High Noon* had opened,

* The other nominees were *High Noon, Ivanhoe, Moulin Rouge,* and *The Quiet Man.*

Foreman was living in self-imposed exile in London. Many liberal members of the Academy voted in protest for *The Greatest Show on Earth* as Best Picture.*

The realm of the Hestons' social life began to expand, and they found themselves gradually spending more and more time in Los Angeles. Having grown tired of checking in and out of hotels, even ones as luxurious as the Beverly Hills Hotel, and with money starting to accumulate in their bank accounts, they decided to keep the apartment in New York and rent another one in Los Angeles. They also purchased 1,280 acres of mostly un-

* Cooper did not attend the awards in support of Foreman, who was blacklisted before the film's release. Cooper was warned by Warner Bros. that it would be a violation of his morals clause to express his support for Foreman in public. Instead, he went fishing with Ernest Hemingway in Montana. Cooper's win opened the door to widespread criticism of the politics behind the awards.

Wayne had turned the role down because he felt that Foreman's story was un-American and an indirect attack on the blacklist, which Wayne actively supported. In a 1971 interview Wayne said he considered *High Noon* "the most un-American thing I've ever seen in my whole life." Despite Cooper's having taken the part, he and Wayne remained good friends. Wayne affirmed this when he told a reporter that he and Cooper "had fallen off horses together and fell into the movies." John Wayne, quoted in Gail Kinn and Jim Piazza, *The Academy Awards: The Complete Unofficial History*, 2d ed. (New York: Black Dog & Leventhal, 2002), p. 106.

developed land in the North Woods of Michigan from Russell. Heston hoped that one day he and Lydia might move back to the forests of his youth and live out their lives together in peace and freedom on God's natural earth.

In L.A., they settled on two high-floor apartments in Park La Brea Towers and, with the landlord's permission, combined them into one. Park La Brea Towers was a relatively new gated housing development in the then sparsely populated Miracle Mile district of Los Angeles, just north of Wilshire Boulevard, in walking distance of the Los Angeles County Museum of Art (LACMA) and its famous tar pits. It had been built just after World War II to accommodate the city's returning GIs and their families in an area otherwise dominated by low-rise single-family units and freeways. Park La Brea resembled a high-end New York City development, its tall buildings angled away from one another, its grounds filled with parks and play areas for kids, garden apartments and tennis courts, which Heston used as often as he could.

The rent for the combined apartments, including unlimited use of the tennis courts, came to $135 a month.

Heston's next picture for Fox was 1953's *The President's Lady*, a mildly entertaining Hollywood-style ex-

cursion into President Andrew Jackson's controversial marriage to Rachel Donelson Robards (Susan Hayward), who was already married to someone else when they met. The film was directed by journeyman Henry Levin and produced by Levin and Sol C. Siegel, with a music score by Alfred Newman. The screenplay was by John Patrick, based on a novel by Irving Stone, who had written several other biographical novels that were eventually adapted for the screen, including Vincente Minnelli's *Lust for Life* (1956), with Kirk Douglas playing Vincent van Gogh, and later on, Carol Reed's *The Agony and the Ecstasy* (1965), about Michelangelo's struggle with Pope Julius II during the painting of the ceiling of the Sistine Chapel, with Heston playing Michelangelo.

The President's Lady revolves around Jackson's relationship with Robards, the married daughter of a farmer, which began in 1799 when Jackson was Tennessee's attorney general. Stopping by the farm during a long trip, Jackson meets and falls in love with Robards, who in the film is separated from her husband (all of this a bit fuzzy historically, no doubt intentionally), which leads to a duel between Jackson and Lewis Robards, Rachel's former husband; no one is hurt. Jackson and Rachel then go ahead and marry, and after, when they learn that her divorce may not have been finalized,

try to untangle all the legal knots that stand in the way of their happiness while living through a series of adventures, including another duel Jackson participates in when someone challenges Rachel's honor (he is seriously wounded but survives) and his leaving her for two years to fight the British in the War of 1812. His return is followed by a few quiet years, until he is encouraged to run for president and once again the scandal of his marriage erupts. He wins the election, and on the eve of his inauguration, Rachel, who has fallen ill, dies in Jackson's arms. He pledges to keep her alive in his heart.

The film works as romantic adventure, less well as historical document, and audiences tended to stay away. It failed to make back its $1.5 million budget (it grossed $1.35 million in its initial domestic release, half of which went to exhibitors). Despite the highly respected Brooks Atkinson's glowing review in the *New York Times* that Heston's "forthright and steely-eyed work in *The President's Lady* should establish him in the top-flight ranks of stardom; he has a superb manner of underplaying through voice and a minimum of gestures," not many saw the movie, and it did nothing to continue the forward momentum of his career. Levin blamed the film's failure on having had to make it in black and white with standard-frame cinematography, and from a script that oversimplified what was a

complex, adult story: "While we were filming Fox was making *The Robe*, the first CinemaScope film. When Zanuck [the head of Twentieth Century-Fox] saw our completed film, he said, 'It's a damn good film. Too bad it won't make a nickel. Films about American history never do.' "

Paramount then decided that, despite having sold his contract, Heston somehow still legally owed the studio two pictures, and after the failure of *The President's Lady*, Fox backed out of the remaining films on their contract with Wallis, and he was happy to hand Heston over. Zanuck had two reasons for doing so. The first was his disappointment that Heston had failed to break through as a romantic leading man in *The President's Lady*, primarily because there was no heat generated between Heston and Hayward (what he really meant about "history" films not making any money). The second was television. In 1953 Zanuck announced the studio would no longer be making B-movies and would instead concentrate only on big-budget, wide-screen color productions to be able to give the public something it couldn't get for free on the small box. *The Robe* broke box-office records everywhere it played.

Paramount put Heston into a western, *Pony Express*, directed by Jerry Hopper, a 1953 Technicolor remake of the studio's 1925 biopic about the men

who helped create the transcontinental mail delivery service. Heston, who played a fanciful Buffalo Bill, obliged the studio by doing a commercial tie-in spot for the film with R. J. Reynolds Tobacco Company, for Camel cigarettes. The film did well and Paramount quickly placed him into yet another western, *Arrowhead,* written and directed by Charles Marquis Warren and costarring newcomer Jack Palance, hot off his appearance in *Shane* that year, and Katy Jurado, who had gained fame as the Mexican "other woman" in *High Noon.* Shot on the Texas-Mexico border, the film tells the story of a heroic but unheralded Indian scout, loosely based on the true story of Al Sieber (Heston in the film), a German-born chief of scouts in the U.S. Army of the Southwest and a veteran of the Civil War, who participated in the hunt for Geronimo.

Arrowhead is a gritty, tough, entertaining film, one of the better if less well-known '50s westerns among the hundreds Hollywood turned out in the decade. It fell between the cracks of *High Noon* and *Shane,* also made at Paramount. *Shane* was the western that got all the studio's attention. It was nominated for six Academy Awards and Loyal Griggs won for Best Cinematography, Color.

Heston's latest commitment to Paramount ended with *Arrowhead,* and he was happy it did. He couldn't

wait to return to New York with Lydia and quickly signed on to do several dramatic TV programs. Because of the movies, his price had risen from $55 per show to $2,000. The couple came back to Hollywood only after a few months, when Heston was summoned by Harry Cohn, the head of Columbia Pictures, for a one-film, one-option deal, the first being Irving Rapper's *Bad for Each Other* (1953), an updated remake of MGM's *The Citadel* (1938), the rights to which Cohn had purchased from Hal Wallis, who had first acquired them as one of the five pictures he had originally wanted Heston to make.* In this one, he was cast as a troubled returning Korean War veteran who is lured into the world of crystal and champagne by a beautiful, wealthy socialite (Lizabeth Scott), but in the end chooses to devote himself to helping others, inspired by the down-home wholesomeness of a nurse he meets and falls in love with (Dianne Foster).

* *Bad for Each Other* came about because Cohn wanted Burt Lancaster to play Sergeant Warden in *From Here to Eternity,* but he was unavailable, having formed a partnership with Harold Hecht to produce their own films. Lancaster still owed Wallis one picture from an old contract, and Wallis agreed to sell that deal to Cohn for $150,000 and the script of *Bad for Each Other,* which Wallis had the rights to, for an additional $40,000. That deal included the services of Heston, who was paid directly by Wallis.

Almost nobody went to see the black-and-white *Bad for Each Other,* and Cohn declined to pick up the option for a second film. Heston made a strong rebound when Paramount quickly signed him to star in Byron Haskin's *The Naked Jungle,* based on a 1938 short story by Carl Stephenson that first appeared in *Esquire,* called "Leiningen Versus the Ants." The film was produced by sci-fi special effects guru George Pal, the real auteur of the film.* The highlight of the movie, and the only thing most people remember about it, is the climactic attack on the plantation by Marabunta, roving gangs of killer ants. Set in Brazil but filmed on the studio's back lot, with some additional stock footage shot in Florahome, Florida, Heston plays Christopher Leiningen, a wealthy plantation owner recently married to Joanna (Eleanor Parker), a mail-order bride from the United States. Everything goes well until he discovers she was previously married and is now a widow (i.e., not pure), and believing he has been deceived, he refuses to have anything more to do with her. As she is packing her things and preparing to return to the States, the ants attack and she pitches in to help fight them. Together

* The Haskin-Pal team had successfully collaborated a year earlier on the hugely successful film adaptation of H. G. Wells's *The War of the Worlds.*

they miraculously defeat the deadly onslaught, and having proved her worth (her love), Joanna is forgiven by Leiningen and they live happily ever after.

The Naked Jungle was by far the most successful film Heston had made since *The Greatest Show on Earth*. The picture earned a grand $2.3 million in its initial domestic release, nearly ten times what it cost to make, and became one of Heston's favorites from that period. "I guess *The Naked Jungle* did turn out quite well. My wife describes my character as one of those hero-heels . . . people come up to me and say 'Oh, those ants . . .' and then 'I remember the scene where you had this girl, Eleanor Parker, and you threw this bottle of perfume all over her!'"

Heston remained at Paramount to work again with *Pony Express* director Jerry Hopper, this time in 1954's *Secret of the Incas*. The film received generally good reviews, and the influential trade publication the *Hollywood Reporter* singled Heston out as one of the new actors worth watching out for: "[Charlton Heston] has shown commendable progress since coming to Hollywood. He has yet to learn that the camera is his friend and that he does not need to act quite so hard to get over his effects, but he's doing fine. Right now, he is about mid-channel in a career that should land him among

such powerful (and relaxed) giants of movie box-office as Gary Cooper, Cary Grant and John Wayne. They all went through (very painfully) what he's going through now." The magazine had put Heston in some very heady company, and everyone in Hollywood was talking about it, and him.

Paramount kept him on for *The Far Horizons*, Rudolph Maté's 1955 film that was a fanciful retelling of the story of Lewis and Clark, with Heston as William Clark and the always dependable and extremely popular Fred MacMurray as Meriweather Lewis. Somewhere mixed in between "Indian" attacks and other assorted "dangers," Clark falls in love with Sacajawea, of the Lemhi Shoshone tribe, played by the extremely pale, all-American farm-girl-type Donna Reed. In the end, Sacajawea decides she can't live in Clark's white world and returns to her own people. Made on the cheap for $200,000, *The Far Horizons* earned a solid $1.5 million in its initial domestic release.*

* In 2011, *Time* magazine rated *The Far Horizons* as one of the top ten most historically misleading films because of the casting of Caucasian Donna Reed as Native American Sacagawea, as well as the creation of a romantic subplot between her character and William Clark, despite the fact that Sacagawea's husband, French-Canadian trader Toussaint Charbonneau, was in real life also a member of the expedition.

Heston's next film, yet again at Paramount, was the bigger-budget, Technicolor, VistaVision production of *Lucy Gallant,* with Jane Wyman, Claire Trevor, Thelma Ritter, and William Demarest. Unfortunately, the interesting World War II–era, Texas-set western failed to find an audience.

With the heat that had been generated by the *Hollywood Reporter* piece starting to dissipate, and unsure of what to do next—return to New York for more live TV or stay in L.A. and continue to appear in hit-or-miss films that had thus far not been able to match the impact of his turn in *The Greatest Show on Earth*—two life-changing events occurred. The first happened when Lydia informed him that after eleven years of a childless marriage, he was about to become a father. As Lydia later recalled: "We were both capable of having children, but had pretty much given up, then something wonderful happened and Chuck faced becoming a parent. He took it quite enthusiastically." Indeed, he believed they had been blessed by God.

The second was meeting God, when Heston was cast as Moses in Cecil B. DeMille's epic remake of his own 1923 silent classic, *The Ten Commandments.*

Sir Cedric Hardwicke, Charlton Heston, and Yul Brynner in Cecil B. DeMille's The Ten Commandments *(1956).* (Courtesy of Rebel Road Archives)

Chapter Nine

DeMille had actually begun planning his grand remake of *The Ten Commandments* in 1948, but with Paramount reeling from the Supreme Court's antitrust decision, which severely weakened the profit structure of the entire industry, and with its future uncertain, studio head Barney Balaban urged DeMille to make budgeting his top priority. This was why he chose the less costly, smaller-cast *Samson and Delilah* that year and followed it up not with *The Ten Commandments,* as everyone at Paramount had expected him to, but with *The Greatest Show on Earth,* which, like *Samson and Delilah,* was relatively inexpensive to produce and became a huge moneymaker and multiple Oscar winner. Now, hearing the ticking of his mortality clock, DeMille felt he had to begin *The Ten*

Commandments and came up with an astronomical $8 million budget for the studio to approve.

He spared no expense in mapping out his plan. He wanted to shoot in the superior three-strip Technicolor process and the studio's pricey VistaVision system, which Michael Curtiz had introduced with great success in Paramount's star-studded 1954 smash-hit holiday musical romance *White Christmas,* with major stars Bing Crosby, Danny Kaye, Rosemary Clooney, and Vera-Ellen, and songs by Irving Berlin. VistaVision involved two strips of 35 mm film shot together horizontally to create a negative image nearly twice as wide as the normal 4:3 ratio and produced an unusually sharp picture, but it required special equipment to be installed in theaters that wanted to show any film shot with the special process correctly.* DeMille knew that shooting in VistaVision added a great deal of expense to the film's budget, but he didn't care. He wanted *The Ten Commandments* to look on-screen like the spectacular event he envisioned it to be.

* VistaVision didn't use the interchangeable anamorphic lenses that had made CinemaScope so easily adaptable to theaters' existing projection systems. The need for special projectors and problems developing stereophonic sound for the process led to the swift demise of VistaVision. The last film to use the process was Marlon Brando's *One-Eyed Jacks* (1961; coproduced by Walter Seltzer).

When Paramount hesitated to immediately green-light the project and instead asked for a detailed breakdown of his proposed budget, an infuriated DeMille threatened to move the film to another studio. After much internal debate, a divided board of directors finally agreed to put the film on its production schedule, but with significant changes to the budget and the script.

Why was Paramount so reluctant to remake DeMille's vision of *The Ten Commandments*? For one thing, the studio didn't want to invest so much money into what some there considered the director's old-fashioned style. Movies were changing, becoming more interior and realistic and, gradually, racially aware, and while the virtually all-white *Greatest Show on Earth* was an undeniable hit, Paramount considered it something of a throwback to another day, to a time when big *did* mean better.

The other was the subject matter. Hollywood had always been reluctant to make movies about Jews. In its entire history, only a handful had ever been made by the studios, and of those, even fewer made money. Part of the reason was the fear of what the Jewish moguls believed was the government's anti-Semitism aimed directly at Hollywood, dating all the way back to the time of Edison and his "trust," the real reason for the

studios' original "Code of Ethics" that led to the formalized, self-regulated Production Code. The Code was a set of rules that demanded films be made about white Anglo-Saxon Protestants for white Anglo-Saxon Protestants, the prevailing social norm in the first half of the twentieth century. By 1954, with the notorious communist-hunting blacklist in full power, the House Un-American Activities Committee (HUAC), formed in 1938 to investigate subversion and disloyalty in the film industry, spearheaded what many in Hollywood considered Washington's not-so-veiled attack on the alleged "Jewish-communist cabal" that had infiltrated the industry before, during, and especially after World War II (Harry Truman later called HUAC the most un-American thing in the country). Along with trouble brewing in the Middle East over the Suez Canal, many at Paramount thought it was a bad idea to produce a film that glorified Jews and vilified Egyptians, even if the story took place fifteen hundred years before the birth of Christ.

DeMille's original 1923 masterpiece had not gone wholly into the life of Moses. In that version, a fifty-minute opening segment showed Moses leading the exodus of the Hebrews from Egypt and ended with the parting of the Red Sea, after which the film switched

to a modern-day setting, with the tablets of the Lord reappearing every time one of the rules of the Ten Commandments is illustrated by the characters in the present.

This time DeMille wanted to tell the whole story of Moses, from birth to his final reunion with God atop Mt. Sinai. What finally convinced Paramount to go ahead with the film was DeMille's insistence that it was really about the modern-day Holocaust, something that had horrified everybody in America, not just Jews, a subject no film as yet had been made about. He assured the studio his film would have a broad appeal and, finally, that Moses would not be played by a Jewish actor.* Once the film was green-lighted and DeMille started preproduction, he began to suffer anxiety at-

* DeMille, always a shrewd negotiator, may have made the promise knowing all along he wouldn't risk having a Jewish actor play Moses. DeMille himself was half Jewish (on his mother's side), and Moses is "Egyptian" for the first half of the film. The film was at least partly autobiographical in the sense that, just as Moses does, DeMille at times struggled with his religious origins. Also, through both the 1923 version, when the government was pressuring Hollywood to clean up its act, and the remake, when the industry was under siege by HUAC, DeMille saw himself as film's moral savior, a modern-day Moses leading the industry out of its fall from grace by reminding it, and the world, of the Old Testament's tale of sin and redemption.

tacks about what would happen to his legacy if the film failed at the box office.

His first challenge was authenticity. There is little written about the early life of Moses after he is sent down the River Nile by his mother to save his life. The Bible doesn't mention him again until he is thirty years old. This is the reason the first half of the film, despite all of DeMille's attempts to fill in the blanks, plays like a typical, if unusually lavish, Hollywood boy-meets-girl love story, complicated by a Freudian rivalry between two half-brothers over the girl, who, of course, winds up marrying the one she doesn't really love. The twist, if that is what it may be called, is that the boy she wants rejects her for a better offer, from the Lord.

The second half of the film is on much firmer biblical ground. Tellingly, when *The Ten Commandments* runs on American network television every spring, the ratings invariably increase as the film progresses; everyone wants to see the more dramatic second half, with its Old Testament parting of the sea.

To come up with a cohesive script, DeMille assigned Henry Noerdlinger, his longtime friend and head of his unit's research division, to put together a scenario based on whatever he could find about Moses's youth. Noerdlinger went to Egypt to do a historical search at the museums there and brought along cameraman

Loyal Griggs to scout locations on the banks of the Nile River.*

Noerdlinger pored over a thousand publications to try to piece together the story of the young Moses and, upon his return to Los Angeles, continued his research. He consulted the Midrash Rabbah's ancient compilation of rabbinic commentaries; the Qur'an; the Hellenic Jewish philosopher Philo of Alexandria's *The Life of Moses*, based on his interpretation of the Old Testament; the writings of Josephus and Eusebius; and modern works, including *The Pillar of Fire* by J. H. Ingraham, *On Eagle's Wings* by A. E. Southon, and even a popular 1949 novel, *Prince of Egypt*, by Dorothy Clarke Wilson.† As it happened, it was Wilson's

* DeMille had started negotiations with King Farouk for permission to film in Egypt, until Farouk was overthrown in a military coup led by General Muhammad Naguib, who was less enthusiastic. He too was overthrown, replaced by Colonel Gamal Abdel Nasser, who was willing to negotiate with DeMille. In mid-1954, Nasser granted permission to film on location after screening DeMille's 1935 film, *The Crusades*, which the director had given him. DeMille knew Nasser would be favorably impressed with the way he had treated the Arabs in the film.

Griggs eventually chose a dry lakebed near Abu Rudeis for DeMille to stage the parting of the Red Sea because he felt its high rocks would make the water flowing into the lakebed look more realistic.

† DeMille spared no expense to ensure his film wouldn't be accused of fabricating any part of the story. So extensive was his

novel that became the script's primary source for the story of the baby Moses being raised as an Egyptian; the sibling rivalry between Moses and his half brother, Rameses, for the love of the throne princess, Nefretiri; and Rameses's eventual marriage to the princess and ascension to the throne.

DeMille next turned to the key task of casting the role of Moses. In his 1959 autobiography, he categorically states that from the start he'd wanted Heston to play Moses: "I was never in any doubt about who should play the part . . ."

This was, however, a more fanciful, after-the-fact recollection. DeMille's first choice to play Moses was Victor Mature, a Roman Catholic, whose performance in *Samson and Delilah* had been a major factor in that film's financial and artistic success. DeMille would have offered Mature the role if he had not agreed to star in Michael Curtiz's *The Egyptian* (made in 1953,

research that a journal of references and notes kept by Henry Noerdlinger was published in 1956, the year of the film's release, by the University of California Press, titled *Moses and Egypt: The Documentation of the Motion Picture* The Ten Commandments. DeMille personally funded the publication, hoping it would help validate the liberties he had taken and the assumptions he had made in the telling of the young Moses's story. The book, which Noerdlinger claimed was the product of several hundred thousand dollars' worth of research, was later criticized in academic circles as a work of pure fiction.

released in 1954), a robes-and-sandals film DeMille was convinced Twentieth Century-Fox had put into production to open ahead of *The Ten Commandments.* Feeling betrayed by Mature, DeMille eliminated him from any further consideration.*

There is a bizarre story in the film's production files at the Academy of Motion Picture Arts and Sciences that also appears in Simon Louvish's biography of DeMille, stating that he originally offered the role to William Boyd. Boyd was a longtime friend of the director's and he had starred in several of DeMille's highly successful films before playing Hopalong Cassidy in a 1935 western and being typecast as "Hoppy" for the rest of his career. In 1952, DeMille had given Boyd a cameo in *The Greatest Show on Earth,* but it was in full "Hoppy" regalia and turned out to be the actor's last film appearance.† According to the production file, the

* When other studios heard about DeMille's plans to film *The Ten Commandments,* they rushed their own competing robes-and-sandals films into production. In addition to Fox's *The Egyptian,* Warner Bros. signed Howard Hawks to direct 1955's *Land of the Pharaohs* and Robert Wise to direct 1956's *Helen of Troy,* both released six months before *The Ten Commandments.* All of them came and went without making a significant impact on audiences or their respective studios' coffers.
† An old newsreel clip of Boyd as Hopalong Cassidy appears at the end of Curtis Hanson's 1997 film adaptation of James Ellroy's novel *L.A. Confidential.*

cameo was really meant to be an audition for *The Ten Commandments,* to see if Boyd could appear young enough on-screen to play Moses. DeMille thought him a prime candidate, with his handsome face and silvery hair, as well as the correct moral image—Hoppy never started a fight, kissed a woman, drank alcohol, smoked a cigarette, or failed to defend a good man being bullied by a bad one—and, significantly, he, too, wasn't Jewish. But in the end, DeMille decided Boyd was out, not for his age, but his identification with the role of Hopalong Cassidy.

If this all sounds preposterous, it's because it is. Boyd was fifty-nine in 1954, and that alone would have made it all but impossible for him to play the young Moses in the first half of the film. More likely it was Boyd who approached DeMille after *The Greatest Show on Earth,* hoping to get the role of Moses, knowing it was a long shot. After an extended lunch, during which Boyd tried to convince DeMille that audiences would accept him out of his black cowboy outfit and ten-gallon hat, and added that he would play the role for little or no money, DeMille told him as gently as he could that there was just no way Hoppy was going to appear in ancient Egypt.

However, DeMille enjoyed driving Paramount crazy with the notion and chortled over the many panicky

phone calls he received from studio executives begging him not to use Boyd. DeMille let the story run its course until, perhaps to save face, Boyd announced, to everyone's great relief, that he could not play Moses after all because of a series of prior commitments to make personal appearances as Cassidy that he just couldn't get out of.

The story has an interesting postscript. DeMille invited Boyd along to Egypt during the shooting of the location scenes. It was thought by some that Boyd was there as an insurance policy—if DeMille decided his chosen Moses wasn't cutting it, Boyd could step into the role. In any case, he came along officially as a friend, hoping DeMille eventually would find something for him to do in the film.

DeMille's real second choice after Mature was Heston. The director had been impressed by the way he had grown into the role of Brad Braden and had been able to convince audiences he could command and coordinate the various crises and complexities that came with running a circus. It was known in the industry that DeMille liked to work with the same people in front of and behind the camera—what he called his movie family—one of the reasons he had first wanted Mature. And, of course, Heston's chiseled features and manly countenance, and the fact that he wasn't Jewish, made him a great sec-

ond choice; he was the quintessential (and commercially viable) Protestant able to pass, as the Italian-Swiss Mature had, as an ancient Hebrew.

DeMille did not tell him he had the role until all the other major parts of the film were cast. The director's always canny sense of publicity made him want to turn his "search" for Moses into a major publicity stunt he hoped would capture the public's curiosity the same way that Selznick's had casting the role of Scarlett O'Hara in *Gone With the Wind.* It didn't happen. In the fifteen years since, the public had lost interest in such overblown Hollywood faux events. Still not wanting to completely tip his hand, DeMille went through the ritual of auditioning Heston, during which he revealed a quite extensive knowledge of the Old Testament. Heston had delved into the subject, learning all he could, hoping it would help persuade DeMille to give him the role he didn't know he already had.

The director then released a story to the trades that on a recent trip to Rome he happened to gaze up at Michelangelo's white marble figure of Moses in the Church of St. Peter in Chains, and he was surprised at how much the face of the Hebrew leader resembled Charlton Heston's. That, DeMille said, was when he realized he had to cast the actor in the role. There was some resemblance, to be sure—the sculpted cheekbones

both marble and man shared—enough for DeMille to seize upon.* What he didn't publicize was how little money Heston had agreed to take to play Moses. Knowing the forward momentum of his career had stalled a bit after *The Greatest Show on Earth,* when DeMille finally offered him the role, via Herman Citron, for a flat fee of $50,000 with no percentage of the profits, Heston accepted without hesitation, instructing Citron not to try to negotiate for better terms. He was grateful for the chance to once more appear in the lead role of a DeMille picture. The hardest thing for any actor in Hollywood is to go from a B+ actor, a more familiar face with a less familiar name, to name-above-the-title stardom. DeMille was offering Heston that opportunity. It's likely he would have done it for nothing.

* Some versions of the story credit Henry Wilcoxon for first pointing out to DeMille the resemblance between the Michelangelo sculpture and Heston. Whatever similarity there is owes more to Michelangelo's perception of the spirit of Moses than any real physicality. Heston's classic features did resemble the sculpture enough to make the story credible, but according to several sources, including film historian Katherine Orrison in her narrative track on the CD release of *The Ten Commandments,* Heston had gone to Wilcoxon, asking for his help in convincing DeMille to cast him, and Wilcoxon, who liked the young actor and thought him right for the part, came up with the idea of drawing a beard and long hair on a print of the sculpture, showing it to DeMille, and pointing out the "likeness."

One of the film's major plotlines was the aforementioned historically improbable romance between Nefretiri ("beautiful companion") and the young Moses.* To play the exquisite Egyptian (who actually lived sixty years before Moses)—what DeMille described in his PR casting campaign as "the most sought after [female] role of the year"—his first choice was Audrey Hepburn, until he had her fitted for period costumes and screen-tested and decided she was too thin and delicate to play the Delilah-like seductress. He then auditioned several well-known actresses for the part—Ann Blyth, Vanessa Brown, Joan Evans, Rhonda Fleming,

* Many questions remain about the authenticity of this part of the film's story. According to Katherine Orrison, an American film historian specializing in the films of Cecil B. DeMille and author of *Written in Stone: Making Cecil B. DeMille's Epic,* The Ten Commandments: "Research by Henry Noerdlinger, who was DeMille's lead researcher for decades, showed that Rameses II did have an older brother. Whether or not that older brother was Moses, there's no way to be absolutely sure, because his images were chiseled off of all the monuments, the pillars, and the tablets. But there was a rival and there was an older brother. The Qur'an says Moses was raised in the house of the Pharaoh as a prince of Egypt . . ." Moses also was said to have a speech impediment, the result of an injury to his tongue at childbirth, but DeMille decided he could not have his movie Moses stutter. Nor did he have Moses's head shaved, despite the fact that he was part of the royal family and it would have been mandatory. Instead, he had Heston's hair short, but left all of it on his scalp.

Coleen Gray, Jane Griffiths, Jayne Meadows, Jeanmarie, Vivien Leigh, Jane Russell, and Joan Taylor—before choosing Oscar-winner Anne Baxter, as good a seductress as any.

For the role of Bithiah, the pharaoh's widowed daughter who finds the baby Moses floating down the Nile, DeMille considered Merle Oberon, Claudette Colbert, and Jayne Meadows (again) but chose Nina Foch on the advice of Henry Wilcoxon, who had worked with her before in George Sidney's *Scaramouche* (1952) and had been impressed with her talent (at the time of the filming of *The Ten Commandments*, Foch was thirty years old, one year younger than her adopted son in the film, thirty-one-year-old Heston).*

For the crucial role of Rameses II, DeMille looked at several well-known film actors, including Anthony Dexter, Stewart Granger, and William Holden, the last of whom DeMille had all but settled on until Holden said he wouldn't shave his head. The British actor Michael Rennie, in demand in America after his notable performance in Robert Wise's *The Day the Earth Stood Still* (1951), was DeMille's second choice for the

* The blue-eyed Foch had to agree to wear brown contact lenses to appear more Egyptian before DeMille officially agreed to give her the part.

role until, in February 1953, he was in New York City and treated his granddaughter Cecilia and two of her friends to see the hottest show in town, Rodgers and Hammerstein's *The King and I.* During intermission, DeMille took the children backstage to meet Gertrude Lawrence, who was playing Anna. She, in turn, introduced DeMille to the show's authoritarian king of Siam, Yul Brynner.

As Cecilia later remembered, "[Grandfather] said good evening to him and the second thing he said was 'How would you like to play the most powerful man on earth?'"

Brynner wanted to accept DeMille's offer on the spot but had already committed to finishing the Broadway run of the show, the national tour to follow, and, immediately after that, the film version of *The King and I.* Not one to be deterred, DeMille offered Brynner $7,500 a week with a guaranteed ten-week minimum and told him not to worry, he would figure out a schedule that would not interfere with his other commitments. Brynner agreed, and later on, when he found out Heston was going to play Moses and that they would both appear together shirtless in several scenes, the vain, peacocky five-foot-eight Brynner began a rigorous weightlifting regimen. (By the time he played the king in the film version of the musical,

he was notably buffer than he had been on Broadway, and his new, stronger physique added to the romantic heft of his performance in the film, opposite Deborah Kerr, who was twenty-three years younger than Gertrude Lawrence.)

For Dathan, the scheming, collaborating Hebrew who takes Joshua's love, Lilia, and turns her into his mistress/slave, and later wants to sacrifice her during the worship of the Golden Calf, DeMille originally wanted Raymond Massey, an actor with no shortage of gravitas, and his being the same height as Heston would make them more evenly matched in their competition for leadership of the Jews. Massey, however, turned the part down, saying he wanting nothing to do with biblical spectacles and instead signed on to play James Dean's father in Elia Kazan's 1955 adaptation of John Steinbeck's *East of Eden*. DeMille next went to Jack Palance, who had been Marlon Brando's understudy in the Broadway production of *A Streetcar Named Desire* and whose film career was on the rise. Palance also said no, fearing he would get lost on-screen among the film's star-studded ensemble, and then, inexplicably, signed on for Douglas Sirk's 1954 robes-and-sandals epic, *Sign of the Pagan*. DeMille then offered the role to Edward G. Robinson. The actor, once one of Warner's biggest stars, had recently been investigated by

HUAC because he had publicly denounced Hitler at the height of the war, but not Stalin (Robinson was Jewish; his real name was Emanuel Goldenberg). Called twice to testify, Robinson was classified as an "unfriendly witness" and was subsequently gray-listed, still able to work but with far less frequency; his fee then plummeted and he had to sell one of his prized van Gogh paintings to stay solvent. DeMille, who had been an avid supporter of the blacklist, but thought Robinson perfect for the role, decided to "forgive" Robinson and hire him. As always in Hollywood, when convenient, political precedent takes a backseat to profit potential. Robinson later graciously credited the director for saving his film career.

DeMille wanted Elmer Bernstein to write the film's lavish score, even though he too had come under suspicion by HUAC. DeMille simply asked him if he was a communist; Bernstein said no and he got the job.

To play Lilia, DeMille had first thought of Sardinian-born MGM discovery Pier Angeli, but the studio had her under exclusive contract and refused to loan her out. He then chose Debra Paget, a pretty starlet who had been knocking around Hollywood in minor roles for nearly a decade. DeMille had first seen her in Delmer Daves's *Demetrius and the Gladiators* (1954), Fox's sequel to *The Robe*, and thought she suffered well on-

screen (the same year she appeared in *The Ten Commandments,* she played Elvis Presley's suffering love interest in Robert Webb's *Love Me Tender*).

DeMille rounded out the rest of the cast with Yvonne De Carlo (Sephora), John Carradine (Aaron), John Derek (Joshua), Vincent Price (Baka), and Martha Scott (Yochabel, mother of Aaron, Miriam, and Moses).* Sir Cedric Hardwicke was cast as Sethi (another Wilcoxon choice), John Ford regular Woody Strode the King of Ethiopia, and future TV series stars Michael Ansara and Clint Walker were given smaller, unnamed parts. Fourteen thousand extras† and fifteen thousand animals filled out the rest of the 308-page script's seventy speaking parts.‡

On October 14, 1954, DeMille set sail for Egypt to personally inspect the massive sets that he had ordered

* Scott was six years younger than Carradine, six years older than Olive Deering (Miriam), and eleven years older than Heston. Scott had played Heston's wife on Broadway in *Design for a Stained Glass Window* (1950) and would play his mother again in *Ben Hur.*

† A long-standing rumor, never proven, has it that Fidel Castro, who was living in Mexico at the time and a lover of American movies, traveled frequently to Hollywood and worked as an extra in the film as an Egyptian soldier.

‡ Feature film scripts are normally a maximum of 120 pages; TV movies have less because of commercial time. One page of script usually equals one minute of film.

built and to film the key location footage. He took most of his crew with him, and the trip over became one long party fueled with expensive champagne and rich food, all of it personally paid for by DeMille. He wanted everyone to have a good time in transit before they'd be working virtually nonstop in the relentless 110-degree desert weather.

DeMille had wanted Heston to make the journey too, but he was still on location in Texas shooting the last of his scenes for *Lucy Gallant* and promised he would fly over as soon as he could. While in Texas, Heston began preparing to play Moses by reading the Old Testament from start to finish. He next tackled twenty-two books on the life of the Hebrew leader.

Lydia, who was in the early months of her pregnancy, had made the trip to Texas with Heston in her official capacity as company photographer, and he drove her nearly crazy with his role and study. Every morning over breakfast he would recount to her the story of the origin of the Jews or discuss the meaning of the Dead Sea Scrolls, subjects in which she had utterly no interest. In the evenings, as soon as they both returned from the set, he would resume these marathon discussions about Moses and the Scrolls (he talked, she listened). After a week of this, it was all Lydia could do not to run screaming to the nearest Protestant church.

DeMille, meanwhile, was growing impatient for Heston to arrive and every day sent him telegrams to hurry and finish the other movie and get himself to Egypt; he was needed for almost every location scene. Heston wanted Lydia to come along, and, as Lydia later remembered, "I wanted very much to go with him to Egypt. I always accompanied Chuck on his travels on location . . . the only problem was, I was expecting our first child. My obstetrician said, 'If you want this baby, you're not going to go hiking across the Egyptian desert.' I had no choice. I stayed [home]."

Three hours after filming his last scene for *Lucy Gallant,* Heston was on a Paramount plane en route to Cairo. Thirty hours and two fuel stops later, he arrived in the dead of the Egyptian night, met by the company's driver, who took him to the Mena House Hotel. The next morning, when he awoke from a much needed few hours of sleep, the first thing he saw when he opened his eyes was the Great Pyramid of Giza just outside his window.

After breakfast, Heston was driven fifteen miles to Beni Youssef in the Sinai desert, where he first saw, and was awed, by the magnificent sets for the Gates of Rameses and the Avenue of the Sphinxes DeMille had ordered built. The dimensions of the span was a hundred feet tall and nearly a half mile wide, with two

dozen fake sphinxes along the way, each about fifteen feet high. Heston greeted DeMille while he was standing in the middle of it all with his hands on hips, angrily shaking his head, pointing a finger and yelling to his painters for more "age" on one of the sphinxes. They shook hands, DeMille asked Heston how his wife was doing, he said fine, and before he could say anything else DeMille's limo pulled up and the director was whisked away, leaving Heston alone in a cloud of desert sand.

That night he attended a welcome party thrown by some of the locals working as extras on the film. One of them offered him the eyeball of a sheep on the tip of a Bedouin dagger. Not wanting to offend his hosts, he gulped it down.

The first scenes DeMille filmed the next day were Yul Brynner leading the pharaoh's chariots past the Avenue of the Sphinxes on his way to trap Moses and the Jews at the edge of the Red Sea. DeMille had managed to get Brynner for one weekend of location work. The actor had flown out of Los Angeles that Friday night, changed into costume during the flight, and landed the next day in Egypt, ready to shoot his scenes as soon as he walked off the company plane. By Sunday night he was on his way back to Hollywood. Although Brynner and Heston shared a lot of exterior screen time

in the film, it was all done on set in Hollywood with background process shots; they had no scenes together while both were in Egypt.*

During filming, Brynner's pharaoh burned like a blowtorch, his piercing brown eyes laser beams of intensity. He was a bit hyped up for the role, but he was no Method actor. He had taken an injection of speed before the cameras rolled, given to him by the film's location doctor, Max Jacobson. Speed was always the drug of choice in Hollywood and it was no different on location in Egypt. The studios loved it because it kept production going at a maximum. Everyone was given it as often as he or she wanted, including the extras and the crew, everyone except Heston who said he didn't need amphetamines, he was energized enough by the chance to play Moses. DeMille was also a regular user of Dr. Jacobson's injections and pills. Fatigued by the journey and his hyper-supervision of every aspect of the shoot, he became addicted to Dr. Jacobson's "pick-me-ups."

That weekend, Heston stood just to the left of one of the custom VistaVision cameras DeMille had brought

* Heston and Brynner were the only two members of the cast invited by DeMille to Egypt. Yvonne De Carlo had come along but had to pay her own way. She wanted to watch the filming to help her understand how to play Moses's wife.

out to the desert, to watch Brynner act. As Heston later remembered, DeMille's directing technique was quite memorable: "He was courteously formal, very pleasant, although he could be a holy terror with ADs [assistant directors] and prop men. He arrived each morning at the set in suit and tie, although jacket and tie would be gone and the sleeves rolled up by midmorning. He was famous for his jodhpurs and puttees out on location, but he explained to me that he just wasn't as young as he had been and wanted the support for his legs."

After shooting several scenes of the pharaoh's soldiers making their approach to the sea, DeMille ordered a certain sequence of Brynner pulling up in his chariot to be shot wide. After a couple of tries, Brynner couldn't hit his mark, and a frustrated DeMille went over and pushed Brynner out of the chariot, rode the horses himself around in a circle two or three times, and landed precisely at the X in the sand. DeMille then shouted, "Print," and everyone on-set burst into thunderous applause. It is DeMille who is seen in the shot, not Brynner.

Heston was impressed by what the director had done to get the scene he wanted, and that evening he began to write about it in the daily planner Lydia had given him to chronicle the making of the film. This journal ritual was something he would continue for the

rest of his life, both on and off film sets. He wrote in it mostly by hand, sometimes typing up his thoughts on the three-hole pages before replacing them in the planner. He later explained that keeping a journal was the best way to remind himself of what he did each day. The more he wrote, the more he liked writing, and his pages became more detailed. Increasingly, he tried to emulate Ernest Hemingway, his favorite writer, using a clipped, factual style.

Here are some never-before-published excerpts from Heston's diaries from those first days observing DeMille directing Brynner:

Now they're working on the departure
of Pharaoh's chariots in pursuit of the
Israelites, so I of course am not called
and have a chance to watch. It's the first
they've actually shot in this set . . . and
for over six months Major Abbas, of the
Egyptian cavalry, has been training the
hundreds of chariots and horses and
men that will work in the sequence and
yesterday the first shots were made . . .
Major Abbas was everywhere, shouting
into a hand mike in crackling Arabic,
and signaling with a twenty-foot bullwhip

to the plunging teams a half-mile across
the sands. DeMille seethed back and
forth between the four grinding cameras,
smouldering at delays, followed by a
scurrying covey of satellite assistants.
And Pharaoh's chariots swept and wheeled
in the hot, hard wind tearing at the
manes of the matched Arab teams, their
hooves muttering like thunder on the
sand; the white Egyptian sun glinting
blindingly off the bronze javelins and
helmets of the charioteers. It's a heart-
stopping thing to see the columns turn
and roar down at you, even though you
know they'll turn in time. What it must
have been to stand against them on foot,
is frightening to think of . . .

It took three days by Jeep for the company to cross
the Sinai to finish filming the desert sequences:

We've just returned to Cairo from the
toughest location I've ever been on; and
I think this goes for the others in the
company too, even those who go back,
like DeMille, thirty years and more of

locations all over the world. The toughest
to get to, the toughest country to work in,
and the longest hours when we got there.
It was terrible . . . and Magnificent.

We went down the Nile road by car
to Suez, across the canal the British
Army is evacuating, then into a desert-
equipped car and into Asia, through the
Sinai desert to Abu Rudeiss on the shores
of the Red Sea; then by camel through
the mountains to Wadi Feiran and St.
Catherine's monastery, where our base
camp was, and finally on foot up Jebel
Moussa to our advance camp within yards
of where God said to Moses, "Put off thy
shoes from off thy feet; for the ground
whereon thou standst is holy ground . . ."

In all, we were gone twelve days,
shooting parts of the Burning Bush and
Decalogue sequences in Sinai, and, on
our way back, all of the scenes of Moses
wandering in the desert, working then out
of a camp at Abu Rudeiss. All of it was
strange and wonderful and awesome . . .
and terribly far away, of course. To wake
and swim at dawn in the Red Sea before

plunging back into the desert again; and
look at the sun rising along the curious
barren mountains, like some strange
landscape out of the Arabian nights,
lacking only a croc circling the water.
The desert itself is the most terrifying
I've seen . . . and this in the fall of the
year. To stand on the peak of Sinai was a
deeply moving experience for me; and to
live, as we all did for five days, inside the
monastery itself, was perhaps the most
fruitful of all we saw and did . . .

While in Egypt, Heston spent all day, every day, depending on which scene he was filming, in one or more of the eleven completely different makeups and costumes that helped visualize the transformation of Moses from a handsome young Egyptian prince, to a Hebrew slave, to a prophet of God, to an aged, bearded patriarchal liberator. It was DeMille's idea to correlate Moses's gaining knowledge and acceptance of his spirituality with physical aging, including the luxurious long white hair and beard, a bold contrast to Rameses II's sleek, bald, ageless character—neither young nor old—who worships false idols. Heston's outfits were weighty and stiff, and the makeup on his face, espe-

cially the spirit-gummed beards, was extremely un-
comfortable to wear in the sticky heat. He was unable
to sit while made up and in costume. As a result,
Heston stood for almost the entire two weeks he was in
Egypt. He even refused to let doubles stand in for the
long tech rehearsals, when lights needed to be set and
focus and exposures worked out for every shot. Heston
later credited his costumes as one of the essential keys
to finding his interior Moses: "Every morning I'd come
in for those make-ups at 5:30. They'd take from two to
three hours to put them on . . . When they'd finish, I'd
stand up and look in the mirror and feel that I had sort
of disappeared . . . That first shot of Moses descending
barefoot from the burning bush—how can you stand
on Mt. Sinai dressed as Moses and not really feel like
that?"

He never complained to DeMille about the director's
well-known penchant for retakes, even in the blistering
desert.

When he wasn't required at the Mt. Sinai shoot,
Heston liked to walk barefoot on the sharp rocks at
its base. At night, as he had with Lydia in Texas, he
drove the weary crew to distraction with his immersion
into the character of Moses. Here he chatted about,
among other things, what he imagined Moses's sex life
might have been like. "He wanted to talk to anybody

and everybody about Moses' id," recalled an American member of the crew, "but we were only trying to find out how the hell to get a cold beer in Egypt."

Among the locals who worked as extras on the film were Christian monks who lived near the entrance to the mountain at the Monastery of St. Catherine, near the Sinai desert where Heston filmed his scenes. They spoke no English and had no idea what was going on, but believed something vastly important was taking place. They were astonished the first time they saw Heston in costume, and instead of offering him another morsel of eye, they started blessing and sprinkling him with holy water, believing he was the actual Prophet Moses returned to earth. Heston later remembered, "As I moved through their thousands in my Levite robe, staff in hand, I was followed by wide eyes and a soft surge of whispers, *'Moussa, Moussa, Moussa.'*"

Filming began every morning promptly at seven thirty so that DeMille and cinematographer Loyal Griggs could catch the sun's golden reflection off the sets and the sand. By then, Heston would be off by himself for a half hour to practice how to move his hands in the upcoming scenes, to try to set the way he thought Moses might have moved his so that by the time places were called, he would be completely in costume and totally in character.

The last three sequences DeMille filmed in Egypt were, in order, Moses's ascension of Mt. Sinai to meet God, the middle scenes of Moses's miracle walk through the desert, and the grand exodus of the Hebrews from Egypt. For the first, DeMille brought a sixty-man crew; dozens of camera people, lighting personnel, soundmen, and assistants; and a fleet of Plymouths filled with food, medical supplies, additional costumes, and anything else they could fit into them. Eighty feet of track was laid down so DeMille could have an uninterrupted dolly shot of Moses's actual ascent. There were no roads up the mountain, so for the entire sequence the crew had to walk in line behind Heston, carrying by hand the heavy cameras, lights, cables, and microphones the last mile.

To set an example, the seventy-three-year-old DeMille stayed at the head of and led the entourage the whole way.

For the second sequence, the crew spent the entire day following Heston as he stumbled through the desert as Moses, growing increasingly weak from the lack of food and water. The need for water was no great acting feat on Heston's part. Someone had carelessly left the spigot open on the ten-gallon supply tank next to the prop truck at the foot of the mountain and it had run out, leaving everyone, including Heston, parched and thirsty.

The last sequence was the exodus. It was filmed just outside of Cairo, mostly in long shots, and filled with crowds of Egyptian extras, with medium close-ups of the individual characters, each one played by real actors, to be inserted in proper order during editing later on back in Hollywood. DeMille ran all three of the VistaVision cameras, which were secured on specially designed cars just behind the set of the fake sphinxes. He used no mikes, knowing the sound quality wouldn't be any good because of the constant braying of the Bedouin extras' menagerie of five thousand animals. The entire aural track would be dubbed in during postproduction.

DeMille moved people around until he was completely satisfied with his frame. The setup took hours, as it appeared at one point that he was going to place each of the thousands of extras and animals exactly where he wanted them to be. "Dear God," Heston said aloud to himself, "is he going to do this with all eight thousand people?"

When DeMille was finally ready to start shooting, he waved everyone silent and, using an amplified megaphone, spoke to the crowd from his seat atop a boom in his familiar, stentorian voice: "Ladies and gentlemen, this will be a nation moving—an entire people, its children, its aged, its goods and livestock. If you have pre-

pared well, this will be the awe-inspiring event that it is in the Bible and in History." DeMille shouted for the cameras to roll and shot off a .45 pistol so all the extras knew to start their action at the same time, and he used it again when he wanted them to stop.

Heston remembered the moment in his journal:

I never felt so heavily the burden that part imposed on me. "Who am I, Lord, that I should bring Israel out of bondage? When I come to the people, they will not believe me," the book of Exodus has Moses say. I knew what he meant. By the time I reached the front of the vast column, half a mile through the wide lane of sphinxes, and stood alone, I felt somehow possessed by where I was and what was around me . . . I lifted the staff of Moses and shouted, "Hear, O Israel! Remember this day, when the strong hand of the Lord bears you out of bondage!"

It took three ten-minute takes (each camera using one complete reel of raw film stock) to shoot, and two hours between each take to reset, during which time hundreds of locals cleaned up the animal waste and

raked the sands smooth. Everyone then had to go back to the starting point and do everything all over again. The first take was done shortly after dawn, the second at noon, the third late in the afternoon. Although it plays in the film as one long sequence, differences in the way the shadows fall clearly shows how long it actually took to finish.

Heston described more of that day in his journal when he woke up the next morning:

> Yesterday was the exodus, and I led them out. When we were discussing the scene the other day DeMille put it to me with apt awe, I think: "When you lift your staff to signal the start of the Exodus, twenty thousand hearts will be beating in front of you." . . . I don't think I can really convey what a genuinely moving experience it was to take part in this . . . I can only say that it was real. We are three thousand years from the time of Rameses II, and Egypt is the world's youngest republic, instead of its oldest empire, but DeMille succeeded in making again, on the sand of Beni Youseff, an instant in history . . . Moses the man

makes a shadow in which the actor
disappears . . . It felt magnificent, and
as we walked I said again to myself the
other words I'd spoken in the scene: "Hear
O Israel! Remember this day, when the
strong hand of the Lord leads you out of
Bondage!"

With the Egyptian sequences completed and every-
one packing for the long journey home, Heston wrote
down in his journal how the time in Egypt had af-
fected him:

All of it was strange and wonderful and
awesome . . . to stand on the peak of Sinai
was a deeply moving experience for me;
and to live, as we all did for five days,
inside the monastery itself, was perhaps
the most fruitful of all we saw and
did . . . Now we are back here in Cairo
[on set] . . . it's a very difficult thing
to describe, because to say that it's the
biggest movie set ever built, and that it
dwarfs everything built in Egypt since the
pyramids, just sounds like a press release.
But to drive across the desert, or ride on

horseback, as I first did, and suddenly
see it loom out of the sand ahead of you
is . . . well, something to see.

I know, too, that nothing I could
have done, nothing I could have read,
would have given me the preparation for
this . . . All the Mosaic literature I'm
working through, all the times I've read
the script, mean little compared to the
weeks I spent wearing Moses' clothes and
breathing the air he knew. And this is
a role that demands such preparation,
and more. If there ever was a character
that could stand in the scales against
the thunder of five hundred chariots, the
mammothry [*sic*] of the largest set ever
filmed, and the color of seven thousand
extras on the Sands of Sinai, then Moses
is that character. If I can realize a tenth
of what is in him, all the extras and all
the sets will fade into the background
for this man. It must work . . . after all
this . . . it really has to.

He was brought back to the present when he took a
final bath before the car was scheduled to pick him up.

"When you're playing Moses," he said, "you go to your hotel and try to part the water in the bathtub. When it doesn't work, you feel pretty humble."

Hard traveling, the desert's furnace-blast heat, the pressure to finish on time, and the injections and pep pills DeMille fist-popped like peanuts finally caught up with him. During the exodus sequence, he had begun to feel ill, but didn't tell anyone until the last foot of film passed through the VistaVision cameras' apertures. Only then had he allowed the company doctors to examine him.

It was more serious than simple heat fatigue. They rushed him to the hospital in Cairo, where it was determined the great C.B. had suffered a major heart attack.

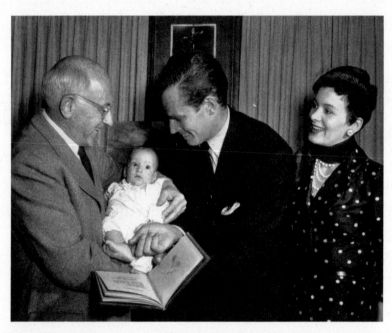

DeMille "signing" baby Fraser to play baby Moses, with Heston holding him and Lydia looking on. The footprint "contract" was DeMille's idea; he staged the photo for publicity purposes. (Courtesy of the Heston Family)

Chapter Ten

After a brief stay in the hospital, DeMille was back in Los Angeles, and ordered to stay in bed for a minimum of four weeks, with an oxygen mask over his mouth and nose at all times. The entire time he was bedridden, he kept insisting there was nothing wrong with him other than a bad case of dysentery. Of course he knew his condition was more serious, but he feared if Paramount executives found out how sick he really was, they might cancel the entire film. He was determined to finish what he started, even if it killed him.

For Heston, the forty-four days in Egypt felt like forty-four weeks. On December 3, 1954, he stepped off the plane at JFK, went through reentry and customs, and finally saw Lydia at the outside gates waiting for him. He threw his arms around her, and pulled her

so close he could feel her belly pressing into him. He grabbed her shoulders and moved her back to look at her. She was in her seventh month, and he marveled at how big she had gotten while he had been away.

They flew to Los Angeles the next day, all the while Heston telling Lydia how it felt playing Moses on the same land where the prophet had once walked, crossing the same desert, being on the same mountain where he had received the Ten Commandments. At one point she interrupted him to say she thought he looked thin and tanned. He asked her what being pregnant felt like. After a few days they settled back into their everyday routines at Park La Brea.

Neither would remember ever being happier.

The Monday of the following week, Herman Citron phoned Heston with an offer for a new picture and urged him to take it. With so much of *The Ten Commandments* left to shoot—only 5 percent was filmed in Egypt—and with DeMille in frail health, no one was sure if the film would ever be completed. Should DeMille die, Citron said, and the word around town was that he probably would, the studio would almost certainly scrap the project. Heston said he would think about it.

DeMille, though, was a tough bird. It had been

touch and go for a while, but in the new year he was strong enough to return to his offices at Paramount. He gradually reimmersed himself into a relentless work schedule, and one day in March he called Heston and asked him to come to the studio to view some of the Egypt footage.

When Heston arrived at the Paramount screening room, he was shocked to see how frail and thin DeMille looked, his face a bloodless pale. They greeted each other politely, then sat together through all the raw footage. During a break Heston finally asked DeMille how he was feeling. The director replied he was in perfect health and planned to resume filming as soon as Paramount finished building the interiors of the sets. Heston knew sets didn't take that long to build and the real reason for the delay was obvious; DeMille was still too sick to return to work. After the meeting, Heston decided to take the other picture, though he remained solidly committed to finishing *The Ten Commandments* if and when it resumed production.

The Private War of Major Benson was a romantic comedy Paramount had originally purchased for the semiretired Cary Grant, before he turned it down when Alfred Hitchcock offered him *To Catch a Thief.* The studio then put *Benson* into turnaround and it was picked up by Universal. The script was sent to Citron,

who thought the part of Major Bernard R. "Barney" Benson, a hard-edged army officer, was perfect for Heston. In the film, Benson, trying to avoid being dishonorably discharged, reluctantly takes an assignment to lead an ROTC program at a Catholic military school for young boys in California ("We've gotta turn these milkshake-drinking schoolboys into whiskey-drinking soldiers!"). The script had a touch of Leo McCarey's *Going My Way* (1944), Paramount's multi-Oscar-winning film that starred Bing Crosby playing a priest who works with neighborhood street kids, and a little of Michael Curtiz's *Trouble Along the Way* (1953), in which John Wayne plays a teacher who becomes the student to his charges, as they teach him the meaning of life.

Heston was eager to play a contemporary character. "It [was] a very funny script," he later said, "exactly what I was looking for as a change of pace after *Commandments*."

With his commitment, Universal was ready to go into production, until a snag prevented that from happening. Citron couldn't get the money he wanted from the studio. Execs claimed that because of the film's minuscule budget, there was almost no money left to pay Heston. At the last minute, Citron suggested to the studio that Heston would do the film for nothing

up front in return for a percentage of the profits—always a risky deal in Hollywood, as very few films ever actually make a profit, no matter how much they gross, owing to the industry-wide practice of creative bookkeeping on the studios' part. As it turned out, because the budget for the picture was so small, it actually made money, and, eventually, so did Heston.*

Jerry Hopper was chosen to direct, at Heston's urging, even though neither had much comedy experience. They had become good friends while making *Secret of the Incas* and were delighted to have a new project they could work on together. *The Private War of Major Benson* was shot quickly and, upon its release on August 2, 1955, received a good review from the *New York Times*'s Bosley Crowther, who called it a "bright little romp" and singled out Heston's acting: "[He] is most entertaining as the champion of the old, traditional style of military training who can't understand why that is wrong."

Private Benson proved to Hollywood that Heston could do contemporary romantic comedy if the opportunity presented itself, which was not that often. In the late '40s to mid-'50s, those parts usually went to Grant, if he wanted them, or Gregory Peck or William Holden,

* The film was released on DVD in 2015.

while Heston remained, to the studios, best suited for westerns, historical films, or action-adventure flicks.

The upside to that was no one ever cast Grant, Peck, or Holden to play Moses.

As the anticipated birth of his child neared, Heston somehow came up with the idea to commemorate his firstborn by honoring Thomas Alva Edison, the man generally credited as the inventor of film, with a permanent memorial in Hollywood. He wrote a letter to Los Angeles mayor C. Norris Poulson detailing his plans and offered to "start the ball rolling with a cash contribution of my own." Heston apparently wasn't aware that Edison was one of the most hated men in Hollywood. The New Jersey inventor had formed the Motion Picture Patents Company in 1908 in an attempt to monopolize New York/New Jersey filmmaking and shut out the mostly Jewish filmmakers and the prurient (to him) films they made for their nickelodeons. Edison eventually drove these future moguls from the East Coast, and they eventually settled in Los Angeles, as far away from Edison and his head-busting (and nickelodeon-smashing) thugs as they could get without falling into the ocean. Despite some early and important films that came out of Edison's film studio, including Edwin S. Porter's *The Great Train Robbery*

(1903), which is generally considered the first real western, putting up a memorial for Edison was, to the studio heads of the '50s, not the best idea.*

The memorial never happened.

When Heston got word production was finally about to resume on *The Ten Commandments,* he set up an appointment at Paramount to refresh his memory by watching Egyptian footage. As he drove up to the Melrose Avenue entrance gate, the guard informed him there was a message waiting from his wife: she had gone into labor and was on her way to L.A. County General Hospital. He turned the car around and sped there, where he then sat in the waiting room for hours. On February 12, 1955, Lincoln's birthday, at three o'clock in the morning, 7-pound, 14.5-ounce Fraser Clarke Heston, named after Lydia's side of the family and the Fraser Clan on Heston's, came into the world.

Heston didn't see his son being born. In those days, for health reasons and for modesty, fathers were not permitted in the delivery room during the actual birth. When he was finally allowed in, wearing a hospital

* Oscar Apfel and DeMille's *The Squaw Man* (1914) is generally acknowledged as the first feature film and western made in Hollywood. *The Great Train Robbery* was shot in Milltown, New Jersey.

gown, he got into bed, wrapped his arms around Lydia and their baby, and stayed that way all night until the nurse brought them breakfast in the morning.

Later that day, a telegram arrived at the hospital:

CONGRATULATIONS. HE'S GOT THE PART.
CECIL B. DEMILLE

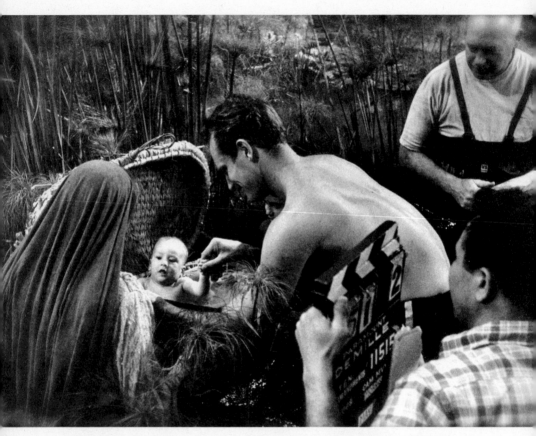

Filming the "Baby Moses" sequence at Paramount, where the Nile was re-created on a back lot. Heston remained just off-camera during the five days it took to complete the sequence, in case anything went wrong with the basket. (Courtesy of the Heston Family. Photo by Lydia Clarke Heston.)

Chapter Eleven

DeMille wasn't kidding. He kept telling Heston during Lydia's pregnancy that if they had a son, he would be in *The Ten Commandments*, and now that it had happened, the director insisted, when the film went back into production a week after baby Fraser was born, he play the baby Moses. In the opening scenes he is put into a basket by his mother, Yochabel, and sent down the Nile River in the hopes he might escape the pharaoh's fearsome order that all Hebrew firstborns be slaughtered, lest a messiah be delivered to them.

Both Heston and Lydia were okay with Fraser being in the film, although they had some misgivings about "Fray" becoming a "Hollywood brat." DeMille scheduled the actual filming for May, waiting until the baby was three months old, the exact same age as the baby

Moses when he was floated down the Nile. The brief sequence took five days to film, with three sets of twins as stand-ins for baby Fraser. To bring him and Lydia to and from the set, DeMille sent a limousine with a personal chauffeur, and also had a maid, a social worker, and a registered nurse present at all times. Heston stayed in the set's river during filming; Lydia stood just to the left of DeMille's elevated director's chair. Later, she recalled that "Fraser was upset one day during the scene, and I asked Mr. DeMille if I might give him a bottle. He held up the shooting, and the entire cast and crew of 500 had to wait until the baby finished his milk. A patient Mr. DeMille remarked afterward that never in his life would Fraser have a more expensive meal."

Fraser later said, "My dad, who was standing just out of the shot in Paramount's artificial Nile River, saw that the basket was leaking a little bit and moved to grab me out of it so I wouldn't drown and dried me off. The social worker stepped up, reached for me, and said, 'Sorry, Mr. Heston, I have to be the one to do that.' And in the voice of God, that dark gray intimidating voice, he pulled me back and said to her, 'Give me that baby!' She did."

When the scene was finished, DeMille called, "Cut and print," and Heston held his boy tightly to his chest, grateful he was all right. It permanently soured him

on the idea that his son should ever appear in front of a movie camera again. Not long after, when Hollywood reporter Hedda Hopper was interviewing him and asked how he felt about Fraser's acting debut, he said this: "Fraser is the youngest retired actor in the profession. I don't want him to act as a child again. It's a terrible life for a kid. Jerry Hopper, a director I worked with a couple of times, once told me, 'A child actor is good for two pictures, and I'd rather have him on the first one. They go fast.' Consider what all the flattery does to adults and with a child, everyone is always saying how sweet he is, and how wonderful. The proper work of a child is play; and no matter how you slice it, it's not play to act. They snatch the kids from a scene and take them right into a school room on a set. The adults can relax, but the children never get a second to themselves."

Lydia, who was there for the interview, agreed, but insisted that "playing the Baby Moses wasn't Fray's first role; he was with me for 17 weeks on the stage [when she was a member of the touring company for the Broadway production of *The Seven Year Itch*] when I was carrying him."

Fraser received seventy-five dollars a day for his appearance in the film. Heston invested the money for him in Paramount stock.

The "Baby Moses" sequence proved a holiday swim compared to the rest of DeMille's schedule: five more months of filming, followed by an additional year to complete all the special effects sequences and seamlessly blend them into the soundstage and location footage. The specially constructed sets matched the ones built in Egypt, slightly scaled down to make room for all of them at Paramount, and included a special pool installed for the parting of the Red Sea sequence. Even then they took up twelve of Paramount's eighteen soundstages. The studio had recently purchased part of the adjoining RKO back lot from Howard Hughes and, to accommodate DeMille, demolished the walls between the two studios, which gave him two hundred thousand additional cubic feet.

The most difficult sequence of all to film was the "Worship of the Golden Calf," an especially grueling set piece that took several weeks to complete. It begins after Moses has gone back up Mt. Sinai to receive the Ten Commandments, which feels like it takes only a few minutes in the film but, according to the Bible, took Moses forty days. During that time, Dathan convinces the people waiting at the foot of the mountain for Moses that he is not coming back, that he has abandoned them, and to save themselves they should build

a golden calf to worship with "debauchery and lascivi-ousness," including human sacrifices.

It was a difficult scene for DeMille to shoot, as he had to be careful none of his actors showed too much skin during what was supposed to be an orgy. He hired hundreds of extras, including several friends or chil-dren of DeMille's friends, including Alfred Hitchcock's daughter, Patricia. Others were future stars looking to pick up a few extra dollars, among them Robert Fuller, who would go on to a career mostly in TV as a series cowboy; Herb Alpert (who played a drummer in the sequence), who would later become a trumpet player, singer, and record-label owner; and Robert Vaughn, future star of TV's *The Man from U.N.C.L.E.* At DeMille's directive, all of them had tans painted on their skins to make them look Mediterranean. Vaughn: "I got a call at work from [my agent at the time] asking what color eyes I had. I said, 'Brown, I guess.' 'Great!' Zev said. 'Get your *tuchus* over to Paramount as soon as you can. DeMille is directing *The Ten Command-ments.* They're casting Jews for the big golden calf scene with Chuck Heston as Moses, and since you have an Actors' Equity union card, you'll get a hundred bucks a day for five days . . .'" DeMille liked Vaughn so much he gave him a second role playing an Egyptian

riding in the first chariot behind Brynner. He was told to keep his helmet low over his eyes so no one would wonder why a Jewish slave was also an Egyptian chariot driver.

To give the Golden Calf sequence some real heat, DeMille had dozens of local beauties hired who danced in men's clubs and performed other assorted acts for money that made them especially well suited for the orgy scene.

The first three days on set felt like one big party. Then Moses returns and is infuriated by what he sees. As directed by DeMille, Heston came down from the mountain holding the tablets, looking straight ahead and holding his head up high, and he tripped and nearly broke one of the tablets that had been made from granite brought back from the Sinai desert. That earned Heston the nickname "Tanglefoot" from the crew, which he bore good-naturedly for the rest of filming, although he was more than a little embarrassed by the incident.

Heston watched the rest of that day's shoot while in full costume, with long white wig and beard, standing near DeMille as he directed the crowd scene through the studio soundstage loudspeakers; the director had an assistant whose only job was to hold a golden micro-

phone in front of the director's mouth when he spoke to the multitudes.

By now, some of the local dancers long on curves and short on attention spans had become irritated by the boredom of the constant retakes, made worse because the hot lights made the coarse material of their costumes uncomfortably itchy to the parts of their bodies where they did not usually wear clothes when they worked. Finally, after one especially difficult scene for DeMille to orchestrate that he reshot dozens of times without a break, one of the girls went over to the assistant director Edward Salven and said in a loud voice that turned everyone's head, "Tell me, Eddie, who do I have to fuck to get *off* this picture?"* Heston heard it too and had to stifle a laugh under his heavy beard. After an awkward silence, DeMille asked if there were any other questions about the shoot, urging people to speak up before the cameras rolled. He noticed one young and pretty extra saying something to her friend. DeMille, already perturbed at the previous girl's comment, said, "Young lady," his amplified voice booming off the walls of the

* This is a story that has been attributed to many of DeMille's pictures, but according to Heston, "It really did happen on *The Ten Commandments.*"

soundstage, "tell us what you are saying that is so important that you have to talk when we are preparing to shoot?" Looking down, afraid to meet DeMille's eyes, and with her face flushed, she said, "I was just saying I wonder when the old bald-headed guy is going to call lunch." An even deeper silence hung over the assemblage like a storm cloud before it burst. Finally DeMille spoke again into his mike. "Lunch! One hour."

He wound up dubbing the entire scene after listening to sound played back and distinctly hearing some choice four-letter words. Visual editing also became a surgical chore when he noticed a couple of the girls in the scene behaving a little too much like true Method actors, blurring the line between acting and real life during the orgy.

Throughout the rest of the filming, several of the established stars had difficulties with the lack of a complete script and having to work off sides (the part of the script that had their lines for that day's shooting). DeMille was constantly revising the dialogue and rearranging his shooting schedule according to the availability of the sets. There was no completed shooting script until the filming and postproduction were done. According to Vincent Price's daughter (he played Baka, the Egyptian master builder who supervises the erection of Sethi's Treasure City), when he grew exas-

perated during a scene shot in front of a blue screen, DeMille had shouted, " 'You're not reading that line with much conviction.' And [Price] told him, 'That's because I haven't the slightest idea what I'm talking about.' "

Brynner, who'd joined the rest of the cast a few days late after filming his final scenes for *The King and I*, was, in the beginning, his usual charming self. He liked to entertain the extras, especially the young female ones, by doing tricks he'd learned in his younger days as a circus acrobat, like lifting a heavy table off the floor with one arm extended straight out, up to the height of his chest, but all of his bonhomie fell away as filming dragged on, and Brynner grew sullen and impatient when he became convinced that DeMille was favoring Heston's performance, the same way the Pharaoh Sethi had favored Moses over Rameses II. Brynner had signed on for what he thought was a starring role; now he was convinced DeMille would cut it down in editing to a supporting one. His real-life narcissism only deepened and intensified his already strong and charismatic performance.

Heston's grip on his portrayal of Moses came and went, as he found it increasingly difficult over so long a period of time to keep his character from slipping into caricature. DeMille kept pushing him to act more ex-

pansive, but to Heston that meant bigger, and in some scenes he appears to be walking in some kind of preternatural trance. In Egypt, the natural physical surroundings had helped lead him to his inner Moses, but on the soundstages of Hollywood he felt a bit lost amid the artifice of the surroundings; it was more difficult to be Moses around lipsticked call girls than native Egyptians. As the production soldiered on at DeMille's snail's pace, it reminded Heston of his time in the Aleutians, the "hurry up and wait"—the full-pack soldiers' mantra.

Paramount also was losing patience with DeMille, as his takeover of so many soundstages had caused other scheduled films to fall behind schedule, forcing the studio to rent out space from some of the smaller independent back lots on nearby Santa Monica Boulevard. When an executive complained about it to DeMille, the director threatened to leave the picture and angrily told him the studio was free to release the film immediately as *The Five Commandments*.

One of the most difficult and as yet unsolved challenges DeMille had to deal with before finally being able to wrap production was one that had bothered him from the beginning—how to vocalize the voice of God. DeMille tested every deep-voiced actor and announcer in Hollywood; he recorded chorales and actors speak-

ing underwater. But he couldn't find anything like what he was looking for. Then he had a brainstorm: in the "Burning Bush" sequence, he would have Heston himself play the voice of God. After all, he reasoned, God created man in His own image, a physical reflection of His spirit. DeMille believed that using Heston as the voice of God and as the physical Moses connected them in a profoundly ingenious and cinematically affecting way. He had Heston record God's lines and afterward had his engineer slow down the tape and add a bit of echo. During the partly animated delivery of the Ten Commandments, for some reason DeMille used deep-voiced actor Delos Jewkes instead of Heston.*

The production might have gone on indefinitely if DeMille hadn't suffered a second, more serious heart attack. With another two months of shooting left, the hospitalized director reluctantly turned the film over to his assistant director, Edward Salven, who, to the relief of everyone working on the film, and Paramount's, sped things up considerably. On August 13, 1955, after a total of 161 days, nearly six times the amount it normally took to make a studio feature,

* Rumors persisted for years that the voice of God during the creation of the Ten Commandments was actually DeMille's, or a combination of DeMille's and Heston's augmented with an organ. None of it was ever proven to be true.

Salven called it a wrap. DeMille then ordered him to give Heston a parting gift—the staff he had used as Moses—the director's way of telling him he had done a good job.

Heston remained uncertain of how the public would receive his portrayal. He hoped *The Ten Commandments* would do for him what *The Greatest Show on Earth* hadn't, but he was worried that if his Moses missed the mark, it could cost him his career. Years later, Heston had this to say about his performance: "So what do I think of my own performance as Moses? Generally impressive, often very good, and sometimes not quite what it needed to be. As a man, Moses was a towering figure, surely one of the best roles in the history of film. My chemistry was right for it; there are moments when that robed figure lives [on-screen]. I wish I could do it again [with] less makeup and could provide a more deeply-honed native gift . . ."

The major difference between acting onstage and acting on-screen is the at times excruciating experience of being able to watch a frozen-in-time performance for the rest of one's life. And like all good actors, Heston was never completely satisfied with any of his filmed performances, the bigger the role, the deeper the self-criticism. At times he would take a religious tone, as

he did with Moses, criticizing his performance for not being faithful enough to the character or the message he wrought.

He was so concerned about how he'd played Moses that he went to visit DeMille in the hospital to talk about it. DeMille reassured Heston that the film, and his performance, would be ranked among the greatest in all of Hollywood history. How could it not be? he told Heston. It had God and DeMille on its side.

Not necessarily in that order.

Charlton and Lydia Heston at their Park La Brea apartment in Hollywood, 1957. (Courtesy of the Heston Family. Photo by Lydia Clarke Heston.)

Chapter Twelve

Heston was looking forward to a well-deserved break from living in the fantastic world of biblical times and returning to the present as a real-life husband and father. At Park La Brea Towers he devoted himself to assisting Lydia every way he could. He awoke at dawn to help out with the new morning routine of changing diapers before breakfast. He also hired a nurse, a Jamaican woman named Mabel, to help in the evenings. Heston and Lydia often ate dinner out, so Lydia would not have to cook (he could barely boil water) and they could have some time just for the two of them. When they did stay home in the evenings, Mabel was there when they had friends over, which they liked to do. After dinner, Heston enjoyed entertaining: "I'd get up and do spoonerized recitations of such classics

as 'The Tortoise and the Hare,' and 'The Laughing Rabbit.'" These were fun, and also rehearsals for the reading he planned to do at night to put Fraser to bed, as soon as he was old enough.

As much as he loved being home with Lydia, domestic bliss had its limitations for Heston. Having been away so long on location in Egypt, he had grown fond of sleeping in the nude with the thinnest of blankets barely covering his long frame, while Lydia, during her pregnancy, had taken to wrapping herself inside an electric blanket in bed. Nudity was out now for more than one reason: Lydia still wanted the electric blanket, and Mabel's early arrivals.

While waiting for *The Ten Commandments* to get through its lengthy postproduction before its release, Heston considered several new film projects, including a possible studio remake by David Bradley of his student film *Peer Gynt,* a project that never materialized (Paramount had bought the rights to all of Bradley's early silent films). Although Heston did do some live TV out of New York—a couple of dramatic episodes and one or two guest-starring bits as himself in various live comedy shows—he was itching to get back to making movies. With another mouth to feed and his bank

account getting lighter by the day, he needed something viable to help pay the rent.

Citron brought him an offer from Paramount to star in a western called *Three Violent People*. With anticipation growing for DeMille's spectacle, Paramount wanted something ready in the can to capitalize on *The Ten Commandments*'s anticipated success. Heston read the script and said yes. The studio then cast Anne Baxter as his love interest, even though no one had as yet seen them on film together. The third "violent person" cast in this rough-and-tough film was handsome newcomer Tom Tryon.

Paramount assigned Rudolph Maté, who had worked with Heston in *The Far Horizons*, to direct from James Edward Grant's script.

Three Violent People was shot mostly on location in Arizona. The story takes place in Texas, in the years immediately following the Civil War. Colt Saunders (Heston) is a former Confederate captain whose one-armed brother, Beauregard "Cinch" Saunders (Tryon), is bitter, jealous, and greedy and tries to grab Colt's land for himself along with Colt's woman friend, a former prostitute (Baxter)—a familiar film triangle with no new angles. Lydia insisted on going to Arizona with Heston for the duration and brought along baby Fraser

and Mabel. Later, Heston said his only real memory of the location shoot was helping give Fraser a bath at night, wrapping his wet boy in a blanket, giving him to the nurse to put to bed, and, afterward, having a glass of wine with Lydia.

In May 1956, DeMille, sufficiently recovered and back in charge of postproduction on *The Ten Commandments,* called Heston and invited him to speak at the Wilshire Methodist Church as part of the annual Madonna Festival. It was DeMille's home church, and he wanted Heston to come and tell the congregation how it felt to play Moses. During the presentation, DeMille intended to give the first public showing of some of the footage from the film, including the scene where baby Moses floats down the Nile. Although he was not a regular churchgoer, Heston could not turn down DeMille, even though he and Lydia were about to leave for New York to begin rehearsals for a national stage tour that summer of *Detective Story,* in which they would star opposite each other. They had planned to fly out the next day.

Everything about *Detective Story* seemed right to Heston. He hadn't been on a theater stage for two years, and more than a decade had passed since the last time he and Lydia had appeared together in a play; this was

their chance to retrieve a bit of those early salad days in North Carolina when they ate, slept, and breathed acting.

At the last minute Heston decided that instead of flying directly to New York, they would all take the Super Chief train from Union Station to Chicago's North Shore, where they could stop off to show Lilla and Chet their grandchild. After spending a few days there, the Hestons traveled to St. Helen, where Heston took baby Fray camping with him for two days. It gave him great joy to replay those days when he was the boy and Russell was the father, doing all the good things he remembered.

Then it was on to Detroit to meet with Russell and Heston's half sister, Kay, his father's daughter with his second wife, who had just graduated from high school. The next day the Hestons all boarded a train headed to New York and the Tudor City apartment. They arrived late in the evening, and early the next morning Heston and Lydia left Fray with Mabel while they went to a midtown rehearsal studio to begin work on *Detective Story.*

This was an especially happy time, as they both loved the semi-itinerate rituals of the stage actor's life: the sweet cool smell of greasy makeup, the bite of icy cold cream after the show to remove it, the half-empty

paper coffee cups that held everyone's fuel during the long hours of rehearsals, the gaffer's tape that marked their spots onstage, the tech/dress days and nights that always took forever, the slow building to the spotlight thrill of opening night, the tactile reactions of the audience members when they got a joke or broke out into applause, the crowds gathered by the stage doors after the final curtain holding out programs for autographs, the late suppers and talking over how that evening's show went.

And they each got to sleep with their costar every night.

The last thing DeMille added to his $13 million film before he delivered the final negative to Paramount was his introduction that ran before the opening credits, filmed with him standing behind a microphone in front of a blue-and-white curtain (the colors of the Israeli flag). His intention was to emphasize the "importance" of what the audience was about to see and how authentic the film really was, and to make the spiritual connection to the Holocaust. DeMille says, in part:

"The theme of this picture is whether man ought to be ruled by God's law, or whether they are to be ruled

by the whims of a dictator like Rameses. Are men the property of the state or are they free souls under God? This same battle continues throughout the world today. Our intention was not to create a story, but to be worthy of the divinely inspired story, created three thousand years ago . . ."

The introduction was almost always cut after the film's initial run.

That September, just two weeks after they returned from their *Detective Story* summer tour, Heston was scheduled by Paramount for dozens of personal appearances to promote *The Ten Commandments*, sometimes with DeMille, when he felt up to it, often two or three cities a day and continuing until the film's gala November premiere. On those nights DeMille came along, ever the canny promoter, he gave every major theater owner Styrofoam replicas of the Ten Commandments tablets to put on display in lobbies during the film's run, after which they could keep the tablets for themselves (DeMille donated the "real" tablets, the granite set made for the movie, to the Wilshire Methodist Church, where they remain on display to this day).

The most prestigious stop on the tour for Heston was on the highly rated CBS network television show *Person*

to Person, hosted by respected newsman Edward R. Murrow. Heston did the live hook-up interview from Park La Brea, no easy task in the early days of mostly studio-bound broadcasting, with Lydia looking dazzling and little Fray smiling in his Dr. Denton's.

With the public's anticipation building, DeMille scheduled a black-tie gala world premiere for the night of November 8, 1956, at New York's Criterion Theatre in Times Square. Its marquee was covered in red with the film's title in huge stylized letters across it. Klieg lights waved at the sky, as crowds stood behind the ropes from Forty-Third Street, past the ADMIRAL TV sign on Forty-Eighth, all the way up to Central Park, screaming as the celebrities arrived.

One of the first was Heston in black tie with Lydia on his arm in a white fur-collared coat. Yul Brynner was next. He stepped out of his limousine, casually waved to the crowd, and then did a previously arranged handshake with Heston, as a blitz of flash cameras went off. Anne Baxter emerged from her limo bathed in a full-length white mink stole over a formal black dress, looking every bit as glamorous for the premiere as she did as Nefretiri in the film. The rest of the stars followed—Edward G. Robinson, Yvonne De Carlo— and then other Hollywood notables, including Mr. and

Mrs. William Holden, Mr. and Mrs. John Wayne, Tony Curtis and Janet Leigh (Hollywood's glamour couple of the day), and finally DeMille himself, making his grand entrance looking weary but excited, accompanied by his adopted daughter, Katherine.

Another premiere was held a week later in Los Angeles, again heavily attended by stars, with orchestrated klieg-light pandemonium sweeping through the cheering crowds.

The reviews for the film were generally positive, with most critics focusing on the film as a visual spectacle rather than a historical document. Bosley Crowther, the chief critic for the *New York Times*, wrote, "In its remarkable settings and décor, including an overwhelming facade of the Egyptian city from which the Exodus begins, and in the glowing Technicolor in which the picture is filmed, Mr. DeMille has worked photographic wonders." *Variety* noted the "scenes of the greatness that was Egypt, and Hebrews by the thousands under the whip of the taskmasters . . . [The film] hits the peak of beauty with a sequence that is unelaborate, this being the Passover supper wherein Moses is shown with his family while the shadow of death falls on Egyptian first-borns," and the review described Heston's performance this way: "[He] is an

adaptable performer as Moses, revealing an inner glow as he is called by God to remove the chains of slavery that hold his people."

The week the film opened, Heston was the "mystery guest" on the enormously popular Sunday night CBS game show *What's My Line?* where the panel guessed his identity relatively quickly. The program was an American institution, with New York celebrities in formal dress playing a variation of the children's guessing game Twenty Questions. Glamour was the key to its popularity, and the "mystery guest" segment a key promotional tool. Every PR agent in the country fought to have his clients on the show whenever they had a picture or a play opening, and Paramount made certain Heston was booked while he was in New York for the film's premiere.

The Ten Commandments proved an enormous hit at the box office, to the great relief of Paramount, DeMille, and Heston. The studio was desperate to recoup its $13 million investment as quickly as possible, the director saw it as vindication for his great gamble that he'd fought the studio so hard to let him do, and Heston believed it was the film that would finally make him a name-above-the-title star.

The Ten Commandments in its initial domestic release played at theaters for more than a year as a road-

show attraction (two screenings a day, reserved seating, tickets sold in advance) and would go on to earn $80 million at the box office, to become the highest-grossing live-action film of the first seven years of the 1950s, topping *The Greatest Show on Earth*, which had earned $36 million in its initial domestic release, making the DeMille-Heston combination the most popular one-two director-star punch of the decade.

Because of it, Heston now stood tall among Hollywood's star elite. His years of hard work had paid off, and the industry that once was indifferent to him and his films now was willing to do anything he wanted. Scripts arrived daily, by the hour. Every morning when he went to the door to get the newspapers, there would be several more waiting for him piled one on top of the other.

And yet he wouldn't make another movie for a year, and when he finally did, it would prove as big a commercial disaster as *The Ten Commandments* was a hit.

Orson Welles and Charlton Heston filming a scene in Welles's
Touch of Evil (1958). Welles had been unable to get a directing
job in Hollywood for a decade until Heston insisted Paramount
hire him for this film. Welles had already signed on as an actor.
(Courtesy of Rebel Road Archives)

Chapter Thirteen

*T*hree *Violent People* opened on February 9, 1957, while *The Ten Commandments* was still in its first run and continuing to break box-office records. Despite a positive review from the *New York Times* that called it a "pull-no-punches story of a lethal family feud," Maté's film faded quickly and remains largely forgotten, a footnote in Heston's career as the last film of his renegotiated film deal with Wallis. Heston himself didn't think much of *Three Violent People,* describing it diplomatically in his memoirs as "not distinguished." He would never again sign a multiple-picture deal with any major studio or independent producer.

Even though it was made before *The Ten Commandments* was completed, *Three Violent People* managed to halt the new momentum of Heston's movie

career and soften the Oscar buzz for his performance as Moses. He was eager to get back in front of a camera, but was unsure what to do next and afraid to make the wrong choice. Moreover, while he was flooded with scripts, none of them jumped out at him, because no one really knew what to do with him. He hadn't yet proven himself a strong personality actor like a Cary Grant or a Jimmy Stewart, stars whose charismatic appeal put people into seats regardless of whatever film they were starring in or character they were playing. Without DeMille's craftsmanship that had now twice custom-fitted Heston like a polished gear into a high-powered machine, lesser directors like Maté had trouble illuminating the characters he played off the gleam of his real-life persona. And there was something else: neither of the two characters he had played for DeMille had much sex appeal, leaving none of the major studios convinced he could successfully carry a love story on his broad shoulders, the essential quality needed for a leading man in Hollywood. He had proven he could draw audiences with the right role, but because no one was quite sure what that right role was, every producer in town threw every script he had Heston's way, hoping one would prove his and its weight in box-office gold. Winning an Oscar for his performance in *The Ten Commandments*, Citron told him, was a real possibil-

ity, and would not just raise his price, but prove to the moneymen of Hollywood he could really act. Taking Citron's words as wisdom, Heston eagerly participated in all the prenomination award campaigns DeMille and Paramount asked him to, accepting awards and citations, and making appearances, even on silly TV game shows, even as he continued to try to figure out himself what type of actor he was going to be moving forward.

In truth, it was easier to define what he wasn't than what he was. Here Jack Gilardi, an agent who would later represent Heston, tries to explain where Heston fit in Hollywood's late-'50s hierarchy: "Montgomery Clift was really a leading man. Chuck was not; he was always just a little off-kilter. He was handsome but not the most classically handsome man Hollywood ever saw. He was closer to his contemporaries like Glenn Ford, who came a little earlier but worked with him, [more like] Henry Fonda, also someone there before him that he also worked with. He was a bigger star than Bob Mitchum, but not [yet on the level of] a Grant or a Stewart."

The one thing Heston was sure he wanted to do besides movies was to return to the stage, to wrap himself in the comfort blanket of the proscenium arch. He was offered and accepted the title role in a New York revival of that Greatest Generation bible of World War II leadership, bravery, and self-sacrifice, *Mister Roberts*.

To help him prepare to play Lieutenant JG Douglas A. "Doug" Roberts, Heston called Henry Fonda, who had originated the role on Broadway in 1948 and starred in the John Ford 1955 film version. Fonda was more than generous with his advice on how to approach the part as was Joshua Logan, who had directed the original production. When the show opened in the fall of 1957 at Manhattan's City Center theater on West Fifty-Fifth Street, audiences could see Heston live on Broadway, Heston on film as Moses in *The Ten Commandments,* and Heston taking a celebrity bow on the nationally broadcast Sunday family institution, *The Ed Sullivan Show.*

Just before the play opened, he received word that the powerful columnist Hedda Hopper wanted to do a major interview with him for her nationally syndicated column. Heston was wary of these types of gossipy pieces, especially Hopper's, but Citron convinced him it was necessary if he wanted to compete in the upcoming Oscars race.

Immediately after appearing on *Sullivan* and with *Mister Roberts* dark the next night, Heston caught a Sunday night flight to Los Angeles for the interview. He would have preferred to do it in New York or by phone, but Hopper insisted on conducting it face-to-face at Heston's apartment at Park La Brea. It went

on for several hours, during which he was frank and thoughtful, answering every question she asked.

Hopper was surprised at what she considered the Hestons' modest lifestyle, measured by traditional Hollywood star standards, and in her curious, invasive way she asked what their rent was to live in this "local housing development." He measured the words of his answer carefully. "I'm sure Moses is the most important part I'll ever play in films. It will have so much meaning to so many people in all parts of the world. But I'm kind of afraid to buy a house here in Hollywood. I'm afraid if I acquire so much in material possessions, I won't be able to do the things I want. I don't scorn possessions, understand, but I want to work and travel. Some of the places where I want to work can't pay much money. For instance, for . . . *Mr. Roberts* [that I'm doing] at City Center theater in New York, I get exactly $85 a week. My agent was furious when I told him. He said, 'Hey, the head usher gets more than that.' But I wanted to do it because it's a wonderful play, and the part is right for me. I know I'll learn something from doing it . . . I haven't been on Broadway in five years. I never had a real hit on Broadway in which I had a leading role. I've come to the opinion that we are in a school of playwriting that doesn't include many parts for me. William Inge and Tennes-

see Williams are currently preoccupied with dramas about delinquents—either juvenile or mature. Emotionally immature characters have become a vogue . . . [Onstage or] in pictures it's not easy to find what you want—a role like Moses doesn't come up every day."

It was an extraordinary answer, a commentary, really, that dismissed the raging youth movement then occupying both the New York stage and Hollywood movies, that rejected the plays of two of America's finest playwrights, in which he essentially admitted that he wasn't a romantic figure in either medium. He then added, talking perhaps more to himself than to Hopper, "I think I'm a good actor—every actor thinks he is, I guess, or he wouldn't be in certain plays or movies . . . And another thing about not accumulating too many possessions is that I want to be able to turn down the ten thousand dollar a week thing if I feel it's not right for me . . . I have one possession I love, and that is 1400 acres of timberland on Lake Michigan. We have a house and outbuildings and a pair of bald eagles live on the lake that mate for life, and live in one place. I find contentment there."

Lydia took Fray and flew back to New York with Heston for the final performances of *Mister Roberts,*

whose limited run ended in mid-December. Heston then decided to drive the family to Michigan so they could celebrate Christmas in the cabin he had built in St. Helen he had referred to in the Hopper interview. Fray, a California baby, had not yet experienced snow, and Heston thought this might be the perfect time to let him experience what December in the North Woods was like.

Once there, Heston chopped down their Christmas tree and tried to fix the clogged toilet, while Lydia kept busy preparing their holiday dinner. Later that evening, after they ate, he sat a tired Fray on his lap, already in his Dr. Denton's, and read to him from *Treasure Island* until the baby fell asleep.

Heston had brought along a fresh pile of scripts, but he didn't feel like reading any of them. Instead, he wanted to savor this moment for as long as he could. Hollywood could wait a little longer.

Or at least two more days. With the toilet still not working, the day after Christmas Heston made the twenty-six-mile drive to town to buy a plumber's snake. While there, he stopped at the one-room post office to pick up a novel Albert Zugsmith, a producer at Universal, had sent him. Later that night, while Lydia was putting down Fray, Heston lit a fire, sighed, sat

back in his rocking chair, and started reading the *policier* by Whit Masterson called *Badge of Evil.*★

The next morning, after an early breakfast, Heston called Zugsmith, known in the industry as the king of the Bs, to thank him for sending the book and tell him he wasn't interested. Zugsmith suggested to Heston he might want to change his mind, as Orson Welles had signed on to play the police chief. Zugsmith had just finished another crime thriller starring Welles, Jack Arnold's *Man in the Shadow,* in which the actor had made his first appearance in a Hollywood film in nearly ten years, following 1948's disastrous *The Lady from Shanghai* that he had directed and starred in with his then wife Rita Hayworth. In *Man in the Shadow,* the rotund Welles had stolen the film from its nominal star, the handsome but limited Jeff Chandler, and the studio wanted to use him again.

Zugsmith was right. Having Orson Welles aboard did make all the difference to Heston. He had loved Welles's movies ever since he had first seen *Citizen Kane* while still in college and had been mesmerized

★ Whit Masterson was the pseudonym for writers Robert Allison "Bob" Wade and H. Bill Miller, who, as a team, wrote more than thirty novels intended to be sold to the studios and made into movies. They also wrote several TV scripts, together and individually.

by it, unaware of anything about Welles or his legend-
ary battles with RKO to get the film released. *Citizen
Kane* had gained a large and controversial reputation
despite, or because of, having not been seen by many
people. After *The Lady from Shanghai*, made only six
years after *Citizen Kane*, Hollywood had had enough
of the temperamental, esoteric, and unprofitable auteur
and turned its back on Welles, who was forced to leave
America to continue making movies. Welles remained
a Hollywood outcast until 1957, when he received a
last-chance call from Universal offering him *Man in
the Shadow*, and then the evil police captain Hank
Quinlan in *Badge of Evil.* That's when Zugsmith sent
the original novel to Heston, believing his star status
would offset the risk of rehiring Welles.

Heston never forgot the impact *Citizen Kane* had on
him, both stylistically and narratively. Like the charac-
ter of Charles Foster Kane, Heston too had suffered the
trauma of separation from his parents that destroyed
his perfect childhood. French critic André Bazin wrote
that "Welles is at his best when he tells stories about
families," and so was Heston when he acted in films
that told those types of stories. *The Ten Command-
ments* was, on a very basic level, a story about a boy
separated from his parents in his infancy, and this was
one of the reasons Heston was able to identify with and

inhabit that character so completely. None of the other films he had made, either before or after, had touched that emotional nerve so deeply in him, and none that he had seen did either, except *Citizen Kane.*

After the holidays, back in Hollywood, Heston met with Zugsmith to further inquire as to how he intended to make the film. "I asked who was going to direct and he said they hadn't signed anyone yet, and I said why don't you have Welles do it? He's pretty good. Zugsmith seemed surprised." He explained to Heston there was no way Universal would hire Orson Welles to direct a three-minute coming attraction, let alone a feature film; that the films he directed did not make any money and that's all Universal and every other studio cared about—not the endless vision of Welles's creative horizon, just the negative mathematics of his bottom line.

According to filmmaker Henry Jaglom, a long-time friend of Welles's, "Heston first suggested, then insisted that Orson direct. The studio resisted, then eventually gave in, because [Heston] pressed so hard for it. [Welles directing *Touch of Evil*] was all thanks to Heston, though everyone forgets that." Film producer Peter Snell: "Heston would certainly have been, at that time in his career, the guy who could tell the studio who was going to direct him."

Zugsmith wanted to make the movie with Charlton Heston, and Heston used that to his advantage, telling the producer he would do the film only if Welles directed. In his memoir, Heston described Universal's reaction this way: "You'd have thought I'd suggested that my *mother* direct the film—'Oh! Ahh, yes, *Citizen Kane* and . . . umm . . . yes. Interesting it would be . . . we'll, ah, get back to you on that.'

"They did get back, a few days later. Yes, Orson would direct the film. I have no idea how intense the debate was, but I doubt anyone at Universal slapped his forehead and said, 'Of *course* he should direct! How come *we* didn't think of it? What a smart guy that Chuck Heston is.' More likely it was, 'Ahh, Christ, let Welles direct it. How bad can it be? Heston'll just get sore if we don't. Fuckin' actors.'"

For his part, Welles was desperate for the job, but even so, as always he had some conditions of his own. He insisted he also be hired to rewrite the screenplay, at which point the studio threw up its hands and agreed. "Once I'd persuaded Universal to accept Welles as director," Heston later wrote, "he flung himself into the project with the full range of his protean creative capacities. He rewrote the entire script in 10 days, vastly improving it." Now called *Touch of Evil,* Welles had turned Quinlan—"an ex-alcoholic, ugly and obese,

who resists the temptations of whiskey by sucking on candy bars, the archangel now only a poor devil, his grotesque genius bent to the least noble of tasks"—into the film's lead, and reduced Heston's part as Ramon Miguel, a Mexican drug enforcement official to a supporting role.* What he had done to Jeff Chandler in *Man in the Shadow* with his acting he did with his writing and directing to Heston in *Touch of Evil.*

When he finished his revision of the script, Welles refused to show it to Universal, knowing executives would object to his making himself the star over Heston, who was the only reason they were making the film. Instead, Welles invited Heston over to the house in Beverly Hills he had rented for the duration and spent an afternoon explaining the film to him. It didn't bother Heston that Welles's script had reduced the status of his character. The film, Welles explained, would be his "definitive denunciation of police brutality against minorities." He acted out all the parts

* It wasn't the first time Heston would play a non-white character; Moses was a Middle Eastern Hebrew and that hadn't seemed to bother anyone. *Ars gratia artis* and all that. Although it would likely not happen today, at the time there was precedent for a white American actor to play a Mexican character in a Hollywood movie. Marlon Brando had played Emiliano Zapata in the 1952 Kazan film *Viva Zapata!* and was nominated for a Best Actor Oscar for it.

that day in his living room, using his hands to place characters and to show how the camera would capture them, and he assured Heston that despite his smaller role, Vargas's character was still the key to the film. Furthermore, Heston would have ample input in the production, as everyone would. That, Welles said, was the way he worked best.

According to Janet Leigh, who played Vargas's fluorescent bride, Susie, the film's female lead, "It started with rehearsals. We rehearsed two weeks prior to shooting, which was unusual. We rewrote most of the dialogue, all of us, which was also unusual, and Mr. Welles always wanted our input. It was a collective effort, and there was such a surge of participation, of creativity, of energy. You could feel the pulse growing as we rehearsed. You felt you were inventing something as you went along. Mr. Welles wanted to seize every moment. He didn't want one bland moment. He made you feel you were involved in a wonderful event that was happening before your eyes."

Welles cast several of his old Mercury Theatre players, many of whom had also appeared in *Citizen Kane*, to be in the film, as well as a young TV actor suggested by Heston, Dennis Weaver (Chester in TV's long-running western series *Gunsmoke*), to play a whacked-out motel manager. Many of the ensemble roles were

small, improvised, and put in after filming had begun, such as Marlene Dietrich's brothel madam, Tanya, who was added by Welles because he wanted Dietrich, his friend and onetime lover, to be in the film. According to Leigh, "We never knew who was going to be on the set the next day . . . when Marlene showed up, her character wasn't even in the original script . . ."

Dietrich did the part for no pay, as a favor to Welles, and she gave a memorable performance. When Quinlan goes to see Tanya early in the film, she doesn't recognize who he is. Too many candy bars, she tells him sarcastically at the start of their verbal joust. "I may come back to taste your chili," he says to her; "It might be too hot for you," she answers before turning her back on him. Universal execs had no idea she was in the film until months later at a screening of the assembled footage, and then they wondered how and why.

The film begins with Welles's bravura single-take shot that blows open the film's plot. Newlyweds Susan and Miguel Vargas are in Tijuana, on their way to America for their honeymoon, when, just after they reach the border, a bomb in another car goes off, killing its two passengers. Susan, who is a bit aggressive and narcissistic, sees the tragedy as an inconvenient disruption of her honeymoon and berates her new, passive husband for it. Filming of the shot took the entire

night and signaled to everyone that the slow and meticulous Welles was in no hurry. At first, nobody seemed to mind. "We were there all night to make this one extraordinary [opening] shot," Leigh later said. "It was tedious, but we knew it was going to be historical."

Heston: "The shot was enormously complicated and difficult to do . . . As we got to the border crossing, after all that went before, the border guard had trouble all night remembering his lines. Dawn was just beginning to break and it was our last chance, so we did it one more time and Orson said to the guard, 'Now don't you say anything, just move your lips and we'll dub it later . . . and for God's sake don't say I'm sorry Mr. Welles!' "

Soon enough, Susan becomes a victim of her own arrogance and good looks, qualities Quinlan will use as a weapon against Vargas, who recognizes the injustice being meted out to Mexican scapegoats by the corrupt American police captain and tries to stop it. Quinlan arranges for Susan to be raped in a motel and falsely imprisoned for using the drugs she was forced to take during her ordeal (a scene that inspired Welles's good friend Alfred Hitchcock to cast Leigh in his 1960 film *Psycho* as a woman who meets an even worse fate in a motel).

The Vargases' interracial marriage (reflected in the

film's crisp black-and-white cinematography) personifies the racial tensions on the border that separates the two countries, as does the portly, cynical American, the symbol of justice jaded vs. the lean, honest Mexican, justice idealized, a classic Wellesian tale of good and evil told noir style, heavily sprinkled with sex, corruption, and violence.

The day after filming began, with Venice, California, substituting for the Mexican town on that country's side of the border, the nominations for the 1956 Oscars were announced. *The Ten Commandments* received seven, *Around the World in Eighty Days* eight, *The King and I* nine. By then, DeMille's picture had become not just the highest-grossing film of 1956, but the second-highest-grossing film of all time behind *Gone With the Wind* ($2.187 billion and $3.44 billion, respectively, adjusted for inflation), giving a much-needed economic shot in the arm not just to Paramount but the entire Hollywood film industry. To show its appreciation the Los Angeles City Council unanimously passed a resolution that said, "*The Ten Commandments* will bring happiness to millions for years to come and everlasting inspiration for the whole family." Not long after, New York City's Cardinal Spellman came out with a huge endorsement for the film and it appeared to be a shoo-in to sweep the awards.

Noticeably left out of the list of nominees was Heston, passed over for Best Actor, as was Brynner for *The Ten Commandments*, though he was nominated for his performance in *The King and I.* It was a disappointment for Heston, but he kept his usual stoic public poise; if he was upset he never showed it. Instead, he turned his attention to the preparations for his thirteenth wedding anniversary. On the night of March 17, 1957, he and Lydia had an early dinner at Perino's, a favorite restaurant of theirs on Wilshire Boulevard. After, they walked to a Beverly Hills gallery and paid the balance they owed on their second original Toulouse-Lautrec sketch, this one of a horse, that they had put a down payment on months earlier. When they arrived home and unwrapped it, they were surprised to find another sketch by Toulouse-Lautrec on the back that the seller apparently did not know was there.

The Oscars were handed out on March 27, during a live simulcast over NBC from the RKO Pantages Theatre in Hollywood, with Jerry Lewis hosting, and the NBC Century Theatre in New York City, where Celeste Holm did the honors.

Heston had planned to attend in person to show support for DeMille and the film, but couldn't because that night he was stuck in Venice, getting soaked to

the skin doing several takes of *Touch of Evil*'s climactic scene: "The shooting went swimmingly tonight, and the adjective is thoughtfully chosen. Thank God it was the warmest night we've had because I spent a lot of it treading water across that damn antique travesty of a Venetian canal. Orson also was very excited about a [new] novel he's found to make."

The shoot had lasted all night. That morning, Welles and Heston went for breakfast, during which Heston politely let Welles know that he was aware his role in the film had been reduced to a supporting one. "We went to a nearby coffee shop and he brought along a bottle of very good champagne we shared while telling each other how happy we were. At one point I said, 'You know, Orson, this is a wonderful film, I think. I'm very proud doing it and to be working with you . . . except for one mistake you made.' He said, 'What is that, my boy?' He always called me 'my boy.' I said, 'There are three or four short scenes in the picture that are only there to kind of indicate that I am the leading role in it. That's not true. This film is about the fall of Captain Quinlan.' "

Welles smiled, uncharacteristically said nothing, and the two men clinked their glasses as they toasted each other and the film.

Production had taken two weeks longer than orig-
inally scheduled, but it was still not enough time for
Welles, who from day one was pressured by Univer-
sal executives to finish on time and to not go over
the modest budget they had given him of less than
$1 million. According to Dennis Weaver, "The guys
in the Black Tower [Universal-International headquar-
ters in Universal City] were concerned, very skeptical
Welles could bring this picture in on budget. They had
a policy that if something wasn't in the can [filmed]
by 9:30 or 10:00 [in the morning] somebody from the
studio was always on set to make sure Orson knew that
he was falling behind schedule. The first day, there
was a scene where Orson comes into a room to talk to
Chuck Heston, and there were about ten other people
in the scene. He started rehearsing it with the actors
first thing in the morning and by 11:00 he hadn't rolled
the camera. By 11:30 they were down there looking
over his shoulder. Their purpose was to tell him by
their body language that he had better roll camera and
get something done. He just kept rehearsing, rehears-
ing, and didn't roll camera until 3:30, 4:00 in the af-
ternoon. Finally, he went to all his crew, one by one,
and asked them if they were ready, and when they said
yes he went to his actors and asked them if they were

ready and they said yes. 'Okay, let's try one,' he said, and rolled the camera. The single shot went from the living room, to the master shot, to over the shoulders, to back to the master, to into the dining room, into the bathroom, to a mirror shot with Chuck, a box falls into the bathtub and the camera followed it, Chuck's hand went in to pick it up, Welles brought the camera back into the mirror shot then followed Chuck back into the living room, over the shoulder shots, close-ups, all of that, and when it was over Orson yelled, 'Cut,' and asked if everybody was happy with it, everybody said yes, and he said, 'Okay, let's print it,' and everybody went home. He had shot about four days of production in that single take. And of course, the guys in the suits [exhaled]."

Heston, relieved the long and at times tedious production had finally come to an end, was eager to start work on his next project, which was all ready to go: *Darby's Rangers,* a war film based on a true story that Citron had set up for him at Warner Bros. The studio had recently scored a major hit with the 1955 film adaptation of Leon Uris's *Battle Cry* and was eager to make another World War II guts-and-glory picture. It bought the rights to the bestselling book, Major James J. Altieri's account of the celebrated commando outfit

of which he was a member. When the film was ready to be cast, its producer, Martin Rackin, approached Citron about the possibility of Heston playing William Darby, the leader of the Rangers outfit. Citron said yes, for 5 percent of the film's gross. At the same time, director Richard Fleischer and producers Jerry Bresler and Kirk Douglas wanted Heston for the part of Eric, a Viking slave who turns out to be a British king, in *The Vikings*, a United Artists film about to go into production (with Douglas also starring and Welles doing the narration). Citron told Rackin, who then agreed to Citron's percentage deal to get Heston for *Darby's Rangers*.

The morning after he finished work on *Touch of Evil*, Heston reported to the *Darby's Rangers* set to be fitted for costumes, only to be sent home a few hours later when the production was unexpectedly shut down by Jack Warner. He had never gotten over Heston's early rejection of his personal offer to join the studio and then signing with Wallis, and after going over Heston's contract and discovering, apparently for the first time, the hefty percentage Rackin had agreed to pay the actor, he decided to cancel the film. Just before his decree was issued, he called Citron on the phone to tell him the news that Heston was being fired. His next

call was to James Garner's agent, to assign the actor the role. Garner was one of the new breed of TV "cowboys" already under contract to the studio.

Citron met with Heston to explain what Warner had done and why, and assured his client they would bring suit. The next morning Heston and Citron sued Jack Warner for $250,000.

Heston was less interested in vengeance than money. He had planned on using *Darby's Rangers* to fund moving his family out of Park La Brea Towers and into a house and was feeling the pinch for agreeing to do *Touch of Evil* for minimal payment in order to work with Welles. Needing an influx of cash, he decided to do an under-rehearsed live broadcast of *The Andersonville Trial* for *Playhouse 90* out of New York. It was a short-term solution that did little to alleviate his problem. With the so-called golden age of live television rapidly coming to an end, Heston didn't know how many more times he would be able to go to that well, and he was criticized for doing it this time by the L.A. press, which still viewed live TV out of New York as an enemy of Hollywood. Bob Thomas, the influential entertainment chronicler, wrote a piece about it for the *Hollywood Citizen-News*, the film industry's local non-trade newspaper that held a lot of sway at the studios, and gave Heston a chance to defend himself: "Ac-

cording to the Hollywood code, Charlton Heston should avoid television like the bubonic plague . . . Heston continues to dabble in TV, which pays him considerably less than films . . . This called for an explanation, and I demanded it while Heston grabbed a lunch [at the studio] between rehearsals. 'Marlon Brando doesn't do TV,' I said. 'Gregory Peck doesn't do it, nor Gary Cooper, nor Burt Lancaster, nor almost every other top name. Why do you?' 'Because I like it,' he replied simply. 'I can't explain why other actors don't do it— perhaps some of them don't have stage training and are afraid of doing live shows. I do it because I enjoy doing it, because I think an actor should keep working, because I can reach an audience that I wouldn't be able to reach with a movie. And on TV, I can do roles that I wouldn't get a chance to do in films.' " He left out the fast paycheck as one of his other reasons.

Not long after, via Citron, he received an offer from William Wyler, who was set to film the western *The Big Country* at United Artists, based on Donald Hamilton's "Ambush at Blanco Canyon," which had recently been serialized in the *Saturday Evening Post*. Wyler's film was coproduced with Gregory Peck, who was also its star. The story involves two rival families—the wealthy Terrill clan and their white-trash neighbors, the Hannasseys—locked in a long-standing feud over

water rights for their cattle. This was a familiar theme in westerns. Only a few years earlier, George Stevens's award-winning *Shane* told essentially the same tale.

The idea of making a big-budget western with Wyler appealed to Heston, but Welles also wanted him to star in an independent film adaptation of Miguel de Cervantes's *Don Quixote*. He was tempted to go with Welles even though the director had not yet secured his financing and hadn't finished editing *Touch of Evil*, and his role in *The Big Country* was only a supporting one; his name would still appear above the title but in fourth position behind Peck and the actresses Jean Simmons and Carroll Baker. Moreover, Wyler wanted him for the role of ranch hand Steve Leech, a bit of a heavy, the kind of character he didn't like to play.

When Heston called Citron to say he hadn't yet decided to take the offer because it was a supporting role and he was thinking of working with Welles again, an annoyed Citron told Heston to stop the "madness" with Welles and commit to *The Big Country* before the role went to someone else. "You have an offer to work with Gregory Peck for maybe the best director in film, and you're worrying the part isn't big enough for you? Don't you know actors take parts with Wyler without even reading the damn *script*? I'm telling you, you *have* to do this picture!"

A few days later, Heston received a phone call from Welles saying he had to postpone *Quixote* because he couldn't obtain the proper work permits to film in Mexico. Heston signed on with Wyler.★

The fact that Peck was the star and also one of the producers hit home with Heston. To this point in his career, he had resisted forming his own production company, knowing his chances of making a profit were nowhere as great as his chances of losing money, but after, in effect, being hired by Peck, Heston met with Walter Seltzer to discuss the possibility of starting their own company (Seltzer would become a principal, not an investor). Russell Lake Corporation was formed, but remained out of the film producing business for years. It was used by Heston mostly as a holding company for some of the family's land properties, with his father, Russell Carter, assigned the salaried position of the corporation's secretary. Heston continued to work for other producers, for increasingly larger paychecks and profit participation. To Heston, it was just as

★ Although he worked on it intermittently until 1969, Welles never finished *Don Quixote*. At one point, Frank Sinatra "invested" $25,000 in the film and helped raise additional funds for it through the years. After Heston left the project, Welles cast Francisco Reiguera in the title role. A version made up of parts of the completed footage was screened in 1995.

good, if not better, than producing. He could make a lot of money, risking only the sweat equity he put into making a movie. Russell Lake became essentially his backup plan, with partners he trusted.

Shooting for *The Big Country* began on August 1, 1957, on location in Stockton, California. It was an auspicious beginning of a journey that would take Wyler and Heston from a few decades back to the Old West, to two thousand years into the past and the crucifixion of Christ.

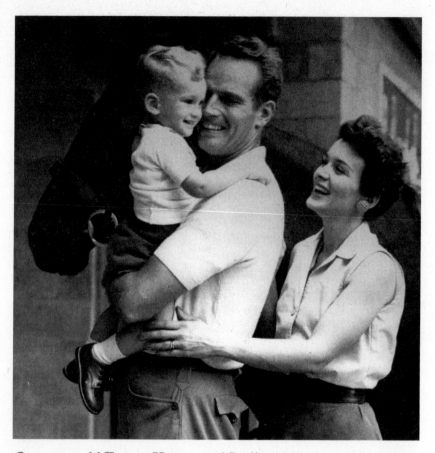

One-year-old Fraser, Heston and Lydia, 1956. (Courtesy of the Heston Family)

Chapter Fourteen

William Wyler was one of the master craftsmen of the studio system's glory days. His career, like DeMille's, had begun in silent films and lasted more than forty years, during which time Wyler produced and directed nearly seventy features, many among the most popular and stylistically distinctive to come out of Hollywood. Collectively, they won more than forty Academy Awards, including three for Best Director. Every actor from the '20s through the '60s wanted the chance to be in a Wyler film, both for the creative experience and to increase his or her odds of winning an Oscar.

If Welles was Hollywood's romantic expressionist (and industrial outcast), Wyler was its ironic realist (and studio darling). The bridge that connected the two

directors was their shared penchant for mise-en-scène that consisted of long, uninterrupted takes and the innovative cinematography of Gregg Toland, whose low-light depth-of-field techniques are on ample display in many of both directors' films, including, perhaps most vividly, in Welles's *Citizen Kane* and Wyler's *The Best Years of Our Lives* (1946). In the '40s, while Welles was getting himself exiled from Hollywood, Wyler was collecting two of his three Best Director Oscars—one for *Mrs. Miniver* (1942), a Hollywood film that showed the sacrifice British families had to make during World War II, and one for *The Best Years of Our Lives*, which dealt with the problems American veterans faced when they returned home from the war. Wyler's winning streak continued into the '50s with a series of films that increasingly illustrated one of his most enduring themes, the heroic stance of pacifism. The success he enjoyed with 1957's *Friendly Persuasion* returned him to the top of his game after a HUAC-induced four-year absence from the screen during the height of the witch hunts; HUAC suspected his pacifist beliefs were evidence of his pro-communist leanings, although he was never officially blacklisted.★

★ The screenplay for *Friendly Persuasion* was written by Michael Wilson, who was classified as an "unfriendly witness" by

Wyler wanted to follow *Friendly Persuasion* with *The Big Country,* a film whose theme spoke to the power of nonviolence. In the film, James McKay (Peck) perseveres through spirituality and intellect rather than force. He is the easterner who inevitably brings civilization to the prairie. Steve Leech (Heston) is his opposite, a born-and-bred western rancher who believes in the inherent self-righteousness of physical might. McKay represents the future while Leech belongs to the past. Everyone remembers the film's signature moment, the fistfight between McKay and Leech that continues on until both are exhausted: no winner, no loser, just a pounding given by each to the other that solves nothing. According to Peck, "Chuck's part was to dislike [my character] at first sight and to do everything he could to make life miserable for me. First of all in his mind we were rivals for the same girl, Carroll Baker, and [he] badgered me and goaded me on, trying to get me to live up to his idea of the macho code of the Old West . . . We went out in the middle of the desert for

HUAC and subsequently blacklisted. Frank Capra was originally set to direct, but dropped the project, which was eventually picked up by Wyler. It was nominated for six Academy Awards, including Best Picture, Best Director, and Best Screenplay. Wilson's name did not appear in the film's credits, and was also omitted from the voting ballots.

one scene where we pounded the daylights out of each other for hours until we could hardly stand and were completely done in and neither one would give up. I forgot who finally said it, Chuck or me, 'Well, have you had enough?' and the other fellow said, 'Yeah, I guess so.' As we staggered to our feet, I think I had the line, 'What did we prove?' So this was really the theme of the picture, in a way." Peck often referred to the film as Wyler's pacifist western.

The Big Country was filmed on location at the Drais Ranch, in the vast, empty desert plains just outside of Stockton, California, and at Red Rock Canyon State Park and Jawbone Canyon in the Mojave Desert, during which Heston discovered how different this director's work technique was from both DeMille's and Welles's. He wasn't pretentiously self-important like DeMille or fluidly poetic like Welles. He didn't make inspirational speeches just before the camera rolled, nor did he drink and tell stories among his players to create a sense of creative bonhomie. Nor did he coddle actors. Wyler also loved to shoot scenes over and over until he had satisfied his well-known obsessive perfectionism, which earned him the nickname among his crews as "Forty-Take Wyler," although he rarely did more than eight or nine; they just *felt* like forty. Heston did film one scene in *The Big Country* twenty-three times.

As a supporting player, he wasn't needed on set every day, and that gave him ample free time to study not just his lines but the entire script. He went over it every day and made notes in the margins that he thought would improve the picture. He intended to give them to Wyler. During a break in filming, while the crew was focusing the lights, Heston, edited script in hand, walked over to Wyler. Just as he was about to say something he noticed the director's leather-bound shooting script on a nearby table. Listed in gold leaf on the cover were the names of several of his previous films: *Dead End, The Heiress, Dodsworth, The Little Foxes, Jezebel, The Westerner, The Best Years of Our Lives, Roman Holiday.* Heston decided to keep his notes to himself.★

As the shoot stretched into September, Heston was still adapting himself to Wyler's style of directing. "When [Wyler finished] a setup he just walked away and told the script clerk which take he wanted printed," Heston later recalled. "The first time this happened [to

★ Heston's version of this story appears in his memoir *In the Arena,* p. 68. Wyler expressed his in a seminar and interview, conducted by George Stevens Jr., for the American Film Institute on December 7, 1975. In Wyler's version, the scene took place during the making of *Ben-Hur.* Heston's is likely the more accurate, as by the time they made *Ben-Hur,* he already would have known better.

me] was after we had worked an hour and a half on a setup. I said, 'Willy, let's not quit now. I can get it. Let's stay with it.' He said, 'Chuck, if I don't say anything, that means it's good . . .'"

Heston called his friend Gary Cooper, who had worked with Wyler on *Friendly Persuasion,* to find out how to please Wyler. Cooper laughed and told him not to worry, that "an actor never feels like a worse actor than when he's being directed by Wyler. But he never feels like a better actor than when he sees the final film."

Still unsure of how he was doing and uncomfortable mingling with the rest of the cast, each of whom was trying to figure out what it was Wyler wanted and how to give it to him, Heston mostly kept to himself on location. He practiced his western-style horseback riding—the script called for a lot of hard galloping—worked out, and, as he did while making *The Ten Commandments,* stayed in costume as much as possible. "I often wore the breeches and boots home at the end of the day and dressed in it the next day on the way to work . . . I think it's very important to wake up in the morning and see [your character's] clothes lying in the corner where you kicked them off the night before . . ."

He brought both Lydia and Fray to the locations, and while he acted she chronicled the production with her

camera. During one of the frequent breaks in shooting, Heston put his two-year-old son on a horse and began to teach him how to ride.

As the film progressed, Wyler kept adding scenes for Heston, which surprised and pleased him. There was a rough and rugged quality he projected that Wyler felt the film needed more of. In one, a dramatic confrontation with Carroll Baker, the Method actress nearly tore Heston's eyes out, and Wyler kept doing retakes until he was satisfied. Heston didn't mind; the more Wyler used him, the more he felt he understood what the director was looking for from him, although he never felt totally secure about his performance: "I think in performance terms I was probably directed better by Wyler [in *The Big Country*] than anyone else. Yet Wyler is not good at communicating. He is somewhat arbitrary and even irritable in his approach, but he has an incredible capacity for knowing when something is right . . . Wyler prepares extensively and pores over the script and glooms through the night thinking about it all . . . the hard thing about doing a scene for Willy is that the actor gets the precarious feeling of building a tower of toothpicks on a milk bottle . . ."

Location shooting wrapped that September and the interior scenes took an additional six weeks to complete back in Hollywood. Heston had only a few of them and

spent much of his off time exercising and playing daily rounds of tennis. He weighed himself before and after each workout to make sure he was never heavier than 180 pounds. By the end of production, he had found a way to get closer to Wyler through their shared love of tennis. It was a game where Heston felt equal, if not superior, to Wyler, and where the director learned from his actor.

Just as the film wrapped, DeMille called Heston and asked if he'd consider making a cameo appearance as Andrew Jackson in the director's next film, a remake of his 1938 swashbuckler, *The Buccaneer,* about the pirate Jean Lafitte's role in the crucial 1812 Battle of New Orleans. Heston agreed to do it. The star of the film was going to be Yul Brynner, which would make *The Buccaneer* a remake of another sort, a mini-reunion of *The Ten Commandments*'s director and stars and, for Heston, a reprise of one of his favorite characters, "Old Hickory."

With the money from *The Big Country,* Heston was ready to move the family out of Park La Brea, which had begun to feel a bit cramped to him and Lydia after the birth of Fraser and the near-constant presence of Mabel. And even more so when they began talking about having a second child. Heston wanted to buy a

house, but he had no idea how to go about it, what he should look for in the way of construction quality, or even where to look. He did, however, know someone who would have all the answers. He decided to call Russell.

"Sometime in 1957," Fraser later recalled, "while I was barely a toddler, my father had made up his mind he wanted to live in a real house, somewhere in the country if possible. It had become clear to him that Los Angeles was where he and my mother were going to be spending most of their time going forward. His dad, Russell Carter, was still back in Detroit, and in the years since his divorce from Grandma Jo he had become a fairly successful building contractor and owned a number of related enterprises. Ever since that time my mom urged my dad to call Russell when they were in Detroit, they'd stayed close, not often in person but they wrote to each other in typed, single-spaced letters. When Dad began to focus on the possibility of buying a house, he called Russell for advice. Calls were a big deal because at that time, using long distance was relatively expensive. Russell then flew out, looked at all the places available, and told Dad he'd be better off buying a raw piece of land and building something from the ground up."

Holly: "It was really a wonderful opportunity for

my father to get to know Russell as a real person, rather than some distant related figure in his life. Yes, they spoke occasionally on the phone, but mainly they wrote endless letters to each other through the years; both loved to write them, and in some my grandfather said he wished my father would come back and visit, but I think the main problem was my grandmother, who still didn't want them to have any relationship at all. Now, because of the house thing, they had a real reason to see each other again in person. My father needed someone he could trust and knew that his father was someone who would look out for his best interests, who would keep the costs down and make sure the quality stayed high. Building a house together was, in a way, an opportunity for them both to put the pieces of my father's broken childhood back together."

At first Heston was reluctant to go forward with Russell's elaborate from-the-ground-up blueprints, believing he was getting in over his head financially, until he received an unexpected windfall. Heston's lawyer, Leo Ziffren, had kept the case against Warner involving *Darby's Rangers* active, and after Ziffren took Jack Warner's deposition, in which he railed about how actors were paid too much money, the studio head quietly settled the case. Heston tells a very funny story in his memoirs about what happened soon after: "I ran

into Warner a month or so later, at some industry function, and he slapped me on the shoulder. 'Hey, Chuck! How ya doin'?' he said jovially. This is a strange town!'" The settlement became the seed money for the house, and Heston gave Russell the okay to start searching for a piece of land.*

Heston, meanwhile, still had some audio dubbing to complete on *The Big Country*, and during one of those sessions, Wyler, to Heston's surprise, offered him the role of the handsome Roman tribune Messala in MGM's planned remake of Fred Niblo's 1925 silent classic *Ben-Hur: A Tale of the Christ*. Starring in another robes-and-sandals ensemble epic so soon after *The Ten Commandments* held little appeal for Heston, but the chance to work again with Wyler did, and he signed on.

* Fraser Heston doubts there was an actual lawsuit, claiming that nothing was ever actually filed by his father. A search of the Los Angeles County courthouse records did not turn up a lawsuit filed by Heston against Jack Warner or Warner Bros.

Charlton Heston, Stephen Boyd, and William Wyler on location in Rome during the filming of Ben-Hur. (Courtesy of Rebel Road Archives)

Chapter Fifteen

In November 1957, Orson Welles finally handed over his rough cut of *Touch of Evil* to the executives at Universal, who had been hounding him for the completed film, before he returned to Mexico. They screened it that same day and were confused by, disappointed in, and extremely angry at what they saw. They felt the film needed additional scenes and better editing to clarify the story, because much of what Welles had given them was sloppy and excessive. They brought in a new editor, Aaron Stell, to replace Virgil Vogel, who had worked with Welles, who superimposed the film's opening credits over what they felt was the overlong opening shot. Years later Welles defended the amount of time he had taken to edit the film this way: "The only moment where one can exercise any control over

a film is in the editing. But in the editing room, I work very slowly, which always unleashes the temper of the producers who snatch the film from my hands. I don't know why it takes me so much time. I could work forever on the editing of a film . . . it is the very eloquence of the cinema that is constructed in the editing room."

Heston had attended the screening, and he too thought the opening was a bit confusing and the plot too ambiguously laid out, but that the film had "truly marvelous things" in it and that "Orson's enormous talent [was] evident throughout." He thought the problems with the rough cut were minor and that Welles himself should be allowed to fix them.

Zugsmith, however, didn't. He felt betrayed by Welles for having turned a simple cops-and-robbers movie intended as a star vehicle for Heston into a noncommercial art film that showcased himself. He thought everything was wrong about Welles's cut, from the actors being too dimly lit to the repulsive-looking (to Zugsmith) Welles being in virtually every scene (he wasn't), and because Welles wasn't available to fix it, in addition to a new editor, Zugsmith brought in director Harry Keller to shoot additional, plot-clarifying scenes.*

* Welles wasn't as heavy as he looked on-screen. He wore a "fat suit" to make himself look bigger than he really was and a false

Not surprisingly, even though he had refused to stay in Hollywood and make the changes Universal wanted, Welles was shocked and hurt by Zugsmith's actions. According to Stell, Welles then became "ill, depressed, and unhappy with the studio's impatience," fearing he had blown the last chance to resurrect his Hollywood studio directing career. Desperate to get his film back, he called the one person with enough clout to save his version of the film, the actor who had gotten him the gig in the first place. He called Heston, who agreed to try to help straighten the situation out for both sides.

He managed to get Welles to agree to shoot additional footage himself and recut the film, which Welles insisted had been his plan all along, that the rough cut he had given executives was meant only to show the progress of the editing, not the finished movie, but Zugsmith wanted nothing more to do with Welles and held firm on his decision that the director's services were no longer required.

Welles then appealed directly to Universal's head of production, Edward Muhl, via a detailed fifty-eight-page letter outlining all the changes he was ready to make and what new scenes he wanted to shoot, but

nose to widen his face. He dominated every scene he was in by the expanse of his acting.

Muhl refused to override Zugsmith and disregarded the letter.

A desperate Welles then wrote to Heston and asked him not to participate in any additional filming by any other director. Here is an excerpt from the letter Welles sent to Heston:

> As Muhl [didn't] reply to my offer, I presume the studio will be in touch with you about those scenes again and things will be pretty much up to you.
>
> Your position is really quite strong, since you accepted the picture only on condition that I directed it and you will be entirely in your rights if you insist that since I am available, the studio must abide by that condition . . .

Heston: "I thought the shoot had gone very well, as did the editing, some of which I watched and learned from . . . I then went off to film *The Big Country* [and] two months later [after viewing Welles's rough cut] the studio called me in the Mojave. Could I reach Welles? On turning in his cut, he'd gone off to Mexico to raise money for *Don Quixote* and hadn't called them since. When I got back in town, I found Welles and read his 58-page memo [to the studio], but by then, the fat was in the fire."

Heston took both the memo and the letter to Citron for advice about whether to do the additional scenes, though he was inclined to agree with Welles. The always practical Citron explained to Heston that his contract with Universal was clear and binding; he had to do the retakes with or without Welles directing them. It was actually something of a relief for Heston, a legal way out of a moral conflict, but it still bothered him that he had to desert Welles. On the last Sunday of that November, meeting with Zugsmith, he agreed to shoot the additional footage, beginning the next morning.

Later that same Sunday, Heston received another letter from Welles, this one hand-delivered to the Park La Brea apartment, "outlining his position so eloquently," Heston remembered, "it prompted me to further soul-searching. In the end I called Citron again and canceled the call for [the next morning]. I told him to tell the studio I'd reimburse them for all costs they couldn't cancel due to my late pull-out." The next call he made was to Leo Ziffren, and a meeting was set up for still later that night between himself, Ziffren, and Citron. Ziffren reiterated what Citron had already told Heston, that he had no legal grounds to refuse to do the retakes, even if Welles wasn't directing them.

Early the next morning, Heston met with Muhl at Universal to make one last attempt to have Welles shoot

the new footage. As Heston noted in his diary, "He was pleasant, but adamant. [He did] not want Orson to do the retakes. So I [will] do them tomorrow. The cost to me of the day's delay will be high, about eight thousand dollars in uncancelable crew calls, mostly . . . but not as high as the moral cost of finking out."

Welles didn't make it any easier on Heston, or express any understanding of the position he had put him in. Monday evening another letter arrived at Park La Brea Towers by messenger, in which Welles told Heston:

What is happening over there is still the ruination
of our picture.
—Much love, Orson

The next day, Heston did the reshoots and new scenes, mostly with Janet Leigh. That night, one final hand-delivered letter arrived from Orson that concluded with:

You are poop but I love you.
—Orson

Later on, when Heston finally saw Universal's new ninety-three-minute version of the film, he wrote in

his diary, "In the end, the extra footage shot was not very significant, consisting of a dozen or so orienting shots . . . contrary to legend, there is no 'lost Welles version' of *Touch of Evil*." The added scenes were mostly for clarification, which the film didn't need, and to give Heston more screen time with Leigh, to help emphasize their relationship and also because he was supposed to be the film's star, not Welles.

That was it for Heston and the film, or at least he thought so, but not for Welles. Although he professed time and again that he had forgiven Heston for shooting the additional scenes, and they almost worked together on Welles's proposed remake of *Julius Caesar* in 1980 before the funding for it fell through, in 2013 Henry Jaglom published a book of lunchtime conversations he'd had with Welles during the '80s that contradicted those claims. In one conversation that took place between 1984 and 1985, the subject of *Touch of Evil* came up. Almost thirty years later, Welles sounded as if he were still furious and got his facts mixed up: "Chuck Heston . . . still claims that *Touch of Evil* is a minor film. Over and over, every time he's asked to speak, he says, 'Let's not talk about *Touch of Evil* as though it's a major work.' He sincerely believes that. And he's a horse's ass, because he's in a film of mine that other people think is important, so why doesn't he

shut up and pretend it's important? . . . He has a bad conscience, too, because he refused to come back to the studio and do the reshoots. He phoned me and told me, 'I signed on to do a picture with Willie Wyler, *The Big Country*,' so he's got that little guilt. That makes *Touch of Evil* a minor film [to him]."

"Orson Welles [was] the most talented man I ever met in film," Heston steadfastly maintained. "He was the quintessence of creative capacity," even if Heston didn't think *Touch of Evil* was the greatest film ever made. Here, in part, is what Heston actually said about *Touch of Evil*, the comments that Welles was referring to: "It is not a great movie, as *Cahiers du Cinéma* wrote many years ago. They said it was undoubtedly the best B picture ever made . . . audiences were uneasy at not knowing what was going on. For example, you never even really know which side of the border you're on. That was Orson's choice. It was this ambiguity that the Universal retakes were designed to clarify, although it is still somewhat ambiguous . . . I think the only basic creative mistake Orson made with the film was that he felt impelled to maintain the fiction that I was playing the leading role, which of course is not true. He felt constrained to attempt to disguise that fact from me by putting in one or two scenes and handling a couple of

other scenes to advance the idea that Vargas is the central part . . . the story is really about the fall of Captain Quinlan."

Welles's memory may have been playing tricks on him, or he was remembering what happened through the wrong end of his moral telescope, sounding as if he were blaming Heston for all that went wrong by claiming that he had abandoned the project to work with Wyler on *The Big Country*. Heston had already finished principal shooting on *The Big Country* when Universal took the film away from Welles, and it had nothing to do with Heston, but with Welles's own lateness in delivering his rough cut, which the studio mistakenly believed was his final cut. Moreover, Heston had *not* wanted to do the reshoots and had pushed hard to keep Welles on the film, but he was legally bound to do them, whether Welles shot them or not. And finally, if Heston ever called *Touch of Evil* a minor film, he was referring to it in terms of its place in *his* overall career, not Welles's.

What Heston did get wrong was the extent to which the changes made to Welles's original version of the film by the studio altered his stylistic intent. In 1976, with a new regime in place at Universal, the studio decided to restore some of Welles's original footage for

a planned theatrical rerelease, with an expanded running time of 108 minutes. Most critics agreed it made the film a better, more personal work.

Then, in 1998, thirteen years after Welles's death, Heston discovered among his papers a copy of the filmmaker's fifty-eight-page memo to Muhl, and he sent it to Lew Wasserman, then the head of Universal, who passed it on to the film editor Walter Murch. Working with Bob O'Neil, Universal's director of film restoration, and Bill Varney, Universal's vice president of sound operations, Murch found more of Welles's original footage in the studio's vaults and recut the film the way it was outlined in the memo, omitting much of the additional Keller footage (except those scenes that weren't replacing Welles's original versions, or new ones that Welles was said by Universal to have approved). It is now considered the definitive version of *Touch of Evil* and proves that it was Welles's film, not Heston's.*

Production on *The Buccaneer* had stalled because of DeMille's failing health. In one final attempt to keep the project alive, late in 1957 the studio offered it to

* Rick Schmidlin produced the 1998 edit, which had a limited but successful theatrical release. It is available on DVD in a package that includes a reproduction of Welles's fifty-eight-page memo.

Anthony Quinn to direct. DeMille's son-in-law had already won two Supporting Actor Oscars for his roles in Elia Kazan's *Viva Zapata!* (1952) and Vincente Minnelli's *Lust for Life* (1956), but had never directed a movie. Quinn reluctantly accepted, knowing it would always be considered a DeMille film no matter who did what amounted to grunt work. He was also angry that his father-in-law hadn't offered him the part of Jackson, giving it instead to Heston, who had never even been nominated for an Academy Award.

Not surprisingly, the shoot was a troubled one. By the middle of the picture a frustrated Brynner refused to take any more direction from Quinn, who had given him what he considered bad line-readings and had him looking the wrong way in several scenes, which would make editing continuity impossible. Moreover, Quinn, one of Hollywood's legendary swordsmen, was openly having affairs with Claire Bloom and Inger Stevens, which enraged DeMille. On December 3, 1957, Heston finally got to film what was really an extended cameo while the entire production teetered in total disarray. Fortunately for him, he was not on set long enough to get involved in all the palpable tensions.*

* *The Buccaneer* opened on December 1, 1958, to mostly negative reviews and lost $2 million domestically but managed to

When DeMille showed up on set to say hello to everyone, Heston couldn't help but notice how frail he looked, how hesitant his gait was, and how the director's once booming voice had been reduced to a whisper. Heston was in makeup, undergoing a two-hour transformation out of himself and into Andrew Jackson, when DeMille sat down in the next chair to have a chat. He told Heston he'd heard Wyler had offered him the part of Messala. "Well," DeMille went on, "Ben-Hur's the part, of course. You can always get good actors to play bad men. Heroes are harder. Ramon Novarro [the silent screen star who played Ben-Hur in the 1925 Fred Niblo version] was wrong for it. Dead wrong. You should do that part. I'll call up Mr. Wyler and tell him, but—directors like to make their own choices . . . and yes, that'll make quite a picture . . ."

Heston was never Wyler's first choice to play Judah Ben-Hur. Like every director in Hollywood at the time, he had wanted Marlon Brando. When Brando turned him down, Wyler went for Rock Hudson, whose pretty

break even after its worldwide release. It was a sad and bitter farewell to Hollywood filmmaking for DeMille, who was disappointed about every aspect of the film and thoroughly disenchanted with Quinn. Quinn and DeMille's adopted daughter, Katherine, who had become an actress, divorced in 1965. Quinn never directed another feature.

face and muscular build had gotten him the lead and an Oscar nomination in George Stevens's 1956 screen version of Edna Ferber's epic novel *Giant*. Hudson turned *Ben-Hur* down to play the lead in Charles Vidor's *A Farewell to Arms*. That was when DeMille called Wyler and urged him to give the role to Heston. Shortly after, Heston turned down Wyler's offer to play Messala and insisted the only role he would accept was Ben-Hur. Wyler said he would think it over.

In his daily diary, in the entry for January 15, 1958, Heston expressed his ongoing anxiety over whether Wyler would give him the part: "As for *Ben-Hur*, there is nothing approaching a final word on it. Willy is proving the champion decision-avoider of the industry, as far as I can determine. Very damaging to the ego."

A week later, January 21, Wyler informed Heston, via Citron, that he was giving him the role of Judah Ben-Hur. From Heston's diary that evening: "I found [out] that Willie had finally approved me for the role . . . I was filled with exaltation, which flowed through the happy evening L [Lydia] and I spent with a bottle of champagne and happy thoughts of eight months [together] in Italy. God, what a thing." When Heston first came home that night after Citron told him he had the part, as soon as he walked through the door she said, "You didn't get it." He broke into a big grin and said,

"Oh, ye of little faith!" "Why, you're playing Ben-Hur right this moment!" she said, smiling. They both broke out laughing as he put his arms around her and kissed her.

Heston was asked by MGM to keep the news secret until Wyler officially announced it to the press. Veteran Hollywood journalist Bob Thomas was the first person Wyler told, and Thomas announced it that February in his column in the *Hollywood Citizen-News:* "Heston will receive $250,000 to enact [the role of] Ben-Hur. MGM will put up the actor and his family in a villa near Rome for the eight-month shooting period. Some actors would shun such a long project, but Heston reasons, 'I think this will be a good time to be away from Hollywood. My agents tell me the movie industry is going to be in a bad way for two years [due to the nationwide recession]. I'll be tied up for one of those years, so I think it's pretty good timing.' "★

★ Heston's deal, negotiated by Citron, was $250,000 for thirty weeks, to be prorated after that—a deadline no one, including Wyler, expected to make. All of Heston's and his family's expenses were to be paid by MGM. One of the peculiarities of Hollywood vernacular in the '50s was that actors almost always referred to their agent in the plural. It may have been a shortening of "agency" that became very popular. Heston's only agent at the time was Citron, who worked for MCA.

Despite what would be a prolonged absence from Hollywood, Heston wouldn't be completely out of the public's eye. Yet to be released were *Touch of Evil*, *The Big Country*, and *The Buccaneer*, and *The Ten Commandments* was still in theaters. For her part, Lydia, having missed going to Egypt, was looking forward to Rome, believing the trip would be good for all of them, especially young Fraser. What better education could a child have than seeing the world and learning its history firsthand? According to Holly, "His childhood was spent mostly overseas, and I think that shaped his whole life and gave him a different and unique perspective at a very early age. It was a tremendous privilege, even if he didn't have a traditional childhood. Neither Fraser nor I ever went to summer camp. Our childhoods were spent to a large degree traveling overseas to wherever Dad was filming, and we grew up on my dad's sets. He always took the children with him, and scheduled a lot of his summer filming overseas so we could go. It was the finest learning than any school could ever give us."

Fraser: "From a very early age, I was dragged along on what I used to call 'Ruin Running' and 'Museum Marching' expeditions. [While my father was filming,] Mom would get us up early to drive out to . . . explore

the Roman Forum or the Roman ruins . . . My mom was a traveler and an adventurer."

Walter Seltzer remembered, "Lydia was the strong right arm of [Heston's] career and always had been. She was really the [first] star in the family, and then when Chuck started to make a name for himself and became a big star, Lydia decided she would like another career . . ." and photography was it. Heston assured her she would have total access to take pictures on location throughout the making of the film.

"They made a pact," Carol Lanning, Heston's future secretary, recalled. "They would always be together. She gave up her career to be with him. If he traveled, she traveled. If he had to go on location, she would go on location with him. Wherever he was, she wanted to be right there with him. He was a family-oriented man and he wanted his family with him wherever he went."

"I think it was crucial," Holly said. "She came from a family of doers and succeeders. She was the first-born in her family, the smart one; she was expected to become a lawyer. She was going places, and then she married an out-of-work actor, didn't get a law degree, became an actress herself—it was, to her family, 'How could she possibly do that?!' She needed to find a creative outlet and she found it in photography."

Lydia: "He always took us with him whenever it was possible. All of a sudden I realized, it was not distressful to me because I had fallen in love with photography. It was a turning point in my life." Surrendering her own ambitions to act would not be that easy for such a strong woman, even though it was an era when married women with children were expected to defer to their husband, the breadwinner, the undisputed head of the house. It would be the basis of ongoing marital tensions between the two that would never fully be resolved. It sometimes manifested itself in jealousy on Lydia's part, one of the reasons she would insist on being wherever Heston went, and Heston acquiescing to her on everyday differences to avoid larger conflicts. And he always made sure no one ever interfered with Lydia's on-set photography. He realized early on that while it was a creative expression on her part—a reflection of real talent and ability—it was also a vent for her frustrations giving up her acting career.

One of the last things Heston did before they left for Rome was to try to settle on an architect to work with Russell on the construction of the planned eight-room house, to be built in a style he would often describe in his journals as "medieval modern." Russell had found a

ridge near the top of Coldwater Canyon, on the Hollywood side of Mulholland Drive, and Heston agreed it was the perfect location.

Holly: "We called it the 'House That Hur Built,' because [the rest] of the money came from Dad's salary on *Ben-Hur.* I remember him telling me that he went to City National Bank [in California] and told them he had this piece of property that he wanted to build a house on, and asked how much money he could get in advance, against his salary. They gave him $75,000. Russell had to make a lot of shortcuts because he wanted to do things a little bigger, because my dad didn't want to go into debt. He had a Depression-generation upbringing and he would have none of that borrowing-from-Peter-to-pay-Paul stuff. He earmarked his *Ben-Hur* money to repay the loan and hoped Russell could build the house as close to his original plan as he could get."

"What was unique about the ridge," Fraser later recalled, "was that looking down from it, three acres belonged to him, there was nothing that interfered with the view of wild chaparral and oak trees. There were two houses above, but they could barely be seen. My father fell in love with the property at first sight."

Once the purchase was made, Russell took a sleeping bag and camped out for a day and a night so he could study the way the light traveled across the land,

while back at Park La Brea, after interviewing dozens of architects, Heston settled on William Sutherland Beckett, a disciple of Frank Lloyd Wright. Heston liked his ideas about a 5,100-square-foot house with heavy beams whose angularities would blend into the rugged contours of the land, the exterior framed in redwood and stone, with glass walls and a Roman courtyard. Inside there would be an interior stone wall that resembled a seventeenth-century fort, a huge freestanding fireplace, and a private steam bath for after tennis on the professional court adjacent to the house. Later on, a fully equipped screening room would be added, a two-floor library with sweeping views of the canyon, a separate photo studio for Lydia, a cobbled court with a fountain, a pool to swim laps in every morning after his leverage exercises and before breakfast, and forty-seven feet of closet space. Heston also shared with Beckett Lydia's design for the interior layout and Fraser's wish for a checkerboard motif in his playroom (and his own for room for a king-size bed for the master bedroom). Even while the Hestons were packing, and right up until the day they left for Rome, they held long daily meetings at the apartment with Russell and Beckett to exchange ideas and suggestions. Heston continued to send Russell suggestions by mail from Rome, and they occasionally talked over the phone about budget over-

ages that Russell said were necessary to get as close to what they all envisioned the house should be.

On February 22, 1958, Heston, Lydia, Fraser, and Mabel took a taxi to Union Station in downtown L.A., where they boarded the Super Chief for Chicago to spend time with their family. After a few days there, they continued on to New York and stayed in the Tudor City apartment just long enough for Heston to perform in what would be his last live TV appearance in a dramatic presentation, *Beauty and the Beast,* for *Shirley Temple's Storybook.* His costars were Claire Bloom and E. G. Marshall.

The next morning they all went to the pier on the West Side of midtown Manhattan and boarded the red-and-black SS *United States* bound for Southampton, England, the first stop on their journey to Rome. Heston and Lydia were extremely happy and a bit anxious, both aware that he was on the cusp of superstardom, and when it came, nothing in their lives would ever be the same.

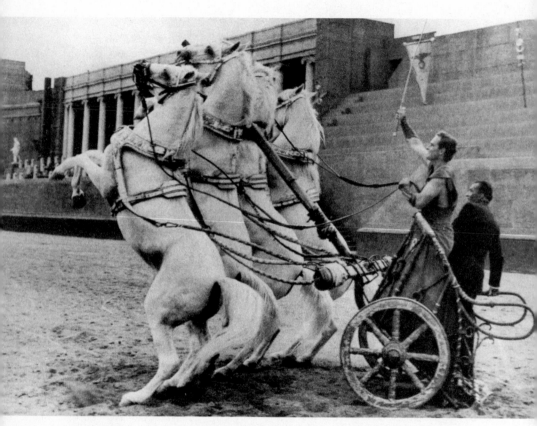

Legendary stuntman Yakima "Yak" Canutt teaching Charlton Heston how to drive a chariot. A separate track was built outside the main set at Cinecittà Studios in Rome, where Heston trained every day for eight weeks prior to filming. (Courtesy of the Heston Family. Photo by Lydia Clarke Heston.)

Chapter Sixteen

MGM, the most glamorous studio in the history of Hollywood, whose majestic lion's roar introduced every one of the studio's releases since 1924 and whose slogan boasted MORE STARS THAN THERE ARE IN HEAVEN!, was, by 1958, on the brink of extinction. Its financial downturn began shortly after the end of World War II, when, along with all the major studios, it struggled against the instant popularity of commercial home television and tried mightily to reestablish America's weekly habit of going out for a night at the movies. Desperate for a hit after the failure of 1957's financially disastrous *Raintree County,* a Civil War–era film MGM hoped would rival *Gone With the Wind*'s grandeur and profitability but did neither, its last great hope was Wil-

liam Wyler's production of *Ben-Hur.** MGM went all in, gambling its future on it, hoping the director could find a miracle in the studio's financial crown of thorns.

As producer Sam Zimbalist had intended, the final shooting script for the picture bore remarkable similarities to the screenplay for the 1956 remake of *The Ten Commandments,* in hopes of catching some of that film's lightning in a chalice. Like DeMille's biblical epic, *Ben-Hur* was a statement film that alluded to the Holocaust, by the Egyptians in the former film, by the Romans in the latter. Both were shot in wide-screen color formats, partly or in whole on location where their stories were set. But as Wyler would later boast, when asked why he thought his film would be better than DeMille's, "It [takes] a Jew to make a really good film about Christ."

Preproduction began in January 1959 at Rome's famed Cinecittà Studios. MGM rented every soundstage and back lot and turned them into one giant dream factory to produce *Ben-Hur.* Only six MGM 65 cameras were in existence, and five of them were shipped from Culver City to Rome. Wyler used two, and he gave

* For a while, the failure of *Raintree County* curtailed the career of the studio's biggest star, Elizabeth Taylor, and all but ended Montgomery Clift's.

three to his second unit to use for the chariot sequence. Wyler, Zimbalist, and cinematographer Robert Surtees, who was known in the industry as the "Prince of Darkness" (for his ability to shoot dimly lit sequences in scope, which requires more light than regular camera equipment), along with a thousand-man crew, arrived several months before Heston and the rest of the principal players to build the film's massive sets. Wyler personally oversaw the construction of every one of the many self-contained units, including Pontius Pilate's palace; the streets of Jerusalem; the Villa Dolorosa; Ben-Hur's house and palace; the streets of Rome; Quintus Arrius's home; the slave galley; and the largest one, the circus, the arena where the film's chariot race would be filmed. Art director Edward Carfagno, who had worked on *Quo Vadis* (1951), modeled the circus after the one in ancient Antioch. Carfagno's crew used a million pounds of plaster to build the arena and, for the track itself, imported forty thousand tons of white sand from the beaches of the Mediterranean, carried in by a caravan of trucks. The crew also built hundreds of housing units just behind the sets, numerous portable bathrooms everywhere they could fit them, and a food installation capable of serving five thousand people in around-the-clock twenty-minute shifts. Wyler's goal was to make audiences feel as if they were transported

back to ancient Rome and given a front seat to the high, wide, dramatic, and bloody spectacle that was to be his version of *Ben-Hur.*

After a leisurely first-class transatlantic journey aboard the SS *United States,* the Hestons arrived in Southampton on April 5 and boarded a train for London. Every step of the way they were swarmed by bulb-popping paparazzi, who kept calling out "Heston! Heston!" to get him to turn their way, while reporters hurled questions about *The Ten Commandments* and the as-yet-unmade *Ben-Hur,* right up to the front steps of the Dorchester hotel, where they were finally turned away by hotel security. It was all new to Heston, who was used to walking the streets of New York City without anybody recognizing him out of his Moses robes or moving about even more easily in car-centric Los Angeles, where he and Lydia were able to go to their favorite restaurants without being disturbed and he could play tennis at private courts where no one bothered him.

After a brief press stop in Dublin, they flew on to Paris, where Heston was scheduled to do some more prearranged interviews, this time for the French newspapers, magazines, and TV, that would be held until the picture opened. Then it was by rail through the French

countryside across into Italy, all the way to Rome's Stazione Termini, where yet another mob of frenzied paparazzi greeted them, along with hundreds of locals who nearly caused a riot when they saw Heston and, in a repeat of what had happened in Egypt during the filming of *The Ten Commandments,* began to chant *È Moses! È Moses!*—"It's Moses! It's Moses!"

The Hestons managed to push their way into one of several black Cadillac limousines waiting to take them on the fifteen-minute drive to the lavish villa MGM had rented, the Horti Flaviani, in the "Beverly Hills of Rome," near the Appian Way and the Baths of Caracalla, that had a staff of ten house servants and a private entrance to the Catacombs. "We brought a maid with us from home," Heston joked, "but I'm afraid they're going to turn up with a maid for her . . . if I take my shoes off, two servants rush out to shine them. We have our own chef who's mad at us for not letting him cook more. He has a helper who cleans the vegetables and the poultry, and a waiter. Then there are two gardeners . . . I have to ask myself if I'm the same guy that chopped kindling in Michigan . . ."

Their first night in Rome, Heston took Lydia to a nearby restaurant to celebrate her thirty-fifth birthday. As they ate and drank champagne, they joked about all the commotion surrounding a couple of kids from

Northwestern University. It would be one of the last times they would be alone together for the next nine months.

Weeks went by before Heston stepped in front of a camera, due to delays building the sets and still-unresolved problems with the script, and he began to get antsy: "They pay me to do the acting. It's the waiting part that's boring." During this time, he and his costar Stephen Boyd, whom Wyler had cast as Messala, started learning how to drive the chariots. They were taught by one of the film's two second unit directors, stuntman Yakima "Yak" Canutt (the other was Andrew Marton). Canutt had been John Wayne's stuntman and close friend ever since 1939, when the two had met during the filming of John Ford's *Stagecoach*. Canutt had doubled Wayne during the action scenes (their faces were similar and they both had powerful physiques, although Wayne had a much larger frame), memorably riding bareback on the stagecoach's runaway horses during the big Indian attack. *Stagecoach* made Duke a star to the public and Canutt a legend in the industry.

Heston and Boyd's chariot lessons were done on the identical oval practice track the crew had built away from the set of the main arena, so that the ongoing construction there would not disturb the horses. Canutt purchased eighty-two prized stallions from Sicily and

Yugoslavia, and the wrangler specialist Glenn Randall had trained them to race in full harness and costumes. The first day, Canutt started Heston on a gentler team and rode alongside him in the chariot for encouragement and support. As they began their third full lap, without warning Canutt jumped out and the team took off down the track. Heston made it around in one piece, confident now he would be able to master that task in the film. Boyd did less well, but he too was determined to succeed.

The next day Heston rode with a team of Canutt's assistant stunt drivers that included his son, Joe, who was there to help his father coordinate the complicated chariot race sequence. He and Heston forged a friendship during the making of *Ben-Hur* that would last for the rest of Heston's life. Joe would go on to be his stuntman on many films over the next thirty-plus years. Both were naturally athletic, loved horses, and being in harmony with nature. Joe would also become close with Fraser as he grew up, often taking him on camping trips to hunt and fish and telling him colorful stories about the life of a movie stuntman.

Yak told Joe to ride Heston hard, not to cut him any slack, and to be careful for the both of them because the backs of the chariots were open. If anything happened to Heston's rig, Yak cautioned, both he and

Joe would be trampled by the team behind them. Yak adapted his methods to Heston's abilities and designed a special harness capable of controlling the four horses with two reins.

As Joe Canutt remembered: "He tended to be clumsy, nothing came naturally to him, so we had to work out everything in advance and allow for nothing to happen to MGM's jewel. The studio was in trouble and had everything riding on *Ben-Hur.* If something happened to Chuck, it wouldn't be just the end of the film; it would also mean the end of the studio. We spent hours, days, weeks, working the clumsiness out by repetition and skill building. I made sure when the sequence was shot he'd be ready, and he was. He was one of the hardest-working, most conscientious actors I ever worked with; he listened, he learned, and he never missed."

After several weeks of hard training, one afternoon Heston felt completely drained and needed a break. Joe Canutt tells what happened next: "I knew he needed to stop, so we broke for lunch. Chuck had a cot set up under a lean-to that he put up so he could get out of the sun when we weren't rehearsing. While I was waiting, a bus pulled up with a lot of newspaper people in it. They came over to me and one guy said they were looking for Charlton Heston. I told him he was over there on the

cot. Then he asked me what I did. I told him I was Ben-Hur. I said it loud enough for Chuck to hear it and he shot up off that cot. 'What about Heston?' they asked. 'Well,' I said, 'he does all my dialogue.'" Heston didn't take any more breaks.

One day he went to Yak and told him he thought he felt able enough to film most of the chariot scenes himself, that he wouldn't have to be doubled, and Yak agreed. He had, after all, ridden horses since he was a child, had handled a three-horse chariot in one scene in *The Ten Commandments*, and had done a lot of his own riding during the making of *The Big Country*. After a few early spills, he knew he could drive a chariot even through the difficult turns (the chariots had axles and the wheels rolled, but they couldn't be turned to the left or right; Heston had to learn how to slide the chariot into the curves). The only thing he still worried about was if he could drive a four-horse chariot when the other seven chariots were all running together. "Don't worry," Yak told him. "You just stay in the chariot. I guarantee you'll win the goddamn race."

Fraser: "I remember riding in a chariot at the age of three or four during *Ben-Hur* and my father coming home in his gladiator outfit with blood all over him. I thought he was a real chariot driver and was hurt."

Heston didn't want his son to be frightened again and came up with a plan. "My dad brought home a Roman costume for me to wear, and I used to put it on and march around the set. I was the best-dressed, best-armed kid on the block. It became playtime for me, and I thought for my dad too, and that helped defuse the sight of all that blood on him."

The next thing Heston had to learn was how to throw a javelin for the scene early in the film in which the handsome, young Hebrew prince Judah Ben-Hur reunites with his equally handsome boyhood friend, Messala, who has been assigned by Rome to be its tribune in Jerusalem. Each then playfully throws a javelin at a crossbeam, a moment that anticipates the film's climactic depiction of the brutal crucifixion of Jesus. It is an awkward scene for many reasons, not the least of which was how much difficulty both actors had trying to figure out how to play it. Ben-Hur's "joy" at seeing Messala after so long looks and sounds stiff and forced, Heston's smile a bit too widescreen to compensate for his discomfort with the overly touchy-feely moments between him and Messala, while Boyd overacted his character's emotional zigzags, going from zero (extremely happy) to a hundred (extremely angry) with no passing chords to smooth the transition. Much of the problem could rightly be attributed to the script, a

problem that plagued Wyler and the actors, not just in this scene but throughout the production.

Wyler had trouble cobbling together a workable shooting script out of the playwrights S. N. Behrman and Maxwell Anderson's screenplay. Behrman had previously written Mervyn LeRoy's highly successful robes-and-sandals epic *Quo Vadis* for MGM, and when the original 180-page Karl Tunberg text for *Ben-Hur* proved unacceptable to Wyler, Zimbalist instructed the film's new writers to use the script for DeMille's *The Ten Commandments* as their template.* Meanwhile, Zimbalist kept pressuring Wyler to start filming even without a complete screenplay, reminding him that time was money. Before a single foot of film was shot, *Ben-Hur*'s shooting budget had doubled from $7.5 million to $15 million.

After a few weeks of filming, Wyler urged Zimbalist to hire more writers to help resolve the ongoing problems in the script. At that point both American novelist, screenwriter, and historian Gore Vidal and British poet and playwright Christopher Fry—who, like Wyler, was a pacifist—were brought in. Vidal was already under

* Tunberg was a veteran studio screenwriter whose previous hit films included Allan Dwan's Shirley Temple vehicle *Rebecca of Sunnybrook Farm* (1938) and Curtis Bernhardt's Regency costume drama *Beau Brummell* (1954).

contract with MGM, and the studio wanted to take advantage of that (it wouldn't have to pay him any additional money), and Wyler believed that Fry could add some much-needed irony to the story of the journey of Judah Ben-Hur.

It remains unclear as to which writer was actually hired by whom and when. According to Heston's diary entry of April 29, both writers arrived at the same time, and it was evident from their first day on set they didn't gel with each other, or, for that matter, Vidal with anyone. Heston suspected there was something not quite right about him, in more ways than one. From Heston's diary: "Vidal has the inevitable cold edge of *his kind* [italics added]."

By the third day of trying to work with Vidal, Heston was concerned enough to talk to Wyler. The director told him not to worry about the writing, to concentrate instead on what he was supposed to be doing, finding his Ben-Hur within. On May 2 Heston wrote, "I had a talk with Willy, who seems to be getting the script under control. I was a little worried that even he might be outnumbered in this one, but he seems to feel confident. Even with Vidal and Fry, I sense it's a long way from home yet."

One afternoon early in May, while Heston was having lunch with Fry, with whom he got along well,

he asked the writer how it was going. Fry told him that Wyler and Vidal could not agree on which of the new versions of scenes to use in the film, Vidal's or Fry's. As Heston got closer with Fry, things got worse between the actor and Vidal. The writer had little use for Heston, believing he was nothing more than a Middle American hick. Years later, in his memoir *Palimpsest,* recalling his days on the *Ben-Hur* set, Vidal wrote that he thought "Chuck had all the charm of a wooden Indian." For as long as Vidal was in Rome, he kept his distance from Heston, which was fine with him.

Vidal, like Heston, had worked extensively in live TV. Each had done *Studio One* several times, Vidal writing and Heston acting (although not for the same episodes). And, like Heston, Vidal was discovered through his television work and brought to Hollywood. In 1956 he signed a four-year contract as a staff writer for MGM, a job he took strictly for the money. By the time he was assigned to work with Fry on *Ben-Hur,* he was on suspension for having turned down several assignments because of a dispute with the studio over money. Shortly after he signed with MGM, he revised for Broadway his original teleplay for *Visit to a Small Planet,* a one-hour satire about the Hollywood blacklist he had first written in 1955 as an episode of *The Goodyear Television Playhouse,* and it became the sur-

prise hit of the 1957 theater season. Zimbalist was there opening night and personally congratulated Vidal for his success, but the next day he refused Vidal's request to renegotiate his relatively modest studio deal. Vidal then asked to terminate his contract, believing he could make more money writing plays and novels than he could writing screenplays in Hollywood. Zimbalist refused, and Vidal kept turning down assignments until MGM suspended him, which effectively stopped the clock on his four-year deal. In 1958, with two years still left on his contract, Zimbalist offered Vidal the rewrite job on *Ben-Hur,* which included a three-month stay in Rome, all expenses paid. The producer knew Vidal wouldn't turn the offer down because he was, at the time, writing a book about Julian, the fourth-century emperor of Rome.*

Wyler, who claimed he had not been consulted about bringing on Vidal, was, like Heston, not happy with the writer's attitude or his output and set up a schedule whereby Vidal would write one scene, then go over it

* Wyler convinced Vidal to stay in Rome for the entire shoot, but after his obligatory three months, Vidal was largely absent from the set, spending most of his time researching his book, checking in occasionally with Wyler to find out how everything was progressing.

with Zimbalist, and only after Zimbalist was satisfied would it be passed on to Wyler. The unspoken problem with Vidal's script was the same problem Vidal had with every script he had done for the studio: he was either unwilling or unable to write convincingly about heterosexual characters. Having to put words into the super-straight Heston's mouth was not something Vidal enjoyed or was at all interested in doing. Zimbalist, who was aware of Vidal's sexual orientation (it was an open secret in Hollywood, one that Vidal made no effort to hide), kept reminding him his job was to write a commercially viable script with clear and simple dialogue for a mass audience.

But even with Zimbalist's careful scrutiny of every scene, Vidal exacted his measure of revenge by "sprinkling homoeroticism over *Ben-Hur.*" Vidal rather gleefully admitted as much to Rob Epstein and Jeffrey Friedman in their 1995 documentary *The Celluloid Closet,* in which the writer claimed that Messala's failed attempt at reinvigorating the homosexual side of his boyhood relationship with Judah Ben-Hur was the real reason he was so cruel to him, and that Boyd was aware and approved of the gay subtext to his character, as did Zimbalist, and they had agreed to keep Wyler and Heston out of the loop, fearing they would refuse

276 · MARC ELIOT

to shoot these scenes.* Wyler always denied having any knowledge of Vidal's intent, and later on, when the subject was raised by the Writers Guild of America over the film's screen credits for Oscar consideration, he claimed he had rejected much of what Vidal wrote.

A reviewing of the film does lend some credence to Vidal's assertion, especially in the initial reunion scene between Ben-Hur and Messala, and later on, when Ben-Hur is seen naked to the waist and glistening with sweat while on a slave ship, then is brought to Quintus Arrius's quarters. When Ben-Hur asks Arrius (Jack Hawkins) why, Arrius says he may want to turn him into a gladiator, the dialogue and direction heavy with implication and innuendo. Then, when Ben-Hur regains his freedom, he returns Arrius's ring, a scene with an oddly romantic tinge.

Whether what Vidal claimed was true (or why homosexuality would be considered unusual in ancient Rome), it had no effect on the film's eventual success. A year later, Kirk Douglas produced and starred in

* Film historian Daniel Eagan, in his *America's Film Legacy: The Authoritative Guide to the Landmark Movies in the National Film Registry*, wrote that Vidal later "insisted that he played up the story's homosexual subtext without Wyler's awareness." (Daniel Eagan, *America's Film Legacy: The Authoritative Guide to the Landmark Movies in the National Film Registry* [New York: Continuum, 2010].)

Stanley Kubrick's *Spartacus,* which was blatantly homoerotic, so much so that a bathtub scene between Laurence Olivier's and Tony Curtis's characters was cut out of the film by the studio and not seen until 1991. And two years later, in *Lawrence of Arabia,* David Lean removed all sexual pretexts in his telling of T. E. Lawrence's experiences in the Middle East. Both of these films were lauded for their dramatic qualities, and few, if any, critics found them sexually offensive or groundbreaking.

The only real relevance any of this has to *Ben-Hur* is how much of Vidal's writing actually made it into the film, which would become a major issue at Oscar time. Heston would insist for the rest of his life that Vidal "did not . . . write any part of *Ben-Hur* as shot . . . As Ronald Reagan pointed out, facts are stubborn things." If he was aware of the fairly obvious implications in the scenes Vidal claimed to have written, he never let on. Only once did he give the slightest hint that he understood the film's essential theme was the close relationship between two men whose friendship was tested, but in a strictly heterosexual context. When asked by a reporter on set during filming, Heston said, "General Lew Wallace . . . decided to write [the novel *Ben-Hur*] after engaging in an all-night dispute with Robert Ingersoll, the famous infidel, on a train between Chicago

and Indianapolis . . ."* Heston did all of his research for the role by reading Wallace's book and several histories of ancient Rome. It was the way he approached all of his roles, intellectually first—the key to understanding his characters—with the emotions following, and because of it Heston's acting in *Ben-Hur* and in all his performances on TV, onstage, and in film rarely displayed any sense of irony or, in acting terms, "subtext." Like most actors in American movies, he played his characters literally, on their and his surface, at least in part because he was never asked to do more. Most Hollywood directors tend to see actors as, essentially, models and messengers, their performances something created by the director, through camera placement, editing, and their vision of the script. Since directors like DeMille never demanded anything more from him, Heston's interpretations rarely went beneath the surface, the reason his acting worked so well for him in *The Greatest Show on Earth* and *The Ten Commandments* (the latter's costume and makeup helped Heston fit into the "mold" of Moses) and less so in the darker, character-driven *Touch of Evil,* a film that is a virtuoso

* Wallace claimed he was not in the least influenced by religious sentiment and had no convictions about God or Christ when he wrote the novel. The fight was about something else.

display of subtext, the plot merely the tray that delivers a banquet prepared by a master chef; nobody cared what the tray looked like, just how the food tasted.

Wyler, whose visual stylistics were closer to Welles's than DeMille's, emphasized character over plot, and he spent a lot of time with Heston trying to get him to understand the emotional arc of Ben-Hur's character, that in the film's early scenes between Ben-Hur and Messala there had to be a playful innocence between them that would then deteriorate as the film went on, and that their relationship was the most crucial and compelling aspect of the plot. As Heston noted in his diary on May 12, 1958, "In a conference with Willy [he explained that Ben-Hur] must be in the beginning untried, an uncommitted man, thus allowing for change, both in the galleys and on Calvary." The problem for Heston was how to play someone untried—something that proved difficult for him, partly because of his tendency to not go beyond a script's literalness.

Although *Ben-Hur* was supposed to be a film based on the power and influence of Jesus Christ, there is very little Jesus in it (compared with *The Ten Commandments*, where Moses, also a "son" of God in a sense, is in virtually every scene). One thinks of Tom Stoppard's brilliant take on Shakespeare's *Hamlet* from the perspective of two minor characters, Rosencrantz

and Guildenstern, in the play's famous play-within-a-play. Wyler's *Ben-Hur* is the story of Jesus as seen through the eyes of someone who encounters him only once, before the day of his crucifixion, but whose whole life, externally and internally, changes because of it. Not surprisingly, the moment Jesus gives the enslaved Ben-Hur a sip of water is arguably the best scene in the film, certainly the most affecting (nicely echoed in reverse when Ben-Hur gives water to Jesus while he struggles to carry his cross to Calvary), because it is the most personal, with Wyler shooting it as an obvious allusion to Michelangelo's *Creation of Adam*. Everything that precedes and follows it, including the chariot scene where one could say Ben-Hur wins because the hand of God is guiding him, leads up to and comes out of that moment.

While Heston was in Rome filming *Ben-Hur,* the *Touch of Evil* saga continued. On May 18 1958, Universal quietly released the ninety-five-minute version of *Touch of Evil* as a B-movie on the bottom half of a double bill, the main attraction Harry Keller's *The Female Animal,* Hedy Lamarr's final Hollywood film. After a brief run *Touch of Evil* disappeared from movie theaters and would not be seen again on the big screen for nearly twenty years. While the film did little for

Heston's career, it had a profound influence on Heston's concept of what a film was and what it ought to be, and after its initial failure he would henceforth seek out the conventional, the mainstream, and the commercial, and resist films that were personal artistic statements made by industry outsiders like Welles. Heston's struggle with his performance in *Ben-Hur* ultimately was not due to his difficulties with the script, but the direction of him in it. Wyler was trying to make a personal film out of a studio epic, while Heston was trying to fit an epic performance into a director's personal vision.

On May 20, Heston filmed the scene where Sheik Ilderim (Hugh Griffith) tries to convince Ben-Hur to drive the quadriga in a race to celebrate the new Judean governor, Pontius Pilate (Ben-Hur initially declines when he finds out he would be competing against Messala). The shoot didn't go well, as Wyler's drive for perfection caused him to reshoot the scene dozens of times. As one reporter present later recalled, "Not all actors can bear up under Wyler's demand for perfection. I saw why the first day I walked on the *Ben-Hur* set in Rome. Heston had a long, hard scene to play. Wyler made 23 takes of that scene before lunch, calling 'cut' every time. After lunch he did it about 10 more times, before he finally said, 'Okay, print it.' Two hours

of solid acting is enough to weary most performers to the point of exhaustion. That day Heston had been acting for six hours straight, just as he had the day before, and would be doing for hundreds of tomorrows. I looked at him. He was thin and there were circles under his eyes. Later, I was to discover that his underweight was deliberate. Chuck, who loves food, had fasted to gauntness because he thought that would make him look more spiritual. But now I said, 'Can you keep on taking this beating?' Mr. Heston looked at me and I could see that his eyes, weary though they were, were completely happy. 'Keep on?' he questioned. 'Keep on—when I truly believe Willy is getting something in my work I've never touched before? When I know this is the greatest role I've played in what I believe will be one of the greatest pictures ever?'" Heston was willing to do as many takes as Wyler wanted, hoping the director would, along the way, help him find the key to unlock the inner character of Judah Ben-Hur.

The galley sequence was also filmed early on, in May, in a huge tank in which an artificial lake had been built. It was difficult to film because the MGM 65 cameras were large, heavy, and immovable, preventing Wyler from being able to get the exact angles he wanted. It required the better part of two weeks to complete the sequence and it was followed directly by the chariot

race. It was an exhausting stretch for Heston, who was on-screen every moment of both and suffering through a terrible cold and accompanying fever.

It took a total of two and a half months for Canutt and Marton to film the race, with Wyler supervising, what would result in a nine-minute sequence in the final film. Dozens of setups were made, at a 263 to 1 ratio of footage (for every 263 feet of film, 1 made it to the final cut), with eighteen chariots, and fifteen thousand local extras packed into the stands, shouting, *Ecco Ben Hur!*—"There goes Ben-Hur!" Heston did all of his own scenes except for two that Joe Canutt doubled for him. One is the scene that always draws gasps, when Ben-Hur's chariot flips over. It looks like Heston but it's really Canutt wearing a full head mask made from a mold of Heston's face. Joe Canutt: "I wore the full face mask so the cameras could come in for close-ups. Other than that, Chuck was able to do just about anything; he had gotten that good driving the chariot. We had some scenes that were just too dangerous. One time we ran over one of the MGM 65 cameras that had been hooked up to a car riding in front of him, and that was me. Another time the black team and the white team were racing side by side, Ben-Hur in one and Messala in the other, and in fact, I was driving both. There's a shot where Messala gets dragged along—that

was me. I was the only one who got hurt, when I cut my chin in the one shot."

Yak Canutt had hooked up a safety chain for Joe to use during the sequence in which Ben-Hur's chariot crashes into another. Without telling anyone, Joe disconnected the chain. Heston: "Joe was the greatest natural athlete I've ever seen. When the chariot flipped, he did a handstand on the rails, turned, and dropped to the singletree [the bar that held the wheels] and somehow managed to throw himself clear of the chariot that weighed a half a ton and its solid steel wheels. One wrong move and it would have killed him. It totally wrecked the chariot and somehow Canutt was able to walk away. When Wyler saw the footage in the dailies, he said, 'My God, we've got to have that in the movie!' Yak said, 'You know, Willy, I thought Chuck was supposed to win that race. I don't think he can catch that demon on foot,' and Wyler said, 'No, no, we'll cut to a shot of him climbing back into the chariot.' Which I did."

The entire race was filmed without sound, all of it added in postproduction, during which Wyler decided he didn't want any additional music; the drama didn't need to be heightened, and the footage was that good.

When they were finished, a fatigued but exhilarated Heston believed the physical action of the two

sequences had somehow helped connect him to Judah
Ben-Hur's character, until one day not long after when
Wyler came to his trailer to have a talk following an-
other especially difficult emotional scene. Wyler had
instructed him simply to walk across a room after re-
turning to the palatial house that Ben-Hur's family
once lived in, now dark and abandoned. Heston had no
lines; all he had to do was walk a few feet. After eight
takes a visibly frustrated Heston asked what he wasn't
doing correctly. Wyler paused, then told him that he
liked the first take in which Heston had kicked a piece
of pottery. He liked the sound it had made. Heston had
assumed Wyler hadn't liked his spontaneous kicking
and that was one of the reasons he hadn't done it again.
When the director finally called an exasperated "Cut
and print," Heston left the set confused. He felt a lot
worse when Wyler told him in the trailer that he had to
try harder. "Chuck," he said, "you've got to be better
in this part." Heston asked him how and the director
said, "I don't know. I wish I did. If I knew, I'd tell you,
you'd do it, and that would be fine, but I don't know."
As Heston later recalled, "That was very tough. I spent
a lot of time with a glass of Scotch in my hand after
that."

According to Catherine Wyler, "My father very def-
initely had a method . . . he wanted actors to find the

characters they were playing by themselves, not be told what to do and then have their performance be artificial. I think he pushed Chuck very hard to find the character in himself, to get what my father wanted from him."

A frustrated and upset Heston asked Lydia for her input. She said Ben-Hur should be a relatively easy part for him to play and gave him a mini acting lesson, an image to work off. She suggested he try to act like he really was a "first-century Jewish prince." That made complete sense to him, to do what they both had been taught all the way back in Alvina Krause's Acting 101 class at Northwestern, to try to organically link his *personality* to Judah Ben-Hur's *character.* It was a great bit of advice. Following Lydia's lead, he allowed himself to find a contemporary aspect to the historical Ben-Hur; it gave him a way to be both intimate and grand, to give a performance that could be authoritative and supple, adding dimension and depth to a complex character. The fundamental between Heston's Moses and his Ben-Hur is that Moses was a purposeful extension of DeMille's personality, whereas Ben-Hur became an evolved projection of his own.

Filming continued through the summer, until Labor Day when Wyler shut down the production to give everyone a few days' rest. By then everyone was ex-

hausted. Heston decided to stay in Rome and get some much-needed sleep, while Lydia took Fraser on a holiday trip to Venice. Heston was happy to see them go, but as soon as they left he knew it was a mistake not to be there. Here is part of his diary entry from September 8: "I am almost too tired to be lonely, though the villa echoed emptily with the footsteps of my son and the shape of Lydia . . ."

Sam Zimbalist had flown back to Los Angeles during the break, hoping not to have to return to Italy, but when filming resumed and Wyler was still unable to give executive producers Joseph Vogel and Sol C. Siegel an estimate as to when he would finish, they dispatched Zimbalist back to Rome. He arrived November 3. The next day, he rose early and met with Wyler, asking if the film would be ready for Christmas 1959, a little more than a year away, and warning if it wasn't the studio would shut down production at Cinecittà and have the film finished, perhaps by another director, on a Culver City back lot.

When the meeting ended, Wyler went back to work to set up the last shot of the day, and Zimbalist went with him. The producer saw Heston there, in costume, and began to chat with him, saying how well he thought he was doing and giving him a squeeze of encouragement on his shoulder. Zimbalist then felt a sharp pain

in his jaw and decided he was suffering from jet lag and went back to his hotel. Once there, he took some aspirin, but the pain didn't subside and he sent for the company doctor. When the physician arrived he had Zimbalist sit on the edge of the bed to examine him. He asked the producer if he wanted a glass of water. He said yes. The doctor went to the phone and ordered a bottle to be sent up. Just then, Zimbalist gasped and fell back on the bed, dead of a massive heart attack.

Heston was shocked by the suddenness of the producer's passing. Wyler was overcome with grief and guilt, fearing the unending production was what caused Zimbalist's death. During a brief memorial service the next day, Wyler asked everyone to finish the film as a way of honoring their late producer and then ordered the next scene to begin.

On January 7, 1959, after nine grueling months of six-days-a-week, twelve-hours-a-day shoots, there was only one sequence left to film: the crucifixion of Jesus Christ. The final shot of the day, and of the film, was a close-up of Ben-Hur as he witnesses the process of the punishment of the man who changed his life. Wyler had left the scene for the end because he didn't know how to do it: "I spent sleepless nights trying to find a way to deal with the figure of Christ. It was a frighten-

ing thing when all the great painters of twenty centuries have painted events you have to deal with, events in the life of the best-known man who ever lived. Everyone already has his own concept of him. I wanted to be reverent, and yet realistic. Crucifixion is a bloody, awful, horrible thing, and a man does not go through it with a benign expression on his face. I had to deal with that. It is a very challenging thing to do that and get no complaints from anybody."

Although he had intended to play it without showing any emotion, when Wyler yelled, "Action," tears began streaming down Heston's face. With his resistance worn and his emotional guard unhinged, the organic reality of the scene overtook him. He wasn't prepared for how deeply this reenactment of the Crucifixion would affect him. Here he was, an actor playing the part of a fictitious witness to the murder of the most famous man in the history of the world, re-created with a realism that was awe-inspiring to Heston and that helped get him through to the end of the sequence. With Zimbalist's death still accessible and heavy on his mind—someone in charge of the film who was more powerful than even Wyler, and also friendlier; who was the true common man of production; and who had, as Jesus does to Ben-Hur in the script, extended a hand to the young actor—everything Heston had left inside

now poured out of him. And cinematographer Robert Surtees's camera caught it all.

When Wyler yelled, "Cut," the nine long months of production finally came to an end. The director walked over to a slightly hunched and tearful Heston, smiled, took his hand, and said, softly, "Well, thanks, Chuck. Next time I'll try to give you a better part."

Charlton Heston with his father, Russell Whitford Carter, who was in Los Angeles to supervise the building of the "House That Hur Built." (Courtesy of the Heston Family)

Chapter Seventeen

Later that same night, Heston and Wyler boarded a private plane for London to attend the world premiere of *The Big Country*. Because production on *Ben-Hur* had gone on for so long, they had both missed the October U.S. opening and hoped to at least be able to make this one. They didn't, barely arriving in time for the after-party. Heston gave several publicity interviews, and Wyler accepted the relieved congratulations from MGM's executive producers Vogel and Siegel, who made the flight to show support for Wyler, even though *The Big Country* was a United Artists production. The British press, which usually saw American westerns as exotic period pieces, also liked the movie, and it would go on to be the fourth

most popular film in England that year, making it a transatlantic hit.*

Lydia had stayed behind in Rome with Fray to pack and get a good night's sleep before Heston returned the next day to gather the clan for the trip home. He arrived early, was driven in the company's limo from the airport to the villa, picked everybody up, and took the car to the train station for the four-and-a-half-hour ride to Genoa. There they boarded the cruise ship *Independence*, bound for New York. The first port of call was Barcelona, where the family disembarked for a traditional Spanish dinner, after which they returned to the ship and, as Heston noted in his diary, he weighed himself. He was relieved to still be at what he considered his ideal weight of 180 pounds.

After one more stop at Madeira, the *Independence* entered the deeper waters of the Atlantic Ocean. That night, the ship hit an especially choppy run. Heston went to the top deck to feel the cold, salty spray on his still-sunburned face. While he was there, Lydia was

* The top three films were Gerald Thomas's *Carry On, Nurse;* Mark Robson's *The Inn of the Sixth Happiness;* and Jack Clayton's *Room at the Top.* In America and Canada *The Big Country* grossed more than $4 million, putting it comfortably into the black.

notified they had received a cable. Telegrams aboard a leisure ship usually carried urgent news, most of the time bad, and this would be no exception. Lydia rushed to get it. She looked at it and brought it to Heston, handing it to him without saying a word. He read it and put his head down. Lydia hugged him.

It was from Citron:

```
Cecil Blount DeMille has passed away after
suffering a massive heart attack. STOP.
```

Heston was saddened by the not entirely unexpected news. Later that night, after checking on Fraser and Mabel, he and Lydia went for a nightcap. He quietly talked about the last time he had seen DeMille, a few months earlier when they had lunch together and had shared an expensive bottle of nineteenth-century wine. After, Heston had thanked DeMille for lunch. Now he told Lydia, "I should have thanked him for my career."

After a few days in the Tudor City apartment in New York, they continued on to Los Angeles by rail, stopping in Chicago to see their families before boarding the Super Chief for the last leg of the long journey home.

Back in L.A., Heston met with Russell for an update on how construction was going and was disappointed to see that after having been away for so long the house was still only partially completed. Russell explained the reasons it was going so slowly, among other things, was the difficulties building out on the jutting property. As Heston later remembered: "The builders were very careful to get the proper angle of slope on the hillside. But someone apparently reported that there wasn't enough slope. An inspector came roaring out and started shouting about regulations. While he was talking, his car started rolling and disappeared over the edge of the cliff into the canyon. It was a complete wreck. The inspector looked at it lying there and said, sheepishly, 'Well, I guess the slope here is adequate.'" There had also been a series of construction union strikes and a brushfire that had burned right up to the edge of the property.

Growing impatient, about a month after they had returned from Rome, Heston decided the family should have an overnight campout at the site of what was soon to be their new home. They cooked outside in the open space where the kitchen was scheduled to be built. Fraser: "My dad loved this kind of family activity." It became a regular Sunday activity until the house was finished.

Back at MGM, Wyler, who had final approval over the negative cut of *Ben-Hur,* continued to edit at a deliberate pace, unaware of or unconcerned by the uneasiness of the studio, which still had the film booked for a 1959 holiday season release.

Heston, meanwhile, was ready to work. Citron recommended he sign on to star in MGM's forthcoming *The Wreck of the Mary Deare,* to be directed by British filmmaker Michael Anderson, with a screenplay by Eric Ambler from Hammond Innes's 1956 bestselling novel of the same name, scheduled to be filmed both in the States and England. Innes's book had originally been acquired by Alfred Hitchcock, who had assigned Ernest Lehman to turn it into a screenplay as a star vehicle for Gary Cooper. However, ongoing script problems with the courtroom drama caused Hitchcock to lose interest in the project and he sold the rights to MGM. He and Lehman then began work on a new project, *North by Northwest,* a romantic thriller Hitchcock wanted to make with Cary Grant in the lead.

Much of Lehman's early drafts of *Mary Deare* made it into Ambler's final version of the action-adventure sea drama, and Cooper remained in the lead role as the ship's first officer, Gideon Patch. Heston signed on to play salvager John Sands, who fights with Patch over

who has the legal rights to the ship. He took the film for three reasons. First, he owed MGM a movie, part of a two-picture deal Citron had made with MGM during the negotiations for *Ben-Hur.* Second, he was eager to work with Gary Cooper, an actor he admired, both for his acting talent and his personal style. He loved Cooper's understated way of performing on-screen, something Heston hoped to achieve in his own film work, and he loved the way his costar presented himself in public, always well-dressed and perfectly groomed. According to Fraser, "Cooper had all of his suits made on Savile Row, and one time he gave my dad some advice about how to dress, which he followed. Cooper said, 'Tall men should not wear garish suits with complicated patterns. They should wear conservative suits, and the lining can be flashy.' Cooper had gold and red silk linings in his suit jackets and, after that, so did my dad." The third and equally important reason was the need for a fast influx of cash to cover the construction cost overruns on the house.

The other "name" in Anderson's cast was Irish actor Richard Harris, an up-and-comer in British cinema. Anderson had been impressed by Harris's performance in the director's IRA-British conflict drama set in the '20s, *Shake Hands with the Devil* (1959), and brought Harris into *Mary Deare* to introduce him to American

audiences. "It was interesting," Anderson later recalled. "When Harris first came on the set and I introduced him to Gary Cooper and Heston he said, 'How are you then, nice to see ya.' He wasn't at all impressed." Cooper either didn't notice or didn't care about Harris's off-putting manner, but Heston's back went up immediately and it stayed that way the entire production. According to Harris, the feeling was mutual. At the time he made this comment about his costar: "He'd played in Shakespeare and to listen to him you'd think he helped the Bard with the rewrites. He was a prick, really, and I liked tackling pricks."

Because of the animosity between the two, Heston's appearance in *Mary Deare* almost didn't happen. When the Shakespeare Festival in Ann Arbor, Michigan, offered him the opportunity to play Macbeth, he was tempted to take it, even if it meant giving up the film, something he didn't mind at all. He'd already done the play three times (once in college, once in Bermuda in 1952 for director Burgess Meredith, and once on TV's *Studio One*), but none of his past performances had completely satisfied him, and he wanted to take another run at the deceptively complex role of Shakespeare's Thane of Cawdor. When he told Citron, the agent set about finding a way for Heston to do both. MGM executives were more than willing to accommo-

date Heston's schedule. They believed *Ben-Hur* was going to be huge, and *Mary Deare* would benefit from it. They worked out a shooting calendar that allowed him to leave in the middle of production to star in the limited run of *Macbeth.*

Filming began in the early spring of 1959, and when Heston returned from Michigan midway through, he became immediately aware that his role had somehow become smaller, while Cooper's had somehow grown larger. As for Harris, there was no letup in the tension between the two; they continued to butt heads.

Just as *Mary Deare* was winding down, Lydia and Heston were offered a summer stint at the Lobero Theatre in Santa Barbara, to star together in a production of *State of the Union,* a play they'd done a decade earlier in North Carolina. Lydia hadn't acted onstage since *Detective Story* in 1955 and she very much wanted them to do it. Heston agreed, aware how difficult it was for Lydia to remain on the sidelines as his career exploded. He wanted to do anything he could to make her feel that she still mattered in more ways than just as a wife and a mother. Not long after, in an interview, he expressed his feelings about how difficult it was for women in the workplace, talking in general but really to Lydia: "You know, show business is especially tough for women . . . there are twice as many girls available

for films as men, but not nearly half as many jobs available. Despite all the talk about more women's pictures have you noticed how many big ones predominantly star men? Most of the key roles are played by men."

State of the Union was scheduled for a limited run but lasted only five performances and by all accounts was a disaster, mostly because the play was outdated. The early closing intensified Lydia's frustrations. She was a strong, career-minded woman who was also a wife and mother in a country and a decade when most women simply couldn't be all three at the same time.

Heston, meanwhile, continued to work constantly, and after the show's early close he quickly signed a deal with Vanguard Records to record the Five Books of Moses—Genesis, Exodus, Leviticus, Numbers, and Deuteronomy—a project he had long wanted to do, with the proviso that he could edit the script to his own liking. "I know what I can read best and I have assembled the stories from the King James Bible, the Douay version and from the modern Bibles. Most of the material is from King James, because it has the most sonorous poetry . . . I feel so deeply about these biblical records . . ." He carried around portions of the script in his back pocket, and whenever he had to go somewhere, or found a few minutes to himself, he took them out and rehearsed by himself. The record-

ings would become seasonal perennials that perfectly showcased his instantly recognizable, deeply resonant voice, a Christmas present for those who wanted a bit of Moses to call their own.

Construction on the "House That Hur Built," was finally completed in late October, at a then final cost of $150,000 ($1.24 million in 2016 money). When the Hestons arrived with their first boxes of things from the apartment at Park La Brea, Russell was there to officially hand over the keys and walk them through. When the tour was finished, he wished everyone luck in their new home and made his good-byes. He was as eager to get out of the house as his son was to get into it. He had had more than enough of L.A.'s touchy contractors, and besides, he missed his own family. Heston drove his father to the airport, and at curbside, with a couple of mutual slaps on the back, they bid each other farewell. Heston stood on the curb and watched as his father disappeared into the terminal.

Not long after, on the back of a sheet of *Ben-Hur* movie production stationery, Heston wrote a letter to Russell to say what he hadn't been able to say to him in person, thanking him for all he had done to make his son's dream of living in a house of his own come true. It read, in part:

You must know that your pride in being turned to [by me] is at least equaled by mine, and that I can do it with much confidence. When people ask me in amazement how I dared begin a house [while I was in Rome], I get a special kind of pleasure out of answering, "Well, you see, my father was taking care of the whole thing for me . . . he's been involved in building all his life." The mark of your hand will be on that whole ridge, and the house you built there, long after we're both dead and Fraser is living there as happily, I hope, as I know we will.

Thanks . . . your son,

Charlton

As the family prepared to spend their first night inside their new home, Heston felt a burst of pride. He had paid for the house with money earned by hard work, and he was able to benefit from the help of his real father, whose imprint and spirit would be in it forever, in every beam, every wall, every plank of the deck. Here in Coldwater Canyon, just above the urban streets of Hollywood, he and his dad had created a rustic and isolated home, with lots of trees all around, and cool nights that reminded him of nothing so much as where he grew up. When he closed his eyes, he could imagine he was a little boy again, back in the North

Woods of Michigan, helping his dad gather wood in the winter for the family's central stove.

This was his family home now, and it would be for the rest of his life. "The house was an expression of who my father was," Fraser later recalled, "and it became the center of my dad's universe. It was his sanctuary. Everything he did, everywhere he went, it was always, 'I just want to go home to the ridge,' meaning back to the house, when it was over. He always called it 'the ridge' or 'my ridge.' It was the one place on earth he knew he could be with his family, away from the madness and the crowds of the outside world.

"His favorite room was his office study, which he filled with his favorite photos of the family and other things that were important to him. Behind its door was where he kept Moses's staff. When he sat in there at his desk and swiveled around in his blue leather chair, he could look out through the glass picture window and see over the canyon to the ocean. From the deck outside of the office, on the clearest of days he could see all the way to Catalina Island, twenty-six miles out in the Pacific. He'd usually get up at five in the morning, sit in his chair, and read. His favorite subject was history, and every time he'd take a role that's how and where he would begin his research.

"I think when Dad wasn't working, his favorite occupation was to hang around the house with his family and play tennis with his buddies on the weekends. The house became his central location for everything, the center of his professional work and his family life, the center of his universe. He wasn't the type of guy to say suddenly, 'Okay, let's take a trip to the Isle of Capri for two weeks!' Once every few years in the summertime, we'd take a big trip on a chartered boat with eight or ten friends to Greece or Italy or somewhere. But most of the time, we usually went no farther than out for a family dinner, and it was always the same few restaurants where he wouldn't be inundated with people asking for autographs all night. He loved Chasen's, and one of his friends—Jimmy Stewart or Ronald Reagan—was always there, or Trader Vic's, the legendary Polynesian restaurant adjacent to the Beverly Hilton hotel; Don the Beachcomber in Beverly Hills; and the Sportsmen's Lodge in the Valley.

"My mother had a full photo studio that was added on to the house in the early 1980s and that gave her ample room to work on her photographs. It had wonderful north light and a darkroom just on the other side of the big screening room. The whole thing was cantilevered off the side of the room to make it as big

as possible. It had been just on the other wall of the screening room first. Her studio was crucial for her well-being and the harmony of our home.

"Although we weren't a typical Hollywood family, my father did have a complete 35 mm screening room later updated to digital, with terrific sound, in a very comfortable setting. Dad didn't show his own films often, but when he did, usually for not more than twenty, twenty-five friends, he would always before it started say the same thing: 'I think we should let the film speak for itself and I hope this one speaks to you.' Most of the time we saw other films. When a new one opened that he wanted to see, he would call whatever studio was distributing and they would deliver the reels and pick them up the next day. We were on what was known as the 'studio circuit,' in the days before DVD screeners, which meant he could make a phone call to the studio and a film print would be delivered to the house. He would then hire a union projectionist; our regular guy was Charlie Agar, and later on his son took over. They knew our routines, how to use our equipment, and my dad liked them. We would make popcorn, and it was always a lot of fun. The neighbors' kids were always invited, and they would come sit on cushions on the floor . . . My father loved the informality of it.

"He was also a big proponent of and sponsor of professional tennis. He felt the pros of his day, the Rod Lavers, Roy Emersons, and Ken Rosewalls were [overshadowed] by stars in other . . . sports; they made something like $500 a win in a tennis tournament and he wanted to do something to correct that. He even sponsored a couple and lobbied to get them better prize money, and when they needed it, he helped out financially. He had had a full-size court built alongside the house . . . Tennis courts are cheap and easy to build if you have the land. He held an open court get-together every Saturday and Sunday when he wasn't away on location somewhere. Dad's friends came, not too many celebrities, maybe Rob Reiner, but mostly industry people. Walter Seltzer was a regular for many years. One of the thrills of Dad's life was to be admitted to the All England Lawn Tennis and Croquet Club, better known as Wimbledon. He considered it the high point of his sports life."

There was just a touch of Hollywood in the house. The two Moroccan chandeliers that hung in the main room had been used in *Casablanca.* Beckett had found them somewhere on a back lot in bad condition, but inexpensive and usable, and he was able to restore much of their lost luster.

It was around this time the IRS decided Heston

owed Uncle Sam a little bit more, perhaps a lot more, than he had paid them. When they came calling, he was worried he might have overextended himself and the worst-case scenario would be that he would have to sell the house. Citron reassured him all his financial problems would disappear once *Ben-Hur* opened, but Heston was not so sure. Even with the money Warner had paid to settle the *Darby's Rangers* situation, he was still seriously short on cash flow.

Although he had always managed his own finances, at Citron's urging he turned all of his legal and financial affairs over to Paul Ziffren, who took all the meetings with the IRS and eventually settled out with the auditors. He then turned Heston into three separate corporations, to make sure that when bigger money started coming in, he wouldn't find himself with the same tax problems. It was a numbing feeling for Heston, to be incorporated. Only a dozen years earlier he had used his natural assets to pose nude to pay his Hell's Kitchen rent. Now he was a big business.

In early November, Wyler finally delivered his completed negative of *Ben-Hur* to MGM, and it was rushed into release by the eighteenth, to benefit from the Thanksgiving-to-Christmas holiday rush. To help promote the film, MGM scheduled a media blitz built

around Heston, beginning in New York City with the gala world premiere at the newly refurbished, glistening Loew's State Theatre on Broadway between Forty-Fifth and Forty-Sixth Streets. Lydia had turned down a small role in a movie so she could accompany her husband to the premiere, and that decision officially closed the book on her personal acting career. Heston was deeply moved by it and vowed he would never let her regret making that decision.

The morning after the big opening, the *New York Times*'s Bosley Crowther gave it a positive review, calling it "a remarkably intelligent and engrossing human drama," complaining only about the 212-minute length (plus intermission)—a little too long for his taste. The following week the film opened in Hollywood, with a klieg-light glamour premiere at Sid Grauman's ornate Egyptian Theatre. The next day, *Variety* predicted that *Ben-Hur* would become "the blockbuster to top all blockbusters."

Then it was on to London for the gala opening there. From Heston's diary entry of December 16:

The London opening, as well as the London reviews, surpassed anything in New York or Los Angeles. The reviews were not only raves, from the *Times* through the

Mirror, but included really extravagant personal notices for me. The premiere was very gala indeed, with an appropriate sprinkling of royals. Willy [Wyler] gave a champagne party afterward; we were all floating on the high tide.

When Heston returned home, he sat down at his desk and, to express his gratitude to Wyler for all he had done for his career, typed up a contract on his personal stationery that read:

I herewith make firm commitment to render professional services as an actor in the role of _____ in the motion picture entitled _____, on which production will commence the _____ day of _____, 19__, and for which I will be compensated as follows: _____. This production to be directed by William Wyler.

They never worked together again.

MGM's big gamble had paid off. From a final negative cost of $15.2 million, *Ben-Hur* grossed ten times that in its initial worldwide theatrical release. It was distributed in every country that showed American films (ex-

cept the United Arab Emirates, where it was banned because it was a film about Jews). Its success saved MGM from bankruptcy and made heroes out of Vogel and Siegel, and a major name-above-the-title superstar out of Charlton Heston.

Just before he had left for the London premiere of *Ben-Hur*, Heston had received an offer to star opposite the blond bombshell and superstar Marilyn Monroe in a film with the provocative title *Let's Make Love*, to be directed by George Cukor, at Fox. It was tempting, to say the least, and he considered taking it, when he received a call from, of all people, Laurence Olivier, who invited him for lunch in Beverly Hills.

The phone at the house had been ringing constantly. Everybody in Hollywood, it seemed, wanted to congratulate him on his performance in *Ben-Hur* and the film's success, and he was gracious and polite to one and all, whether they were reporters who had somehow gotten his number or friends and actors, but when he received the call from Olivier, he was quite moved. Heston considered Olivier the greatest living Shakespearean actor and was honored to have the chance to meet with him.

As they ate, Olivier brought the conversation around to a new show he was going to direct on Broadway, Benn W. Levy's *The Tumbler*, a blank verse play in

three acts, and wanted to know if Heston would be interested in playing the lead, a part Olivier thought Heston was perfectly suited for. In the script, a young farmer and farm woman meet and make love, meet and make love. Everything is fine until she learns he is actually her stepfather and may have killed her real father. When Heston said he might be making a film with Marilyn Monroe, Olivier rolled his eyes. He had worked with Monroe two years earlier when he directed and costarred with her in the film *The Prince and the Showgirl.* The experience, he told Heston, had been a total nightmare, the biggest mistake he had ever made in his career. It took Heston about ten seconds to make up his mind. Bye-bye, Marilyn; hello, Olivier.

Only after did Heston realize doing the play meant he would have to move the family back to New York City for the duration of what would likely be a long run. Things that had once been so simple—a script, a deal, a suitcase, a flight—had now become so complicated. He wasn't sure how Lydia would feel about being uprooted again. When he told her that night over dinner, she just shook her head, smiled, and said she would start preparing everything for the move. There was, however, something else she wanted to talk to him about. Fraser had just turned four and a half years old and she said she wanted to have that second child. Heston was

surprised; he hadn't expected this to be part of their talk. It had been a touchy subject between the two for a while, until Lydia suffered a hysterectomy and couldn't have any more children, and Heston thought that would be the end of it. Instead, she suggested now they adopt. He was less than enthusiastic about the idea. Holly: "My parents had waited eleven years to have a son, and he was the fabulous prize they'd been hoping for. My mom wanted more, but Dad said, 'Ah, no, I'm fine the way we are now.' She kept pushing him and pushing him, and he kept resisting and resisting."

The subject was tabled for the time being.

Later that night, after everyone was asleep, Heston slipped into his study to make a late entry in his diary:

This year may have done it. *Ben-Hur* certainly turned out to be everything we hoped for and very nearly everything I hoped for as well . . . During the year I became a better actor, and a happier man. The house that means so much to us all is all but finished and my family is thriving in it, I know. As I said to Lydia not long ago, we certainly aren't living canned peaches kind of lives . . .

At the 1960 Academy Awards ceremony: Simone Signoret
(Best Actress, Room at the Top), Charlton Heston (Best
Actor, Ben-Hur), Shelley Winters (Best Supporting Actress,
The Diary of Anne Frank), William Wyler (Best Director,
Ben-Hur). (Courtesy of Rebel Road Archives)

Chapter Eighteen

As it turned out, doing the play for Olivier was not as bad as working with Marilyn Monroe might have been, but also not much better. From the first day of rehearsals, Olivier appeared distracted, and with good reason, as he was in the endgame of his disastrous marriage to Vivien Leigh. More than once he had to abruptly stop rehearsals and fly back to London to put out another fire, then fly right back to continue working on the production.

It became increasingly clear to Heston well before opening night that nothing was working onstage, and by the time the show had begun its pre-Broadway Boston run, Heston had had enough. He was ready to go home. To him, failing in front of a live audience was like undressing in public to let strangers take your

measurements and hearing them say you needed to lose a couple of pounds.

And believing it.

Nonetheless, despite all the warning signs, *The Tumbler* moved to the Helen Hayes Theatre on West Forty-Sixth Street, in the heart of Broadway. Opening night was Wednesday, February 24, 1960, with Heston having to learn a whole new second act the week before, based mostly on what the Boston critics felt was wrong with the play. The evening began well enough, and at the end the audience gave the cast a standing ovation. After, everyone went to Sardi's for the opening night party and the ritualistic wait for the all-important *New York Times* review. In those pre-computer days, the paper was still being printed in Manhattan at the "Gray Lady's" headquarters on West Forty-Third Street, and a first copy was usually available by midnight at the newsstand on the corner. Sardi's always sent a runner on opening night to get it and race back to the second floor, where the show's producer stood on a table to read the notice out loud.

The room became quiet as it became clear that Brooks Atkinson's review was negative, its only decent comment about Heston, whom Atkinson called "massive, masculine and fluent." The next day the *New York Herald Tribune* called the production ghastly.

The show posted a closing notice that after only five performances, Saturday night would be the play's last. Before they went on, Heston and Olivier sat in Heston's dressing room and shared a bottle of brandy. When the curtain went up, much to Heston's relief, the theater was almost empty. As he later wrote, "I was young and green then—*greener*, anyway. In striving for what I thought was a proper note of philosophical detachment, I said, 'Well, I suppose you learn to discount the bad notices, dismiss them.' Olivier took hold of my wrist and said, 'Chuck, it's much, much harder and much more important to dismiss the *good* ones and that's the truth.' It is, in fact, easy to dismiss bad notices because they hurt your ego. You say what-the-fuck-do-they-know and that's the end of it. But you can be seduced by good notices." Heston remained philosophical about the experience and fond of Olivier: "I'm the only one who came out of it with any profit. The producers lost money, and [playwright] Benn Levy lost months' worth of work because of it. Larry Olivier lost out too. But I got out of it precisely what I went in for—the chance to work with Olivier. I learned more from him in six weeks than I ever would have learned otherwise. I think I ended up a better actor, with more responsibility." And later he said this about Olivier: "There have been few times in any art when one individual

has so dominated. You would hardly find an actor who wouldn't say Olivier's the best."

The same week *The Tumbler* opened and closed on Broadway, Heston was nominated for an Academy Award for his performance in *Ben-Hur*. The film received eleven nominations in all.* Up to that time, only one film had ever been nominated for more Oscars, Joseph L. Mankiewicz's *All About Eve* (1950), which received fourteen.†

Shortly after the family returned to Los Angeles, Heston got together with Wyler to talk about the upcoming awards. He was happy to be nominated, but bothered that Best Adapted Screenplay had gone only to Karl Tunberg. None of the other writers who worked

* *Ben-Hur* was nominated for Best Picture (Sam Zimbalist, MGM); Best Director (William Wyler); Best Actor (Charlton Heston); Best Supporting Actor (Hugh Griffith); Best Adapted Screenplay (Karl Tunberg); Best Score of a Dramatic or Comedy Picture (Miklós Rózsa); Best Sound (Franklin Milton, MGM Studio Sound Department); Best Art Direction–Set Direction, Color (William A. Horning and Edward Carfagno, and Hugh Hunt, respectively); Best Cinematography, Color (Robert L. Surtees); Best Costume Design, Color (Elizabeth Haffenden); Best Film Editing (Ralph E. Winters and John D. Dunning); Best Special Effects (A. Arnold Gillespie, R. A. MacDonald, and Milo Lory).
† *All About Eve* won six Oscars.

on the screenplay—Behrman, Anderson, Vidal, or Fry—was acknowledged by the Academy. Heston, who had never met Tunberg, believed Fry had written most of the film as it appeared on-screen and was the only one who should have received the nomination.

With Wyler's encouragement, Heston made an appointment to visit the Hollywood offices of the Writers Guild of America, West, and its then president, Curtis Kenyon. A few days later, in Kenyon's office, after exchanging polite greetings, they got down to business. Kenyon explained to Heston that the guild's rules clearly stated the first writer on a film was the only one eligible to be nominated. Otherwise, he said, a writer could work on a film for years and be let go in favor of someone who came in at the end, did little or nothing, and might then be nominated or even win an Oscar.

Heston was not satisfied with that answer. He felt that Fry deserved at the very least to share the nomination with Tunberg and patiently explained to Kenyon that Wyler had, early on, rejected Tunberg's entire script. In fact, Tunberg had never worked a day on the version of the film that Wyler directed. Heston then left.

The next day Kenyon took out full-page ads in the trades to explain to everyone the guild's official position, which amounted to an attack on the director. Kenyon was annoyed, believing that Heston was the front man

for Wyler, who had sent him in his place to the meeting and that it was really Wyler who objected to Fry being left off the nomination: "Mr. William Wyler is engaged in a systematic attack against the writing credits," the ad announced, and went on to state in no uncertain terms that Fry himself had not protested the guild's decision. The effect of Kenyon's statement was to further polarize an already divided Hollywood over what was then an ongoing battle involving credits—a battle as old as Hollywood itself. Higher billing has always been a negotiable item, because the higher the placement of a name the greater that person's salary and, conversely, the greater the salary, the higher the placement. Fry could have made an argument that being ignored by the Academy had cost him money. However, with Heston and Wyler, the issue was fairness, not finance. Soon, Sol C. Siegel, the head of production at MGM, entered the dispute by making his own appeal on behalf of Fry, but Kenyon wouldn't budge.

Heston decided to wait until the right time to continue his argument, when he was certain he would have the last word on Fry's contribution to *Ben-Hur.*

The Thirty-Second Annual Academy Awards presentation was held on April 4, 1960, at the Pantages Theatre on Hollywood Boulevard, broadcast over the

NBC television network and hosted by the venerable Bob Hope, whose one-liners were as reliable as the warm Santa Ana winds that periodically blew across Los Angeles.

The two films battling to win the most Oscars were Wyler's *Ben-Hur* and Otto Preminger's *Anatomy of a Murder,* a steamy courtroom drama about a rape and murder, starring James Stewart, George C. Scott, Ben Gazzara, and Lee Remick, that was nominated for seven Academy Awards. Another Best Picture nominee was *Room at the Top,* a black-and-white British kitchen-sink drama directed by Jack Clayton, the year's dark horse with six Oscar nominations. Even though it made British actor Laurence Harvey and French actress Simone Signoret stars in America, nobody gave the film much of a chance.

As the night wore on, *Ben-Hur* made its run to glory as it took every Oscar it was up for except, tellingly, Best Adapted Screenplay, which went to Neil Paterson for *Room at the Top,** something that pleased Heston, still upset that Fry hadn't been nominated and believing if he had he would surely have won. (It was the

* According to Academy rules, films originally made in English are not considered foreign films, which are a separate category.

general feeling in Hollywood that the award to Paterson was the result of Wyler and Heston's dispute with the Writers Guild.)

Heston and Lydia, both in formal attire, were seated near the front and on an aisle, in the event that he won for Best Actor and needed to quickly get to the stage. He sat patiently through the long show, applauding for all the winners and waiting for the Best Actor Oscar to be given, one of the major awards that comes near the end of the endless evening. He was up against newcomer Harvey, whose chances had improved with Paterson's win; the veteran Paul Muni for his performance in Daniel Mann's *The Last Angry Man,* who was considered a long shot at best; Jack Lemmon for his colorful and funny performance in Best Director nominee Billy Wilder's *Some Like It Hot,* although Lemmon's chances were hurt by the film's somehow not being nominated for Best Picture; and Jimmy Stewart for *Anatomy of a Murder.* The Hestons and the Stewarts, all friends, had arrived at the Pantages Theatre at the same time, causing a flurry of paparazzi cameras to go off. As the two couples walked into the theater, Stewart took Heston by the arm, pulled him over to the side, and quietly said to him, "I hope you win, Chuck. I really mean that." Heston was moved by his friend's selflessness.

Just before eleven P.M., nearly three and a half hours

into the awards telethon, John Wayne came out to great applause and pigeon-toed to the microphone to announce the winner for Best Director. It was William Wyler, *Ben-Hur*'s ninth award. The director went up to the stage, said his thank-yous, and left with his Oscar in his fist and Wayne by his side. The next award was for Best Actor. It was presented by Susan Hayward, the previous year's Best Actress winner for her performance in Robert Wise's *I Want to Live!* She was greeted warmly by the audience and then began speaking: "It is my honor to present the Academy Award to the artist voted by his fellows in the industry as having given the best performance by an actor. The nominees are . . ."

"As she was reading [the names]," Heston said later, "I looked across the orchestra and something popped in my head . . . 'I'm going to get it . . .'" Because the show was running late, instead of opening an envelope Hayward was handed the name of the winner, looked at it, smiled, and said, "Charlton Heston!"

He immediately turned to his wife, kissed her full on the mouth with one hand on her face, just like in the movies, and then he leaped out of his seat and bounded toward the stage, almost tripping going up as he took the steps two at a time. When he got there he kissed Hayward on the cheek and she handed him his Oscar, his first, the film's tenth. He stared down at the statu-

ette as he clutched it, looking up only when the applause began to fade. "It's really true," he said into the mike. "When you stand here you want to thank everyone you ever knew in this business. I . . . I feel like starting with the first secretary who ever let me sneak into a Broadway casting call. Ten years ago this month I made my first picture in Hollywood, and since that time I've worked with a great many of you and every one of you did something to put me here tonight. As for *Ben-Hur*, the men who worked on that, most of them you have been applauding . . . most of them you've been applauding earlier this evening, including Willy [Wyler]." He paused, and his tone changed a bit—less appreciative, more straightforward. This was the moment he had been waiting for to have the final word about Fry. "I would especially like to thank all of you, all of them, but Willy and Christopher Fry and Sam Zimbalist, who gave more than any of us, thank you."

He walked off the stage to solid applause as a smiling Bob Hope, moving back to the mike, held out his hand. Heston shook it briefly, then disappeared backstage, led by a handler to the winner's circle. There, in front of a phalanx of media, he stood proudly holding up his Oscar. One reporter wanted to know which scene in the picture he most enjoyed shooting. "I didn't enjoy any of it," Heston said, smiling. "It was hard work." With

that, he thanked everyone again and moved to where Wyler was standing, posing with his third Best Director Oscar. "I guess this is old hat to you," Heston said softly. "Chuck," Wyler said, "it never gets old hat!"

Lydia, meanwhile, had made her way backstage and was taken to the winner's circle, joining Heston and Wyler, while onstage Gary Cooper, presenting the Best Picture winner, announced it was *Ben-Hur*, followed by thunderous applause in recognition of the film's record-breaking eleventh Oscar. Sam Zimbalist's widow accepted for him.

A few minutes later, still backstage, Best Original Song winners Sammy Cahn and Jimmy Van Heusen ("High Hopes") were posing for pictures, and Cahn quipped to the press, "We're glad *Ben-Hur* didn't have a title song!"

When the award presentations ended, Heston and Lydia attended the prestigious Governor's Ball at the Beverly Hilton hotel. "After the party," Heston said, "we got in our car and drove out to the Valley and started calling on all our friends. At dawn, we were back home, sitting on the front steps of our new house reading all about the Academy Awards in the early edition of the *Examiner* that had arrived at the doorstep before we did."

Fraser: "That morning I was up early, just as my

mom and dad were getting home. I remember seeing them walk into the courtyard, Mom in her gown, Dad still in his tux, a grin on his face and the Oscar in his hand, glinting in the early-morning sun as they gathered the papers."

Heston collapsed into bed and got up late the next day. He stayed in his bathrobe and, with a cup of coffee in his hand, put on the sound track for *Ben-Hur* over the house's booming sound system, which included ten miles of wiring and speakers that brought whatever was being played to every corner of the house, including the steam room. (He later told one reporter, "If you made as much money as I did from *Ben-Hur* you'd like to be reminded of it too.") He was supposed to return the Oscar to the Academy to get his name engraved on it but didn't do so right away. He was hesitant to let it out of his sight even for a minute. "I don't know about that. Maybe I'll just hang on to it and scratch my name on there."

His euphoria didn't last long. Later that same day, the *Beverly Hills Citizen* was the first to report on the brewing battle over Heston's acceptance speech the night before: "Four words spoken by actor Charlton Heston in his Academy Award acceptance speech exploded into a controversy between the Oscar winner and

the Writers Guild of America." The paper described as "reprehensible and damaging" the four words Heston had used as a "tribute to writer Christopher Fry for his contribution to the award-winning movie, *Ben-Hur*." The four words? Thank you Christopher Fry.

Later that afternoon, Heston, still in his robe, responded to the article by writing a letter to Paul Gangelin, the secretary of the WGA, copying the *Beverly Hills Citizen*, in which he said that his disagreement with the WGA's decision over Fry's billing didn't make him anti-union, and that "it never occurred to me to get clearance from your organization for my expression of gratitude." He then went on to ask Gangelin if it "is your intention to expunge Mr. Fry's name off the lips of men?"

Gangelin responded by writing only to the newspaper and not to Heston. In his letter he said that "in mentioning punitive action, [Mr. Heston] was merely exercising his imagination . . . we thought he was out of line in speaking those words and we told him so."

The next day the story escalated, when *Variety* reported that the WGA had sent a copy of its response to Heston's letter to every WGA member in Hollywood, and this time to Heston, with parts of it that had not been published by the *Citizen*:

By gratuitously interjecting the name of a writer who did not receive screen credit for the picture *Ben-Hur* [in your acceptance speech], you reopened what seems a calculated campaign to detract from the reputation of the man who did in fact receive credit and more important, reflected on the repute of the Writers Guild in respect to its credit arbitration function generally, in spite of the fact that this issue regarding *Ben-Hur* had been resolved long before the time of the broadcast.

It also printed a previously unpublished paragraph of Heston's letter to the WGA that underscored his main argument: "Since Mr. Fry is not, I believe, a member of your guild, and since I am certainly not, it's hard for me to see how you can take issue with any such sentiment on my part." *Variety's* article also reported that Heston had reminded the guild that no representative of the WGA had been in Rome during the making of the film, suggesting that it could not know who actually wrote what, while he, Wyler, and Fry were . . . He was careful not to say that Fry had been there from the beginning, which he wasn't, and omitted any reference to Vidal's also not getting any screen credit.

Heston's feud with the WGA quickly faded, along with all the hoopla over the awards, but to Heston, the

situation remained unresolved. He felt strongly that he had been bullied by the WGA for using his First Amendment right to mention the name of one of the unrecognized screenwriters who had worked on *Ben-Hur*. He believed that being left off the nomination would translate into lost opportunities and revenue for Fry, if he even wanted to write more for the screen, and that Kenyon's actions amounted to unofficially blacklisting Fry because he wasn't a Guild member.

Something had to be done about how industry unions treated artists, and Heston decided that if and when he had the chance, he would be the one to do it.

The Fry controversy did nothing to tarnish Heston's becoming, after a decade of making movies, Hollywood's newest golden boy, but his anger at the actions of the WGA did catch the attention of another actor, the head of the Screen Actors Guild, which was, at the time, embroiled in a bitter strike over the payment of residuals. That actor was looking for someone he could bring into the battle against the hypocrisy of old Hollywood and help lead it into a new morning in the industry. He decided that someone was Charlton Heston.

The actor's name was Ronald Reagan.

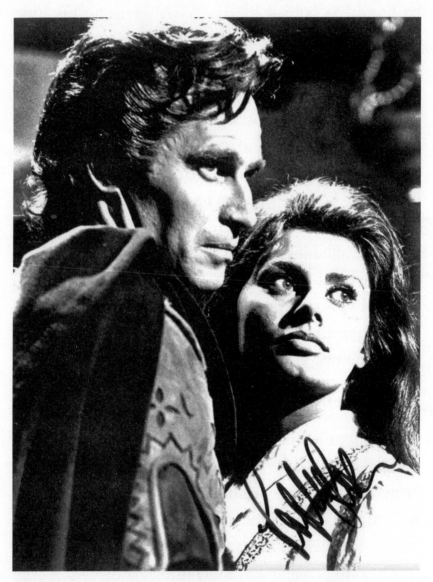

Charlton Heston with Sophia Loren, in Anthony Mann's
El Cid *(1961). Note Loren's signature.* (Courtesy of Rebel
Road Archives)

Chapter Nineteen

I n 1940 Ronald Reagan married actress Jane Wyman. By then he had appeared in more than twenty films and believed his star was rising after a notable appearance in Lloyd Bacon's *Knute Rockne, All American.* Yet a year later, he was practically broke. With America about to enter the war, and Reagan an active member of the reserves, it was just a matter of time before his number would be called. Because of that, he couldn't get much meaningful film work. Reagan filled his time by going to meetings at the Screen Actors Guild and hanging out after, talking with his fellow actors about their stalled careers. The more meetings he went to, the more he became interested in the business of the union. He began to see the need for some kind of organized, fair representation for actors like himself, who worked

under a contract that left nothing to fall back on during difficult times like these.

On April 18, 1942, Reagan was called to active duty, but instead of being shipped overseas, due to poor eyesight Jack Warner was able to pull some strings to get him assigned to appear in government-mandated movies to be made at Warner Bros., mostly motivational training shorts for the military. Because he was stationed in Hollywood, Reagan was able to continue going to SAG meetings. He always wore his uniform when he went to the guild's offices.

Later that year, when its annual elections were held, he was elected vice president, an office he held until 1947, when Robert Montgomery resigned as the president of SAG to join the other side of the negotiating table by forming his own independent production company. Gene Kelly, a SAG member and a good friend of Reagan's, nominated him to be the next president. He won easily and held the position for six consecutive one-year terms, during which he presided over one of the most tumultuous periods in the history of Hollywood. Reagan helped to settle major disputes between the studios and the guild, created a pension and health plan for its members, testified as a "friendly witness" at the HUAC hearings, officiated over the burgeoning anticommunist blacklist, and granted a controversial

waiver to MCA that allowed the agency to produce films at the same time it represented talent, something that didn't sit well with his fellow actors.*

Reagan left the Guild presidency in 1954. During his run he and Wyman had divorced and he married Nancy Davis. With his film career winding down, he took a job in television as the emcee of *General Electric Theater,* an anthology show he hosted and occasionally appeared in for the next decade. In 1959 he was asked to return as president by a majority of SAG members, who felt he was the only one who could get the studios to agree to give film actors residuals for their films when they were shown on TV. He was reelected that November, and on his first day in office he opened negotiations with the heads of the majors to avoid a strike over recurring replay payments.

He got nowhere. Most of the studios were hovering on the brink of bankruptcy and refused to give any more concessions to the guild, knowing that if they gave in to actors' demands for residuals, the screenwriters and directors would want the same

* The waiver made it possible for an agency representing actors to also serve as the producers who hired them, creating a major conflict of interest. As agents, they negotiated the best deal for their clients. As producers, they wanted to make the best deal for themselves.

deal. Unable to reach a settlement, on March 7, 1960, Reagan took SAG out on strike, effectively shutting down all film production in Hollywood. Only then did the studios agree to serious negotiations, and at that point Reagan sought a dependable ally to help forge an industy-wide settlement.

That was when Heston, a SAG member who had just won his Oscar and gone through the battle with Kenyon and the WGA, caught Reagan's eye. He was impressed with Heston's fearlessness in taking on the Writers Guild and he invited him to join the negotiating committee. "Since I [couldn't] make any movies," Heston said later, "I was glad to accept [Reagan's] offer. I was already a member, as I was required to be, of three performing unions . . . I felt a certain duty on me."*

The negotiations brought Reagan and Heston closer together, both professionally and personally. They spent a lot of time talking about strategies and also about Reagan's favorite subject, the movies. Reagan's politics and acting were always intertwined and he rarely talked about one without bringing up the other. His guiding principle, he told Heston, was always to

* Heston was a member of the Screen Actors Guild, Actors' Equity (Broadway), and the American Federation of Television and Radio Artists (AFTRA).

let the creative leadership remain with the studios and their producers, as long as actors got their fair share of the profits.

Reagan did his job well, and five and a half weeks after SAG went out on strike.

With Heston's help, Reagan was able to broker a deal with the studios that ended it. The settlement, credited solely to Reagan's negotiating skills, granted residuals to actors who appeared in films made after 1948. A lot of older members were furious, believing Reagan had sold them out, but the general consensus was the deal was a good one and would get better as more movies became eligible. By the time the deal was finished, Reagan had lost interest in union politics and, like his predecessor Montgomery, joined the side of management and formed his own production company, notifying the guild that he would be surrendering his SAG card at the end of his term.

He was also leaving the Democratic Party. He had little use for its rising star, John Kennedy, and in a letter he wrote to Richard Nixon around this time, he stated that underneath Kennedy's tousled boyish haircut was old Karl Marx.

Heston, meanwhile, was still an impassioned Democrat, a position that amused Reagan, who had once been a Roosevelt supporter himself. He told Heston that

sooner or later he too would abandon the party, when he saw it for what it was, too left-leaning. Two years later Reagan officially registered as a Republican, telling anyone who wanted to know why that he hadn't left the Democratic Party, the party had left him—a variation on Gloria Swanson's famous line from Billy Wilder's *Sunset Boulevard* (1950), "I am big. It's the pictures that got small." (Reagan, as always, turned to film to find ways to express his political ideas. "Win one for the Gipper" came from *Knute Rockne, All American* [1940], and the title of one of his memoirs, *Where's the Rest of Me?* [1965], is from Sam Wood's *Kings Row* [1942], widely considered Reagan's best film.) Four years after changing his party affiliation, Reagan was the governor of California.

All during the strike, Heston read through piles of scripts delivered to his front door every morning, sent over by Citron, who served as a clearinghouse, weeding out the ones he thought were real possibilities from the hundreds he was being sent after Heston's Oscar win. The last thing Heston wanted to do was to repeat the mistake he'd made following *The Ten Commandments* choosing *Touch of Evil,* which reduced him from a star back to a featured supporting player in his next film, *The Big Country.*

Because of the Oscar campaign, the embattled aftermath, the SAG strike and its negotiations, Heston hadn't been in front of a camera for five months. He was eager to get back to the business of making movies, but nothing he read leaped off the page. Welles had made overtures about having him play Brutus in a new film version of *Julius Caesar* he said was set to start filming in London that May, and despite his own better judgment, Heston wanted to do it, until he received a telegram from the director saying that his funding had fallen through and the picture would have to be postponed. It was a disappointment for Heston, but also a relief.

The first script he read that had any appeal was one about the life of Don Rodrigo Díaz de Vivar, or El Cid, "The Lord" (another "God" character). Heston believed that he did better when he played historical characters because, as he told a reporter from *Variety* when asked about what he was going to do next, "I don't have a face that fits well into modern times."

Though most people think *El Cid* is another biblical tale, it is based on the life of the eleventh-century Castilian who valiantly fought to defend his Christian homeland against the North African Almoravides and, by defeating them, helped to unify Spain.

The script's dialogue didn't scan all that well, but

Heston felt the story was there and he set up a meeting with the screenwriter, Philip Yordan, and Citron. Yordan agreed to make any changes Heston wanted. After the writer credit debacle over *Ben-Hur*'s script, Citron had made it clear to Yordan and any other writer his client worked with in the future that Heston would have writer approval over any project to which he signed on.

Even with Heston aboard, *El Cid* was still going to be a tough sell. The war that had made Don Rodrigo a legend in Spain, which had to do with an Islamic plot to take over the world, held little interest to American audiences of the '60s. When none of the major studios expressed interest in making the film, Citron struck a deal with independent producer Samuel Bronston.

Heston's new deal was big news in Hollywood, as it was his first film after his Oscar-winning performance in *Ben-Hur.* When a reporter called to ask why he was doing another period film, Heston was quite frank about both the aesthetics of his new role and its practicalities: "It isn't that I haven't made pictures in modern dress . . . give me a cloak, or a suit of armor, and audiences start lining up around the block . . . I enjoy wearing costumes. I like portraying heroes of antiquity whose values were grander and more spectacular than those of today. And not every star can do this convinc-

ingly. I do not mean this as a judgment of anyone's acting ability, but can you picture Elvis Presley in a suit of armor?"

Bronston set up the picture in association with Dear Film Productions, an Italian financial firm; Allied Artists would distribute the film in America and the Rank Organisation in England. Some additional financing came from European theater chains in return for domestic exclusivity to the film's first run. He then hired Anthony Mann to direct, with Heston's approval, and production was slated to begin that summer.

Heston arrived in Madrid the first week of August by himself, just after he and Lydia attended the Democratic National Convention in Los Angeles. He had gone in support of Adlai Stevenson, but when JFK wrested the nomination away, Heston promised to campaign for the Kennedy-Johnson ticket.

The next day he began meetings with Bronston, Yordan, and Mann about the script changes he had submitted to them in advance. Everyone agreed the revised script was still not right, and Yordan was given two more weeks to do another rewrite. Heston flew back to Los Angeles to accompany Lydia to a final meeting with a child adoption committee.

He had finally agreed to the idea. Lydia had, after all, given up her career in deference to his; he could not

in good conscience deny her wanting to have another child. Once he had made the decision, he fully committed to it. He went along to as many meetings as he could and answered all the questions the agency people had. They assured the Hestons they would have no problems and that they would call as soon as they had a baby girl for them. Lydia wanted a girl, and Heston happily went along with her choice.

When they returned to the house, they packed their bags for Spain and another extended European stay. He had committed himself this time to a six-month production shoot. They all flew to New York, where Bronston had booked the three Hestons and Mabel first-class accommodations on the luxury liner *Leonardo da Vinci* (a slow, pleasant journey meant to give Yordan time to finish his rewrite). Because this was not a studio production, Citron had insisted Bronston deposit Heston's entire salary in an American bank before the family made the voyage across the Atlantic. Bronston managed to complete the money wire the day of the ship's departure.

While the Hestons were in transit, Bronston went to Rome to try to sign Sophia Loren to play Doña Ximena, El Cid's love interest. Bronston felt he needed her to ensure foreign box-office success, as she was the hottest actress in Europe. After winning a local beauty pageant

in 1950, Loren had begun making movies in Italy. In 1958 she signed a five-picture contract with Paramount to star in several Hollywood movies. She returned to Rome in 1960 to be in the Italian-German production of Vittorio De Sica's *Two Women*. When Anna Magnani refused to play Loren's mother in the film, she took over the role herself, with Eleonora Brown brought in to play the role of the daughter. Loren would go on to win the Best Actress Oscar for her performance.

Carlo Ponti, Loren's husband and manager, finalized the deal with Bronston for Loren to play the female lead opposite Heston in *El Cid*, a film she was reluctant to be in because of her unhappy experience costarring with Cary Grant in Melville Shavelson's *Houseboat* (1958). Grant fell in love with Loren during filming and wanted her to leave Ponti, marry him, and have his baby. She refused and decided, for that and other reasons, to leave Hollywood and return to Italy when her contract at Paramount was up. She agreed to appear in *El Cid* only after Bronston, via Ponti, assured her that Heston was a happily married man and that his wife was going to be in Spain with him for the whole shoot. Bronston also agreed to pay her $200,000 for ten weeks of work on the film (plus $200 a week more for her hairdresser). He then returned to Spain in time to greet the Hestons when

they arrived and to escort them to their temporary home at Madrid's Castellana Hilton.

El Cid takes place in eleventh-century Spain. Ximena (Loren), the daughter of Count Gormaz (Andrew Cruickshank), is betrothed to nobleman and military leader Rodrigo Díaz de Vivar (Heston), whom Gormaz accuses of being a traitor, after Rodrigo captures two Moorish emirs whose armies have attacked Spain and then releases them when they give their word they will not try to attack again. Gormaz challenges Rodrigo to a duel and is killed. Ximena then swears revenge on him and plots to have him killed. Rodrigo is ambushed, but his life is saved by one of the emirs whom he let go. Rodrigo then weds Ximena, but the marriage is never consummated and she joins a monastery. Several plot twists later, Rodrigo is banished from Spain, and Ximena, who realizes she loves him after all, decides to join her husband in exile. Eventually, Rodrigo resolves his issues with the king, who recognizes he needs the warrior to fight against the enemy. He then rejoins the Spanish army, and while defending the country against the invaders, Rodrigo is wounded and his body is tied to his horse and sent back into battle. The invaders think he is a ghost and, believing the Spanish army is blessed and can't be defeated, they

lose their will to fight and are defeated. Rodrigo is declared by the king to be "the purest knight of all." Thus is born the legend of El Cid.

As the November start date approached, there was still no final shooting script, despite Heston having given extensive notes to Yordan, who felt that the star was being overly intrusive. At the same time, Heston had Bronston hire Yak Canutt to find the exact right horses for the crucial death-ride scene. After several weeks of scouring Spain, Canutt found two white studs in Portugal he thought looked right and were trainable. Yak brought over his son, Joe, to train Heston how to ride them while doing broadsword combat. This work proved long and hard, and the only good thing about it for Heston was that he lost six pounds. His weight continued to be a concern for him, but it was something he could fix. His hair had recently begun to thin, his scalp was showing through, and there was nothing he could do about that.

When Yordan finally had a script that Heston approved, it was sent off to Loren, still at her villa in Rome. She read it and wanted to quit the film, believing her part had been reduced in favor of making Heston's bigger. Bronston was both furious and worried; offending Loren, who was considered a national treasure by the Italian government, might result in the

film never being shown there. Bronston sent Yordan to talk to Loren while he hastily drew up a list of actresses to replace her, headed by the French actress Jeanne Moreau, not a major star in America but who would cost considerably less. Just as Bronston was about to approach Moreau, word came from Yordan that Loren had decided to be in the film after all.

On November 10, Heston had his first production meeting with his director to discuss how he intended to shoot the film. Mann was best known at the time for the eight westerns he'd made with Jimmy Stewart in the '50s that "were directed with a kind of tough-guy authority with psychological intensity and an undercurrent of didacticism that never found favor among the more cultivated critics of the medium," according to film critic Andrew Sarris. Mann's career had gone into decline after the Stewart films. It had an uptick after he made *Cimarron* in 1959, a film Bronston liked, and he offered Mann *El Cid,* pending Heston's approval, knowing he could get him at a bargain rate.

With all the attendant fanfare of a big star, Loren arrived November 12 at Madrid-Barajas Airport swarming with paparazzi. Her entourage included her own writer to translate her dialogue into Italian, after which Loren would rewrite it back into a simpler English she

could understand. After a warm greeting by everyone on the set, followed by a late-night company dinner and a day of rest for Loren, filming began November 14.

Bronston wanted the picture to be shot in the European fashion, where production began daily at twelve P.M. and ended promptly at eight P.M., to accommodate Loren, whose contract stated she could not be filmed before noon, and even then she was usually late arriving on set, not ready to go before the cameras until two in the afternoon. This was a big problem for Heston, who wanted to shoot as early as possible, when he felt he was his freshest and most energetic, and he could not stand lateness. According to producer and good friend Peter Snell, "It was about the only thing that ever really got him angry, and Loren was one of those actresses who got under his skin with her chronic lateness." Fraser concurred: "It all had to do with how late she was in hair and makeup, and it drove him to distraction, a manifestation of his impatience with how slow things happen on movie sets. When she insisted her part be rewritten to make it bigger, Dad thought there was already too much dialogue in the film."

The resulting tension between Heston and Loren made for an uneasy set. There was zero chemistry between the two stars and Mann finally had to hire a stand-in for Heston to feed Loren her lines while he

shot as much of her as he could in isolated close-ups. Heston was not impressed with any of it, or her acting: "She sometimes tends to carry her remarkable beauty through a scene as though it were a soufflé . . . very, very gently, lest it break." As Heston's patience grew increasingly thin, Mann took him aside and told him to try to relax, to not make things worse. Not surprisingly, Heston was most uncomfortable doing love scenes with Loren, and his unease required several retakes that made him more and more impatient, even if these were the best non-battle scenes in the film.

Heston believed the real problem was Mann's inability to control Loren, or the film's big action sequences. Heston convinced him to let Yak help stage some of the most complex ones and the famous "death ride" (Joe doubled Heston for most of it).

In the end, Heston was disappointed with Mann and the finished film as a whole. He felt it was not as good as *Ben-Hur*, and he never worked with the director again. The film had too much plot, in particular too many unnecessary subplots and a love story that made no sense; it did have a great performance by Heston, but it was lost amid the many convolutions of the script and the film's overly busy mise-en-scène.

Production was completed in April 1961, and after several stops in Spain, Italy, and France for meet-and-

greets with the European investors, Heston and family journeyed back to the States aboard the *Queen Mary*.

Later on, he had this to say about the film and its director: "There are scenes . . . where a second unit director is simply able to do it better . . . Tony Mann was a decent man and a good film-maker, but he made terrible mistakes and missed the chance of having *El Cid* be the greatest epic film ever made, because it's by far and away the best story of any epic film. Physically, in visual terms, it's a beautiful film, and I bitterly regret that it fell so short of its potential . . . *El Cid* is a very fine film. But not great."*

* *El Cid* remains a favorite of Martin Scorsese's, who called it "one of the greatest epic films ever made." Scorsese was personally responsible for the film's 1993 restoration and limited rerelease. It was released in a deluxe, two-disc DVD set in 2008 after a prolonged battle over rights, and has not yet been converted to Blu-ray. It has not had a theatrical rerelease since 1993. (Martin Scorsese, quoted in James Berardinelli, review of *El Cid*, ReelViews, http://www.reelviews.net/reelviews/el-cid.)

Peacefully protesting with Jolly West in Oklahoma City, fall 1961. (Courtesy of the Heston Family. Photograph by Lydia Clarke Heston.)

Chapter Twenty

A month after returning to Los Angeles, Heston heard from his and Lydia's old friend Jolly West, a medical intern during Heston's Hell's Kitchen years, now the head of the department of psychiatry at the University of Oklahoma Medical School. West wanted Heston to join him at a civil rights protest that was set to take place that May in Oklahoma City. Several restaurants in the state's capital had banded together and refused service to the young African Americans who had moved there, and West wanted Heston to take part in the "new" and changing America. He said yes.

This was 1961, the dawn of Camelot, the "ask what you can do for your country" years, the advent of Kennedy's youth-driven Peace Corps and the burgeoning civil rights movement. The young president had won

the election while Heston was away making *El Cid*, and he had missed the burst of new excitement that had pulsed through the country after eight years under the leadership of the grandfatherly Dwight Eisenhower. West was offering Heston a chance to do something new and courageous in an America that was, itself, new and courageous. As Heston put it, "I just wanted to stand up and be counted."

He arrived in Oklahoma City, checked into his hotel, and met up with West for dinner. Afterward, back in his room, he prepared to turn in, to get some rest for the next day's march. Just before he fell asleep, the phone rang. On the other end was a very nervous MGM executive who had somehow found out where he was staying and was now trying to talk him out of going through with the protest, worried it might hurt *Ben-Hur*'s box-office numbers. The Oscar-winning film was still going strong in its first-run release. Nonsense, Heston told him, shrugging off the executive's concerns. The studio should be standing with him on the right side of this issue. And anyway, didn't actors have the same freedom of speech as the rest of the citizenry?

The demonstration went peacefully, with about eighty marchers showing up, including West and Heston, who later had this to say: "We were completely successful in our campaign against segregation—without

violence and without civil disobedience. There were a few banners which said 'Actor Go Home,' and 'Are Schools in Beverly Hills Segregated?' but there was no violence and the campaign achieved our goals . . . I feel that the civil rights issue is a moral cause . . ."

Upon his return to Los Angeles, he was given the news that in the guild's annual election, the members of SAG had voted him into the office of vice president and George Chandler the new president. Obviously, his appearance at the march hadn't hurt him in the film community. Not very long after, the State Department asked Heston to serve as an official delegate to the Tenth International Berlin Film Festival that June. He accepted the appointment, believing Kennedy was sending one more message to the Soviet Union and the people of Germany that America was not going to abandon West Berlin.

It had been a meaningful week for Heston, in which he demonstrated peacefully in one of the earliest civil rights demonstrations of the 1960s, was given a significant international diplomatic assignment by the government, and was elevated to the second-highest office in the Screen Actors Guild. Taken together, these actions signaled a continuing of Heston's gradual entry into social activism, political stature, and union leadership that had begun with his speech at the Oscars

and his working side by side with Reagan to settle the actors' strike.

Heston left for Germany without Lydia, insisting she stay behind with Fray. He thought it a bit too dangerous for the family to travel with him this time. The whole world was watching West Berlin as it had been surrounded on all sides by Russian soldiers, an outpost of freedom that could very well be the flashpoint for the next world war.

While there, Heston was taken on a diplomatic tour of East Berlin, a half-city that appeared drab and depressing, as if it were a film shot in black and white. He could see the wan, helpless faces of its citizens, a contrast to how enervated the West Berliners were, even with weapons constantly pointed at them from across the dividing line. This was not a good thing for either side, he noted. Berlin could not function this way for long. Nor could the world. He made a note to try to talk to Kennedy about Berlin. That is, if he ever got the chance.

While he was away, Lydia received the call from the adoption agency she had been working with. After seventeen years of marriage, she was going to be a mother again. As soon as Heston returned, he went with her to the agency to pick up their six-pound sixteen-day-old baby girl. "My dad always loved to tell me the moment

he saw me he fell completely in love with me," Holly later remembered. "He said, 'It was more about you picking us than we picking you.' I always loved that he said that. He used to talk about holding me for the first time, my body in one of his arms, my small head in his palm, my body along his inner forearm against his chest." All his doubts and hesitations about having another child evaporated the first time he looked into his new baby's eyes. "My mother had been desperate to have a daughter. My dad was fine with having a son, Fraser, and that was enough for him, but my mother insisted she wanted a daughter. I was named Holly Ann after my aunt Holly Clarke Nash, my mother's sister, and my aunt Lilla Anne, my dad's sister, and my godmother Annmarie Guyer, one of my mother's girl-friends."

Six-year-old Fraser was less thrilled with the arrival of his new sister. Shortly after Holly was brought home for the first time, Fraser asked his father if they could sell her.

That fall Heston was ready to return to filmmaking and for the buildup to the big December opening of *El Cid*. Citron had brought him a new script, *The Pigeon That Took Rome*, for his consideration. He read it and was interested. He had been looking to try another

comedy, and something more contemporary than his recent films, one that was easy to make and would get him a fast and significant influx of cash. Now, with a second child, he felt he needed to shore up his finances. As he later said, "The delights of our completed family and the home where we would raise our children deepened my determination to make it all secure." Holly noted, "He didn't have the desire or the flexibility of his early years by the time I came along. My mother told me he didn't want to go off for long periods of time anymore . . . Family life was very important to my father, and he was determined to find the right balance between the two." After *The Pigeon That Took Rome* was announced as his next project, he was asked by one reporter what the difference was between *El Cid* and a World War II comedy, he quipped that this time around "I don't think the swash will buckle."

Citron's deal earned him a straight fee of $500,000, no percentage, the fast cash Heston was looking for. He verbally agreed to do it, hesitating only when it appeared Sophia Loren might also be in it. He waited until she turned down the project and Italian actress Elsa Martinelli was cast, then called up Kirk Douglas, who had worked with Martinelli in André de Toth's 1956 western *The Indian Fighter,* to find out how it

went. Douglas assured him she was fine. Only then did Heston officially sign on.

He almost did a cameo in another film while shooting *Pigeon*, Darryl Zanuck's deluxe reenactment of the World War II invasion of Normandy, *The Longest Day*, a star-studded extravaganza where everyone had at least one good scene. Zanuck wanted John Wayne for the role of the real-life Lieutenant Colonel Benjamin Hayes "Vandy" Vandervoort, who, during the actual invasion, led part of the paratroopers of the Eighty-Second Airborne, breaking his leg when he tried to land in Sainte-Mère-Église. Wayne had had his differences with Zanuck and demanded a huge paycheck to do what amounted to a couple of days' work. Zanuck offered $25,000, Wayne turned it down, and the producer then went to Heston, who was already filming location scenes in Italy for *Pigeon* but was sure he could get away to do Zanuck's film. At that point, Wayne and Zanuck reconciled their differences and Wayne took the part. Heston continued filming *Pigeon*, with nothing but kind words for both Zanuck and Wayne.

After finishing the film, Heston rolled right into the promotional campaign for *El Cid*, leading up to the world premiere on December 6, 1961, at the Metropole Theatre in Victoria, London, followed by a

series of European openings before the big New York City premiere on December 15 at Warner Theatre on Broadway and Forty-Seventh Street and one in Hollywood. Bronston had promised his European investors the film would open in London and on the Continent before the States.

The advance word-of-mouth on the film was good, and Heston wanted to appear enthusiastic about the film in public, but he still had serious doubts about the finished picture, mostly having to do with Mann's direction. On November 16 he finally saw the finished film before its official release, with a negative running time of 178 long minutes. That night in his diary, he wrote: "Saw *El Cid* and was very disappointed, though I'm sure it will make a lot of money . . . the flaws are excessive length, one minute too much footage in each fight scene, and ten feet too much in each silent close-up of Sophia (who is very good). I'm very good in the last, a bit stiff in the opening, patchy in the middle 'til I get into the beard scenes."

He knew while in production *El Cid* was not going to be another *Ben-Hur,* and not just because of the film's many flaws. If America thought about Muslims at all, it was mostly from the way Hollywood portrayed them in films like *Road to Morocco* (1942), a Crosby-Hope comedy in which all the Muslims are insane and all the

women look like Dorothy Lamour running around in negligees, or *Casablanca* (also 1942), where everyone is either a Nazi, a European freedom fighter, or an American, the only visible natives selling trinkets in the street or making corrupt side street deals. For most Western viewers who saw it, *El Cid* was their first real exposure to the other history of the Middle East. A year later they would get their second; *Lawrence of Arabia* would glorify the terrorist activities of T. E. Lawrence in Arabia, where the British considered themselves the naturally superior race in every way—eyes (blue), skin (white), mentality (brainy), fighting ability (infallible).

The last week in November, another fire broke out at the top of Coldwater Canyon that caught the brush surrounding Heston's house and burned through part of the roof. The fire department, whose station was only a few hundred feet away, arrived quickly, and Heston, who happened to be home spending an afternoon with the family, joined them to fight the blaze. He was determined not to lose his house. Everything he valued in the world was inside.

Everything and everyone.

On December 1, Heston had interrupted his *El Cid* prepromotion schedule to fly to Washington, D.C. As

the vice president of the Screen Actors Guild, he was asked by Chandler to be its representative at a special Saturday morning session of the House Labor Sub-committee on the growing problem of American films being made abroad and taking jobs away from Ameri-can workers (and tax revenue from the government). In the previous year, more than 60 percent of "Holly-wood" films had been made overseas, compared with only 15 percent fifteen years earlier (the first year after the war, when the studios were cranking out features to make up for the lost profits incurred the past four years).

Heston testified that the guild was seeking congres-sional action to change the tax laws to make it finan-cially advantageous for studios to make more of their pictures in America.

Heston knew what everyone in the industry did, even if Washington didn't. Hollywood was changing; the old studio system could no longer fund movies the way it had during its heyday, and making films over-seas was far less expensive. The tax breaks were ample, and the studio space unlimited. The guild, Heston said, also placed some of the blame on the craft unions, among the most outspoken advocates of making Amer-ican films in America, for solely focusing on keeping their members employed over artistic (i.e., geographic)

freedom. He went on to say, "If the Screen Actors Guild and the Film Council, working hand-in-hand, could get the Small Business Administration to [fully] finance even one film to be made in Hollywood, this would be a more positive step to the problem of so-called 'runaway' productions than all the jumping up and down and negative screaming going on now." The irony in all this was, of course, that Heston's three biggest movies, *The Ten Commandments, Ben-Hur,* and *El Cid,* were shot wholly or in part overseas.

After his speech, when a reporter asked Heston why he continued to make movies away from Hollywood, he said: "I pick my pictures solely on the basis of how good I think the parts will be . . ." He then admitted he was conflicted about the situation. "Since 1950 I have made 75 percent of my pictures outside Hollywood. We have a lovely home there and I would prefer working in Hollywood, but until the unions become more realistic about salaries and overtime and who does this or that it will always be cheaper to make big pictures away from Hollywood. And this I deplore."

At the same time, Heston became embroiled in a different kind of battle—less ideological, closer to home. The Coldwater Canyon house and its spectacular view of the Pacific Ocean was being threatened by a pro-

posed $25 million high-rise apartment complex—six buildings thirteen stories each and an eighteen-hole golf course—all to be built next to the nearby Franklin Canyon Reservoir. Although he was due in Europe for various preproduction meetings on his next scheduled film, *55 Days at Peking,* he pushed that trip back one day to be able to speak at a city planning department hearing, attended by him and sixty of his neighbors in the canyon.

He made an impassioned plea to prevent the complex from being built. He said he had invested in his home so that his children would be able to grow up knowing what a real cypress tree looked like. He had planted tall cypresses along his private driveway just like the ones that had lined the drive to the villa in Rome they had stayed in during the making of *Ben-Hur.* The actress Ruth Warrick, one of his neighbors, testified that the spirit of the master plan for the Santa Monica Mountains would be violated. Robert Alexander, a spokesman for the proposed development, insisted it would increase everybody's property values. A low grumble rose from the attendees.

The issue was taken under advisement. The project would eventually be blocked, and Heston's view would remain undisturbed. Holly and Fraser would grow up knowing what a cypress tree looked like after all.

Lilla Heston,
Charlton's mother.
*Courtesy of the Heston
Family*

Lilla holding two-month-
old baby Heston.
Courtesy of the Heston Family

Charlton Heston, age fifteen months.
Courtesy of the Heston Family

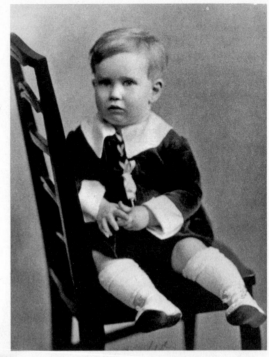

Young Charlton at the Michigan
cabin with his father Russell
"Russy" Whitford Carter.
Courtesy of the Heston Family

Young Charlton, with his mother, Lilla, and
the family's German Shepherd, Lobo, in a
scene reminiscent of the opening of *Citizen
Kane*, down to the "Rosebud"-like sled
Courtesy of the Heston Family

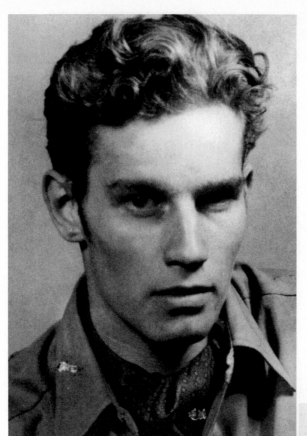

Heston at Northwestern,
circa 1940.
Courtesy of the Heston Family

Still in uniform,
Heston in New York City
searching for an apartment in
New York City in 1946.
Courtesy of the Heston Family

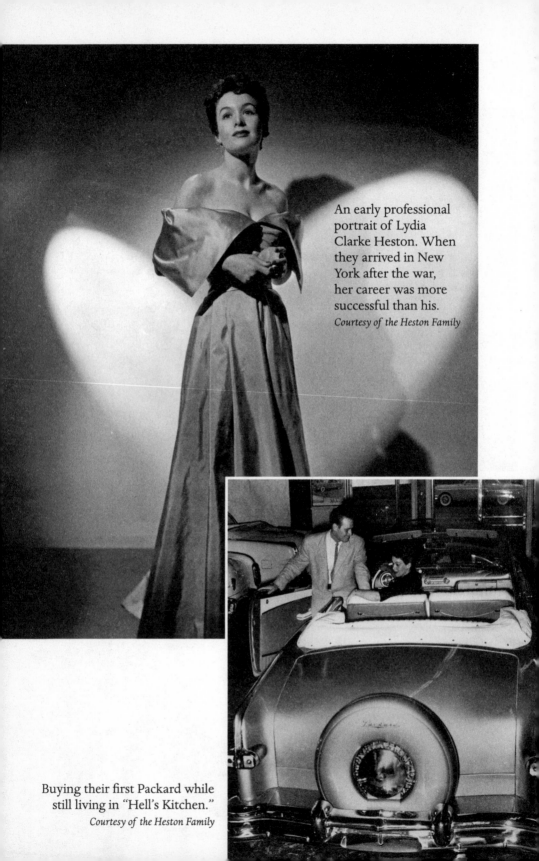

An early professional portrait of Lydia Clarke Heston. When they arrived in New York after the war, her career was more successful than his.
Courtesy of the Heston Family

Buying their first Packard while still living in "Hell's Kitchen."
Courtesy of the Heston Family

Heston holding baby Fraser, eighteen months old, with Lydia looking on.
Courtesy of the Heston Family

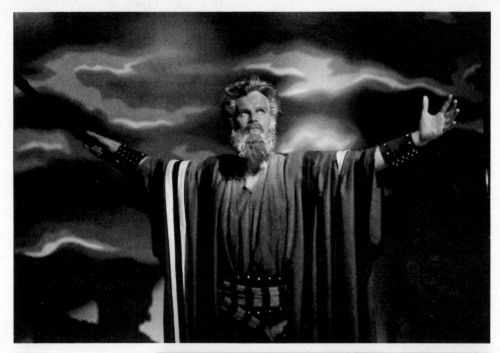

Heston as Moses in *The Ten Commandments*.
Courtesy of Rebel Road Archives

Heston playing Mexican Miguel Vargas, with Janet Leigh in Orson Welles' 1958 *Touch of Evil*. Note the autograph by Heston.
Courtesy of the Heston Family

Fraser, Lydia, and Charlton Heston in Rome, during filming of *Ben-Hur*.
Courtesy of the Heston Family

Heston and Joe Canutt training with the chariot horse team, for *Ben-Hur*.
Photo courtesy of Joe Canutt

The big *Ben-Hur*
premiere in New York
City, November 18, 1959.
Courtesy of the Heston Family

Heston and his father, Russell,
taking a tennis break during the
building of "The House that Hur
Built." *Courtesy of the Heston Family*
Photo by Lydia Clarke Heston

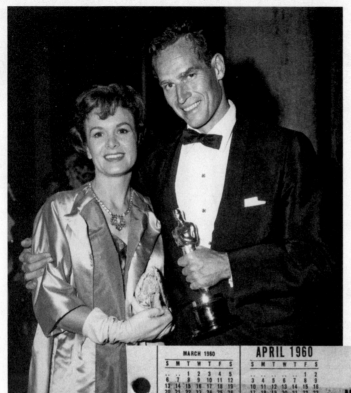

April 4, 1960, the night Heston won the Academy Award for Best Actor, for *Ben-Hur*. After, with Lydia, posing for pictures before heading out to the Oscar parties.

Courtesy of the Heston Family

A page from Charlton Heston's diary, writing in it the next morning after he won the Academy Award. Note the TV pictures pasted in.

Courtesy of the Heston Family

95 Well, I made it!! Looking across or-
chestra, just before category was read off, some-
thing popped in head.. "I'm going to get it.." And
so I did. Walked up dripping wet all over, except
for paperdry inside mouth..felt swept by conflict
of symptoms for classic stagefright. Moment..in-
deed night..w/never forget. It's all they say it
is, for my money. As WW said to question concernin
his numberous wins, "It never gets old hat!"

Heston at the tennis court of the House that Hur built, in Goldwater Canyon. He loved to play with the pros, and they loved playing with him. Left to right: Roy Emerson, Rod Laver, Heston, Ken Rosewall.
Courtesy of the Heston Family. Photo by Lydia Clarke Heston

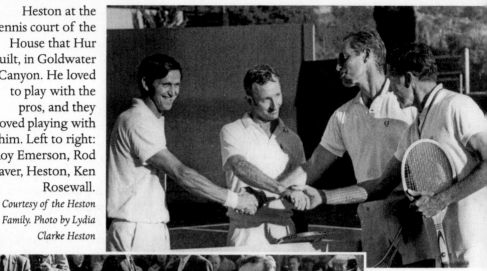

January 18, 1962, Heston puts his handprints in the cement at Grauman's Chinese Theater, in Hollywood.
Courtesy of the Heston Family. Photo by Lydia Clarke Heston

Three-year-old Holly Heston, with her father, on location in Mexico during the filming of *Major Dundee*.
Courtesy of the Heston Family. Photo by Lydia Clarke Heston

Charlton Heston in *The Mountain Men*. *Courtesy of the Heston Family. Photo by Lydia Clarke Heston*

Screenwriter Fraser with his father, Charlton, on location, 1980. *Courtesy of the Heston Family Photo by Lydia Clarke Heston*

Lydia, shooting the family, on location. She became a proficient and talented photographer. *Courtesy of the Heston Family*

Heston's mentor at the Screen Actors Guild. They were friendly adversaries in the battle over federal funding of the Arts in the first years of the Reagan presidency. *Courtesy of the Heston Family*

Fraser and Holly, on location during *The Mountain Men*.
Courtesy of the Heston Family

Heston was always sketching. This was his favorite sketch of Lydia.
Courtesy of the Heston Family

Heston in character for the TV movie *Proud Men*, 1987.
Courtesy of the Heston Family. Photo by Lydia Clarke Heston

The cast of *A Man for All Seasons*, a made-for-TV network film for TNT (Turner Network Television), 1988. *Courtesy of the Heston Family*

In 2003, the Hestons pose with the Bushes at the White House just after Heston was awarded the Presidential Medal of Freedom. Left to right: Laura Bush, President George W. Bush, Charlton Heston, Lydia Clarke Heston. *Courtesy of the Heston Family*

Near the end. *Courtesy of the Heston Family*

Carrying on. Lydia Clarke Heston and Fraser. *Courtesy of the Heston Family*

The first week in December, Heston and Lydia flew to London for the gala premiere of *El Cid*. The next morning the film received mixed to good reviews in the press, as it would in the States, but as Heston predicted, it proved a smash hit, playing in every country on a reserved-seat basis for nearly a year. From its $6 million budget, *El Cid* would go on to earn nearly $60 million worldwide.

Later on, reflecting on the success of his last two features, Heston wrote in his diary: "If I'd known how both films would come out, and had the power to make it happen, I'd have had Tony Mann direct *Ben-Hur* and Wyler *El Cid*. In Tony's hands, *Ben-Hur* might have been a somewhat lesser film creatively but I think it would have done nearly as well commercially as Wyler's . . . I think *El Cid* would have been far and away the best epic film ever made [if Wyler had directed it]."

Heston's thoughts about *Ben-Hur* were clarified for him after *El Cid*. As he stated, he felt Wyler's personal style never completely conquered the physical apparatus of *Ben-Hur*, and that the film did not have a strong romantic spine on which to center the drama, and without it, some of Wyler's strengths as a director were wasted. Mann's film also favored violent action but with a romantic track. Wyler would have been more

successful bringing out Ximena's real emotions instead of turning her into something of a female film cliché; Mann emphasized her need for revenge over her desire for true love. Wyler also would have humanized the character of El Cid, while Mann would have brought out more of Ben-Hur's aggressive ambition.

In the end, *El Cid*'s popularity was a lavish demonstration of star power, both Heston's and Loren's, and provided another terrific showcase for Yak and Joe Canutt, whose skills affected the look of *El Cid* as much as they had *Ben-Hur*. Because of the Canutts, El Cid's final death ride was as thrilling, in its way, as Ben-Hur's chariot race.★

Going into the new year, thirty-eight-year-old Charlton Heston was sitting on top of his world, filled only with optimism for the future.

★ El Cid was not actually killed by an arrow; he was wounded and could have survived. As the film suggests, he chose to sacrifice himself by having his soldiers lash him into his saddle, thereby inspiring awe in the minds of the Moors who had seen him hit and who then watched him ride, literally, into legend.

Charlton Heston, Ava Gardner, and David Niven on location near Madrid for 55 Days at Peking (1963). (Courtesy of Rebel Road Archives)

Chapter Twenty-One

The year 1962 began for Heston on a productive note, with two big-money, gross-participation, mainstream film deals put together by Citron. The first was *55 Days at Peking,* another Bronston production, conceived by the producer after the cultural and financial success of Walt Disney's *Davy Crockett* TV miniseries and, a few years later, John Wayne's big-screen version of the Battle of the Alamo. Bronston based it on the little-known (in America) two-month assault in 1900 by the Boxer triads of China on the relatively small contingency of foreign soldiers guarding the diplomats and representatives of the eleven occupying nations and their families. Known as the Boxer Rebellion, it was the real beginning of the end of China's two thousand years of dynastic rule and paved the way for

the establishment of the republic in 1912. The soldiers had to hold the Boxers at bay until reinforcements could rescue them. It was, essentially, the Alamo aimed at an international market.

To direct, Bronston chose Nicholas Ray. Ray was a product of the Group Theater of the '30s, where he had met and worked with Elia Kazan, after Kazan hired Ray to be an assistant on his 1945 film debut, *A Tree Grows in Brooklyn,* he quickly climbed the Hollywood ladder, along the way working with some of film's biggest stars, including Humphrey Bogart in *Knock on Any Door* (1949) and *In a Lonely Place* (1950). *Johnny Guitar* (1954) became a cult favorite and made Ray a darling among the French New Wave critics and filmmakers. After seeing it, Jean-Luc Godard famously proclaimed, "The cinema is Nicholas Ray."

The director's biggest success came with 1955's iconic *Rebel Without a Cause,* which perfectly captured the angst of the new teen age, personified by James Dean, who made his feature debut in it. Dean was another actor who had paid his dues in New York on live TV in the '50s (when and where Heston had met him). After *Rebel,* Dean and Ray were planning to make more movies together until the actor's early and shocking death in an automobile crash. Ray was deeply disturbed by the loss of Dean and began to drink heavily.

His career floundered until 1961, when, in the wake of
Ben-Hur's outsize success, he was hired by Bronston to
direct MGM's 70 mm remake of DeMille's silent bibli-
cal epic *King of Kings,* with narration by Orson Welles
(unbilled) and a score by Miklós Rózsa, who had also
scored *Ben-Hur.* For Ray it was a chance to restart his
career. The film did well enough for Bronston to hire
Ray to direct *55 Days at Peking.*

Bronston, via Citron, then offered Heston the part
of Major Matt Lewis, which was based (very) loosely
on John Twiggs Myers, known to his friends as "Hand-
some Jack," the U.S. Marine Corps general who, after
seeing action in the Spanish-American War, earned a
slew of military honors and gained his place in history
when the forty-eight marines dispatched with him to
Beijing in May 1900 helped to defend the wall that was
all that stood between the Boxers and the foreign lega-
tions' headquarters. A ferocious battle ensued that led
to the end of the rebellion. Heston was eager to play a
character that would honor a real-life general, and the
more he learned about the Boxer Rebellion, the more
he wanted to be in the film.

As always, Bronston had one eye on foreign box-
office potential, and signed the smoothly articulate,
sophisticated, British-born David Niven—a member of
the so-called Brit Pack of expat Hollywood movie stars

368 · MARC ELIOT

that included Cary Grant, Olivier, and a host of others—to play Sir Arthur Robertson, a character based on Sir Claude MacDonald, the British minister to the Qing dynasty at the time of the rebellion and to the Empire of Korea (MacDonald, who joined forces with General Myers, is best remembered for negotiating Britain's ninety-nine-year lease for Hong Kong, thought at the time to mean forever). In the film, Niven's is the voice of reason against Heston's more eager-for-battle Major Lewis. Niven was an actor Heston admired; he'd been one of the frontline members of the Brit Pack who was among the first to return to Britain to fight, without any prompting or fear of losing his American visa.

With Ray in place to direct, production was scheduled to begin in Spain that summer. No one in Washington or the guild seemed to notice or mind that after Heston had campaigned for the change in economic structure to keep movie production in Hollywood, he had signed on to star in yet another overseas-based production.

Citron's second film for Heston was *Diamond Head,* a Hawaii-based soap opera set on the Big Island, produced by Jerry Bresler at Columbia, directed by British veteran Guy Green, and starring a host of names meant to appeal to a younger audience: up-and-coming Yvette Mimieux, who had gained Hollywood atten-

tion in George Pal's *The Time Machine* (1960); George Chakiris, a Best Supporting Actor Oscar nominee for his performance in 1961's *West Side Story* (he would go on to win); the French-Vietnamese actress France Nuyen, a discovery of Joshua Logan's, who had cast her in his 1958 film version of *South Pacific;* young pop star James Darren. The cast also included Elizabeth Allen, a stage and screen actress whom Heston had worked with in the early days of live TV.

Diamond Head was an opportunistic film, made in the aftermath of Hawaii's becoming the fiftieth U.S. state in 1959, which had created a temporary fascination on the mainland with all things Hawaiian; *Diamond Head* was essentially a travelogue with a convoluted plot. Here is part of Turner Classic Movies' earnest overview of the film:

> Richard "King" Howland, a ruthless and bigoted land monarch on the Hawaiian island of Kauai, is bitterly upset when his younger sister, Sloan, announces that she wants to marry a full-blooded Hawaiian, Paul Kahana, although he himself is having a clandestine affair with the native-born Mei Chen. At the young couple's engagement party, Mei Chen's drunken brother attacks Howland with a knife, and Paul is accidentally stabbed to death when he

intercedes. Blaming her brother for Paul's death, Sloan refuses to speak to him and goes to Honolulu. There Paul's brother, Dean, finds her in a drunken stupor and takes her to live at his mother's home. A short time later, Mei Chen dies while giving birth to a son, but Howland refuses to accept the child, and Sloan decides to care for it. Following a fight with Howland, Sloan and Dean take the child and leave, but Howland, forced to accept the fact that he will soon have a halfcaste brother-in-law, finally decides to give his son the family name.

Diamond Head was made quickly, on location, and completed before production began on *55 Days at Peking,* then held for release until the winter of 1963, to attract audiences looking for a film to warm them up for a couple hours. Bresler's strategy was a good one. The film was a huge box-office success.

Early in January, Citron called Heston before breakfast to tell him he was to be the 139th star to put his handprints, footprints, and signature in cement at Grauman's Chinese Theatre on Hollywood Boulevard. The tradition had begun in 1927 as a gimmick by the theater's original owner, Sid Grauman (who was not Chi-

nese), and has since become a major tourist attraction.* Heston wasn't eager to do it, but Citron convinced him his refusal would bring more unwanted publicity than just going through the messy ritual, and he agreed.

On the morning of the ceremony, Heston kneeled above Marilyn Monroe's and Jane Russell's handprints, something that led him to quip, "How many men can say they've been on top of Marilyn Monroe and Jane Russell?" That about summed up the otherwise prestigious but meaningless moment. The *Hollywood Reporter* noted that more than one thousand fans showed up to catch a glimpse of and cheer for Heston, and Lydia dutifully photographed him as he put his hands and feet into a wet block of cement. The *Los Angeles Times* described the moment this way: "Charlton Puts Foot in It, Makes Lasting Impression."

Not long after, the Academy nominations for 1961 were announced, and notably absent from the Best Picture and best performance categories was *El Cid*. It was nominated for three minor awards—Best Art Direction–Set Direction, Color; Best Original Song; and Best Score of a Dramatic or Comedy Picture—but

* The ritual's first inductees were Norma Talmadge, Mary Pickford, and Douglas Fairbanks.

when the Oscar ceremony took place in April 1962, it won nothing. The big winner for 1961 was *West Side Story*, which took home ten trophies.*

The next month Heston was invited to the White House to mingle with others who had supported Kennedy's run for office and to lobby for support for SAG issues, and he was properly awed by what he considered real star power, the close-up charisma of JFK. Then it was back again to Hawaii for some pick-ups that took him into May. A month later, he was on a plane with the family, headed to Spain to begin filming *55 Days at Peking*.

Bronston had chosen a 250-acre onetime barley field, Las Matas ("The Shrubs"), sixteen miles northwest of Madrid at the base of the Sierra de Guadarrama that he thought resembled Beijing at the turn of the twentieth century. He had arrived before Heston and the rest of the cast to supervise construction of what would replace the circus in *Ben-Hur* as the largest film set ever

* Sophia Loren was in town for the announcement of the nominees, fully expecting to be named as one for Best Actress for her work in *Two Woman*. She subsequently brought suit against Bronston when she saw her name was listed below Heston's on a Sunset Boulevard billboard advertising *El Cid*. Her contract called for the names to always be listed side by side above the film's title.

built, a replica of Beijing and the Forbidden City, using as a foundation sets already in place, but not yet used, for Bronston's postponed historical epic *The Fall of the Roman Empire.*

Philip Yordan, who had written *El Cid,* had since been promoted to creative head of Bronston Productions. His writing team of Bernard Gordon, Robert Hamer, and Ben Barzman did extensive research on the Boxer Rebellion, but despite all the work they did, the cultural divide proved too much for them. In their screenplay, the Boxers are the bad guys and the foreign occupiers, representing the countries of the Eight-Nation Alliance, are the heroes. Its Chinese characters come off as the racists, and little attention is paid to the motivation behind the rebellion, which makes no sense. (The Boxers were surely vicious, but their goal was to rid China of its Western occupiers, who had carved up the land and enslaved the Chinese, forcing them to trade their tea for opium.) Moreover, Bronston cast white actors in almost all the Chinese-speaking roles, including the important part of the Empress Dowager Cixi (Dame Flora Robson). Of the film's 3,500 extras, most were restaurant or laundry workers imported from London, Paris, or Rome because there weren't enough Chinese in Madrid.

But even if the script had been more accurate and the

casting more authentic, the film would still have been a commercial long shot, as nobody in America knew much about China or its history except for the name Mao Zedong—and even then most couldn't care less. Furthermore, a preposterous Hollywood-style conventional love story was inserted, at Bronston's insistence, even as the tension builds between the Chinese and the foreigners that will lead to confrontation. If Bronston had studied *Davy Crockett* or *The Alamo* more closely, he would have realized that neither Disney nor Wayne had tried to dress the Alamo story up with much romance. Somehow, Major Lewis becomes entangled with a Russian baroness, Natalie Ivanoff (Ava Gardner), while she is caught behind the walls of the foreign delegations compound. Heston wasn't happy about it, but if there had to be a romance, Heston would have preferred a European actress who could bring something exotic to the role. He had suggested Jeanne Moreau when he first read the script, the French actress who almost appeared in Sophia Loren's place in *El Cid*, but Bronston was set on the aging Gardner because he believed she could still attract American audiences.

Heston was concerned about working with her. He had heard all the horror stories in Hollywood about her diva outbursts, her sexual adventurousness, and

her drinking, none of which he wanted any part of. He did have casting approval in his contract and tried to reject Gardner, but Bronston pleaded with him to reconsider, although when she hesitated to sign her contract, Bronston approached Moreau, who declined the offer. When Gardner heard Moreau was being considered, she immediately signed on, and to get the picture into production, to keep the peace with Bronston, Heston reluctantly approved her.

At a final meeting in Spain between the actors and Ray before filming was to begin the next day, an inebriated Gardner showed up late and proceeded to trash the script. She remained drunk for most of the filming, beginning her intake earlier every day, until in order to get any usable scenes, Ray had to film her before one in the afternoon (shooting began each day at noon using the same traditional European schedule as *El Cid*).

But for all the disruption Gardner was causing, Heston began to think the real problem was Ray, who was unable to control her. One day an extra who didn't know any better took a photo of the actress without permission and she threw a fit, walked off the set and refused to do any more work the rest of the day, even though she was scheduled to shoot a key scene. Heston witnessed the whole thing and wondered why

Ray couldn't better handle the situation. With filming stopped for the day, Ray slunk back to his hotel room and drank himself to sleep.

The next morning, September 11, after a couple of hours of outdoor filming on a day that was especially warm and dry, under an unforgiving Spanish sun, Ray suffered a coronary.

Once again, filming was halted. When Ray was well enough, Heston visited him at the local hospital. He asked him how he was feeling, and Ray responded by wanting to talk about script revisions. Heston listened patiently, but it was clear that if Ray survived, which didn't seem likely, he wouldn't be able to finish the film.★

With not very much footage to show for the first six weeks of filming, and with firm stop dates written into the contracts of both Heston and Niven, the picture was in danger of shutting down. At an emergency meeting with Bronston, Heston suggested he hire Guy Green, *Diamond Head*'s director, to finish the film. Bronston called Green and made a quick deal to bring him to Spain, and as soon as he arrived production resumed, even though Green had not seen any of the

★ He never directed another foot of film the rest of his life. He died of lung cancer in 1979.

daily rushes and had no clear idea what the film was even about. Second unit director Andrew Marton, who had come as part of Ray's deal to assist in filming the action sequences, tried to bring Green up to speed even as rumors began to spread throughout the production of a new problem: Bronston didn't have enough money to pay the locals hired on as crew.

When Heston found out about it, he paid them out of his own pocket, then went directly to Bronston to find out what was going on. Bronston apologized, claimed he had run short of payroll cash, and told Heston not to worry, he would get reimbursed when they returned to the States.

Meanwhile Gardner, perhaps feeling a bit of guilt over Ray's heart attack, stopped drinking for a few days, but then, her guilt assuaged, she fell off the wagon. When she was due on set one day and no one could find her, Heston found her outside the studio, using a red cape to play matador with the local cabs, trying to flag one down to take her back to her hotel. Heston then huddled with Niven, and they agreed that if the picture was going to be finished, they would have to carry the production on their own broad shoulders. Heston decided to run two shifts with two separate units, one during the day and one at night, one unit directed by Green, the other by Marton.

When shooting was finally completed, an exhausted Heston wasted no time arranging for a flight back to New York. The family had been with him for most of the shoot, but they had to return to Los Angeles on Labor Day so Fray wouldn't miss his first day of the new school year. The entire time Heston was in transit, he was convinced he had just participated in the filming of a first-class disaster.

He wasn't home for very long. A month later he was on a flight to Page, Arizona, to baptize extras in the Colorado River, a stand-in for the Jordan. Heston had promised George Stevens he would do a cameo as John the Baptist in Stevens's biblical epic *The Greatest Story Ever Told,* and now that the film was in production he intended to keep his word. Biblical films were still viable, and Heston finished out the year about to lose his head in widescreen.

Soon enough, he would lurch back into the present, to begin planning a different type of spectacle: he intended to march on Washington that August with the Reverend Dr. Martin Luther King Jr. in the service of Civil Rights.

Burt Lancaster, Harry Belafonte, and Charlton Heston in front of the Lincoln Memorial during the March on Washington, August 28, 1963. (The National Archives)

Chapter Twenty-Two

Early in 1963, at Marlon Brando's house on Mulholland Drive, Heston was elected chairman of a local political organization that called itself the Arts Group. It had a liberal membership consisted of two dozen or so SAG leaders, theater people, painters, and musicians who were committed to improving the job opportunities for minorities in Hollywood. Heston later described the position as a "meaningless title." In his journal, he wryly noted that "I suppose I was elected because of the time I'd put in with SAG . . . or maybe just because I'd gotten all those folks through the Red Sea . . ." Later on, he elaborated more thoughtfully on the group and his appointment as its leader: "Some of us in the film community decided to organize a group from the arts. Our original thought was to include stage

people and writers and painters as well, although I don't recall that we got many volunteers there. For that matter, we didn't get as many film people as I'd hoped. I was voted honcho of our little band, probably because the SAG presidency gave me some official status (though I was careful every time I spoke publicly about civil rights to make clear that I was speaking for myself, not the entire Guild)."

The group's roster included some of the biggest postwar liberals in Hollywood. Most had come to prominence in films of the '50s, among them Paul Newman, Burt Lancaster, James Garner, Sidney Poitier, Harry Belafonte, and Brando. With the notorious HUAC-driven blacklist a dustbin artifact nesting alongside the old-guard studio system structure, there was a new, freewheeling sense of influence among this crop of romantic rebels no longer afraid of suffering career consequences or political tainting if they marched in protest, practiced civil disobedience, or supported what were then considered controversial causes like job discrimination against minorities.

JFK was the Hollywood heroes' hero, more for his image than his initiative; to the motorcycle-jacket generation, image was everything. In truth, the president was only a moderate liberal on civil rights, unwilling to offend the powerful bloc of southern conservative

Christian white voters he needed for reelection (the same bloc he would fly to Dallas to court that fall, with fateful consequences). And although Hollywood had rid itself, for the moment at least, of its radical Right base of the '50s, the industry still had no united voice against racial prejudice. Some things in the movie-making business would never change; morality, as always, was dictated by the bottom line. Into the '60s, no major producer working in the studio system was yet willing to put a black performer in the starring role of a romantic mainstream film, because the financial risk was just too great. The widespread belief was that white mainstream audiences, the lifeblood of the American moviegoing habit, would not buy it. For all the progress made in pushing Hollywood to the center (from the right)—breaking the blacklist and rehiring those who had been denied work, mostly but not all Jewish men—there had not been any real drive for racial equality in movies (or third-world or religious equality). In that area things remained the way they were. The that'll-be-the-day sentiment, which permeated the Hollywood film industry from its inception and continued into the '60s, was that a black man could be elected president easier than he could star in a major Hollywood film.

To that end, Heston was the shrewd choice to head the

multiracial, left-leaning Arts Group. He was not just a white mainstream liberal, he was Christian *fluorescent,* which meant the Arts Group could not be dismissed as a gang of fringe malcontents consisting of minorities and youth rebels like Brando, Newman, and the rest of the young-stud Method-acting protesters. Heston believed in political moderation, legislative procedure over radical action, and he authored the group's statement of purpose, which advocated the passage of the Civil Rights Act (currently wending its way through Congress and going nowhere fast), peaceful demonstrations, and meetings with members of Congress and, separately, with the president, rather than any specific actions on the part of Hollywood filmmakers.

By May, Heston's extracurricular activities for SAG had taken over the majority of his time. He had not spent a day on a soundstage in months. The closest he came to anything directly related to film was *55 Days*'s gala premiere in Paris on the tenth and the star-studded after-party at the exclusive Lasserre on the Champs-Élysées. He and Lydia had flown in for the night, and then worked their way back via stops for the film's premieres in London, New York, and Los Angeles.

In June, back at the ridge, Heston received a direct telephone call from Martin Luther King Jr., inviting

him, in his dual capacities as an officer of the Screen
Actors Guild and the head of the Arts Group, to a pri-
vate one-on-one breakfast in New York the following
week to talk over what was being done about the lack
of work for black actors in Hollywood.

Heston said he would be there.

The same day he landed at Idlewild Airport (today
John F. Kennedy International Airport), he taxied into
the city, to his apartment, and because the weather was
so nice, walked the couple of blocks over to Dr. King's
hotel. After an exchange of handshakes and some lunch,
they got into what the issues were that concerned Dr.
King. Heston was impressed with King's manner, less
so his knowledge of how Hollywood operated. He re-
membered the meeting with Dr. King this way: "He
was a special man, put on this Earth, I believe, to be
a twentieth-century Moses for his people. Over coffee
and toast in his hotel, I found him to be a very quiet
man. Passionately quiet. 'You tell me, Mr. Heston, that
there are *no* blacks on Hollywood film crews. As presi-
dent of the Screen Actors Guild, what can you do about
that?' 'I'm afraid not too much,' I said. 'Our guild has
always welcomed black actors, but I must tell you, the
technical unions not only won't accept black members,
they wouldn't accept me, or anyone else who is not
the son of a member. I'm glad to speak for SAG at the

inter-guild conference you've called with the studios
[scheduled for later that afternoon], but I don't believe
you have much of a chance with the technical unions.'

"I was dead wrong. At the conference, Dr. King
talked them around. They agreed to eliminate the
family rule and accept black apprentices. Amazingly,
they also began to take in non-family whites and women,
which wasn't even on Dr. King's agenda. He was an
awesomely persuasive man, even unintentionally . . . at
the time I met Dr. King, he was already planning his
march on Washington at the end of August, almost two
months later . . ."

That night, Heston was in bed by nine to get his
normal eight hours before catching an early flight back
to the West Coast. Meanwhile, at his hotel, Dr. King
called Belafonte, who was one of the organizers of the
planned march, and suggested to him that he invite
Heston and the Arts Group to participate in it. Bela-
fonte initially balked; he didn't believe Heston march-
ing alongside civil rights heavyweights sent the right
message. Here is how Belafonte recounted that call:

"Have you reached out to anyone across the
divide?" [Dr. King asked me.] I told him I didn't
see how I could reach out to Ronald Reagan, George
Murphy, two of Hollywood's best-known Republi-

can actors. I really didn't know them at all. I did know Charlton Heston; he was on the other side of the divide.

"What did you say when you spoke to him?"

"I didn't speak to him."

"I think it would be in our interest," Martin said, "to have such a presence."

I pondered how to do this. Then I called Marlon [Brando]. I told him I hoped he'd chair the march's delegation. "Someone needs to lead the posse," I said. "But I'd like to exploit you a bit."

"A bit?"

I chuckled. "Yeah, I'd like to ask Charlton Heston to join us, and I'd like to propose that he co-chair the delegation with you."

Marlon groaned. If I had such a galaxy of stars, he said, why did we need Heston? I pitched Martin's point, and Marlon gave a grudging sigh. But then I added one of my own. The fact was, I said, Heston knew he wasn't a great actor. Behind those iconic good looks and macho swagger was an insecure guy who yearned for the approval of his peers. Co-chairing a Hollywood delegation with Marlon was exactly the blessing he needed. And he would help our cause. Charlton Heston marching with us would be a powerful image for mainstream Amer-

ica. "Okay," Marlon said with a laugh. "Enough! You got me."

So I flew out to Heston's home and proposed that he and Marlon co-chair [March's] the Hollywood delegation. Heston gave me a look—that craggy, deep Charlton Heston look. "Co-chair with Marlon?" he echoed. "I'd be delighted."

And could we bring the Hollywood delegation to Heston's home for a press conference when we announced that? No problem. I called Martin as soon as I got back to my hotel. "We got Heston!" With that, Martin's spirits went way high. Now he, too, knew the march would succeed, and lead us where we needed to go. How could it not? We had Moses!

Back in Hollywood, Heston called a meeting of the Arts Group to see who would join in the march. "We had a good group, Burt, Jim, Marlon, Paul, and several others. Sidney Poitier and Harry Belafonte [were already] signed on, but we had no other prominent black performer . . . Anyway, Marlon provided enough passion for us all."

Brando announced at the meeting that at one point during the march, he thought they should chain themselves to the Thomas Jefferson Memorial or lie down in front of the White House to block its entrance. No,

Heston said, that wasn't what they were invited to do. They were going to respect the spirit of Dr. King's vision and march peacefully, obeying the law; that was the whole purpose. "I'm not deeply involved in the civil rights movement," he told Brando, "but every so often you have to stand up and be counted. It's important for average citizens—for disinvolved citizens, but I do not believe in civil disobedience. Civil disobedience is for dictatorships." He implored Brando not to blur King's message by doing something that would distract from it. Dr. King wanted a moderate representation to show popular culture that the civil rights movement was not made up of a bunch of fringe radicals.

As soon as word got out in Hollywood that Heston was organizing a group of performers to march with Dr. King, he was pressured by some of the industry's biggest power players not to go through with it. Fraser: "He was vigorously counseled against joining the march by executives in the studios where he worked and [by] other colleagues. They said things like, 'Chuck, let's not fly off the handle here. Let's just take things one step at a time. Civil Rights will happen, but let's not push it along.' None of it affected him at all. He was determined to go through with it. I think playing Moses had convinced my father that everyone deserved an equal chance in life—Jews, immigrants,

blacks, everyone. Throughout his life, whenever my dad believed something was the right thing to do, he didn't back down because of pressure. He believed it was his constitutional right to express his support for Dr. King." Unable to be deterred, and not afraid of the consequences he might face in Hollywood, Heston went ahead with his plan to take the Arts Group committee and anyone else who wanted to join them to D.C.

The March on Washington for Jobs and Freedom, popularly known as the March on Washington, brought out approximately 250,000 people and became one of the largest rallies in the history of the country. It began at the Washington Monument and continued to the Lincoln Memorial. Brando and Heston walked together, directly behind Dr. King, and wound up standing on the steps of the Lincoln Memorial during his famous "I Have a Dream" speech, able to look out at the vast gathering. Lydia was there too, but Dr. King's security team did not allow her to walk next to her husband, though she got close enough to take photos of the Arts Group and Dr. King speaking.

Heston would remember this day as one of his most significant accomplishments. He was filled with pride, being at the center of real-life history as it unfolded before his eyes, more dramatic than anything he had ever reenacted on film.

The march paved the way for the signing into law of the Civil Rights Act one year and one president later.

As 1963 drew to a close, Heston was offered the lead in an NBC *Hallmark Hall of Fame* presentation of Sidney Kingsley's 1943 hit stage play, *The Patriots,* about the political battle between a young Thomas Jefferson, who was trying to lead the country toward greater democracy, and Alexander Hamilton, who envisioned a more aristocratic order. The ninety-minute special was to be shot in color on the new invention of videotape. Although Heston did not want to appear too often on television these days, he took the job because it was immediate and he was itching to get back to acting.

After that, Citron sent him three proposals to consider. One was a partially finished script for a Civil War action-adventure film called *Major Dundee,* which Citron thought Heston was right for. The second was a deal that Walter Seltzer had devised as part of a new production agreement between the two of them under the banner Court Productions, but Heston wasn't sure it was the correct way for him to go. He had dissolved Russell Lake Corporation, of which he was one of the officers, when he became vice president of SAG to avoid anything that even remotely resembled a conflict of interest, even though Russell Lake was really noth-

ing more than a holding company, and he didn't want to give up his vice presidency for the sake of coproducing a film. Citron assured him that he would remain a "blind" investor in Court Productions, with no say in anything, and that the Heston name had real marquee value; it added box-office clout to any picture it was attached to. Shouldn't he be able to benefit from the value of his own name? Citron assured him that the way the company was structured, Seltzer would be in charge of all business-related affairs, and Heston would be a silent partner of Court Productions but not an officer of the corporation. Therefore, Citron concluded, there was no conflict of interest—the only conflict Heston would have would be how to spend the extra money.

He signed on.

Seltzer's project was *The War Lord,* a screen adaptation by John Collier of the Leslie Stevens play *The Lovers,* set in twelfth-century France about the *droit du seigneur,* where the lord of the manor has the right to the wedding night of a peasant bride before the groom. It was not a comedy. Heston liked the script, and Seltzer came up with a modest $1.5 million budget, intending for the film to be shot on location in France.

On November 22, Heston arrived at Seltzer's office at Universal for a meeting with him, Citron, and Frank

Schaffner, the director they'd signed for *The War Lord* (whom Heston had last worked with on the *Studio One* live presentation of *Macbeth*), to discuss the script changes Heston wanted. He had arrived early to have after-breakfast coffee with Seltzer before the others were due. He had just settled into his seat, waiting for his cup of coffee to be served by Seltzer's secretary, when she came running in empty-handed, looking panicky and upset, telling Seltzer to turn on the TV.

Heston and Seltzer froze as they watched the flickering black-and-white screen image and listened to the trembling voice of Walter Cronkite.

JFK had just been shot in Dallas.

Charlton Heston as Major Dundee. (Courtesy of Rebel Road
Archives)

Chapter Twenty-Three

That night, Heston flew by private corporate jet to New York City. CBS had sent for him to read the eulogy for a memorial it was going to air nationally Sunday afternoon. The morning of the broadcast, he woke up and turned on the TV to watch, along with the rest of the country, the continuous news coverage of the assassination. As he was sipping his coffee, he saw Jack Ruby shove a gun into Lee Harvey Oswald's belly, pull the trigger, and kill him. He performed his piece as scheduled that afternoon, after which he caught an evening flight back to Los Angeles.

He did not work for the rest of the year, preferring to spend the holidays up at the ridge with his family. After the tragedy that had traumatized the nation, life had become more precious to him. Ordinary things like

having dinner at home, going for a swim, taking Fraser horseback riding, changing Holly's diaper, and sitting by the fire at night sharing a bottle of wine with Lydia made him feel more thankful than ever for the life he was living and all that he had. The death of the president had shut down Camelot, and Heston and nobody else knew what lay beyond the gilded castle walls that had, until that day in November, protected Americans from the outside world.

The new year brought much activity. Citron had closed the deal with Columbia Pictures for a straight $750,000 salary, no percentage, for Heston to star in *Major Dundee,* and the studio wanted the picture as soon as possible. This was good news for Seltzer, as it gave *The War Lord* team more time for development.

Columbia signed producer Jerry Bresler, who had worked on the successful *Diamond Head,* and he, in turn, hired Sam Peckinpah to direct, after Bresler's first choice, John Ford, turned it down. The film was Peckinpah's third directorial effort, following the little seen *The Deadly Companions* (1961) and the following year's acclaimed *Ride the High Country.* He had come to film via TV as a protégé of Don Siegel's, writing episodes for several western TV series. Heston approved him because he too had come up through television and

admired Peckinpah's work on *Ride the High Country*, which was also produced by Bresler. The word floating through Hollywood about Peckinpah was that he might very well be the next John Ford.

Problems began before a single foot of film was shot, due to the script's lack of a clearly defined point of view. Columbia had commissioned a two-hour cavalry-and-Indians picture, but after reading Harry Julian Fink's screenplay, Heston thought it read more like a Civil War epic and was unsure how to approach the title character. Peckinpah was eager to use the film as an experiment in a stylized form of visual violence that anticipated his 1969 masterpiece, *The Wild Bunch.*

Fink's screenplay concerns a tough, overzealous Union cavalry officer, a survivor of the bloody Battle of Gettysburg, who is sent to a New Mexico Territory outpost to run a prisoner-of-war camp. Shortly after his arrival, an Apache war party raids the outpost and then flees to Mexico. Dundee sets off after them with a war party of his own that includes an old enemy of his, Rebel captain Benjamin Tyreen, played by none other than Richard Harris, Heston's temperamental costar from *The Wreck of the Mary Deare*. Harris had since gained international acclaim for his performance in Lindsay Anderson's *This Sporting Life* (1963), which

earned him a Best Actor nomination.* Heston was still wary of Harris, but thought he was talented and right for the part, so for the good of the film he approved him.

As work on the production progressed, it became clear to Heston that Peckinpah did not have control of the Mexico location shoot; that he was unable to decide what the film was, a western or a historical drama; and that he remained preoccupied with his personal style. Worse, his many demons—drink, drugs, whoring— caused several delays and escalated the budget. When Columbia executives demanded to see a rough assembly of the footage, they were so disappointed they cut off any more funding. A group was sent to supervise Peckinpah and speed up the remaining location time.

Things quickly came to an ugly head when the film had wrapped and Peckinpah and Heston agreed they needed to shoot two additional scenes to better illuminate Heston's character, and Columbia's operatives ordered them to shut down the location and film the scenes on a soundstage in Hollywood. Heston and Peckinpah stood their ground, and when Columbia wouldn't budge, Heston offered to return a portion of his salary to the studio, estimated by various sources

* He lost to Sidney Poitier in *Lilies of the Field.*

to be between $100,000 and $300,000,* if they let him and Peckinpah film the two disputed scenes in Mexico.

The offer was not taken well by the studio executives, who believed Heston was trying to embarrass them. At the time, Columbia Pictures Corporation, as the studio was now called, was on the brink of bankruptcy. After founder Harry Cohn's death in 1958, a series of takeover attempts, stock manipulations, and a lack of corporate leadership had drained the studio's profits. What kept it going was its Screen Gems television division. The studio called what it believed was Heston's bluff. He then received a call from a furious Citron, who thought the offer to fund the shoot was the absolute wrong move and that he should immediately give in to Columbia's demands.

In his diary, Heston rationalized his offer this way: "Frankly, actors have come to be considered pretty lousy as irresponsible individuals. As an actor I am sensitive on the subject. I found myself in a position and

* *Time* estimated it to be $200,000. The magazine also interpreted the deal as having the opposite effect than what was intended: "Heston had an attack of ethics . . . 'Ghastly precedent,' thought his fellow performers. 'Gem of a nation,' thought Columbia." However, the unsigned piece did not explain how the writer knew what each side was thinking. Either way, the deal was the talk of Hollywood for weeks and made it into the national press. (*Time*, May 15, 1964.)

took the only way out open to me." Regardless of what Citron thought, he believed he was saving the film. Soon enough, all of Hollywood was buzzing about the impasse.

Variety wrote this about the deal: "A film star responsible for a film going over-budget has returned his salary to the company. This conscience gesture, believed without parallel in Hollywood annals, was made by Charlton Heston because he sided with the director of *Major Dundee* on certain sequences and thereby upped shooting costs. Heston's return-of-fee is believed to amount to around $300,000, with Columbia nothing loath to accept this *noblesse oblige.* Much of *Dundee* was filmed in Mexico."

The studio finally agreed to the offer, and the extra scenes were shot in Mexico (because of the budget overruns, Heston wound up doing a few of his own stunts and seriously hurt his arm). But the issue didn't die there. He was so angry at Columbia he talked to all the newspapers and did a lot of local radio to make sure everyone knew that the studio actually took his money. This marked him once again as an industry activist (as opposed to a political one) a troublemaker among the new generation of post-studio-era execs, who did not like having their business conducted in public. But to the creative community he was a hero for putting his

money where his mouth was and winning a measure of creative control without caving in to the demands of the executives. The fact that he paid up only made it look, to them, like a more noble gesture—to everyone, that is, except Richard Harris.

The actor, still riding high on his Oscar nomination, was not at all used to the rigors of location shooting and did not appreciate the extended filming time required in Mexico. Being a Brit in Peckinpah's macho western, he felt from day one like the outsider of the company, and he believed that Heston, more than the others, "looked down on me like a preacher" or "some high-handed twat"—a feeling not helped by the good-natured kidding that went on among the crew, especially when Heston was in on it. Harris was the victim of an exploding cake, and he felt humiliated when everyone guffawed at his face dripping with frosting; the incident sent him "hiding and quivering somewhere in Durango," according to Fraser, who was on the set with Lydia and witnessed the whole thing.

After, Harris told one reporter, "Heston's the only man who could drop out of a cubic womb—he's so square. We never got on. The trouble with him is he doesn't think he's just a hired actor, like the rest of us. He thinks he's the entire production. He used to sit there in the mornings and clock us in with a stop-

watch. I got sick of this, so I brought an old alarm clock and hung it around my neck and set it to go off at the moment he walked in one day. 'I don't find that amusing,' he said. 'Well,' I said, 'you know what you can do, don't you?'" Harris tried to figure out a way to put some LSD in Heston's coffee "to loosen him up," but never found the chance. One of the crew members, who also disliked Harris, slipped a lit firecracker into his boot.

When the film wrapped, Columbia took it away from Peckinpah and removed most of the scenes Heston had paid to finish. In his journal he noted that he still wanted to make a real Civil War film, because this one wasn't it. He also had a pang of remorse over the way he and the others had treated Harris:

> I seem to have been unloading all my
> frustrations over the location on poor Dick
> Harris. In retrospect, I was unfair. It was
> a grueling location, and Dick wasn't used
> to working with either horses or guns. If
> he was a fuck-up, I was a hard-nosed son
> of a bitch.

As for the much-publicized return of his salary, Heston went into detail explaining to the press how

everything became so complicated, and that he felt
he really had no choice but to support his director:
"The more incidents you put into a film, the flatter
the [characters] become. It was Willie Wyler's genius
that brought the people to the foreground in *Ben-Hur*.
But Christopher Fry who wrote the script told me he
thinks it would have been a better picture if some of
the incidents and the love story had been left out. All
you cared about was the conflict between Ben-Hur and
Messala . . . I have learned through the bitter bleeding
years, you've got to have a good script before you start.
When Sam Peckinpah brought me the script [for *Major
Dundee*], we both agreed it would have to be rewrit-
ten. 'Who will do it?' I asked. 'I will,' Sam said . . . It
meant postponing the picture for four months. I had
no approval of anything nor a percentage—just an old
straight six-figure flat salary. We made the film in
Mexico. It went six days over-schedule. They wanted
to cut some of the scenes that Sam considered vital to
the story. We had several fighting meetings with the
front office. I supported Sam. I wanted to give his tal-
ents every chance to succeed. I said to the bosses, 'I
will give you back my salary and then you can afford to
keep these scenes in the picture.' I felt a moral duty to
make the gesture because by interfering I had breached
my contract. I didn't expect them to take me up on it.

But then they did, what could I do? I couldn't say, 'Hey give it back to me.' "

Later on, always the coherent rationalist, he said, "At least I got my meals paid for." And still later, he expressed a slightly different perspective on what went wrong with *Major Dundee* that was probably closer to the mark: "The film failed because the studio, Sam and I all had different pictures in mind. The studio thought we were making a cavalry-and-Indians movie. I wanted to make a film about the Civil War, and Sam wanted to make *The Wild Bunch*, which he did a couple of years later."

Too many talented cooks to make a couple of boiled hot dogs.

At the end of April, having completed filming in Mexico, Heston and the family returned to Los Angeles, where he looked forward to enjoying the simple pleasures of getting up early, dropping Fraser off at school, stopping by the studio, taking the leisurely drive back to Coldwater, going for an afternoon swim, then sitting by the pool and reading new scripts. The routine was calming, but Heston still retained some anger and regret over what he now considered the wasted opportunity to make *Dundee* a better picture, not to mention the money he'd put up to finish a film he

wasn't sure anymore had been worth it. He began to take out his frustrations on those nearest to him, especially Lydia, with whom he started bickering over meaningless things that escalated into arguments that always ended with him apologizing. He later summed up the secret to the longevity of his marriage to Lydia this way: "You've got to pick the right girl in the first place. And much more important, as a husband you have to remember the crucial importance of three little words—'I was wrong.' That will take you a lot further than 'I love you.'"

In the first week of May, Heston was on a plane headed for Rome, family in tow, to begin work on a film that he hoped would be a return to form and replenish his bank account. He had accepted an offer from Twentieth Century-Fox, via Citron, to star as Michelangelo in the studio's $7 million screen adaptation of Irving Stone's *The Agony and the Ecstasy,* to be shot in two versions, one in Todd-AO and one in CinemaScope.* Fox had

* Because of its superior picture quality, the film was released on DVD using the Todd-AO version. Todd-AO was a 70 mm film format developed jointly by producer Mike Todd and the American Optical Company. *The Agony and the Ecstasy* was shot with two systems because special equipment was needed to project Todd-AO and not many theaters were equipped with it, while CinemaScope required only a special lens that fit on most

purchased the rights to the 1961 biographical novel a year before it was published and commissioned Philip Dunne to write a screenplay that would be directed by Fred Zinnemann, with the ideal cast of Burt Lancaster as Michelangelo and Laurence Olivier as Pope Julius II. When both actors turned the film down, Spencer Tracy was offered the role of the pope, and he too declined. Carol Reed was then brought in to replace Zinnemann and Rex Harrison was cast as the pope. Reed had made several movies Heston admired, none more than *The Third Man* (1949), in which Orson Welles does some of his best screen acting.

Dunne's screenplay focused on the four-year battle of wills between Michelangelo and Pope Julius II over the painting of the ceiling in the Sistine Chapel; Heston called it "the best screenplay I had ever read." He had done well filming another Stone novel, *The President's Lady,* and signed on to play Michelangelo for a sizable percentage of the gross, starting from the first dollar the film earned; no matter how expensive it was to make or if Fox broke even, his money would be the first paid. As far as he could see, the deal had no downside.

He spent the weeks before production began re-

projectors. Todd-AO Company is no longer used and the company eventually went bankrupt.

searching everything he could find about the artist—his familiar, comfortable route to finding his character—including six hundred letters written by the artist. "Letters are usually the best material for finding out the true character of a person, the most valuable research of all. Michelangelo's personal letters showed his deep misanthropy, his antisocial, paranoid nature."

He was surprised to discover that the great artist considered himself a sculptor more than a painter and had done only two major painting projects, the ceiling of the Sistine Chapel and the wall behind the chapel (*The Last Judgment*). It led him to conclude that Michelangelo was really an outsider with enormous talent, forced to paint on assignment against his will. Somewhere in that revelation he found a parallel with his own place in Hollywood, the pope an amalgam of all the studio heads, directors, and even costars who had misused or mistreated him, who thought of him as a moneymaking commodity rather than the artist he believed he was.

Still, his biggest challenge was understanding the nature of Michelangelo's intensity. As he told one reporter, "I had only played one genius before: Thomas Jefferson, but Michelangelo was the first genius I ever played who was also a great artist." He later added, "I know from my own failures as an actor the kind of

frustration that is involved. I'm sure that when Michelangelo finished his great sculpture of Moses, he must have stepped back and raged at it. I'm sure he said something like, 'Why can't you *speak!*' "

To try to capture the technique as much as the emotion, Heston studied local marble sculptors at work and then spent long hours trying to, if not master the craft, at least look like he knew how to handle the tools. He read material on fresco painting. And he increased his workout schedule, as the filming, while less strenuous than a chariot race or walking through the Sinai desert, would likely require hours-long sessions on a scaffold platform, not to mention all the fresh paint that would undoubtedly splatter and run down his face and clump his hair in bunches.

Left out of all of his available research notes was any mention that Michelangelo was homosexual, something that Heston did not believe. "There's no record of his being gay," he declared, in the face of overwhelming evidence to the contrary (beginning with Michelangelo's poetry), "but if there had been I wouldn't have played him as straight . . ." Also, the real Michelangelo stood five feet, four inches and was decidedly not the leading man type, a physical disparity that Heston used as another way into playing him, emphasizing stature over size: "He was four times the size of any man."

As MGM had with *Ben-Hur,* Fox now placed all its cards on *The Agony and the Ecstasy.* The studio had just suffered a potentially fatal investment that had left it at the brink of bankruptcy: the production budget for 1963's *Cleopatra,* a vehicle for Elizabeth Taylor, was $2 million but cost Fox more than $31 million to finish, making it the most expensive film ever produced by a Hollywood studio at the time (Taylor's negotiated fee began with a base of $1 million that turned into $7 million after all the overtime and penalties were factored in).* The studio was willing to give Heston the participation deal Citron pushed for, believing his popularity in period films would put a much-needed influx of immediate cash back into its coffers.

Filming began in Rome on June 8 with a scheduled three-month shoot, and Heston brought the family with him (he always filmed abroad during the summer so Fraser would not miss any school time). They arrived just in time to celebrate Fraser's ninth birthday. The morning after, Heston settled into his usual location routine, rising at dawn and going for a swim and exercising, followed by a long steam, breakfast with the family, and some more exercises. For lunch he

* Although it took years, the film did eventually gross $57 million, enough to bring it to a break-even point.

had a protein drink, or a high-protein stick that had originally been developed for astronauts, and a glass of tomato juice. After filming, dinner was usually a steak or a whole fish, washed down with a bottle or two of cold beer.

Before any filming began, production was delayed when the long and at times tortured negotiations with the Vatican to allow filming to be done in the actual chapel fell through at the last minute, and Zanuck had to scramble to find a place big enough to build a usable replica. He settled on Dino De Laurentiis's studios just outside of Rome, which at the time had the largest soundstage in Europe. The real ceiling of the Sistine Chapel was photographed, and the faded colors restored to their original hues in an impressive replication. While that was happening, apart from his training schedule, Heston joined the family on long walks through the Appia Antica and the Hadrian ruins. He even managed to steal Lydia away to Rome for a romantic evening, leaving the kids with Mabel.

The following week, during a few free hours he planned to use viewing the real Sistine Chapel, Heston decided to visit the still-standing sets of *Ben-Hur* and was saddened to see that grass had grown over the entire chariot track and the stables were completely gone. At least that Rome would live on in the film. He

then visited the Sistine Chapel, to see the ceiling in person and contemplate the ecstasy of the achievement, despite all the agony it took to create. In his diary that night, he compared the artist's suffering with that of Jesus's on the cross, "wrought there over the four years he was nailed to its ceiling."

Once filming began, Lydia, with camera in hand, chronicled its progress, while the children found their own places to observe all that went into the making of their dad's movie. Fraser: "I feel like I grew up on movie sets. That's what my childhood memories are all about. My dad would always find a good place for Holly and I to watch, out of the way of the shot, not in the actors' line of sight, and that was safe. He'd tuck us away so we could see everything that was going on. During breaks he would take my mother and me and Holly across the set, under the lights. Sometimes by myself I would sit on an apple box and watch it all for hours. Between sets Dad would come over and say, 'Tiger'—that's what he called me when I was a young boy, or 'Fray'—'are you bored? Do you want to color, or go to my trailer and watch TV?' and I'd say, 'No, Daddy, I just want to sit here and watch.'"

By September, Heston had put his last strokes on the ceiling—what had taken Michelangelo four years that felt like a lifetime had taken Heston three months

that felt like four years. The great artist was ten years younger when he painted the Sistine Chapel than Heston was when he played him, and he found this his most physically challenging role yet. When filming concluded, he was certain he had done his best film work to date.

The family flew out of Rome and made a brief holiday stopover in Paris before going on to New York City. In the limo ride from the airport to the Tudor City apartment, Heston could see the city in the distance bathed in the sun's golden reflection and wrote in his diary, "As we drove into Manhattan, the paling lines of buildings were incredibly beautiful. Eighteen years and a couple of weeks ago, I came here for the first time . . . Eighteen years . . ." He could feel the afterburn of aches and pains that came with both his age and his experience, like a ballplayer who gives up in youthful enthusiasm what he gains in knowledge of the game. Heston wondered if this was the film that would return him to the high level of commercial and artistic success he had experienced only twice before, with *The Ten Commandments* and *Ben-Hur;* if, in a sense, he could ever really go home again.

Charlton Heston, 1965. (Courtesy of the Heston Family)

Chapter Twenty-Four

*T*he *War Lord* was Heston's next film, the project Seltzer had first begun thinking about for their initial foray into production two years earlier via Court Productions. It takes place in eleventh-century Normandy and tells the story of Chrysagon de la Creux (Heston), a knight of the Duke of Normandy charged with defending a Druid village in the Norman marshes along the Channel coast. He aids his brother Draco (Guy Stockwell) and their manservant Bors (Richard Boone) in driving out the invading Frisians from the Netherlands and Germany. To add some authentic British flavor to the cast (and some additional foreign box-office heft), Maurice Evans was brought in to play Priest, and the aging Henry Wilcoxon found his way into the project, at the personal invitation of Heston.

The film is, at its best, a deglamorized depiction of medieval feudal life, with a little bit of Hollywood mixed in to heighten its commercial appeal. During his stay in the village, Chrysagon spies Bronwyn (Rosemary Forsyth), a peasant teen beauty, bathing in a stream and rescues her after she is taunted by his own soldiers. He is, of course, smitten but soon discovers she is engaged to her childhood sweetheart, Marc (James Farentino), the son of the village leader. Following the local custom of *le droit du seigneur,* the night of her wedding Chrysagon has his way with Bronwyn. Although he is supposed to return her to Marc the next day, he refuses to do so. Conveniently, she doesn't want to leave either, having fallen in love with Chrysagon. Her new husband is enraged and rallies the residents of the town to storm the castle, and they imprison the war lord. Eventually Chrysagon is freed and defeats both the locals and the invaders, but he is wounded in battle and dies in Bronwyn's arms. Heston wrote in a Hemingwayesque speech for Chrysagon, of the "Where you go, I go" type, which he took almost verbatim from *For Whom the Bell Tolls.* And if Heston saw the makings of Shakespearean tragedy in *The War Lord,* none of that vision made it to the screen, thanks in no small part to the pedestrian direction by Schaffner, who Heston had

hoped would bring some of his touches from the live TV production of *Macbeth* they had done together. Unfortunately, that did not happen.

Still, if audiences had little interest in the intricacies of eleventh-century bridal-sharing customs, the action sequences were the film's real money shots, and as always, they were Heston's strongest suit. He wisely put Joe Canutt in charge of the second unit and he shot them on location in the marshlands of Marysville, California, just outside of Sacramento, that doubled as the Druid village (the interiors were filmed at Universal Studios). During production, Heston was asked by reporter Harrison Carroll about appearing in nonhistorical films. Heston's answer was familiar and jovial, and a bit revealing of how he saw his place in the hierarchy of Hollywood: "I'd like to [make some], but I think that Cary Grant and Jack Lemmon split all those roles between them."

The question was well-intentioned and Heston's answer was good-humored. Of the fifteen films he'd made since 1955's *Lucy Gallant,* only five were set in the present, and none of those was successful. By the time of *The War Lord,* he was well aware that he had branded himself into a type of character that, as he was on the other side of forty, would have increasingly limited commercial appeal.

While Heston was busy toiling in the celluloid world of the eleventh century, Lyndon Baines Johnson was running for a full term as president of the United States against Barry Goldwater, who represented the conservative wing of the Republican Party. Campaigning for Goldwater was Ronald Reagan, who made his famous "Rendezvous with Destiny" speech on a Tuesday night in October that was broadcast live to the nation and confirmed Reagan's shift from a Roosevelt Democrat to a Goldwater Republican (although he did borrow his "rendezvous with destiny" phrase from FDR's 1936 acceptance speech for his party's nomination).* The Democrats also wanted an actor who could deliver the goods for their candidate that effectively. They sought out Heston, and he likely would have agreed to campaign for Johnson if he hadn't been in Rome filming *The War Lord.*

In his memoir, Heston tells an interesting, obviously apocryphal, but effective story of how he recognized he was shifting his allegiance to the political Right: "We worked very long six-day weeks out of Marysville [filming *The War Lord*] . . . that was then empty country, with only one intersection on the route. There was a large billboard featuring a portrait head of Barry

* Also known as "A Time for Choosing."

Goldwater on a field of blue. There were only seven words of copy—'IN YOUR HEART, YOU KNOW HE'S RIGHT.' . . . [I]t made me very uneasy to drive by that billboard every day—'IN YOUR HEART, YOU KNOW HE'S RIGHT.' But one morning there was a convoy of trucks coming through the crossroad. As we waited, I experienced a true revelation, almost an epiphany, like St. Paul on the road to Damascus. I looked at that photograph of Goldwater and said, softly, 'Son of a bitch . . . he *is* right!' And I knew he was."

That May, Heston accepted an invitation to open the swanky new Mill Run Playhouse in Chicago, playing Sir Thomas More in a limited run of *A Man for All Seasons,* which he considered one of the finest dramas of the twentieth century. He signed on when the producers agreed to his request that Lydia play Alice More. She hadn't performed in years, and he knew she missed it and at times felt left out of the action. He wanted to do something to help remedy that.

The play opened to strong reviews for both Heston and Lydia.* They were thrilled to be back on the

* *Variety* used some of its special headline lingo to announce the Heston's opening on May 4, 1965: "Heston, Wife, to Tee New Silo in Chi."

boards together after so many years, and Heston would have happily extended the show's run; there was talk of bringing it to Broadway, which didn't happen. As always, they brought the children with them. Holly remembers, "My father loved to work, and my mother, who always accompanied him when he traveled on location in the States or abroad, she found her own joys in life. She absolutely loved and adored going on these trips. While my dad was filming or making official appearances, she would build on another trip wherever we were. She would do research on nearby places—on the churches, the ruins, whatever was there—and that would become part of our journey. These were educational explorations rather than beach trips, and for Fraser and me, it was the best education. When they did the play, it was wonderful to see them together onstage."

By November 1965 Heston had steadily climbed up the ranks of the Screen Actors Guild. He was assigned to the board by Reagan in 1960 to help with the strike, became the third vice president in 1961, served as second vice president from 1962 through 1965, and that year replaced the liberal left-wing actor Dana Andrews as president. Andrews had stepped down after two one-year stints, citing his heavy workload as the reason (he

made eight movies his last year in office). Former guild president Reagan had urged the membership to elect Heston, but he likely would have been elected without Reagan's endorsement, for all the tireless work he had done for SAG. As soon as he had returned from Rome, and before going to Chicago, he was once more dispatched by the union to Washington to lobby for better tax incentives to keep American films from being made overseas. From there he met up with Lydia and the children when they flew into D.C., and together they traveled to Nigeria on a State Department–sponsored goodwill tour. Heston described the trip in his diaries as an obligation left over from a commitment he had made to Kennedy just before his assassination. Nigeria had huge natural resources and a British-trained bureaucracy, and JFK wanted to keep the country in the West's sphere of influence. He liked to send celebrities there as goodwill ambassadors, what one observer called the movie stars' Peace Corps.

Also in November, *The War Lord* opened to strong holiday season competition at the box office. The big films that year were *A Patch of Blue*, with Sidney Poitier coming off his Best Actor Oscar win the previous March for his performance in 1963's *Lilies of the Field; Doctor Zhivago*, David Lean's highly anticipated adaptation of Boris Pasternak's bestselling novel, star-

ring Omar Sharif and Julie Christie; *Thunderball,* with Sean Connery returning as James Bond; Disney's *That Darn Cat!* starring Dean Jones and Hayley Mills; the Beatles' *Help!;* and *The Sound of Music,* starring Julie Andrews in what would be the year's highest-grossing film, earning a phenomenal $164 million in its initial theatrical release.

The Agony and the Ecstasy had already opened in September to kick off the fall season, but it couldn't find an audience and only grossed $8 million, approximately what it cost to make (translating to an $8 million loss, as a film needs to gross twice its negative cost to break even). The film came in at number 19 of the top 100 films of the year, one notch behind John Schlesinger's swinging London black-and-white neo-documentary *Darling,* starring Julie Christie, that cost $500,000 to make and grossed $12 million, and one notch ahead of *Do Not Disturb,* a $4 million Doris Day romantic comedy that earned twice as much. *The War Lord,* which cost $3.5 million to make, failed to make back its negative cost and landed out of the year's top 100 at number 107.

It was not difficult to see that the most popular films in America were increasingly being made abroad and intended for international audiences, with young, romantic, sexy, hip stars. Those roles were no longer

available to Heston unless he hired himself (via his partnership with Walter Seltzer) or the film was not founded on a romantic involvement. *The Agony and the Ecstasy* was devoid of any young, romantic lovers (Diane Cilento played the only significant female role, that of Michelangelo's nurse when he collapses from fatigue) and *The War Lord* had little sensual appeal.

In January 1966, Sheilah Graham, one of the last of the powerful, gossipmonger syndicated Hollywood columnists, wrote, "Producers just don't see [Heston] as a 20th Century man," and quoted one theater chain executive's complaint to filmmakers that historical movies were no longer profitable if they didn't have a contemporary love story that showed some skin: "Don't give me any of those pictures where they write with feathers!"

Graham had interviewed Heston several months earlier for the piece, and he had confirmed the truth of that statement to her. "I was gradually sneaking up on the 20th Century, one picture at a time, but now I'm back sliding toward antiquity once again. *The War Lord* [took] place during the 11th Century and my role of John the Baptist in *The Greatest Story Ever Told* [took] me back to B.C. where my career began . . . the characters I play seldom have time for girls. If I'm not leading the Jews out of Egypt or besieging Valen-

cia I seem to be baptizing someone. I've played Moses, Andrew Jackson, Thomas Jefferson, Michelangelo and other great men of history and fiction. [A] character like Marty [played by Ernest Borgnine in the Oscar-winning film of the same name] is easy because the problems and choices are faced by everyone in day-to-day living [but] an actor is followed by the shadow of all the parts he plays. I imagine that applies especially to me."

Indeed, it was not difficult for Heston to read the handwritten scripture on the wall, and with the financial failure of *The War Lord*, he was determined to try to change his screen image, which is why he turned down one of the leads in Ken Annakin's *Battle of the Bulge*. It wasn't necessarily because *Bulge* was historical—World War II was still fresh in the minds of older moviegoing audiences and continued to provide a seemingly endless supply of subject matter—but because he would be surrounded by other big stars all on the downside of their careers, including Henry Fonda, Dana Andrews, and Robert Ryan, playing cardboard clichés of American officers in a script that was a slave to the film's action sequences and never bothered to explore the internal workings and motivations of its characters (the film was released in December 1965

and would earn back only two-thirds of its $6.5 million production cost in its initial domestic release).

The official reason Heston gave for turning down the film was a useful one that was at least partially true: it was going to be filmed in Spain and he wanted to spend more time at home on the ridge with his family. But it was also true he was actively looking for more contemporary parts that would lower the median age of his audience.

To that end he had optioned a screenplay called *Quarterback,* intending to play the lead role of a football player, a part he was, realistically, at least ten years too old for, and for those reasons he couldn't find any outside funding for it. Producers wanted him only in period costume, fighting in hand-to-hand combat and riding off on his horse into a wide-screen sunset. And he wanted to make more films in Los Angeles, to help support the SAG policies that, as the guild president, he was more inclined to support. "From now on," he announced, "I shall try to stay more in Hollywood. I owe it to my fellow actors who elected me [president of SAG] to stay closer to home."

"My dad cared about his fellow workers in Hollywood, about their welfare," Fraser said later. "He always used to say the guild wasn't there for stars—they

didn't need looking after; they weren't paid scale, or needed wage protection, job security, etc.—it was there for the [Hollywood] working actor earning on the average less than $2,400 a year, to see to it he could pay his rent and feed his family. He knew he was privileged and wanted to help those less fortunate than himself." Money was an issue for another reason as well; Heston had recently discovered through an audit that he had been cheated out of profits that was due him by Bronston's creative bookkeeping. Finances were easier to track, he now believed, when the films he made came out of Hollywood.

Unable to get his football film going, Heston continued to read scripts Citron sent over, one of which was by Robert Ardrey, called *Khartoum*, that he had first heard about years earlier when he was pitched it during a breakfast meeting at the Beverly Hills Polo Lounge by producer Julian Blaustein. *Khartoum* was about the British defense of the Sudanese city of Khartoum against the Muslim Mahdist army in 1884–85. At the time, Laurence Olivier was committed to star in it as the leader of the Mahdists, and Lewis Gilbert was in place to direct. Heston was eager to work with Olivier and agreed to do the film, until Gilbert decided he wanted Burt Lancaster instead of Heston, after which the project fell apart over funding issues (Gilbert went on to

make *Alfie* instead, a film that made Michael Caine an international star). In the interim, Blaustein found the money for *Khartoum* overseas and was able to secure an international distribution deal at United Artists. With Olivier still committed, and having added Ralph Richardson and Richard Johnson to the cast, Blaustein sent the script to Citron, who, in turn, passed it on to Heston.

Over lunch with the producer and Citron, he agreed to be in the film. When Blaustein mentioned he hadn't yet found a director to replace Gilbert, no longer with the project, Heston suggested Carol Reed. Blaustein liked the idea, but Reed, who wanted to do it, had prior commitments he couldn't get out of and had to pass. Blaustein then signed veteran British director Basil Dearden to film the story of the siege of Khartoum.

Heston was to play General Charles Gordon in a star-studded cast made up of the cream of the British stage and screen, and he welcomed the chance to work again with Olivier, whom he considered "the greatest actor of our day."

During preproduction, Heston and Olivier met for dinner one evening in Hollywood, and they chatted less about the film than their experiences as fathers. Heston noted, "We were talking today about how difficult it is to have a daughter. Larry has two, the oldest

one is four. So is my daughter Holly. A daughter is a woman. A son is a ticket to immortality. With a son a man gets to do it all over again. He can do all the things he couldn't do as a boy. He can make the same mistakes and go through the same process. It is a remembering of what it was like to be a boy. Having a girl is like wooing a tiny woman—and don't think they don't know it. Larry was saying, 'I do feel sorry for the man who has no daughter.' "

Filming was tentatively slated to begin sometime that winter in Egypt and London, so as to accommodate Olivier's busy schedule. "It was a coup for Julian Blaustein to snare L.O. for the pic," Heston said later. "Olivier was tied up two more years with the National Theater and it was incredibly difficult to get him for *Khartoum*." Blaustein agreed to three weeks of filming at London's Pinewood Studios in extra-wide and super-expensive Ultra Panavision 70, with the remainder of Olivier's scenes set to be filmed in Egypt with him doubled in long shot.★

Filming *Khartoum* on location marked Heston's

★ *Khartoum* was the last feature to be shot in true 70 mm until Quentin Tarantino used it for his 2015 western spectacle, *The Hateful Eight*.

fifth trip abroad in the past twelve months and created an awkward situation for him, as it was a direct contradiction of his renewed promise to make his movies in America. He knew it would cause a stir, but he decided the chance to work with Olivier was more important to him than industry politics.

With the children and a new nanny in tow, Mabel had retired and was replaced by a young German girl named Dore, the Hestons flew to New York and set sail on the *Queen Mary*, bound for Southampton. During the voyage, Heston worked on trying to master a Victorian accent. Most of the films he'd made, especially the historical ones, were aimed at an international market that expected to hear Heston speaking "American." Producers always preferred having a Hollywood star because of their stateside box-office clout, and Blaustein was no exception. If his film had an all-British cast, he believed, it wouldn't do nearly as well in America. Although virtually unknown there, the nineteenth-century British general Heston was portraying, Charles "Chinese" Gordon, was a huge military hero and something of a folk hero in England, a veteran of the Crimea War who had also helped the Chinese put down the Taiping Rebellion (1850–1864), a long guerrilla-driven civil war that had attempted to overthrow the Qing dynasty. *Khartoum* focuses

on General Gordon's later exploits in the Sudan. As Heston put it, "Gordon is one of those cross-grained kind of men the English seem to produce at intervals. The soldier fanatic like Lawrence of Arabia . . ."

Heston was more than a little aware of T. E. Lawrence and his achievements, and the movie version of his life that had made Peter O'Toole a star in America. Heston wanted *Khartoum* to have that kind of success. He knew American audiences normally didn't seek out foreign history lessons when they went to the movies; they wanted to be entertained. O'Toole's sensational performance was the key to the popularity of *Lawrence of Arabia*, not its history (which is fairly inaccurate). Heston hoped his portrayal of the equally fascinating Gordon would make *Khartoum* his *Lawrence of Arabia.*

It wasn't. Dearden's dreary direction managed to bury Richardson and Olivier beneath an over-convoluted script, and Heston looked old on-screen as General Gordon, although Gordon was a decade older than Heston at the time the film takes place. Besides the age factor, there was nothing especially remarkable about his performance, as the script ignored some of the interesting aspects of Gordon's real life. (Gordon, like Lawrence, was believed to be homosexual. In *Law-*

rence of Arabia, a film with virtually no women, this is a key element of the story. In *Khartoum,* where there are no female leads, it is not dealt with at all.) Heston would later admit, "I think *Khartoum* is the only picture I've made which I consider a very good picture that I didn't think was very well directed . . ." Later on, he added, "I tried to part the Red Sea again—but without DeMille, it wouldn't work."

While the film proved a big hit with London audiences after its June 1966 opening, it was largely ignored in America and failed to earn back even half of its $6 million negative cost in its initial domestic release.

With his last three films—*Major Dundee, The War Lord,* and *Khartoum*—all failing at the box office, Heston's career was on an undeniable downturn, and he knew it. In a diary entry written while he was making *Khartoum* (and would later quote in his memoir), he noted: "Largely liked by critics and me: *The Big Country, Ben-Hur, The Wreck of the Mary Deare, El Cid.* Busts with me and critics: *Pigeon That Took Rome, Diamond Head, 55 Days at Peking, The Buccaneer, Major Dundee.* Liked by me, not critics: *The Greatest Story Ever Told, The Agony and the Ecstasy . . .* There were not many I liked myself, let alone the critics. Obviously, *The Agony's* [critical] notices smarted a

bit. Actually a lot of them were very good. Even some of the critics who didn't like the film had good things to say about Rex and me. I expected a great deal more than that, though . . ."

Where he was going to find it, he didn't know. With the box-office failure of *Khartoum,* he wondered, on the occasion of his forty-second birthday, if he had lost the magic touch that had turned some of his earlier, leaden movies into box-office gold. And if so, what could he do to get it back? As he told one reporter, "I don't seem to fit really into the 20th Century."

His friend Ronald Reagan might have said he hadn't changed, his audiences had.

If that was true, and all signs pointed to it being so, the challenge for Charlton Heston became: Could he ever get them back?

Heston, the constant diarist. (Courtesy of the Heston Family.
Photo by Lydia Clarke Heston)

Intermission

BOOK TWO

Hollywood's Last Icon

A screen star pontificating on politics is about the equivalent of a high school boy describing the charms of Sophia Loren; he's just in way over his head.

—*Charlton Heston*

Charlton Heston visiting the troops in Vietnam, 1966. (Courtesy of the Heston Family)

Chapter Twenty-Five

Herman Citron continued to operate like the effi-
cient machine he was, humming along smoothly
as he searched for the right film projects for his clients.
Big clients, big films, big paydays, big profits—that
was his mantra. He had been a canny component in
Heston's Hollywood career almost from the beginning,
and the actor was grateful to have him as an agent, but
after his latest string of less-than-successful films, he
began to feel that Citron was perhaps pushing projects
on him to keep the cash flowing without much regard
for their cumulative effect on his career. He well un-
derstood Citron's process: acting was about work, work
was about money, and actors earned money when they
worked and so did he.

In Heston's Hollywood, it was both a blessing and

a curse when an agent's only measure of success was the amount of money his clients earned, when the bottom line was more important to him than the lines in a script. To an agent, it was always the newbies, the young "rebels," who wanted to make movies that *meant* something, and that marked them as naive in the world of industrial moviemaking. Citron could spot them coming a mile away. If he took them on, which was not very often, it was because he could see an eventual large return on his investment of time and placement. Sooner (he hoped) or later, or before it was too late, they would forget about the meaning of anything except the size of their bank accounts. If they wanted to talk about art, they should teach English lit at UCLA. Early on, he had agreed that Heston would have final approval of the films he made, as long as Citron could have the final approval of the deal, and neither would interfere with the other's field of expertise, even if that wasn't always the way their relationship really worked.

As for Heston, like every big earner, he always had a healthy paranoia about the sustainability of his career. The arc of popularity that translated into box-office returns for most top-of-the-line Hollywood actors was known in the business as steep and deep, about seven years max for a hot star (less for women), after which it became all about the next job, the next part, forever

searching for that one role to put them back on top. It was the nature of the beast.

With no scripts from Citron he liked, and after an offer to revive *A Man for All Seasons* for a Los Angeles theatrical production costarring Lydia ran into financial problems, Heston decided to make a trip to Vietnam to visit the troops.

It was, in a way, a decision to get himself out of town. He was convinced his career was stalled on a lateral trajectory—in his diary he described the negative reviews of *The War Lord* and *Khartoum* as feeling like "two swift kicks in the balls." In his memoirs, he wrote that he wasn't really sure why he went to Vietnam in 1966, other than it was a state-sponsored trip via the Hollywood Overseas Committee of the United Service Organizations (USO) and he had no good reason not to go.★

★ The USO was formed in 1941 by Mary Ingraham at the request of President Franklin D. Roosevelt, who sought to unite several service associations into one organization to lift the morale of the military and nourish support on the home front. Those entities—the Salvation Army, Young Men's Christian Association, Young Women's Christian Association, National Catholic Community Service, National Travelers Aid Association, and National Jewish Welfare Board—became the United Service Organizations. It is a private, nonprofit organization that depends on donations and grants. No performers are ever paid for their appearances.

As early as 1966, the war in Southeast Asia was escalating out of control, and President Johnson was not just looking for a military victory there but, with reelection looming in the near future, a public relations one at home. He was eager to "sell" the war to an American public increasingly unwilling to buy. At the request of the White House, the USO arranged for Heston's visit in order to, according to its official announcement, "help the morale of the American troops there." It was intended as a so-called nonpolitical hand-shaking, talking, and listening tour among small groups of American soldiers. As a World War II veteran, Heston was always on the side of the soldiers and welcomed the chance to tell these GIs that America hadn't forgotten them. "There's so much extremism from both sides on the Vietnam question," Heston said, "I thought there's a place for a moderate view." Meaning his. He wanted to see the situation for himself and possibly write about his experience there.

Fraser thinks his father believed it was his duty as an American and a veteran to make the trip: "He felt that he wanted to make a personal statement to the public, and also to fulfill the Texas code of honor, something like, 'You keep your promises, you never cut and run, you attend all wars, and you don't shoot quail on the ground.' The fellow who taught him that

was his friend Jack Valenti, the special assistant to LBJ before he became president of the MPAA and instituted the modern film rating system. Dad felt he wanted to attend that war in some capacity that would be useful, and he realized that he could go out and give these poor guys on the ground in all these shithole outposts some personal thanks, with a personal touch from an American who didn't think they were monsters, just young guys stuck in a terrible situation. He wanted them to feel they were appreciated back home, not forgotten. He couldn't sing and dance, he couldn't tell jokes like Bob Hope, but he could go there, meet the soldiers, eat their shitty food and share their muddy trenches with them, and shake as many of their hands as he could, which is exactly what he did."

Vietnam had been a thorn in the side of the West for decades. With the defeat of the Japanese in 1945, Ho Chi Minh took control of Vietnam and the French, who had colonized the country in 1862, tried to take it back from him. When they were defeated in 1954, the country was divided into North Vietnam (Communist) and South Vietnam (non-Communist), and president Eisenhower called it a defeat for the free world if South Vietnam fell to the Communist North, one that would snowball, the basis of the famous domino theory. Eisenhower sent in the CIA to try to disrupt the insur-

gency from the north. When JFK took office, he kept sixteen thousand "special forces" in South Vietnam, but shortly before he was killed he had said he intended to withdraw America's soldiers. After the assassination, LBJ decided to expand America's presence in Vietnam, a move that created a firestorm at home and exacerbated a brutal generation gap that threatened to bring down his presidency.

By the time Heston made his trip, the president's Operation Rolling Thunder was in full force. By January 1966, America had four hundred thousand combat "advisers" on the ground fighting an undeclared war against North Vietnam and, indirectly, Mao Zedong's People's Liberation Army. With morale falling among the soldiers and demonstrations at home escalating, LBJ and the Pentagon launched the Hollywood Overseas Committee, which worked under the auspices of the USO and arranged for many of Hollywood's biggest stars to go to Vietnam to entertain the troops. Among them was Bob Hope, who mounted several shows with name entertainers, big-band orchestras, and showgirl types that aired on TV. When Heston agreed to go, he wanted to keep his visit a one-man operation and try to reach those soldiers who didn't normally get a chance to see any big-name entertainers from home.

He left Los Angeles on January 13, 1966, en route to

Vietnam via commercial flight to Hawaii, then a military plane filled with replacements, arriving two days later. Several reporters accompanied him, courtesy of the USO. "Out there Ben-Hur rode a chopper, not a chariot," reported columnist Victor Riesel. "Into the foothills of South Vietnam, into tiny jungle clearings and thigh-deep rice paddies, he drove a personnel carrier, rode an Am-track and roared along in a tank on a project virtually unknown to the folks back home."

Heston and the reporters were surrounded by soldiers everywhere they went; the last thing the government wanted was a celebrity casualty, and it made sure that wasn't going to happen. From Saigon, Heston was flown to Da Nang, closer to the front lines of the war. There, with the sound of helicopters hovering above, Heston visited American soldiers crowded into makeshift barracks, where every GI seemed not just ready but eager for battle. Another stop he made was in a remote part of the Montagnard highlands near Le Hai, where he drank a mixture of rice wine and blood taken from a freshly killed bullock given to him as a joke among the marines, who had befriended the locals and set up camps on their turf. Heston could barely keep it down, but he laughed along with the boys, happy to be considered one of them now.

On January 19, Heston visited a hospital close to the

DMZ, where for the first time he saw the spilled blood of the war. Mud-caked bodies were laid out on stretchers everywhere, as doctors tried to stanch the bleeding to save their lives in makeshift operating units. Heston knelt beside one wounded soldier, asked him how he was doing, and said he'd be happy to call the boy's mother or girlfriend when he got back home. One name became ten, ten became a hundred, and a hundred became four hundred. Heston filled a spiral notebook with their names and phone numbers, and he made it his business to personally call for each and every one of them back in L.A.

Heston's visit to Vietnam had a powerful effect on him. He saw firsthand that the war was more dramatic than anything he had seen so far in American news stories. It reminded him of his days in the Pacific. If he were younger, he knew, he could be one of these soldiers. "Like everyone, I had my doubts, misgivings, questions [about the war in Vietnam] . . . I talked to the men, outposts, small complements. I found no doubts there . . ."

Heston returned home with a better perspective on Johnson's military expansion. He wrote in his diary, "I'm concerned about Vietnam just as everyone is. It seemed to me that the people I had talked with who knew the most about it were those who had been there

and since I was able to go, I did . . . I didn't find a solu-
tion . . . I didn't go looking for one. There is no easy
solution [to what is a moral issue, not an imperialistic
one]."

One thing he was sure of: seeing those baby-faced
soldiers laying their lives on the line moved him deeply,
and he felt a renewed sense of gratitude for living in a
country where he enjoyed the privilege of freedom.

As soon as he could, he called Richard Zanuck,
Darryl F. Zanuck's son, who was the new head of pro-
duction at Twentieth Century-Fox, and Zanuck gave
him free office space and secretarial assistance to help
him contact the four hundred names by phone and to
mail out personal handwritten notes of gratitude and
reassurance.

Not long after, the funding finally came together
to bring the previous summer's revival of *A Man for
All Seasons* to L.A. via producers Nick Mayo and
Randolph Hale, who wanted it for their huge, circu-
lar Valley Music Theater in tony Woodland Hills, just
north of Hollywood. It would be the first time the
Hestons performed live together onstage in Los Ange-
les. Although he was quite familiar with the role, his
trip to Vietnam made him feel as if he had never before
quite gotten a full grip on the character of Sir Thomas
More. The line he loved most in the play became a

mantra for him in real life, a quote by Sir More that Heston increasingly used by way of an answer, when decisions he made concerning his choice of films or his politics were questioned by press: "When a man takes an oath, he's holding his own self in his own hands like water. And if he opens his fingers then, he needn't hope to find himself again." To him it meant that adhering to one's principles outweighed whatever consequences resulted, and if you didn't, you had nothing.

After a brief series of rehearsals, *A Man for All Seasons* opened on March 2, 1966, to raves, with all five of the then major L.A. print reviewers agreeing how wonderful the production was. Cecil Smith, at the time the dean of West Coast theater critics, wrote in the *Los Angeles Times* the following day that "rarely has any production [of *A Man for All Seasons*] been so enriching as that staged by the Valley Music Theater, with Charlton Heston as Sir Thomas More. Heston's saint has grit and iron and earth in him, great wit and a greedy appetite for life. The thing beneath the skin haunts him. Call it conviction, conscience; individual integrity . . . Heston's performance is magnificent, rooted in lush soil. He has caught not only the grandeur that was More and the saintliness and passion, but the guts of the man . . ."

It had been a long time, too long, as far as Heston

was concerned, since he had received such a high level of positive attention from both critics and audiences. The run sold out, and when the Hestons were offered a brief run of the play in Florida, they took it and again played to capacity houses.

However, his need (if that's really what it was) to reconnect with audiences was only partially fulfilled by performing live in a play. He also wanted to reconnect through his movies, if for no other reason than to see if he still could.

The Hestons arrived back in Los Angeles that August, and the next day Heston took off by himself to San Diego, where, as president of SAG, he was scheduled to represent its sixteen thousand members at the annual AFL-CIO convention for three days of parties, dinners, meet-and-greets, and, in between all that fun, actual business meetings. It all went quickly and easily, and Heston floated through it like confetti, until, when asked by a reporter whom he was supporting in the upcoming California state gubernatorial election, he made news when he said he was backing Democratic incumbent Pat Brown, whom he had voted for twice previously, even though he was running against Heston's friend and union mentor, the Republican Ronald Reagan.

It had long been a foregone conclusion among SAG's rank and file and throughout Hollywood that Heston would support Reagan. Eyebrow raising has always been one of Hollywood's favorite pastimes, and Heston's decision lifted them all over town. To him, it was a matter of politics over friendship. Reagan's platform included a surprising and surprisingly strong antiunion plank, which felt odd to a lot of his Hollywood friends who knew him when he was a pro-union activist whose strong leadership of SAG during the 1945 strike and later on helped to implement the residual payment system. Although Heston downplayed his support of Brown, he felt he couldn't support Reagan because of his current position on unions: "I am not an extremist on labor and will not be."

According to Fraser: "My dad and Reagan were friends, going all the way back to their days together at SAG. I think he learned a lot from Reagan about how Hollywood unions operated—negotiating, gaining a consensus, cordial discourse—and came to believe that it was a fundamental part of a democracy. I also think he liked Reagan's style a lot. And he also shared the idea of standing up for what he believed in, so when they had opposing stands on [Reagan's run for governor], it was not a deal-breaker for their friendship by any means. Later on, my parents were frequent guests

of the Reagans at the White House, and they flew with him on *Air Force One* during his presidential campaigns. I remember Ronald and Nancy coming over for dinner a couple of times.

"Where they really differed was that my dad was much more liberal in a social sense and in terms of the arts."

That September, Reagan won the governorship of California, and Heston was elected for a second one-year term as president of the Screen Actors Guild prompting reporters to ask him if, like his predecessor, he had any plans to use the guild presidency as a springboard for higher office. Heston said no, but he was hoping to get the new governor to encourage more film production in America by introducing legislation similar to the passage of the Eady Levy in Great Britain, where the monies from an added tax on movie tickets went to producers of films that were made there.

But before he even had time to savor his own election or push for an American version of Eady, personal tragedy intervened. The day after the results of the SAG vote were announced, Heston received word that sixty-eight-year-old Russell Carter had suffered a heart attack from which he was not expected to recover. Heston dropped everything and flew with his family to Detroit, and was at Russell's bedside when

he passed. After a brief memorial, a distraught Heston took his family to St. Helen. There, while a light but steady rain fell, they all went to a clearing in the woods his dad had cut out of the forest fifty years earlier, the place he had chosen to be buried. Heston helped lower the coffin into the ground.

After, he took Fraser to the house where young John Charles Carter had grown up, to the streams where the boy and his father had fished together, and showed him the targets still hanging from the trees where they had practiced shooting.

At sundown, they returned to town, where the rest of the family was waiting. He gave the boy over to his mother, as the whole family sat in quiet mourning. Everyone but Heston. He wasn't mourning. He was at peace, believing his dad was in a better place.

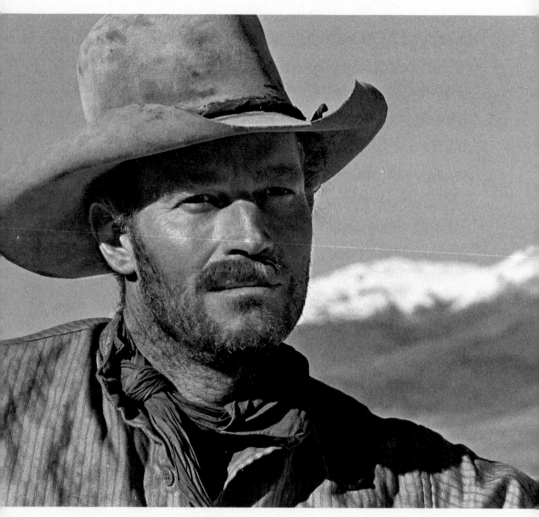

Charlton Heston as Will Penny. (Courtesy of the Heston Family.
Photo by Lydia Clarke Heston)

Chapter Twenty-Six

He was eager to get back to making movies. Citron had secured a "go" for a World War II melodrama at Universal called *Counterpoint* and convinced Heston to take it, after he had turned down a tempting offer by Elia Kazan to star in the movie version of his autobiographical novel, *The Arrangement*. Heston had wanted to work with Kazan until he read the screenplay and was disappointed by it. The role of Eddie Anderson—Kazan's suicidal on-screen other who is trapped in a loveless marriage, unhappy at his job, and unfulfilled by his mistress—had originally been offered to Brando, who turned it down for a number of reasons, he, too, disliked the screenplay. (After many delays, the film was finally released in 1969, with Kirk Douglas playing Anderson; it was universally panned by critics and

bombed at the box office, and effectively marked the end of Kazan's directing career).

The screenplay for *Counterpoint*, by James Lee and Joel Oliansky, was based on Alan Sillitoe's novel *The General*, about the conductor of an American symphony orchestra who, while on a USO tour in Belgium, is taken captive by the Nazis, during the Battle of the Bulge, no less. The story revolves around the tug-of-war between the conductor, Lionel Evans (Heston), and General Schiller (Maximilian Schell) that becomes a metaphor for Hitler's attempt to conquer the world. Twenty-two years after the end of the war, Hollywood was still going strong milking its seemingly endless commercial appeal.

Heston was appropriately stoic in his portrayal, and Schell reprised the charismatic, fanatical Nazi character he had won a Best Actor Oscar for in *Judgment at Nuremburg*. Unfortunately, Lee and Oliansky's plot got washed with too much soap: Evans is eventually (and miraculously) saved, and the two men on opposite sides come to "understand and respect" each other.

Counterpoint was a small film, produced by Dick Berg and directed by Ralph Nelson, a friend of Heston's from live TV. It was shot in ninety days on the 1923 *Hunchback of Notre Dame* sets still standing at Universal and released in March 1968, where it died

quickly and quietly at the box office. It was not, as Heston had hoped and Citron believed it would be, the film that marked his return to the top.

During production of *Counterpoint*, Heston was approached by a committee of Republican backers and asked if he would consider running for the California U.S. Senate seat that would be opening up in 1971. George Murphy, a former hoofer and president of SAG (1944–1946), and recipient of an honorary Oscar in 1951, had defeated JFK's press secretary, Pierre Salinger, in the 1964 election for it. While successful in helping other conservative candidates win their seats across the country, it was felt by the right wing of the Republican Party that Murphy was not popular enough in California to win reelection. The committee wanted Heston to run in 1970.

His reply was short, adamant, and direct: "Absolutely not. I've played three presidents, two saints and two geniuses. That's enough for me." Privately, he smiled when he told friends he couldn't afford to be a senator because of the cut in salary. Playing politicians was steadier work with better pay than being one.

There may have been another, more serious reason he said no: he did not like the vindictiveness toward Reagan from former friends in Hollywood who resented his move into politics. Hollywood was the least

friendly place in the country to the Reagans while he was governor. Heston wanted none of that for himself or his family. Nor did he want to have to leave the ridge and live in Washington, D.C.

At the same time Universal put *Counterpoint* into production, Citron found what he thought was the perfect career script for Heston, *Will Penny,* a rough-and-tough western that would better show off his physical attributes than playing a captured World War II orchestra conductor. Heston read it and liked it, but when Citron presented it to Dick Zanuck at Fox, he rejected it. Zanuck's position was understandable; westerns were dead at the box office, having found their place on network prime-time television, where they'd dominated the ratings for years. Moreover, with Heston's post-*Agony* films having not done that well—including *Major Dundee* and all the problems that went on with the studio with its filming—Zanuck wasn't sure Heston's name was still big enough to open a cowboy film.

He spoke to Heston about it, to make sure there were no hard feelings between them. Heston was disappointed, and then Universal and United Artists also passed on it, and he realized Zanuck had probably made the right decision. Citron, meanwhile, continued to shop the script and it eventually landed at Paramount.

Heston was excited that the project had been green-

lighted and that he would, after all, have a chance to play "an illiterate man of limited opportunities," and hoped a major director would be attached. "I read it and wanted to do it straightaway. I assumed that the man who wrote it, Tom Gries, was a historian or some kind of authority on the Old West, but he turned out to be a sportswriter who'd never written a script before. I said to Walter [Seltzer, the film's coproducer along with Fred Engel] that I thought we could get Wyler or George Stevens interested, but he told me that there was a snag. Gries wanted to direct it himself. I asked what he had directed before—nothing, said Walter. But the script was so good and I wanted so much to do it, that we finally gave in."*

Just before production began on *Will Penny*, Heston was invited to the unveiling of a new portrait of Franklin D. Roosevelt at LBJ's White House and asked to read a portion of Dore Schary's hit play *Sunrise at Campobello* as part of the ceremony, after which Johnson would personally swear Heston in as a member of the National Council on the Arts (NCA). That evening,

* Gries had actually written dozens of western TV episodes and a handful of film scripts prior to *Will Penny*, which was based on an episode Gries had written and directed for the short-lived Sam Peckinpah TV series *The Westerner*, titled "Line Camp."

Lydia held the Bible while Heston took the oath. He was happy and grateful she was a part of this. With all the extracurricular duties he had taken on lately for the State Department, SAG, and now the NCA, he felt he had not been spending enough quality time alone with her. He was always wary of upsetting the delicate balance they had managed to keep in their marriage, him off doing movies, her coming along when she could, herding the children, and taking her photographs. When she, which was increasingly the case, stayed behind and managed the affairs of the house. "You fall short of what you should contribute to each [assignment,] not to mention your career and your marriage," Heston wrote in his diary. He never wanted to take Lydia for granted. Nothing was worth that.

After an extensive meeting with Gries that somewhat alleviated Heston's concerns, he began to work on finding a balance in his acting between the "laconic flatness the character and dialogue require against the comment the scene often demands." In other words, how to play an interior character in the external context of a scene, something he continued to wrestle with as an actor. Ultimately, in this film at least, the problem would prove unfixable, because it wasn't an acting problem at all, but a script and a directorial one, which became increasingly clear to him as the shoot progressed.

Will Penny belongs to that subgenre of westerns that depict the end of the Old West and the end of western movies about the end of the Old West. It is an elegiac saga, similar to George Stevens's 1953 classic, *Shane.* Clearly Gries borrowed more than a little from that award-winning film, including villains who terrify innocent homesteaders, a mysterious stranger (Penny) who arrives and defends one of them from the bad guys, and a little boy through whose eyes we see much of the story unfold. The major differences between the two films are Stevens's directorial flourish, *Shane*'s superior screenplay (by A. B. Guthrie Jr. and Jack Sher), and Gries's near-total inability to keep the focus of his story sharp without giving in to his own script's many digressions. While Stevens exploits Shane's mythic persona in order to shape his understanding that he has no place in the coming new world of the West, Penny's experiences have aged but not enlightened him. Penny remains unaware, adrift, neither running from nor haunted by his past. Shane rises to perform one last heroic and ultimately sacrificial act before he rides off to Boot Hill to bury his own and the West's history; Penny too performs one last heroic deed, but he is emotionally unmoved by the consequences of his action. He too rides off alone, but his is into an existential sunset.

Some have also seen similarities between the end of

Will Penny and the final moments of *The Ten Commandments;* both protagonists leave behind meaningful relationships and go off by themselves, either deeper into the primitive wilderness or up the holy mountain. It may be a bit of a stretch, but it does point out the preference of peaceful solitude over aggressive societal interaction shared by so many of the characters Heston played. As his career progressed, his canny choice of screen roles illuminated what had become his essential cinematic persona: the heroic, self-sacrificial, eternal loner, alone in the crowd of the world.

Will Penny was filmed in February 1967, with cinematography by veteran cameraman Lucien Ballard, who shot the exteriors on location in Bishop, California. His picturesque snowcapped mountain ranges offered a clear visual metaphor for Penny's obsession with aging. In the script he is described as fifty years old, a weathered cowboy adrift in a world of horses, cattle, men, and death, with chivalry and grace the dominant characteristics of a man unable to understand or commit to an intimate relationship with a woman.

There is much that is right with this film, beginning with Heston's strong, realistic, restrained portrait of Penny, the closest to date among his post–El Cid films that tapped into his real-life determination, natural reticence, and proclivity to be the loner living high on the

hill above the action of industrial Hollywood. But there is also much that is wrong. The film looks, at times, locked into its interior sets, giving the film a claustrophobic feel. In *Will Penny,* the lack of physical expansiveness does not translate into emotional intimacy, of which there is virtually none in the film, despite a cute bathing sequence in which Mrs. Allen (Joan Hackett) forces Penny to clean himself up in a barrel tub to rid him of his acquired stench (to wash away the primitive exterior and reveal the man within).

It was a good scene, and a costly one. Heston did it wearing a flesh-colored pair of skintight shorts. "It's my first screen bath," Heston joked to Seltzer, who was standing just out of camera range, viewing the filming with one eye and watching the budget with the other. "Counting the building of this set, salary breakdowns for crew and cast, etc., the two-days it takes to shoot the bath sequence will cost $30,000," Seltzer told a reporter. "It will last all of five minutes onscreen, an average of $6,000 a minute. We're using a lot of water for the scene—and we're spending money just like it." There was very little to spare and the film's lean production values reflected it, giving the film the look of a TV western more than a theatrical one.

The best scenes are ones in which Penny becomes both husband-substitute (in an unconsummated rela-

tionship) and father-surrogate. There are unrequited moments between Heston and Hackett that are genuine and lovely. And we watch Penny and the boy in close-up and in medium and long shots outdoors, gathering wood, riding horses, talking about their lives, about life—an unexpectedly powerful, if a bit overly nostalgic, glimpse into Heston's own boyhood and the precious days he spent with Russell in the Michigan woods (Russell's recent death was still very much on Heston's mind during filming and deepened the emotional layers of these scenes). Perhaps because of it, as much as any other reason, Heston often cited *Will Penny* as his favorite of all the films he made.

According to Fraser: "My dad loved westerns and loved making them, and he was good in them because he could identify with the rugged individualism they displayed about that period in American history. *Will Penny* was a character-driven western about a quiet, principled, practical man who didn't take stuff from anybody and knew how to defend himself without losing his head. That character was probably closer to who Dad was in real life than any other he played."

By the time production ended, Heston's hopes for the film had diminished. He thought that Gries had done a good job—that wasn't the problem—Paramount was. It had undergone a leadership shake-up, with

Will Penny among the last projects signed by studio cofounder Adolph Zukor. In 1966, with the company bleeding money and an aging, enfeebled Zukor unable to exert any influence over the board of directors, executives voted to sell Paramount to Charles Bluhdorn's Gulf + Western conglomerate. One of the first things Bluhdorn did was to install Robert Evans as the new head of production. Evans's rapid rise to power came via his association with Hollywood's new wave cabal that included Jack Nicholson, Warren Beatty, Steve McQueen, Robert Redford, Roman Polanski, and Francis Ford Coppola. *Will Penny*, and for that matter Charlton Heston, held no interest for Evans. The film and the actor represented everything and everyone he had been brought in to dispose of. Heston knew that the film, scheduled for the next year's spring opening, would be buried by Evans in favor of his two big Paramount projects: Gene Saks's *The Odd Couple* and Polanski's *Rosemary's Baby* (both of which would be blockbusters). Heston could only hope for a miracle, the kind of parting-of-the-Red-Sea Paramount was no longer interested in.

Waiting for the film to open, Heston returned to Coldwater Canyon to obsessively work off the extra pounds he imagined he had put on. He would examine him-

self in a full-length mirror every morning and grab his stomach to see if he could pull any fat off it. When he could (which was, like most people, most of the time), he would go into his tennis regimen, bookended by push-ups before and after each session. Sometimes he would get up at dawn and jog along Mulholland Drive just above the house. Fraser often ran with him.

When he wasn't working out, he spent time with his children. Holly, four now, was already taken with the wonder and beauty of the world of art, and she liked to stay with her mother in her studio when she did her photographic work. Fraser, eleven, shared his father's enjoyment of physical activity and his curiosity about languages and symbols. Heston encouraged both children's developing interests. "I consider, as a father, that my prime responsibility to my children is trying to create an atmosphere in which learning is counted as valuable. My son and I are at the moment working with precast lead figures that we got from kits in the hobby shop," he told *Redbook*. "We got information on how to paint the uniforms of the Dutch hussars that fought under Napoleon, and the British Royal Scots. I find it, and I think my son finds it a more stimulating and interesting way to build models. You feel you've done more than if you just paste a model together. To a certain extent, every home is by definition a learning

unit, even if you don't teach the children anything more than which channel 'The Beverly Hillbillies' comes on. That's what a family is, a place where the parents teach their children how to live whatever kind of life they themselves live."

Early in 1968, a dormant project that had once interested Heston came back to life. In 1963 he had read an English-language script adapted from a French novel by Pierre Boulle, called *La Planète des Singes (Monkey Planet)*. Citron had sent it over because another Boulle novel, *Le Pont de la Rivière Kwai,* had been turned into 1957's multiple-Oscar-winning film *The Bridge on the River Kwai. Monkey Planet* was about an American astronaut stranded on a planet inhabited by intelligent apes. The rights to the novel had been quickly optioned by Arthur Jacobs, an ambitious young producer looking to make a name for himself in Hollywood with it. Jacobs's favorite film was *King Kong,* and that was the basis for his acquiring *Monkey Planet.* Heston passed.

For the next several years, Jacobs tried to sell the novel to every studio in town. He came close to a package deal at Warner Bros. with Blake Edwards directing; Rod Serling, a '50s TV pioneer who had made his name and reputation with the classic series *The Twilight Zone,* rewriting the screenplay; and Shirley

MacLaine as the chimpanzee scientist Zira, but it didn't happen.

Undeterred, Jacobs managed to get Serling's new script to Citron, who sent it to Heston. This time he was intrigued and amused enough to invite Jacobs to come up to the ridge to talk about it. The meeting resulted in Heston giving Jacobs development money to fund another rewrite by Serling. After reading the new draft, Heston said he would call Frank Schaffner and ask him if he'd be interested in directing. Schaffner said yes, and Heston personally walked Jacobs into Dick Zanuck's office at Fox to ask for a real development deal, even though he didn't think any major studio would put any significant money into the project. "I expected them and every other studio to say, 'Talking monkeys? Rocket ships? Buck Rogers? Ming the Merciless? Come on . . .'"*

However, Zanuck wanted to work with Heston, especially after having passed on *Will Penny*, a film Zanuck admired, and even though the apes picture was

* George Lucas had the same ideas about science fiction— rocket ships, creatures (not apes), and Buck Rogers and Ming the Merciless—all of which appear in one form or another in *Star Wars* (later retitled *Star Wars: Episode IV—A New Hope*). Also made at Fox, its chances of getting made were greatly helped by the success of *Planet of the Apes*. Both films became long-running franchises.

risky on every level, he gave it a provisional green light, not only because Heston was attached, but because of the unexpected success of Richard Fleischer's *Fantastic Voyage* (1966), produced at Fox by Saul David.* They were in business. Heston characteristically gave all the credit to Zanuck (and Schaffner) for giving the film a go. "Dick Zanuck deserves a great deal of credit for the fact that Fox undertook the picture . . . he had a lot of confidence in Franklin Schaffner . . ."

Zanuck did, but not the board of directors. To convince them to give the project a green light, Zanuck asked Schaffner and Heston to first shoot a test scene between the stranded astronaut, George Taylor (Heston), and Dr. Zaius, the head of the apes, played in the test by Edward G. Robinson as a personal favor to Heston. It was screened on a Friday night for a handful of Fox executives, none of whom had any idea what

* "Ape" movies were nothing new. There was a memorable ape sequence in Josef von Sternberg's Dietrich vehicle *Blonde Venus* (1932). Apes also appeared in W. S. "Woody" Van Dyke's *Tarzan the Ape Man* (1932), costarring Cheetah; Merian C. Cooper and Ernest B. Schoedsack's *King Kong* and the several remakes through the years; Schoedsack's *Mighty Joe Young* (1949); Frederick De Cordova's *Bedtime for Bonzo* (1951); Howard Hawks's *Bringing Up Baby* (1938) and *Monkey Business* (1952), the latter with Cary Grant, Marilyn Monroe, Ginger Rogers, and Esther the chimpanzee; and Stanley Kubrick's *2001: A Space Odyssey* (1968), released after *Planet of the Apes*.

they were being called in to see. After, when the lights came up, they cheered, and the film was put into production.

There were still some real issues to be resolved, beginning with Serling's screenplay. To simplify the script and reduce the "advanced civilization" settings of the ape world, Schaffner and Zanuck brought in a lesser-known, less-expensive writer, Michael Wilson, to polish and prune. Wilson was a veteran screenwriter who had written all or part of such film classics as Frank Capra's *It's a Wonderful Life* (1946), Otto Preminger's *The Court-Martial of Billy Mitchell* (1955), William Wyler's *Friendly Persuasion* (1956), and David Lean's *The Bridge on the River Kwai* and *Lawrence of Arabia* (1962).*

Production began on May 21, 1968, on what Heston affectionately referred to as his "space opera." The exteriors were all shot at the Fox ranch; in the deserts of California, Utah, and Arizona, including the Glen Canyon National Recreation Area; and Lake Powell,

* Wilson was blacklisted in the '50s and wrote under assumed names. Eventually his credits were restored and all due honors and awards for *Friendly Persuasion, The Bridge on the River Kwai,* and *Lawrence of Arabia. Planet of the Apes* would be his penultimate film. He retired after writing Richard Fleischer's *Che!* (1969) and died of a heart attack in 1978 at the age of sixty-three.

to approximate the surface of the previously unknown planet a crew of astronauts on a mission sometime in the distant future crash-land on, where they quickly discover a civilization run by apes and in which all humans wear animal skins and are kept silent, collared and leashed.

Just before the first day of filming, Robinson bowed out, claiming John Chambers's heavy ape makeup and the body heat his ape suit generated was too difficult for him to put up with. He was having health problems and didn't think he would make it through the film. Heston suggested to Schaffner that he get Maurice Evans to replace Robinson and fill out the cast that now included Roddy McDowall as Cornelius (an ape), Kim Hunter as Zira (an ape), and a young beauty by the name of Linda Harrison to play Nova, a mute human girl who lives in fear of the apes. Harrison was the least known of the otherwise star-studded cast, but had three essential things in her favor: she was drop-dead gorgeous, she looked great in animal skins that showed off much of her beautiful body, and she was also Zanuck's girlfriend (she became his second wife shortly after the film opened). She was cast as Nova after Raquel Welch, Ursula Andress, and Angelique Pettyjohn all turned the role down.

The film begins in the year 3978, when a spaceship

carrying astronauts from Earth crashes into an unknown planet (they left Earth in 1972, but we all know from watching dozens of *Twilight Zone* episodes and PBS shows about Albert Einstein that this is possible; "It's a long time to sit in a theater," Heston quipped about this plot point).* Miraculously, the planet's atmosphere is human-friendly. Taylor and the other members of his crew run into fur-clad humans, including Nova, to whom he is immediately attracted. Without warning they are taken prisoner by horseback-riding apes; Taylor is shot in the throat and taken prisoner with the others. Eventually they escape and Taylor and Nova ride off on horseback into the sunset as the remnants of the Statue of Liberty come into view. Taylor realizes the planet they are on is actually post-thermonuclear war Earth.

Production was completed by August 10, with ten shooting days cut for budgetary reasons. Interiors were shot on Fox's back lot and at the studio's ranch in Malibu State Park, the Statue of Liberty sequence filmed near Point Dume on the Pacific Coast Highway

* This premise strongly resembles two Serling 1960 *Twilight Zone* episodes, "I Shot an Arrow into the Air" and "Eye of the Beholder," the latter included in the closing narration: "What kind of world where ugliness is the norm and beauty the deviation from that norm?"

north of Malibu. The shoot was an especially physical one, with torture scenes that were difficult and dangerous to do. Most of the barefoot running, rubber-rock pounding, fighting, and chaining were mostly done by Heston: "In the first place, I was all but naked through the whole thing, thrashing through the bushes. I was fire-hosed and dragged and choked and whipped and caught in a net and held upside down and all kinds of fun things. Had rocks thrown at me. And, I'll point out to you, even rubber rocks hurt." (Joe Canutt did the stunt where Taylor is lifted in a net and jerked upside down.)

When asked why he chose this film to make, he said: "I previously turned down other sci-fi films because they were either pointers or followers—'Here they come or they went thataway,' but this, like *Gulliver's Travels,* had a bitter satire within it. It shows how man can dehumanize man." Later on, he added, with his tongue firmly planted in his cheek, "I've gone from 3000 B.C. to 4000 A.D. and I guess that's about as far as an actor can hope to go . . ."

Nobody, especially Heston, thought the film, retitled *Planet of the Apes*—"Monkey Planet" sounded too much like a film about a zoo and had no connection to science fiction—was going to do anything when it opened. *If* it opened. This was strictly a payday proj-

ect, a way for Heston to pay off the remainder of what he still owed the IRS.

That fall, in one of the oddest interviews he ever gave, it appeared that Linda Harrison was still very much on his mind. During filming, it became apparent that they had great chemistry together cavorting with very little clothes on. There were even rumors that Heston and Harrison had had an affair (there are always rumors like this on sets; it's a great way to pass the time between gin rummy games), something not likely, considering that Heston was happily married and that Harrison was twenty-two years old—half his age—and, of no little consequence, Dick Zanuck's fiancé. The rumors did, however, speak to the problem of image. While Fraser says his father certainly appreciated beautiful women, he loved his mother too much to risk everything for a meaningless thrill.

Holly, however, acknowledged the obvious: "He was a man, not a saint. He may have played a few in movies, but he was a real human being, with feelings, sensibilities, and all that goes with being a handsome, strong, capable, famous Hollywood movie star. He was all of that, but he was also just a man, and sometimes things happen, although I have no idea whether anything ever did. I think probably not. I also think it was one of the reasons he was always in such a hurry to get home. It

was as if he had some internal clock that went off and he had to be back at the house, up at the ridge. In a way, it was a bit of a reinforcement, and a reassurance that he shouldn't be away too long. He knew from his own experience as a child [that] bad things happen when husbands are not home with their wives for too long. That's why he never allowed himself to get wrapped up in the insanity of the movie business. He knew who he was, and he never forgot where he came from."

Harrison might have been the reason for this strange reaction Heston gave to *Los Angeles Herald-Examiner* columnist Dorothy Manners just after filming was completed. He met with her at a drugstore in Beverly Hills after a vigorous round of tennis at a nearby club. In the middle of the interview, Manners whispered to Heston that a young miniskirted cutie was trying to get noticed by him. His response was "Ugh, awful . . . who designs all these ridiculous things!" He paused and then added, "It is impossible to look ridiculous and sexy at the same time . . . when the girls in the cast of *Planet of the Apes* got their monkey faces on, they looked uncommonly like some of these young monkeys you see on the street."

With two films finished and unreleased (*Will Penny, Planet of the Apes*), Heston planned to take a break

and travel with Lydia and the children to Greece, to see firsthand where the cradle of civilization was located. He chartered a 110-foot yawl and, with the Seltzers and another couple, sailed the wine-dark Aegean Sea. Heston then went on to Istanbul and Karachi alone, on his way back to Vietnam, at the behest of the State Department. The war was raging on, and since Heston's last visit it had ignited an even greater war of protest in the States, with LBJ at the center of it. Heston unequivocally supported Johnson's position on the war. As a Greatest Generation veteran, he believed the U.S. military was the best in the world and was convinced the unrest on American campuses was instigated by foreign agents looking to cheapen the country's moral resolve by turning the students against the draft and making it a statement of counterculture integrity (part of that miniskirt insurgency he was so against).

The first week in September he was back to Vietnam, and when he was asked by a reporter why, he said, "It's significant that almost without exception none of the leading 'doves' has ever gone over to Vietnam . . ."

Everything about Saigon felt strikingly different to him. The first thing he noticed was how little American brass was visible on the street, and when he did get to talk to GIs, they no longer spoke of the war in Vietnam as much as they did the war at home. He trav-

eled with a military escort to the U.S. base in the city of Pleiku, located in the jungle of the central highland region, and after a stop there, it was on to the special forces base at An Khe Valley.

He then traveled to Tan An and Long Binh before returning to Saigon. Everywhere he stopped he visited as many wounded as he could once and again took the names of family and loved ones, promising he would contact them when he returned to the States. On September 19, he boarded a military transit headed for Manila, and three days later, he was home. Again, as promised, he called and wrote to every one of the names he had been given.

A week later he went back to work, preparing to do *Elizabeth the Queen* as a taped TV special produced by George Schaefer, after which he called Seltzer to see how far along the football script was. Seltzer messengered over the latest draft. Heston thought it was good, not great, and still had misgivings about doing it. He was feeling every day of his forty-four years, and even a great script, he feared, might not be able to save him from looking ridiculous on a football field.

In December, the Hestons had to cancel a planned Christmas vacation in Las Vegas when Lydia's back went out. Heston put her to bed and hired a private nurse to help her. With the kids home from school, he

kept them busy all day, until they were so tired they piled into their beds.

New Year's Eve, with everyone in the house asleep, Heston decided to ring in the new year by pouring himself a tall one, going into his study, sitting back in his chair, and looking out the picture window into the Los Angeles night. It had been one hell of a year, he told himself. Then he turned back to the desk and glanced at his messages, neatly written out for him in longhand by Cora, his assistant. Seltzer, Citron, Schaffner, the White House. *The White House.* Lyndon Johnson's people had called. He wanted to talk about something having to do with the American Film Institute. Heston was supposed to call him back. Ah, well, this was New Year's Eve—whatever it was could wait.

Heston finished his drink and went back to the living room. The Christmas tree was still lit, and Fray was there. He had gotten up and turned on the TV to see the New Year celebrations. Heston lit a fire and curled up with his boy on the sofa and together they watched the ball drop in Times Square, just a couple of blocks from where he and Lydia had lived when they first moved to New York City.

One hell of a year.

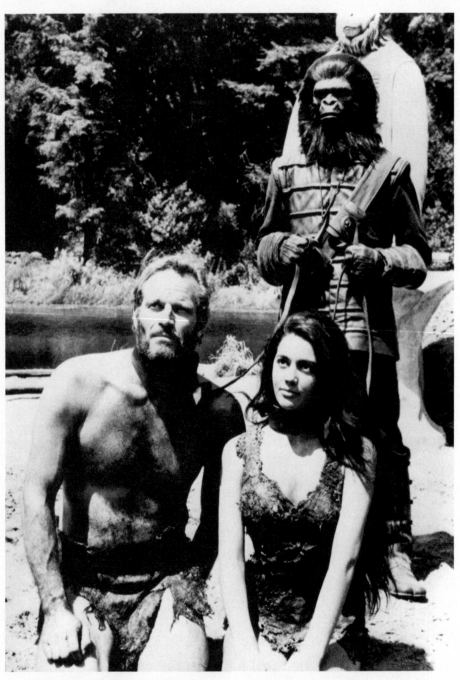

Charlton Heston, Linda Harrison, and Roddy McDowall in
Planet of the Apes *(1968).* (Courtesy of Rebel Road Archives)

Chapter Twenty-Seven

In his first full term as president, to which he was elected by a landslide over Barry Goldwater, Lyndon B. Johnson was determined to lead the country back to greatness. To show what a Johnson presidency could do for his country, he wanted to continue the progress Kennedy had made with civil rights, expanding the realm of the Peace Corps, moving ahead with the space race, and, above all, maintaining America's hard line against the spread of communism in Southeast Asia. He did some good things in the early years of his self-titled Great Society, before his manic escalation of the Vietnam War.

Those good things are worth looking at, especially the passage of the Civil Rights Act and the National Foundation on the Arts and Humanities Act of 1965,

whose origins began with JFK, and the creation of the National Endowment for the Arts (NEA) that acknowledged the importance of "hundreds of thousands of devoted musicians, painters, architects, those who work to bring about changes in our cities, whose talents are just as important a part of the United States as any of our perhaps more publicized accomplishments."*

Just before Kennedy's assassination, he had appointed veteran theatrical producer and real estate developer Roger L. Stevens to help the administration establish a national cultural center. Stevens, a Detroit native, had been the general administrator of New York's famed Actors Studio, a producer at the Playwrights Company, a board member of the American National Theatre and Academy, and a founding member of a Broadway company that produced some of the finest shows of the '50s and '60s, including *Bus Stop, Cat on a Hot Tin Roof,*

* According to the NEA website: "The National Council on the Arts advises the Chairman of the National Endowment for the Arts, who also chairs the Council, on agency policies and programs. It reviews and makes recommendations to the Chairman on applications for grants, funding guidelines, and leadership initiatives." Its first members, appointed by President Johnson, included Ralph Ellison, Paul Engle, Elizabeth Ashley, Gregory Peck, Oliver Smith, William Pereira, Minoru Yamasaki, George Stevens Sr., Leonard Bernstein, Agnes de Mille, David Smith, and Isaac Stern. ("About the NEA," National Endowment for the Arts, https://www.arts.gov/about/national-council-arts.)

and *West Side Story*. Stevens became chairman of the board of trustees that, at Johnson's directive, oversaw the development of what eventually became the Kennedy Center in Washington, D.C.

The seed of the National Council on the Arts (NCA) was planted in JFK's first year, when he invited the distinguished TV and radio journalist Edward R. Murrow to head up the U.S. Information Agency (USIA), a propaganda organization dedicated to helping tell "America's story" overseas. Murrow then met with some of Hollywood's most important figures, including George Stevens Jr., the son of the Academy Award–winning director and an author, playwright, director, and producer, who agreed to join the USIA as director of its motion picture service and supervised the production of more than 1,500 government-funded films.

The core work of the USIA laid the foundation for what, under LBJ, became the NEA. On January 8, 1964, less than two months after he took office, Johnson urged Congress to rededicate D.C.'s National Cultural Center as the John F. Kennedy Center for the Performing Arts and to establish the NCA to assist in the growth and development of the arts in the United States. The bill was passed through both houses in 1965, and on September 29 of that year, in the White House Rose Garden, Johnson officially signed it into existence.

To the end, LBJ considered the NCA as one of the greatest accomplishments of his Great Society. He appointed Roger L. Stevens its first chairman and gave him the title of the presidential arts adviser. George Stevens Jr. was assigned to head a separate committee to advise the NCA on creating what Johnson saw as an "American Film Institute, bringing together leading artists of the film industry, outstanding educators and young men and women who wish to pursue the 20th-century art form as their life's work." Together, the two Stevenses organized a long-range fund-raising campaign for the AFI. They eventually raised millions for it from the NEA, the Ford Foundation, and private donations from an elite group of wealthy Hollywood-based studio heads.

On June 6, 1967, at a press conference held in Washington, D.C., Gregory Peck was named AFI's founding director.* Two years later the Center for Advanced Film Studies opened in Beverly Hills to help the train-

* The founding trustees of the AFI were George Stevens Jr., Charles Ruttenberg, Gregory Peck, Daniel Taradash, Jack Valenti, Sidney Poitier, Arthur Knight, John Hall, Arnold Picker, Sherrill Corwin, the Reverend John Culkin, Charles Benton, David Mallery, Bruce Herschensohn, Francis Ford Coppola, Richard Leacock, William L. Pereira, George Seaton, and Arthur Schlesinger Jr.

ing of student film directors (most of whom had already earned advanced degrees from other universities with film study programs) by having them make films utilizing the AFI's Hollywood location and drawing upon the ample pool of available industry talent. Another goal was the preservation of the original cellulose nitrate negatives of Hollywood films, which were rapidly disintegrating in the cans in which they were inadequately stored. For many older films it was already too late and they couldn't be saved, which meant parts of Hollywood's history were gone forever. The AFI wanted to rescue and preserve as many of these national treasures as possible.*

A major obstacle soon threatened the existence of the AFI. Because it was mandated to be a nonprofit, tax-exempt organization, it could not pay for the services of Hollywood's union community, and the Screen Actors Guild bylaws (and many technical unions) did not allow its members to work without being paid, even for appearances in student films. George Stevens

* Martin Scorsese's Film Foundation estimates that more than 90 percent of American films made before 1929 were lost due to neglected and/or poorly stored negatives and subsequent nitrite deterioration; the Library of Congress estimates that 75 percent of all silent films are lost forever.

prevailed upon Heston, the president of SAG at the time, to issue an exemption. Heston suggested a deal: SAG would grant the exemption as long as none of the student films that used SAG actors would be exhibited commercially.

Heston knew it was not going to be easy to convince his guild's membership to work for nothing, and he had some doubts himself about the wisdom of the exemption agreement. From the time he had first been elected to the board of SAG, he had steadfastly been on the side of wage protection for actors. He was always wary of union member exploitation by studios and independent producers—long hours, seven-day workweeks, low or no pay, no residuals, no benefits. Now he was asking his membership to consider working for nothing. It was the reason SAG had come into existence, to make sure actors were treated fairly by the studios and rightly compensated for their work.

He met and talked it over with Stevens several times before he was finally convinced it was a good thing for the industry and formally introduced the waiver. He sold it to SAG two ways: First, that actors needed to act, to flex their muscles to keep their skills in good working condition, not just in classes but in front of real cameras with other actors, on a set with a director

and a script. Second, that it was truly a worthy cause, the education of young filmmakers who one day might be in a position to make movies and might hire some of the actors who gave them an early hand. "Prior to the formation of the council," Heston told the guild, "there was an uneasy skepticism about the appropriateness of using public monies to fund art . . . [A]t the time the National Council on the Arts was created, President Johnson recognized that the only effective way to [federally] fund film was to create an institute. It is the AFI's purpose to preserve the great American films of the past and promote what can be greater in American films in the future . . . at the Center for Advanced Film Studies, they will be devoted to the latter concern . . . They get half their budget from the Federal Government. They raised the rest themselves by the contributions of the networks, the studios, the exhibitors . . . [T]here are various people studying all phases of picture-making, and AFI interns are assigned to work on actual films . . ."

After a long and at times contentious deliberation, the members approved Heston's waiver and the AFI was in business with the guild. It was times like these that he better understood how impressive a job Reagan had done when he led the guild. He had acted

like a wartime consigliere through several contentious strikes, two of which had threatened to destroy the infrastructure of the entire industry. Now it was Heston's turn to be the head man, to convince actors he was doing something for them that was positive even though there was no immediate financial return. It was a job he found exasperating, exhausting, and thankless, yet completely rewarding.

Heston wanted to go back to making movies and returned to his familiar routine of reading scripts. After a couple of weeks of not finding anything that interested him, as if on cue Walter Seltzer called to say the football project, now called *Number One,* had been picked up by the new regime at United Artists. In 1967, the San Francisco–based insurance conglomerate Transamerica had bought virtually all of UA's outstanding stock and installed a new leadership team; David and Arnold Picker took over the direct supervision of the studio. The Pickers were looking for projects that would not cost a lot of money and could turn a quick profit. When *Number One* came to them with Heston's name attached, the executives immediately greenlighted it. They liked the combination of sports and an Oscar-winning star as long as the price was right. Citron made sure it was.

With his deal in place, Heston began training for a role both he and Seltzer believed had Best Actor written all over it (every actor and producer shares some measure of this feeling at the outset of a new film). Seltzer hired Craig Fertig, a former USC star quarterback, to give Heston a crash course in how to play the position. Fertig also set up a training program to help him build his body to make it look more like a footballer's. Heston had a long, lean tennis player's body; Fertig wanted him to bulk up his upper torso. He also wanted him to learn how to throw a football like a pro and how to run with it tucked between his biceps and his forearm. They worked two hours a day, five days a week, for nearly two months, at the house and on the football field at the Harvard School for Boys (the private military-prep institution Fraser was attending), before relocating to Louisiana where Heston could work out and practice with the New Orleans Saints and the team's star QB, Billy Kilmer.

While Heston began to look more like a football player, he hadn't as yet found an emotional path to the character of Ron "Cat" Catlan, the fictitious Saints quarterback of the film. Catlan once led his team to a Super Bowl but is now in the last, fading stage of his career and having trouble accepting that he is no longer the league's golden boy. He begins to drink and starts

an affair with a younger woman (Diana Muldaur), and when Catlan's wife (Jessica Walter) threatens to leave him, he begs her to stay, vowing he will straighten his life out and lead his team to one more championship. He begins to work out obsessively and leads the Saints all the way to a big game against the Dallas Cowboys, during which, in the final play, he gets physically crushed by the opposing team. As he lies on the ground, broken and bloody, we see his wife leave the stadium, unconcerned and unmoved.

It was a hard film for Heston, who had never played a character like Catlan and had no idea how to. Back at the ridge, he continued to research the part, reading every article he could find about football, every player interview, anything. He came across the famous photograph of New York Giants quarterback Y. A. Tittle taken by Morris Berman on September 20, 1964, during an intense game against the Pittsburgh Steelers. The tough, strong Tittle was, like Catlan, nearing the end of his playing days. At one point he reared back to launch a bomb. John Baker, the Steelers' six-foot-seven, 280-pound defensive end blitzed, hitting Tittle so hard he knocked his helmet off, exposing his bald head and giving him a concussion, as well as breaking his sternum. Berman's photograph of Tittle—bald, bloody,

dazed, and on his knees—perfectly captured the exact moment Tittle knew it was over for him. Heston was mesmerized by the photo, unable to take his eyes off it; it proved the key to finding Catlan's character. Looking at Tittle, he could see the way he wanted Catlan to feel. As he said later, "There's a great deal of me in Catlan. He is, as I am, somewhat reclusive, somewhat obsessed with the disciplines and demands of his profession and there is nothing else that he wants to do with his life than what he does. His only goal is to be as good as he can be."

While Heston continued to prepare for the role, Seltzer hired Tom Gries to direct. He wasn't Heston's first choice, but he didn't argue against him. The goal here was to get the film made, and personally he liked Gries and believed he could do the job. This was really a performance film, and if Gries just stayed out of the way, he would be all right. To round out the casting, Seltzer signed Bruce Dern, who had been one of the psycho brothers in *Will Penny,* to play the team's wide receiver. Dern, like Heston, was big, lean, and strong and completely believable as a football player. The two actors had gotten along well during the making of *Will Penny* and Heston was happy to have him aboard.

During filming, Dern, who was an avid runner, no-

ticed that Heston was subsisting on three bites a day of that American Astronauts diet bar, and a glass of skim milk, sometimes with a raw egg or raw meat blended in. When Dern asked him about it, Heston told him it was getting harder and harder to keep weight off, especially around his middle where it always seemed to show first. Dern advised Heston he could lose the extra weight without starving himself by running every day. After that, both men ran together in the early morning before their first scenes, then went directly to the set without washing to give their characters a more authentic, lived-in look. Heston, whose preferred way of staying in shape was playing tennis, had always been an undisciplined jogger, but after this film he would continue to run two miles a day most mornings for the rest of his life, until his knees eventually gave out.

Seltzer, at UA's directive, wanted to complete filming as soon as possible, but Heston had to halt the production in mid-January to travel to meet with California's two senators, Republicans Thomas Kuchel and George Murphy, both of whom had stepped up the pressure on SAG to stop permitting its members from appearing in films that were made overseas, to entice more American productions to be filmed in Hollywood. Heston sat with them, listened to what they had

to say, and then gave them a lesson in the facts of Hollywood life. He explained that overseas production was an economic necessity for producers, not an aesthetic choice for actors, who, if they wanted to work, had to go where the work was. Pressuring SAG was looking in the wrong direction.

Murphy, a veteran studio-era song-and-dance man before retiring from show business to go into politics, also wanted to know if SAG was going to do anything about the "extras" situation in Hollywood. Most extras were perennially unemployed, which meant lower revenues for the state. Couldn't Heston bring them into SAG so they could get union cards and find more work? This was an old dispute that kept getting resurrected every time a California politician was running for re-election. No, Heston told Murphy, he couldn't. Extras depended upon productions, not union membership, and then he brought the argument back to where it had begun. The reason more extras didn't work as often as they wished was because it was less expensive to make movies oversees, where foreign locals worked as extras for ten dollars a day, while those in Hollywood averaged twenty-seven dollars a day. Moreover, he said, he had to protect his union's actors by not bringing in more members who would then be able to compete for real

parts and soak up the guild's health pension dollars. Being a member of the guild, he said, was an earned privilege to which extras were not entitled.

It all went in one ear and out the other to the senators. Hollywood's problems, Heston explained again and again, were economic, not social. Since the demise of the old studio system it was simply good business for producers to make films overseas, and SAG had to go along with it or even fewer of its actors would be able to find work.

Heston was frustrated with their lack of understanding of the business realities of post-studio Hollywood. He left Washington tired and in a mean mood, but he had no time to ruminate. He was due in New York for a SAG disciplinary action against the popular actor and independent film director John Cassavetes for producing and directing a nonunion feature. The film was *Faces,* starring Cassavetes's wife, Gena Rowlands, and it cost all of $275,000 to produce. In a face-to-face meeting, Heston quietly admonished Cassavetes for not using SAG members in his film and that he therefore faced a probable fine for doing so. Cassavetes said he couldn't care less. Go ahead and fine me, he told Heston. Cassavetes was one of the mavericks of the new independent cinema that had risen in the wake of the old studio system, whose films looked a lot like

those that came out of the French New Wave of the late '40s and '50s and were made on shoestrings with no special effects, no fancy costumes, no big sets, shot on real streets, in the subway, in friends' apartments, wherever they could set up a camera. There were some good films, maybe a few even great ones, being made by directors like Cassavetes, Martin Scorsese (*Who's That Knocking at My Door*, 1967), Brian De Palma (*Greetings*, 1968), and Francis Ford Coppola (*You're a Big Boy Now*, 1966), all of whom were at the forefront of the American independent film movement of the 1970s.

Heston got it. When he looked at Cassavetes, he saw David Bradley making *Peer Gynt*, and himself in it. Was what Cassavetes doing really that awful? And if he were making his films for the AFI, would that be okay? He didn't want to sanction Cassavetes; he wanted to shake his hand and encourage him to keep going.

Heston never levied the fine against Cassavetes, who continued to make movies his way, while SAG officially looked the other way. Independent films soon became so prevalent that eventually the guild added a provision that allowed its members to be in them.

Planet of the Apes was scheduled to open on February 15, 1968, and Fox wanted Heston in New York for

the opening. That meant production on *Number One* would have to be halted again. On the flight, Heston only hoped he wouldn't be laughed out of Manhattan when the apes got the better of him.

He wasn't. No one, especially Heston, had any idea that this was the film he had been waiting for. Audiences loved it and him in it. It became his biggest hit in the seven years since *El Cid*. Profit-to-cost, *Planet of the Apes* eventually became the most successful film of his career.

Even the *New York Times*'s esoteric Renata Adler got its pop appeal, if she couldn't resist a catty little swipe at Linda Harrison:

> "Planet of the Apes," which opened yesterday [in New York City] at the Capitol and the 72d Street Playhouse, is an anti-war film and a science-fiction liberal tract, based on a novel by Pierre Boulle . . . It is no good at all, but fun, at moments, to watch . . . Maurice Evans, Kim Hunter, Roddy McDowall and many others are cast as apes, with wonderful anthropoid masks covering their faces. They wiggle their noses and one hardly notices any loss in normal human facial expression. Linda Harrison is cast as Heston's Neanderthal flower girl. She wiggles her hips when she wants to say something.

Newsweek saw more than masks in the film, its reviewer writing that the film "catches us at a particularly wretched moment in the course of human events, when we are perfectly willing to believe that man is despicable and a great deal lower than the lower animals." The *New Yorker*'s Pauline Kael also liked it; she could be surprisingly receptive, especially to non-auteurist flicks, although she may have been stretching a bit too far this time searching for "meaning" in *Planet of the Apes,* as with her assumption that somehow the film had to do with the collective American guilt over racism:

I don't think the movie could have been so forceful or so funny with anyone else [in the lead except Heston] . . . he's an archetype of what makes Americans win . . . He represents American power . . . He is the perfect American Adam to work off some American guilt feelings or self-hatred on . . .

During the making of the film, Heston had worried about Harrison's acting (which, of course, completely missed the point of why she was in the film, like being concerned about the quality of writing in *Playboy*): "Linda H. has problems, but Frank's keeping her nearly immobile in her scenes, which works."

Not completely immobile; ask the men in the audiences buying tickets—she was mobile enough for them. And then some.

Incredibly, at the age of forty-five, because of this throwaway science fiction romp, Heston once again was the newest, hottest darling of Hollywood. *Planet of the Apes* gave him renewed big box office and a jolt of pop-culture buzz. It also liberated him from the role of deliverer of history that his chiseled face and stoic manner had locked him into for so long. *Planet of the Apes* was a film that, beyond any of its ersatz sociopolitical messages, was happily and redemptively about nothing except giving the audience a great two-hour flight of fancy (and a little flash of skin, of course; this was Hollywood, after all).

While the success of *Planet of the Apes* came as a complete surprise to everyone, its impact was so strong it helped free science fiction films from the prison of B-movies into the mainstream for 1960s audiences, and it broadened Heston's demographic appeal. Younger audiences that couldn't have cared less about Heston in full historical military gear in *Khartoum* lined up to see him in a loincloth as George Taylor.

With the film bringing in big bucks, Paramount's publicity machine kicked into overdrive. Suddenly

everyone wanted Heston for a magazine interview, a guest slot on a TV show or radio program. Even Johnny Carson's *The Tonight Show* came calling, the Mecca of movie promotion. That March, Heston headed east, first to Manhattan and then on to a hastily thrown together European tour that Dick Zanuck personally supervised. The film was breaking attendance records in every country it played. He didn't really want to make the trip by himself, but the kids were still in school and Lydia had lately developed painfully recurring migraines that limited her ability to travel, especially by air.

On March 31, Heston was booked on *The Ed Sullivan Show*. He spent much of the afternoon at rehearsal, mostly sitting around and watching the other acts perform so the show could be timed out, and shortly after he did his bit that evening he was driven directly to Kennedy International Airport to catch a flight to London. While in the VIP lounge, he called Lydia and heard something in her voice that troubled him. He asked what was wrong, and she told him President Johnson had just announced on live TV that he was not going to seek reelection.

Heston was surprised and saddened by the news. It had to be Vietnam. After all Johnson had done for the

country, for civil rights and the arts, it was the lousy war that had defeated him. Heston was well aware of the groundswell of public opposition to the president's escalation in Vietnam, but in his opinion that was no reason to back down. It lessened Heston's opinion of the deeply divided Democratic Party when it had not unified behind its leader.

On April 4, while Heston was in London, the Reverend Dr. Martin Luther King Jr. was assassinated as he stood on the balcony of a Memphis motel. Heston was shocked when he heard about it and immediately canceled the rest of his tour. Back at his hotel, he received a long-distance call from Lydia. The guild was trying to reach him, she said, to ask that he wire the Academy to request a postponement of the Oscar awards ceremony that was scheduled for the evening of April 8, the night before Dr. King's funeral. Already several black performers had bowed out of their planned appearances, including Louis Armstrong, Sidney Poitier, Sammy Davis Jr., and Diahann Carroll, and the president of the Academy, Gregory Peck, wanted to postpone the entire proceedings but needed SAG's permission. The Oscars were by now primarily a promotion for Hollywood films and an expensive live television show to put

on. Postponement was not an easy thing to coordinate without all the unions agreeing to it.

Heston called Peck to tell him he could count on the guild's support and sent an official telegram to the Academy. He then boarded a flight headed back to the States. The next morning Peck announced the Oscars would be held on the tenth, a day after the funeral, the same Wednesday that *Planet of the Apes* was set to open in Piccadilly Circus.

Will Penny opened in America on April 10 to so-so box-office numbers. It may just have been that nobody wanted to go to the movies so soon after King's murder, but the reviews didn't help any. This time, Renata Adler was not at all amused:

> But for one scene too cruel for the story to support, and one scene in which the hero is taught Christmas carols too maudlin to believe, "Will Penny" might have been the best cowboy movie in some time. But by some mistaken model of artistic integrity— taken, probably, from "Shane," or some other movie better than "Will Penny" is—this movie has a realistically unhappy ending. It is simply not good enough to support that either.

Adler also mentioned that the film had opened at the RKO Coliseum, which was significant because it was all the way uptown, near the George Washington Bridge, far away from Manhattan's big, first-run Broadway palaces, and that she liked the theater more than she did the film, which was part of a double bill with a Tarzan flick (in some cities *Will Penny* was released without a second feature). The double billing confirmed for Heston what he had feared, that Bob Evans was dumping the film.

Roger Ebert liked *Will Penny* more than Adler, but he was not yet the star film critic he was to become, and his review in the *Chicago Sun-Times* did not have much clout. Still, it hit closer to the mark, even if it was unable to resist the perhaps inevitable, *Shane* comparison:

"Will Penny" occupies [the] land of "real" cowboys most convincingly. Its heroes are not very handsome or glamorous. Its title character, played by Charlton Heston, is a man in his mid-40s who has been away from society so long he hardly knows how to react when he is treated as a civilized being. And its love story, involving Heston and Joan Hackett, is one of the most satisfying I can remember. It is never quite convincing when two lovers fall into

each other's arms three minutes after being introduced, and it isn't very erotic either. Love, in many recent movies, has become as mechanical as marriage used to be. But in "Will Penny," the man and woman are quite properly shy about each other, even though the situation is complicated when they are snowbound in a remote cabin with Miss Hackett's young son. They never do make love, and it takes them most of the movie to work up enough momentum to kiss; the effect is a great deal more fascinating (and erotic) than Jane Fonda fans might believe. The admirable thing about the movie is its devotion to real life. These are the kind of people, we feel, who must really have inhabited the West: common, direct, painfully shy in social situations and very honest. "Shane" was a cowboy movie of this type.

Will Penny did not find a sufficient audience in its initial theatrical run earned about $1.8 million, below break-even with its $1.4 million budget, nearly $1 million of which went to Heston up front. Nor could it escape the many comparisons to George Stevens's classic. In 1969, the highly respected film historian William K. Everson, in his book-length definitive study

of the Hollywood western, wrote this about the film: "The pretentious and derivative *Will Penny* wouldn't exist at all had it not been for [John Ford's 1950 film] *The Wagon Master* and [Stevens's] *Shane*."

The film's stature did grow in the ensuing years and eventually took its place among Hollywood's better westerns, and Heston's performance would be regarded as one of his finest.* Years later he remained bittersweet about the film's failure. "People still talk about *Will Penny*," he said, "even though it didn't make a penny."

Shortly after midnight on June 5, 1968, Robert Kennedy gave his thank-you speech to a cheering crowd of followers at the Ambassador Hotel in downtown Los Angeles after winning the California Democratic primary. Moments later, as he was leaving through the kitchen, he was shot and killed by an anti-Israel extremist. Heston, like the rest of the country, was once again horrified. Less than a month after Dr. King's assassination, here was another brutal political murder, and it sent the presidential election into chaos.

In his diary that night, Heston wrote:

* Clint Eastwood named his character's two kids in the multiple-Oscar-winning western *Unforgiven* (1992) Will and Penny, in tribute to Heston's film.

I don't think Robert Kennedy's death
reveals a hidden core of violence in the
American spirit . . . simply that it runs
like a red threat through the heart, or the
reflexes, of the human animal. I do think
it reveals that we've been wrong in letting
our honorable fervor for the protection
of dissent as one of the cornerstones
of democracy blur the fact that dissent
breeds disorder, and disorder breeds
violence, and violence breeds murder . . .

It is an altogether remarkable statement that blames
the freedom to dissent as the root of the violence and
murder raging in '60s America; it disregarded Dr.
King and RFK's devotion to peaceful protest and also
the latter's opposition to America's involvement in
Vietnam, where the United States had sent troops to
protect the freedom of expression of the South Viet-
namese, their right to dissent against the Communist
insurgency coming down from the north.

What Heston left out of his diary and later in his
memoirs was this document, now in the LBJ Presiden-
tial Library in Austin, Texas, signed by him, Gregory
Peck, Kirk Douglas, and James Stewart, and released
to the media as a reaction to the senseless killings of

Dr. King and RFK, in support of President Johnson's Gun Control Act of 1968:*

TWO WEEKS AGO, ROBERT F. KENNEDY BECAME ONE OF THOUSANDS OF AMERICANS STRUCK DOWN BY AN ASSASSIN'S BULLET. SOMETIME TODAY, IN SOME CITY IN AMERICA, A GUN SHOT WILL RING OUT AND SOMEONE ELSE WILL FALL DEAD OR WOUNDED. THE VICTIM MAY BE A PUBLIC LEADER OR A PRIVATE CITIZEN, BUT, WHOEVER HE IS AND WHEREVER HE FALLS, HE IS NOT ONLY THE VICTIM OF THE GUNMAN....HE IS THE VICTIM OF INDIFFERENCE.

THE TRAGEDY IS STARK AND REAL. THE SCARS LAST FOREVER, AND THE ULTIMATE AND SENSELESS HORROR IS THAT SO MUCH OF THIS SLAUGHTER COULD BE PREVENTED. OUR GUN CONTROL LAWS ARE SO LAX THAT ANYONE CAN BUY A WEAPON....THE MENTALLY ILL, THE CRIMINAL, THE BOY TOO YOUNG TO BEAR THE RESPONSIBILITY OF OWNING A DEADLY WEAPON.

THE SOUND OF THAT GUNFIRE WILL ECHO AGAIN...TOMORROW, THE DAY AFTER, AND ALL THE DAYS TO FOLLOW, UNLESS WE ACT!!! 6,500 PEOPLE ARE MURDERED EVERY YEAR WITH FIRE-ARMS IN THESE UNITED STATES. THIS IS AN OUTRAGE AND WHEN IT IS COMPARED WITH THE FAR, FAR LOWER RATES IN OTHER FREE COUNTRIES, IT IS INTOLERABLE.

LIKE MOST AMERICANS, WE SHARE THE CONVICTION THAT STRONGER GUN CONTROL LEGISLATION IS MANDATORY IN THIS TRAGIC SITUATION. WE DO NOT SPEAK FROM IGNORANCE OF FIREARMS. THE FIVE OF US COUNT OURSELVES AMONG THE MILLIONS OF AMERICANS WHO RESPECT THE PRIVILEGE OF OWNING GUNS AS SPORTSMEN OR AS PRIVATE COLLECTORS. WE HAVE USED GUNS ALL OUR LIVES BUT THE PROPER USE OF GUNS IN PRIVATE HANDS IS NOT TO KILL PEOPLE.

In June, Heston was approached this time by the Democratic Party to run for George Murphy's Senate

* The Gun Control Act of 1968 regulates the firearms industry and firearms owners, via the Bureau of Alcohol, Tobacco, Firearms and Explosives (ATF), by prohibiting interstate firearms transfers except among licensed manufacturers, dealers, and importers. It was signed into law by LBJ on October 22, 1968.

seat. He declined, repeating that he had no interest in running for elective office. In the fall elections, Murphy was defeated by Democratic U.S. representative John V. Tunney.*

That same month, Heston was back in New York City, for the National Council on the Arts. Roger Stevens needed his deciding board vote to deliver a sizable grant to the financially struggling Lincoln Center. Conceived in the 1950s, it was the nation's first massive urban arts complex, the brainchild of New York's legendary "master builder" Robert Moses. Its purpose was to prevent the Upper West Side's middle class from fleeing the ravages of urban blight, rising crime rates, and the resulting property devaluations. The area, known as Lincoln Square, a four-block box between Sixty-Second and Sixty-Sixth Streets, bordered by Broadway, Columbus Avenue, and Amsterdam Avenue, had been condemned by the city, and 1,600 families were evicted to make room for the new arts center (Robert Wise and Jerome Robbins shot the exteriors for *West Side Story* in the vacated area before it was razed). Moses then called upon John D. Rockefeller III to provide the

* Tunney was the son of Gene Tunney, a former heavyweight champion. He was a frequent tennis partner of Heston's and is believed to have been the model for Robert Redford's character in Michael Ritchie's 1972 feature, *The Candidate.*

center's seed funding. He did, and the Lincoln Center for the Performing Arts was incorporated in 1956 as a nonprofit organization, but it could never earn enough to cover its operating costs and went through endless reconfigurations of personnel, management, and goals, kept afloat mostly by wealthy patrons whose patience had begun to run out, along with their donations.

Heston, who was always parsimonious when it came to giving away someone else's money, after much consideration, and to Stevens's surprise, voted against the grant. He believed the arts center in Manhattan was a lost cause and that the grant money could be put to better use by an organization whose future was not as dire. Heston's no vote made him something of a pariah in the city's art world, but he didn't care about any of that. He did not think it was the government's obligation to use taxpayer money to subsidize a privately owned arts complex (although it was, indirectly, since all the patrons' donations were tax-deductible) and believed an elitist Manhattan trophy showcase should live or die by its ability to survive in the private sector.

About the same time *Planet of the Apes* had been released, another science fiction film also made its debut. *2001: A Space Odyssey,* produced and directed by American expat Stanley Kubrick at MGM's British stu-

dios and Shepperton Studios, had opened slowly, unlike *Apes*, but by summer had built a huge word-of-mouth audience, eager to see the film's Super Panavision 70 predigital special effects, and its mysterious "monolith." If *Planet of the Apes* had been about nothing, *2001* was about everything, with a stoner appeal for the college crowd that turned the experience of going to the movies into a communal experience (someone suggested the technical adviser on the film should have been listed as "Mary Jane"). If *Planet* was a conventional, concrete drama set in an unconventional world, *2001* was an unconventional, abstract drama set in outer space, the moon, and Jupiter. If *Planet* was a throwback to classic TV, *2001* was a nod to cinema's future. And although there were virtually no women in Kubrick's film and it generated nothing like sexual heat, the dismantling of HAL's operating system set against the brothel-like red-light background was, in its way, one of the most erotic movie scenes of the year.

Pot helped.

Kubrick's flamboyance managed to steal some of *Planet*'s science fiction thunder, and after its release, nobody under thirty that summer talked anymore about *Planet*. Still, each film, in its way, had helped to bring science fiction back to cinematic prominence as a viable Hollywood genre.

Filming for *Number One* was delayed yet again when Heston broke a rib working out in New Orleans with the Saints (some of the pros good-naturedly teased him by shouting during practices that "Moses throws like a girl!"). When he was well enough, he resumed training back at the Harvard School, with Fraser sometimes throwing the ball back and forth with him after classes, while Lydia photographed them both. Heston had gained a few pounds while recuperating from his broken rib, and he refused to start filming until he felt he was in top condition so as not to embarrass himself. "My weight is my fortune," he kept telling Seltzer, who had no answer for that.

At one point, his preoccupation with fitness and aging took off on an obsessive track that Lydia happily participated in. Holly: "It was my understanding that my mom, who was a brilliant photographer and an expert at touching up in the dark room, changed the date of his birth on his passport. It was the most ridiculous and nonsensical idea and I don't know who came up with it, but they did it as a team. It's the reason so many people believe my dad was born in 1924 and not 1923. I remember it vividly because it was an official government document, and you don't ordinarily mess around with something like that. It was shocking to

me, even more so because my parents were so strait-laced. And even more bizarre was that they changed it only one year. If you're going to do that to make my dad 'younger,' change it by five years—an 8 is easy to make out of a 3—or three years—to a 6. But one year? A 3 to a 4 is much harder to do, and who cares about one year? What's the difference? I believe she did it to make my dad feel younger. It all had to do with our family's preoccupation with age and fitness. Growing up, we always ate healthy food together at dinner; we rarely had dessert unless it was a special occasion, like a birthday cake. Everybody exercised all the time, because it was all about looking good on the outside. This was the mentality of the business; if you don't look good on the outside, you're not going to get a role. I grew up with that every day of my childhood. My mom was always after my dad to buy new clothes, to make sure he was always dressed right, in case a photographer happened to take a picture. He believed his looks were his meal ticket and he wanted to keep them for as long as he could."

When he felt fit enough, he resumed work on the film, but was then offered the sequel to *Planet of the Apes*. Zanuck wanted it made as soon as possible, and because of that, Heston turned it down. Zanuck then told him the studio wouldn't make it without him. He

finally agreed, but only if Taylor "disappears" in the first scene and is killed off in the last (thereby assuring there would be no more Heston-driven sequels).* Zanuck agreed, and Heston's scenes were shot quickly. James Franciscus, a good-looking golden-boy type, was brought in to fill the void brought on by Taylor's death. Kim Hunter, Maurice Evans, Roddy McDowall (in archived footage from the original film), and Linda Harrison came back for *Beneath the Planet of the Apes*. Schaffner did not direct the sequel; that assignment went to Ted Post. Although the film was not nearly as well received or as popular as the first, from its negative cost of $4.7 million it still earned more than $19 million worldwide.

That fall, Heston was nominated for a fourth one-year term as SAG president. His earnest lobbying for higher minimum pay for actors, his new contract with television (whose players had their own union, the American Federation of Television and Radio Artists [AFTRA]) that brought feature film actors' pay more in line with the higher minimums for TV actors, and his continued

* Heston appears twice, briefly, in the second sequel, Don Taylor's *Escape from the Planet of the Apes* (1971), in flashback, using previously filmed material.

refusal to allow the Screen Extras Guild (SEG) to merge with SAG kept his popularity at a high level among the members.

The only point of contention came when actor Norman Stevens, who had also been up for president, kept blaming SAG policies for pushing too many films out of Los Angeles. Just before the election, Stevens went public with his complaints, stating to reporters that Heston had been "mouthing off" for some time, placing the blame for these productions on SEG, and threatened to have Heston brought up on charges before the Associated Actors and Artistes of America, of which both SAG and SEG were members.

Stevens's words did not change the minds of many SAG members, who agreed with Heston regarding SEG. More important, under Heston, the guild's members had earned a collective $108.9 million, nearly double what they had made the year before he became president, and they gave him the credit for bargaining for improved salary minimums and better residual rates. Heston was reelected by an overwhelming majority.

Heston was on an upswing. The election had given him a renewed sense of purpose as a leader and a SAG "activist," as he was now calling himself, and *Planet of the Apes* had brought him back to prominence with the moviegoing public. From its negative cost of $5.8

million, *Planet of the Apes* would become the ninth-highest-grossing film of 1968, earning $33 million domestically. The number one film of the year, with a budget of $10.5 million, was *2001: A Space Odyssey*, which grossed $68 million.*

It was great news for Heston, but also a milestone of a different sort; no film of his would ever again make the annual top ten list.

The Hestons spent Christmas quietly at home on the ridge. Holly: "For dad, the holidays were about the four of us and he was very serious about that. His career took him away so often that when he could be home, he wanted to spend that time just with his own family. He was a very private man and he only let people outside the family get so close to him and that would be it. He was very careful about what he gave out about the family, or anything not connected with a new film. He could be entertaining, engaging, he had great stories to

* The other top ten grossing films of 1968 in America were 2) William Wyler's *Funny Girl* ($58.5 million); 3) Robert Stevenson's *The Love Bug* ($51 million); 4) Gene Saks's *The Odd Couple* ($44.5 million); 5) Peter Yates's *Bullitt* ($42.3); 6) Franco Zeffirelli's *Romeo and Juliet* ($38.9 million); 7) Carol Reed's *Oliver!* ($37.4 million); 8) Roman Polanski's *Rosemary's Baby* ($33.3 million); 10) George A. Romero's *Night of the Living Dead* ($30 million). Some sources put *Planet of the Apes* at number five, but most agree it is number nine.

tell, he was genuine, all of it. He could convince everyone he was giving them everything when he was giving them nothing, because there was a line that he wouldn't allow to be crossed. I think only his family really knew him beyond it. My mother was like that too, only there were no promotional responsibilities for her. She could be sociable when necessary and very charming, tell great stories, dress beautifully, but only up to a point. She, like my father, had very specific limits for the outside world. Her only real focus was him."

Early Christmas Eve, Heston took the children down to Hollywood to see the Christmas lights, before returning with them to light the family tree. As he did every year, Heston had had a fifteen-foot tree shipped in from the Michigan woods. While Fraser and Holly were about to go to bed, Lydia, who had been suffering from another relentless migraine and Heston began arguing, a fight that turned into a screaming match in front of the kids and ended with tears and Lydia slamming the bedroom door behind her. A few minutes later, Heston went into the bedroom to apologize, always the fastest and surest way he knew of to end a fight with Lydia. After the kids went to bed, Heston stayed up by himself and put some fresh logs on the fire. Then he fixed himself a stiff one and went into his office to write in his journal. Perhaps it was the fight or

the drink, but in it he noted his feelings about *Number One,* that he believed it was going to bomb, and that his concern about it was perhaps behind his short fuse with Lydia. He wrote that she was the closest person to him, his best friend, and sometimes that meant she bore the brunt of his frustrations. That had to stop. She had given up everything for him, and she deserved better. He must be more considerate.

As midnight approached, he went outside, stood by the pool, and stared up at the sky, lost in his own thoughts as he listened for the sound of reindeer.

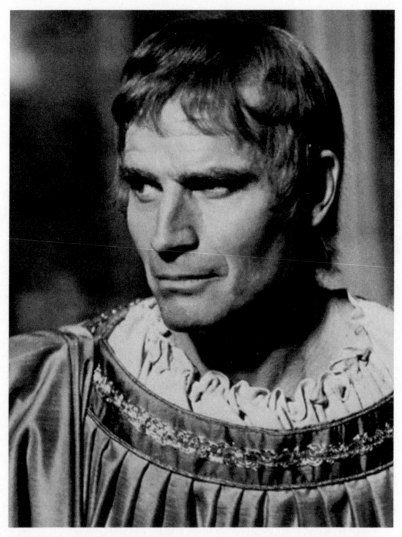

Charlton Heston as Mark Antony in Julius Caesar *(1970).*
(Courtesy of the Heston Family. Photo by Lydia Clarke Heston)

Chapter Twenty-Eight

In the spring of 1969, the British Film Institute honored forty-five-year-old Charlton Heston with the first major retrospective of his career, the highlight of the nine-film program being the appearance of Heston himself. When he stepped onstage on closing night, he was greeted with a standing ovation by the audience. He bowed deeply, then waved to the cheering, sold-out house.

While in London for the festival, Heston was approached by a young Canadian producer named Peter Snell with an offer to be in a film. Here is Snell's account of that meeting and how *Julius Caesar* came out of it: "I was thirty-one years old and just getting started in the business. I had been hired by Commonwealth United, a British company financed by Rexall, the

American retailer, looking to invest in movies. They chose Shakespeare's *Julius Caesar* as their first film. They asked me to produce it with a relatively modest budget of $1.6 million. I told them the only way they could get it made is if they hired some big stars whose names could sell films. The first name I came up with was Charlton Heston, to play Marc Antony. I knew he loved Shakespeare and that he had done a 16 mm version of *Julius Caesar* early in his career, and thought perhaps he might want to do it and we could get him at a somewhat reasonable price. So I sent him a telex offering him the part, we met, and he accepted it, with some conditions, including cast and script approval."

Snell agreed to pay Heston $100,000 up front and 15 percent of the film's worldwide gross. Then, for less money, he signed Sir John Gielgud to play Caesar, Richard Johnson as Cassius, Richard Chamberlain as Octavius, Robert Vaughn as Casca, Jill Bennett as Calpurnia, Diana Rigg as Portia, and . . . Orson Welles as Brutus. Heston said he was fine with everyone (and everyone was fine with him). And despite all that had gone down between them before, during, and after *Touch of Evil*, he was actually looking forward to acting with Welles again, as long as he wasn't also writing or directing. Finally, Snell hired Stuart Burge, a stage director with relatively little film experience except for

Othello (1965), starring Olivier, which gave him sufficient film credits and Shakespeare credibility.

And then the fun started.

Before filming even began, Welles rejected Burge and said he wanted to direct the film himself. When he was turned down, he angrily quit the production, and Jason Robards was brought in at the last minute to replace him. After that, the production never quite gelled, and by May, when the cast relocated to Spain to shoot the film's exteriors, everyone connected to it knew it wasn't working. As it turned out, Snell was too young and inexperienced to handle the production, Heston was under-rehearsed, and Robards was a complete disaster. Snell: "Early on in Spain, during rehearsals, on the rehearsal hall pay phone, Jason received a call from Bacall telling him she wanted a divorce. That was it for him. From then on he had trouble learning his lines, and he was never really in sync with the production. His awful performance looked even worse because the rest of the cast were such seasoned Shakespearean pros. Richard Johnson, who had been schooled in Shakespeare in England, did his best to coach Robards through it."

Robert Vaughn: "At the end of the day Jason and I had a few drinks together. He confessed that he'd never read or even seen *Julius Caesar* before and he asked

me if I would help him [too]." He also joked about the film's star: "Heston, who was very large, powerfully built, and his already broad physique was enhanced by some sort of golden wings that broadened his shoulders by at least a half a foot on each side. When Jason noticed this, he said slyly to me, 'Maybe Chuckles will be too wide to get through the tunnel, and then we can all flee this fucking fiasco.' "

Not long after, Robards threatened to drop out, and Snell flew to Paris and asked Omar Sharif if he would step into the role. Sharif said yes, and Snell said he would find out for sure if Robards was out. When Snell returned to Spain, Robards assured him he would finish the picture. He stayed until the last day of filming, and Sharif, who was ready to take over at a moment's notice, never got his chance.

The day the location shoot ended and the cast members were preparing to go their separate ways, no one believed the picture would move any cinematic mountains, but they also didn't realize how bad it was. As Vaughn later remembered, "When I played Casca in 'Chuckles' Heston's ill-fated production of *Julius Caesar*, I had no idea it would be such a fiasco."

Despite Snell's difficulties running the show, Heston had taken a liking to him and began referring to him as the "boy producer." While making their good-byes,

Heston made an overture to Snell: "Chuck said to me, 'I'd love to adapt and star in Shakespeare's *Antony and Cleopatra*.' I was young, still fairly inexperienced, and I didn't know any better than to say, 'Sure, let's do it!' I put together a conglomerate of money people from all over the world, using Chuck's name as the draw, and as soon as we were ready, we shot it. Fraser had a bit part in it too, the first time he had appeared on-camera since *The Ten Commandments*."

Snell spent nine months raising the magic $700,000 start number, trying to sign up distributors country by country ("I got $100,000 from Japan alone"), while Heston completed filming for *The Hawaiians*, another Gries project, the sequel to George Roy Hill's *Hawaii* (1966), a film Heston had turned down at the time because he had no room for it in his already packed schedule (the role of Captain Rafer Hoxworth went instead to Richard Harris). That year, he had worked on *The Agony and the Ecstasy, Major Dundee*, and *The Warlord* and committed to *Khartoum*. Of the two *Hawaii* films, Hill's was the far superior one.

Heston was cast as Captain Whipple "Whip" Hoxworth, the grandson of the character Harris played in the original. Hoxworth was a supporting character in this production (for which Heston was grateful), a relatively minor role in a screenplay that centered

around Nyuk Tsin (Tina Chen), a Chinese-born girl, and her family living on the islands. Location shooting was done on Maui and Kauai and took up most of the summer of 1969. Heston, as always, brought the family along, and during filming Holly celebrated her eighth birthday. Lydia continued to suffer from migraines that sometimes sent her into spasms. She spent several days in a local hospital as the doctors tried, unsuccessfully, to find out if there was some deeper medical issue that was causing the headaches.

As the warm, sunny days of filming dragged on, despite the fact Heston had promised to give the film his all, he found himself increasingly detached from it. He was unsatisfied with Gries's direction, worried about Lydia, and distracted by daily telexes from Snell about all the problems he was having finding the rest of the funding for *Antony and Cleopatra* that would allow the film to go into production.

Heston, from his diaries:

The Hawaiians is one of the few films in my career I've undertaken less than full-heartedly. I feel very guilty about this and can't really explain it. Perhaps my awareness of how far short we'd fallen with Caesar, and how hard it was proving

to be to mount *Antony and Cleopatra,* dampened my spirits. In any event, it was very non-constructive on my part.

Gries too was unsatisfied with Heston and his apparent lackadaisical approach to both his character and the film: "I was annoyed with Chuck on this picture. He was preparing . . . *Antony and Cleopatra* at the time and, frankly, his mind was more on that than on *The Hawaiians.*"

Heston's best memories of the shoot were the daily morning swims he took in the warm blue Pacific waters, caring for Lydia and helping out with the kids, and, during the long downtime between setups, writing his longhand screenplay adaptation of *Antony and Cleopatra.*

That fall, tanned and healthy-looking, Heston was back in Los Angeles for some SAG business he had tabled during filming. He had, for a while, been attempting to broker a deal being pushed by the representatives of film producers that would lower the guild's minimum wage levels of actors in films with budgets below $2 million. They believed that was the way to generate increased film production in Los Angeles. Most independent films made in Hollywood on low budgets had, with greater frequency, been using

non-SAG actors to save money, something Heston had long been against. At one point he had tried and failed to get legislation passed to make California a closed-shop state (it would have been a disaster for Hollywood, as virtually every production would have relocated to friendlier open-shop locales). Now, Heston's pragmatic side allowed him to see the virtue of compromise to keep more productions from fleeing, and he brought the producers' proposal to the rank and file, supporting it to keep local members working. The motion passed and the conditional lower minimum was instituted.

On November 11, 1969, Heston was elected by a three-to-one margin over his opponent, actor David Greene, to a fifth one-year term as president of the Screen Actors Guild. Despite having received overwhelming support for the provisional wage deal, the election proved more contentious than he anticipated, as a faction of the union remained angry over the concessions, believing they were the first step in what would be a series of salary reductions that would affect every working actor in Hollywood. Greene had been against the wage deal and for the merging of SAG and SEG, two issues that had divided the guild. For Heston, his reelection was not the mandate he had expected, and he began to think his run at the top of SAG was coming to an end.

The year and the decade ended for Heston with a Christmas family vacation in the Florida Keys, where the days were filled with fishing, tennis, diving, and photography. In the evenings, with the kids in bed and Lydia resting with a cold rag on her forehead to try to relieve her headaches, Heston liked to walk along the beach, reflect about the past and contemplate the future. The children were growing up so fast—too fast—and he and Lydia had, like all married couples, managed to get through some rocky times. He was growing older—he had just turned forty-six. He remained optimistic, as always, but concerned too about what lay ahead for his acting career moving into the 1970s. He had had some good days surfing, and also hoped to be able to catch a wave back to both artistic relevance and mainstream popularity in the always fickle and often cruel business of making movies.

With funding still not in place, Snell found that getting a director to commit to *Antony and Cleopatra* was proving more difficult than he had initially thought, as he discovered the name "Charlton Heston" no longer had enough box-office clout to make most A directors jump aboard, especially after *Julius Caesar* opened in London in June 1970 to mixed to negative reviews and did poorly at the box office (although that was at

least partly due to distribution issues rather than the film's critical reception). Commonwealth had received few bids for the U.S. rights and wound up selling them to American International, a minor production-and-distribution house that specialized in B-movies and horror flicks.

A week later, *The Hawaiians* opened and did $2.3 million at the box office—less than half its negative cost, about a quarter of what it needed to break even. The failure of both films, Heston knew, made it even more difficult to bring a quality director aboard for *Antony and Cleopatra*. This is what he told a reporter from the Associated Press shortly after: "It's important for an actor not to be associated with big losers . . . And if you are the star of a picture that lays a big bomb, that's when your collar gets tight. The bankers start saying, 'Oh, yes, he's the guy in the picture that lost all that money.'"

Major U.S. distributors stayed away from preproduction rights acquisitions for *Antony and Cleopatra* for reasons other than his recent box-office disappointments. As head of SAG, Heston had continued to loudly press for greater production of films in Hollywood, but both *The Hawaiians* and *Julius Caesar* were made overseas.* In the past, he had been able to shrug

* *The Hawaiians* was made off.

off this apparent contradiction between what he practiced and what he preached, as it were, by claiming he was just an actor wanting to bring home a paycheck, but this wasn't the case with *Antony and Cleopatra*. He was one of the film's primary, if unaccredited, producers, and everyone in Hollywood knew it.

Snell: "We were finally able to cobble together some of the financing for *Antony and Cleopatra*. I found a Spanish distributor, Izaro Films, willing to put up half the money in return for theatrical rights in Spain because Chuck was officially attached to the project. To Spaniards, he was and would always be El Cid, and could still attract Spanish audiences to his films and money from investors there.

"Chuck and I then went to a Los Angeles bank and they gave us the funding with his guarantee, so really he was the one who put up most of the money for the film. Not surprisingly, Citron was incensed that Heston was putting his own money into the project. He warned him against it, told him he would regret it, but Heston was, at this point, borderline obsessed with making the movie and believed he would have no trouble earning back his investment. Even if he didn't, he reasoned, he could absorb the loss. The film was that important to him."

According to Fraser: "It was an important film for

him, no question, and one of his more personal projects. I think *Will Penny* and *Charlton Heston Presents the Bible* were the others, his babies in a sense, as opposed to *Ben-Hur,* which was a different kind of favorite. My dad loved performing Shakespeare and he had done *Antony and Cleopatra* before—it was his Broadway debut, when he played Proculeius."

With the financing in place but still no American distributor, Heston went to London to try to help Snell attract a major British director. The first person he approached was Olivier, hoping to convince him to come aboard, but he demurred. At that point, Heston, determined to get the picture made, decided to direct it himself.

For Cleopatra, he had wanted Anne Bancroft. Heston: "She was very eager to play the part and we also thought of Irene Papas, but by the time we were ready to begin filming both were committed to other things." Heston then cast two other actresses. The first was Barbara Jefford, a British actress best known for her work with the Royal Shakespeare Company, the Old Vic, and the National Theatre. Heston had seen her in the title role in *Helen of Troy* at the Aldwych Theatre and asked her to lunch. It went well, and Jefford believed she had the part, but Heston still wanted to test South African ac

tress Hildegard Neil, known in her own country and in England for her TV work. She had appeared in a 1963 BBC production of *Julius Caesar* that Heston had been able to get a copy of, and she had recently made her first movie, Basil Dearden's *The Man Who Haunted Himself* (1970), opposite Roger Moore. Heston left the final decision up to Snell, who gave the role to Neil.

Around this time, Seltzer sent him a script for yet another sci-fi feature, *I Am Legend,* based on a popular Richard Matheson novel. Seltzer had found a gold mine in the two *Apes* movies, and he believed that Heston was a big reason for their success. The only problem was Heston didn't want to do any more sci-fi, but he didn't rule it out completely. If *I Am Legend* hit big, it could help get *Antony and Cleopatra* a major American distributor. He called Seltzer and signed on.*

Unlike his Shakespeare film, *I Am Legend* came together quickly, with Seltzer able to strike a deal with

* This was the second adaptation of Matheson's novel. The first had been Ubaldo Ragona's *L'ultimo uomo della Terra* (1964), which was shot in Italy and starred Vincent Price. A third adaptation, *I Am Legend,* starring Will Smith, was released in 2007. Another film, Ranald MacDougall's *The World, the Flesh and the Devil* (1959), starring Harry Belafonte, also bore some resemblance to Matheson's original story. It was based on the novel *The Purple Cloud* by M. P. Shiel and the story "End of the World" by Ferdinand Reyher.

Warner Bros to distribute. The studio believed Charl-
ton Heston in a science fiction film was good enough
to invest in. John William Corrington and his wife,
Joyce H. Corrington, were hired to write the screen-
play. That autumn, a shooting script was ready, with
the film renamed *The Omega Man* (*omega* means "the
end" in Greek; the character of Neville is one of the last
men left on Earth). Rosalind Cash, an attractive Af-
rican American actress/singer who had made her film
debut earlier that year in a small role in Alan J. Pakula's
Klute, was cast as Heston's love interest (in Hollywood
movies, even the last man on Earth has to be able to
find a beautiful woman to fall in love with). Anthony
Zerbe, from *Will Penny,* was given the role of one of
the leaders of the rebel mutant gang. Boris Sagal signed
on to direct—*Omega Man* would be his first feature
film after spending a decade locked in series TV—and
Warner's hired Russell Metty, the cinematographer on
Touch of Evil. Filming began early Sunday morning on
November 15 in the relatively underpopulated down-
town L.A., when there would be few people around.

 The Omega Man is an end-of-the-world saga that
opens in the near future, amid the aftermath of a biologi-
cal war between Russia and China that has killed almost
everyone on the planet. One of the few survivors is
Colonel Robert Neville (Heston), a U.S. military doctor

who comes up with a vaccine that cures him. He then dedicates the rest of his time trying to inoculate the few other survivors he comes across, while battling a band of rogue albino vampires, the incurable final mutation of the infection. Neville is captured by them (an effective echo of *Planet of the Apes*) and rescued by Lisa (Cash), a survivor who has a natural immunity to the poison that annihilated mankind and with whom he falls in love. Neville encounters the mutants again and this time is killed from a spear wound, his arms spread out Christlike as he lies bleeding. Neville gives his life defending the survivors so they may start the world over again.

The Omega Man wrapped by the end of the year, with the final cut clocking in at ninety-eight minutes. It turned out to be a better film than anyone expected, including Heston. The interracial romance between Neville and Lisa hardly raised an eyebrow when the film opened in August of the following year.*

During production, Heston also fielded yet another offer from a right-wing PAC to run for senator of Cali-

* Years after the film's release, Whoopi Goldberg had Heston on her nationally televised talk show. When she asked him how the interracial kiss between him and Cash went, he responded by kissing her. During filming, Rosalind Cash, who was fifteen years younger than Heston, noted that she was a bit uncomfortable costarring in a movie where she "screwed Moses."

fornia, to which, like every time before, he politely said no.

Having finished *The Omega Man,* and with everything in place, he flew to London to film *Antony and Cleopatra.* Snell: "We returned to Los Angeles and wound up editing the film at Chuck's house. I brought my English editor over to work on it, and every time we'd need a half hour to cut the sequence, Chuck would say, 'Great, I'll be on the tennis court.'"

As the year came to a close, Lydia's headaches became even more frequent, as did the tensions between her and Heston, who traveled several times alone to London to film *Antony and Cleopatra* and, when he was home, remained preoccupied with editing and SAG business, attending meetings, making speeches, and settling disputes. Moreover, Fraser was entering adolescence, never an easy time for boys or parents, and Holly was no longer a toddler. When Dore left to get married, Heston felt there was no need to replace her, which put the job of raising the children almost completely on Lydia's shoulders. As much as he loved hunting with Fraser and holding Holly up in the air to make her giggle, or reading to both of them until they fell asleep, he wasn't around very much for the day-to-day business of caring for them, and it became the lat-

est basis for bickering between Heston and Lydia. "We had violent [verbal] ups and downs" during that period, Lydia said later.

Their arguments came faster and with less provocation from either side, and Heston tried to remain stoic, his strong jaw thrust forward, his lips locked, until he would give up and apologize for whatever it was Lydia was angry about, hoping that would put an end to the latest fight between them. There were times it appeared he just didn't get that there were underlying issues that kept coming up, mostly having to do with Lydia's feeling confined to the house, and caring for the children, while he was able to run freely about for his work. According to Fraser: "He did get it, but was helpless to do anything about it."

That December, after another contentious campaign, Heston was reelected to his sixth one-year term as president of SAG. The margin of victory was impressive, but did not come that easily. The union's membership had grown to eighteen thousand, but the average annual earnings per member was still about $3,000, and many of them felt that Heston should be pushing harder for more films to be made in Hollywood. And although he repeated to them his oft-stated belief that American films were being made abroad because of costs that

had little to do with SAG, the anti-Heston sentiment was led this time by actor Ed Asner, who considered him a hypocrite, saying one thing, doing another, and blaming the rest of the industry while he made movies overseas.

Asner was a liberal-leaning character actor who'd knocked around for years in New York and Hollywood before hitting it big with audiences as the gruff but lovable Mr. Grant on *The Mary Tyler Moore Show.* His anti-Heston coalition was not big enough to take away the presidency, but Asner had made enough noise so that the industry could not help but be aware of the growing factionalism inside the guild. To spread the word, Asner's supporters had circulated flyers of columnist John Austin's article in the *Hollywood Citizen-News,* which had appeared the previous March, about Heston's having signed on to make another movie overseas:

WOULD YOU BELIEVE? (YOU CAN!) . . . It's a rather strange anomaly but after all the work he's done this past year to spur production in Hollywood, Charlton Heston has just signed with producer Peter Snell, whose last picture was *Julius Caesar* for Commonwealth-United, to star in *Antony & Cleopatra.* (Haven't they run out of barges yet?) Where will the epic be made? That's

right. England and Spain. Come now, Chuck, prac-
tice what you have been preaching . . .

Asner was determined this would be Heston's final
year as the president of SAG.

Early in 1971, Snell called from England with the good
news that the Rank Organisation, a huge British pro-
duction/exhibition/distribution facility, had picked up
the British distribution rights to *Antony and Cleopa-
tra,* and would pay off Heston's debt to the bank. Hes-
ton was thrilled by the news, especially the part about
the settling of the loan. After a quick trip to London
to meet with, congratulate, and accept congratulations
from Rank's executives, Heston flew back to L.A. to
see the first fully assembled version of *The Omega
Man* at Warner's prior to returning to London.

Before he did, he stopped by SAG, and for the first
time he became aware of how much loud chatter there
was about his continuing to make movies outside of
Hollywood. He knew that Asner was behind most of
it, and he had to admit he didn't entirely disagree. He
began to think that maybe the time had come for him
to step down, but only as long as he wasn't replaced by
Asner. John Gavin, a tall, dark-haired, good-looking
movie actor who'd starred in several popular movies,

among them Douglas Sirk's 1959 remake of *Imitation of Life* and Alfred Hitchcock's *Psycho,* wanted to make a run at the presidency. Heston liked Gavin, a Republican and a Korean War veteran, and thought he would make a much better head of the guild than Asner. Heston announced that this would be his last term as president and he would support Gavin in the next election.

Still in L.A., Heston got a call from Gregory Peck, then chairman of the American Film Institute, who said he wanted to have a meeting. Over lunch, Peck asked Heston to consider joining AFI's board of trustees. He was, after all, the one who had gotten SAG to grant the special dispensation that allowed professional actors to work on student films there for no pay. Heston said he'd be happy to, since it wasn't a competitive post and he wouldn't have to run a campaign every year to keep his seat.*

* Heston was appointed to the board for a six-year term. The other members when Heston joined were Richard Brandt of Trans-Lux Corporation; Joan Ganz Cooney of the Children's Television Workshop; motion picture securities analyst Emanuel Girard; director John Korty; Mary Wells Lawrence of the Wells Rich Greene ad agency; Peggy Cooper Cafritz of Workshops for Careers in the Arts (for two years, filling the vacancy left by Fred Zinnemann, who had taken a leave of absence to fulfill various overseas film commitments); and Andrew Sarris, the noted film critic and historian who had introduced the auteur theory of film criticism to America.

Back at the ridge, as he was packing, Citron called with an offer for him to star in John Boorman's film adaptation of James Dickey's novel *Deliverance*. He was eager to do it, but in the end the producers decided to go with the younger Burt Reynolds instead.

In May 1971, the forty-seven-year-old Heston was finally able to leave for London, with Lydia agreeing to come over with the children as soon as the school year ended. In his absence, Snell had, meanwhile, cast most of the other main roles with British actors: Eric Porter (Enobarbus), John Castle (Octavius Caesar), and Julian Glover (Proculeius). Several lesser-known locals were yet to be cast; they would join the production in Spain (as part of its investment deal, Izaro Films insisted some of the cast be Spanish).

Having never directed before, Heston, who took no salary for either acting or directing in exchange for a substantial percentage of the ownership of the negative, wanted at least two weeks to rehearse the script as a play. Snell found a bare hall in Covent Garden, where Heston could run the cast through its paces to see if he could get a feel for the beats that worked onstage, so he could then transfer them to fit the screen.

According to Hildegard Neil, "Chuck wanted to see what sort of directions in which to go. He didn't neces-

sarily want to get everything right in rehearsals, but by the time we had finished the two weeks, you had a pretty clear idea of what he was going to be looking for. You were able to go on working with his ideas in your head. It was necessary for him to do this, because when you get to making the film, you become concerned with the position of the camera, where you're going to track and so on."

At the same time, to prepare himself for the dual roles of acting and directing, every morning Heston would leave the Dorchester hotel at 7:30 and run two miles through Hyde Park, before meeting up with Snell and the rest of the cast to continue rehearsals.

On June 3, the production moved to Spain, where Heston had arranged to use some of the unused footage, of which there was plenty, from *Ben-Hur* to save money on long shots they could blue-screen behind the actors. MGM was now under the control of Kirk Kerkorian, a billionaire entrepreneur in the Howard Hughes mold who had bought a majority stake in MGM. Kerkorian, ever the canny businessman, had agreed to let Heston use the footage, but wanted something in return, although he wasn't as yet sure what that might be. Heston hated quid pro quo deals but he really wanted that footage.

That July, Lydia arrived in Spain with the children, and Fraser was enlisted to work on the film. Snell: "We needed someone Fraser's age—he was fifteen, I think—to do a bit part, an extra really to dress the set. Chuck was a little hesitant about it but said, 'Okay, let him do it,' and Fraser loved it. He wound up being an assistant director on the second unit, under Joe Canutt, who Chuck had brought to Spain for the shoot."

Lydia, meanwhile, didn't like the apartment Heston had arranged for them to stay in and moved the family into the Monte Real, a far more luxurious dwelling. Heston had no objection, even if it meant more money that one way or another would eventually come out of his earnings. If he did, he didn't say anything. It wasn't worth fighting over, especially since he knew he wouldn't win anyway.

The shoot proved long and more expensive than Snell had figured, and by August, the production was $194,000 over budget. According to Fraser: "My dad had two big things working in his favor. He had adapted the script himself, so he knew it front to back, back to front, and he had done the play several times before. So really, he had been preparing for years to make this movie. He knew every part, word for word. In rehears-

als, Julian Glover acted out dad's part in addition to his own, Proculeius, with the other actors so my dad could see the scene through the camera lens.

"When my dad made Joe Canutt assistant, my first day on the job, Joe had a big battle scene to film. He said, 'Get yourself a bag of rocks,' and handed me a spear. 'What am I supposed to do with the rocks?' I asked him. 'You get behind the horses in the big battle scene and you throw those rocks at the horses' butts. It'll make them move; otherwise they'll just stand there while the actors wave their swords at each other. I know these Spanish riders—they're lazy and they won't do anything.' 'Okay,' I said. 'What's the spear for?' 'That's to defend yourself when they turn around and come after the son of a bitch who's throwing rocks at them. And they've all got swords, so you'll need that spear.' Knowing Joe, if I was hurt or killed or something, at least he could tell my dad I died with a spear in my hands! I loved Joe. He and my dad taught me so much about movies."

The last night in Spain, the company threw a cast party, and the next morning the Hestons flew to New York to catch the opening of *The Omega Man*.

The film premiered at Loew's State Theatre in midtown Manhattan and Loew's Cine on East Eighty-Sixth Street, and the next day widened to theaters all

over the country. It received mixed reviews—the *New York Times*'s Howard Thompson didn't like anything about the movie or anybody in it except Rosalind Cash: "The climax is as florid and phony as it can be, like a tired Western, with Dracula and company thundering after Hopalong Heston. They nail him down, quite literally, in an embarrassing fade-out carefully suggesting a crucifixion. If only the picture had sustained the brisk vigor introduced by Miss Cash, a doll with no nonsense about her. Even she gets trapped at the end." *Variety*'s unsigned reviewer liked it better, calling it "an extremely literate science-fiction drama."

More important, audiences loved it, and the film proved a big commercial success, extending Heston's run as a sci-fi action hero. He hadn't seen the completed film, as he had been making *Antony and Cleopatra*, and wasn't sure what to expect. "I was very happy with it and even happier to discover that we had a hit." *The Omega Man* became one of Heston's most popular films and remains, to this day, a cult favorite among his fans.

That fall, back in Los Angeles, Heston was approached by a group of prominent Democrats who wanted to know if he would reconsider running for the Senate, and this time, Heston didn't say no right away: "The

query was not the first, and it wouldn't be the last . . . the Democrats figured they could raise a war chest of several million to fund [my] campaign. So, they asked, 'Will you do it?' I said I would think about it. That's what I did, and talked it over with some of my friends who are in the know about this sort of thing. Interestingly enough, they all liked the idea and encouraged me to do it. Why? No reason other than that which has motivated men and women for centuries: just plain service to the nation . . . I broached the subject with my most trusted and most important advisor, Lydia. She knows me better than anyone else, and was best qualified to render advice. So my girl heard me out, thought about it, and then asked a simple question: 'What do you want, Charlie?' It was as if the light went on. Suddenly, I realized that deep down inside, I didn't want to do it. The thought of never being able to act again, go on stage, or wait for the first take was simply unbearable. The next day I called them up and said, 'Thanks but no thanks.' "

It was around this time that Heston decided to release his longtime assistant, Cora. He was always loath to make personnel changes, but the situation with her had gotten out of hand. Her personal problems had started to interfere with her ability to do the job. After interviewing several candidates, he decided on a young

woman named Carol Lanning, but wanted to try her out first, to make sure she could handle the job. As Lanning later remembered, "It was a part-time temporary job at first. A friend of mine had called me who had been approached by Mr. Heston, but couldn't do it herself. He said he needed somebody who could work for him for a few days to take care of his affairs, and that it would probably only be for a couple of days. I said sure, why not? I went over to the Coldwater house, we made our introductions, and he showed me his office that had a mound of unanswered mail piled on it a mile high. I started to go through it and he came quickly into the room and said, 'You have to leave me a certain amount of mess.' I said okay, no problem, I could do that.

"After a few days, he came back and said, 'Would you be willing to take this job on for a while longer?' And that's how it began. Every once in a while he would say, 'Do you think we should make this a permanent job?' And I'd say, 'No, I like it just the way it is.' We stayed that way for forty years. Every morning it was the same routine—he would call me at my home at seven in the morning before I came in and ask, 'What have you got for me today?' meaning what interviews he had, what appointments, who had I heard from, where did he have to be and when. Then I'd drive to his home,

go through all the mail, answer a million phone calls. Because he was a celebrity, sometimes people outside of the business tried to get to him, and I had to be the bulldog who stopped all those in their tracks."

Holly: "I think my dad became something of a father figure for Carol. She adored him and made his life as easy as she possibly could. She was a perfect fit for him because she was a kind, caring individual, well educated, she knew how to handle people, she had deep humility, and that's the kind of person Dad wanted to be around for so many hours every day. They quickly became the perfect team."

Carol: "One thing I got used to very quickly was the noise from his sports cars. He loved those cars. His favorite, as far as I could tell, was a Corvette, and he would gun its engine and speed off down the driveway. It was one of his great pleasures, and about the only really 'Hollywood' extravagance he had, and even then he thought about each one before he bought it, agonized really, for days. He'd go back and forth and ask me if he should get this one or that, and I would say, 'Just go and buy a darn car!' It was almost as if he needed permission to spend the money. Coming from where he did, I don't think he ever felt 'rich.' He was never a big spender in the Hollywood way. But he did love his cars, and I think he would have posed nude

again if it meant the difference between being able to buy one or not."

"From that day on, Carol was like a member of the family," Holly said later on. "They had a very intimate relationship in every way but sexually. They were friends. He relied on her when he wasn't sure what to do. He believed she was smart, honest, and always placed his needs first. He'd call her every morning at six A.M. Eventually, he had to wait a little longer in the morning, after her husband became angry that the phone rang so early."

That November, Gavin won the presidency of the Screen Actors Guild by a considerable margin. Heston was then given SAG's annual award for Outstanding Achievement in Fostering the Finest Ideals of the Acting Profession. It was presented to Heston by Gavin at SAG's annual membership meeting at the Hollywood Palladium.*

With the guild's torch officially passed, the family left for an end-of-the-year ski holiday at Yellowstone Park, and when they returned early in January, Heston

* Previous recipients included Bob Hope, Barbara Stanwyck, William Gargan, James Stewart, Edward G. Robinson, and Gregory Peck.

went to work on a film called *Airborne*, renamed *Sky-jacked* prior to its opening. When asked why he made this kind of film, Heston said, "It was necessary to do some acting for which I got paid, after *Antony and Cleopatra*." *Skyjacked* was a Walter Seltzer production, made at MGM after a rash of plane "skyjackings," as the crime was being called. But the real reason he made the film was because Kirk Kerkorian asked him to.

Payback can be a bitch.

Charlton Heston and Edward G. Robinson in Soylent Green.
(Courtesy of Rebel Road Archives)

Chapter Twenty-Nine

In *Skyjacked,* Heston played Captain Henry "Hank" O'Hara, the pilot of a 707 that is hijacked by a crazed passenger (James Brolin), who wants to take the plane to Russia. Yvette Mimieux, who had played Heston's kid sister in *Diamond Head* a decade earlier, this time played the chief stewardess who has a sexual relationship with O'Hara, but without sufficient heat to fuel that track of the story, which was not entirely her fault. Heston remained weakest in the romance department in his films. Also featured in *Skyjacked* was a mix of old and new Hollywood that rounded out the cast, including Claude Akins, Jeanne Crain, Susan Dey, Roosevelt Grier (the former football player who had gained notoriety as RFK's bodyguard the night he was

assassinated), Mariette Hartley, Walter Pidgeon, Leslie Uggams, Ross Elliott, Ken Swofford, Nicholas Hammond, Mike Henry, and Jayson William Kane.

Skyjacked is based on a novel by David Harper that Seltzer had purchased expressly for Heston to star in, and he hired Stanley R. Greenberg to write the script. The film would do for disaster films what *Planet of the Apes* did for science fiction movies, giving Heston the opportunity to kick-start another dormant genre. The last tragedy-in-the-sky disaster film that hit big had been William Wellman's *The High and the Mighty* eighteen years earlier, shot in CinemaScope and starring the iconic John Wayne in the pilot seat.

Skyjacked was filmed in January 1972—much of it in a flight simulator at Los Angeles International Airport—directed by John Guillermin, a veteran of Tarzan movies, and shot in Metrocolor by Harry Stradling Jr. It was a fast, rough, and cramped cockpit ride that Heston later compared to Hitchcock's *Lifeboat,* which was set entirely in the space of a raft filled with survivors afloat at sea. After seeing the dailies, Kerkorian decided he would make *Skyjacked* MGM's summer tentpole production, holding its opening for the Friday of Memorial Day weekend.

Just as filming was winding down, Heston received a call from Snell about what was going on with the re-

lease of *Antony and Cleopatra*. They had wanted to hold the London premiere at the Odeon theater, but the James Bond action thriller *Diamonds Are Forever,* released in December, was breaking box-office records at the venue and held over indefinitely. The only house available was the Astoria, and it wouldn't become available until March. Snell recommended they take it and Heston agreed. Neither was happy with Kerkorian's decision to have *Skyjacked* compete with the big summer releases. Heston intended to be in London with the family for the Rank Organisation's *Antony and Cleopatra* red carpet premiere.

It might have been better if Heston had been skyjacked.

The morning-after British reviews for *Antony and Cleopatra* were awful. It appeared that the critics' knives were especially sharpened for an American daring to try to film Shakespeare. The only one who could get away with it, they insisted, was Orson Welles. One London critic described Heston's performance as his "being back in a toga playing with swords."

The film closed quickly in London, had a very limited run in Spain, and never made it to America.★

★ *Antony and Cleopatra* was released on VHS in 1985 and DVD in 2011. In his memoir, Heston says the film received a limited

Skyjacked opened two months later and hit the ground running. It grossed more than $2.5 million its opening week and was well received by most critics. A. H. Weiler, in the *New York Times* wrote:

"Skyjacked" [shows] a basically standard melodramatic movie situation can be made diverting and occasionally gripping. Aerial hijacking is a shocking fact of life these days and "Skyjacked," a straightforward, simple thriller, which, if memory serves, is the first in this genre, treats it without glamour and as the madness it is . . . John Guillermin, the director, handles an essentially familiar plot with speed and efficiency.

Audiences may not have wanted to see Heston do Shakespeare, but they loved him when he saved people's lives, riding this wounded horse in the sky to safety. Once more, the canny producing talents of Walter Seltzer and financial deal-maker Herman Citron had yo-yoed Heston back to the top of his game in a broadly

independent release in the States; if so, it was done without a distributor and "four-walled" (renting out a venue and hoping to sell enough tickets to make a profit).

popular action thriller, and the triumvirate was ready and eager to do more.

The film business is and has always been a hit-or-miss affair. Every project is like an entry in a horse race that no one knows for sure who will win, but every steed makes a run for glory. On paper, MGM's film version of Jack London's *The Call of the Wild* added up to a sure thing, and it became Heston's next film. It was a German-Spanish-Italian-French collaboration, which meant the money was secure, and had British director Ken Annakin attached, best known for helming "big" films such as *The Longest Day* (codirected with Darryl F. Zanuck, Bernhard Wicki, Andrew Marton, and Gerd Oswald, 1962), *Those Magnificent Men in Their Flying Machines* (1965), and *Battle of the Bulge* (1965). Yet on this production, Annakin broke out of the gate and was never able to regain his rhythm; he actually appeared a bit lost. Filmed on location with Oslo, Norway, doubling for Alaska during the 1897 Klondike Gold Rush, *The Call of the Wild* stars Buck, a heroic German shepherd in the service of prospector John Thornton (Heston) and Black Burton (George Eastman). Eastman was a well-known Italian actor who made a valiant effort to play an American. His English

was not very good and he was in the film solely to attract European audiences. The cast also included Raimund Harmstorf, a German actor best known in his home country for being able to squash a raw potato in one hand.

Together the three battle the elements while searching for gold until Thornton is killed by the Yeehat Indians, after which Buck sits by the river and mourns him. This reads better in London's novel than plays in the film, which is inferior not just to the book but to the 1935 Hollywood version of it directed by William Wellman and starring Clark Gable as Thornton.

Heston had been initially attracted to the project because of his love of nature and adventure stories, and he believed the picture could extend his *Omega Man* winning streak, but when it was released and bombed, he was clearly embarrassed by this misadventure of a movie. "He should never have done it," Fraser said, "but I never told Dad what he should or shouldn't do."

For the rest of his life, whenever *The Call of the Wild* came up in conversation, Heston pleaded with people not to actually see "the worst film I ever made . . . only the *dog* was good!" It wasn't, in fact, seen in America until 1975, three years after it was made. MGM, which held an option for its release in the States, declined to

distribute it, and the film eventually received a very limited release by a small independent distributor, before it quietly disappeared.*

The film didn't stick, but what did was the increasingly loud criticism of Heston for continuing to participate in films made outside of Hollywood with non-American actors and crews. Even if he was just a hired hand, as he was in *The Call of the Wild,* the prevailing sentiment was that he could surely afford to pass up a foreign-financed production and make a Hollywood film to help the local industry's economy.

A bitter film disappointment and growing disapproval of him among SAG members left him uncertain of what to do next, for whom and where. Like every actor, rejection caused him to put himself under a magnifying glass to see if he could see what everyone else did. He wasn't crazy about what he saw. At the age of forty-nine, his hair was too thin and his belly too soft. Blaming his physical attributes was all part of the game, part of the territory, a nonnegotiable clause in every actor's, producer's, and director's deal with the devil. Whenever one of his films failed, Heston's vulnerability meter jumped, and the emotional storm

* A DVD version was released in 2002.

began to gather within. More often than not these days, he brought his professional fears and frustrations home with him, and the results weren't pretty.

Early that June, on a Saturday night at home, Heston and Lydia got into what he described in his memoir as a "disastrous" quarrel in front of Fraser and Holly that triggered a "rare" loss of his temper. Lydia was having one of her migraines while Heston kept going on and on about something, nobody remembers what, until one of them, or both, said the wrong thing, reacted the wrong way, the vent opened and the steam came blasting out. After a heated exchange of words, Heston stormed out of the house, sprinted to the top of Cold-water Canyon, and then ran along Mulholland Drive until he could feel the steam begin to dissipate. When he got back, he saw Holly nervously riding her bicycle in circles in the driveway, waiting for him to come home. He lifted her up, hugged and kissed her, and reassured her everything was all right. This was nor-mally when Heston would apologize and try to smooth things over, but not this time. Lydia hadn't waited for him to come back. She had gone to bed, assuring this bout was not over.

At breakfast, Lydia calmly announced at the table that she was leaving for Honolulu to write a play. When Heston asked if she wanted him to come along, she said

no so icily Heston could almost see her breath as she spoke. She was gone before the end of the afternoon.

The next few days were agonizing for Heston. Holly: "I don't remember exactly when he said it—it might have been this fight or another one—but I was still a child, maybe ten years old, and we were talking, when all of a sudden my dad said to me [that] the single most difficult experience for him growing up was going through his parents' divorce: 'In retrospect I would rather go back and fight in World War II again, and face the guns of my opponent one more time, than have to live through a family being broken apart.' "

Not long after, Heston told the kids to pack their bags—they were all going to Honolulu. He booked the tickets and had a car take them to the airport. They landed in Hawaii later that day and Lydia was waiting at the airport to meet them. They all checked into a big suite at one of Honolulu's best hotels. The fight had ended. It wouldn't be the last, but a mutual desire to keep their marriage intact was its strongest bond, one neither was willing to break. As a couple, they had learned how to fight and, crucially, how to let it go and move on.

Holly: "I think it was very difficult for my mother to have been married to my dad. He was a big movie star, internationally acclaimed, a sex symbol, although

it's difficult for me to think of him that way, and he had all these actresses and civilians throwing themselves at him. That would have made me upset if I'd been married to him. Plus, my mother had given up her career for him and I think sometimes he forgot that. And she was a pretty high-strung woman, volatile in a passionate way, not at all passive, and it wasn't easy for either one. But they loved each other, and that was what had brought them together and kept them together."

Fraser: "Dad used to say that 'the secret [to a lasting marriage] is having a perfect husband, and I happen to be a perfect husband.' My mom was asked once by a reporter if she ever considered divorcing my father. She said, 'Divorce? Never! Murder? Often!' I think that the secret is you have two loving people who are willing to work out their challenges together and to face them together, whatever they may be."

Holly: "My dad would say to me, after he and Mom had a fight or something, 'You know, Holly, happy wife, happy life.' And then it would be over. My father didn't have a lot of weaknesses, but one of them, for him, was my mother. He didn't like to confront her or disagree with her, and he learned early on how not to. Even if he was right. It didn't matter. Their relationship took a lot of caring and attention to maintain. She was a firecracker, very smart, and she knew how to

fight. He had to work very hard to make sure she felt secure, to make her feel good, to make her feel loved, decade after decade, while the rest of the world adored him and didn't know who she was."

Fraser: "My mother did have migraines; she also had a thyroid issue, a terrible back problem from an injury she sustained photographing the coral on the Great Barrier Reef one time for which she eventually had to have two or three back surgeries, and several knee surgeries. There was a lot of pain, the pain caused the migraines, and so on. Like any marriage, there were tensions that came and went. They had their verbal disagreements, sometimes spirited, but I don't think my parents ever seriously considered getting a divorce. They were great at getting over the bad moments and figuring them out. They were adults and they were in love and they handled it like people who were in love and married for a long time. And they were getting older."

Heston was an avid reader, preferred the classics, but kept his hand in popular genre fiction, always on the lookout for something he could turn into a feature he could star in. After the success of *The Omega Man,* he had taken to reading science fiction novels and found one he especially liked, Harry Harrison's *Make Room!*

Make Room! which takes place in the near future, when the world is severely overpopulated. The story is set in New York City, where 40 million people are suffering from a chronic shortage of food.

He gave a copy of it to Seltzer, who took it to MGM, where it sat gathering dust until *Skyjacked* proved such a big hit that Kerkorian wanted another Heston vehicle yesterday. He bought *Make Room! Make Room!* with the proviso that Seltzer change the name to *Soylent Green,* so people wouldn't think it was a Danny Thomas family comedy (Thomas had a long-running TV sitcom called *Make Room for Daddy*). Seltzer hired Stanley Greenberg, who had done the screenplay for *Skyjacked,* to write *Soylent Green* and Richard Fleischer to direct. The supporting cast included Joseph Cotten, Leigh Taylor-Young, Chuck Connors, Brock Peters, Paula Kelly, and, at Heston's urging, Edward G. Robinson, in what would be the 101st and final film of his long and illustrious career.

The actor was seventy-nine years old now and in failing health, but he agreed to be in the film. According to Seltzer: "Chuck's affection was returned by Robinson's affection and warmth, and I think it was that very real magic between the two that was the key to the picture's success." *Soylent Green* would be Robinson's swan song to the screen and to life. He died

twelve days after he filmed his last sequence—fittingly, the death scene.

While the film was in what would prove to be a long preproduction period, Heston spent most of the summer playing tennis. He threw a birthday party for eleven-year-old Holly, for which he screened the Marx Brothers' *A Day at the Races* for all of her friends. And he decided, after much thought, that he could not support the Democratic nominee for president, George McGovern. With the Vietnam War dragging on and no end in sight, McGovern seemed ready to end it by giving up, and Heston did not believe in surrendering South Vietnam to the Communists. The worst part of it, for him, was the way veterans were being treated, like pariahs rather than the heroes he believed they were, shunned in America as the antiwar movement produced a Woodstock-flavored counterculture that wanted to blame the soldiers, most of whom had been drafted, not just for losing in Vietnam, but for being there at all. To a Greatest Generation vet, this was intolerable, and it became one of the turning points in Heston's political allegiance. He threw his support behind Richard Nixon, who, he felt, deserved a second term to finish the war in Southeast Asia "with honor."

Like Nixon, Heston had no sympathy or tolerance

for the war-resistant, left-leaning youth of America. As he wrote in his memoirs, "I recognize [Nixon] is a political animal, but I question whether any man can be anything else in a political job . . . also I reject McGovern . . . America is not spelled with a k."

He was a little more forthcoming when he told one reporter that while he was still a registered independent and that he considered "Senator McGovern basically a decent, intelligent man, I disagree with his positions on such public issues as defense, welfare, and aerospace. I [also] think many of his supporters are doom-watchers and nay-sayers, including Miss [Jane] Fonda." In August, Heston appeared at the Republican National Convention in Miami, completing his transition from Roosevelt liberal to Nixon conservative.

That same month, Lydia had a major cancer scare that turned out to be benign. Fraser: "She had a lot of health issues through the years. She had several doctors, they put her on different medications, and all that pain and discomfort brought back the headaches and other ancillary problems." Heston dealt with Lydia's emotional struggles that were, to him, as real and threatening as her physical ones.

Production on *Soylent Green* began that September; Heston's only change to the script (which he had ap-

proval over) was his insistence that his love scenes with the high-priced hooker Shirl (Taylor-Young) be toned down. The official reason was he wanted the film to be rated PG (as did Seltzer and Kerkorian), but as always, he was not comfortable shooting romantic interludes.

The film begins with Detective Thorn (Heston) investigating a wealthy citizen, William R. Simonson (Cotten), and he questions Shirl—apparently the rich can afford to buy hookers as "furniture" for their apartments. Rather absurdly, Thorn falls in love with her (Taylor-Young was twenty-seven; Heston was a month away from fifty), and together, through a series of increasingly improbable events, they discover the prime food of the day, Soylent Green, is made from the corpses of dead people. The "secret" is spoken in the memorable last line that Thorn mutters as he is carried, mortally wounded and bloody, from a food manufacturing plant: "Soylent Green is people."

It's an entertaining film, albeit a bit goofy, but nevertheless (or because of that) it caught the imagination of the public, and while it didn't do as well as *The Omega Man*, it managed to turn a good profit and is today a cult sci-fi classic.

With production finished, Heston wanted to leave the alien world of science fiction, and movies in general,

and return to live performing. The Ahmanson Theatre, part of a four-venue complex under the umbrella of the Center Theatre Group and located near downtown Los Angeles, was built by insurance and savings and loan magnate Howard F. Ahmanson Sr. as a gift to the Los Angeles cultural scene. It opened in 1967 as a subscription, for-profit complex, and its artistic director was none other than Robert Fryer, who had given Heston his first break in television all the way back in the Hell's Kitchen years. They had remained friends, and when Fryer wanted to beef up subscriptions with a marquee name, he approached Heston, who immediately said yes. Fryer assigned him the juicy role of John Proctor in the upcoming Ahmanson production of Arthur Miller's *The Crucible*.

Proctor is one of Miller's best characters in a play rich with drama and allegorical links between the Salem witch hunts and the '50s-era blacklisting. It packs a heavyweight punch whenever it is performed. Heston, as always, heavily researched the history of the play and at one point even called Miller to talk to him about what it was really about and how he had written the dialogue. Miller graciously discussed his work with Heston, and the two began a long-distance friendship that lasted until Miller's death in 2005.

The Crucible opened with a cast that included, be-

sides Heston, Ford Rainey, Gale Sondergaard, Donald Moffat, Sandra Washington, Inga Swenson, James Olson, and Beah Richards. The limited run quickly sold out and accomplished all of its intended goals: it gave Heston a chance to return to live theater, and the theater organization a much-needed infusion of cash. Over the next dozen years, Heston would do six more plays at the Ahmanson, each one selling every available seat.

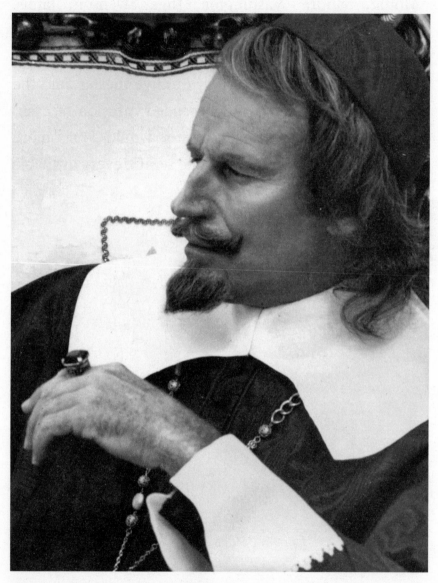

Charlton Heston as Cardinal Richelieu in The Three Musketeers *(1974).* (Courtesy of the Heston Family. Photo by Lydia Clarke Heston)

Chapter Thirty

I n January 1973, Heston and Lydia were invited by President Nixon to attend his swearing-in ceremony. Nixon had won reelection in a landslide over Senator McGovern and wanted to reward Heston for having been one of his most enthusiastic supporters and effective fund-raisers in California, the president's home state. Heston and Lydia decided to take Fraser along, but Holly was still too young so they asked his mother, Lilla, who was visiting, to babysit.

They arrived in D.C. the night before the inauguration, and the city was alive with excitement. The next day was cold, even for January, and at noon they stood, bundled up, on the dais, only steps away from the president as they watched Chief Justice Warren E. Burger swear Nixon in for a second term. It was a moment

the boy from the backwoods would never forget. He squeezed Lydia's hand as the president finished his speech and kissed the First Lady.

Back in Los Angeles, after a slow couple of weeks during which the phone did not ring very often (the loudest and most feared silence in an actor's life), until Heston received a call from British director Richard Lester, who wanted him to play Athos in a new, satiric film version of *The Three Musketeers* (a.k.a. *The Queen's Diamonds*). When Heston hesitated because he thought he might be too old for the character, Lester offered him the larger (and better) role of Richelieu. That intrigued him; the evil Cardinal Richelieu, the architect of modern France, who plots to form an illicit alliance with England, was not the kind of character he usually got a chance to play. What sealed the deal was Lester's promise to shoot all of Heston's scenes in ten days.

Lester had been a '60s critics' darling after he directed what was supposed to be a quickie cash-in on Beatlemania, 1964's *A Hard Day's Night*. Instead, he turned it into a clever movie with wit and pathos by casting the Beatles as an updated version of the Marx Brothers (the difference being, according to Andrew Sarris, with a nod to J. B. Priestley, the Marx Brothers tried to be mad in a sane world, while the Beatles tried to be sane in a mad world)—a perfect blend of Carnaby

Street commercialism and sixties counterculturalism. What George Martin did for the band on records, Richard Lester did for them on film. He repeated the feat with the group's 1965 follow-up, *Help!* Unfortunately, he couldn't sustain that level of success through a series of problematic films that included the John Lennon oddity *How I Won the War* (1967), the cynical *Petulia* (1968), and the black comedy *The Bed-Sitting Room* (1969), a last-minute substitute for the film he was supposed to make, *Up Against It,* with Joe Orton from his original screenplay, which was shelved after Orton's untimely and grisly murder. *The Bed-Sitting Room* bombed so badly United Artists' foreign distribution branch, Lopert Pictures Corporation, went bankrupt. Lester lost his audience and his financing, and he wasn't able to make another film for four years, until *The Three Musketeers* came along, which had originally been conceived as the third Lester-Beatles collaboration, shelved when the band broke up.

The George MacDonald Fraser adaptation of the Dumas novel had languished for years, until Lester was able to sign a then very hot Richard Chamberlain (TV's Dr. Kildare) to play Aramis. The film was greenlighted by Fox's new regime, headed by Gordon T. Stulberg and Alan Ladd Jr. Both were aware of the success of the *Apes* pictures and strongly suggested Heston

be attached to the film, which was how and why Lester called him that day to offer him a role in the film.

In March, Heston was chosen to be one of the Academy Awards' four cohosts for its 1973 awards presentation broadcast—Carol Burnett, Michael Caine, and Rock Hudson were the other three—and he was also asked to present a posthumous lifetime achievement award to Edward G. Robinson, who had since passed without ever winning a competitive Oscar. The award was to be accepted by his widow, Jane Robinson.

The awards ceremony was held Tuesday evening, March 27, 1973, in downtown Los Angeles at the Dorothy Chandler Pavilion, and televised live on NBC in America and around the world via satellite. The preshow was scheduled to start promptly at four P.M. Pacific time to accommodate East Coast prime-time ratings. At one in the afternoon, three hours before Heston was to open the show with a cutesy bit about the rules of the Academy and how the votes were tabulated (known in the industry as the bathroom break), Heston put his plastic-covered tuxedo in the small trunk of his black Corvette convertible and slid into the driver's seat to make the forty-minute drive from home to the pavilion. Lydia was to follow later, taken to the pavilion by a driver Heston arranged for her,

and they would come home together in his car. At this time of the day, the traffic was always light, and Heston thought if he caught all the lights he might even save himself a few minutes' more of driving time.

At 3:30 P.M., the stage manager of the telecast walked amid the pinball activity of celebrity presenters chatting, hugging, and exchanging kisses, checking each one in. The complete roll was accounted for, all except Heston, who was nowhere to be found. As the minutes counted down to airtime and the audience was seated out front, Howard W. Koch, the show's producer, came down from the broadcast booth to ask the stage manager what was going on. The live orchestra finished its warm-up—a cacophony of stray trumpet notes, timpani hits, piano trills, harp plucks, and violin strings fading out—the lights went down, and the announcer's voice boomed over the air: *"The following program is brought to you in living color!"* Heston was still a no-show.

After a prerecorded package of some of the arrivals, a flourish of trumpets introduced Angela Lansbury's interminable opening number about how great the magic of making movies was, which went on for nine minutes but felt like ninety. As the polite applause ended, she introduced the president of the Academy of Motion Picture Arts and Sciences, Oscar-winning screenwriter Daniel Taradash. Just before he made his

entrance, Koch grabbed him backstage and told him to change his introduction of the first host from Charlton Heston to Clint Eastwood. Koch then turned to Eastwood, who was standing in the wings, and told him it was an emergency—that nobody could find Heston and he would have to fill in, and that Heston was scheduled to go on next. As Taradash finished his tedious speech, he said, "To start us off, a *real* professional, Mr. . . . *Clint Eastwood!*"

The audience was a little bewildered as a trickle of applause guided Eastwood down from atop a staircase in the center of the stage. The sound of program pages could be heard turning throughout the auditorium as people began to check—wasn't Charlton Heston supposed to be the first host? Isn't that why they rushed to get here on time?

Eastwood walked to the podium, a sheaf of papers in one hand, and shook Taradash's with the other, looking half flustered and half annoyed. He said into the microphone, by way of explanation, "This was supposed to be Charlton Heston's part of the show but somehow he hasn't shown up." He then broke out into a half-smile and said, "So who do they pick? They pick the guy who hasn't said but three lines in twelve movies to substitute for him." That got a tension-relieving laugh and a round of appreciative applause. Eastwood shifted ner-

vously, looked offstage to his left, and then back into the camera. "So, yeah, okay, if you don't mind I'll just keep this book next to me." What book? As Eastwood struggled with the pages he had brought out, he said, "Heston is supposed to say something about . . . something biblical here, referring to him playing Moses . . ." And then he read the following line off the teleprompter with no expression: "He says when I brought the tablets down from the mountain Cecil B. DeMille's research staff assured me there would be only ten commandments. C.B.'s people were wrong. There are eleven commandments. The eleventh commandment comes from the Federal Communications System. So spoke the commission, 'Thou shalt have full disclosure . . .'" Then Eastwood's face went pale. "Come on, flip the card, man," he said, obviously stressed and annoyed at the cue-card handler, as the camera cut to a shot of Burt Reynolds sitting next to Dinah Shore in the audience, both looking bewildered. "This isn't my bag, I'll tell ya," Eastwood said, smiling grimly, droplets of sweat visible on his forehead, and everybody laughed a little louder this time. Another shot of Reynolds showed him cracking up in his seat. Eastwood continued: "In the book of Genesis it is written that the first day all eligible Academy members are asked to vote for nominations for Best Picture of the Year. On the second day, the other

nominations are made." Eastwood paused and suddenly looked to his right, as seconds later Heston came rushing onstage. He hurriedly shook Eastwood's hand, as Eastwood put the other over his heart and said, "Oh, Jesus, man . . ." The audience exploded into applause, partly in recognition of the agony that Eastwood had gone through and partly in relief that Heston appeared to be all right. Eastwood fled the stage, saying under the applause, "It's all yours, man."

Heston then started the bit over from the top as if nothing had gone wrong—"When I brought those tablets down from the mountain . . ."—realized how ridiculous the situation was, he murmured into the microphone, "I should have brought that staff . . ." A smattering of chuckles floated through the room. "There are eleven . . ." and on through the whole cornball recitation of the rules of the Academy. After some more polite applause when the routine was finally over, Heston took a deep breath and introduced the first two presenters. He left the stage without ever explaining to the audience that he had had a flat tire on the drive over and had to change it himself.

Eastwood was reportedly angry at Koch for making him cover for Heston and at Heston for not coming over to him after and apologizing.

Nonetheless, it made for great live TV. The rest of the three-and-a-half-hour broadcast seemed more dull than usual, except for the Sacheen Littlefeather incident, when Marlon Brando sent the actress and Native American activist in his place to refuse the Best Actor Oscar he won for *The Godfather*.

The next day the *Los Angeles Herald-Examiner* called the one-two punch of Heston's late arrival, in which he "practically straight-armed Clint Eastwood," and Littlefeather's appearance a demonstration of the award show's "hidden talent for cinema verite. It was a cinema verite the French never achieved."

Talking about it later with a reporter, Heston was able to poke a little fun at himself, but with a defensive edge: "I'm rebuilding my reputation for punctuality. It'll take me 20 years. The first entrance I ever missed—and I had to miss it in front of 81 million people! I was only 40 seconds late. *Only 40 seconds!* You go in the stage door, you start up two flights and on the squawkbox you hear Clint Eastwood speaking your lines! To the people who think it's amusing when a man slips on a banana peel, it's funny—'Where was Moses when the tire blew out'—gags like that."

In his journal, Heston called it one of the "outstanding humiliations of my life."

———————

A month later, as he was preparing to leave for Spain to film his scenes in *The Three Musketeers*, Lydia kept complaining about an especially severe migraine; their talk led to an argument that Heston later described as "one of the very worst days of my life. Everything was wrenched out of joint. For the first time in my life, I believed Lydia would leave me." It was no idle fear; Lydia had made it clear she could no longer tolerate the fighting. Heston had to catch a plane, which was probably a blessing.

While he was in Spain, Lydia's doctors decided to have another thyroid operation she had been putting off for a while. Her glandular imbalance may have explained the increasing intensity of their arguments, as it likely had affected her emotionally. Meanwhile, Heston was in Madrid at his favorite suite at the Castellana. The first night there he met up with Oliver Reed, one of his costars in the film. Heston shared his tales of marital woe, and together they drank at the hotel bar till closing time, a difficult thing to do in Madrid because the bars are open all night.

"Great men are more interesting to play than ordinary men," Heston told an interviewer while in full costume as Cardinal Richelieu, who was, in reality, small and

frail, something Heston had discovered while he was researching the role. To compensate for his own big- ness and the strength he usually projected on-screen, Heston gave the character a limp and had the makeup artist create a fake nose to match Richelieu's.

Heston stayed in Spain for several weeks longer than his original ten-day agreement, because Lester decided he wanted to expand his role and make it the foun- dational center of the film. Heston reluctantly agreed and wound up giving one of his more entertaining performances, leading a talented supporting cast that included Reed, Richard Chamberlain, Michael York, Faye Dunaway, and Raquel Welch.

Meanwhile, Lydia had recovered from surgery and felt strong enough to travel to Spain with Holly for the duration of the shoot. (Fraser was already there. He'd gone backpacking through Europe for most of the summer before settling in with his dad.) Holly: "My mother loved going on these trips when Dad would be in his element and Mom would be in hers."

Things went so well, both on set and back at the villa, that when filming ended, Heston suggested they all travel to Stuttgart and Vienna before going back to London, where he had made arrangements for them all to attend Wimbledon. One night there, after an espe- cially long match, Lydia's headaches returned. Doctors

were called to the hotel and they knocked her out with a heavy sedative so she would sleep through the night. Soon after, the tension between Lydia and Heston returned, and by the end of the summer, everyone was more than happy for this vacation to be over.

That fall, twelve-year-old Holly was enrolled in the exclusive, private Westlake School for Girls while Fraser began his freshman year at the University of California at San Diego (UCSD). It meant Heston and Lydia would be alone together, and although they still had some bad moments between them, they discovered that middle-aged, married love without children around made them feel like they were on the craziest of extended (and existential) second honeymoons, which more than made up for the first one they had never gotten around to taking.

Days flew by like the calendar pages in a movie until that December, when Heston had to return to L.A. to open in *The Crucible*. That's when Heston learned the real reason for Lester wanting him to stay on longer. Filming had run so long because he'd actually made two films (the second, *The Four Musketeers: Milady's Revenge,* was very loosely based on Alexandre Dumas's *Twenty Years After,* and Lester intended to release it the following year). Citron had not been aware of what

Lester was up to, nor were any of the other stars or crew, and none of them was paid for two films. Lawsuits flew the day after the premiere (the situation was eventually resolved with substantial out-of-court settlements).*

The Three Musketeers opened in December 1974 and *The Four Musketeers* opened in February 1975 to great reviews. The two-for-one sequel grossed nearly $10 million in its initial domestic release and nearly twice that overseas. It brought Heston a new level of popularity among audiences used to seeing him in other types of films and also allowed him to gracefully age on-screen, which he welcomed.

Shortly after, Heston received a call from Walter Mirisch, the producer of *The Hawaiians,* to talk about the possibility of his playing Captain Matt Garth in a star-studded cameo-rich film about the Battle of Midway, a re-creation of the decisive World War II naval confrontation in the Pacific. Mirisch intended to model his film after Zanuck's successful, if outsize, re-creation of the invasion of Normandy in *The Longest*

* The film was produced by Alexander, Ilya, and Michael Salkind with associate Wolfdieter von Stein. After the two-for-one situation, Heston lobbied SAG to add what is today known as the Salkind Clause, a stipulation in all contracts as to how many movies may be made from the footage being shot for one contracted picture.

Day (1962). Hollywood had since produced a series of self-glorifying World War II films that focused on a single battle: John Guillermin's *The Bridge at Remagen* (1969), Otto Preminger's *In Harm's Way* (1965), and Anthony Mann's *The Heroes of Telemark* (1965).

Heston liked Mirisch's idea, even more so because he wouldn't have to carry the entire film and therefore spend months away from home. He gave Mirisch a provisional yes, after he finished starring in veteran producers William Frye and Jennings Lang's *Airport 1975*, the sequel to the phenomenally successful *Airport* (1970), a cameo-rich production (Dean Martin, Burt Lancaster, Jean Seberg, George Kennedy, Helen Hayes, and Van Heflin) about a plane stuck in the sky above a storm with a suicide bomber aboard, based on Arthur Hailey's bestselling novel. *Airport*, like *Skyjacked*, had been, essentially, an updated remake of William Wellman's *The High and the Mighty* (1954), which had been made for $10 million and grossed ten times that amount. Universal wanted to repeat that success and did with *Airport*—new decade, new model plane—and now it planned a "sequel," of the formula as much as the setting.

Airport 1975, directed by Jack Smight, involves a 747 red-eye flight that collides midair with a private plane when its pilot (Dana Andrews) suffers a heart attack.

The impact kills the 747's first officer (Roy Thinnes) and flight engineer (Erik Estrada) and blinds the captain (Efrem Zimbalist Jr.), who soon loses consciousness, leaving no one aboard able to land the aircraft, which is flying on autopilot. A daring plane-to-plane delivery of another pilot is attempted. Captain Alan Murdock (Heston) is the pilot who makes the daring transfer to land the plane (and also happens to be the ex-boyfriend of the chief stewardess [Karen Black]). Along with the "nail-biting" action, Frye and Lang bulked up the production with an even bigger number of stars-of-the-moment cameos than the original *Airport:* George Kennedy, Susan Clark, Helen Reddy, Linda Blair, Sid Caesar, Myrna Loy, Ed Nelson, Nancy Olson, Larry Storch, Martha Scott (Heston's mother in *The Ten Commandments* and *Ben-Hur*), Jerry Stiller, Guy Stockwell, and Gloria Swanson.

As with most sequels, *Airport 1975* was twice as expensive as the original and grossed half as much ($47 million), still good enough to make it the seventh most popular film of the year when it opened in the fall of 1974, in time for the holiday season.

At the same time, Mark Robson was preparing *his* disaster film, *Earthquake*, from a script he had commissioned a few years earlier by Mario Puzo, before the then struggling writer hit it big with his *Godfather*

novel and screenplays, and disaster flicks were back in vogue. Robson's original inspiration for the story was the 1971 San Diego earthquake that many thought was California's "big one" (it wasn't). Robson couldn't get his movie off the ground until the success of Irwin Allen's *The Poseidon Adventure* (1972)—a cameo-riddled disaster epic (the cast tries to survive a sinking luxury ship) with some neo–Malcolm Boyd thrown in to make the film more "meaningful"—after which Universal quickly gave Robson the green light for *Earthquake.* Robson asked Heston to be in it, this time playing a building executive who ultimately drowns trying to save others (Joe Canutt did all of Heston's stunts).

And Universal, of course, was happy to have him in both pictures; the name "Charlton Heston" still brought a measure of stature to any film, and his recent popular appearances in science fiction films had lowered his brow a bit. His task in *Earthquake* was not quite as challenging as the parting of the Red Sea, but no walk in the park. "We need you to survive and rebuild Los Angeles!"

The only problem was just that script called for Heston to survive, and he didn't like it. Heston: "I had script approval, so in the end, they grudgingly agreed [I could die]. It's amazing when you think of it. People always assume the hero has to live. That's not true.

Take me, for example. I have died at least a dozen times [on film]."

There was another, more practical reason for his insistence that his character not make it. He wanted to make sure that if there was a sequel he couldn't be in it. One *Earthquake* a career was Heston's new mantra. So he died in Sensurround, a kind of three-dimensional aural process that made the theaters that were wired for it literally shake during the earthquake. Plaster fell from the ceiling when the film played at Grauman's Chinese Theatre, making audiences run for the exits, believing the earth had cracked in half in Los Angeles during the film.*

Earthquake opened on November 15, only a month after *Airport 1975*, a month before *The Three Musketeers*, and broke the house record at Grauman's. The film grossed $80 million in its initial release, nearly twice as much as *Airport 1975*, and went on to become the fifth-highest-grossing film of the year. It won two Oscars, one for Best Sound (Ronald Pierce and Melvin Metcalfe Sr.) and one for Special Achievement in Visual

* Built by Cerwin-Vega and powered by BGW amplifiers, Sensurround was created by placing a series of large speakers around the theater. The system pumped in subaudible "infra bass" sound waves at 120 decibels to give the viewer the sensation of being in an actual earthquake.

Effects (Frank Brendel, Glen Robinson, and Albert Whitlock).

Why did Heston make these three fast-food movies? Here is his very well put explanation about what he felt was an unshakable, if more subtle form of typecasting that had defined much of his career: "This [tragedy genre] really isn't a new thing. It's a pattern that goes back as far as movies. And one reason for the return of the group jeopardy movie, as I prefer to call them, is that filmmakers can once again afford to burn down an office building, or destroy Los Angeles, or rent a 747 . . . and audiences need someone they can identify with and say to themselves, 'He's going to do something about all this,' and because people know me as an authoritative presence, there's no problem in featuring me as a person who takes charge of a holocaust. Part of the reason for this is my shadow. No matter how versatile an actor may be or how he strives to widen his range, he must deal with his shadow. And my shadow has been Moses, El Cid, and Michelangelo, not to mention a president or two. If you need a chariot race run, a ceiling painted, or the Red Sea parted, you think of me. So in this film it isn't necessary to explain that my character will be responsible. You don't have to take time out to explain that to the audience. It's built in."

These two disaster films and his Musketeer satire

were so successful, due in no small part to Heston's marquee value, that he was approached by Universal to star in yet another variation of the genre, a new film a young and largely unknown Steven Spielberg was set to direct, *Jaws,* co-starring a giant mechanical shark. Lew Wasserman, the head of the studio, personally asked Heston to play the role of Police Chief Martin Brody, and he said yes until Wasserman wouldn't negotiate with Citron for a percentage of the gross. The part went instead to Roy Scheider.

Heston was then asked to be in a filmed theatrical production of Ibsen's *An Enemy of the People,* produced by Ely Landau, the head of the American Film Theatre, and he wanted to do it, but the organization folded before negotiations even started.

With *Midway* nowhere near ready to begin filming, Heston accepted an offer from the Ahmanson to play the title role in *Macbeth,* which was scheduled to open in the winter of 1975. It would be the fifth time in his career that he would get to play Shakespeare's killer king.

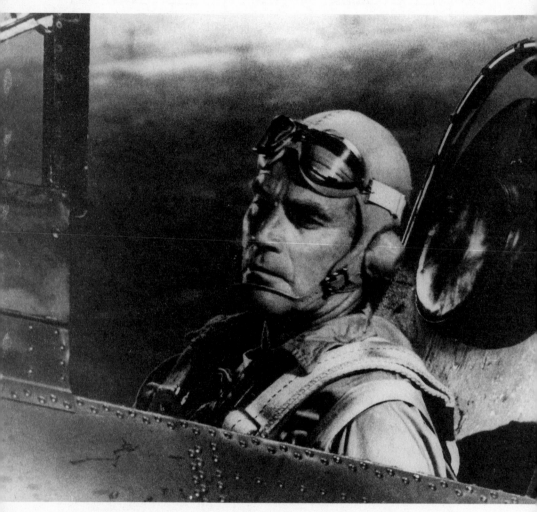

Charlton Heston as Captain Matthew Garth in Midway *(1976).*
(Courtesy of the Heston Family)

Chapter Thirty-One

While his latest run of films did well at the box office both domestically and overseas, where Heston's popularity had never wavered, they were, ultimately, more diverting than definitive. They lacked the early promise of dimension of character and major creative vision so promising in *The Ten Commandments, Ben-Hur,* and *El Cid.* Simply put, safely landing a plane full of passengers was not as stylistically grand as parting the Red Sea. Or, to put it another way, in *Airport 1975* and *Skyjacked,* God was not Heston's copilot.

A descending line after relatively early success is not unusual in Hollywood for an actor whose career stretches over several decades (one wonders what types of movies the eternally young James Dean, who had aspirations of becoming a director, would have made in

the independent 1970s; one knows what kind Marlon Brando did post-*Godfather*). Diminishing returns is the norm in an industry where youth is its most sellable commodity.

Heston was as aware as any actor about Hollywood's never-ending search for newer actors and actresses to replace its older stars. He well knew the arc of his long (for Hollywood) career had, in its third decade, begun a quality descent that was probably irreversible. He still wanted to work, not only for the money—he had, by now, made plenty of that—and not for prestige—he had more than most in Hollywood ever get and was still greeted with shouts of "Moses" by fans wherever he traveled all over the world. He simply loved acting and being a player in the game. The question was: How long would the game let him play?

In the fifteen years since the blacklist had been broken in Hollywood, and the structure of the studio system had shifted from an industry of in-house film production to one of purchasing and distributing outside features and television, the rise of independent filmmakers had shifted the political definition of Hollywood. As the younger liberal Left began to displace the older conservative Right in the film business, the singular old-school moguls were replaced by outside investors who knew little about film or filmmaking and didn't care to, who

were only looking to make money, regardless of what a filmmaker's personal politics were. Screenwriters and directors whose subject matter would have gotten them blacklisted in the 1950s were now being celebrated as the young geniuses of the new American cinema.

In 1969, Nancy Hanks, a former member of the National Council on the Arts, was appointed the chair of the National Endowment for the Arts by Richard Nixon, under whom the NEA had become a much larger and more powerful agency, thanks to the president's huge increase in its funding budget. That year, Nixon asked for and Congress gave him $40 million for the NEA. Nixon's ample support came as a surprise to many; he had shown no previous interest in the performing arts (aside from his amateurish piano tinkling) or any of the arts for that matter (whenever he visited an American embassy abroad, the artwork hanging in the hallways was routinely removed until he left, because Nixon disdained the look of European-style paintings). According to author Emilie Raymond, the president felt he needed to support the NEA because of "the corrosive moral relativism of the hippie counterculture and the growing acceptance of obscenity . . . [He] believed that uplifting cultural expression through federal arts programs could counteract these trends, but he did not

believe that America's intellectual establishment could lead the way, having long mistrusted intellectual elites. He preferred to rely on nonacademics for the nation's future. Thus, his argument to democratize the arts—'to enhance the quality of life for all Americans'—fit in with both his desire to promote spiritual uplift through the arts and his unwillingness to use intellectuals to promote the arts."

In February 1973, as chairman of the AFI board of trustees, Heston had presided over the ribbon cutting of the institute's new home, the aging Tudor-style Greystone Mansion, built in 1928 by the oil tycoon Edward L. Doheny as a gift for his son and eventually purchased by the city of Beverly Hills with the intention of turning the property into a public park. Heston and the other trustees had managed to convince the city to lease it to the AFI instead, for one dollar a year.

Attending the ceremonies and dinner had been Jack Valenti, the president of the MPAA and LBJ's former right-hand man at the White House. During a toast, Heston saluted Jack Warner for his hefty financial contribution toward the soon-to-open AFI Silver Theatre in Washington, D.C. Heston then announced, "From this year and every year forward there will be an award to someone whose body of work deserves it. This year's award will go to John Ford." The prize, which would

henceforth be known as the AFI Life Achievement Award, would be given to Ford at a dinner on March 31 at the Beverly Hilton Hotel. So far so good. Then Heston's bombshell: Richard Nixon would be the presenter.

At the time, the AFI was undergoing one of its frequent investigations by the Senate as to whether Washington should continue to fund the organization. Without Nixon's endowment, the AFI could not survive, and there was a feeling that inviting the president to be the presenter at the Ford dinner was a bit of a stroke job on Heston's part to get Nixon's continued support for the institute and get him to intercede with the NEA on the institute's behalf.

That may have been so, but more likely it was Heston's way of rewarding Nixon for his past support. Because most industry people in Hollywood were not even aware of what he had done (it received almost no press coverage compared with Nixon's less gracious activities), the announcement that he would be presenting at a prestigious awards ceremony surprised and disappointed the liberal film community, which was always suspicious and fearful of any Washington presence in Hollywood, mindful of the various Supreme Court antitrust decisions that had crippled the industry and HUAC's actions that led to the blacklist that all but killed it. The AFI's student body was even warier;

many of them were still angry at Nixon for having reneged on his first-term campaign pledge to quickly end the Vietnam War that was still raging and costing thousands of American lives every year.

Inevitably, some of Hollywood's confusion and anger at having Nixon in their midst spilled over to Heston. Even though he believed that the film industry and especially the AFI owed Nixon a lot, he didn't feel the need to justify the invitation to anyone. (A year later, in August 1974, when the Watergate scandal drove Nixon from office, there was great relief on Hollywood's Left, disillusion on the Right, and sadness on Heston's part—in his diary he wrote that "the Republic was shaken"—and he soon found himself on the receiving end of the residual industry anger for his embrace of the now disgraced president—anger that turned to rage with the disclosure of Nixon's "enemies" list that had many of Hollywood's biggest liberals' names on it, but not Heston's.)

If any event in his career pinpointed the beginning of the loss of Heston's popular base of support within the industry and of a gradual, insistent professional shunning, it was his 1973 AFI invitation to Nixon.

In January 1975, Heston opened in Peter Wood's production of *Macbeth* at the Ahmanson, with Vanessa

Redgrave as Lady Macbeth. He got along well with the politically controversial Redgrave and her then boyfriend, Italian actor Franco Nero (whom she later married), and even invited them over for dinner at the ridge one evening after rehearsals.

However, as rehearsals continued, Heston, who'd had his troubles with divas in the past, became increasingly annoyed at Redgrave's refusal to have so much as a syllable of the play changed or cut. *Macbeth* is Shakespeare's shortest play and there is very little fat on its bones, but Wood wanted to cut some of whatever there was to make it move along more quickly for the Ahmanson audience, many of whom were subscribers and often left productions before they ended to "beat the traffic," a practice indigenous to L.A.'s car-dictated nightlife. Heston, writing in his diary during rehearsals: "Vanessa is proving a strange lady to work with. She is not bitchy, or late, or any of the boring things I've found actresses can be, but she's a balking kind of performer to work with . . . she's *very* reluctant to accept any deviation from the published text . . . talking to Peter about Lady V, he said, 'Well, at least you don't get any of the standard great-actress behavior . . . they rehearse with their hats on!'"

And there was a political bump in the road as well. Heston and Redgrave were not in sync at all. He was a

big supporter of Israel, while she was vehemently anti-Zionist (which may have actually enhanced the tension of their characters' tumultuous marriage). Heston told one member of the company that he thought her politics made Jane Fonda look like Herbert Hoover.

Macbeth's sold-out black-tie opening at the Ahmanson on January 28, boasted an audience filled with celebrities, donors, and critics. When the curtain fell, they gave Heston and his fellow players standing ovations, even as the critics were sharpening their knives. The next day, Dan Sullivan, the *Los Angeles Times*'s theater critic, eviscerated the production on the front page of the influential Calendar section of the *Times,* and no one more than Heston:

> There are a good many interesting ideas in Peter Wood's production of *Macbeth* . . . But the central idea—to cast Charlton Heston in the title role—proves not at all interesting . . . his performance at Monday night's press opening was as featureless as an annual report and as slow-pouring as motor oil at 15 below zero, and Shakespeare simply won't run on that. Wood does his best to distract us from all that Heston is not doing in his solos and duets with Lady Macbeth (Vanessa Redgrave, rigid, too . . .) . . . [With] Heston, there is, one assumes,

a ground plan . . . but it is very hard to read. What it seems to say is that Macbeth was a sluggish, civilized kind of guy who sort of wanted to be king and who found that once he got into the swing of it he rather liked killing people—within the limits of good taste, of course. When at the end of the play this Macbeth finds himself without love, friends or the hope of heaven, he is mildly annoyed. That's life for you . . . if we didn't look for subtlety and inner truth from Heston . . . one could at least expect physical gusto. But no, Heston looks like a Viking, moves like a suburbanite . . . His Macbeth neither illumines the play, colors it, nor shakes it. The production moves, its center stalls. Not interesting.

It should be said that at fifty-one, Heston was probably too old to play the young warrior Macbeth, and the talk of his sluggishness might have been a reaction to an actor perhaps better suited to play Lear. As Heston himself admitted: "As a kid of twenty, playing *Macbeth* is a piece of cake. Every time you do it after that, it gets harder and harder." Welles did his filmed version of the play when he was thirty-three years old, and Olivier, coming off his Oscar-winning performance in his self-directed 1948 version of *Hamlet,* wanted next to film *Macbeth* with his wife, Vivien Leigh, as Lady Macbeth.

He tried for years, couldn't get the funding for it, and finally gave up. The feeling was both were too old. And everybody in the theater knows the litany of "curses" associated with the play (it is considered blasphemous to even mention the title in dressing rooms).

Shortly after the sold-out limited run of *Macbeth* ended, Heston resigned his seat on the SAG board of directors, citing "other industry-related commitments." He was diplomatic about it, but he did manage to express his displeasure at the direction the board had been moving toward, a younger, more aggressively liberal leadership. "I should never have come back [to be on the board] of course [after leaving the presidency]; I probably did it out of ego. The board's changed radically recently and I've become a surly curmudgeon, bitching about policies they go ahead and vote through anyway. I'll miss it, but I can no longer serve effectively enough to be worth the irritation and the time it takes."

Now that his schedule was finally clear, he decided to take Lydia on a vacation to Spain as a way to renew their commitment to each other, a romantic affirmation of their twenty-nine years of marriage. Columnist Dorothy Manners heard about it and couldn't resist taking one more shot at Heston for his recent critical drubbing: "Charlton Heston, superstar of 'disasters'

(including critical reaction to his recent stage appearance here as Macbeth), is getting away from it all for his first vacation in years. He and his wife Lydia will leave for six weeks of 'doing' Spain . . ."

Heston booked a suite for the two of them at the Sevilla, the same room they'd stayed in while he was filming *El Cid,* and an adjoining one for Holly, who was on Easter vacation from school. The day they arrived at the hotel, Heston received a phone call from Carlo Ponti, asking him to costar in a new film with Sophia Loren. No, sorry, Heston said, he couldn't do it; he was taking a much-needed break.

They stayed in Spain through Easter Sunday, and the following day Heston took Holly to the airport and put her on a plane so she would be back in Los Angeles in time for the resumption of classes. He and Lydia then flew to London to spend a few days going to the theater and meeting with old friends, before departing for Johannesburg, where Richard Lester had invited them to the charity premiere of *The Four Musketeers.* While there, Heston played in an exhibition tennis match, which Lydia photographed.

This was an important trip for them, during which they reignited the romantic side of their marriage. As far as Heston was concerned, it could have gone on for-

ever, but on April 21, as planned, they began the long
journey back to L.A., rested and refreshed, in time for
Heston to work on *Midway*, which was now ready to go
into production.

Walter Mirisch had put together an impressive cast
of stars for his cameo-rich pseudo-documentary, with
Heston playing one of the film's few fictional characters,
Captain Matt Garth, who unifies the film's narrative.
Other big-name cast members included Henry Fonda
(Admiral Nimitz), Glenn Ford (Rear Admiral Spru-
ance), Hal Holbrook (Commander Rochefort), James
Coburn (Captain Maddox), Cliff Robertson (Com-
mander Jessop), Robert Mitchum (Admiral Halsey),
Tom Selleck (aide to Captain Simard), Toshiro Mi-
fune (Admiral Yamamoto), James Shigeta (Vice Admi-
ral Nagumo), and at least a dozen more. The onboard
scenes were filmed on an actual World War II carrier,
the USS *Lexington*, that was still in service and that the
navy lent to Universal Pictures; the ship was docked at
the U.S. Naval Station at Terminal Island off the coast
of Long Beach, California, and Naval Air Station Pen-
sacola on the Florida Gulf Coast. Interior set pieces
were filmed at Universal's soundstages in Studio City.

When filming ended that June (Heston's total shoot-
ing schedule was less than twenty days), he returned

home and, with Lydia, decided to make Chicago and Michigan their destinations for the summer. He had mixed emotions about the trip, because his mother, who had returned home after an extended visit to the ridge, was moving out of the house she had lived in for many years, to smaller, more manageable quarters. He noted in his journal with some sadness that this "might be the last time I'll ever be in this house. The new one will do Mother and [his sister] Lilla very well, but I'll miss this rambling, slightly ramshackle repository of so many memories. So much of what I am began here. My work, my wife. This last visit, then, [will be] the last memory here."

During the visit, Heston took one day off for himself, to travel to an even earlier home, St. Helen, and recorded his impressions in his diary: "The scenes of my childhood, through misting rain, deepening the dark landscape of pines crowding in on the highway . . ."

The woods, the place Heston missed the most, the land of his happy childhood before it was all taken away.

His Rosebud.

Charlton Heston and Deborah Kerr in the 1977 Ahmanson Theatre production of Eugene O'Neill's Long Day's Journey into Night. (Courtesy of the Heston Family. Photo by Lydia Clarke Heston)

Chapter Thirty-Two

*M*idway was released on June 18, 1976, presented, as *Earthquake* had been, in Sensurround. The studio executives were encouraged by the unusually strong advance word-of-mouth from test screenings, and with good reason. The film proved an unqualified smash, grossing more than $43 million internationally in its initial theatrical release, and because of the hefty gross percentage deals that Citron had negotiated, *Earthquake* and *Midway* were the two most profitable films of Heston's career and helped reaffirm his place in Hollywood's hierarchy of stars with staying power. Heston was unequivocal in his praise of producer Walter Mirisch for the two films' enormous popular success. Heston and Lydia became close with the Mirisches, and the couples remained friends for the rest of Heston's life.

Midway resonated especially well with Heston's core audience, the Greatest Generation Americans who had been angered by and disappointed in America's defeat in Vietnam (Saigon had fallen to North Vietnam the previous year, with indelible images broadcast on the network news programs of the American military dumping helicopters overboard and retreating). Mirisch had read the mood of the country accurately and skewed the film to those soldiers who had fought in World War II, the last war the country had won, with just the right balance of power, determination, and strength the victorious U.S. military stood for in the first half of the twentieth century.

Mirisch's entertaining, comfort-food film was dressed up with terrific big-screen special effects, some action sequences borrowed from a number of earlier films, including the Pearl Harbor film *Tora! Tora! Tora!* (1970, Fox), Mervyn LeRoy's *Thirty Seconds Over Tokyo* (1944, MGM), and Guy Hamilton's British-German-American film *Battle of Britain* (1969), plus Japanese and U.S. Department of Defense war footage, the latter of which was actually shot by John Ford. *Midway* may not have been the best film of the year—some of the dialogue was a bit stilted, and the lack of an abundance of female characters was always problematic demographically (men wanted to see "war" films, their

female companions wanted to see the war between the sexes)—but it was still a big winner at the box office.*

Heston was well aware the picture wasn't Shakespeare, but he understood the realities of where he was in his career, that linear ensemble action films were the best major venue still available to him. Defending his appearance in them he said, "A good film today is really no harder to make than it was 50 years ago. Unfortunately, it is the only art where the raw materials are so expensive that the artist cannot afford to buy them for himself. Therefore, he has to enter in a business relationship with someone who will give him the money and expect it back. In the '30s and '40s, every studio had about 50 actors and actresses under contract, with two-dozen directors and writers. There was more work to go around. Nowadays an actor or director can be shoved out of the business if he has one major flop on his hands."

That wasn't his problem now. Approaching his fifty-third birthday, in his third decade of making movies, Heston was once more at the top of his game.

* For a TV version of the film, a major character named Ann (Susan Sullivan) was edited into the movie as the girlfriend of Captain Garth. Later video releases dropped the added scenes.

Fraser, meanwhile, was attending UCSD, majoring in biology and not enjoying it at all: "Technically it was biology, but I was angling toward marine biology and oceanography. I was a devotee of marine sciences, looking for a major that was a cross between Jacques Cousteau, Errol Flynn, and *Sea Hunt*.* I studied history, anthropology, and creative writing. I was actually doing pretty well my first two semesters when, after taking an English lit course I really liked, I decided that writing was what I really wanted to be doing. I decided to return to Los Angeles, and Coldwater, and enroll in UCLA for my sophomore year, where I studied creative writing, because the prevailing wisdom in the family was that I wasn't going to be an actor—I had never studied acting or theater or anything related to it, which looking back was probably a mistake. It would have helped me a great deal later on as a director and producer, and also I think to understand how my dad approached his work as an actor. I also got into literature with that course, and it was the real gateway for me, even if, for a time, I foolishly thought I would

* *Sea Hunt* was a popular '50s TV series starring Lloyd Bridges as Mike Nelson, a former navy frogman and freelance scuba diver.

become a novelist." Although he insists it wasn't his in-
tention, he was, in a sense, setting himself up to take
over the family business.

That still wasn't his father's preference. It usually
isn't for people who understand how difficult life in
Hollywood really is. Whenever he was asked by a re-
porter about the possibility his children might want to
follow in his footsteps, he always said most definitely
no. To one he said, "They know how hard it is to be in
this business, from living around it. Fraser isn't inter-
ested. Neither is Holly Ann, though I suppose all little
girls are actresses at heart."

He was right about Holly, wrong about Fraser, al-
though no one, including Fraser, knew that yet.

For the time being, Heston and Lydia were happy
having their son back home while going to UCLA.
With Holly still in high school, Fraser brought a burst
of familial energy with him into the house. Heston
loved having his favorite tennis partner back, even if he
could no longer beat him: "I haven't taken a game from
him in the past three and a half years. His reflexes are
too good for me . . ."

Coming off the success of *Midway*, Heston continued
to be in demand, and, via Citron, he signed on to play
a Los Angeles police captain running down a sniper

during a championship football game in Larry Peerce's *Two-Minute Warning*. Shot on location at the Los Angeles Memorial Coliseum and released in November 1976, Heston aptly summed up the film this way: "*Two-Minute Warning* was actually a pretty good film; Universal was positive it would out-gross *Earthquake*. It was a flop [because] the public didn't want anything to do with terror in a Super Bowl." The film disappeared quickly and quietly.*

That same month, Heston was reelected chairman of the AFI board of trustees, a post he had held since 1972. Although he was extremely proud of his association with the AFI, he tried to downplay the importance of his continued role, as the institute still ruffled some in the industry who never approved of how it was, to their thinking, subsidized competition and benefited from the same actors' talents for which they had to pay top dollar. He also sensed what he believed was a measure of jealousy: "I'm a spokesperson, a glorified doorman. In a sense it's almost become counterproductive, almost a provocation. Those who disagree with us can say, 'He gets to appear before a congressional commit-

* During its brief run, the Chicago Film Festival programmed in a twelve-hour Charlton Heston marathon, which lasted longer than *Two-Minute Warning*.

tee and we don't. He gets to go on Johnny Carson and we don't.' It's true, they're quite right. I get to go on Johnny Carson and they don't . . . but then I say something in support of the AFI."

Heston filmed yet another Walter Mirisch–produced cameo-rich disaster film for Universal, actor-turned-director David Greene's *Gray Lady Down,* about the rescue of a sunken submarine (the film gets an asterisk for being the first big-screen appearance of Christopher Reeve). Heston did this one as a personal favor to Mirisch and later justified it as more than that: "Although a large commercial success means a lot of money to me, that isn't the reason for doing the film. An actor has to have a commercial success every so often or you don't get other parts."

He may have been growing weary of these films, but he appreciated that they had extended his film career into middle age: "I'm luckier than any actor deserves to be . . . After an actor becomes established in the public mind you become followed throughout your career by the lengthening shadow of the parts you've played. It blocks you out of certain things, but it makes you credible by just standing there. I'm usually accepted in whatever I try . . . what can I do?"

To keep his stage chops in shape, Heston returned

to the Ahmanson Theatre in February 1977, this time playing the father in Eugene O'Neill's *Long Day's Journey into Night,* in an all-star production that included Deborah Kerr, Andrew Prine, and Robert Burke as the mother and two sons, respectively, of the Tyrone family. The play opened on schedule, February 20, despite Heston's having had to miss a few days' rehearsal to make a quick flight to France at the behest of Mirisch for the Paris premiere of *Midway.*

Seated on the aisle opening night was Dan Sullivan, whose highly negative review appeared the next day in the *Los Angeles Times* and, once more, singled out Heston. It read, in part:

> . . . directed by Peter Wood, who once did a BBC-TV version of *Long Day's Journey* with Sir Laurence Olivier. He has Charlton Heston here— and it is a big step down, but it wouldn't be fair to say that Heston's the major problem in this production. To be sure, dull, but so is everybody else— Deborah Kerr, Andrew Prine and Robert Burke. The flatness is universal . . . a tremendous disservice to a great American play . . .

Heston had little to say publicly about Sullivan's review and instead, when asked, emphasized that the

production broke another Ahmanson box-office record that had been set by his *Macbeth,* and that "it's a daunting experience to follow actors like Fredric March and Sir Laurence Olivier" in the role of James Tyrone. When the interviewer from *People* magazine expanded the boundaries and asked if he thought that his politics had anything to do with the *Times*'s much-publicized and talked-about attacks on his stage performances, he emphatically denied it: "I'm too dull, square and protestant, in the philosophical not religious sense, to be a big popular [political] figure. I'm not a public drunk. I've only had one wife. My kids aren't runaways. People don't find a big public flaw in me, and they seem to need that from anyone who's had success and attention."

People's comment in the piece (not said during the interview): "Well, it's not a Cinerama-size flaw, but will smugness do for Charlton Heston?"

By 1978, at the age of fifty-four, the gracefully aging Heston was still a force to be reckoned with, even if he was becoming an increasingly controversial one. Like John Wayne, another long-run actor continually scrutinized and criticized for his politics and other controversies, as long as he could put bodies in movie and live theater seats and make enough money for himself

and those who funded his films and stage productions, he didn't much care about what people thought of his politics. As if to underscore his contribution to film, his work for SAG, and his involvement with the AFI, the Academy of Motion Picture Arts and Sciences awarded him a second, noncompetitive Oscar, the prestigious Jean Hersholt Humanitarian Award, "in recognition of his contributions to community and film work."*

Heston's initial reaction was "I've never gone to jail and I've never vomited in Sardi's, so you see I've been a very unsatisfactory movie star." If this sounded like a cross between defiant and defensive, it was aimed directly at the Academy's well-known practice of anointing honors as redemption (as was obviously the intent with Charlie Chaplin's honorary Oscar, given to the self-exiled legend late into his life in 1972). "It is a basic part of a public's adoration of a star to want to see that star shot down." To his way of thinking, the award meant that Hollywood was forgiving him for expressing himself politically, even when it went against the liberal bias of the industry.

The Fiftieth Annual Academy Awards were pre-

* Named in honor of the Danish American screen actor who served as president of the Motion Picture Relief Fund for eighteen years; it is considered the most prestigious honor awarded by the Academy.

sented the evening of April 3, 1978, at the Dorothy Chandler Pavilion, hosted by Bob Hope, televised by ABC in America and seen via satellite around the world. Heston's Oscar was presented to him by the feisty former AMPAS president Bette Davis, despite her well-known dislike of the recipient, for his political bent. She had once publicly referred to him as "a pompous ass, and he [was] lousy as Ben-Hur."

To introduce that portion of the show, Hope put on his serious face and said, "Some people in Hollywood do more than make movies or headlines. They are citizens in the best sense of that good word. To honor the best of them, the Academy's Board of Governors occasionally awards the Jean Hersholt Humanitarian Award. This year, it will be presented by one of our best, Bette Davis." The diminutive actress walked out to thunderous applause, Heston's Oscar in hand, owlish glasses on her face, and she proceeded with her introduction that sounded more like an obituary than a celebration:

"Charlton Heston served six terms as the president of the Screen Actors Guild, a post that provided two of his predecessors with a springboard into the political arena. Chuck wants no part of politics . . . [T]he Board of Governors voted him this award because he is one of the most generous gentlemen in the film community,

he has been on the National Council on the Arts for six years, and is currently chairman of the American Film Institute and the Center Theatre Group in Los Angeles. He has performed countless services for the Motion Picture and Television Fund, Planned Parenthood, Muscular Dystrophy [Association], the Heart Fund, and the American Cancer Society. Chuck Heston has not done any of these things for recognition or credit. It's just the way he is, a man of conscience. And to boot, a darn good tennis player, who turns even that hobby into charity. I am honestly proud to present the Hersholt Humanitarian Award to Charlton Heston!"

She graciously omitted the "pompous ass" part.

The audience broke out in enthusiastic applause and the orchestra played its serious-moment music as a tanned and tuxedoed Heston, looking ten years younger than he was, strode out and kissed Davis on the cheek. She handed him his Oscar and strode off the stage. "When Bette Davis says it, you figure it must be true," he said, before beginning his prepared acceptance speech. "Really, I think I won this award for doing the kind of chores a whole lot of other people do, but because I'm an actor, when I do them they take my picture. Nevertheless, I'm very glad, very proud, and very grateful to the Academy to have this. Like all the awards given tonight, it represents the good opinion

of the men and women you do your work with, and always, for all of us, that's the best praise of all. Thank you very much."

Backstage he jokingly told a reporter, "Now that I'm a certified humanitarian there will be no more of this 'nice guy' crap."

Later that year, Heston announced he would return to the Ahmanson yet again, to star in *A Man for All Seasons,* throwing down the gauntlet and daring Dan Sullivan to criticize Hollywood's newest Hersholt humanitarian.

Or as Orson Welles put it, "To go on stage in Los Angeles, you either have to be crazy or Charlton Heston!"

Charlton Heston, Jean Firstenberg, and Gregory Peck at the offices of the American Film Institute. (Courtesy of Rebel Road Archives)

Chapter Thirty-Three

At the same time Heston was enjoying a new wave of public popularity and industry approval, Fraser had taken the next step on his journey of self-discovery. "After my last year at UCLA, that summer I went up to Alaska, I'm not really sure anymore why, except I was always something of an adventurer, I always loved the outdoors and thought it would be fun. I'd been there several times before, hunting and fishing, and this time I drove up from Los Angeles and got some odd jobs, first on the Yukon River running riverboats as a river guide, and then in Bethel, way up in the Arctic, where I worked in a native salmon-packing plant, the worst job I ever had in my life. Somewhere along the way I decided to try to finish writing a novel about mountain men I started, called *Wind River.* I'd been thinking

about it for some time and worked on it intermittently. I had a finished outline by the time I returned to Los Angeles.

"My tennis pal in those days was my friend Martin Shafer, with whom I'd gone to the Harvard School. He often came by the house to play a few sets of tennis with me, and he was just getting into the film business. He wanted to be a producer. I told him about my outline and he asked if he could read it."

Shafer picks up the story: "Fraser was my best friend from the time I was about thirteen. Chuck actually helped get me into the Harvard School. He became like a second father to me. I was like a part of the family. I used to go by the Coldwater house every Saturday to play tennis with Fraser, and Chuck would play with his friends as well. I remember seeing Rod Laver there many times, playing in the daylong tournaments that Chuck organized. The games were never all that competitive, more social affairs; no one ever went for the jugular.

"After, it was movie time. Everyone would move to the screening room, and some of his non-tennis pals would come by. His best friends were the two Walters, Seltzer and Mirisch; his neighbor Mark Isaac; and Dr. Louis Jolyon 'Jolly' West, the psychiatrist he had first met when Chuck was living in Hell's Kitchen who then

became the head of [the] Neuropsychiatric Institute at UCLA. Occasionally Hitchcock and Wyler would drop by, and Jimmy Stewart, sometimes Frank Schaffner, just to watch the movies.

"When Fraser came home from Alaska that fall, he gave me the outline of his novel to read."

Fraser: "Martin read it, loved it, and said, 'Why don't we do this as a movie?' He also asked if I had anything else I could show him. I told him I didn't have anything of my own, but that I had fallen in love with this book, *Leviathan,* by John Gordon Davis, a sort of Greenpeace eco-warrior high seas drama with a Jacques Cousteau–type character who creates a militant organization to fight Japanese whaling on the high seas. The next day Martin came back and said he thought we should option *Leviathan* and then take it to Columbia Pictures and try to make a deal for me to write the script.

"He found a producer at Columbia named Martin Ransohoff, and we got a deal for me to write a screenplay based on the book. I was all excited about it and wrote it in a burst; the studio execs then read it and said no, they didn't want to do it and backed out. The reason, I think, was because the Russians were the bad guys. This was during détente and they didn't want to appear to be politically incorrect. Martin then asked

if they'd look at my outline for my novel, now called *Mountain Men*. They liked that and hired me to turn it into a full screenplay. The two Martins then took it to my dad, without me. I was as surprised as he was, and even more so when he agreed to be in it."★

Fraser then formed a production company, Agamemnon Films, in partnership with his father, to produce *The Mountain Men*. Heston: "It was a marvelous part with much more humor than most of my parts have. For another, I liked the period aspect of the script, the opening of the fur trade. The film is concerned with the whole fur-trapping era. It's a remarkable stretch of the history of this country. I think an examination of it can teach us a great deal about who we are."

And partly, it was a way of holding on to the family unit by beginning the formal process of handing the family business, as it were, down to the next generation. It's difficult to see how, even if it was subconscious, there was not some desire on Fraser's part to

★ *Wind River* was changed to *The Mountain Men* when Columbia tried to register the name with the Writers Guild and discovered another film company had previously registered the title. Heston wanted Columbia to call it *The Last of the Mountain Men,* but the studio said no, insisting short titles looked better on movie marquees.

want to be in the same field as his father and to benefit from the Heston name. He had been born into film, he was surrounded by film people as a child, and many of his schoolmates were the children of celebrities. It seemed natural that he would want to be a part of that world.

Ironically, that desire would become the senior Heston's lifeline. In 1979, fifty-six-year-old Heston said, "I sometimes feel like one of the last surviving saber-toothed tigers, lifting his nose and smelling the chill of the glaciers coming down from northern Europe. One day you start to look around and say, 'Hey, where did everyone from my crowd go?' . . . I can't argue with actors who say acting is no longer a challenge to them. I think we're all uneasily aware that it's really kids work. Acting is pretending, and pretending is what children do. And I'd be the last to make a case for it as a proper activity for grown-ups. But I *like* it. And I've been extremely fortunate doing it because I've been able to support my family and send my children to school . . . and get people to take down all my opinions and print them."

In January 1979, Columbia Pictures announced in the trades that Heston had been signed to star in *The Mountain Men*, executive-produced by Richard St.

Johns, produced by Martin Shafer and his new partner Andrew Scheinman (neither was a partner in Agamemnon), directed by Richard Lang, and based on Fraser's screenplay about two trappers who survive in the Wyoming mountains.

At the same time, Heston began rehearsals for the Ahmanson production of *A Man for All Seasons*. He easily slipped back into the role of Sir Thomas More, his age helping to deepen his understanding of the character. The production was directed by Jack O'Brien, with a cast that included John Glover, Jack Gwillim, J. Kenneth Campbell, Gerald Hiken, Patrick Hines, Stephen Macht, Katherine McGrath, Ken Ruta, G. Wood, and Inga Swenson. All was going well until the morning of January 31, when the police burst into the Ahmanson and whisked Heston away. A female skyjacker had commandeered a United Airlines jumbo jet on the tarmac at New York's Kennedy Airport with 131 passengers aboard and demanded that Heston, or Lindsay Wagner, or Jack Lemmon, read a religious message live on all three TV networks, and if they didn't, she was "prepared to die." While Heston was being driven to LAX, where the FBI wanted him (neither Wagner nor Lemmon was available), officials searched the United and TWA terminals at Kennedy

Airport. The hijacker had told the pilot that the message was at a TWA ticket counter in the terminal.

No message was found. The real-life drama unfolded like one of Heston's disaster movies, down to the star cameos; aboard the hijacked plane were actors Theodore Bikel, Sam Jaffe, Dina Merrill, and Dean Martin Jr.; producer Max Palevsky; talent agent Sue Mengers; and environmental activist Selma Rubin. The hijacker had not allowed anyone to deplane. Adding to the surrealism of the moment, to keep all the hostages calm, Bikel took out his guitar and led the other passengers in song.

By the time Heston arrived at LAX, the FBI in New York had talked the woman into surrendering. With the crisis averted, Heston returned to the theater, relieved the situation had ended safely, and resumed working on the play.

A Man for All Seasons opened with much fanfare, some of it unintended, on February 10 (the aborted hijacking hadn't hurt, as it put Heston on the front page for a day, where it reminded everyone what a "hero" he was). It was Heston's fourth go-around at the Ahmanson, and this time, both he and the production received across-the-board positive reviews. The *Los Angeles Times*, for whatever reason, did not have Dan Sullivan

review the production (he was still at the paper), the assignment going instead to second-stringer Lawrence Christon, who wrote, in part:

[Heston] will never be an Olivier, but of all the characters we've seen him play downtown, he is most physically and temperamentally suited to More. Heston has the kind of rugged patrician face that could be minted on a coin, and here he is free of the lurching physical movement that gave him such a discomfited, constipated look as John Proctor [in Arthur Miller's *The Crucible*]. There's enough lightness and crispness to Robert Bolt's dialogue so that he's not burdened by the thickness of the Shakespearean language that made his Macbeth so opaque. He has played More frequently enough to be at home in the role, and in his comparative ease (the entire cast looked tense opening night) carried over into natural authority. Heston's principal drawback as a stage actor is vocal. His voice is a little hoarse and its timbre too broad to cut through distance over a broad range . . . but the clear, honest man More must have been is given a clear, honest performance here. He looks grayer and less florid, and he defers—a wise decision because most of the other portrayals are rich. And when finally he's

broken down, he comes apart in sections, as a man who's used to being erect would. It is one of the more painful sights to see such men break, and he brings us the full force of it.

And Ron Pennington of the *Hollywood Reporter* wrote in his February 20 review that:

Heston's very natural performance occasionally becomes too casual and once in a while, particularly in the final scenes, he slips into forced melodrama . . . but it is a lucid and intelligent [performance] and it serves the production and the play quite well.

Heston was unmoved by any of the notices. He had grown accustomed to the Tower of Critical Babel that appeared whenever he performed live and had developed a thicker skin when the attacks took a personal bent: "You're only risking your vanity. And we should expose our vanity every so often anyway. Putting aside the question of whether bad notices may be incorrect or not, they may function like the courtiers in Byzantine times whose function was to whisper in the emperor's ear, 'You must die, too.' Just to keep everything in perspective. It's wrong not to chance it."

Playing Henry VIII in the production was up-and-

coming actor Stephen Macht. Heston took an immediate liking to Macht, whose strong physical presence reminded him of a younger version of himself. Macht was a New York–born and –raised actor who had followed Heston's film and theater career, admired his ability, and could never understand why the critics were always so hard on him: "He used to get nailed in almost everything he did onstage there, especially from one *Los Angeles Times* critic. The fear of failure has always bothered me. After we opened, I said to him, 'Why do you do this? Why do you constantly put yourself at the mercy of these people?' He looked at me, smiled, and said, 'Because, Stephen, one day I will get it right.' That's when I realized he had no fear of failure because he was so humble, and that he loved performing, and it was the performance, not the critics' reaction to it, that mattered to him."

Preproduction on *The Mountain Men* began that May, to be filmed on location in Wyoming at Bridger-Teton National Forest, Grand Teton National Park, Shoshone National Forest, and Yellowstone National Park. The story takes place in 1830 in the western Blackfoot territories of the United States, where fur trappers helped open up the trails that would soon carry wagon trains

and those seeking their fortune in gold in the California Gold Rush. These trappers were among the first white men to discover Native American culture. "They had the whole country from the Missouri River to the Pacific Ocean virtually to themselves," Fraser told one interviewer. "Their monastic existence appealed to me, as did the way their freedom was dictated by economics. Yet, ultimately, it wasn't beaver that kept them up there, it was the lifestyle. In many ways, it's an old-fashioned picture and an old-fashioned [lead] role—with action, adventure, and romance. But in the shifts of character, the part presents Charlton Heston as an actor with some challenges that his recent roles haven't allowed."

The film's plot concerns the annual "rendezvous" at the foot of the Rockies that took place every year between 1825 and 1840, where traders, trappers, and Native Americans gathered to barter, sell, and celebrate the year's accomplishments, sitting around campfires in the evenings telling stories, listening to and playing music, getting drunk. More than one young Native American woman found her husband among the ripe and ready trappers. "Most mountain men were illiterate," Heston said later. "The reason why very few personal chronicles of the period exist. They had a highly

verbal culture and would appropriate stories from each other with the slightest provocation. We used that technique in the film."

In it, two mountain men, Bill Tyler (Heston) and Henry Frapp (Brian Keith)—a character based on Henry Fraeb, a real-life nineteenth-century beaver trapper and fur trader—are hunting beaver in Blackfoot territory when they come across Running Moon (Victoria Racimo) running from her vicious Blackfoot warrior husband, Heavy Eagle (Macht). Henry is scalped (he survives), Bill and Running Moon escape. Eventually they become lovers, and Bill and Heavy Eagle become entangled in a personal war over whose woman she is.

Macht and Heston spent a lot of time together during filming, and the friendship they had begun with the production of *A Man for All Seasons* deepened. While continuing his acting career, Macht, a PhD, started studying to become a rabbi. "As I was maturing, and getting to know Chuck better, I felt he always appreciated so much from everybody. I think I got the part in the film because Chuck had seen me play an Indian in something. He called me and asked me if I could ride a horse. Like any actor, I said of course, even though I had never been on a horse in my life, and he gave me the part, although I think he knew that I was giving him the actor's bluff. Here I was, a Jewish boy from

Brooklyn, playing an Indian, dressed in buckskin, and I had to run out of my tent and mount the biggest horse I'd ever seen, and this was my first day of filming, my first scene. Standing on the side of the camera and watching was Heston, who began laughing hysterically when I couldn't get on the horse. One of the other Indians said to me under his breath, 'Heavy Eagle, huh?' Heston finally came over and put his arm around my shoulders and said, 'It's all right,' and I sighed in relief. Then he said, 'You're going to learn to ride that horse, and we have a lot of stunt people who can help you.' That was Chuck, graceful and generous with actors. I learned a great deal from him."

Fraser: "All in all, *The Mountain Men* did not turn out as well as we had hoped. My dad saw it as a lyrical paean to the West, while the studio saw it as a madcap comedy romp. But in the end, it started our career together and that was the real reward for both of us."

Also in 1979, George Stevens Jr. announced he was leaving his post as president of the American Film Institute at the end of the year to devote more time to his film and television work. In recognition for all that he had done for the AFI, the institute made him a life trustee and cochairman of the board and presented him with an honorary life achievement award.

Stevens left just as the AFI was experiencing new financial and political challenges. He was replaced by Jean Picker Firstenberg, a former advertising executive with a background in broadcasting. In 1980, when the rent at the Greystone Mansion was raised to an unreachable amount, forcing the institute out, Firstenberg guided the purchase of the Immaculate Heart College's 8.6-acre campus located in Los Feliz, just southeast of Hollywood, for a hefty $4.9 million. The college had been established in 1916 by the Sisters of the Immaculate Heart of Mary and had lately fallen into financial disarray.

As a board member, a mostly ceremonial position, Heston had limited say in the decision, but he approved of the move: "If you're talking about a film center, you're talking about Hollywood—the heart of the film capital of the world. Beverly Hills conveyed an elitist color."

His role was about to become more active, and more meaningful, when he was assigned to be one of the cochairs of a new task force established by the newly elected president of the United States, friend and former SAG mentor Ronald Reagan, to look into the financial health of the nation's cultural institutions: "I am naming this task force because of my deep concern for the arts and humanities in America. Our cultural insti-

tutions are an essential national resource; they must be kept strong." And yet, just after making this statement, Reagan announced a budget proposal that called for $85 million to be cut from the $152 million earmarked for the National Endowment for the Arts (NEA) and National Endowment for the Humanities (NEH). According to Reagan, this was a generous cut, because it could very well have been much worse: "While I believe firmly that the federal government must reduce its spending, I am nevertheless sympathetic to the very real needs of our cultural organizations . . ."

Firstenberg doubted Reagan's sympathy was genuine. As she later recalled: "One of Ronald Reagan's major campaign promises when he ran for president in 1980 was that he would completely eliminate the National Endowment for the Arts and the National Endowment for the Humanities. He took office in January 1981 and that May named a task force for the arts with Chuck Heston as its chairman, along with the very distinguished academician Hanna Gray, who was president of the University of Chicago, and a third cochair, Daniel Terra, who happened to be one of Reagan's chief fund-raisers during the presidential campaign whom Reagan had also named as his cultural ambassador at large."

To Firstenberg and others, Reagan had created the

task force as a buffer, so the blame for the cuts wouldn't fall solely and directly on him, and had stacked the deck in his favor.* What he may not have counted on was Heston's impassioned commitment to the AFI, which depended on government funding to survive, and he left no doubt as to where he stood on the issue: "The Arts and Humanities represent a significant national resource and deserve a share of the taxpayers' dollar. Without that position, there is no consensus for the Arts Endowment. Since the vote in the Congress in the Johnson Administration to create the Endowment, that's the closest to any official registering of national opinion on either Endowment."

Former actor and SAG president Reagan was not against the arts, only the public funding of them. He had grown up in an industry that was a private enterprise business without the benefit of public money, and he believed that the AFI and other arts organizations should exist the same way. The administration's NEA chairman, Livingston L. Biddle Jr., was more inclined

* The NEA and NEH budgets are decided on an annual basis. In one of his last acts as president, President Carter reauthorized both his budgets for an additional five years to prevent the dismantling of the two agencies, the reason President Reagan had commissioned the task force rather than just making the cuts himself was so the new budget would not seem overtly political.

to keep the funding intact, as was NEH chairman Joseph D. Duffey, both President Carter appointees held over by Reagan. They did not automatically agree with Reagan's policy, or rationale, that major budget cuts would give the funding agencies "a chance to start over."

Biddle's term was set to expire that September, and rumors were rampant in both Washington, D.C., and Hollywood that Reagan intended to appoint Heston as his permanent replacement at the NEA. Anticipating the appointment, *Variety* reported that Heston had already told Reagan's chief of staff, James Baker, that he was not interested in any full-time post in the new administration and would not accept one if it was offered. He was an actor, he reportedly told Baker, and that's all he wanted to do: act.

If the offer was being made as a way for Reagan to enlist Heston's support in the budget fight, no matter how indirect or ceremonial, it didn't work. Heston signaled as much when he insisted that he and Reagan were not as close as everyone assumed (apparently including Reagan). Not long after, Heston told *Playboy* magazine, "I am a great admirer and supporter of President Reagan's, but our intimacy is exaggerated . . . We've sat around in social situations. I've known him for years. But it would never occur to me to call him

Ronnie now—although I did when we were both on the SAG board together . . . It's never occurred to me to try to increase the informality of our relationship." Still, should Reagan make Heston's appointment as the new head of the NEA official, he didn't feel he could say no to the president.

Reagan added two dozen additional members to serve on the task force under Heston, Gray, and Terra, mostly entertainment movers and shakers, including arts activist Margo Albert, film director (and Heston's good friend) Franklin Schaffner, soprano Beverly Sills, and Dr. Franklin Murphy, CEO of the Times Mirror Company. They were given until Labor Day of that year, 1981, to report back on three specific areas: how to increase support to arts and humanities commissions at the state and local levels, how to increase the role of nongovernmental advisers, and the possibility of converting the endowments into public companies like the Corporation for Public Broadcasting that would have to depend more directly on the private sector for financial support.*

* The Corporation for Public Broadcasting is a private, non-profit corporation that supports noncommercial radio and television through grants, contracts, and other programs. Its budget prior to the proposed cuts was $162 million, about the same as that of each of the endowments that were earmarked by Reagan

There was a great deal of outrage in Hollywood from Heston and others who believed the task force was a prelude to budget cuts that would affect not just the AFI but all arts-related projects, many of which existed largely from the endowments, and to a lesser degree private subsidies. Charles Champlin, the *Los Angeles Times* arts editor, put it this way:

What seems clear is that the real task of the task force is to energize all the additional financial support it can from the private sector of the economy for the arts and humanities. What is inescapable is the funds will be found in the private sector, or not at all. A reasonable corollary would seem to be that the major, established cultural organizations will be better based to solicit and obtain significant private fundings but that newer, smaller activities may find their prospects very bleak.

With the issue now out in the open, Heston found himself on a high wire; he didn't want to support Reagan's budget cuts, but he also didn't want to get into

for substantial cuts. All the endangered agencies and corporations were legally able to accept private donations before the proposed cuts went into effect.

a public battle with the president. Nor did he want to shirk what he thought was his responsibility: "It would be stupid to say you'll take on a job when the final action had already been decided on. [As for me,] it's hard to say 'no' when they ask you to do a hard job and say they can't pay you, of course, and what you do will probably make everybody sore as hell at you . . ."

To avoid any potential conflicts of interest, Heston temporarily resigned from the AFI board of trustees and as cochairman of the Center Theatre Group, which was associated with the Ahmanson Theatre and L.A.'s Mark Taper Forum, until the resolution of the NEA and NEH budgets. He then plunged ahead, like Moses into the desert, to take on what became a fierce public battle with the administration to save the budgets.

In the end, after several months of prolonged outcries from various arts groups, Reagan blinked. Believing he may have underestimated the outcry from the leaders of Hollywood's and New York's creative communities, which were thick with potential party donors, he announced that he was happy to say that most of the Carter budget for the arts would remain intact.

On June 10, 1981, *Variety* was the first to report his decision as a personal win for Heston as much as for the NEA:

The National Endowment for the Arts has won a reprieve from Reagan Administration budgetcutters for fiscal year 1981, thanks in no small part to the intervention of Charlton Heston, close Reagan chum who chairs the White House Task Force on the Arts . . .

Following news of a White House plan to require the endowments to return to the U.S. Treasury coin already received and earmarked for arts groups, an angry Heston made a plea to the White House crying "foul."

Upshot: the Administration's budgeteers have decided to take back [cut] only $6,650,000 instead of the $30 [sic] million first planned.

A jubilant Livingston Biddle, chairman of the Arts Endowment, thanked Heston for his high level intervention and the Office of Management and Budget for its flexibility. "NEA can now honor commitments which it has made [during the Carter Administration]."

Still, not everybody was happy with what many in Hollywood were already calling "Heston's victory." The National Urban Coalition, for one, sent him a Mailgram questioning his comment that the "expansion

arts program," which benefited minorities in artistic and scholarly endeavors, was essentially "recreational" and was where most of the $6.5 million cut came from:

> To define their work as "recreational" and to consign their support to the Department of Health and Human Services would be literally to add insult to injury. We are dismayed by reports that you have stated apparently without serious study that the programs that are most active in supporting work of minority artists should be eliminated.

Heston had no comment. He knew that nothing ever got done without criticism from someone or someplace, and he stood by what he and others saw as a major victory for public funding, including Jean Firstenberg: "Reagan may have been expecting an easy time of it, but the results of his task force were exactly the opposite. Reagan blew it because he appointed the wrong people to head it. All of them were sympathetic to the NEA, especially Chuck. Talk about carrying the staff, Chuck was a key player in preserving the National Endowment for the Arts. His leadership of the task force was brilliant. He considered film a legitimate art form, and that was one of the goals of the endowment, to help make people understand that moving images were art,

at least as much as, if not more than, commerce. He was spectacular at a time when it would have been very easy for him to have capitulated to those who wanted to defund the endowments. He was, after all, a Republican and a friend of Reagan's, but he stood up to his buddy in the White House and played a crucial role in saving the NEA. He was majestic in his determination. He did five months of intense meetings and negotiations, and lobbied all around the country, before the task force handed in its report. Everywhere he went, he was strong and powerful in his presentations because he cared so deeply about the arts."

When the *Los Angeles Times* asked Heston about his victory, he replied with typical modesty, "By and large, I'm quite content, optimistic and satisfied." Had he had enough of political battles, or had this whetted his appetite for more? What did he intend to do next?

"I'm an actor; I want to act."

Six of the former presidents of the Screen Actors Guild (left to right): *Ed Asner, Leon Ames, Dana Andrews, William Schallert, Charlton Heston, Dennis Weaver.* (Courtesy of Rebel Road Archives)

Chapter Thirty-Four

The following year brought with it another series of milestones. In June 1982, Fraser married Marilyn Grace Pernfuss, of Vancouver, B.C., and Holly graduated from the Harvard-Westlake School (as it was now called). She then moved to Paris to study at the Sorbonne for a year, intending to return to Los Angeles afterward to complete a degree in art history at Pepperdine University. Like her mother, she had taken up photography, which led her to want to pursue a career in art exhibition, a choice Heston encouraged. "I'm very relieved," he said, "that my daughter seems absolutely determined against a career in films."

Heston was home more often than usual these days. Part of the reason was Citron had announced his retirement. Heston took time to make his decision about who

to sign with next. He had been with Citron for so long, it was like losing a member of the family. At the end of the summer he went with Fred Specktor at Creative Artists Agency (CAA). Specktor was one of the most powerful agents in the business, and he assured Heston he would soon be back at work. But even with Specktor on board, there was still a significant drop-off in offers. Part of it was expected; in Hollywood there is always a decline in available parts for aging action-adventure actors, which was how Heston was categorized. Even with the understanding that Specktor had to find his rhythm and his fit into Heston's career, he thought he would be more in demand than he was.

Things picked up when Fraser, rather than Specktor, brought his dad another adventure/survival screenplay, this one called *Mother Lode* that he had written as a spec script and said he wanted to produce under Agamemnon's banner. And, he wanted Heston to star in it and his mom attached as the film's official photographer. Heston not only agreed to be in the film but also said he wanted to direct it, the first time he had done that kind of double duty since *Antony and Cleopatra*. Fraser: "It was another wonderful chance for Dad and I to work together as adults, this time both with some experience under our belts, and we grew closer because of it."

Fraser brought on Martin Shafer and Andy Scheinman to coproduce. He raised the film's $2.5 million budget from Canadian backers, who funded it on condition that it be shot entirely in British Columbia, where costs would be significantly less than if it were filmed in the States (it would be only the second American feature to be filmed in its entirety there). Although Heston played dual character roles as the gold-mining brothers Silas and Ian McGee, his combined screen time amounted to only half the film's 101 minutes, which allowed him to concentrate on directing. Newcomer Kim Basinger was brought on board to play Andrea Spalding, the wife of a missing pilot, and Canadian actor Nick Mancuso filled out the cast as another bush pilot hired by Andrea to help find her husband, who falls for her while everyone is looking for the pilot and gold.

The informal extended family reunion continued when Peter Snell was brought on to executive produce. Snell: "Chuck directed and for once played the bad guy, and he loved doing it. It was great fun and a bit of a relief for him not to have to carry the whole picture on his shoulders." Fraser said his father's performance was "heavily influenced by Walter Huston's in his son John Huston's 1948 masterpiece, *The Treasure of the Sierra Madre,* though structurally the film more closely resembles a Canuck version of Peter Benchley's *The*

Deep: young adventurer becomes obsessed with buried treasure; voluptuous girlfriend wants to pack up and go home; eccentric but experienced treasure hunter manipulates them both."

Heston said he saw the film as a cross between Huston's film and John Boorman's *Deliverance.* He also diverted any suggestions that an Agamemnon Films production couldn't raise the financing to be made in America because of the failure of *The Mountain Men.* He palmed off that film's lack of box-office clout on Ransohoff's "appalling editing" and the current economics of all Hollywood-based productions, which had been negatively affected by the out-of-control spending of Michael Cimino's $44 million debacle *Heaven's Gate,* which returned less than $4 million in its initial domestic release. Any film, he suggested, set back a century in time had little chance of getting funding (*Variety* would call *Mother Lode* a vanity production), but as for working with his son again, he said, "We [he and Lydia] had a remarkably good working relationship with Fraser on *Mother Lode.* Of course, he and I disagreed on certain things; it's part of any creative relationship. As somebody said, 'Reasonable men can reasonably differ,' and both Fraser and I are reasonable men. I found that, if anything, it was easier to resolve

creative differences with him than with some people I have worked with."

Just as Heston arrived in Canada to begin filming, he had to quickly return to Hollywood when SAG rescinded its earlier decision to honor Reagan for his lifetime of achievement, because of his recent firing of all the striking air traffic controllers who had refused to return to work. The controllers were members of the Professional Air Traffic Controllers Organization (PATCO), a certified trade union that had been in existence since 1968. The rescinding of the planned award was an act of union solidarity and marked SAG's shift even further to the left, which had begun with the 1980 election of Ed Asner as the guild's new president.*

In July 1980, SAG president William Schallert had led the guild in a strike after failing to reach an agreement with producers over pay TV and video cassette ancillary rights and residuals. The walkout had dragged on for ninety-four days until a settlement was

* When *The Mary Tyler Moore Show* ended in 1978, Asner signed on to do a network spinoff based on his character, Lou Grant, the grump with a heart of gold and now a *Washington Post*–like newspaper editor. Asner won two Outstanding Lead Actor Emmys for the series, one in 1978 and again in 1980.

finally reached that October. Heston had been among SAG's most vocal dissenters against the strike, believing it was unnecessary and potentially harmful to the industry, and that negotiation was the better way to go. When word spread that Heston was working at Reagan's behest to either prevent or end the strike, he vehemently denied that he had had any contact with Reagan about it.*

Asner had enthusiastically supported the walkout and walked the picket lines every day, even on the hottest of California summer afternoons, although he later described his participation as that of a reluctant activist: "I got pulled into it because a band of SAG dissidents were unhappy with the way Bill [Schallert] led them in the strike. While I was on the street [I] managed to capture the hearts of my countrymen, and as a result the so-called radicals thought I'd be a good front man to put in as the next president of the union." When Schallert's second one-year term came to an end that December, the guild ousted him because a majority of members felt he had not been a strong enough negotia-

* Author Emilie Raymond asserts that Heston did, in fact, personally keep Reagan apprised of the situation. Reagan had opposed the strike and wanted Heston to try to discourage it. The president was reportedly upset by the guild's rescinding of his lifetime achievement award.

tor during the strike. By an overwhelming majority of votes, Asner was elected to succeed Schallert, even though he had not previously served on the board, the traditional route to the union's presidency. Asner had campaigned on a platform of left-leaning activism: "I have no magic solution for the problems facing the Guild but, if elected, I will totally dedicate myself to enhancing our identity as proud workers and unionists. To strike out at the attitude that the performer is not a worker. To enlighten the performer who feels guilt at success and divorces himself from his peers. To work toward that unity of performer unions wherein all artists will feel strength in numbers and freedom from jurisdictional squabbles. With these accomplished, the two contracts we face by 1983 will be satisfying realities. We are family."

Heston was not happy about Asner's election and, after his victory, publicly criticized him for having taken advantage of the rank and file by "imposing his political views on the membership."

That statement set off an ideological war between Heston and Asner. Heston was proud of the fact that he had kept his personal politics out of the guild's affairs during his presidency, and was furious about how, he believed, Asner had used his newfound position of power to persuade the guild's membership to

deny Reagan the lifetime achievement award. As if in response to Heston's grumblings, Kim Fellner, the information director for the guild, issued a public statement explaining that giving the award to Reagan would "alienate us from the rest of the [national] labor movement, subject us to embarrassment and ridicule, and cause severe and unhealthy disruptions within the membership." Heston then reminded the guild of how much Reagan had done for it during his tenure as president and warned the Asner administration that it was creating major opposition for itself, both in Hollywood and in Washington, that could very well jeopardize any future funding for the arts.

At this point, Heston was considering returning to SAG's board of directors, a seat he had temporarily given up while fighting to keep the NEA's budget intact, but in January 1982, he turned it down because he believed Asner had succeeded in dividing and politicizing the guild. Heston was not at all surprised when his seat went to Dean Santoro, who had been Asner's campaign director when he ran for guild president.

In November 1981, Asner was reelected to a second term, and one of his first acts in 1982 was to propose a merger between the Screen Actors Guild and the Screen Extras Guild, something Heston had always opposed. He was "shocked," he told the *Hollywood Reporter*,

to which Asner, in response, called Heston Reagan's "stooge." Later on, Asner added this: "The vast majority of extras on the West Coast already belonged to SAG. Only 1,500 weren't already in the union anyway."

Heston then called for a day of hearings, where referendums were argued back and forth, and after, Asner's merger proposal failed to pass.

A few days later, Asner presented a check for $25,000 to the leftist group We the People, the money to be used, he said, for medical aid to El Salvador's Communist guerrillas. Asner had, for a long time, been an outspoken critic of Reagan's policies in Central America, particularly his sending aid to the country's right-wing military opposing the rebel incursions. "We gave the money to an archbishop of Mexico who would then take it into El Salvador to purchase medical supplies for the people in the hills not getting anything from the government."

Heston was, once again, furious and told one reporter, "He has the perfect right to give money to El Salvadoran guerrilla rebels for money or arms or anything he wants. But as long as he's president of SAG, he has an extra responsibility, which he may not understand." Heston insisted that Asner's much-publicized presentation of the check had made it look as if it were guild money.

Asner strongly disagreed: "He assumed I was giving the union's money to the Revolutionary Democratic Front, and a lot of people believed him. I was then urged by several different people to make an explanatory statement to clarify that it wasn't union money we were giving, but funds that had been privately raised."

Asner then added, "When he went to Vietnam, he never clarified it wasn't as a representative of the guild, even though he was on the board."

When the controversy didn't die down, due mostly to Heston's continuing to criticize Asner in the industry press and on local TV, Asner called a media conference outside the SAG offices to clarify the issue of his donation to El Salvador. In response to a question about the money from one TV reporter, Asner, who apparently had had enough, angrily called Heston a "scumbag," a reply broadcast on every local news broadcast that night (bleeped, but everyone knew what the word was). The next day at the SAG board meeting, a still-heated Asner this time called Heston a "cocksucker." That was leaked to the *Hollywood Reporter* (who referred to it as a "dirty word"). Asner then claimed his comments were misconstrued, that it was all in fun, that cocksucker was a term of affection: "When I was a kid growing up in Kansas, whenever anyone pulled off a stunt, we would say, with affection, 'That cocksucker!

He did it!' Cocksucker was part of our vernacular, and really meant nothing more than a wise-guy term for affection. During the meeting I was telling someone, 'That cocksucker got me to shake his hand,' and someone overheard it. That's the context of what I said and why I said it."

Not surprisingly, Heston was enraged by the off-color slur and wrote a long, detailed letter to Asner, chastising him for his language, and sent copies of it to everyone on the SAG board and to the *Hollywood Reporter.* It read, in part:

President Ed Asner:

Yesterday I wired my congratulations to you for appearing at Monday's demonstration opposing SEG Merger . . . Today I'm disgusted to hear that, speaking to a board member at the meeting in the hearing of several, including some of the press, you called me a cocksucker.

The attack on me is meaningless. I'm only sorry you can't understand how deeply demeaning this is to you, to your office, and our Guild. It's as permanent and repellent a stain on a man as Khrushchev pounding his shoe on the table at the U.N.

If you plan a political career, you have
to learn that people will disagree with you.
In this country, we are allowed to. Right?

Asner had no direct response for Heston or the *Hollywood Reporter*'s many requests for one.

Heston then formed a new special interest group, Actors Working for an Actors Guild (AWAG), whose sole intent was to pressure Asner to resign as SAG president. Sensing his position might be in real jeopardy, in a gesture of conciliation, Asner offered Heston a new seat on the board. Heston said no. AWAG quickly developed into a powerful body of resistance and seriously compromised Asner's ability to lead. Although Heston insisted he was not trying to force him out of office, everything he did indicated that was exactly what he was doing.

The situation got even hotter and heavier when more than one assassination threat was made against Asner (none was ever attempted). Threatening letters were sent to Heston as well. After a meeting set up by SAG at its offices intended to restore peace between the two, Asner privately told one reporter Heston was "down in his cups," meaning drunk. When the *Hollywood Reporter* called Heston for a response, he had none.

At that point, Heston returned to Canada to film *Mother Lode*. Working on the movie took all the pressure from his SAG-related political battles off his shoulders, and for the next several weeks, he happily concentrated on his acting and directing. He seemed more at peace being with his family and working on a picture.* Upon his return to Los Angeles, however, the fallout from his war with Asner landed on both of them.

Just as the 1982 fall TV season was about to begin, after five seasons and 114 episodes, and despite drawing consistently high ratings, CBS abruptly canceled *Lou Grant*. Asner maintains to this day that his political views and the bad publicity surrounding his feud with Heston (including the colorful language episodes) were the reasons for the show's cancellation, which was probably true. What Asner did with his intemperate comments about Heston was to destroy the professorial image of Mr. Grant. Right or wrong, the network felt he had crossed a line and that his gruff-but-lovable

* *Mother Lode* had a limited release that fall, making enough to pay back its investors and establish Agamemnon as a legitimate Hollywood player.

character could never be quite as lovable again, at least not to the television-watching public. Asner continued to work after *Lou Grant* went off the air, in films and TV, but none of the movies he appeared in on-screen was a major hit, and while he played major roles in the TV miniseries *Rich Man, Poor Man* and *Roots,* he never starred in another prime-time series.

Heston felt it too when he had a falling out with Paul Newman, an actor he had been friendly with back in the days of live TV when they were both starting out. This dispute was over Newman's support of a nuclear weapons freeze between the Americans and the Soviets. Newman, a committed liberal Democrat, had been appalled when Reagan was elected president of the United States in the fall of 1980. According to his biographer Shawn Levy, "On election night, with Reagan's victory assured, the Newmans held a party at which they screened Reagan's infamous comedy *Bedtime for Bonzo;* they and their well-lubricated friends banged spoons on pots and pans to drown out Reagan's dialogue until reality dampened their giddy mood and they turned the film off."

Newman was a strong supporter of the Center for Defense Information (CDI), a lobby to counter public statements from the Pentagon and Reagan to present what it believed was a true picture of the president's

escalation of the Cold War with the Soviet Union. In 1983, the CDI managed to get a proposition on the California State ballot urging both nations to seek nuclear disarmament. Heston then held a press conference on his tennis court and said, "Paul is a good man and a good actor, but if he is going to speak out, he has a responsibility to check out the facts first."

Newman, who almost never did TV talk shows, began to appear on as many as he could, as long as the subject was his support of a nuclear freeze. He was annoyed at Heston's constant indirect refutations and accused him of seeking publicity from the feud: "Heston is riding piggyback on me, really outraging us. He's refuting my points, but I'm not getting any rebuttal." Newman then challenged Heston to appear with him on the ABC TV program *The Last Word,* and Heston agreed. One reporter referred to it as Cool Hand Luke vs. Ben-Hur. According to Levy, "Heston ran circles around [Newman]."

And Heston knew it. Afterward, he chuckled when he told Carol Lanning, "He can't touch me!"

The two actors never reconciled their differences after that.* "Although Paul and I have never been

* In 1982, Newman had formed the Scott Newman Center to assist health care professionals and teachers in educating chil-

close," Heston said later, "I've always respected him. He's a Democrat, I'm independent, but we've often found ourselves in support of the same candidate. And I think he's a fine actor . . . therefore I was shocked when I went in to do the debate [about the nuclear issue] and he wouldn't shake hands with me . . ."

The liberal Hollywood press sided with Newman and criticized Heston for using his fame to promote political issues. After an especially hostile run of columns negatively reacting to Heston's nuclear position, he told one interviewer, "I don't think I should have to abandon my right as a citizen to speak out in public. And if I sound like a jerk, there's a faint risk that someone will, out of context, distort what I say and make me seem like a jerk . . . what can I do about it, anyway?"

Heston's view was that it was the media's fault, but it was more complicated than that. Politics inevitably reduces a star's appeal. In the end, it doesn't matter if one leans left or right; a political personality divides the audience, and it hurt Heston going forward, as after, his already tottering film career fell off a cliff. He never

dren about the dangers of alcohol and drug use (his son, Scott, had died a few years earlier from a drug overdose). Before his feud with Heston began, Newman was organizing a fund-raising benefit and invited Heston to sit on the dais and introduce him. After the debate, Newman rescinded the invitation.

again starred in a big box-office hit, and he eventually moved back to television, coming full circle from where he had begun. Hollywood's cold shoulder eventually warmed a bit, but Heston never fully recovered professionally from the Asner/Newman wars. As the screenwriter Garson Kanin once put it, "The trouble with film as an art is that it's a business, and the trouble with film as a business is that it's an art." It is when the politics of the business interfere with the idealism of the art that the trouble begins, and that is precisely how industrial Hollywood has always operated. Anything that interrupts the flow of revenue is simply not compatible with what sells, and uncomplicated optimism and nonpolitical idealism are and always have been the two major products of the industry of dreams.

Charlton Heston as Captain Queeg in The Caine Mutiny Court-Martial. (Courtesy of the Heston Family. Photo by Lydia Clarke Heston)

Chapter Thirty-Five

I n October 1983, on the occasion of his sixtieth birth-
day, Heston started making arrangements to donate
his extensive archives to UCLA, which included more
than forty years of scripts, books, notes, photographs,
diaries, letters, and personal prints of his professional
and family films. At a small ceremony to mark the oc-
casion, Heston said, in a slightly mordant-sounding
monotone, "I'm relieved and proud and delighted to be
turning all this stuff over to UCLA. If such collections
are to be more than nostalgic monuments to actors'
egos, they have to be used. Scrapbooks and papers
stacked in files unread are just wastepaper. If mine is
to have any value, it is to students and historians of film
and theater."

Heston's next public appearance came nearly two

months later at the April 11 Academy Awards ceremony, where he presented that year's Jean Hersholt Humanitarian Award to Walter Mirisch. Heston was still without a new film offer and would not appear on the big screen starring in a major motion picture for the next eleven years.

Heston had been a critic of television ever since it moved to the West Coast, and through the years its entertainment programming had become, in his view, increasingly trivial. Even miniseries like *Roots,* he said, seemed better than they really were because the rest of the stuff on television was so awful. As early as 1977, he had flatly stated, "I will not do TV. I don't like the pace of television, and audiences won't pay to see actors in the movies if they can see them for free on the small screen."

That was then, this was now. He signed on as one of the stars of *Chiefs,* a three-part, six-hour miniseries, shown in two-hour segments over three consecutive nights on CBS that November. He attempted to put his return to the small screen in the best possible light: "I was watching *Brideshead Revisited* on PBS and it suddenly struck me that the miniseries gives you the opportunity to do something you can't do on stage and can't do on film, which is to tell a long story . . ." A

good part of the deal Specktor had negotiated for him was a hefty fee and a piece of the gross if the show was reedited and released as a feature in Europe. The producers agreed, sort of. Jerry London, Martin Manulis, and John E. Quill held the option to either agree to the "gross" clause or remove Heston from the feature if it was made. Since he appeared in only the first episode, with his narration continuing throughout, he could easily be eliminated entirely, with a different voice dubbed in. Specktor acquiesced and contracts were signed, and after nearly forty years, Heston had come back to acting on the small screen.

From a script by Robert W. Lenski, based on the novel by Stuart Woods, *Chiefs* is set in the fictional town of Delano, Georgia. Heston was cast as family patriarch Hugh Holmes. In 1924, the town decides Delano has grown large enough to warrant its own law-keeping force. The story follows the lives of several generations of the city's police chiefs.

The series had an all-star TV cast, which, besides Heston, included Wayne Rogers, Keith Carradine, Stephen Collins, Brad Davis, Danny Glover, Tess Harper, Paul Sorvino, and Billy Dee Williams. The broadcasts pulled in big ratings, and went on to be nominated for three Emmys. Although Heston was not one of the nominees, it brought him back into the

public consciousness. After *Chiefs* ran, Heston praised the show and hinted that he might want to do more television. "Last year, films were geared to the 17-to-20 year-old audience, with actors under 25. This year, films are made for 16-year-old audiences with casts of 16-year-olds. I don't want to be in a movie where I'm the only one who can vote."

And then, just when it seemed he had left politics behind and restored some order to his career, the Heston-Asner wars flared up again. Asner, in his last year as the president of SAG, was still pushing for the guild to merge with the extras union. In a speech he made to the membership the first week of January 1984, he charged those opposing the merger as ascribing to a "master race" philosophy. Heston was incensed by that comment. He believed Asner had directed it at him. The situation grew tenser when *Variety* reported to the police that the publication had received death threats: hand-scrawled notes, all of which appeared to have been written by the same person, saying, "We will kill the master race-ists," signed by the "Workers Death Squad."

Similar threats were sent to the offices of SAG that explicitly pointed the finger at their intended target— "Death to Heston (Bang!)"—also signed by the Workers Death Squad. They were turned over to the police,

who immediately placed Heston under their protection. Squad cars sat outside the entrance to the ridge twenty-four hours a day. Heston blamed the threats on Asner's incendiary speeches and called for him to repudiate his "master race" remark.

In a letter to *Variety*, Heston wrote,

This is, of course, not the first death threat produced by Mr. Asner's intemperate public style. Morgan Paull, when opposing the last merger attempt, was also the target of death threats, placing him under police protection for some weeks. The LAPD has recommended this for me as well. Clearly, Mr. Asner's radical allegiances and El Salvadorian rebel enthusiasms trigger the adrenaline in the extreme fringe of his supporters.

In response, Ken Orsatti, SAG's national executive secretary, wrote Heston a slightly condescending letter in which Orsatti shrugged off the threats as part of the price for being in the public eye:

The board was very sorry to read about the death threat you recently received. We can certainly sympathize with your discomfort since we receive between one and two dozen such threats each year

*aimed at officers and staff members. We unfortu-
nately have had to accept these threats and vulgar
epithets as an unfortunate byproduct of life in the
public eye. We of course deeply deplore threats and
abuse made against any individual, and we regret
that the world has so many disturbed and angry
people in it. We wish you all the best in the coming
new year.*

Heston was not amused.

Later that same month, at the behest of the State De-
partment (a request that conveniently got him out of
town), Heston traveled to the U.S. Marine encampment
at the Beirut airport, where "the granite-jawed actor,"
as one magazine called him, shook hands, signed au-
tographs, and, a little later, suited up in a helmet and
flak jacket to protect himself while he placed a wreath
at the exact site of the bombing on "Bloody Sunday,"
the previous October 23, when 241 U.S. servicemen
were killed. "There was a little flurry—random fire—
while I was there," he later recalled. "I couldn't sleep
on-shore. At night, I went aboard the U.S.S. *Guam* and
the next night, the U.S.S. *Ft. Snelling.* The Muslims,
Christians and Syrians were firing at each other."

When he returned home, as he had done each time after visiting Vietnam, he delivered mail from the soldiers, made phone calls, and wrote private notes to the parents and loved ones of the soldiers he met.

In February, he accepted an invitation from Robert Fryer, in conjunction with the resident Center Theatre Group, to return to the Ahmanson stage for a sixth go-around, this time in a new production of *Detective Story*, with actress Mariette Hartley his female leading lady. He did the play.

The morning-after reviews were scathing. Bruce Bebb, one of the theater critics for the *Reader*, made what he must have thought was a cool meal out of Heston and his performance, with enough bravado and self-importance to make his opinions almost too big for the page they were printed on. Apparently speaking for all of Los Angeles, he wrote, "For anyone who cares about legitimate theater in Los Angeles, Heston is an embarrassment, because what is needed in the main part [of *Detective Story*] is not an axiom so much as an actor." It was apparent that Bebb had no love for Charlton Heston.

In May, Heston agreed to be in *The Overlord*, set in the time of the Trojan War. It was another Agamemnon

production and would have been Heston's fifty-fourth film, except it never got made. According to Fraser, "It was a script I wrote and developed, budgeted, and location-scouted, but all the pieces just wouldn't come together at the same time and I couldn't put the financing in place."

Heston's commentary on it was more to the point: "My career has exactly paralleled the erosion of the major studio system." In other words, it was history.

That November, when Senator Alan Cranston (D-CA) decided to seek reelection, the Republican Party once more approached Heston about running against him and once more he declined, writing in his journal: "I do not belong to either [major political] party; I have always been an independent. When George Murphy was a Republican senator from California, it was the Democrats who wanted me to run. When Democrat John Tunney was a senator, the Republicans called. My response this time is about the same as before. I don't want to give up acting."

By acting he now meant television, for the moment the only place he could find steady work. As a follow-up to *Chiefs,* Heston did a TV movie in 1984 called *Nairobi Affair,* shot on location, in which he played the

owner of a safari camp who has an affair with his estranged son's ex-wife, played by John Savage and Maud Adams, respectively.* About the film, John O'Connor, then the TV critic for the *New York Times,* wrote,

> Charlton Heston, he who once was Moses in the movies, gets himself embroiled in some sticky stretching of the Ten Commandments in the television movie "Nairobi Affair" on CBS at 9 this evening . . . In their carefully constructed scenes together, Mr. Heston, Mr. Savage and Miss Adams are as convincing as circumstances will allow. If their story seems interminable, look on the bright side. Two hours of "Nairobi Affair" can leave you feeling as if you've just spent two weeks on a safari with Charlton Heston.

Heston next appeared on an episode of a TV series called *Aspel & Company* (season 1, episode 2) and then three episodes of *Dynasty,* a popular '80s prime-time soap opera, one of those "inside looks" at how the wealthy live—or rather how audiences wanted to believe they do, with all the troubles and tragedies of

* *Nairobi Affair* was released theatrically overseas.

"you and me." Heston's appearance drew such high ratings that he was signed as a regular for the *Dynasty* spinoff, *The Colbys*.

In the fall of 1984, while he was filming his first round of episodes, he told one reporter: "Yesterday I worked two-thirds of the day and all I did was say to the actress playing my daughter, 'Have you seen anything of Miles?' Then I said to Barbara Stanwyck in another scene, 'Where the hell is that son of mine?' Then I said to Diahann Carroll, 'I'm very pleased to meet you,' and it would be one of the most important lines in the whole film."

In the winter of 1985, having completed that season's shows for *The Colbys*, Heston was offered the chance to star in the play *The Caine Mutiny Court*-Martial in the West End. He had originally hoped to bring the Ahmanson production of *Detective Story* to London, with the Los Angeles cast intact as part of an Equity-approved exchange, in return for Alan Bates bringing *A Patriot for Me* to Broadway and/or the Ahmanson. (This was standard exchange practice with Actors' Equity, the American theater union, and Equity, the British theater union.) But that deal fell apart over Heston's insistence that his entire cast be allowed to come with

him. Both unions said no, because Bates was going to use American actors in his play.

Instead, Heston agreed to do *The Caine Mutiny Court-Martial* with five American actors and an otherwise all-British cast. The novel it was based on had been made into a movie in 1954, directed by Edward Dmytryk, with Humphrey Bogart as the disturbed Captain Queeg who, in the key scene, memorably plays with pinballs in his fingers while being interrogated. The film's success inspired the book's author, Herman Wouk, to rework it as a play, which opened on Broadway in January 1954 and ran for a year. In this new production, Heston was given the choice of playing either of the play's two leading roles, Lieutenant Greenwald or Captain Queeg. He chose Queeg and looked forward to performing his memorable breakdown under cross-examination, a rambling and emotionally wrenching six-minute monologue, even more intense done live.

In January 1985, Heston flew to Washington to confer with Wouk on the complexities of the play. Wouk talked to him at length about the Jewish naval lieutenant Greenwald (brilliantly played in the movie by José Ferrer and in the Broadway production by Henry Fonda), who must defend the mentally disturbed Queeg. At first Heston said he wanted to direct

and play both roles, alternating each night with Ben Cross, an actor Fraser had suggested (who had gained fame for his role in 1981's *Chariots of Fire*). "Finally, I realized that I couldn't direct and play two parts as well—that would be impossible. I'm a bit old for that now, so Queeg was the obvious choice . . . the public conviction persists that I play only saints, heroes, and great humanitarians."

Because Queeg appears in only two scenes (the part was larger in the film than either the novel or the play because Bogart wouldn't play a supporting role), Heston was given the chance to also direct.

From Washington, Heston flew to London for what he knew would be at least six months. On the way he booked a stopover in Chicago to visit his now-frail mother. His half brother, Alan, had recently passed away after losing his battle with cancer at the relatively young age of sixty-one. Heston wanted to permanently move Lilla to Los Angeles, but she still refused to leave Chicago. After an extended visit of several days, when he realized he would not be able to change her mind, he boarded a plane bound for London.

Upon his arrival he checked into a suite at the Dorchester, his residence of choice, where a case of Red Wing peanut butter was waiting for him, sent over by the play's producers, with a silver spoon on

the mantel. After two weeks of rehearsals, Heston flew back to Washington, D.C., on the Concorde, where he met up with Lydia, Fraser, and Fraser's wife, Marilyn, to attend Ronald Reagan's second inaugural. He and Lydia then flew back to London and the Dorchester, where they would stay for the duration.

Holly was by then living in London, which made it something of a family reunion. Having completed a year at the Sorbonne in Paris and her studies at Pepperdine, she was now living in a flat in South Kensington and working at Christie's.

After three weeks of rehearsals, the company moved to Brighton and then on to Manchester for pre–West End tryouts to do some fine-tuning.

The play opened on February 28, 1985, at the Queen's Theatre to mostly rave reviews—the *Daily Express* enthusiastically wrote that "Heston Scores with a New Line in Heroics." It was the first time he had appeared in the West End, and he was delighted by the critical reception to both his acting and his directing. For the big opening, Fraser and Marilyn had flown over, as did Heston's assistant, Carol Lanning.

That March, in London, Lydia elected to have back surgery to repair the rest of the injury she had incurred on the Great Barrier Reef, and while she convalesced Heston made her as comfortable as he could. When

his initial contract for the play was up that April, and the show continued to sell out every night with Brits and American tourists wanting to see Heston (and with Lydia not yet able to make the long flight back to the States), he extended his run of the show for an additional two months.

When the final curtain fell that June, the Hestons flew back to Los Angeles in time for a July 4 barbecue bash at the ridge with all their friends, Fraser, and Marilyn.

For the moment, all was well with the Hestons. He was, once again, on top of the world he loved with the one he loved. It was how he always wanted it to be.

However, everything in both their lives was about to change again.

Charlton Heston directing The Caine Mutiny Court-Martial
in Beijing. (Courtesy of the Heston Family. Photo by Linda
Clarke Heston)

Chapter Thirty-Six

In the fall of 1985, Heston came out in support of Idaho's contentious battle with SAG to gain right-to-work status, meaning that producers making films there could hire nonunion workers and thereby considerably lower their expenditures. As a partner and producer in Agamemnon, he had experienced firsthand the rapidly rising cost of making movies, and despite his long history with SAG, he believed right-to-work was good for the industry and would result in more films being produced, even if they weren't all made in Los Angeles. In December, SAG formally censured Heston. It wasn't just for his position on Idaho—that was more like the last straw. The guild, and Hollywood, were unhappy about his public feud with Ed Asner. Heston

then criticized SAG for acting like a Soviet tribunal and labeled the guild "an errand boy for the AFL-CIO," which adamantly opposed right-to-work anywhere.

The lines were drawn. Heston received strong support in his battle with SAG from Hollywood's conservative Republican flank, which included Jimmy Stewart, Tom Selleck, Leon Ames, Howard Keel, Rory Calhoun, Burt Reynolds, Clint Eastwood, and John Gavin, while its liberals remained staunchly against him. Richard Dreyfuss, then one of Hollywood's most popular and liberal stars, called Heston's position on right-to-work "bizarre and distasteful."

Undeterred, he dug in, jaw first, and next lent his support to New Mexico's right-to-work battle.

Although its ratings had held steady, in March 1987, *The Colbys* was canceled by ABC. The spinoff, for which Heston made $80,000 an episode, never dominated the way *Dynasty* had after its first season, despite having won a People's Choice Award. Executive producer Aaron Spelling, one of Hollywood's most powerful figures in television at the time and an outspoken liberal, insisted that the decision didn't have anything to do with the off-screen activities of any of its stars, but some of those who worked with Heston on the show believed that his being in it was one of the

reasons it was taken off the air by Spelling, with the network's consent.*

Heston refused to acknowledge that it meant anything more than a show having naturally come to the end of its run. Not long after the cancellation, he flew to New York City and did a good-humored, self-deprecating guest appearance on *Saturday Night Live*, as if to say, "Hey, Hollywood, lighten up, I can take a joke!"

The next day he flew down to Washington, D.C., to receive the National Right to Work Committee's Everett Dirksen Award, named after the storied Republican senator. The only press the event received in Hollywood was a one-paragraph blurb in *Variety*.

In August, Heston accepted an invitation, for a fee, to participate in an all-day celebrity shooting competition sponsored by the Institute for Legislative Action (ILA), the Washington lobbying arm of the NRA. The ILA ran a series of programs similar to this one all over the country, where for $1,000 its members could attend and mingle with celebrities, congressmen, and presidential hopefuls. While Heston was not a gun collector

* Shout! Factory released all forty-nine episodes on DVD, which also includes cast interviews.

and, at the time, not an avid supporter of the NRA, he had grown up around guns, and some of the happiest memories of his childhood were the hunting trips he and his father went on in the Michigan woods. He saw no reason not to accept the invitation.

Heston arrived for the weekend via helicopter, dressed in bleached jeans, a CLAN FRASER T-shirt, and cowboy boots. Later that day, he was invited to say a few words to the crowd during the program's stage presentations. Taking the small platform stage, he leaned toward the microphone and said, "I can't speak for the whole Hollywood community, but I know a lot of people use guns. There is a larger constituency than [most people] would imagine. On my ridge alone there are two households and probably 20 firearms of various kinds between my neighbor and me. Within a couple of miles there must be 500—that's an uninformed guess."

The invitation had come to him directly from Tony Makris, the president of the Mercury Group, a subsidiary of the Oklahoma-based communications firm Ackerman McQueen. Among Mercury's biggest clients was the NRA. Makris had originally connected with Heston and put him in touch with the NRA in 1982. Makris: "I first worked with C.H. by phone, mail, and every other way possible on the nuclear-freeze issue in California in 1982. I got in touch with him after he de-

bated Paul Newman. It was an issue Hollywood really got into and took sides. Heston was very vocal on his side, which was also our side, and Newman was on his, which was anti–nuclear proliferation. We needed someone with impeccable credentials and the perfect image to be our spokesman opposing the freeze, and after I saw how Chuck handled Newman, I knew he was our man.

"I approached him and he said he was willing and eager to work with us. When Proposition 15 came on the ballot in California, the handgun ban, we asked him to make some appearances opposing it, and he did. It was about that time I first introduced him to Wayne LaPierre. LaPierre had first joined the NRA in 1977 after he had worked as a legislative aide to Vic Thomas, a Democratic Virginia delegate.

"Heston and I next saw each other at the 1984 Republican convention in Dallas, where Reagan was nominated to run for a second term. During that visit, the Mercury Group spent about fifty grand promoting Reagan's platform, but I noticed that the Democrats always had much better presentations at their conventions, because so many actors were Democrats. At one point during our convention, I began talking to C.H. about the Mercury Group, and how I thought that since he was on the right side of so many issues he ought to

be more actively involved in politics, especially since the Republicans didn't have enough Hollywood personalities to sell our side of the story.

"I could tell right away he was interested. I then introduced him to Wayne, and we explained that the NRA was a bipartisan group that was pro–Second Amendment, and that we needed someone who could spread that message in support of it and of the NRA. I said to him that the American Security PAC, my organization, would raise all the money, pay all of his staff, do all the research, and hire all the lawyers—that all he had to do was to make public appearances and deliver our message, and he agreed.

"For the next several years, whenever his schedule permitted, and sometimes even when it didn't, Heston would hit the road and campaign for candidates we felt were ideologically on the right side of issues, and he became so good at it, toward the end of the 1980s I was convinced that C.H. was the most prolific nonprofessional political figure in American history.

"We didn't just send him to easy races. We organized pro-NRA PACs and sent him along to close head-to-head battles where his appearance often made the difference between victory and defeat. It was a much bigger and more sophisticated operation than most people were aware of. C.H. definitely made a differ-

ence getting our people elected. In 2000, for instance, when Gore was running against Bush, in Michigan one week, Gore drew six hundred people, the next week Bush drew eight hundred, then the week after that C.H. headlined our NRA lobby group and he drew seven thousand."

Heston went into it with his eyes open and saw it as his patriotic duty, his right as an American living in a free country, "like enlisting in the Army." The defense of the Second Amendment became his number one cause. "As a citizen, I have every right to say what I believe or feel about issues . . . I take the responsibility proportionate to the amount of pull the microphone will have because I'm talking into it. It's very important."

Makris: "We grew into a huge, powerful, and influential organization, thanks in no small part to C.H."

After 1984, Makris and Mercury Group became Heston's unofficial PR representatives in the service of the Second Amendment, as more and more of his appearances were tied to the single issue of gun control. What had begun as an informal commitment became as close to a full-time obligation as possible, while Heston also continued to pursue his show business career.

According to Makris, "In 1985 I became involved with the government doing some independent work

and could no longer handle all the requests I was getting for C.H. I hired Tyler Schropp to handle the political requests, which continued to grow because everyone wanted C.H. At the height of a campaign cycle, which is every two years, he would go to twenty-five states, five states a week, five cities a day, and after Memorial Day right up to the election, for those candidates who supported the Second Amendment and the right to carry firearms.

"He only wanted to go where he would make a difference. If the candidate we were supporting was ahead by twenty-five points or behind by thirty, he didn't feel it was necessary for him to make an appearance. If the race was close then, yes, he wanted to go. We'd supply him with a book of background and talking points for every stop and he'd study it like he would one of his characters in his films. He was always prepared and had incredible recall. He never worked from a prepared script and, of course, he never took any money, never asked for any pay, never received a cent for his time and efforts."

Fraser: "I think the NRA was the last major chapter, the last extracurricular activity he was involved in, and in his last years what he was most remembered for, which is kind of unfortunate, I think. There was so much more that he had accomplished—in film,

with the AFI, with SAG and other things—than his work with the NRA. Do I think he was co-opted by the organization, either unwittingly or unfairly? Did they get more out of it than he did? Maybe. I will say this, they got a lot. It was a great bargain for the NRA. On the other hand, he knew his acting career was winding down. He was getting lesser roles, fewer and farther between, and this was a way for him to regain some of that performing excitement. It was a thrill for him to speak before massive crowds, to be cheered. In its own way it brought him back into the limelight. If anyone had any regrets about his involvement with the NRA, it was more me than him. I don't think he made a mistake supporting them, but maybe it went a little further than it should have. I can see why he eventually became the president of the NRA, as opposed to just being on the board or a spokesperson, and I think they put some pressure on him to do so, and yes, I do think it hurt his career to a degree, but I don't think he had any regrets at all about his involvement with them. He was his own man and it brought him pleasure and a sense of accomplishment. I was never his manager and never advised him on what to do. Maybe I should have, but that was not the way we did things."

As Heston's commitment to the Mercury Group and

the NRA continued to expand, liberal Hollywood increasingly marginalized him. In some circles he became an object of cynical ridicule and abuse. During an appearance on CNN with the always-acerbic Christopher Hitchens, Heston became quite insistent on a point he was trying to make, only to be cut off by Hitchens mid-sentence, who told him to "keep your hairpiece on."

In the spring of 1987, Heston was invited to perform in Frank Hauser's production of *A Man for All Seasons* at the Savoy Theatre in London's West End. Getting out of Hollywood seemed like a good idea, especially with SAG threatening to sue Heston over his latest campaign, to prevent members' dues from being used to fund the guild's political positions, namely the right-to-work issue that was headed for the Supreme Court. SAG insisted no member money was ever used in that way and warned Heston that if he didn't stop misleading the members (and the public) he would face a libel lawsuit.

He sent back a telegram daring the guild to sue him. Heston's public display of support for the NRA was a hot topic in Hollywood, and the escalation of his war with SAG resulted in his being further isolated from the liberal-dominated mainstream of the industry.

When the invitation came from London, it gave him a chance to jump out of the political fire and get back into the performing frying pan.

However, physical distance didn't cool the situation. The already heated friction between Heston and SAG grew even hotter when Asner's campaign to merge SAG and SEG gained new life under the regime of the current president of the guild, actress Patty Duke. Heston angrily predicted mass defections from the union if the merger went through: "If you defy our members and inhale the extras, the steady trickle of financial core resignations will swell to a flood . . . SAG's members already have twice rejected proposed mergers of the two guilds."

Those comments set off a renewed fury among SEG members who were overwhelmingly eager for the merger, among them Gordon Hodgins, a working actor and SEG cardholder for thirty years. Hodgins wrote a letter to *Variety* that said, in part, "I never thought I would feel pity and sorrow towards Charlton Heston . . . Actors are people—extras are people . . ." And actor Julian Ayrs wrote this one to *Variety*:

I would like to remind Mr. Heston that movies could not be made without extras . . . and I would

like to point out that a large number of SEG members are also members of SAG. Not all actors have the good fortune to be in the upper bracket of income like Mr. Heston.

Heston declined to write a reply.

Later that same year, Fraser acquired the TV film rights to the London production of *A Man for All Seasons* and struck a deal with Ted Turner at one of his cable TV channels, Turner National Television (TNT), that reunited the team of Heston, Heston, and Snell, with Heston Sr. directing.

As that production was coming together, Heston accepted an offer from the Beijing People's Art Theatre to direct a nonprofit production of *The Caine Mutiny Court-Martial* in China *in Mandarin.* It was the culmination of a cultural exchange association formed by theater impresario James A. Doolittle and Bette Bao Lord, author and wife of Winston Lord, the American ambassador to China. "This exchange will celebrate the 10th anniversary of expanded relations between our two countries," the Chinese ambassador announced. "I'm sure it will be very warmly accepted by the Chinese people."

There was no doubt the governments on both sides wanted it to happen. Paramount Leader Deng Xiao-

ping had risen to power after Mao's death in 1976 and in the wake of the country's disastrous decade-long Cultural Revolution, he promised to restore order to China and to open the door to the West (the screen door, to let the fresh air in and keep out the flies). Ying Ruocheng, China's then most famous actor and the vice minister of culture, with the encouragement of Lord and Doolittle, invited Heston to direct a Chinese-language version of *The Caine Mutiny Court-Martial.* He wanted Heston because he was familiar with the film *55 Days at Peking* (most ordinary Chinese had never heard of it) and thought he would be well suited to direct the play. The sixty-four-year-old Heston was also politically correct; like Richard Nixon, no one could ever accuse him of being a communist. Not in a million years.

Heston was thrilled. As he told one friend, at least there were no unions in China.★

That September, after finishing filming all of his scenes for *A Man for All Seasons* at London's Pinewood Studios, Heston left the postproduction in the hands of Fraser and Snell and began to prepare for the

★ The trip was financed by the U.S. Information Agency (USIA) and several private corporations, none of which was made known to the public.

trip to Beijing. Lydia was going to accompany him, as well as Herman Wouk, *The Caine Mutiny*'s author, who had also been invited by the Chinese government after granting it ceremonial permission to do the play. Before they left for Beijing, Heston and Wouk once more spent long afternoons discussing its intricacies and how to convey them to actors, most of whom were professionals, but few who understood even a word of English.

Heston was puzzled as to why the Chinese government wanted to put on a play about a mutiny, but that was because he didn't understand the culture of the People's Republic of China. To the Chinese, seeing a powerful naval captain brought down by his peers was easily understandable and oddly satisfying. *The Caine Mutiny Court-Martial* represented rebellious authority justly punished; Queeg is a captain but incapable of running his ship and must be replaced. He had to be relieved of duty not just because of his state of mind but for the preservation of the state. Going against the party meant he had to be crazy.

Lydia was especially excited to be going to China. Through her photography, she had become friendly with Chinese-born watercolorist Dong Kingman and centurian Jingshan Lang, widely regarded as the father of Chinese photographers, both living in America.

They had, separately, encouraged her to go on the trip to experience the extraordinary beauty of the land and to try to meet and photograph as many Chinese as she could.

The Hestons landed in Beijing on September 14, 1988, at two in the morning and were taken by limo to the Great Wall Hotel in Beijing. Once they were in their suite, they unpacked their sixteen bags of luggage. They had made sure they would have enough clothes, shoes, toilet paper, and, not knowing how he would take to mainland Chinese food, many jars of peanut butter. They then went down to the lobby and had a Tsingtao beer with the welcoming committee that had patiently waited for them despite the hour. When they finished, at about four A.M., the Hestons went back to their suite and crashed.

Early the next morning, after a breakfast of eggs, bacon, and a warm bowl of rice *conjee*, Heston headed for the rehearsal hall, located in the huge, ornate People's Art Theatre, where the *Caine* military tribunal set he had designed himself had been constructed, and was ready and waiting.

He had intended to work through interpreters, but because he repeated several phrases over and over, the actors eventually came to understand most of them: "Everybody ready?" "Stop," and "Let's do it again."

For Zhu Xu, the fifty-seven-year-old actor playing Queeg, Heston acted out the famous monologue he had performed more than two hundred times himself on-stage, during which the captain falls apart and plays with those pinballs in his fingers.

As the days went by and the play began to come together, with Lydia meticulously photographing every aspect of the production, the big opening was scheduled with great fanfare for the night of October 18. Heston and Lydia arrived early that evening in formal dress, and they were surprised to see the audience showing up in plain clothes, the men wearing short-sleeved white shirts, no ties. It was the Chinese people's way.

Standing at the back of the house during the performance, Heston watched the audience members as they sat facing forward without uttering a sound—not a cough, not a sneeze, not a yawn—intensely focused on what was happening onstage. "You wouldn't think it would work," Heston said later. "But if the dialogue works, the language problem fades away. It was quite extraordinary." When the final curtain fell, the audience applauded politely, clapping also not being a regular Chinese custom. A small reception followed for the cast, crew, and some officials, and then the evening was over. Heston was filled with a combination of pride and accomplishment. He had pulled it off.

The play ran to sold-out houses (with tickets being scalped, Western style, at ten times the normal price), and then the production moved to Shanghai, where it was scheduled to continue playing even after the Hestons left. He wrote in his diary, with delight, "In the States I can't go to a ball game or to Disneyland without drawing a crowd. Here, the only place people recognize me is in the lobby of the Great Wall Sheraton Hotel, because it is filled with American tourists." And he noted that when he got home he wanted to buy a bigger bed, like the one he had at the hotel, which was bigger than his own even though he towered over most of the Chinese: "I don't think I've ever slept in such a big bed. Catherine the Great could easily have handled three imperial guardsmen in it!"*

Their last day in China was October 27, 1988. After an official ceremonial farewell lunch, feeling equal parts victorious and exhausted, they boarded a plane to America, flying back across the dateline, going forward and picking up that lost day, finally touching down at LAX.

If anything, Heston's journey to the East had moved

* Catherine the Great was an eighteenth-century empress of Russia, remembered as much for her sexual exploits as her rule, and never slept in Beijing.

him even further to the political right. He wrote in his diary that though he admired his actors, who were willing to learn how to perform in a Western-style stage presentation, he never felt completely at ease in China. He had been impressed with the warmth of the ordinary Chinese but remained suspicious of the government, especially when he learned of the State policy of subsidies for actors. He believed the Chinese government's funding inhibited free thinking—only those who agreed with the official policies were subsidized by the Communist Party—and that the arts in China should be free of any government interference (a somewhat ironic sentiment considering how hard he had fought to keep the Reagan administration's NEA budget intact).

In his book *Beijing Diary*, Heston wrote that the entire time he was in China he felt a little bit like George Taylor, a stranger in a strange land. It made him appreciate even more the freedoms he enjoyed in America. So enthused was he about what he felt he had accomplished on this journey into what he perceived as the heart of the Chinese political darkness that he wanted to do another version of the play, this time in Moscow, in Russian, a modern American version of *Darkness at Noon*.

It never happened, nor did he ever return to China. The following June, the youth-driven uprising in Ti-

ananmen Square erupted and brought Beijing and the Communist Party to the brink of revolution. As the tanks rolled in, the doors that Deng had so cautiously opened to the West slammed shut, and the Chinese government tightened its grip on the people in order to maintain power. It would take several years for the trauma of Tiananmen to begin to heal and China's government to ease the strictures on ordinary Chinese.

Heston followed all the events at Tiananmen through a series of correspondences with Barbara Zigil of the American Institute in Taiwan. That was how he discovered that the cast members of *The Caine Mutiny*, during a break in their run in Shanghai, had returned to Beijing and gone to the square one afternoon to support the uprising, wearing the black satin production jackets Heston had given them as gifts. When they returned to Shanghai to complete their scheduled performances, they discovered the power in the theatre had been cut off and they couldn't go on.

Later on, when things calmed down, Heston tried to contact some of the actors from his production and was advised by the State Department not to try to reach any of the Chinese he had worked with, that it would only worsen their situation. It sent a chill through him.

"I'm still glad I did the play [with them]," he wrote in his diary. "I'll bet they are too."

Charlton Heston as Long John Silver in the 1990 TV film version of Treasure Island, *produced and directed by Fraser Heston.* (Courtesy of the Heston Family. Photo by Lydia Clarke Heston)

Chapter Thirty-Seven

In December 1988, the filmed version of the stage production of *A Man for All Seasons* was televised on TNT and received mixed reviews, but none more scathing than Terry Atkinson's in the *Los Angeles Times*. Heston's anger got the better of him and he wrote a long letter to Atkinson responding to his criticism of the film. In it he accused the critic of disliking the production because he disagreed with Vanessa Redgrave's anti-Zionist political beliefs and with him for being too far to the right. He concluded by stating that "professional critics should judge performance, not politics. He rejects Vanessa on the left and me on the right . . . a device so transparently biased it defies defense. What's next? I smell blacklist here."

Heston's nose was right on the money.

———

On April 10, 1989, an advertisement appeared in *Newsweek* that pictured a smiling Heston holding a rifle and contained this blurb:

> I've always spoken out on issues I feel strongly about. Voting, civil rights, defense, the environment. Also, the Bill of Rights. Why am I comfortable as a member of the NRA? Because I'm comfortable with the Bill of Rights . . . I support the freedoms our Constitution guarantees. But democracy is fragile. It's threatened all the time from many quarters. Eternal vigilance is the price of liberty. And the NRA helps maintain that vigil.

The fallout was immediate and mostly negative in Hollywood, as he suspected it would be. Not long after, he called Jean Firstenberg. Here is how she remembered that call: "He was still on the masthead of the AFI as [a former] president and it meant a great deal to him, but that day he said to me, 'Jeanie, if you want to take my name off the masthead, I understand.' How thoughtful of him, knowing there was going to be a political backlash [because of the ad] and not wanting to hurt an organization he cared so deeply about. I never took his name off the masthead."

Most of Hollywood took him off theirs. The only real work he was able to get was a TV film via Atlanta-based Ted Turner—who couldn't care less about Heston's politics or Hollywood's—and with Agamemnon.*

In 1989, the Fraser-Snell team was called on for another project. Peter Snell: "From Turner's point of view, *A Man for All Seasons* had been a great success. It launched TNT with prestige, and he won all kinds of [Cable] ACE awards for it. He then came back to us in 1989 and asked if there was anything else we'd like to do. Fraser said, 'I'd like to direct *Treasure Island*,' and Turner said okay." Turner acquired the TV rights and Warner Bros picked up foreign theatrical.

Robert Louis Stevenson's *Treasure Island* was a longtime favorite of both Hestons. "My father used to read it to me over and over when I was 5 years old," Fraser recalled. Now he was producing and first-time directing a $6 million film version of it, shot on location on a Jamaican beach, utilizing the same fully rigged but creaky twenty-nine-year-old "pirate ship" left over from Lewis Milestone's 1962 version of *Mutiny on the Bounty,* starring Marlon Brando, to double for Steven-

* In 1985, Heston appeared as himself in Arnold Leibovit's *The Fantasy Film Worlds of George Pal,* a documentary about Pal.

son's *Hispaniola*.* "Directing my father was wonderful. In a way, he spoiled me because he was such an easy actor to work with.

According to Snell, "Chuck suggested during casting, when we were having trouble finding our Jim Hawkins, [that we] should really take a look at this young man he had just seen in Spielberg's *Empire of the Sun*. That was fifteen-year-old Christian Bale, and of course, he was just what we were looking for and we gave him the part."

The cast was rounded out by Oliver Reed, Christopher Lee, Julian Glover, Richard Johnson, and Peter Postlethwaite. Snell also hired fifty-two-year-old Joe Canutt to be the second unit director and supervise the stunts.

The production had its usual problems, mostly having to do with budget and controlling Reed. Fraser: "The first day we brought Oliver in for wardrobe fittings and fencing rehearsals, he was stinking drunk by the end of lunch, sneaking out to the bar at Pinewood to visit his friends. Not only could he not hold a sword,

* The ship was built by MGM and scheduled to be destroyed when *Mutiny on the Bounty* completed filming, but Brando protested and the studio instead sold it to Turner when he acquired the studio. The *Bounty* sank off the coast of the Carolinas in October 2012 during Hurricane Sandy.

he couldn't stand up straight. I convinced him it was simply enough just to watch the others for now, because he was so experienced with swords . . . then I turned to Peter and said, quietly, 'He's a total drunk. We're completely fucked.' Peter said, 'Just try to shoot all his stuff before lunch . . .' "

Treasure Island aired January 22, 1990. Snell: "The ratings were great, and the two films we did for Turner helped establish TNT as a cable network that specialized [at the time] in original TV films.

"It was not the last one we did for them, and the three of us—Fraser, Chuck, me—continued our great friendship. The Agamemnon team had become like one big family, and that was the best thing that came out of it."

Fraser saw the familial thing a bit differently: "Hollywood is kind of like the Mafia. If you're born into it, I guess the only way out of it is to die."

Early in 1990, Heston was asked by Paul Hogan, the popular Australian actor who had hit it big at the U.S. box office with his fish-out-of-water Crocodile Dundee franchise, if he would do a cameo playing God in Hogan's new non-Dundee comedy, *Almost an Angel*, directed by John Cornell. Heston said yes. The film opened a month after a limited rerelease of *The Ten*

Commandments and a month before a limited rerelease of *Ben-Hur;* the two Heston films did quite well, but Hogan's flopped big-time at the box office. Apparently, audiences wanted to see Hogan as Dundee and Heston listening to God, not playing him.

The only other film Heston did that year was *Solar Crisis,* a Japan-U.S. venture that had a budget of $55 million but managed a very limited theatrical release in America and disappeared quickly. Asked by a reporter about the undeniable downturn in his career, Heston quoted Winston Churchill, "Never give up, never give up, never ever ever give up!"

Then, in August, he abruptly resigned from Actors' Equity, the powerful union for stage actors. Although Heston loved performing before live audiences, he could not tolerate Equity having barred British actor Jonathan Pryce from starring in the highly anticipated Broadway production of *Miss Saigon* because he was playing an Asian character, a role he had originated in the musical's record-breaking run in London. The controversy had exploded when actor B. D. Wong, who was of Chinese descent, objected to a Caucasian Brit taking a potentially star-making role away from a real Asian actor.

This outraged Heston; he had played a Hebrew in

The Ten Commandments and *Ben-Hur,* a Mexican in *Touch of Evil,* and a Spaniard in *El Cid,* and he never felt he was taking anything away from anybody. He believed he was hired for his ability to act, not his ethnic or religious background. If this was allowed to stand, he believed, only Jewish actors like Dustin Hoffman would be allowed to play Shylock on Broadway, or Scots like Sean Connery, Macbeth. "Actor's Equity was the first union I joined," he said in a letter to the head of the union. "Until now, I've always been proud of my membership. I'm now deeply ashamed. The council's obscenely racist rejection of Jonathan Pryce's right to play the part he created in *Miss Saigon* revolts me."

The union promptly announced it would reconsider its decision after the show's powerful producer, Cameron Mackintosh, threatened to cancel *Miss Saigon*'s American production. Mackintosh reminded the union that he had previously brought *Les Misérables* to Broadway after it too had broken records in London, and in doing so he had given a lot of American actors and crew members jobs. Canceling the New York run of *Miss Saigon,* he knew, would cost New York City millions in revenue from hotels, restaurants, taxis, souvenirs, and other tourism industries. Many show business luminaries joined in the fight on the side of Heston

and Mackintosh. Pryce was eventually allowed to play "The Engineer" on Broadway and won a prestigious Best Actor in a Musical Tony Award for it.

Heston rescinded his resignation.

That fall, he signed on to do a third film for TNT, *The Crucifer of Blood,* based on the Paul Giovanni play that had originally run on Broadway and in the West End, and that he had recently done live at the Ahmanson, playing Sherlock Holmes (Paxton Whitehead was New York's Sherlock; Keith Michell did the part in London). Fraser wrote the screenplay, produced, and directed, and Peter Snell was brought in once more as executive producer. Filming began that fall in London and the movie debuted on TNT in 1991.

In 1992, sixty-eight-year-old Heston signed on, with Agamemnon Films in association with Jones Entertainment, to do a four-hour filmed docu-performance presentation of *Charlton Heston Presents the Bible,* to be shot in Israel and locations all over the world, directed by Tony Westman. Fraser: "It began when we both decided it would be great for him to do a reading of the Bible for audio. He'd done an earlier version, in the '50s, for Vanguard Records, and we thought, Why not film it? The original plan was to do it on a soundstage,

with Dad at a lectern, and then we decided we should do it on location in the Holy Land as a performance art piece, where he could kind of act out the scenes instead of just reading them. We found a partially restored ancient Roman amphitheater in Israel. We did two hours for the Old Testament and two hours for the New Testament. We strove to make it as ecumenical as we could."

When Heston returned home, it was to the happy news that Holly had gotten engaged. Both he and Lydia were thrilled and immediately began making plans with the groom's parents to throw a grand wedding. It took so much of their time that they stopped only to accept the gush of honorary awards Heston was lately receiving, mostly from various NRA-related organizations. He didn't really give them that much value or meaning, as these were the kinds of things groups gave to celebrities all the time. He always tried to oblige, but his acceptance speeches, which he wrote himself, were basically the same, touching all the key points: thanking DeMille for giving him his big break, how important his family was to him, how blessed he was to have such a wonderful wife and two great children. Inevitably, during the Q&As, someone would ask him who his favorite actor was. He had three, he would say, the first

of which was expected: Laurence Olivier. The next two weren't: Robert De Niro and Dustin Hoffman.*

Heston turned seventy in October 1993. To celebrate his arrival at the biblical three score and ten, he and Lydia decided to have a quiet dinner at one of their favorite Beverly Hills restaurants, where nobody would bother them and they could eat, drink, and toast his milestone together. So much had happened to them since that day long ago at Northwestern, when Lydia had asked him for his advice on how to read "Minnie, my frog is dead!" Now here they were, sharing the memories of the life they had shared, and after all the after alls, still very much in love.

* Heston qualified his enthusiasm for De Niro and Hoffman in 1997 this way: "De Niro is one of the best film actors we have, but he is short. Dustin Hoffman is tiny, Brad Pitt is small, Val Kilmer is small—very strange. Someone should do research on what happened to tall actors." (Charlton Heston, quoted in, *Time Out London*, August 13, 1997.)

Wayne LaPierre, the executive vice president of the National Rifle Association, and Charlton Heston. (Courtesy of Rebel Road Archives)

Chapter Thirty-Eight

Although major Hollywood film roles were no longer coming Heston's way, he kept busy doing cameos, narrating films and TV documentaries, and recording books on tape. He did a play/reading of A. R. Gurney's *Love Letters*—the perennial senior citizens' ode to love remembered—appeared again on *Saturday Night Live*, read the Gettysburg Address aloud on Lincoln's birthday in Westwood (the college neighborhood adjacent to UCLA), attended opening nights of several different exhibits of Lydia's photographs, and, in the fall of 1993, appeared in a brief story arc on the daytime soap opera *The Bold and the Beautiful*, ostensibly to promote the AFI's film preservation program (he played himself and received no pay). He tried to put his best face on it, pointing out that *B&B* was seen in forty-five countries.

"I've made a lot of movies that were not seen by 35 million people and this show is seen by that many people around the world," he told the cast members as they applauded him at the completion of his first episode.

He continued to receive numerous awards that did as much to promote the organizations giving them as they did to honor his lifetime body of work, but he always showed up, made the same little speech—usually with a couple of "Moses" gags thrown in—took the awards home and put them wherever he could find space in the house. During one of L.A.'s periodic droughts, reporter Army Archerd jokingly asked him in print to stop sending plagues upon Los Angeles, and Heston promised he would work on it. Elbow-to-rib comments like that happened far more often than Heston would have wished, although he always smiled and agreed.

And he continued to go out on the campaign trail for Tony Makris's Mercury Group, to promote the Second Amendment and rally against gun control. His prepared speech included part or all of the following:

As a boy, I was raised in a tiny hamlet in upstate Michigan. There were about 100 people living there, owning at least 250 firearms, most of them used for hunting for the table, the rest for sport and collecting. None were really regarded then as de-

fensive weapons; there was almost no crime in the county . . . The Bill of Rights is the cornerstone of our liberty, envied around the world as the bulwark of individual freedoms against the intrusion of the government. Its Second Amendment states: ". . . the right of the people to keep and bear arms, shall not be infringed." . . . We're still armed, and still free, thanks to those dead white men who made our revolution, and codified our freedoms. God bless them—every one.

At one point in 1994, he got into an ugly name-calling match with former guild president William Schallert over whether to give agents an increased percentage of "overscale" actors' work (those actors who made more than the minimum) that appeared on pay TV, free TV, home video, and cable. Heston was against the proposal, Schallert for it. At one point Schallert publicly accused Heston of having called him a "piece of shit" at a meeting. Heston replied that he had done no such thing, "just an anti-union S.O.B."

On March 28, the Hestons threw a black-tie fiftieth anniversary dinner-dance at the plush Hotel Nikko in Beverly Hills. The invitees included many of Hollywood's power elite: Universal head Lew Wasserman; Mike Medavoy, at the time the chairman of TriStar

Pictures; former manager of the Beverly Hilton and well-known Beverly Hills boutique owner Fred Hayman; Washington and Hollywood power player Jack Valenti; Los Angeles mayor Richard Riordan; former education secretary and drug enforcement chief William Bennett; Paramount producer A. C. Lyles. The ample roster of on-screen celebrities included Liza Minnelli, Wayne Rogers, Martin Landau, Veronique and Gregory Peck, Rosemarie and Robert Stack, and Mel Tormé (who performed that night). And, of course, Fraser and Marilyn and Holly and her husband, Carlton Rochell, were there.

Not invited was liberal antigun activist Barbra Streisand, whom Heston had recently derided as the "Hanoi Jane of the Second Amendment" for her much-publicized support of gun control. In response, Streisand had insisted that she didn't oppose gun ownership for defense or hunting, but that you didn't "need an AK-47 to kill game, or an Uzi to defend yourself."

Drama-Logue called the bash Beverly Hills' social event of the season. No other Hollywood publication considered it important enough to mention.

In 1995, Heston found himself before the House Appropriations Subcommittee on the National Endowment for the Arts and the National Endowment for the Hu-

manities. The question of whether to continue to fund the arts was once more a hot topic after Representative Newt Gingrich (R-GA) and several other Republicans came up with a "Contract with America," which laid out ten policies that Republicans promised to bring to a vote on the House floor during the first hundred days of the new Congress. The contract, which was signed by Gingrich and other Republican candidates for the House of Representatives, ranged from issues such as welfare reform, term limits, tougher crime laws, a balanced budget, restrictions on U.S. military participation in UN missions and trimming public funding for the arts. Gingrich went so far as to say that the NEA was "intellectually corrupt and biased against mainstream American values." The fight was back on, and Heston strapped on his symbolic six-gun.

During his quite eloquent testimony, Heston noted, among other things, that "art is the bread of the soul," and quoted the final lines of Shakespeare's *The Tempest:* "As you from crimes would pardoned be, let your indulgence set me free." He said that at the end of World War II, theater existed in only forty square blocks of Manhattan, but "now it flourishes across the country and regional theater is one of the spectacular successes" of the NEA. He acknowledged that he understood everyone was feeling the economic pinch and

hoped Congress would not be too severe in its trimming.

Former secretary William J. Bennett (who had been one of the guests at Heston's recent anniversary party) and Lynne Cheney (who once headed the humanities agency) were unmoved by Heston's impassioned speech, and when they spoke they made it clear they believed the motivation of the NEA was not only artistic. Cheney: "The agencies subsidized many works that made political statements rather than revealing truth or revealing beauty . . ." Bennett: "The government had no business putting its official stamp of approval, its imprimatur, upon any particular work of art or scholarship that corrupt the arts and the humanities, causing them to deteriorate or decline from accepted standards." He also testified that "the agency [NEA] was too corrupt to be salvaged" and that the endowments "subsidized people who seemed less interested in creating art or fostering knowledge than in ridiculing and antagonizing mainstream American values." So, really, after all the verbiage and flag-waving, to them it was about censoring any ideas that were critical of the government, a standard practice in mainland China.

As hard as it tried, the "Republican Revolution," as Gingrich's movement was called (or called itself), failed

to entirely eliminate the funding for the NEA, but it did manage to institute gradual decreases to take place over several years and insisted that private institutions play a larger funding role. Heston considered salvaging any part of the NEA a victory, even if it went unheralded in Hollywood.

That same year, the American Film Institute awarded him an honorary degree.

In 1996, seventy-two-year-old Heston had hip replacement surgery to fix an old injury he'd suffered during the filming of *Planet of the Apes.* The surgery temporarily halted his daily tennis playing. He swam every day instead, standing in the pool reciting Shakespeare between laps.

Age was catching up with him and he knew it. Still, he intended to continue campaigning for the NRA and, if anything, to widen his reach by supporting lower taxes and advocating against legalized abortion.

In 1997, Heston ran for and was elected to the board of the NRA as its first vice president. LaPierre enthusiastically celebrated Heston's victory: "He's Moses to our people. I'm serious!"

Heston lost no time in putting his newfound NRA status to use, giving a speech that same year in Washington, D.C., before the National Press Club, the world's

leading professional organization for journalists and a vigorous advocate of press freedom worldwide. Heston believed there was no better place to ensure press coverage of his comments, and declared the Second Amendment "the most vital of all the amendments and more essential than the First Amendment . . . it is America's first freedom, the one that protects all the others . . . Among freedom of speech, of the press, of religion, of assembly, of redress of grievances, it is the first among equals. It alone offers the absolute capacity to live without fear. The right to keep and bear arms is the one right that allows these rights to exist at all." Heston's presence at the National Press Club, and his bold comments, made headlines around the world. The *New York Times* dedicated a quarter page to it.

Heston relished all the newfound attention he was receiving, even if it was not on the entertainment pages, and he stepped up his campaigning in support of the NRA. "What Heston brings to the NRA," explained a spokesman for the group, "is the ability to get on TV and get into Congressmen's offices. He's opened doors in terms of getting our message out."

Also in 1997, the NRA organized Arena PAC, a political action committee to help fund Heston's increased travels around the country in support of Republican

candidates. The press nicknamed it the "Moses PAC." In its first year of formal existence, it raised just under $100,000 and in 1998 twice that amount. A typical Moses PAC–funded speech usually ended with Heston making this impassioned plea: "Join me, join us, join today. There is a cultural war raging across America. Anti-gun media, politicians, educators and thought police are storming your values, assaulting your freedoms, killing your self-confidence!"

Matthew Campbell wrote about Heston's newfound visibility in a piece for the *Sunday Times of London*: "Charlton Heston, whose gravelly tone is familiar to generations of film-goers, has tried all the big parts— from presidents to prophets, even including God. Yet none of these roles compares for drama and suspense with the epic part he is playing in real life as champion of the constitutional right of Americans to bear arms." He followed this with a quote from Heston: "The first act of a dictatorship is to disarm the people. Fidel Castro, Hitler, Stalin, Mao, Idi Amin—the first thing they do is take away private arms."

On December 26, 1997, the seventy-four-year-old Heston was named one of that year's Kennedy Center honorees, along with Lauren Bacall, Bob Dylan, Jessye Norman, and Edward Villella. He was given his award

"for his 62 movies and more than a half-dozen appear-
ances in plays." It was presented to him by President
Clinton.

In June 1998, at the NRA's annual meeting, held in
Philadelphia and attended by more than forty thousand
members, Heston was elected by an overwhelming
margin to be the organization's fifty-sixth president.
In his acceptance speech, he blamed the media for the
tarnished image of the NRA and vowed to restore its
luster: "[The decline] has been to a large extent driven
by the media to demonize the NRA." He also said he
wanted to expand the organization's membership to in-
clude more women and minorities, and took the oppor-
tunity to sharply criticize President Clinton: "America
did not trust you with our health care system. America
did not trust you with gays in the military. We did not
trust you with our 21-year-old daughters, and we sure,
Lord, don't trust you with our guns!"

That part of the speech set off a firestorm of criti-
cism from politicians and the public. Charles Schumer,
a congressional representative from New York, chided
Heston in a statement that bordered on mockery: "If
Charlton Heston wants to lead the NRA out of the
wilderness to the promised land, then they have to
abandon their extremist position." Democratic senator

Robert G. Torricelli of New Jersey said, "Even a good messenger can't make something out of a bad message."

Angry letters to the editor were sent to every major news publication, objecting to Heston's speech. Josh Sugamann, the executive director of the Violence Policy Center, in a letter to the *New York Times* said, in part,

While the National Rifle Association promotes Mr. Heston as a kinder, gentler face to soften its hard-core image, he is as extreme as the rest of the group's leadership. A Heston speech last December before the ultraconservative Free Congress Foundation in Washington was so hateful that David Duke, the former Ku Klux Klan leader, praised it and circulated it on his Web site. In his remarks, Mr. Heston repeatedly invoked "cultural warfare," spoke warmly of "white pride" and attacked "blacks who raise a militant fist with one hand while they seek preference with the other." He also compared criticism of gun owners and the NRA to the Nazi oppression of European Jews. Whether Mr. Heston does the talking or not, the National Rifle Association remains the same extremist organization that blocks sensible gun laws and markets guns to children.

In a letter to *People* magazine, Rhonda Erickson of Bartlett, Illinois, wrote:

> I can assure Charlton Heston that 200 years ago the creators of the Constitution never imagined that irresponsible adults would allow children access to firearms with the intent of killing fellow students within the safe haven of a school.

Shirley Temple, the former child star and now the U.S. representative to the United Nations, weighed in, telling *Variety* that "Charlton Heston, aka Moses, should emphasize the Ten Commandments, not the Second Amendment . . . Thou shalt not kill, Charlton!"

Al Martinez, in the *Los Angeles Times,* said, "Every time I see the face of Charlton Heston and hear his theatrical, B-movie stentorian on behalf of guns, I wince. In my mind's eye, I can see another child falling. The man's an actor, and not a very good one at that, but the role he's currently playing as president of the National Rifle Association is inherently dangerous because of its quasi-religious appeal . . . I wonder as I listen to Moses thundering from his mountaintop of ignorance how much more sadness will result from the products he so enthusiastically endorses."

Heston's response to all of this is summed up in a

single sentence he told to a reporter from *Time* magazine: "I've never been afraid of doing the right thing."

In the fall of 1998, the seventy-five-year-old Heston came on board the production of *Town & Country,* a major new film with a stellar cast headed by Warren Beatty (Heston said they got along "beautifully"), Diane Keaton, Goldie Hawn, Garry Shandling, Andie MacDowell, Jenna Elfman, and Nastassja Kinski—by far the biggest names he had worked with in years. The romantic comedy was directed by Peter Chelsom and distributed by New Line Cinema, which had recently been purchased by Turner Broadcasting. It was at Turner's insistence that Heston be cast in the relatively small part of Mr. Claybourne, "a colorful gun-toting lunatic" the husband of Mrs. Claybourne (Marian Seldes) and the father of Eugenie (MacDowell), a sexually voracious heiress; he had no objection to the character.

Town & Country cost $90 million to make and grossed less than $10 million, laying a huge box-office bomb. That year, Heston won a Golden Raspberry for Worst Supporting Actor in a Feature Film.

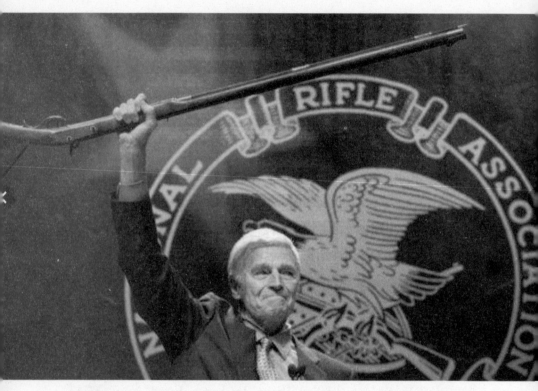

"From my cold, dead hands": Charlton Heston, speaking on May 20, 2000. (Courtesy Rebel Road Archives)

Chapter Thirty-Nine

Three months after his seventy-fifth birthday, in January 1999, a balloon payment of what Shakespeare called the debt that every man owes God came due for Heston.

He spent that New Year's day recovering from seven weeks of radiation treatments to fight the prostate cancer his doctors had discovered during his annual physical the previous June. "It's not totally gone," he announced to the press, after rumors began to appear in the trades that he was being treated for cancer. "It's on the path to it. Happily, I seem to have survived. It's very good news." He had gotten his doctors' permission to postpone treatment until after the November elections so he could finish filming his scenes for *Town*

& Country and campaign for the California Republican congressional candidates.

While at home recovering, Heston wrote an article for the *Wall Street Journal* defending the Academy's decision to give Elia Kazan a lifetime achievement award after an impassioned plea to do so by actor Karl Malden. Kazan had directed some of the finest films of Hollywood's postwar era, until his career was derailed after he cooperated with HUAC and named names for the committee, which made him a pariah of both the Left and the Right (*On the Waterfront*, Kazan's 1954 masterpiece, may be seen as Kazan's combined justification of and apology for "ratting" when the cause is just). Heston believed that Kazan had made a mistake by joining the Communist Party in the 1930s and that his body of work was "matchless." In the piece he chastised not just those Academy members opposing the award, but also the AFI for having thrice denied Kazan a lifetime achievement award for the same reason.

As soon as he was able, with his doctors' approval, he went back to work. The first thing he did was to film a new infomercial in support of the NRA.

In April, Heston felt well enough to attend the Society of Operating Cameramen's annual banquet at the Ritz-Carlton Hotel in Marina del Rey, a beachside village a few miles south of Malibu, where the camera

operator Phil Lathrop was being posthumously honored for the seamless opening shot he filmed for *Touch of Evil.* However, Heston changed his mind after the April 29 Columbine school-shooting massacre. Carol Lanning had to field dozens of phone calls for Heston from the press, wanting him, as president and spokesperson for the NRA, to comment on the tragedy. He took none of the calls and canceled his appearance, not wishing to pass through the press gauntlet that would certainly be waiting for him, or make anyone at the banquet feel uncomfortable by his presence.

Janet Leigh presented the award in his place and never mentioned Heston's name.

If he had tactfully avoided one awkward situation, he was about to discover it was only the beginning of an increasingly organized series of hostile attacks aimed at the NRA, and him, in the weeks and months following Columbine. That May, against the wishes of Denver mayor Wellington Webb and bereaved friends and relatives of the Columbine victims, the NRA decided to hold its annual meeting in that city's Mark Hotel, with its president, Heston, scheduled to speak opening night. In anticipation, four thousand protesters gathered outside, having marched from the state capital to the hotel, many carrying placards that read GUNS KILL PEOPLE and NRA, HAVE YOU NO SYMPATHY?

and CHARLTON HESTON: BAD ACTOR, BAD WIG, BAD IDEAS, BAD TIMING.

"They say don't come here," Heston told the audience that evening as he began his speech before twenty-one thousand members (three thousand had canceled their visit). "It implies that you and I and 80 million honest gun owners are somehow to blame," Heston continued, "that we don't care as much as they, or that we don't deserve to be as shocked and horrified as every other soul in America mourning for the people of Littleton. We have the same right as all other citizens to be here, to help shoulder the grief, to share our sorrow and to offer our respectful, reasoned voice to the national discourse that has erupted around this tragedy."

After his speech, Heston praised the NRA members for their courage in attending the convention, while refusing to meet with any of the protesters or family members of the victims. The next day he appeared on ABC's *Good Morning America* to respond to the protesters, the victims' families, and the rest of America. The convention and the demonstrations had become a national story, and he felt the best way to respond was to do it once, on national TV. "If there had been even one armed guard in the school [at Columbine]," he told the interviewer, "he could have saved a lot of lives and perhaps ended the whole thing instantly."

After the show, someone posted a sign outside the studio that said DO THAT AGAIN JOHNNY AND I'M SENDING YOU TO THE PRINCIPAL'S OFFICE—IN A BOX.

And there had been an armed guard at the school.

Dozens of Hollywood celebrities continued to express their displeasure at the tone and the timing of Heston's remarks, while those sympathetic to him, including actor Tom Selleck, remained silent. *Newsweek* reported that the day after Heston returned to Coldwater from the convention, the singer Lorna Luft, one of Heston's neighbors, left a note in his mailbox that read, "Dear Mr. Heston, I hope you're happy now." At the Cannes Film Festival later that May, filmmaker Spike Lee was quoted as saying that Heston should be shot with a .44 bulldog, a snub-nosed pistol. Later he said he was only joking.

That July, Heston attended Wimbledon in London, where he revealed for the first time that Lydia was recovering from a mastectomy.*

In November, the seventy-seven-year-old Heston was scheduled to do a series of readings from Shake-

* Holly had urged Lydia to get a routine checkup, and the cancer was found. She had her breast removed and a new one constructed immediately, from her own tissue. There was no chemotherapy or radiation, and she recovered completely.

speare, Byron, Shelley, and Frost at the Skirball Cultural Center, a leading Jewish institution in Los Angeles. His appearance was vehemently opposed by Women Against Violence, who objected to anyone from the NRA speaking at Skirball, especially after an attack at a Jewish community center in the San Fernando Valley the previous August, in which several people were wounded and one killed. The group's letter of protest to Skirball's board, written by Ann Reiss Lane, said, in part,

> We support everyone's First Amendment right to speak and your institution's right to have a speaker of your choice. However, we wonder whether you fully appreciate how identified Mr. Heston is with a group that advocates absolutely no regulations whatsoever on private gun ownership, including assault weapons and other weapons of mass destruction.

Heston called the letter "entirely irrational" and appeared as scheduled.

In April 2000, Heston told a reporter that "the NRA spends $1 million a year every year solely on teaching gun safety for small children, so a kid doesn't walk into

a hall and pick up a gun that is loaded. There is no government agency that has even touched that issue. If other people spent more of their money, you wouldn't have something like the little six-year-old kid the other day killing another."

It was clear now that the NRA had gained international attention for its position opposing gun control, immeasurably assisted by Heston as its president and public face.

That same April, Heston and Lydia were asked to step in as last-minute replacements for Robert Wagner and Jill St. John, who had had to cancel their scheduled one-performance engagement of *Love Letters* at the Colonial Theatre in Idaho Falls, Idaho. It was the first time Heston appeared in that play with Lydia as his costar. The night went off without incident.

A week later, the NRA asked him to run for an unprecedented third one-year term as president. He said yes.

And then it happened.

On May 20, at the 129th NRA convention in Charlotte, North Carolina, Heston surprised some and shocked others when he gave the most unexpected performance of his career. Here is Army Archerd's colorful description of what took place:

728 · MARC ELIOT

President Heston, in one of his most dramatic stances, with his chin jutted out, brandished a gold-plated Colonial musket replica [flintlock long rifle] above his head in a gesture that mimicked Moses when he lifted his staff to part the Red Sea, and in that same stentorian voice bellowed, "I'll give up my gun when you take it from my cold, dead hands! I want to say those words again for everyone within the sound of my voice, to hear and to heed, and especially for you, Mr. Gore, *from my cold, dead hands.*"

The moment was captured by several news organizations covering the convention, and the video clip went viral. It was seen and heard everywhere and secured Heston's place as that year's most polarizing figure in America. He had intended the speech to be aimed directly at Hillary Clinton and Al Gore, both of whom happened to be in Hollywood for a Democratic Party fund-raiser at the same time Heston was in Charlotte delivering his diatribe before two thousand enthusiastic followers. Here is the whole speech, including what preceded those lines that nobody remembers, because this part of the speech is almost never reprinted or replayed:

For the next six months, [Democratic presidential candidate and then vice president of the United States, Al Gore] is going to smear you as the enemy. He will slander you as gun-toting, knuckle-dragging, bloodthirsty maniacs who stand in the way of a safer America. Will you remain silent? I will not remain silent. If we are going to stop this, then it is vital to every law-abiding gun owner in America to register to vote and show up at the polls on Election Day. So, as we set out this year to defeat the divisive forces that would take freedom away, I want to say those fighting words for everyone within the sound of my voice to hear and to heed, I'll give up my gun when you take it from my cold, dead hands. I want to say those words again for everyone within the sound of my voice, to hear and to heed, and especially for you, Mr. Gore, *from my cold, dead hands!*

The next morning at the Beverly Hills Hotel, Gore gave his reply: "Charlton Heston said I was the #1 target of his organization. But the last time Moses took advice from a [burning] Bush, his people wandered 40 years in the wilderness!"

Why did Heston say what he did in the manner he

said it? Was he looking for publicity to reignite his dormant film career? Not likely. This late in the game, he wasn't looking and had no need to draw any more undue attention to himself. Was it planned at all or completely spontaneous? Or was it something else? Here are three opinions from people who should know:

Wayne LaPierre: "He shocked all of us that night. We were all in that room when he held up that firearm and, in the voice that can only be Charlton Heston's, said those words that after became his signature. It was nonscripted, totally ad-libbed. No one knew he was going to do it, and when he did everyone went, 'Oh my gosh . . .' Did he have it planned in advance? That's a really good question and I don't know the answer to it."

Tony Makris: "Especially after the assassinations of JFK, Robert Kennedy, Martin Luther King Jr., he thought maybe some gun control was all right, until he realized the opposition wasn't going to stop, that it wasn't about fixing a problem, that it was a political issue. [When he spoke to groups] he always told the story about what happened during the L.A. riots in the '90s, how all of his liberal friends wanted to know if they could borrow guns from him to protect themselves, and they would have to be reminded that it was against the law to own guns without a forty-eight-hour waiting period. The 'from my cold, dead hands' con-

cept was nothing new; gun owners had been saying essentially that for years before Heston made the speech in 2000. He'd been using that line for at least ten years. The only difference was where he was giving speeches weren't major news events. It's just that one time when all the media was there and C.H. was especially fired up and the country was still reeling from Columbine that it became a front-page story. It wasn't a stunt or a one-time improvisation; it was C.H.'s way of connecting to the people. There was no cheese in him; he was the real thing."

Grover Norquist, the founder and president of Americans for Tax Reform, a strong supporter of Ronald Reagan, and a member of the NRA board of directors: "Heston's overall involvement with the NRA, and that night, came late enough in his incredibly successful career that it didn't hurt him as much as it might have someone less famous, less established, less bankable. He could afford to take some heat for his political positions. Bob Hope was a lot more outspokenly political for a lot longer than Heston, and it never hurt his career or slowed him down any. Personally, [after that night] I think Heston should have run for political office. If I were advising him I would have urged him to run for the Senate. He could have been much more effective than just as a spokesman for the

NRA, although I do think he helped save the Second Amendment from revision and even possibly revocation. He also helped strengthen the NRA. He gave them greater visibility and helped stabilize them when he first became associated with them, when they were in trouble and falling apart. He helped put them on the road to success and credibility."

And finally, Fraser: "The Hollywood press and the general media wrote only about [Heston's involvement with the NRA] and in a negative way, while people he would meet at airports or public appearances would either congratulate him on a favorite movie of theirs, mostly *The Ten Commandments* and *Ben-Hur,* but also *Soylent Green* and *Planet of the Apes,* depending on their age, or congratulate him on his stance for the Second Amendment and his work with the NRA.

"It was the Hollywood press and the glitterati that shunned him. It may not have been as obvious as people like to think, but it hurt him career-wise. There were important supporting roles that he could have played. He didn't consult me on projects he did outside of Agamemnon, so I won't mention anything specific, but I would hear from people in the industry who would say to me things like, 'Why did your father say this?' or 'Why did he stand up for that?' and always with the implication that it cost him professionally. It

was almost as if he were backing something like child molestation rather than the Second Amendment. I even heard things after Columbine from the liberal community in Hollywood, which is nearly everybody, like, 'Why is your dad a proponent of child murder?' What do you possibly say in response to something like that? I simply didn't participate in gun-control discussions with people, because I knew where it was going to lead.

"I heard foreign producers talking about my father in unflattering ways, and they will never understand what the real issues were. I remember one European producer sitting with me and raving about my dad's films, how great he was and all that, and then saying, 'But I just can't do a film with him . . .' So it was damaging, but probably not to the degree that a lot of people on the Left take some satisfaction from, or the Right who were outraged by the unofficial ostracizing that went on. He still got work through all of it, maybe not the parts he would have wanted, but some important projects, including *Town & Country.*

"It didn't seem to bother him all that much. He was a principled man and willing to stand up for what he believed in, even if there was some price to pay. In the end, it wasn't about guns. Tom Selleck has a huge gun collection and is a member of the NRA, but he doesn't talk about it much and he isn't going to run for

the presidency of the organization, and he works all the time. Steven Spielberg has a huge collection of antique guns. Dad didn't care that much about owning guns. It was the principle behind the constitutional right to bear arms that he was defending. In the end, it wasn't about liberalism or conservatism. It was about freedom."*

The phrase "from my cold, dead hands," which, as Makris said, Heston had been using for ten years, did not originate with him. It was first heard as part of a campaign mentioned in a 1976 report from the Senate Judiciary Subcommittee to Investigate Juvenile Delinquency—"I Will Give Up My Gun When They Peel My Cold Dead Fingers From Around It"—and was used by the Citizens Committee for the Right to Keep and Bear Arms, based in Bellevue, Washington. It also appeared in the 1997 film *Men in Black,* when an upstate New York farmer confronts a recently landed alien who tells him to drop his shotgun, "You can have my gun when you pry it from my cold, dead fingers."

Nonetheless, Heston had to know the uproar that would follow his dramatic use of it that night, and, as Fraser points out, it didn't matter to him.

* Heston did have a pair of Turkish pistols once owned by Thomas Jefferson and a note signed by Jefferson boasting of their accuracy. He also owned a Glock and a Colt .45 that he kept under his bed at night when he slept.

Holly concurred: "Dad lost jobs because of his politics, there was no question, and he was okay about it. He said to me one day at the height of the controversy, 'I worked long and hard to get where I am so I can stand behind what I believe in, and I don't care if I don't get a job. I've had plenty of great jobs. It's okay.'"

Heston proudly reiterated that position in *Parade* magazine early in 2001, even if he sounded just a bit defensive about the consequences: "I [still] get as many parts as I want . . . One advantage of being an old actor with a lot of credits is that you get treated well . . ."

What he may not have been prepared for was the extent to which holding the long gun over his head and uttering "those words" would take momentary precedence over all that he had accomplished in his life. Taking such a strong stand had made him nearly unbankable, because Hollywood's primary order of importance has been, from day one, profit over politics. Half an audience means half the profits. It was Heston's being a spokesperson for the NRA that hurt his career, not the ideology of freedom. Hollywood has always been, from Edwin Porter's *The Great Train Robbery* on, the biggest de facto promoter of guns. In film, virtually every conflict is resolved by either real or symbolic shootouts—the industry's great solution for settling all differences in films.

In one of the supreme ironies of Hollywood history, Heston's graylisting—that place between being officially barred from working because of his beliefs and greenlisted, where any big-budget film that required a Charlton Heston character automatically went first to Charlton Heston—was enforced by the children of those whose careers were curtailed by the blacklist because of their political beliefs in the '50s.

Heston had always been a social drinker, but in recent years, with all that was going on, his intake slipped out of control. A short time after "the speech," he quietly checked into an alcohol rehabilitation program at a private facility in Utah for three weeks, then returned to semi-isolation up at the ridge. His only public comment about it was to *People* magazine, in an interview in which he admitted that he had given up Scotch years before but had continued to drink white wine until he entered rehab. "I wasn't slurring my words, I wasn't falling over, but I realized it had become an addiction for me."

After the treatment, he and Lydia ran a dry house. "I think it gave him an extra five or ten years of useful life," Fraser said. "I don't think any one thing was the reason he drank. Everyone in Hollywood did a lot of drinking in those days. It was nothing for people to

have two or three martinis a night, wine at lunch, and so on. It was pervasive, like smoking. When he took care of it, I think it felt like a heavy weight had been lifted from his shoulders."

In October 2000, on the occasion of his seventy-seventh birthday, Heston announced he would be making his first film appearance in almost two years, a brief cameo in the newest *Planet of the Apes*, produced by Heston's old friend Richard Zanuck, still shaking the franchise's lucrative money tree, and directed by Tim Burton. It was a one-day gig in which Heston played an ape (George Taylor had long ago been killed off). He spent four hours that day getting into Rick Baker's makeup that rendered him unrecognizable: an actor without a face.

And then the time came for him to settle the last remaining part of that debt.

The Hestons, 2004. (Courtesy of the Heston Family)

Chapter Forty

The day began for Heston like so many others. After breakfast, he planned on driving to Paramount to record the voice of Judah for a new feature-length, animated version of *Ben-Hur*, produced by Agamemnon in association with Tundra Productions. He was hoping to finish it before the holidays began. He got into his Vette—parked in the driveway at Coldwater—waited until the road was clear, then turned right to start the ten-minute drive down to Santa Monica Boulevard, where he would make a left, continue until branching off onto Melrose, and then drive straight to the Paramount arch on the left.

Only somewhere along the way, according to Carol Lanning, he couldn't remember where the studio was and wound up driving around for nearly two hours

until he finally found his way home. He was confused and disturbed and called Carol in a panic, who called Holly in New York to tell her what had happened. That day in the fall of 2003 was the first clear signal that something was not right.

Lanning recalled the next chilling incident that took place soon after. Heston, a lifelong lover of automobiles, always had a couple of sports cars in his driveway. "He loved driving them fast, revving the engines, putting the tops down and just racing along, going down into Hollywood. He took great pride in his cars. One day, when someone asked him what kind of car he had, he hesitated, then said, 'I've never had a car.'"

Things went downhill from there. According to Fraser, "To be honest, I had noticed a certain amount of forgetfulness." At first he attributed it to his father's advancing age, but when it appeared to worsen, he pressed his dad to see a doctor, just to make sure.

The news that came back was devastating.

Holly: "We had a family meeting around the kitchen table at the house that I flew out for. Fraser was there, the doctor, my mother and I, and Carol. In the middle of it, my dad finally confessed to us that his thinking wasn't normal, that he was missing things. Then he paused, as if he had rehearsed what he was about to say, and began: 'Well, I guess something was going to take

me out. I hope you don't feel sorry for me, because I have lived a most amazing life and I have no regrets . . . I couldn't have asked for more. I have a beautiful wife I've been married to for sixty-five years, I have two beautiful children whom I adore, I have had an incredible career . . .' He was very sincere in his acceptance of his fate, without self-pity or sadness. I remember my mom, who was normally quite vocal and dramatic about things, didn't say anything. She just sat there quiet and in shock, stoic and strong. And then he said to us all, 'I have lived the life of two people . . . I'm sorry for you, for what you're going to have to experience.' "

The diagnosis was the first stage of a terminal disease for which there was no cure, just a slow and increasingly painful state of suffering for the victim and those close to him.

People began to remember other incidents that were hard to explain when they happened. New Line executive Lynn Harris, talking about working with Heston on *Town & Country,* later recalled, "I always felt incredibly bad for Heston, because I felt like somehow the movie was poking fun at him, and he didn't understand it." Tony Makris later wondered if Alzheimer's had had something to do with the "cold, dead hands" moment.

———

In a statement reminiscent of the one Ronald Reagan had issued in November 1994, in which he famously said he was heading into the sunset of his life, Heston wrote an open letter to his "Dear friends, colleagues and fans" to officially inform them he had a neurological disorder with symptoms consistent with Alzheimer's disease. He delivered it via prerecorded videotape he arranged to have played for the press at the Beverly Hills Hotel the afternoon of August 8, 2002. Lisa Powers, Heston's spokesperson at the time, had told reporters to come to the hotel to watch the video "because of the nature of the announcement. It is very emotional and personal and he wanted to deliver the statement appropriately and in its entirety."

Fraser: "It was a tough decision. He didn't want people to think he had disappeared for no reason, so he decided to do a video rather than just some kind of statement by a PR person, or constantly to be grilled by the press. He made the video like he did everything—direct, honest, to the point, and with dignity."

After the video ended, to a silent crowd of reporters, Powers said that Heston intended to keep working as long as he could.

Two days later, he sent out a two-page version of the videotape, including the letter as he typed it, with

a handwritten notation by Carol about a thank-you he received from the U.S. Postal Service.

The news sent shockwaves throughout Hollywood and the world, spreading like the concentric circles in a tranquil pond after a rock has been tossed into it. Reporters began calling, wanting to confirm the story. To one he allowed to come up to the house, for whatever reason he still hesitated about admitting what he knew was true: "I can say for certain that I don't have it now," to which Fraser interrupted with "Well, I wouldn't say that is correct, Chuck. That is not quite what they told you. They are as certain as they are going to be."*

Heston was overwhelmed with notes, calls, and visits from friends, some of whom he hadn't seen for years. Among the first to call and allowed to get through was Nancy Reagan, who had been caring for her disabled husband for eight years, since the onset of his Alzheimer's in 1994. Fraser later noted how moved his father had been by the grace of her gesture.

President George H. W. Bush was also among the callers. He wanted to thank Heston for all that he had done for his country. After hanging up, Heston smiled and Fraser asked if Bush had offered him the vice presidency. "I was hoping for that," Heston joked, then

* The only definitive proof is when an autopsy is performed.

CHARLTON HESTON

Los Angeles
August 12, 2002

My Dear Friends, Colleagues and Fans:

My physicians have recently told me I may have a neurological disorder whose symptoms are consistent with Alzheimer's disease. So... I wanted to prepare a few words for you now, because when the time comes, I may not be able to.

I've lived my whole life on the stage and screen before you. I've found purpose and meaning in your response. For an actor there's no greater loss than the loss of his audience. I can part the Red Sea, but I can't part with you, which is why I won't exclude you from this stage in my life.

For now, I'm not changing anything. I'll insist on work when I can; the doctors will insist on rest when I must. If you see a little less spring in my step, if your name fails to leap to my lips, you'll know why. And if I tell you a funny story for the second time, please laugh anyway.

I'm neither giving up nor giving in. I believe I'm still the fighter that Dr. King and JFK and Ronald Reagan knew, but it's a fight I must someday call a draw. I must reconcile courage and surrender in equal measure. Please feel no sympathy for me. I don't. I just may be a little less accessible to you, despite my wishes.

I also want you to know that I'm grateful beyond measure. My life has been blessed with good fortune. I'm grateful that I was born in America, that cradle of freedom and opportunity, where a kid from the Michigan Northwoods can work hard and make something of his life. I'm grateful for the gift of the greatest words ever written, that let me share with you the infinite scope of the human experience. As an actor, I'm thankful that I've lived not one life, but many.

Above all, I'm proud of my family... my wife Lydia, the queen of my heart, my children, Fraser and Holly, and my beloved grandchildren, Jack, Ridley and Charlie. They're my biggest fans, my toughest critics and my proudest achievement. Through them, I can touch immortality.

Finally, I'm confident about the future of America. I believe in you. I know that the future of our country, our culture and our children is in good hands. I know you will continue to meet adversity with strength and resilience, as our ancestors did, and come through with flying colors - the ones on Old Glory.

William Shakespeare, at the end of his career, wrote his farewell through the words of Prospero, in *The Tempest*. It ends like this:

> Be cheerful, sir.
> Our revels now are ended. These our actors,
> As I foretold you, were all spirits and
> Are melted into air, into thin air:
> And, like the baseless fabric of this vision,
> The cloud-capp'd towers, the gorgeous palaces,
> The solemn temples, the great globe itself,
> Yea all which it inherit, shall dissolve
> And, like this insubstantial pageant faded,
> Leave not a rack behind. We are such stuff
> As dreams are made on, and our little life
> Is rounded with a sleep.

Thank you, and God bless you, everyone.

Cordially,

Charlton Heston

Charlton Heston

Today
the USPS
says —
Thank you
Charlton Heston

added soberly, "If the president calls you, that's a good thing." Then he said, "Sooner or later, the man with the scythe comes along and says, 'It's time.' When that time comes, I'll say, 'OK, I had a great run.'"

That October, Heston made his penultimate appearance for the NRA, at a rally in Manchester, New Hampshire. After he spoke, Wayne LaPierre came onstage, stood next to him, and said into the microphone, "I want to tell you how much what you've done, not just here tonight but through the years, has meant to me." He then leaned into the mike and said, "C.H., we want to hear from you those five words that have come to be your signature." Heston unsteadily held a long rifle over his head and repeated the "from my cold, dead hands" declaration, this time as a farewell, even as his words were drowned out by the cheering crowd.

A shaken Tony Makris then said of the Hestons, "They're very strong people. They'll greet this the same way they greet everything else—holding hands and their heads held high."

After one final appearance in April 2003 at the annual NRA convention held in Orlando, where Heston was too frail to stand and make a farewell speech, he was rarely seen again in public, preferring

to stay within the confines of his beloved house on the ridge. Holly: "It wasn't sad, it was peaceful. We had many fun-filled nights with close, dear friends playing the piano, singing show tunes, and watching old and new films. My dad had moments of remarkable lucidity. He could recall passages from Shakespeare or old songs perfectly. He was amazing."

Most of the Hollywood community continued to treat Heston with a fair degree of respect, if not reverence, but there were notable and at times cruel exceptions.

One such incident happened in 2003, when the actor George Clooney was accepting an award from the National Board of Review and quipped that "Charlton Heston announced again today that he is suffering from Alzheimer's." When a reporter asked him the next day if he thought he might have gone too far, Clooney said, "I don't care. Charlton Heston is the head of the National Rifle Association; he deserves whatever anyone says about him."

The reaction to Clooney's remarks was immediate and universally negative. No one thought it was funny or clever, just nasty and insensitive. Heston responded to Clooney in typical fashion by remembering the actor's late aunt, singer-actress Rosemary Clooney: "It just goes to show that sometimes class does skip a gen-

eration." When the short-fused Fox News host Bill O'Reilly heard about Clooney's remarks, he said on his TV show, "I believe most Americans will find these remarks mean-spirited." O'Reilly was also annoyed by the mainstream (to him, liberal) press's apparent lack of reporting on Clooney's comments.

Kimberly A. Strassel, writing in the *Wall Street Journal*, disagreed. "Nobody gives a flip what George Clooney says. When Mr. Heston spoke, America listened."*

If the actor's seemingly spontaneous, poor-taste joke did not get as much attention as O'Reilly and others thought it should have, documentarian Michael Moore's tasteless "ambush" of Heston in *Bowling for Columbine*, released at the end of 2002, outraged many who thought his "interview" with an obviously frail Heston was unfair, low, and poor journalism (although some places, like *Esquire* magazine, inexplicably hailed it as terrific cinema).†

In the film, Moore—who had recently joined the

* Clooney sent a handwritten note of apology to the Hestons, who forgave him.

† *Bowling for Columbine* won the Academy Award for Best Documentary Feature, the Independent Spirit Award for Best Documentary, a special Fifty-Fifth Anniversary Prize at the 2002 Cannes Film Festival, and the César Award (France) for Best Foreign Film.

NRA with the intention, he said, to gain control and dismantle it—went unannounced to Heston's front door at the ridge, and he was greeted in the courtyard by the gracious actor, who agreed to give him an interview without checking with his PR people or Carol. During the barrage of unfriendly, antigun questions hurled at him, Moore's cameraman caught Heston's confusion in close-up, and followed him as he just stood up and walked, with dignity, back inside. *Esquire* contributor Tom Carson noted, "Heston's waddle suddenly reminds you of his age, and I'd like Moore better if he'd noticed that that exit is eerily beautiful. Or appreciated that it's probably goodbye." According to Carol Lanning, "Mr. Heston was already in his early stages of Alzheimer's, and Mr. Moore should not have taken such advantage of him, or been so cruel. It was both unfair and manipulative."

It marked the penultimate film appearance of Charlton Heston.*

* Heston appeared briefly as Dr. Mengele in Egidio Eronico's Italian-German-Portuguese-Hungarian *Rua Alguem 5555: My Father*. Heston's role as Dr. Mengele is little more than a cameo, filmed sometime during the twelve years the film was in production (it is listed on IMDB with a release date of 2003). It was never commercially released in the United States.

As if in response to Moore, and to limit the many requests he was getting from the press to talk about his condition, Heston invited Peter Jennings of ABC News to come to Coldwater with his crew to do one final interview, promising to hold nothing back. It took place that December. Heston, looking stiff and expressionless, remained gracious, and Lydia smiled throughout, although the strain on her face was impossible to disguise. During the entire interview (edited down to six minutes for TV), Heston and Lydia sat on the sofa and held hands. Lydia responded this way to Jennings's question about how she felt when she found out that her husband had Alzheimer's: "I was appalled, I was stunned. It never occurred to me that there was anything wrong." Regarding the night of the infamous NRA appearance, she said, "I came into the room, had the radio on and heard 'Charlton Heston.' I didn't hear anything else but I thought, I knew . . . there goes my life." When asked by Jennings if he was afraid, Heston said, "I probably will be afraid, when it gets closer, but I don't feel those things. [I need to know] how long and how well I can sustain my condition as it is now. When it stops being that my life will change. Beyond a certain point, my life will be over."

In July 2003, President George W. Bush announced that Heston would receive the nation's highest civilian

honor, the Presidential Medal of Freedom. Fraser remembered the news brought his father to tears.*

That September, the AFI established the Charlton Heston Award in honor of all that he had done for the institution and to honor future individuals who made distinguished contributions to both the film and television industries. It was presented to him at a private ceremony at Coldwater by Jean Firstenberg. "Chuck has been really a remarkable figure in AFI history as both chair and president of the organization," Firstenberg told the *Hollywood Reporter.* "We felt his contribution deserved some longtime recognition. He was very pleased and took great pride in how the AFI has evolved."

Heston's family and close friends were not happy with what they felt was a too-little, too-late token effort on the part of the AFI, which they believed had flatly refused to honor him with a lifetime achievement award because he had fallen out of favor with the liberal ruling class of Hollywood over his continued support

* The other recipients that year were John R. Wooden, the legendary UCLA basketball coach; scholar Jacques Barzun; the chef Julia Child; the late ballplayer Roberto Clemente; pianist Van Cliburn; Vaclav Havel, the dramatist and former president of the Czech Republic; physicist Edward Teller; Wendy's founder Dave Thomas; former Supreme Court justice Byron Raymond White; and scholar James Q. Wilson.

of the NRA. One person close to the family likened what had happened to Heston with what had happened to Dalton Trumbo during the blacklist years, only in reverse; this time it was the actor on the Right who was ostracized for being politically incorrect.

Holly: "The Charlton Heston Award was a consolation prize, once they realized my father was sick and they had not recognized him for all the support he had given that organization, for keeping it alive . . . They did it privately, at the house one afternoon, with little fanfare, no TV show as they had with so many other winners. They should have done the right thing. My father never said anything about it, but it was obvious he was very hurt. He wanted to be recognized for all he had done for that organization. They were in existence because of him. Those whose jobs were made possible by my dad will live with guilty consciences for the rest of their lives."*

Fraser: "The AFI did the same thing to my dad that SAG had done to Ronald Reagan when they rescinded that award, not that they gave my dad one and then took it back—they never gave a real one in the first place,

* Jean Firstenberg was instrumental in getting Heston's face on a U.S. postage stamp in 2014. On April 11 of that year, Heston became the eighteenth inductee into the Legends of Hollywood stamp series.

but again for reasons other than whether or not he deserved it. The Reagan award had to do with unions, my dad's not receiving one was political. Rightly or wrongly, I think they perceived they didn't want to be associated with him because of the NRA. The lifetime achievement award is an annual event, so they have to pick someone every year, and we all just assumed that sooner or later it would be him. Word then began to filter back to us from certain people that it was never going to happen because some members on the board, not Jean Firstenberg, could not reconcile his work for the NRA with giving him the award. Isn't it ironic that the man who kept them in existence was then shunned by them because they didn't want to jeopardize their future fund-raising and political standing in the community?

"There were meetings reported to me, not by Jean but by others, where each time his name came up they said, 'Oh, we disagree with his politics, we're not going to give it to him.' It was a shitty thing to do. I also know that Jean was heavily lobbying for him. She knew better than the newer members that if anybody deserved that award it was him.

"I'm sure it hurt my father's feelings to a degree; he never said so, but it certainly hurt my sister and me, and of course my mother. We were a little shocked and

754 · MARC ELIOT

disappointed because of the amount of work he had done for them through the years. My dad was more sanguine about it than we were, more philosophical. There was never a moment I can remember where he ever expressed any bad feelings over the award. He was a class act, and he was proud of how he had saved the AFI that time. That was more important to him than any award."*

One of the few visitors allowed to see Heston during this time was Stephen Macht. Here Macht recalls those emotionally wrenching days: "Three-quarters through my relationship with Chuck, I began to study

* The American Film Institute has awarded the AFI Life Achievement Award to one person each year since 1973: John Ford, 1973; James Cagney, 1974; Orson Welles, 1975; William Wyler, 1976; Bette Davis, 1977; Henry Fonda, 1978; Alfred Hitchcock, 1979; James Stewart, 1980; Fred Astaire, 1981; Frank Capra, 1982; John Huston, 1983; Lillian Gish, 1984; Gene Kelly, 1985; Billy Wilder, 1986; Barbara Stanwyck, 1987; Jack Lemmon, 1988; Gregory Peck, 1989; David Lean, 1990; Kirk Douglas, 1991; Sidney Poitier, 1992; Elizabeth Taylor, 1993; Jack Nicholson, 1994; Steven Spielberg, 1995; Clint Eastwood, 1996; Martin Scorsese, 1997; Robert Wise, 1998; Dustin Hoffman, 1999; Harrison Ford, 2000; Barbra Streisand, 2001; Tom Hanks, 2002; Robert De Niro, 2003; Meryl Streep, 2004; George Lucas, 2005; Sean Connery, 2006; Al Pacino, 2007; Warren Beatty, 2008; Michael Douglas, 2009; Mike Nichols, 2010; Morgan Freeman, 2011; Shirley MacLaine, 2012; Mel Brooks, 2013; Jane Fonda, 2014; Steve Martin, 2015; John Williams, 2016.

for the Rabbinate when I wasn't working as an actor. I had gone up to the house on Coldwater with my family every Christmas, but then I didn't see Chuck in a while, and when I heard he had Alzheimer's and the end was near, I called Lydia and asked her if I could come up and spend some time with him and she said yes.

"I brought all the pictures I had of the two of us, from the shows and movies we had done together. We sat in his library and went through them, and it was heartbreaking because he couldn't recognize any. Then I would sit and read him psalms and remind him of all the funny things that had happened to us on our various productions, and he would laugh, almost in recognition, and then go back to a stone face.

"One visit I asked him if he wanted to pray and if I could put my tallith [prayer shawl] over him. I told him that the tallith was the metaphor for God's wing and that you, Moses, of all people, should know what a tallith is. Nothing. Then I said the blessing of the tallith in Hebrew. Nothing. Then I asked him if he wanted me to read him some Shakespeare. He looked at me and said, 'You go.' So I started packing my things, and then he said, 'Come back,' meaning the next time.

"I never saw him alive again."

By late March 2008, the eighty-four-year-old Heston, nearly unreachable, even by Lydia, was in the final

stages of Alzheimer's, bedridden and under twenty-four-hour supervised care at the house. When the time drew near, Carol called Holly in New York, and she immediately flew out to be with the family at the house, where they all huddled together waiting for the end.

On the clear and peaceful evening of April 5, 2008, with Lydia, Fraser, Holly, and Carol at his bedside, in the "House That Hur Built," Charlton Heston closed his eyes and was gone.

The Heston family spending Christmas at the "House That Hur Built," 1982. (Courtesy of the Heston family. Photo arranged by Lydia Clarke Heston)

Epilogue

The funeral was held the morning of April 12 at the Episcopal Parish of St. Matthew, in the wooded canyon above the Pacific Palisades. Two hundred and fifty invitees attended—family members, politicians, and friends, including Olivia de Havilland, Keith Carradine, Pat Boone, Oliver Stone, and Rob Reiner. A frail Nancy Reagan came, one arm held by Tom Selleck, the other by Arnold Schwarzenegger.

The Reverend Michael Scott Seiler officiated. Carol Lanning read a gospel passage. Tony Makris read a favorite quote of Heston's by Teddy Roosevelt that began, "It is not the critic who counts; not the man who points out how the strong man stumbles, or where the doer of deeds could have done better. The credit belongs to the man who is actually in the arena . . ." Julian Glover

read "Prospero's Farewell." Stephen Macht was next. While he was still able, Heston had edited Moses's last speech (Deuteronomy 31) to the Israelites before he goes and dies on the mountainside, and had told Macht he wanted him to deliver it at the funeral:

At last, on the day of morning, on the plains of Moab, when the Lord said to Moses, "Rise up Moses, get up this mountain, and behold the land I give unto Israel. Thou shalt see the land before thee, but thou shalt not go thither. I shall give thee rest . . ."

When it was Holly's turn, she spoke about her father's love of poetry. She then recited Edgar Guest's "Love Me but Let Me Go," which she said her dad had wanted her to read.

Fraser then came to the podium and said his father had wanted him to read "Crossing the Bar," by Alfred, Lord Tennyson.

Sunset and evening star,
And one clear call for me!
And may there be no moaning of the bar,
When I put out to sea,
But such a tide as moving seems asleep,

Too full for sound and foam,
When that which drew from out the boundless
 deep
Turns again home.
Twilight and evening bell,
And after that the dark!
And may there be no sadness of farewell,
When I embark;
For tho' from out our bourne of Time and Place
The flood may bear me far,
I hope to see my Pilot face to face
When I have crost the bar.

When he finished, he paused and then looked up. "He was my father," he said softly, "and my friend. And he was the finest man I have ever known. He was the finest man I will ever know. May God bless you, Dad, and hold you in the hollow of his hand, forever and ever. You did your best. You kept your promises."

When the service ended and Heston was laid to rest in the columbarium, the mourners quietly filed out of the church. Holly remembered thinking it was a perfect service and that her dad would have loved to have been there.

A gentle warm breeze blew past, and someone murmured that it felt like a wave of farewell.

Bibliography

BOOKS

Bazin, André, with a foreword by François Truffaut, *Orson Welles: A Critical View,* trans. Ron Rosenbaum (New York: Harper & Row, 1978).

Belafonte, Harry, and Michael Shnayerson, *My Song: A Memoir* (New York: Alfred A. Knopf, 2011).

Biskind, Peter, *Star: How Warren Beatty Seduced America* (New York: Simon & Schuster, 2010).

Brownlow, Kevin, *The Parade's Gone By* (New York: Knopf, 1968).

DeMille, Cecil B., *The Autobiography of Cecil B. DeMille* (Englewood Cliffs, NJ: Prentice-Hall, 1959).

Doherty, Thomas, *Hollywood and Hitler, 1933–1939* (New York: Columbia University Press, 2013).

Druxman, Michael B., *Charlton Heston* (New York: Pyramid Publications, 1976).

Eagan, Daniel, *America's Film Legacy: The Authoritative Guide to the Landmark Movies in the National Film Registry* (New York: Continuum, 2010).

Essoe, Gabe, and Raymond Lee, *DeMille: The Man and His Pictures* (South Brunswick, NJ: A. S. Barnes, 1970).

Everson, William K., *A Pictorial History of the Western Film* (Secaucus, NJ: Citadel Press, 1969).

Eyman, Scott, *Empire of Dreams: The Epic Life of Cecil B. DeMille* (New York: Simon & Schuster, 2010).

Herman, Jan, *A Talent for Trouble: The Life of Hollywood's Most Acclaimed Director, William Wyler* (New York: Da Capo Press, 1997).

Heston, Charlton, *The Actor's Life: Journals, 1956–1976,* ed. Hollis Alpert (New York: E. P. Dutton, 1978).

———, *Beijing Diary* (New York: Simon & Schuster, 1990).

———, *The Courage to Be Free* (Kansas City, KS: Saudade Press, 2000).

———, *In the Arena: An Autobiography* (New York: Simon & Schuster, 1995).

———, *To Be a Man: Letters to My Grandson* (New York: Simon & Schuster, 1997).

Heston, Charlton, and Jean-Pierre Isbouts, *Charlton Heston's Hollywood: Fifty Years in American Film* (New York: GT Publishing, 1998).

Heston, Lydia Clarke, *Jack Heston, from 1067: A Family History* (Baltimore, MD: Gateway Press, 1996).

Higham, Charles, *The Films of Orson Welles* (Berkeley: University of California Press, 1970).

Holden, Anthony, *Behind the Oscar: The Secret History of the Academy Awards* (New York: Simon & Schuster, 1993).

Kael, Pauline, *5001 Nights at the Movies: A Guide from A to Z* (New York: Henry Holt, 1991).

Kaplan, Fred, *Gore Vidal: A Biography* (New York: Anchor Books, 2000).

Kinn, Gail, and Jim Piazza, *The Academy Awards: The Complete Unofficial History,* 2d ed. (New York: Black Dog & Leventhal, 2002).

Leaming, Barbara, *Orson Welles: A Biography* (New York: Viking, 1985).

Levy, Shawn, *Paul Newman: A Life* (New York: Harmony Books, 2009).

Louvish, Simon, *Cecil B. DeMille: A Life in Art* (New York: Thomas Dunne Books/St. Martin's Press, 2008).

Munn, Michael, *Charlton Heston: A Biography* (New York: St. Martin's Press, 1986).

———, *Kirk Douglas* (New York: St. Martin's Press, 1985).

Orrison, Katherine, *Written in Stone: Making Cecil B. DeMille's Epic,* The Ten Commandments (Lanham, MD: Vestal Press, 1999).

Parini, Jay, *Empire of Self: A Life of Gore Vidal* (New York: Doubleday, 2015).

Price, Victoria, *Vincent Price: A Daughter's Biography* (New York: St. Martin's Press, 1999).

Raymond, Emilie, *From My Cold, Dead Hands* (Lexington: University Press of Kentucky, 2006).

Reagan, Ronald, *An American Life* (New York: Simon & Schuster, 1990).

Rovin, Jeff, *The Films of Charlton Heston* (Secaucus, NJ: Citadel Press, 1977).

Sarris, Andrew, *The American Cinema: Directors and Directions, 1929–1968* (New York: Da Capo Press, 1996).

Sellers, Robert, *Hellraisers: The Life and Inebriated Times of Richard Burton, Richard Harris, Peter O'Toole, and Oliver Reed* (New York: Thomas Dunne Books, 2009).

Small, Melvin, *The Presidency of Richard Nixon* (Lawrence: University Press of Kansas, 1999).

Stevens, George, Jr., *Conversations at the American Film Institute with the Great Moviemakers: The*

Next Generation (New York: Alfred A. Knopf, 2012).

————, *Conversations with the Great Moviemakers of Hollywood's Golden Age at the American Film Institute* (New York: Alfred A. Knopf, 2006).

Thomas, Bob, *King Cohn: The Life and Times of Harry Cohn* (New York: G. P. Putnam's Sons, 1967).

Urwand, Ben, *The Collaboration: Hollywood's Pact with Hitler* (Cambridge, MA: Belknap Press of Harvard University Press, 2013).

Vaughn, Robert, *A Fortunate Life* (New York: Thomas Dunne Books, 2008).

Welles, Orson, and Henry Jaglom, *My Lunches with Orson: Conversations Between Henry Jaglom and Orson Welles*, ed. Peter Biskind (New York: Metropolitan Books/Henry Holt Books, 2013).

Wilcoxon, Henry, with Katherine Orrison, *Lionheart in Hollywood: The Autobiography of Henry Wilcoxon* (Metuchen, NJ: Scarecrow Press, 1991).

Wiley, Mason, and Damien Bona, *Inside Oscar: The Unofficial History of the Academy Awards* (New York: Ballantine Books, 1986).

DVDs

Ben-Hur: The Epic That Changed Cinema, produced and directed by Gary Leva (Glendale, CA: Leva

FilmWorks, 2005); feature on *Ben-Hur: A Tale of the Christ,* directed by William Wyler (Burbank, CA: Turner Entertainment Company, 2005).

Charlton Heston: For All Seasons, directed by Gene Feldman (West Hollywood, CA: Wombat Productions; Harrington Park, NJ: Janson Media, 1995).

Charlton Heston and Ben-Hur: A Personal Journey, directed by Laurent Bouzereau (Burbank, CA: Warner Home Video, 2011).

Orrison, Katherine, commentary track, *The Ten Commandments,* directed by Cecil B. DeMille (Hollywood, CA: Paramount DVD, 2006).

NEWSPAPERS AND MAGAZINES
(By publication and in chronological order)

Chicago Sunday Tribune
Hedda Hopper: "Hedda Hopper Picks Film Stars of 1951," December 31, 1950; "No Restin' for Heston," April 6, 1952; "Hollywood's Happiest Star," December 23, 1956.

Esquire
John H. Richardson, "Heston," July 2001.
Tom Carson, Screen, February 2003.

Hollywood Citizen-News

Sidney Skolsky: March 17, 1955; February 16, 1968.

Lowell E. Redelings: March 22, 1961.

Abe Greenberg, Voice of Hollywood: July 28, 1966; April 6, 1967.

Bob Thomas, "Charlton Heston Should Avoid TV, It Says Here," February 13, 1958.

Robert Musel, "Charlton Heston Bound to Task," August 18, 1959.

"Actor Heston to Walk for Integration," May 27, 1961.

Sheilah Graham, "Charlton Excited About Election," July 30, 1964.

Sheilah Graham, "Heston Just Can't Escape Dark Ages," April 21, 1965.

Sheilah Graham, "Charlton Heston Will Try to Stay Home," January 8, 1966.

Peer J. Oppenheimer, "Happy Man in a Million-Dollar Trap," June 26, 1966.

Victor Riesel, "Heston Tells GI Reactions to Visits," December 28, 1966.

John Austin, "Heston to Spain," March 9, 1970.

Hollywood Reporter

Issues: 1975; February 12, 1982.

Jack Moffitt: 1954.

Hedy Kleyweg, " 'No More Nice Guy,' Says New Hersholt Winner Heston," April 3, 1978.

"Urban Coalition Debates Heston over Arts Program," June 30, 1981.

Ray Loynd, "Heston Accuses Asner of Slurring Him at Meeting," February 19, 1982.

"Heston Raps Asner for Inciting Threats," January 10, 1984.

Duane Byrge: July 19, 1988.

Stephen Galloway, "Schallert: Heston Libeled Me," October 13, 1993.

"Cries and Whispers," April 9, 2001.

Josh Spector: September 25, 2003.

David A. Keeps, "When Aaron Spelling Ruled Television: An Oral History of Entertainment's Prolific, Populist Producer," September 18, 2015.

Interview

Michael Viner, "Charlton Heston," June 1976.

Ina Ginsburg, "Charlton Heston," September 1985.

Los Angeles Daily News

Issue: February 10, 1955.

Earl Wilson: June 16, 1951.

Jack Gaver: November 13, 1951.

Los Angeles Herald-Examiner

(as Los Angeles Examiner *prior to 1962*)

Issues: March 29, 1973; May 18, 1982.

Earl Wilson: April 27, 1974.

Dorothy Manners: April 2, 1975.

Louella Parsons, "The Hestons—Family of Stars," September 18, 1955.

Ruth Waterbury, "Chariot Race to Destiny for Heston in *Ben Hur*," August 31, 1958.

Jean Bosquet, "Director Wyler Films Scene 32 Times," November 25, 1959.

Kay Waymire, "No Restin' for Heston," April 6, 1960.

Erskine Johnson, "Heston Tries Change of Pace from Toga Heroics to Farce," November 24, 1961.

" 'Aid Films Here!' Plea of Heston," December 3, 1961.

Harrison Carroll, "Shaggy *War Lord*," December 6, 1964.

Dorothy Manners, "A New Heston Looks at Outdated Girls," September 17, 1967.

Camilla Snyder, "The Camera Artistry of Mrs. Charlton Heston," September 29, 1968.

Bill Slocum, " 'Moses' Dons T-shirt and Helmet for *Pro*," December 8, 1968.

"Nixon Gets Backing of Charlton Heston," August 4, 1972.

Patricia Nolan, "Conversation with Charlton Heston," May 17, 1981.

"And from the Mountaintop," September 7, 1981.

"Get Down, Moses," February 17, 1982.

Los Angeles Mirror-News

Earl Wilson, "Heston Lives Regally in Rome," June 6, 1958.

Dick Williams, "Heston Says Hollywood Has No Middle Ground," May 4, 1959.

Los Angeles Times

Morning Report: November 5, 1993; May 29, 1999.

Lawrence Christon: April 18, 1981.

Charles Champlin: May 8, 1981.

"Television Pushes Actor to Top in Movie World," June 25, 1950.

"Heston Goes from Video Fame to Film Fame," March 23, 1952.

Philip K. Scheuer, "Chariot Race to Be Rerun," April 4, 1958.

"Actor to Talk to Methodist Church Festival," May 14, 1958.

Philip K. Scheuer, " 'Ben-Hur' Looses New Biblical Flood," December 1, 1959.

Bob Baker: May 8, 1960.

Wanda Henderson, "Charlton Puts Foot in It, Makes Lasting Impression," January 25, 1962.

Hedda Hopper, " '55 Days' Has Gala Premiere in Paris," May 13, 1963.

"Heston Solves 'Dundee' Conflict by Returning Fee to Columbia," May 9, 1964.

Don Alpert, "Heston Willing to Be a Face in the Crowd," December 5, 1965.

Cecil Smith, "Charlton Heston—A Man for All Seasons," February 27, 1966.

Harry Bernstein, "Heston Tells of Need for Actors Guild," August 14, 1966.

Jeanne Beaty, "TV Shirking Its Creative Responsibilities—Heston," April 2, 1967.

Patricia Johnson, "Heston Dons Director's Badge for 'Antony,' " September 12, 1971.

Joyce Haber, "Nixon May Attend AFI Award Dinner," February 28, 1973.

Wayne Warga, "Heston: A Heroic Type Essays Role in Reality," February 6, 1977.

Marilyn Funt, "Lydia Heston: Cold-Water Flat . . . to Coldwater Canyon," May 7, 1980.

Jack Slater, "Arts Task Force: Heston's New Role," August 26, 1981.

Lee Dembart, "Heston, in Political Role, Hits Newman's Pro-Freeze Stance," October 15, 1982.

Isobel Silden: December 15, 1985.

Jeannine Stein, "Shooting Competition Brings in Backers for NRA Lobbying," August 24, 1987.

Charles Champlin, "Heston Revisits 'Ten Commandments,'" May 16, 1990.

Jeannine Stein, "Hestons Mark 50 Years of 'Symbiosis,'" March 21, 1994.

Charles Champlin, "Heston: The Past Is Present," September 10, 1994.

Kristine McKenna, "An Old Warrior Back in the Arena," September 16, 1995.

"Charlton Heston Seeks Election to NRA Board," May 3, 1997.

Carla Hall, "Fire Power," May 21, 1997.

Charlton Heston, "'Touch of Evil' Needed Final Touch of Welles," February 9, 1998.

Eric Slater and Lianne Hart, "NRA Event Draws 1,800 Protesters," May 2, 1999.

"Reading by Heston Opposed," November 30, 1999.

Susan King, "Heston Tells of Disease," August 10, 2002.

Robert Welkos, "Heston Faces His Illness Squarely," August 18, 2002.

Newsweek
Issues: May 19, 1997; May 10, 1999.

New Yorker

Pauline Kael, "Raising Kane," February 20, 1971.

David Denby, "Hitler in Hollywood," September 16, 2013.

Leo Robson, "Delusions of Candor," October 26, 2015.

Alex Ross, "The Shadow: A Hundred Years of Orson Welles," December 7, 2015.

New York Times

"Big Ma, What Now?" October 15, 1950.

"Charlton Heston Makes His Film Debut at the Paramount Theater," October 19, 1950.

Eugene Archer, "Movie Producer Cites Star Power," October 19, 1960.

A. H. Weiler, "Observations from a Local Vantage Point," September 2, 1962.

"Oriental War on Plains of Spain," December 9, 1962.

"Heston Has Explanation," September 1, 1980.

"Urban Groups Dispute Heston on Arts Cuts," June 29, 1981.

Robert Pear, "Actor Urges House Panel to Spare Money for the Arts," January 25, 1995.

Michael Janofsky, "Enthusiastic N.R.A. Gives Mandate to Charlton Heston," June 3, 1998.

Nick Madigan, "Charlton Heston Reveals Disorder That May Be Alzheimer's Disease," August 10, 2002.

Katherine Q. Seelye, "Heston Takes Last Lap in the Cause of Guns," October 23, 2002.

Manohla Dargis, "A Word With: Steven Spielberg," May 19, 2016.

People

Issues: July 28, 1975; April 4, 1977; January 16, 1984.

Susan Schindehette: July 3, 1989.

Champ Clark: September 7, 1998.

Paula Chin and Doris Bacon, "The Bamboo Curtain Rises on Charlton Heston's *Caine,* an SRO Hit in Beijing," October 31, 1988.

"Clean and Sober," August 8, 2000.

Photoplay

Beverly Linet, "I Was There," June 1953.

Beverly Ott: 1954.

Saturday Evening Post

Pete Hamill, "Heston: Larger Than Life," July 3, 1965.

Helen Van Slyke, "From Moses to 'Midway,' Charlton Heston Is Larger Than Life," January/February 1976.

Donald Chase, "Between Scenes with Charlton Heston," November 1983.

Maynard Good Stoddard and Cory SerVaas, "Charlton Heston: He'd Rather Pretend Than Be President," September 1984.

Sunday Times of London

Jani Allan, "Great Sport with a Line in Heroic Role Models," June 17, 1990.

Matthew Campbell, "Heston Stars in US Gunfight," December 14, 1997.

Variety

Issues: March 12, 1958; June 12, 1964; January 27, 1982; October 16, 1995; November 3, 1993.

Army Archerd, Just for Variety: June 10, 1958; August 26, 1965; December 24, 1965; July 11, 1967; January 11, 1984; June 8, 1992; March 31, 1998; June 10, 1998; June 13, 2000.

"Heston Thinks His Face Ideal for Antiquity," April 13, 1960.

"Actors 'Way Over Their Heads' When Engaged in Politics: Heston," November 2, 1960.

"Do Something, Just Don't Wall-Wail, Heston's Advice to Craft Unions," May 9, 1962.

"Heston Returns Fee on *Dundee*," May 13, 1964.

"Heston Voices Regret in Production Slump," December 7, 1970.

"Heston Among 8 New Trustees of the American Film Institute," July 2, 1971.

"SAG Award Is Given to Charlton Heston," November 15, 1971.

"Charlton Heston Exits 15-year-old SAG Board Seat," June 25, 1975.

"Heston Stands By in Plane Hijack; Show Folk Aboard," January 31, 1979.

"Heston Yelp Limits Coin Return by Endowment; Biddle Is Joyous," June 10, 1981.

"Dreyfuss Adds 2 Cents to Heston Dispute," January 7, 1987.

Ken Orsatti, "Heston Predicts Mass Defections from SAG," September 14, 1988.

"AFI to Bestow Degrees on Heston, Wise, Cooper," June 8, 1995.

Other Periodicals

"Quickies," *Paramount News,* May 29, 1950.

Freida Zylstra, Chicago Tribune Press Services, February 22, 1951.

Joan Beck, "Backstage Glimpses: How an Actor's Family Lives," *McCall's,* November 1956.

André Bazin and Charles Bitsch, "Senses of Cinema," *Cahiers du Cinéma,* June 1958. Translated and annotated by Sally Shafto.

"Heston Fried for Saying Fry Fires a Reply," *Beverly Hills Citizen,* April 19, 1960.

"The House That *Ben-Hur* Built," *Look,* May 24, 1960.

Jim Liston, "At Home with Charlton Heston," *American Home,* May 1962.

Robert Hutchins, *Redbook,* December 1965.

Time, August 12, 1966.

"Heston Voted for Brown, Likes Reagan," *Film Daily,* November 21, 1966.

Bob Thomas, Entertainment, Associated Press, March 29, 1968.

Marilyn Beck, "Charlton Heston: Between an Actor and His Public, It's a Love-Hate Relationship," United Features, 1971.

Gordon Gow, "Actor's Country," *Films & Filming,* May 1972.

Joan Dew, "Charlton Heston Reveals," *Coronet,* November 1975.

Nan Musgrove, *Australian Women's Weekly,* July 21, 1976.

Jean Cox, *Women's Wear Daily,* February 25, 1977.

Doris Nieh, "Charlton Heston: Super Star in Movies and Life," *Easy Living,* Fall 1977.

Jim Clements, "Down in the Depths with Charlton Heston," *Hamilton Spectator,* January/February 1978.

Hollywood Studio Magazine, April 1979.

Roberta Plutzik, *Horizon,* March 1980.

Janet Eastman, *Orange Coast Magazine,* August 1980.

Lawrence Linderman, *Penthouse Magazine,* August 1980.

UPI (United Press International), May 7, 1981.

Drama Quest, July 1981.

David Alexander, *Season Ticket,* September 1981.

"Hollywood's Divided Unions," *BusinessWeek,* July 5, 1982.

David Rensin, "20 Questions: Charlton Heston," *Playboy,* May 1983.

Isobel Silden, "Hollywood's King of the Hill," *Ford Times,* December 1983.

Bruce Bebb, *The Reader,* February 17, 1984.

Denise Abbott, *Beverly Hills 213,* October 30, 1985.

Malcolm Hay, *Plays and Players,* March 1985.

Dodie Kazanjian, ARTS Review, Spring 1985.

David Galligan, "Charlton Heston," *Drama-logue,* September 19, 1985.

Gordon Hodgins, letter to editor, *Daily Variety,* September 19, 1988.

Janet Kinsian, "Hollywood Hero Is a Solid Citizen," *Palm Springs,* July 1990.

Elle, February 1993.

Andrew Sarris, "It's All Over: Orson Welles and the Pull of the Masses," *New York Observer,* November 1, 1993.

George Wayne, *Vanity Fair,* September 1994.

Long Beach Press-Telegram, February 12, 1995.

Barbra Streisand, "Feud of the Week," *Time,* May 18, 1998.

Martin Schram, *Daily Breeze,* June 10, 1998.

Julian Ayrs, letter to editor, *Daily Variety,* September 21, 1988.

Mary Murphy, "Prime Chuck," *TV Guide,* February 10, 1999.

Barbara Paskin, *London Times,* April 14, 2000.

Walter Scott, "Personality Parade," *Parade,* January 14, 2001.

Henry Coman, filmed interview with Dennis Weaver, September 24, 2002.

Kimberley A. Strassel, "Modern-Day Moses, on a Masson," *Wall Street Journal,* September 2, 2006.

Daniel Eagan, "Restoring *Ben-Hur:* Catherine Wyler Reminisces About Her Father's Biggest Film," Smithsonian.com, September 30, 2011, http://www.smithsonianmag.com/arts-culture/restoring-ben-hur-catherine-wyler-reminisces-about-her-fathers-biggest-film-93580422/?no-ist.

Notes

A note about the author interviews (AI): With certain people, including Fraser Heston and Holly Heston Rochell, dozens of interviews were conducted in person, by phone, and by e-mail. I have noted the starting interview date, after which I merely note that the material is from an interview I conducted. All interviews were recorded digitally and will eventually be donated to the Charlton Heston Archives.

CHAPTER ONE

5–6 "She came from a very interesting family": Holly Heston Rochell, author interview (AI), May 1, 2015.

6 "I believe she loved him": Ibid.

7 "This was a woman": Ibid.

7 "I lived a very solitary life": Charlton Heston, quoted in Joan Dew, "Charlton Heston Reveals," *Coronet*, November 1975.

8 "That was the real beginning": Charlton Heston, quoted in Freida Zylstra, "Young Wilmette Actor's Star Rises in Hollywood," *Chicago Tribune*, February 22, 1951.

8 "I liked to draw cowboys": Charlton Heston, quoted in Maynard Good Stoddard and Cory SerVaas, "Charlton Heston: He'd Rather Pretend Than Be President," *Saturday Evening Post*, September 1984.

9 "I pictured myself like Tom Sawyer": Charlton Heston, quoted in Ina Ginsburg, "Charlton Heston," *Interview*, September 1985.

9 "My first pubescent juices": Charlton Heston, *In the Arena: An Autobiography* (New York: Simon & Schuster, 1995), p. 24.

10 "After my grandmother gave birth to a third child": Holly Heston Rochell, AI.

10 "It was an extremely traumatic experience": Charlton Heston, quoted in Michael B. Druxman, *Charlton Heston* (New York: Pyramid Publications, 1976), p. 15. No further source attribution is given by Druxman.

11 "I missed my dad greatly": Heston, *In the Arena*, p. 30.

11 "Lilla had basically dumped Russell": Holly Heston Rochell, AI.

CHAPTER TWO

16 "Even though my dad deeply respected his step-father": Holly Heston Rochell, in *Charlton Heston and Ben-Hur: A Personal Journey*, directed by Laurent Bouzereau (Burbank, CA: Warner Home Video, 2011).

16 "Dad took the new name": Holly Heston Rochell, AI.

17 "When I first [moved to Chicago,]": Charlton Heston, quoted in Pete Hamill, "Heston: Larger Than Life," *Saturday Evening Post*, July 3, 1965.

17 "When I first went to high school": Charlton Heston, quoted in Ina Ginsburg, "Charlton Heston."

18 "I can't emphasize enough": Charlton Heston, in *Charlton Heston: For All Seasons*, directed by Gene Feldman (West Hollywood, CA: Wombat Productions; Harrington Park, NJ: Janson Media, 1995).

18–19 "I was homely and self-conscious": Charlton Heston, quoted in Janet Eastman, *Orange Coast*, August 1980.

19 "I began my life": Heston, *In the Arena*, p. 37.

23 "I found I had discovered a natural": David Bradley, quoted in Michael Munn, *Charlton Heston* (New York: St. Martin's Press, 1986), p. 30.

23 "Northwestern was part of the family tradition":
Holly Heston Rochell, AI.

24 "My performance as Peer": Heston, *In the Arena*,
p. 43. *Peer Gynt* is available on several Internet sites
in its entirety but never received a commercial the-
atrical release.

25 "He wore tight green corduroys": Holly Heston Ro-
chell, AI.

26 "Method acting is like masturbating": Charlton
Heston, quoted in "Charlton Heston's Last Stand,"
Los Angeles, February 2001.

26 "I consider myself lucky": Charlton Heston, quoted
in Zylstra, "Young Wilmette Actor's Star Rises in
Hollywood."

26 "He just loved sketching": Holly Heston Rochell, AI.

27 "print freak": Charlton Heston, quoted in Janet
Kinosian, "Hollywood Hero Is a Solid Citizen,"
Palm Springs, July 1990.

27 a tumbling mane of black Irish hair: Heston, *In the
Arena*, p. 45.

CHAPTER THREE

30 "I had, at that time" : Lydia Heston, in *Charlton
Heston: For All Seasons*.

31 "the tallest, skinniest man I ever saw in my life": Ibid.

31 "I thought he was arrogant and conceited": Lydia Heston, quoted in Marilyn Funt, "Lydia Heston: Cold-Water Flat . . . to Coldwater Canyon," *Los Angeles Times*, May 7, 1980.

32 "breathtakingly beautiful": Heston, *In the Arena*, p. 46.

32 "We were insufferably rude to each other": Lydia Heston to syndicated columnist Sidney Skolsky, 1952, quoted in Druxman, *Charlton Heston*, p. 22.

32 "I wonder if I could ask your advice": Lydia Heston, quoted in Ruth Waterbury, "Charlton Loves Lydia," *Photoplay*, June 1953.

32 "We had a very stimulating conversation": Ibid.

32 "That was my first date": Charlton Heston, quoted in Jeannine Stein, "Hestons Mark 50 Years of 'Symbiosis,'" *Los Angeles Times*, March 21, 1994.

32 "One day he played the lead in a class play": Lydia Heston, quoted in Jim Liston, "At Home with Charlton Heston," *American Home*, May 1962.

33 "It was the best job outside of acting": Charlton Heston, quoted in Gordon Gow, "Actor's Country," *Films and Filming*, May 1972.

36 "a beautiful white church with a flowering cherry tree in bloom": Lydia Clarke Heston, *Jack Heston*, from *1067*, p. 6.

36 "If only they'd been real flowers": Lydia Clarke, quoted in Beverly Ott, "Their Marriage Is a Lifetime Honeymoon," *Photoplay*, April 1954.

37 "He was hesitant because he didn't want": Holly Heston Rochell, AI.

38 "It was the beginning": Ibid.

39 "It was hard to have him go off": Lydia Heston, in *Charlton Heston: For All Seasons.*

CHAPTER FOUR

43 "If we had to go through that invasion": Charlton Heston, quoted in *Long Beach Press-Telegram*, February 12, 1995.

CHAPTER FIVE

48 "The flat had just two little windows": Charlton Heston, quoted in Earl Wilson, "It Happened Last Night," *Los Angeles Mirror-News*, June 6, 1958.

49 One of the first things Lydia did: Some of the details of how the Hestons furnished their apartment and Charlton Heston's first salary are from Earl Wilson, "It Happened Last Night," *Los Angeles Daily News*, June 16, 1951.

50 "That was when you could be": Charlton Heston, quoted in Gow, "Actor's Country."

50 "I was a very difficult actor to cast": "Charlton

Heston on Acting and the Birth of Live Television," Screen Actors Guild Foundation Conversations, June 1994, https://www.youtube.com/watch?v=PMt-tSKS-VI.

50 "I did get an erection once": Charlton Heston, *In the Arena,* p. 45.

52 "No one who hasn't been an actor": Heston, quoted in Waterbury, "Charlton Loves Lydia."

55 "We went there to do one play": Charlton Heston, quoted in Jeff Rovin, *The Films of Charlton Heston* (Secaucus, NJ: Citadel Press, 1977), p. 12.

56 "The offices [were] jammed by people": Charlton Heston, quoted in George Stevens Jr., *Conversations at the American Film Institute with the Great Moviemakers: The Next Generation* (New York: Alfred A. Knopf, 2012), p. 233.

63 "The whole new medium": Charlton Heston, quoted in ibid.

63 "The stretching capacities were fantastic": Charlton Heston, quoted in Patricia Nolan, "Conversation with Charlton Heston," *Los Angeles Herald-Examiner,* May 17, 1981.

CHAPTER SIX

69 "We signed a young actor": Walter Seltzer, in *Charlton Heston: For All Seasons.*

70 "How do you like everything": Ibid.

70 "He still wouldn't admit": Fraser Heston, AI, June 8, 2015.

71 "After all, I haven't made a fortune yet": Charlton Heston, quoted in Jack Gaver, "Along the Great White Way," *Los Angeles Daily News*, November 13, 1951.

71 "Charlton Heston, new discovery from Broadway": *Paramount News*, May 29, 1950.

73 "I had never heard of *film noir*": Charlton Heston and Jean-Pierre Isbouts, *Charlton Heston's Hollywood: Fifty Years in American Film* (New York: GT Publishing, 1998), p. 36.

74 "A new star named Charlton Heston": Bosley Crowther, "Charlton Heston Makes His Film Debut in 'Dark City,' Feature at the Paramount Theatre," *New York Times*, October 19, 1950.

75 "A huge, talented fellow": Hedda Hopper, "Hedda Hopper Picks Film Stars of 1951," *Chicago Sunday Tribune Magazine*, December 31, 1950.

76 "I [know I] learned to deal cards": Heston, *In the Arena*, pp. 98–99.

76 "I don't think *Dark City* is a good film": Heston, quoted in Rovin, *The Films of Charlton Heston*, p. 25.

78 "But one day you will be": According to Charlton

Heston, quoted in Ruth Waterbury, "Chariot Race to Destiny for Heston in *Ben Hur*," *Los Angeles Examiner*, August 31, 1958.

79 "Um, I liked the way he waved just now": Cecil B. DeMille, quoted in Heston, *In the Arena*, p. 102.

82 "He would never say": Charlton Heston, quoted in Gabe Essoe and Raymond Lee, *DeMille: The Man and His Pictures* (South Brunswick, NJ: A. S. Barnes, 1970), p. 256. This is a slim, anecdotal, apparently privately printed biography of DeMille.

CHAPTER SEVEN

86 "The first of you gentlemen": Essoe and Lee, *DeMille*, p. 270.

87 "Look, Harry": Henry Wilcoxon, quoted in Scott Eyman, *Empire of Dreams: The Epic Life of Cecil B. DeMille* (New York: Simon & Schuster, 2010), p. 199.

88 "I've been particularly fortunate": Heston, quoted in Gaver, "Along the Great White Way."

91 "I didn't find him a tyrant": Charlton Heston, quoted in Eyman, *Empire of Dreams*, p. 48.

92 "You are going to have to take the publicity photos": Count Rasponi, quoted in Camilla Snyder, "The Camera Artistry of Mrs. Charlton Heston," *Los Angeles Herald-Examiner*, September 29, 1968.

92 "I told him I was terribly unmechanical": Lydia Heston, quoted in Bob Baker, "Lydia Heston Shoots as Charlton Acts," *Los Angeles Times,* May 8, 1960.

94 "I shut my eyes and waited": Charlton Heston, interviewed by Darr Smith, *Los Angeles Daily News,* May 10, 1951.

94 "They brought in an elephant": Ibid.

CHAPTER EIGHT

99 "to be shot in glorious water color": Charlton Heston, quoted by Darr Smith, *Los Angeles Daily News,* August 11, 1951.

99 "Don't you ever smile": Milburn Stone, quoted in Druxman, *Charlton Heston,* p. 38.

102 "the train wreck looks as luridly contrived": *New York Herald Tribune,* n.d.

103 "a huge, mawkish, trite circus movie": Pauline Kael, *5001 Nights at the Movies: A Guide from A to Z* (New York: Henry Holt, 1991).

103 · "The captivation of this picture": Bosley Crowther, "DeMille Puts 'Greatest Show on Earth' on Film for All to See," *New York Times,* January 11, 1952.

104 "If you can't make a career": Heston and Isbouts, *Charlton Heston's Hollywood,* p. 45.

104 "Money and better eating": Hedda Hopper, Hedda

Hopper's Hollywood, *Los Angeles Times,* March 23, 1952.

105 "My waistline is my living": Charlton Heston, quoted in Abe Greenberg, Voice of Hollywood, *Hollywood Citizen-News,* July 28, 1966.

106 "I think [*The Savage*] is more": Heston, quoted in Smith, *Los Angeles Daily News,* August 11, 1951.

108 "Jennifer Jones, as a Ruby Gentry": Armond White, "At the Mayfair," *New York Times,* December 26, 1952.

109 "It was a pretty steamy": Charlton Heston, *In the Arena,* p. 115.

110 "I thought *High Noon*": DeMille, quoted in Mason Wiley and Damien Bona, *Inside Oscar: The Unofficial History of the Academy Awards* (New York: Ballantine Books, 1986), p. 231.

114 The rent for the combined apartments: *Look* did a story about the house (May 24, 1960). Heston gave the magazine a history of his living quarters and quoted the Park La Brea rent.

117 "While we were filming": Henry Levin, quoted in Druxman, *Charlton Heston,* p. 45.

121 "I guess *The Naked Jungle* did turn": Charlton Heston, quoted in Gow, "Actor's Country."

123 "We were both capable": Lydia Heston, quoted in Funt, "Lydia Heston."

CHAPTER NINE

130 DeMille assigned Henry Noerdlinger: Katherine Orrison, commentary track, *The Ten Commandments*, directed by Cecil B. DeMille (Hollywood, CA: Paramount DVD, 2006).

132 "I was never in any doubt": Cecil B. DeMille, *The Autobiography of Cecil B. DeMille* (Englewood Cliffs, NJ: Prentice-Hall, 1959), p. 203.

140 "[Grandfather] said good evening": Cecelia DeMille, quoted in Eyman, *Empire of Dreams*, p. 441.

145 "I wanted very much to go": Lydia Clarke Heston, quoted in Heston and Isbouts, *Charlton Heston's Hollywood*, p. 59.

148 "He was courteously formal": Charlton Heston, quoted in Charles Champlin, "Heston Revisits *Ten Commandments*," *Los Angeles Times*, May 16, 1990.

149 "Now they're working on": All excerpts from Heston's personal diaries provided to the author by the Heston family and used with permission.

153 "Every morning I'd come in": Charlton Heston, quoted in Hedda Hopper, Hedda Hopper's Hollywood, *Los Angeles Times*, December 23, 1957.

153 "He wanted to talk to anybody": Quote in Hamill, "Heston: Larger Than Life."

154 "As I moved through": Heston, *In the Arena*, p. 134.

156 "Dear God": Charlton Heston, quoted in Eyman, *Empire of Dreams*, p. 451.

156 "Ladies and gentlemen": Cecil B. DeMille, quoted in Munn, *Charlton Heston*, p. 66.

161 "When you're playing Moses": Charlton Heston, *Hollywood Studio Magazine*, April 1979.

CHAPTER TEN

166 "It [was] a very funny script": Heston, *In the Arena*, p. 136.

167 "bright little romp": Bosley Crowther, review of *The Private War of Major Benson*, *New York Times*, August 3, 1955.

168 "start the ball rolling": Charlton Heston, quoted in "Edison Memorial Proposed by Actor," *Los Angeles Times*, February 10, 1955.

CHAPTER ELEVEN

174 "Fraser was upset": Lydia Clarke Heston, quoted in Joan Beck, "Backstage Glimpses: How an Actor's Family Lives," *Chicago Daily Tribune*, September 29, 1955.

174 "My dad, who was standing": Fraser Heston, AI.

175 "Fraser is the youngest retired": Charlton Heston, quoted in Hopper, Hedda Hopper's Hollywood, December 23, 1956.

175 "playing the Baby Moses": Lydia Clarke Heston, quoted in Louella Parsons, "The Hestons—Family of Stars," *Los Angeles Examiner,* September 18, 1955.

177 "I got a call at work from": Robert Vaughn, *A Fortunate Life* (New York: Thomas Dunne Books, 2008), p. 50.

179 "Tell me, Eddie": Heston, *In the Arena,* p. 140.

181 " 'You're not reading that line' ": Victoria Price, *Vincent Price: A Daughter's Biography* (New York: St. Martin's Press, 1999), pp. 174–75.

184 "So what do I think of my": Heston, *In the Arena,* p. 145.

CHAPTER TWELVE

187 "I'd get up and do spoonerized recitations": Charlton Heston, quoted in Sidney Skolsky, Hollywood Is My Beat, *Hollywood Citizen-News,* March 17, 1955.

192 "The theme of this picture": The complete introduction reads as follows: "Ladies and gentlemen, young and old, this may seem an unusual procedure, speaking to you before the picture begins, but

we have an unusual subject, the story of the birth of freedom, the story of Moses. As many of you know, the Holy Bible omits some thirty years of Moses's life, from the time he was a three-month-old baby, and was found in the bulrushes by Bithiah, the daughter of Pharaoh, and adopted into the court of Egypt, until he learned that he was Hebrew and killed the Egyptian. To fill in those missing years, we turn to ancient historians, such as Philo and Josephus. Philo wrote at the time that Jesus of Nazareth walked the earth and Josephus wrote some fifty years later and watched the destruction of Jerusalem by the Romans. These historians had access to documents long since destroyed or perhaps lost, like the Dead Sea Scrolls. The theme of this picture is whether man ought to be ruled by God's law or whether they are to be ruled by the whims of a dictator like Rameses. Are men the property of the state or are they free souls under God? This same battle continues throughout the world today. Our intention was not to create a story, but to be worthy of the divinely inspired story, created three thousand years ago: the five books of Moses. The story takes three hours and thirty-nine minutes to unfold. There will be an intermission. Thank you for your attention."

195 "In its remarkable settings": Bosley Crowther, review of *The Ten Commandments, New York Times,* November 9, 1956.

CHAPTER THIRTEEN

201 "Montgomery Clift was really": Jack Gilardi, AI, February 12, 2015.

203 "I'm sure Moses is the most important part": The full transcription of Charlton Heston's interview with Hedda Hopper is in the Charlton Heston files at the Margaret Herrick Library, Fairbanks Center for Motion Picture Study, Academy of Motion Picture Arts and Sciences, Beverly Hills, CA. All quotes here are taken directly from the transcript.

207 "Welles is at his best": François Truffaut, foreword to *Orson Welles: A Critical View,* by André Bazin (New York: Harper & Row, 1978), p. 4.

208 "I asked who was going to direct": Charlton Heston, Rick Schmidlin, and Janet Leigh, commentary track, *Touch of Evil,* directed by Orson Welles (Universal City, CA: Universal Studios Home Entertainment, 2008).

208 "Heston first suggested": Henry Jaglom, AI, November 11, 2013.

208 "Heston would certainly have been": Peter Snell, AI, February 19, 2016.

209 "You'd have thought I'd suggested": Heston, *In the Arena,* p. 154.

209 "Once I'd persuaded Universal": Charlton Heston, " 'Touch of Evil' Needed Final Touch of Welles," *Los Angeles Times,* February 9, 1998.

209 "an ex-alcoholic, ugly and obese": Bazin, *Orson Welles,* p. 19.

210 "definitive denunciation of police brutality": Alex Ross, "The Shadow: A Hundred Years of Orson Welles," *New Yorker,* December 7, 2015.

211 "It started with rehearsals": Janet Leigh, quoted in Barbara Leaming, *Orson Welles: A Biography* (New York: Viking, 1985), p. 153.

212 "We never knew who was going": Janet Leigh, in *Charlton Heston: For All Seasons.*

213 "We were there all night": Heston, Schmidlin, and Leigh, commentary track, *Touch of Evil.*

213 "The shot was enormously complicated": Ibid.

216 "The shooting went swimmingly": Charlton Heston, *The Actor's Life: Journals, 1956–1976,* edited by Hollis Alpert (New York: E. P. Dutton, 1978), p. 23.

216 "We went to a nearby coffee shop": Charlton Heston, interview by Peter Bogdanovich, *Bringing Evil to Life,* 1998, featurette on *Touch of Evil,* directed by Orson Welles (Universal City, CA: Universal Studios Home Entertainment, 2008).

217 "The guys in the Black Tower": Dennis Weaver, interview by Henry Colman, Malibu, CA, September 24, 2002, Archive of American Television, http://www.emmytvlegends.org/interviews/people /dennis-weaver.

221 "Heston should avoid television": Bob Thomas, "Charlton Heston Should Avoid TV, It Says Here," *Hollywood Citizen-News*, February 13, 1958.

222 stop the "madness": Herman Citron, quoted in Heston, *The Actor's Life*, p. 27.

222 "You have an offer to work with Gregory Peck": Herman Citron, quoted in Heston, *In the Arena*, p. 164.

CHAPTER FOURTEEN

229 "Chuck's part was to dislike": Gregory Peck, in *Charlton Heston: For All Seasons*.

231 "When [Wyler finished] a setup": Charlton Heston, American Film Institute Series of Seminars with Master Filmmakers, November 14, 1979.

232 "an actor never feels like a worse actor": Gary Cooper, quoted by Charlton Heston in Army Archerd, *Variety*, June 10, 1958.

232 "I often wore the breeches and boots": Charlton Heston, quoted in Gow, "Actor's Country."

233 "I think in performance terms": Ibid.

235 "Sometime in 1957": Fraser Heston, AI.

235 "It was really a wonderful": Holly Heston Rochell, AI.

236–237 "I ran into Warner": Heston, *In the Arena*, p. 162.

CHAPTER FIFTEEN

239 "The only moment where one can": Orson Welles, interviewed by André Bazin and Charles Bitsch, "Senses of Cinema," *Cahiers du Cinéma*, June 1958.

240 "truly marvelous things": Heston, *The Actor's Life*, p. 34.

241 "ill, depressed, and unhappy": Aaron Stell, quoted in Charles Higham, *The Films of Orson Welles* (Berkeley: University of California Press, 1970), pp. 150–151.

242 "As Muhl [didn't] reply to my offer": Letter from Orson Welles to Charlton Heston, n.d., courtesy of the Heston family.

242 "I thought the shoot had gone": Heston, " 'Touch of Evil' Needed Final Touch of Welles."

243 "outlining his position so eloquently": Ibid.

244 "He was pleasant": Ibid.

244 "What is happening over there": Letter from Orson Welles to Charlton Heston, n.d., courtesy of the Heston family.

244 "You are poop": Ibid.

245 "In the end, the extra footage": Heston, *The Actor's Life*, p. 35.

245 "'Let's not talk about *Touch of Evil*'": Orson Welles and Henry Jaglom, *My Lunches with Orson: Conversations Between Henry Jaglom and Orson Welles*, edited by Peter Biskind (New York: Metropolitan Books/Henry Holt Books, 2013), p. 271.

246 "Orson Welles [was] the most talented": Charlton Heston, in *Charlton Heston: For All Seasons*.

246 "It is not a great movie": Charlton Heston, American Film Institute Series of Seminars with Master Filmmakers, November 14, 1979. Excerpts from that lecture and others are included in Stevens, *Conversations at the American Film Institute*, pp. 232–255.

250 "Ben-Hur's the part": Cecil B. DeMille, quoted in Heston, *In the Arena*, pp. 177–178.

251 "You didn't get it": Waterbury, "Chariot Race to Destiny for Heston."

252 "Heston will receive": Thomas, "Charlton Heston Should Avoid TV."

253 "His childhood was spent": Holly Heston Rochell, AI.

253 "From a very early age": Fraser Heston, quoted in Peggy Bowes, "Winning the Parent Lottery: An Interview with Fraser Heston, Son of Charlton

Heston," Catholic Lane, April 4, 2011, http://www
.catholiclane.com/winning-the-parent-lottery-an
-interview-with-fraser-heston-son-of-charlton
-heston/.

254 "Lydia was the strong right arm": Walter Seltzer, in *Charlton Heston: For All Seasons.*

254 "They made a pact": Carol Lanning, AI, March 20, 2015.

254 "I think it was crucial": Holly Heston Rochell, AI.

255 "He always took us with him": Lydia Clarke Heston, in *Charlton Heston: For All Seasons.*

255 "medieval modern": Charlton Heston, quoted in Hamill, "Heston: Larger Than Life."

256 "We called it the 'House that Hur Built' ": Holly Heston Rochell, AI.

256 "What was unique about the ridge": Fraser Heston, AI.

CHAPTER SIXTEEN

262 "It [takes] a Jew": William Wyler, quoted by Catherine Wyler in Daniel Eagan, "Restoring *Ben-Hur:* Catherine Wyler Reminisces About Her Father's Biggest Film," Smithsonian.com, September 30, 2011, http://www.smithsonianmag.com/arts-culture /restoring-ben-hur-catherine-wyler-reminisces -about-her-fathers-biggest-film-93580422/?no-ist.

265 *È Moses!:* Munn, *Charlton Heston,* p. 85.

265 "Beverly Hills of Rome": Earl Wilson, "Heston Lives Regally in Rome," *Los Angeles Mirror-News,* June 26, 1958.

265 "We brought a maid with us": Charlton Heston, quoted in ibid.

266 "They pay me to do the acting": Charlton Heston, quoted by Fraser Heston, in *Charlton Heston: For All Seasons.*

268 "He tended to be clumsy": Joe Canutt, AI, March 18, 2015.

268 "I knew he needed to stop": Ibid.

269 "Don't worry": Yak Canutt, quoted in Munn, *Charlton Heston,* p. 86.

269 "I remember riding in a chariot at the age of three or four": Fraser Heston, quoted in Susan Schindehette, "Charlton Heston's Son Has Come a Long Way from the Bulrushes: Baby Moses Is Now Dad's Director," *People,* July 3, 1989.

270 "My dad brought home a Roman": Fraser Heston, AI.

273 "Chuck had all the charm": Gore Vidal, from his memoir *Palimpsest,* quoted in Chris Petrikin, "Heston and Vidal Tell Conflicting Tales," *Variety,* October 16, 1995.

275 "sprinkling homoeroticism over *Ben-Hur*": Leo

Robson, "Delusions of Candor: How Will We Re-
member Gore Vidal?" *New Yorker,* October 26,
2015.

276 he claimed he had rejected: Eagan, "Restoring *Ben-
Hur.*"

277 "did not . . . write any part of *Ben-Hur* as shot":
Charlton Heston, "Love and Chariots II: Heston Re-
sponds to Vidal," *Los Angeles Times,* June 24, 1996.
Heston's letter was in response to a piece Vidal had
written: "Writing *Ben-Hur:* On Love in the Time of
Chariots," *Los Angeles Times,* June 17, 1996.

277 "General Lew Wallace": Charlton Heston, quoted
in Wilson, "Heston Lives Regally in Rome."

281 "Not all actors can bear up": Waterbury, "Chariot
Race to Destiny for Heston."

283 "I wore the full face mask": Joe Canutt, AI.

284 "Joe was the greatest natural athlete": Charlton Hes-
ton, in *Ben-Hur: The Epic That Changed Cinema,*
produced and directed by Gary Leva (Glendale,
CA: Leva FilmWorks, 2005), feature on *Ben-Hur:
A Tale of the Christ,* directed by William Wyler
(Burbank, CA: Turner Entertainment Company,
2005).

285 "Chuck," he said, "you've got to": William Wyler,
quoted by Charlton Heston in ibid.

285 "That was very tough": Charlton Heston in ibid.

285 "My father very definitely had a method": Catherine Wyler, in *Charlton Heston: For All Seasons*.

286 "first-century Jewish prince": Lydia Clarke Heston, in *Charlton Heston: For All Seasons*.

288 "I spent sleepless nights": William Wyler, quoted in Jan Herman, *A Talent for Trouble: The Life of Hollywood's Most Acclaimed Director, William Wyler* (New York: Da Capo Press, 1997), p. 410.

290 "Well, thanks, Chuck": William Wyler, quoted in Charlton Heston, diary entry, January 7, 1959.

CHAPTER SEVENTEEN

295 "I should have thanked him for my career": Charlton Heston, quoted in Eyman, *Empire of Dreams*, p. 501.

296 "The builders were very careful": Charlton Heston, quoted in Liston, "At Home with Charlton Heston."

296 "My dad loved this": Fraser Heston, AI.

298 "Cooper had all of his suits made": Ibid.

299 "It was interesting": Michael Anderson, quoted in Robert Sellers, *Hellraisers: The Life and Inebriated Times of Richard Burton, Richard Harris, Peter O'Toole, and Oliver Reed* (New York: Thomas Dunne Books, 2009), p. 63.

299 "He'd played in Shakespeare": Richard Harris, quoted by Michael Anderson in ibid., p. 64.

300 "You know, show business is": Charlton Heston, quoted in Dick Williams, "Heston Says Hollywood Has No Middle Ground," *Los Angeles Mirror-News,* May 4, 1959.

301 "I know what I can read best": Charlton Heston, quoted in Robert Musel, "Charlton Heston Bound to Task," *Hollywood Citizen-News,* August 18, 1959.

304 "The house was an expression": Fraser Heston, AI.

309 "The London opening, as well as": Heston, *The Actor's Life,* p. 81.

313 "My parents had waited eleven years": Holly Heston Rochell, AI.

CHAPTER EIGHTEEN

316 "massive, masculine and fluent": Brooks Atkinson, "Pedantic Fable: 'The Tumbler,' by Benn Levy, Stars Heston," *New York Times,* February 25, 1960.

317 "I was young and green": Charlton Heston, quoted in David Galligan, "Charlton Heston," *Drama-Logue,* September 19, 1985.

317 "I'm the only one who": Charlton Heston, quoted in Munn, *Charlton Heston,* p. 102.

317 "There have been few times": Charlton Heston, quoted in Roberta Plutzik, "Last of the Epic Heroes," *Horizon,* March 1980.

320 "Mr. William Wyler is engaged": The Writers

Guild ad is quoted in Wiley and Bona, *Inside Oscar*, p. 309. It appeared in the major Hollywood trade publications.

322 "I hope you win, Chuck": James Stewart, quoted in Heston, *In the Arena*, p. 233.

323 "As she was reading": Heston, *The Actor's Life*, p. 91.

324 "I didn't enjoy any of it": Charlton Heston, quoted in Kinn and Piazza, *The Academy Awards*, p. 135.

325 "I guess this is old hat": Wiley and Bona, *Inside Oscar*, p. 313.

325 "After the party": Charlton Heston, quoted in Kay Waymire, "No Restin' for Heston," *Los Angeles Examiner*, April 6, 1960.

325 "That morning I was up early": Fraser Heston, AI.

326 "If you made as much money": Charlton Heston, quoted in Hamill, "Heston: Larger Than Life."

326 "I don't know about that": Charlton Heston, quoted in Kay Waymire, "He Could Have Danced All Night," *Los Angeles Examiner*, August 6, 1960.

326 "Four words spoken": "Heston Fried for Saying Fry Fires a Reply," *Beverly Hills Citizen*, April 19, 1960.

328 "Since Mr. Fry is not": Charlton Heston, quoted in " 'Actors Way Over Their Heads' When Engaged in Politics: Heston," *Variety*, November 2, 1960.

CHAPTER NINETEEN

337 "I don't have a face": Charlton Heston, quoted in "Heston Thinks His Face Ideal for Antiquity," *Variety*, April 13, 1960.

338 "It isn't that I haven't": Charlton Heston, quoted in Lowell E. Redelings, "Heston Prefers Costume Films," *Hollywood Citizen-News*, March 22, 1961.

341 She agreed to appear in *El Cid:* Information about Loren's deal with Bronston is from Eugene Archer, "Movie Producer Cites Star Power," *New York Times*, October 19, 1960.

344 "were directed with a kind of tough-guy": Andrew Sarris, *The American Cinema: Directors and Directions, 1929–1968* (New York: Da Capo Press, 1996), pp. 98–99.

345 "It was about the only thing": Peter Snell, AI.

345 "It all had to do with how late": Fraser Heston, AI.

345 "She sometimes tends to carry": Heston, *The Actor's Life*, p. 105.

346 "There are scenes": Charlton Heston, quoted in Munn, *Charlton Heston*, pp. 108–109.

CHAPTER TWENTY

350 "I just wanted to stand up": Charlton Heston, quoted in "Actor Heston to Walk for Integration," *Hollywood Citizen-News*, May 27, 1961.

350 "We were completely successful": Charlton Heston, quoted in Sheilah Graham, "Charlton Excited About Election," *Hollywood Citizen-News,* July 30, 1964.

352 "My dad always loved": Holly Heston Rochell, AI.

354 "The delights of our completed": Heston and Isbouts, *Charlton Heston's Hollywood,* p. 134.

354 "He didn't have the desire": Holly Heston Rochell, AI.

354 "I don't think the swash": Charlton Heston, quoted in Erskine Johnson, "Heston Tries Change of Pace from Toga Heroics to Farce," *Los Angeles Examiner,* November 24, 1961.

359 "If the Screen Actors Guild": Charlton Heston, quoted in "Do Something, Just Don't Wall-Wail, Heston's Advice to Craft Unions," *Variety,* May 9, 1962.

359 "Since 1950 I have made": Charlton Heston, quoted in Graham, "Charlton Excited About Election."

CHAPTER TWENTY-ONE

366 "The cinema is Nicholas Ray": The entire quote by Godard is: "There was theater (Griffith), poetry (Murnau), painting (Rossellini), dance (Eisenstein), music (Renoir). Henceforth, there is cinema. And the cinema is Nicholas Ray."

369 "Richard 'King' Howland": *Diamond Head,* Turner Classic Movies, http://www.tcm.com/tcmdb/title /73053/Diamond-Head/.

371 "Charlton Puts Foot": Wanda Henderson, "Charlton Puts Foot in It, Makes Lasting Impression," *Los Angeles Times,* January 25, 1962.

CHAPTER TWENTY-TWO

381 "meaningless title": Charlton Heston, interview by Viner, *Interview.*

381 "I suppose I was elected": Heston, *The Actor's Life,* p. 177.

381 "Some of us in the film community": Charlton Heston, *The Courage to Be Free* (Kansas City, KS: Saudade Press, 2000), p. 277.

385 "He was a special man": Heston, *The Courage to Be Free,* p. 277.

386 " 'Have you reached out to anyone' ": Harry Belafonte and Michael Shnayerson, *My Song: A Memoir* (New York: Alfred A. Knopf, 2011), pp. 277–278.

388 "We had a good group": Heston, *The Courage to Be Free,* p. 12.

389 "I'm not deeply involved": Charlton Heston, quoted in Don Alpert, "Heston Willing to Be a Face in the Crowd," *Los Angeles Times,* December 5, 1965.

389 "He was vigorously counseled": Fraser Heston, AI.

CHAPTER TWENTY-THREE

399 "Frankly, actors have come": Charlton Heston, quoted in "Heston Solves 'Dundee' Conflict by Returning Fee to Columbia," *Los Angeles Times,* May 9, 1964.

400 "A film star responsible": "Heston Returns Fee on *Dundee,*" *Variety,* May 13, 1964.

401 "looked down on me": Richard Harris, quoted in Sellers, *Hellraisers,* p. 98.

401 "hiding and quivering somewhere": Fraser Heston, AI.

401 "Heston's the only man who": Richard Harris, quoted in Munn, *Charlton Heston,* p. 123.

402 "I seem to have been unloading": Annotation to diary entry, April 17, 1964, in Heston, *The Actor's Life,* p. 197.

403 "The more incidents you put": Charlton Heston, quoted in Graham, "Charlton Excited About Election."

404 "At least I got my meals": Charlton Heston, quoted in Sheilah Graham, "Heston Just Can't Escape Dark Ages," *Hollywood Citizen-News,* April 21, 1965.

404 "The film failed": Charlton Heston, interview by Lawrence Linderman, *Penthouse Magazine,* August 1980.

405 "You've got to pick the right girl": Charlton Heston, quoted in Chuck Arnold, Chatter, *People,* September 28, 1998.

406 "the best screenplay": Charlton Heston, quoted in Graham, "Heston Just Can't Escape Dark Ages."

407 "Letters are usually the best": Charlton Heston, quoted in Helen Van Slyke, "From 'Moses' to 'Midway,' Charlton Heston Is Larger Than Life," *Saturday Evening Post,* January/February 1976.

407 "I had only played one genius": Charlton Heston, quoted in Hamill, "Heston: Larger Than Life."

408 "There's no record": Charlton Heston, quoted in Kristine McKenna, "An Old Warrior, Back in the Arena," *Los Angeles Times,* September 16, 1995.

408 "He was four times": Charlton Heston, quoted in *Variety,* June 12, 1964.

411 "wrought there over the four": Heston, *An Actor's Life,* p. 201.

411 "I feel like I grew up": Fraser Heston, AI.

412 "As we drove into Manhattan": Heston, *An Actor's Life,* p. 209.

CHAPTER TWENTY-FOUR

417 "I'd like to [make some]": Charlton Heston, quoted in Harrison Carroll, "Shaggy War Lord," *Los Angeles Herald-Examiner,* December 6, 1964.

418 "We worked very long six-day weeks": Heston, *In the Arena*, pp. 354–355.

420 "My father loved to work": Holly Heston Rochell, AI.

423 "Producers just don't see": Graham, "Heston Just Can't Escape Dark Ages."

425 "From now on": Charlton Heston, quoted in Sheilah Graham, "Charlton Heston Will Try to Stay Home," *Hollywood Citizen-News*, January 8, 1966.

425 "My dad cared about his fellow workers": Fraser Heston, AI.

427 "the greatest actor": Charlton Heston, quoted in Graham, "Charlton Heston Will Try to Stay Home."

427 "We were talking today": Charlton Heston, quoted in ibid.

428 "It was a coup": Charlton Heston, quoted in Army Archerd, Just for Variety, *Variety*, December 24, 1965.

429–430 "Gordon is one of those cross-grained": Charlton Heston, quoted in Rovin, *The Films of Charlton Heston*, p. 159.

431 "I think *Khartoum* is the only": Charlton Heston, quoted by Peer J. Oppenheimer, "Happy Man in a Million-Dollar Trap," Family Weekly, *Hollywood Citizen-News*, June 26, 1966.

431 "Largely liked by critics and me": Heston, *The Actor's Life*, p. 248.

432 "I don't seem to fit really": Charlton Heston, quoted in Alpert, "Heston Willing to Be a Face in the Crowd."

CHAPTER TWENTY-FIVE

439 Herman Citron continued to operate: Heston wrote about Citron's choices of movies he should make in Heston, *In the Arena,* p. 372.

442 "There's so much extremism": Charlton Heston, quoted in Archerd, Just for Variety, *Variety,* December 24, 1965.

442 "He felt that he wanted": Fraser Heston, AI.

445 "Out there Ben-Hur rode a chopper": Victor Riesel, "Heston Tells GI Reactions to Visits," *Hollywood Citizen-News,* December 28, 1966.

446 "Like everyone, I had my doubts": Charlton Heston, quoted in Cecil Smith, "Charlton Heston—A Man for All Acting Seasons," *Los Angeles Times,* February 27, 1966.

448 "rarely has any production": Cecil Smith, "Heston Whets Appetite for More," *Los Angeles Times,* March 3, 1966.

450 "I am not an extremist": Charlton Heston, quoted in *Film Daily,* November 21, 1966.

450 "My dad and Reagan were friends": Fraser Heston, AI.

CHAPTER TWENTY-SIX

457 "Absolutely not": Charlton Heston, quoted in Drux-man, *Charlton Heston,* p. 102.

459 "an illiterate man of limited opportunities": Charl-ton Heston, quoted in Gow, "Actor's Country."

459 "I read it": Charlton Heston, quoted in Munn, *Charlton Heston,* p. 140.

460 "You fall short": Heston, *The Actor's Life,* p. 265.

460 "laconic flatness": Ibid., p. 267.

463 "It's my first screen bath": Charlton Heston, quoted in Abe Greenberg, "When Heston Bathes—in Pub-lic!" Voice of Hollywood, *Hollywood Citizen-News,* April 6, 1967.

463 "Counting the building of this set": Walter Seltzer, quoted in ibid.

464 "My dad loved westerns": Fraser Heston, AI.

466 "I consider, as a father": Charlton Heston, in Robert Hutchins, "A Dialogue with Robert Hutchins and Charlton Heston," *Redbook,* December 1965.

467 Early in 1968, a dormant project: Some of the back-ground information on *Planet of the Apes* is from Don Kaye, "Human See, Human Do: A Complete History of 'Planet of the Apes,'" *Rolling Stone,* July 1, 2014.

468 "I expected them and every other studio": Charl-

ton Heston, quoted in Munn, *Charlton Heston*, p. 143.

469 "Dick Zanuck deserves": Charlton Heston, quoted in ibid.

470 "space opera": Charlton Heston's full quote was: "It was actually the first of the high-budget studio space operas . . ." (interview on KPWR radio, Los Angeles, CA, c. 1990).

472 "It's a long time to sit": Charlton Heston, quoted in Dorothy Manners, "A New Heston Looks at Outdated Girls," *Los Angeles Herald-Examiner*, September 17, 1967.

473 "In the first place, I was": Charlton Heston, quoted in Champ Clark, "Picks and Pans Review: Talking With . . ." *People*, September 7, 1998.

473 "I previously turned down other sci-fi films": Charlton Heston, quoted in Army Archerd, Just for Variety, *Variety*, July 11, 1967.

473 "I've gone from 3000 B.C.": Charlton Heston, quoted in ibid.

474 "He was a man": Holly Heston Rochell, AI.

475 "Ugh, awful . . .": Charlton Heston, quoted in Manners, "A New Heston Looks at Outdated Girls."

476 "It's significant that almost": Charlton Heston, quoted in Archerd, Just for Variety, *Variety*, July 11, 1967.

CHAPTER TWENTY-SEVEN

484 "American Film Institute, bringing together": "History," American Film Institute, http://www.afi.com/conservatory/about/history.aspx.

487 "Prior to the formation of the council": Charlton Heston, quoted in "Film: The American Art Form," *Hollywood Reporter,* 1975.

491 "There's a great deal of me": Charlton Heston, quoted in Eastman, *Orange Coast.*

491 During filming, Dern, who was: Information about Heston's diet during the making of *Number One* is from Bob Thomas, Entertainment, Associated Press, March 29, 1968.

496 "'Planet of the Apes,' which opened yesterday": Renata Adler, review of *Planet of the Apes, New York Times,* February 9, 1968.

497 "catches us at a particularly wretched": Joseph Morgernstern, "Monkey Lands," *Newsweek,* February 26, 1968.

497 "the movie could have been": Pauline Kael, "Apes Must Be Remembered, Charlie," *New Yorker,* February 17, 1968.

497 "Linda H. has problems": Heston, *The Actor's Life,* p. 74.

501 "But for one scene too": Renata Adler, review of *Will Penny, New York Times,* April 11, 1968.

502 "'Will Penny' occupies [the] land": Roger Ebert, review of *Will Penny, Chicago Sun-Times,* June 5, 1968.

504 "The pretentious and derivative": William K. Everson, *A Pictorial History of the Western Film* (Secaucus, NJ: Citadel Press, 1969), p. 241.

504 "People still talk about *Will Penny*": Charlton Heston, quoted in Wayne Warga, "Heston: A Heroic Type Essays Role in Reality," *Los Angeles Times,* February 6, 1977.

505 "I don't think Robert Kennedy's": Heston, *The Actor's Life,* p. 295.

510 "Moses throws like a girl": Bill Slocum, "'Moses' Dons T-shirt and Helmet for 'Pro,'" *Los Angeles Herald-Examiner,* December 8, 1968.

510 "My weight is my fortune": Charlton Heston, quoted in Nan Musgrove, *Australian Women's Weekly,* July 21, 1976.

510 "It was my understanding": Holly Heston Rochell, AI.

514 "For dad, the holidays were": Holly Heston, AI.

CHAPTER TWENTY-EIGHT

519 "I was thirty-one years old": Peter Snell, AI.

521 "Early on in Spain": Ibid.

521 At the end of the day": Vaughn, *A Fortunate Life,* p. 277.

522 "Heston, who was very large": Ibid., p. 278.

522 "When I played Casca": Ibid., p. 109.

522 "boy producer": Peter Snell, AI.

523 "Chuck said to me": Ibid.

523 "I got $100,000 from Japan alone": Peter Snell, quoted in Patricia Johnson, "Heston Dons Director's Badge for 'Antony,' " *Los Angeles Times*, September 12, 1971.

524 "*The Hawaiians* is one of": Heston, *The Actor's Life*, p. 288.

525 "I was annoyed with Chuck": Tom Gries, quoted by unnamed source in Druxman, *Charlton Heston*, p. 112.

528 "It's important for an actor": Charlton Heston to Bob Thomas, Associated Press, quoted in Druxman, *Charlton Heston*, p. 115.

529 "We were finally able to cobble": Peter Snell, AI.

529 "It was an important film for him": Fraser Heston, AI.

530 "She was very eager to play the part": Charlton Heston, quoted in Johnson, "Heston Dons Director's Badge."

534 "We returned to Los Angeles": Peter Snell, AI.

535 "We had violent [verbal]": Lydia Heston, quoted in Funt, "Lydia Heston."

535 "He did get it": Fraser Heston, AI.

535 And although he repeated to them: Heston blaming overseas production as one of the reasons production was down around the world is from "Heston Voices Regret in Production Slump," *Variety*, December 7, 1970.

536 "WOULD YOU BELIEVE": John Austin, "Heston to Spain," *Hollywood Citizen-News*, March 9, 1970.

539 "Chuck wanted to see what": Hildegard Neil, quoted in Munn, *Charlton Heston*, p. 157.

541 "We needed someone": Peter Snell, AI.

541 "My dad had two big things": Fraser Heston, AI.

543 "The climax is as florid": Howard Thompson, review of *The Omega Man*, *New York Times*, August 14, 1971.

543 "I was very happy with it": Heston, *In the Arena*, p. 456.

543–544 "The query was not the first": Heston and Isbouts, *Charlton Heston's Hollywood*, pp. 170–171.

545 "It was a part-time temporary job": Carol Lanning, AI.

546 "I think my dad": Holly Heston Rochell, AI.

546 "One thing I got used to": Carol Lanning, AI.

547 "From that day on": Holly Heston Rochell, AI.

548 "It was necessary to do some acting": Charlton Heston, quoted in Gow, "Actor's Country."

CHAPTER TWENTY-NINE

554 " 'Skyjacked' [shows] a basically": A. H. Weiler, review of *Skyjacked, New York Times*, May 25, 1972.

556 "He should never have done it": Fraser Heston, AI.

556 "the worst film I ever made": Charlton Heston, quoted in Munn, *Charlton Heston,* p. 165.

559 "I don't remember exactly when": Holly Heston Rochell, AI.

559 "I think it was very difficult": Ibid.

560 "Dad used to say": Fraser Heston, quoted in Bowes, "Winning the Parent Lottery."

560 "My dad would say to me": Holly Heston Rochell, AI.

561 "My mother did have migraines": Fraser Heston, AI.

564 "I recognize [Nixon] is a political animal": Heston, *In the Arena,* p. 393.

564 "Senator McGovern basically a decent": "Nixon Gets Backing of Charlton Heston," *Los Angeles Herald-Examiner,* August 4, 1972.

564 "She had a lot of health issues": Fraser Heston, AI.

CHAPTER THIRTY

577 "practically straight-armed": Earl Wilson, It Happened Last Night, *Los Angeles Herald-Examiner,* April 27, 1974.

577 "I'm rebuilding my": Charlton Heston, quoted in ibid.

577 "outstanding humiliations": Heston, *The Actor's Life*, p. 404.

578 "one of the very worst days": Ibid., p. 407.

578 "Great men are more interesting": Charlton Heston, quoted in Druxman, *Charlton Heston*, p. 127.

579 "My mother loved going on these trips": Holly Heston Rochell, AI.

584 "We need you to survive": Heston and Isbouts, *Charlton Heston's Hollywood*, p. 180.

584 "I had script approval": Charlton Heston, quoted in ibid.

586 "This [tragedy genre] really isn't": Charlton Heston, quoted in Rovin, *The Films of Charlton Heston*, p. 220.

CHAPTER THIRTY-ONE

591 "the corrosive moral relativism": Emilie Raymond, *From My Cold, Dead Hands* (Lexington: University Press of Kentucky, 2006), p. 142.

592 In February 1973: Some background information regarding the AFI and the opening of the Greystone Mansion as its headquarters is from Joyce Haber, "Nixon May Attend AFI Award Dinner," *Los Angeles Times*, February 28, 1973.

592 "From this year and every year forward": Ibid.

595 "Vanessa is proving": Heston, *An Actor's Life*, p. 429.

596 "There are a good many": Dan Sullivan, review of *Macbeth, Los Angeles Times,* January 29, 1975.

597 "As a kid of twenty": Charlton Heston, quoted in Plutzik, "Last of the Epic Heroes."

598 "other industry-related commitments": Charlton Heston, quoted in "Heston Exits 15-year-old SAG Board Seat," *Variety,* June 25, 1975.

598 "I should never have come": Heston, *An Actor's Life,* p. 449.

598 "Charlton Heston, superstar of 'disasters' ": Dorothy Manners, *Los Angeles Herald-Examiner,* April 2, 1975.

601 "might be the last time": Heston, *An Actor's Life,* pp. 452–453.

601 "The scenes of my childhood": Ibid.

CHAPTER THIRTY-TWO

605 "A good film today": Charlton Heston, quoted in Nolan, "Conversation with Charlton Heston."

606 "Technically it was biology": Fraser Heston, AI.

607 "They know how hard it is": Charlton Heston, quoted in Van Slyke, "From 'Moses' to 'Midway.' "

607 "I haven't taken a game from him": Charlton Hes-

ton, quoted in Nan Musgrove, *Australian Women's Weekly*, July 21, 1976.

608 "*Two-Minute Warning* was actually": Heston, *In the Arena*, p. 473.

609 "Although a large commercial": Charlton Heston, quoted in Eastman, *Orange Coast.*

609 "I'm luckier than any actor": Charlton Heston, quoted in ibid.

610 ". . . directed by Peter Wood": Dan Sullivan, "Long Night's 'Journey' at the Ahmanson," *Los Angeles Times*, February 27, 1977.

611 "it's a daunting experience": Charlton Heston, quoted by Jean Cox, *Women's Wear Daily*, February 25, 1977.

611 "I'm too dull": Charlton Heston, quoted in *People*, April 4, 1977.

611 "Well, it's not a Cinerama-size": Ibid.

612 "I've never gone to jail": Charlton Heston, quoted in Marilyn Beck, "Charlton Heston: Between an Actor and His Public, It's a Love-Hate Relationship," United Features, 1971.

613 "a pompous ass": Bette Davis, quoted in Munn, *Charlton Heston*, p. 184.

615 "To go on stage in Los Angeles": Orson Welles, quoted in Charles Champlin, *Los Angeles Times*, February 11, 1979.

CHAPTER THIRTY-THREE

617 "After my last year at UCLA": Fraser Heston, AI.

618 "Fraser was my best friend": Martin Schafer, AI, January 22, 2016.

619 "Martin read it, loved it": Fraser Heston, AI.

620 "It was a marvelous part": Charlton Heston, quoted in Joan Dew, "Charlton Heston Reveals," November 1975.

621 "I sometimes feel like": Ibid.

622 "prepared to die": Irene McKinney, quoted in "Heston Stands By in Plane Hijack; Show Folk Aboard," *Variety*, January 31, 1979.

624 "[Heston] will never be": Lawrence Christon, review of *A Man for All Seasons*, *Los Angeles Times*, February 17, 1979.

625 "Heston's very natural performance": Ron Pennington, review of *A Man for All Seasons*, *Hollywood Reporter*, February 20, 1979.

625 "risking your vanity": Charlton Heston, quoted in the *Los Angeles Times*, Calendar section, February 14, 1979.

626 "He used to get nailed": Stephen Macht, AI, November 15, 2015.

627 "They had the whole country": Fraser Heston, quoted in Plutzik, "Last of the Epic Heroes."

627 "Most mountain men were illiterate": Charlton Heston, quoted in ibid.

628 "As I was maturing": Stephen Macht, AI.

629 "All in all": Fraser Heston, AI.

630 "If you're talking about a film center": Charlton Heston, quoted in "Heston Has Explanation," *New York Times*, September 1, 1980.

630 "I am naming this task force": Ronald Reagan, press release, quoted in United Press International, May 7, 1981.

631 "While I believe firmly": Ibid.

631 "One of Ronald Reagan's major": Jean Firstenberg, AI, July 15, 2015.

632 "The Arts and Humanities represent": Charlton Heston, quoted in Dodie Kazanjian, *ARTS Review*, Spring 1985.

633 "a chance to start over": Quoted in Lawrence Christon, *Los Angeles Times*, April 18, 1981.

633 "I am a great admirer": Charlton Heston, quoted in David Rensin, "20 Questions: Charlton Heston," *Playboy*, May 1983.

635 "What seems clear": Charles Champlin, *Los Angeles Times*, May 8, 1981.

636 "It would be stupid": Charlton Heston, quoted in ibid.

637 "The National Endowment for the Arts has won": "Heston Yelp Limits Coin Return by Endowment; Biddle Is Joyous," *Variety,* June 10, 1981.

638 "To define their work as 'recreational'": National Urban Coalition, telegram, quoted in Peter Khiss, "Urban Groups Dispute Heston on Arts Cuts," *New York Times,* June 29, 1981, and "Urban Coalition Debates Heston over Arts Program," *Hollywood Reporter,* June 30, 1981.

638 "Reagan may have been": Jean Firstenberg, AI.

639 "By and large, I'm quite": Charlton Heston, quoted in Jack Slater, "Arts Task Force: Heston's New Role," *Los Angeles Times,* August 26, 1981.

639 "I'm an actor": Charlton Heston, quoted in ibid.

CHAPTER THIRTY-FOUR

641 "I'm very relieved": Charlton Heston, quoted in Donald Chase, "Between Scenes with Charlton Heston," *Saturday Evening Post,* November 1983.

642 "It was another wonderful chance": Fraser Heston, AI.

643 "Chuck directed and for once": Peter Snell, AI.

643 "heavily influenced by Walter": Fraser Heston, AI.

644 "appalling editing": Charlton Heston, quoted in *Los Angeles Herald-Examiner,* September 7, 1981.

644 "We [he and Lydia] had a remarkably": Charlton

Heston, quoted in Chase, "Between Scenes with Charlton Heston."

645 In July 1980: Some of the background information regarding the SAG strike is from Raymond, *From My Cold, Dead Hands,* and a timeline and profile of Ed Asner published by SAG-AFTRA.

646 "I got pulled into it": Ed Asner, AI, November 10, 2012.

647 "I have no magic solution": Ed Asner, quoted in "Edward Asner," SAG-AFTRA, https://www.sag aftra.org/edward-asner.

647 "imposing his political views": Charlton Heston, quoted in Raymond, *From My Cold, Dead Hands,* p. 230.

647 That statement: The Heston-Asner feud was chronicled in "Hollywood's Divided Unions," *Business-Week,* July 5, 1982.

648 "alienate us from the rest": Kim Fellner, quoted in Raymond, *From My Cold, Dead Hands,* pp. 227–228.

648 politicizing the guild: *Variety,* January 27, 1982.

648 "shocked": Charlton Heston, quoted in *Hollywood Reporter,* February 12, 1982.

649 Reagan's "stooge": "Lou Grant Calls Ben-Hur a Stooge," *Los Angeles Herald-Examiner,* May 18, 1982.

649 "The vast majority of extras": Ed Asner, AI, November 11, 2012.

649 "We gave the money": Ibid.

649 "He has the perfect right": Charlton Heston, quoted in "Get Down, Moses," *Los Angeles Herald-Examiner,* February 17, 1982.

650 "He assumed I was giving": Ed Asner, AI.

650 "When he went to Vietnam": Ibid.

650 "When I was a kid growing up": Ibid.

651 "President Ed Asner": Letter from Charlton Heston to Ed Asner, in Ray Loynd, "Heston Accuses Asner of Slurring Him at Meeting," *Hollywood Reporter,* February 19, 1982.

652 "down in his cups": Ed Asner, quoted in ibid.

654 he had a falling out: Background information on the Newman-Heston feud is from Shawn Levy, *Paul Newman: A Life* (New York: Harmony Books, 2009), and Lee Dembart, "Heston, in Political Role, Hits Newman's Pro-Freeze Stance," *Los Angeles Times,* October 15, 1982.

654 "On election night": Levy, *Paul Newman,* pp. 330–331.

655 "Paul is a good man": Charlton Heston, quoted in ibid., p. 331.

655 "Heston is riding piggyback": Paul Newman, quoted in ibid.

655 "Heston ran circles": Ibid.

655 "He can't touch me": Charlton Heston, quoted by Carol Lanning, AI.

655 "Although Paul and I have never": Charlton Heston, quoted in Rensin, "20 Questions: Charlton Heston."

656 "I don't think I should": Charlton Heston, quoted in ibid.

CHAPTER THIRTY-FIVE

659 "I'm relieved and proud": Charlton Heston, presentation ceremony, quoted in Jack Searles, "Hollywood's Epic Hero Lands at UCLA," *Los Angeles Herald-Examiner,* January 29, 1983.

660 "I will not do TV": Charlton Heston, quoted in Doris Nieh, "Charlton Heston: Super Star in Movies and Life," *Easy Living,* Fall 1977.

660 "I was watching *Brideshead*": Charlton Heston, quoted in Chase, "Between Scenes with Charlton Heston."

662 "Last year, films were geared": Charlton Heston, quoted by Denise Abbott, *Beverly Hills* 213, October 30, 1985.

662 "master race": Ed Asner, quoted in "Heston Raps Asner for Inciting Riots," *Hollywood Reporter,* January 10, 1984.

662 "We will kill the master race-ists": The two notes

from the "Workers Death Squad," Heston's written reactions, and SAG's response are in Dave Robb, "Heston Says Asner Speech Touched Off Death Threats," *Variety*, January 11, 1984.

663 "This is, of course, not the first death": Charlton Heston, quoted by David Robb, "Heston Says Asner Speech Touched Off Death Threats, *Variety*, January 11, 1984.

663 "The board was very sorry to read": Ken Orsatti, quoted by David Robb, "Heston Says Asner Speech Touched Off Death Threats, *Variety*, January 11, 1984.

664 "the granite-jawed actor": *People*, January 16, 1984.

664 "There was a little flurry": Charlton Heston, quoted in Army Archerd, Just for Variety, *Variety*, January 11, 1984.

665 "For anyone who cares about legitimate theater": Bruce Bebb, review of *Detective Story*, *Reader*, February 17, 1984.

666 "It was a script I wrote": Fraser Heston, AI.

666 "My career has exactly paralleled": Charlton Heston, quoted in Charles Champlin, "Heston: The Past Is Present," *Los Angeles Times*, September 10, 1994.

667 "Charlton Heston, he who once": John O'Connor,

"Charlton Heston in a 'Nairobi Affair,'" *New York Times,* October 17, 1984.

668 "Yesterday I worked two-thirds of the day": Charlton Heston, quoted in Galligan, "Charlton Heston."

670 "Finally, I realized": Charlton Heston, quoted in Malcolm Hay, *Plays and Players,* March 1985.

CHAPTER THIRTY-SIX

676 "an errand boy": Charlton Heston, quoted in "Dreyfuss Adds 2 Cents to Heston Dispute," *Variety,* January 7, 1987.

676 "bizarre and distasteful": Richard Dreyfuss, quoted in ibid.

678 "I can't speak for the whole": Charlton Heston, quoted in Jeannine Stein, "Shooting Competition Brings in Backers for NRA Lobbying," *Los Angeles Times,* August 24, 1987.

678 "I first worked with C.H. by phone": Tony Makris, AI, April 20, 2015.

681 "As a citizen, I have": Charlton Heston, quoted in Janet Kinsian, "Hollywood Hero Is a Solid Citizen," *Palm Springs,* July 1990.

681 "We grew into a huge": Tony Makris, AI.

681 "In 1985 I became": Ibid.

682 "I think the NRA": Fraser Heston, AI.

684 "keep your hairpiece on": Christopher Hitchens to Charlton Heston, CNN, quoted in *Newsweek*, March 4, 1991.

684 Hollywood seemed like a good idea: Charlton Heston, quoted in John H. Richardson, "Heston," *Esquire*, July 2001.

685 "If you defy our members": Letter from Charlton Heston to SAG national executive director Ken Orsatti, excerpted in "Heston Predicts Mass Defections from SAG," *Variety*, September 14, 1988.

685 "I never thought I would feel": Gordon Hodgins, letter to the editor, *Daily Variety*, September 19, 1988.

685 "I would like to remind": Letter from Julian Ayrs, quoted in *Variety*, September 21, 1988.

686 "This exchange will celebrate": Quoted in Duane Byrge, *Hollywood Reporter*, July 19, 1988.

690 "You wouldn't think it would": Charlton Heston, quoted in Paula Chin and Doris Bacon, "The Bamboo Curtain Rises on Charlton Heston's *Caine*, an SRO Hit in Beijing," *People*, October 31, 1988.

691 "In the States": Charlton Heston, quoted in ibid.

691 "I don't think I've ever slept": Charlton Heston, *Beijing Diary* (New York: Simon & Schuster, 1990), p. 170.

693 "I'm still glad I did the play": Heston, *Beijing Diary*, p. 174.

CHAPTER THIRTY-SEVEN

695 "professional critics should judge performance": Charlton Heston, "The Actor's Response," *Los Angeles Times*, December 24, 1988.

696 "I've always spoken out on issues": NRA advertisement, *Newsweek*, April 10, 1989.

696 "He was still on the masthead": Jean Firstenberg, AI.

697 "From Turner's point of view": Peter Snell, AI.

697 "My father used to read it to me": Fraser Heston, quoted in Susan Schindehette, *People*, July 3, 1989.

698 "Directing my father was wonderful": Fraser Heston, AI.

698 "Chuck suggested during casting": Peter Snell, AI.

698 "The first day we brought Oliver in": Fraser Heston, AI.

699 "The ratings were great": Peter Snell, AI.

699 "Hollywood is kind of like the Mafia": Fraser Heston, AI.

700 "Never give up": Charlton Heston, quoted in Jani Allan, "Great Sport with a Line in Heroic Role Models," *Sunday Times of London*, June 17, 1990.

701 "Actors' Equity was the first union": Letter from Charlton Heston to the head of Actors' Equity, excerpted in *Los Angeles Times*, August 15, 1990.

702 "It began when we both decided": Fraser Heston, AI.

CHAPTER THIRTY-EIGHT

708 "I've made a lot of movies": Charlton Heston, quoted in Morning Report, *Los Angeles Times*, November 5, 1993.

708 As a boy": Taken from pages of one of Heston's speeches, found in the private Heston archives.

709 a "piece of shit": Charlton Heston, quoted in Stephen Galloway, "Schallert: Heston Libeled Me," *Hollywood Reporter*, October 13, 1993.

709 "just an anti-union": Charlton Heston, quoted in ibid.

710 "Hanoi Jane of the Second Amendment": Charlton Heston, quoted in Morning Report, *Los Angeles Times*, May 5, 1998.

710 "need an AK-47": Barbra Streisand, quoted in "Feud of the Week," *Time*, May 18, 1998. The feud escalated when Streisand executive-produced a TV documentary, *The Long Island Incident*, about Carolyn McCarthy, who won a seat in Congress after a gunman killed her husband and five other people

on a New York commuter train in 1993. Heston also jokingly challenged Streisand to a duel, which she may have took seriously, calling it counterproductive. The film came in last in the ratings, not at all helped by her ongoing feud with Heston.

711 "art is the bread of the soul": Charlton Heston, testimony, House Appropriations Subcommittee on the National Endowment for the Arts and the National Endowment for the Humanities, quoted in Robert Pear, "Actor Urges House Panel to Spare Money for the Arts," *New York Times*, January 25, 1995.

712 "The agencies subsidized": Lynne Cheney, quoted in ibid.

712 "The government had no": William Bennett, quoted in ibid.

713 That same year, the American: Heston's honorary AFI degree was reported in "AFI to Bestow Degrees on Heston, Wise, Cooper," *Variety*, June 8, 1995. Karen Cooper was the director of New York City's Film Forum, one of the premier art and revival cinemas in the country.

713 "He's Moses to our people": Wayne LaPierre, quoted in *Newsweek*, May 19, 1997.

714 "the most vital of all": Charlton Heston, National Press Club, Washington, D.C., quoted in Katharine Q. Seelye, *New York Times*, September 12, 1997.

714 "What Heston brings to the NRA": Bill Powers, quoted in Matthew Campbell, "Heston Stars in US Gunfight," *Sunday Times of London*, December 14, 1997.

715 "Join me, join us": Charlton Heston, quoted in Army Archerd, Just for Variety, *Variety*, March 31, 1998.

715 "Charlton Heston, whose gravelly": Campbell, "Heston Stars in US Gunfight."

715 "The first act of a dictatorship": Charlton Heston, quoted in ibid.

716 "[The decline] has been to a large": Charlton Heston, quoted in Michael Janofsky, "Enthusiastic N.R.A. Gives Mandate to Charlton Heston," *New York Times*, June 3, 1998.

716 "If Charlton Heston wants to lead": Charles Schumer, quoted in ibid.

717 "Even a good messenger": Robert G. Torricelli, quoted in ibid.

717 "While the National Rifle Association promotes": Josh Sugamann, "Under Heston, Same Old N.R.A.," *New York Times*, June 9, 1998.

718 "I can assure Charlton": Rhonda Erickson, letter to the editor, *People*, July 13, 1998.

718 "Charlton Heston, aka Moses": Shirley Temple

Black, quoted in Army Archerd, Just for Variety, *Variety*, June 10, 1998.

718 "Every time I see the face": Al Martinez, "The Children of Moses," *Los Angeles Times*, June 23, 1998.

719 "I've never been afraid": Charlton Heston, quoted in *Time*, May 18, 1998.

719 "beautifully": Charlton Heston, quoted in Mary Murphy, "Prime Chuck," *TV Guide*, February 10, 1999.

719 "a colorful gun-toting lunatic": Peter Biskind, *Star: How Warren Beatty Seduced America* (New York: Simon & Schuster, 2010), p. 514.

CHAPTER THIRTY-NINE

721 "It's not totally gone": Charlton Heston, quoted in Morning Report, *Los Angeles Times*, January 7, 1999.

722 "matchless": Charlton Heston, "A Filmmaker Worth Honoring," *Wall Street Journal*, January 20, 1999. It is worth noting that no Los Angeles newspaper was interested in publishing the piece; the *Wall Street Journal* is published in New York City.

724 "They say don't come here": Charlton Heston, quoted in Eric Slater and Lianne Hart, "NRA

Event Draws 1,800 Protesters," *Los Angeles Times*, May 2, 1999.

725 "Dear Mr. Heston": Note from Lorna Luft to Charlton Heston, quoted in *Newsweek*, May 10, 1999.

725 At the Cannes Film Festival: Spike Lee, quoted in Morning Report, *Los Angeles Times*, May 29, 1999.

726 "We support everyone's": Letter from Ann Reiss Lane, Women Against Violence, to Charlton Heston, quoted in "Reading by Heston Opposed," *Los Angeles Times*, November 30, 1999.

726 "entirely irrational": Charlton Heston, quoted in ibid.

726 "the NRA spends $1 million a year": Charlton Heston, quoted in Barbara Paskin, *London Times*, April 14, 2000.

728 "President Heston": Army Archerd, Just for Variety, *Variety*, June 13, 2000.

729 "Gore gave his reply": Vidal, quoted in *Variety* and other media, May 21, 2000.

730 "He shocked all of us that night": Wayne LaPierre, AI, February 2, 2015.

730 "Especially after the assassinations": Tony Makris, AI.

731 "Heston's overall involvement": Grover Norquist, AI, July 15, 2015.

732 "The Hollywood press": Fraser Heston, AI.

735 "Dad lost jobs": Holly Heston Rochell, AI.

735 "I [still] get as many parts": Charlton Heston, quoted in Walter Scott, "Personality Parade," *Parade,* January 14, 2001.

736 A short time after: Details of Charlton Heston's stint in rehab were reported by the *Los Angeles Times, New York Times,* and *Hollywood Reporter,* August 1, 2000.

736 "I wasn't slurring my words": Charlton Heston, quoted in "Clean and Sober," *People,* August 8, 2000.

736 "I think it gave him an extra": Fraser Heston, AI.

CHAPTER FORTY

740 "He loved driving them fast": Carol Lanning, AI.

740 "To be honest": Fraser Heston, quoted in Robert Welkos, "Heston Faces His Illness Squarely," *Los Angeles Times,* August 18, 2002.

740 "We had a family meeting": Holly Heston Rochell, AI.

741 "I always felt incredibly bad": Lynn Harris, quoted in ibid., p. 524.

742 In a statement reminiscent: Some of the information about Heston's announcement of his Alzheimer's disease is from Nick Madigan, "Charlton Heston

Reveals Disorder That May Be Alzheimer's Disease," *New York Times*, August 10, 2002.

742 "because of the nature": Lisa Powers, quoted in Susan King, "Heston Tells of Disease," *Los Angeles Times*, August 10, 2002. Powers was associated with the NRA. According to Fraser, the organization was quite helpful during the last part of Heston's life, and there was great personal affection between the group and Heston.

742 "It was a tough decision": Fraser Heston, AI.

743 "I can say for certain": Charlton Heston, quoted in Welkos, "Heston Faces His Illness Squarely."

743 "Well, I wouldn't say": Fraser Heston, quoted in ibid.

743 "I was hoping for that": Charlton Heston, quoted in ibid.

746 "I want to tell you": Wayne LaPierre, quoted in Katherine Q. Seelye, "Heston Takes Last Lap in the Cause of Guns," *New York Times*, October 23, 2002.

746 "They're very strong people": Tony Makris, quoted in *People*, August 26, 2002. Makris actually said this line many times, including at the October rally. He was, to the end, unfailingly positive and filled with praise for all Heston had done for the NRA.

747 "It wasn't sad": Holly Heston Rochell, AI.

747 "Charlton Heston announced": George Clooney, quoted in the *Hollywood Reporter,* January 23, 2003.

747 "It just goes to show": Charlton Heston, quoted in ibid.

748 "I believe most Americans": Bill O'Reilly, quoted in ibid. Liz Smith also included O'Reilly's comments in her syndicated column of January 22, 2003.

748 "Nobody gives a flip": Kimberley A. Strassel, "Modern-Day Moses, on a Mission," review of *From My Cold, Dead Hands* by Emilie Raymond, *Wall Street Journal,* September 2, 2006.

749 "Heston's waddle": Tom Carson, writing in the February 2003 issue of *Esquire,* also wrote that Moore's "interview with Heston . . . is still one of the truly great scenes [Heston] has ever appeared in on film . . ."

749 "Mr. Heston was already in": Carol Lanning, AI.

750 "I was appalled": Charlton and Lydia Heston, "The Last Interview," conducted by Peter Jennings, ABC, December 20, 2002. In the unedited transcript, Heston apologized for belittling Bill Clinton the night of the "cold, dead hands" speech, saying, "Probably that was unkind of me. You shouldn't, you shouldn't call people names like that." He said he also regretted calling Clinton a liar, and that when

he made the speech he knew what he was going to do: "They call it acting. I know when I stand and say, 'from my cold dead hands,' I know that I'm not really doing that. I'm, I'm acting . . ."

751 "Chuck has been really a remarkable": Jean Firstenberg, quoted in Josh Spector, *Hollywood Reporter,* September 25, 2003.

752 "The Charlton Heston Award was": Holly Heston Rochell, AI.

752 "The AFI did the same thing": Fraser Heston, AI.

754 "Three-quarters through my relationship": Stephen Macht, AI.

Complete Charlton Heston Filmography and Television and Radio Work

FILM

The Quigley Poll of film exhibitors ranked Heston as one of the most popular stars in the United States in the following years:

1953—23rd most popular

> 1960—16th
> 1961—18th
> 1962—12th

1. *Peer Gynt* (1941)—Producer: David Bradley. Director: David Bradley. Student film made at Northwestern University. With Charlton Heston, Betty Hanisee, Lucielle Powell. Rereleased in 1965 with

an added sound track utilizing the music of Edvard Grieg.

2. *Macbeth* (1941)—Producer: David Bradley. Director David Bradley. Heston does not appear in the film. He designed the costumes.

3. *Julius Caesar* (1950)—Producer: David Bradley. Director: David Bradley. Screenplay by David Bradley, from the play by William Shakespeare. Distributed by Brandon Films Inc. With Charlton Heston, Harold Tasker, David Bradley, Theodore Cloak, Mary Sefton Darr.

4. *Dark City* (1950)—Paramount. Producer: Hal B. Wallis. Director: William Dieterle. Screenplay: John Meredyth Lucas, Larry Marcus, Ketti Frings. With Charlton Heston, Lizabeth Scott, Viveca Lindfors, Dean Jagger, Don DeFore, Jack Webb.

5. *The Greatest Show on Earth* (1952)—Paramount. Producer: Cecil B. DeMille. Director: Cecil B. DeMille. Screenplay: Fredric M. Frank, Barré Lyndon, Theodore St. John. With Betty Hutton, Charlton Heston, Cornel Wilde, Dorothy Lamour, Gloria Grahame, James Stewart, Henry Wilcoxon.

6. *The Savage* (a.k.a. *Warbonnet*, 1952)—Paramount. Producer: Mel Epstein. Director: George Marshall. Screenplay: Sydney Boehm, based on the novel by L. L. Foreman. With Charlton Heston, Susan Mor-

row, Peter Hanson, Joan Taylor, Richard Rober, Don Porter.

7. *Ruby Gentry* (1952)—Twentieth Century-Fox. Producer: Joseph Bernhard, King Vidor. Director: King Vidor. Screenplay: Silvia Richards. With Jennifer Jones, Charlton Heston, Karl Malden, Tom Tully, Bernard Phillips.

8. *The President's Lady* (1953)—Twentieth Century-Fox. Producer: Sol C. Siegel. Director: Henry Levin. Screenplay: John Patrick, from the novel by Irving Stone. With Susan Hayward, Charlton Heston, John McIntire, Fay Bainter, Whitfield Connor.

9. *Pony Express* (1953)—Paramount. Producer: Nat Holt. Director: Jerry Hopper. Screenplay: Charles Marquis Warren. With Charlton Heston, Rhonda Fleming, Jan Sterling, Forrest Tucker, Richard Shannon.

10. *Arrowhead* (1953)—Paramount. Producer: Nat Holt. Director: Charles Marquis Warren. Screenplay: Charles Marquis Warren, from the novel by W. R. Burnett. With Charlton Heston, Jack Palance, Katy Jurado, Brian Keith, Mary Sinclair.

11. *Bad for Each Other* (1953)—Columbia. Producer: William Fadiman. Director: Irving Rapper. Screenplay: Irving Wallace, Horace McCoy, from McCoy's novel. With Charlton Heston, Lizabeth Scott, Di-

anne Foster, Mildred Dunnock, Arthur Franz, Ray Collins.

12. *The Naked Jungle* (1954)—Paramount. Producer: George Pal. Director: Byron Haskin. Screenplay: Philip Yordan, Ranald MacDougall, from the short story "Leiningen Versus the Ants" by Carl Stephenson. With Eleanor Parker, Charlton Heston, William Conrad, Norma Calderón, Douglas Fowley.

13. *Secret of the Incas* (1954)—Paramount. Producer: Mel Epstein. Director: Jerry Hopper. Screenplay: Ranald MacDougall, Sydney Boehm. With Charlton Heston, Robert Young, Nicole Maurey, Yma Sumac, Thomas Mitchell, Glenda Farrell.

14. *The Far Horizons* (1955)—Paramount. Producer: William H. Pine, William C. Thomas. Director: Rudolph Maté. Screenplay: Winston Miller, Edmund H. North, from the novel *Sacajawea of the Shoshones* by Della Gould Emmons. With Fred MacMurray, Charlton Heston, Donna Reed, Barbara Hale, William Demarest.

15. *Lucy Gallant* (1955)—Paramount. Producer: William H. Pine, William C. Thomas. Director: Robert Parrish. Screenplay: John Lee Mahin, Winston Miller, from the novel *The Life of Lucy Gallant* by Margaret Cousins. With Jane Wyman, Charlton

Heston, Claire Trevor, Thelma Ritter, William Demarest.

16. *The Private War of Major Benson* (1955)—Universal. Producer: Howard Pine. Director: Jerry Hopper. Screenplay: William Roberts, Richard Alan Simmons. With Charlton Heston, Julie Adams, William Demarest, Tom Considine, Tim Hovey, Sal Mineo.

17. *The Ten Commandments* (1956)—Paramount. Producer: Cecil B. De Mille. Director: Cecil B. De Mille. Screenplay: Aeneas MacKenzie, Jesse L. Lasky Jr., Jack Gariss, Fredric M. Frank. With Charlton Heston, Anne Baxter, Yul Brynner, Yvonne De Carlo, John Derek, Nina Foch, Debra Paget, Judith Anderson, Edward G. Robinson, Sir Cedric Hardwicke, Martha Scott, Vincent Price, Henry Wilcoxon.

18. *Three Violent People* (1957)—Paramount. Producer: Hugh Brown. Director: Rudolph Maté. Screenplay: James Edward Grant. With Charlton Heston, Anne Baxter, Gilbert Roland, Tom Tryon, Bruce Bennett, Forrest Tucker, Elaine Stritch.

19. *Screen Snapshots: Salute to Hollywood* (1958)— 11-minute short. Director: Ralph Staub. With Charlton Heston, John Wayne, Virginia Mayo, Ann Miller, Jayne Mansfield and Mr. and Mrs. George Montgomery, Dinah Shore.

20. *Touch of Evil* (1958)—Universal International. Producer: Albert Zugsmith. Director: Orson Welles. Screenplay: Orson Welles. With Charlton Heston, Janet Leigh, Orson Welles, Joseph Calleia, Akim Tamiroff, Marlene Dietrich, Zsa Zsa Gabor, Joseph Cotten.

21. *The Big Country* (1958)—United Artists. Producer: Universal. Director: William Wyler. Screenplay: James R. Webb, Sy Bartlett, Robert Wilder, from the novel by Donald Hamilton. With Gregory Peck, Jean Simmons, Carroll Baker, Charlton Heston, Burl Ives, Charles Bickford, Chuck Connors.

22. *The Buccaneer* (1958)—Paramount (distributor). Producer: Henry Wilcoxon for Cecil B. De Mille Productions. Director: Anthony Quinn. Screenplay: Jesse L. Lasky Jr., Bernice Mosk. With Yul Brynner, Charlton Heston, Claire Bloom, Charles Boyer, Inger Stevens, Henry Hull, E. G. Marshall, Lorne Greene.

23. *Ben-Hur* (1959)—MGM. Producer: Sam Zimbalist. Director: William Wyler. Screenplay: Karl Tunberg, Christopher Fry (uncredited), Gore Vidal (uncredited), from the novel by Lew Wallace. With Charlton Heston, Stephen Boyd, Haya Harareet, Jack Hawkins, Hugh Griffith, Martha Scott, Cathy O'Donnell, Frank Thring.

24. *The Wreck of the Mary Deare* (1959)—MGM. Producer: Julian Blaustein. Director: Michael Anderson. Screenplay: Eric Ambler, from the novel by Hammond Innes. With Gary Cooper, Charlton Heston, Michael Redgrave, Emlyn Williams, Cecil Parker, Alexander Knox, Virginia McKenna, Richard Harris.

25. *El Cid* (1961)—Allied Artists, Samuel Bronston–Dear Film. Producer: Samuel Bronston. Director: Anthony Mann. Screenplay: Philip Yordan, Fredric M. Frank. With Charlton Heston, Sophia Loren, John Fraser, Raf Vallone, Geneviève Page, Gary Raymond, Herbert Lom, Douglas Wilmer.

26. *The Pigeon That Took Rome* (1962)—Paramount. Producer: Melville Shavelson. Director: Melville Shavelson. Screenplay: Melville Shavelson, from the novel *The Easter Dinner* by Donald Downes. With Charlton Heston, Elsa Martinelli, Harry Guardino, Brian Donlevy.

27. *Diamond Head* (1963)—Columbia. Producer: Jerry Bresler. Director: Guy Green. Screenplay: Marguerite Roberts, from the novel by Peter Gilman. With Charlton Heston, Yvette Mimieux, George Chakiris, France Nuyen, James Darren.

28. *55 Days at Peking* (1963)—Allied Artists. Producer: Samuel Bronston. Director: Nicholas Ray.

Screenplay: Philip Yordan, Bernard Gordon, Robert Hamer. With Charlton Heston, David Niven, Ava Gardner, Robert Helpmann, Flora Robson, Leo Genn, John Ireland, Paul Lukas, Harry Andrews.

29. *The Greatest Story Ever Told* (1965)—United Artists. Producer: George Stevens, in creative association with Carl Sandburg. Director: George Stevens. Screenplay: James Lee Barrett, George Stevens, based on the book by Fulton Ourslet and writings by Henry Denker. With Max Von Sydow, Michael Anderson Jr., Carroll Baker, Ina Balin, Pat Boone, Victor Buono, Richard Conte, Joanna Dunham, José Ferrer, Van Heflin, Charlton Heston, Martin Landau, Angela Lansbury, Janet Margolin, David McCallum, Roddy McDowall, Dorothy McGuire, Sal Mineo, Nehemiah Persoff, Donald Pleasence, Sidney Poitier, Claude Rains, Cary Raymond, Telly Savalas, Joseph Schildkraut, Paul Stewart, John Wayne, Shelley Winters, Ed Wynn.

30. *The Agony and the Ecstasy* (1965)—Twentieth Century-Fox. Producer: Carol Reed. Director: Carol Reed. Screenplay: Philip Dunne, from the novel by Irving Stone. With Charlton Heston, Rex Harrison, Diane Cilento, Harry Andrews.

31. *Major Dundee* (1965)—Columbia. Producer: Jerry Bresler. Director: Sam Peckinpah. Screenplay: Ju-

lian Fink, Oscar Saul, Sam Peckinpah. With Charlton Heston, Richard Harris, Jim Hutton, James Coburn, Michael Anderson Jr., Senta Berger, Warren Oates, Ben Johnson.

32. *The War Lord* (1965)—Universal. Producer: Walter Seltzer. Director: Franklin J. Schaffner. Screenplay: John Collier, Millard Kaufman, from the play *The Lovers* by Leslie Stevens. With Charlton Heston, Richard Boone, Rosemary Forsyth, Maurice Evans.

33. *Khartoum* (1966)—United Artists. Producer: Julian Blaustein. Director: Basil Dearden. Screenplay: Robert Ardrey. With Charlton Heston, Laurence Olivier, Richard Johnson, Ralph Richardson, Alexander Knox, Nigel Green, Michael Hordern.

34. *Counterpoint* (1968)—Universal. Producer: Dick Berg. Director: Ralph Nelson. Screenplay: James Lee, Joel Oliansky, from the novel *The General* by Alan Sillitoe. With Charlton Heston, Maximilian Schell, Kathryn Hays, Anton Diffring.

35. *Will Penny* (1968)—Paramount. Producer: Fred Engel, Walter Seltzer. Director: Tom Gries. Screenplay: Tom Gries. With Charlton Heston, Joan Hackett, Donald Pleasence, Lee Majors, Bruce Dern, Ben Johnson, Slim Pickens, Lydia Clarke.

36. *Planet of the Apes* (1968)—Twentieth Century-

Fox. Producer: Arthur P. Jacobs. Director: Franklin J. Schaffner. Screenplay: Michael Wilson, Rod Serling, from the novel *Planet of the Apes* by Pierre Boulle. With Charlton Heston, Roddy McDowall, Kim Hunter, Maurice Evans, James Whitmore, Linda Harrison.

37. *Number One* (a.k.a. *Pro*, 1969)—United Artists. Producer: Walter Seltzer. Director: Tom Gries. Screenplay: David Moessinger. With Charlton Heston, Jessica Walter, Bruce Dern, John Randolph, Diana Muldaur, Mike Henry.

38. *Beneath the Planet of the Apes* (1970)—Twentieth Century-Fox. Producer: Arthur P. Jacobs. Director: Ted Post. Screenplay: Paul Dehn, Mort Abrahams, from the novel *Planet of the Apes* by Pierre Boulle. With James Franciscus, Charlton Heston, Kim Hunter, Maurice Evans, Linda Harrison.

39. *The Hawaiians* (a.k.a. *Master of the Islands*, 1970)—United Artists. Producer: Walter Mirisch. Director: Tom Gries. Screenplay: James R. Webb, from the novel *Hawaii* by James A. Michener. With Charlton Heston, Tina Chen, Geraldine Chaplin, John Phillip Law, Alec McCowen.

40. *Julius Caesar* (1970)—Commonwealth United. Producer: Peter Snell. Director: Stuart Burge. Screenplay by Robert Furnival, from the play *Julius Caesar*

by William Shakespeare. With Charlton Heston, Jason Robards, John Gielgud, Richard Johnson, Robert Vaughn, Richard Chamberlain, Diana Rigg, Jill Bennett, Christopher Lee.

41. *To Memphis* [TK]
42. *The Omega Man* (1971)—Warner Bros. Producer: Walter Seltzer. Director: Boris Sagal. Screenplay: John William Corrington, Joyce H. Corrington, from the novel *I Am Legend* by Richard Matheson. With Charlton Heston, Anthony Zerbe, Rosalind Cash, Paul Koslo.
43. *Antony and Cleopatra* (1972)—Transac, Izaro, Folio Films. Producer: Peter Snell. Director: Charlton Heston. Screenplay: Charlton Heston, from the play *Antony and Cleopatra* by William Shakespeare. With Charlton Heston, Hildegard Neil, Eric Porter, John Castle, Fernando Rey, Juan Luis Galiardo, Freddie Jones, Julian Glover, Douglas Wilmer.
44. *Skyjacked* (1972)—MGM. Producer: Walter Seltzer. Director: John Guillermin. Screenplay: Stanley R. Greenberg, from the novel *Hijacked* by David Harper. With Charlton Heston, Yvette Mimieux, James Brolin, Claude Akins, Jeanne Crain, Walter Pidgeon.
45. *The Call of the Wild* (1972)—Massfilms (London), CCC Filmkunst (Berlin), Izaro (Madrid), Ocea-

nia (Rome), UPF (Paris). Producer: Harry Alan
Towers. Director: Ken Annakin. Screenplay: Peter
Welbeck (Harry Alan Towers), Wyn Wells, Peter
Yeldham, from the book *The Call of the Wild* by
Jack London. With Charlton Heston, Michele Mer-
cier, Raimund Harmstorf, George Eastman.

46. *Soylent Green* (1973)—MGM. Producer: Walter Selt-
zer, Russell Thacher. Director: Richard Fleischer.
Screenplay: Stanley R. Greenberg, from the novel
Make Room! Make Room! by Harry Harrison. With
Charlton Heston, Leigh Taylor-Young, Edward G.
Robinson, Chuck Connors, Joseph Cotten.

47. *The Three Musketeers* (1973)—Twentieth Century-
Fox. Producer: Alexander Salkind. Director: Rich-
ard Lester. Screenplay: George MacDonald Fraser,
from the novel *The Three Musketeers* by Alexandre
Dumas. With Michael York, Oliver Reed, Raquel
Welch, Richard Chamberlain, Frank Finlay, Charl-
ton Heston, Faye Dunaway, Christopher Lee, Ger-
aldine Chaplin, Jean-Pierre Cassel, Spike Milligan.

48. *Airport 1975* (1974)—Universal. Producer: William
Frye. Director: Jack Smight. Screenplay: Don In-
galls. With Charlton Heston, Karen Black, George
Kennedy, Susan Clark, Gloria Swanson, Linda
Blair, Efrem Zimbalist Jr., Roy Thinnes, Myrna

Loy, Dana Andrews, Nancy Olson, Martha Scott, Sid Caesar, Linda Harrison, Helen Reddy.

49. *The Four Musketeers* (1974)—This film was a sequel to *The Three Musketeers,* shot at the same time and comprised mainly of footage not used in the original.

50. *Earthquake* (1974)—Universal. Producer: Mark Robson. Director: Mark Robson. Screenplay: George Fox. With Charlton Heston, Ava Gardner, George Kennedy, Lorne Green, Geneviève Bujold, Richard Roundtree, Marjoe Gortner, Victoria Principal.

51. *Midway* (a.k.a. *Battle of Midway,* 1976)—Universal. Producer: Walter Mirisch. Director: Jack Smight. Screenplay: Donald S. Sanford. With Charlton Heston, Henry Fonda, Toshiro Mifune, Edward Albert, Robert Mitchum, James Shigeta, Christina Kokubo, James Coburn, Glenn Ford, Hal Holbrook, Cliff Robertson, Ed Nelson, Robert Wagner, Robert Webber, Kevin Dobson.

52. *Two-Minute Warning* (1976)—Producer: Edward S. Feldman. Director: Larry Peerce. Screenplay: Edward Hume, from the novel *Two-Minute Warning* by George La Fountaine. With Charlton Heston, John Cassavetes, Beau Bridges, Martin Balsam, Jack Klugman, Gena Rowlands, David Janssen,

David Groh, Joe Kapp, Walter Pidgeon, Marilyn Hassett, Brock Peters, Mitchell Ryan.

53. *The Last Hard Men* (1976)—Twentieth Century-Fox. Producer: Russell Thacher, Walter Seltzer. Director: Andrew V. McLaglen. Screenplay: Guerdon Trueblood. With Charlton Heston, James Coburn, Barbara Hershey, Christopher Mitchum, Jorge Rivero, Michael Parks.

54. *The Prince and the Pauper* (a.k.a. *Crossed Swords*, 1977)—Rank. Producer: Alexander Salkind. Director: Richard Fleischer. Screenplay: George MacDonald Fraser. With Oliver Reed, Mark Lester, Charlton Heston, Ernest Borgnine, Rex Harrison, George C. Scott, David Hemmings, Raquel Welch.

55. *Gray Lady Down* (1978)—Universal. Producer: Walter Mirisch. Director: David Greene. Screenplay: James Whittaker, Howard Sackler, from the novel *Event 1000* by David Lavallee. With Charlton Heston, Stacy Keach, David Carradine, Ned Beatty, Stephen McHattie, Ronny Cox, Dorian Harewood, Rosemary Forsyth.

56. *The Mountain Men* (1980)—Columbia. Producer: Martin Shafer, Andrew Scheinman. Director: Richard Lang. Screenplay: Fraser Heston. With Charlton Heston, Brian Keith, Victoria Racimo, Stephen Macht, John Glover, Seymour Cassel.

57. *The Awakening* (1980)—EMI-Orion. Producer: Robert H. Solo. Director: Mike Newell. Screenplay: Allan Scott, Chris Bryant, Clive Exton, from the novel *The Jewel of Seven Stars* by Bram Stoker. With Charlton Heston, Susannah York, Jill Townsend, Stephanie Zimbalist, Patrick Drury, Bruce Myers.

58. *Mother Lode* (1982)—Manson International. Producer: Fraser Heston. Director: Charlton Heston. With Charlton Heston, Nick Mancuso, Kim Basinger, John Marley, Dale Wilson.

59. *Call from Space* (1989)—Showscan Film Corporation. Producer: Peter Beale, Roger Wielgus. Director: Richard Fleischer. Screenplay: Chris Langham, Sarah Paris. With Charlton Heston (voice of Alien), Sherrié Austin, Brandon Stirling Baker, Richard Brestoff.

60. *Solar Crisis* (1990)—Japan America Picture Company. Producer: Robert Edlund, James Nelson. Director: Richard C. Sarafian. Screenplay: Joe Gannon, Crispan Bolt, from the novel *Solar Crisis* by Takeshi Kawata. With Charlton Heston, Tim Matheson, Peter Boyle, Annabelle Schofield.

61. *Almost an Angel* (1990)—Paramount. Producer: John Cornell, Paul Hogan. Director: John Cornell. Screenplay: Paul Hogan. With Paul Hogan, Elias Koteas, Linda Kozlowski, Charlton Heston.

62. *Wayne's World 2* (1993)—NBC Films/Paramount. Producer: Lorne Michaels. Director: Stephan Surjick. Screenplay: Mike Myers, Bonnie Turner, Terry Turner. With Mike Myers, Dana Carvey, Christopher Walken, Tia Carrere, Ralph Brown, Aerosmith, Charlton Heston (cameo).

63. *Tombstone* (1993)—Buena Vista Pictures. Producer: James Jacks, Sean Daniel, Bob Misiorowski. Director: George P. Cosmatos. Screenplay: Kevin Jarre. With Kurt Russell, Val Kilmer, Charlton Heston.

64. *True Lies* (1994)—Twentieth Century-Fox. Producer: James Cameron, Stephanie Austin. Director: James Cameron. Screenplay: James Cameron, Randall Frakes, from a story by James Cameron. With Arnold Schwarzenegger, Jamie Lee Curtis, Tom Arnold, Bill Paxton, Art Malik, Tia Carrere, Eliza Dushku, Grant Heslov, Charlton Heston.

65. *America: A Call to Greatness* (1995)—Paige-Brace Cinema, Millennial Entertainment (distributor). Producer: Warren Chaney. Director: Warren Chaney. Screenplay: Warren Chaney. With Charlton Heston (narrator/host), Mickey Rooney, Deborah Winters, Peter Graves, Rita Moreno, Dorian Harewood, Jane Russell, Gene Autry.

66. *In the Mouth of Madness* (a.k.a. *John Carpenter's In the Mouth of Madness*, 1995)—New Line Cinema

(distributor). Producer: Sandy King. Director: John Carpenter. Screenplay: Michael De Luca. With Sam Neill, Julie Carmen, Jürgen Prochnow, David Warner, John Glover, Bernie Casey, Peter Jason, Charlton Heston, Frances Bay, Wilhelm von Homburg.

67. *The Dark Mist* (1996)—Alpine Pictures. Producer: Carroll Brothers. Director: Ryan Carroll. Screenplay: Stacey Upton, Bruce A. Young. With Olivia Hussey, Patrick Cassidy, Ron Hale, Charlton Heston (narrator).

68. *Alaska* (1996)—Columbia Pictures (distributor). Producer: Andy Burg. Director: Fraser Heston. Screenplay: Andy Burg, Scott Myers. With Thora Birch, Vincent Kartheiser, Dirk Benedict, Charlton Heston, Gordon Tootoosis.

69. *Hamlet* (1996)—Castle Rock Entertainment, Columbia Pictures (distributor). Producer: David Barron. Director: Kenneth Branagh. Screenplay: Kenneth Branagh, from the play *Hamlet* by William Shakespeare. With Kenneth Branagh, Julie Christie, Billy Crystal, Gérard Depardieu, Charlton Heston, Derek Jacobi, Jack Lemmon, Rufus Sewell, Robin Williams, Kate Winslet.

70. *Hercules* (1997)—Buena Vista Pictures. Producer: Ron Clements, John Musker. Director: Ron Clements, John Musker. Screenplay: Ron Clements,

John Musker, Barry Johnson. With the voices of Tate Donovan, Danny DeVito, James Woods, Susan Egan, Rip Torn, Charlton Heston (narrator).

71. *Armageddon* (1998)—Jerry Bruckheimer Films, Valhalla Pictures, Touchstone Pictures (distributor). Producer: Jerry Bruckheimer, Gale Anne Hurd, Michael Bay. Director: Michael Bay. Screenplay: Tony Gilroy, Shane Salerno, Jonathan Hensleigh, J. J. Abrams. With Bruce Willis, Billy Bob Thornton, Liv Tyler, Ben Affleck, Will Patton, Peter Stormare, Keith David, Owen Wilson, Michael Clarke Duncan, William Fichtner, Steve Buscemi, Charlton Heston (narrator).

72. *Gideon* (1998)—Baldwin/Cohen Productions, STTM Productions, World International Network. Director: Claudia Hoover. Screenplay: Brad Mirman. With Christopher Lambert, Charlton Heston, Carroll O'Connor, Shirley Jones, Mike Connors, Barbara Bain, Shelley Winters, Crystal Bernard, Christopher McDonald, Mykelti Williamson, Taylor Nichols, Michael Bowen, Harvey Korman.

73. *Any Given Sunday* (1999)—Warner Bros (distributor). Producer: Richard Donner, Oliver Stone, Dan Halsted, Lauren Shuler Donner, Clayton Townsend. Director: Oliver Stone. Screenplay: John Logan, Oliver Stone, from a story by Daniel Pyne, based on

the novel *Any Given Sunday* by Pat Toomey. With Al Pacino, Cameron Diaz, Dennis Quaid, James Woods, Jamie Foxx, LL Cool J, Charlton Heston.

74. *Town & Country* (1999)—Sidney Kimmel Entertainment, New Line Cinema (distributor). Director: Peter Chelsom. Screenplay: Michael Laughlin, Buck Henry. With Warren Beatty, Diane Keaton, Goldie Hawn, Garry Shandling, Andie MacDowell, Jenna Elfman, Nastassja Kinski, Charlton Heston.

75. *Cats and Dogs* (2001)—Village Roadshow Pictures, Mad Chance, Zide/Perry Productions, Rhythm and Hues Studios, Warner Bros. Producer: Ed Jones, Christopher DeFaria, Andrew Lazar, Craig Perry, Warren Zide. Director: Lawrence Guterman. Screenplay: John Requa, Glenn Ficarra. With Jeff Goldblum, Elizabeth Perkins, Alexander Pollock, Charlton Heston (voice only).

76. *Planet of the Apes* (2001)—Zanuck Company, Twentieth Century-Fox. Producer: Richard D. Zanuck. Director: Tim Burton. Screenplay: William Broyles Jr., Lawrence Konner, Mark Rosenthal, based on the novel *Planet of the Apes* by Pierre Boulle. With Mark Wahlberg, Tim Roth, Helena Bonham Carter, Michael Clarke Duncan, Paul Giamatti, Estella Warren, Charlton Heston (cameo).

77. *The Order* (2001)—TriStar Pictures. Producer:

Avi Lerner. Director: Sheldon Lettich. Screenplay: Jean-Claude Van Damme, Les Weldon. With Jean-Claude Van Damme, Charlton Heston, Sofia Milos, Brian Thompson, Vernon Dobtcheff.

78. *Bowling for Columbine* (2001)—United Artists, MGM. Producer: Michael Moore. Director: Michael Moore. Screenplay: Michael Moore. With Charlton Heston, Michael Moore.

79. *Rua Alguem 5555: My Father* (2003)—Gam Film (Italy), Total Entertainment (Brazil), Focus Film (Hungary). Producer: Gherardo Pagliei. Director: Egidio Eronico. Screenplay: Egidio Eronico, Antonella Grassi, Peter Schneider, Fabio Carpi, from the novel *Vati* by Peter Schneider.

80. *Genghis Khan* (2010)—International Cinema Company, Madison Motion Pictures Group. Director: Ken Annakin, Antonio Margheriti. Screenplay: Andrzej Krakowski. With Bekim Fehmiu, Daniel Greene, Charlton Heston, James Hong, Richard Lee-Sung, James Mitchum, Tricia O'Neil, Nigel Terry, Richard Tyson, Hal Yamanouchi.

TELEVISION

1. March 15, 1949, *Suspense,* "Suspicion."
2. June 15, 1949, *Studio One,* "Smoke."

3. September 26, 1949, *Studio One,* "The Outward Room."

4. October 24, 1949, *Studio One,* "Battleship Bismarck."

5. November 8, 1949, *Suspense,* "Suspicion."

6. November 21, 1949, *Studio One,* "Of Human Bondage."

7. December 12, 1949, *Studio One,* "Jane Eyre."

8. February 27, 1950, *Studio One,* "The Willow Cabin."

9. March 22, 1950, *Studio One,* "The Hypnotist."

10. June 5, 1950, *Studio One,* "The Taming of the Shrew."

11. June 25, 1950, *The Philco Television Playhouse,* "Hear My Heart Speak."

12. October 30, 1950, *Studio One,* "Wuthering Heights."

13. December 4, 1950, *Studio One,* "Letter from Cairo."

14. October 2, 1951, *Suspense,* "Santa Fe Flight."

15. October 9, 1951, *Lux Video Theater,* "Route 19."

16. October 13, 1951, *Your Show of Shows,* "Episode: October 13, 1951."

17. October 22, 1951, *Studio One,* "Macbeth."

18. November 12, 1951, *Studio One,* "A Bolt of Lightning."

19. November 23, 1951, *Schlitz Playhouse of Stars,* "One Is a Lonesome Number."

20. December 22, 1951, *Your Show of Shows*, no title, comedy-variety.

21. January 14, 1952, *Robert Montgomery Presents*, "Cashel Byron's Profession."

22. January 25, 1953, *The Philco Television Playhouse*, "Elegy."

23. December 12, 1953, *Medallion Theater*, "A Day in Town."

24. January 16, 1954, *Your Show of Shows*, no title, comedy-variety.

25. February, 2, 1954, *Danger*, "Freedom to Get Lost."

26. March 3, 1955, *The George Gobel Show*, no title, comedy-variety.

27. June 12, 1955, *The Colgate Comedy Hour*, no title, comedy-variety.

28. June 26, 1955, *The Colgate Comedy Hour*, no title, comedy-variety.

29. August 7, 1955, *The Colgate Comedy Hour*, no title, comedy-variety.

30. August 28, 1955, *The Colgate Comedy Hour*, no title, comedy-variety.

31. September 4, 1955, *The Colgate Comedy Hour*, no title, comedy-variety.

32. September 25, 1955, *Robert Montgomery Presents*, "Along Came Jones."

33. October 9, 1955, *Omnibus,* "The Birth of Modern Times."

34. October 14, 1955, *Person to Person,* interview with Edward R. Murrow.

35. December 11, 1955, *General Electric Theater,* "The Seeds of Hate."

36. December 29, 1955, *Climax,* "Bailout at 43,000 Feet."

37. October 4, 1956, *Playhouse 90,* "Forbidden Area."

38. October 28, 1956, *What's My Line?*

39. December 2, 1956, *The Steve Allen Show.*

40. May 17, 1957, *Schlitz Playhouse of Stars,* "Switch Station."

41. June 27, 1957, *Climax!,* "The Trial of Captain Wirtz."

42. November 17, 1957, *The Ed Sullivan Show.*

43. December 11, 1957, *This Is Your Life.*

44. January 12, 1958, *Shirley Temple's Storybook,* "Beauty and the Beast."

45. February 20, 1958, *Playhouse 90,* "Point of No Return."

46. January 25, 1959, *The Ed Sullivan Show.*

47. March 15, 1959, *The Steve Allen Show.*

48. July 26, 1959, *The Ed Sullivan Show.*

49. December 27, 1959, *The Ed Sullivan Show.*

50. April 11, 1960, *The Steve Allen Show.*

51. May 1, 1960, *The Ed Sullivan Show* (dramatic reading).

52. May 5, 1960, *The Revlon Revue*, "Tiptoe Through TV."

53. November 6, 1960, *The Ed Sullivan Show*.

54. October 17, 1961, *Alcoa Premiere*, "The Fugitive Eye."

55. November 15, 1963, *Hallmark Hall of Fame*, "The Patriots."

56. June 8, 1966, "A Whole Scene Going."

57. January 31, 1968, *Hallmark Hall of Fame*, "Elizabeth the Queen."

58. March 31, 1968, *The Ed Sullivan Show*.

59. June 9, 1968, *The Ed Sullivan Show*.

60. June 4, 1970, *The Merv Griffin Show*.

61. October 1, 1970, *The Tonight Show Starring Johnny Carson*.

62. August 18, 1971, *The Tonight Show Starring Johnny Carson*.

63. August 21, 1971, *The Irv Kupcinet Show*.

64. December 12, 1971, *Parkinson*.

65. February 26, 1972, *Film Night*.

66. May 11, 1972, *The Tonight Show Starring Johnny Carson*.

67. December 12, 1972, *The Tonight Show Starring Johnny Carson*.

68. March 28, 1973, *The Tonight Show Starring Johnny Carson.*

69. August 23, 1973, *The Tonight Show Starring Johnny Carson.*

70. October 18, 1973, *Jack Paar Tonite.*

71. October 23, 1973, *Dinah's Place.*

72. May 29, 1974, *ABC's Wide World of Entertainment.*

73. October 15, 1974, *The Mike Douglas Show.*

74. May 3, 1976, *Dinah!*

75. September 17, 1976, *Dinah!*

76. December 10, 1976, *The Tonight Show Starring Johnny Carson.*

77. April 10, 1978, *America 2-Nite.*

78. December 15, 1981, *The Tonight Show Starring Johnny Carson.*

79. December 13, 1983, *Chiefs* (miniseries).

80. October 17, 1984, *Nairobi Affair* (TV movie).

81. January 2, 1985, *Aspel & Company* (TV series).

82. October 9, 1985, *Dynasty* (recurring character).

83. October 16, 1985, *Dynasty* (recurring character).

84. November 13, 1985, *Dynasty* (recurring character).

85. November 20, 1985, *The Colbys* (recurring character; Heston appeared in 48 episodes through March 26, 1987).

86. December 4, 1985, *The Tonight Show Starring Johnny Carson.*

87. April 3, 1986, *Good Morning America.*
88. November 9, 1986, *The Wonderful World of Disney.*
89. March 28, 1987, *Saturday Night Live.*
90. October 1, 1987, *Proud Men* (TV movie).
91. October 10, 1987, *The Dame Edna Experience.*
92. December 25, 1987, *The Two Ronnies,* a.k.a. *Christmas Night with the Two Ronnies* (Christmas special).
93. December 21, 1988, *A Man for All Seasons* (TV movie).
94. February 20, 1989, *Original Sin* (TV movie).
95. January 22, 1990, *Treasure Island* (TV movie).
96. August 17, 1990, *The Little Kidnappers* (TV movie).
97. February 20, 1991, *The Man Who Saw Tomorrow* (documentary).
98. November 4, 1991, *The Crucifer of Blood* (TV movie).
99. Undated, *Cults: Say No to Pressure* (documentary).
100. February 24, 1992, *Crash Landing: The Rescue of Flight 232* (TV movie).
101. December 1, 1992, *Noel* (TV movie).
102. November 10, 1993, *The Mysteries of the Sphinx* (TV episode).
103. December 4, 1993, *Saturday Night Live.*
104. April 13, 1994, *This Is Your Life.*
105. May 1, 1994, *SeaQuest DSV* (TV episode).

106. December 26, 1994, *The Great Battles of the Civil War* (documentary).

107. January 22, 1995, *The Avenging Angel* (TV movie).

108. April 16, 1995, *Texas* (TV miniseries).

109. November 17, 1995, *Clive Anderson Talks Back* (TV series).

110. December 2, 1995, *Corazón, Corazón* (TV series).

111. January 22, 1996, *Angels de Nit* (TV series).

112. February 25, 1996, *The Mysterious Origins of Man* (documentary).

113. February 25, 1996, *Goldie Hawn* (TV series).

114. December 2, 1996, *Corazón, Corazón* (TV series).

115. January 17, 1997, *Dennis Miller Live.*

116. March 17, 1997, *Biography,* "Sophia Loren: Actress Italian Style."

117. June 4, 1997, *The Rosie O'Donnell Show.*

118. December 5, 1997, *Space Ghost Coast to Coast* (TV series).

119. January 1, 1998, *Special Screenings.*

120. February 5, 1998, *Friends* (TV series).

121. March 15, 1998, *Biography,* "John Wayne, American Legend."

122. July 13, 1998, *Sword to Secrecy: Secrets of War* (documentary).

123. August 13, 1998, *Biography,* "Rex Harrison: The Man Who Would Be King."

124. October 8, 1998, *Late Night with Conan O'Brien.*

125. October 8, 1998, *Biography,* "Roddy McDowall, Hollywood's Best Friend."

126. May 8, 1999, *The Howard Stern Radio Show* (TV/radio simulcast).

127. September 1, 1999, *Bagpipe: Instrument of War, Pts. 1 & 2* (documentary).

128. December 4, 1999, *Camino de Santiago* (TV miniseries).

129. September 3, 2000, *The Outer Limits* (TV series).

130. December 4, 2000, *Cursed* (TV series).

131. January 1, 2001, *Intimate Portrait* (documentary).

132. November 4, 2001, *Mad TV* (TV series).

133. January 1, 2002, *Film Genre* (TV series).

134. August 18, 2002, *Biography,* "Jennifer Jones: Portrait of a Lady."

135. December 20, 2002, *20/20* (TV series).

RADIO (SELECT APPEARANCES)

1. September 21, 1952, *Hollywood Star Playhouse,* "The Last Chance."

2. November 3, 1952, *Lux Radio Theatre,* "Viva Zapata!"

3. February 2, 1953, *Lux Radio Theatre,* "Captain Carey, USA."

4. September 28, 1953, "The President's Lady" (radio version of the movie; Heston played Andrew Jackson in both).

5. June 7, 1954, *Lux Radio Theatre*, "The Naked Jungle" (radio version of the movie; Heston played Christopher Leiningen in both).

6. December 14, 1954, *Lux Radio Theatre*, "Secret of the Incas" (Charlton Heston played Harry Steele in both).

Author's Note and Acknowledgments

I spent the summer of 1956 with my mother and our pet dog in an upstate cottage near White Lake, New York, thirteen years before the Woodstock festival was held there on nearby Yasgur's farm, a name and a place that had no special cultural meaning to me or anyone else at the time. Like all the other city kids my age, I was shipped up to "the country" as soon as I finished school that year to keep me off the mean streets and get some "fresh country air."

Exiled from my friends from the end of June until Labor Day weekend, to relieve my aching preadolescent ennui, twice a week I'd go to the movies. My mother would give me seventy-five cents to take the bus into town, where I would buy a ticket to one of the two palatial, air-conditioned white stucco theaters

(a blue sign hung from the marquee of both with the words AIR-CONDITIONED shaped like ice cubes). My three quarters bought me a duffel-size bag of popcorn with a salt mine's worth of the stuff doused with melted motor oil, a gallon of cold Coke more ice than soda, and a day trip to heaven.

The first film I saw that summer was on an especially humid Thursday in July. It was also the first film I ever saw by myself. I knew nothing about the story, I had no idea who Cecil B. DeMille was, and I had never heard of Charlton Heston. Or Moses, for that matter. The only reason I chose *The Ten Commandments* was I had seen the film playing at the other theater the previous Saturday night with my mother.

On these sweltering summer afternoons the theaters, despite their inviting cold insides, were almost always empty. I sat down in front as the film unfolded on the biggest screen I had ever seen, and soon I was swept into the epic tale of a little boy given away by his Jewish mother to the family of pharaohs, who grew up to be an Egyptian prince, then became a slave, then walked across a desert that looked like another planet, then somewhere along the line became an old man who went up a mountain and spoke directly to God, *and then God spoke back!* When the film ended, I stood up and brushed some stuck kernels of corn off my shirt

and swore my solemn allegiance to the Burning Bush, whoever or whatever that might be. I was also greatly relieved that I had an older brother who was my parents' firstborn.

That night I asked my mother if there was really a god who could do all the things he did in the film, and if so, could I see him, I had some things I wanted to talk to him about. "What movie did you see today?" she asked for the first time, as she opened a red can of dog food. I said, "*The Ten Commandments.*" She sighed, paused, and said, "Ask your father." I did the next time I saw him, that weekend. He coughed, lit a stinky Camel, took a deep drag, let out two streams of white smoke through his nostrils, and said to "ask your grandmother." I did the next time I saw her, the next weekend. She wrinkled her lips, shook her head, and said I was spending entirely too much time at the movies, that my brain was being destroyed by Hollywood nonsense.

The summer I graduated from college, I drove across the country with my best friend, Ernie. We arrived in Hollywood a week later, and the very first thing we did, after settling in, was to go to Grauman's Chinese Theatre on Hollywood Boulevard. I didn't care what was playing; I just wanted to see the theater itself. What happened to be on the bill was a revival of . . .

The Ten Commandments! As I walked into that grand temple of projected dreams, I thought of my grand-mother and half expected her to be standing next to the ticket-taker, warning me to stay away from the movies.

But I couldn't. And still can't.

How This Book Was Written

When I first decided to write a biography of Charlton Heston, I signed a contract with my publisher to produce the type of bios I usually write, heavy on critical observation, light on self-serving interviews. I started out doing what I always do: I found a close living relative of my subject, in this case Fraser Heston, Charlton and Lydia Heston's son, and wrote a letter to him explaining what I was doing and asking for his cooperation, on condition that I retain full editorial control. Almost no one ever agrees to that, and then I go ahead, write my book, and after, when all the complaints and too-late "corrections" come, I remind one and all that I had given them every opportunity to help, before the fact.

Fraser was different; he asked to meet to talk it over. We had lunch, joined by his lawyer, Jeffrey C. Biggs, appropriately enough at the legendary Musso and Frank Grill on Hollywood Boulevard, the oldest restaurant in Tinseltown that had served the stars during

the golden age and was still standing, the walls filled with the aroma of history and greatness. I laid out my plan for the book. Fraser and I shook hands, and he said he would let me know. A few days later he agreed to my conditions, and we were off. Not long after, he and his sister, Holly Heston Rochell, sat, separately, for what became a seemingly endless run of interviews (he lives in Los Angeles, she in New York City). Fraser then connected me to virtually every key person we each thought could contribute something to the book: personal friends, professional associates, assistants, etc. Throughout, I tried to get everyone to be as objective as they could, to tell their story the way they remembered it. Fraser gave me access to documents, photographs, personal diaries, and private letters, really whatever I asked for that he had.

I never once had to remind any of them about the terms of the original deal, that they could make suggestions but not demand changes to any of the manuscript, because they never asked. Fraser and I butted heads a couple of times, which is to be expected. I'd be surprised and suspicious if we didn't. Both Holly and Fraser showed an uncommon amount of patience, always listened to what I had to say, answered virtually every question I had, and almost never tried to propagandize or soften some of the harder parts of the

story. Any biographer will tell you how rare this really is—the reason most will not even bother to deal with a subject's family. I learned a lot from the Hestons, not just about their father, but about them.

I was, from the start, totally committed to telling the story *as I saw it.* Thank you, Fraser, Holly, and everyone who helped as I played biographical detective, tracking down the pieces of the puzzle of Charlton Heston's life and trying to fit them together to make one unified whole.

I wish to thank the following people as well, my primary sources, for their enormous and important contributions:

Ed Asner, whom I had interviewed a few years earlier for a different project and who generously let me use parts of those interviews for this book.

Jeffrey C. Briggs, Esq., lawyer for Fraser's family, estate, and production company, Agamemnon Films. This simply would not be the book it is (for better or worse) without his generous time and cooperation.

Joe Canutt, for his time and his memories. He answered all my questions and added some stories that were informative and enlightening.

Film historian Daniel Eagan and I exchanged e-mails and met once on a cool early spring day outside

the New York Public Library to talk about Heston. I value his sage advice and sharp insights.

Jean Firstenberg was open and frank about Heston's role in the American Film Institute. I thank her for all the good information and insights that she so generously shared with me.

Jack Gilardi made time in his busy day to speak to me at his office at ICM in Century City.

I spoke to Julian Glover by phone; he was in England at the time, and he generously shared his insights and some of his experiences working with Heston.

Henry Jaglom opened up the world of Orson Welles and set me straight on how *Touch of Evil* came together. He knew Welles, and his book was also a good reference (it's listed in the bibliography). Henry has been a good friend for a long time and never turns down any interview requests from me. He also makes good movies.

I went up to the Pacific Palisades to interview Carol Lanning, who had a wealth of material and was eager and generous to share it. She was extremely helpful.

Wayne LaPierre was a bit hesitant to talk at first but eventually opened up and answered every question I had for him, with a frankness I appreciated.

Michael Levine and I had dinner at Shutters one night in Santa Monica, where he reminisced about his

twenty-year professional relationship with Heston as his public relations representative. Michael and I have known each other for also twenty years, and he has always been there for me, ready to help.

I went down to Virginia to interview Tony Makris and found him gracious, entertaining, and informative. Not once did he try to push an agenda on me or the book.

Stephen Macht was one of the first people I interviewed, and he blew me away with his stories about making movies with Heston, appearing with him onstage, and, especially, the final days.

Chris Chesser generously sat for a long interview, via telephone.

George Mendeluk, a film producer and a friend of mine, remembered a couple of nice moments from his interactions with Heston that proved helpful.

Grover Norquist gave me an overview of Heston's involvement with the NRA and a frank assessment of what he thought about the ostracism that followed.

David Rensin, a fine writer and another good friend, went back into his files to pull up an interview he had done years earlier with Heston.

Martin Shafer was extremely helpful in the interview we did, as was Peter Snell, who happily reminisced about the films he made with Fraser and Heston.

Joseph Schleimer came up with some interesting print material I found quite useful.

I interviewed Perry Zimel in Los Angeles. He arrived with his thoughts neatly typed out, from which he verbally expounded. After, he generously left me those notes.

While I was writing this book, Fraser decided the time had come to move his mom, Lydia, now ninety-five years old, out of the big, empty "House That Hur Built." She was getting on in age and not able to move about as she once had, and extremely lonely since her husband's death. Fraser arranged to move her to a care facility and then had the daunting job of breaking down the house, piece by piece, arranging an auction of most of the material objects, and putting the files and everything else in storage for possible future donation. I was fortunate, during a visit to the house, to meet Lydia briefly and then, on another visit, to be there for some of the packing up. Those were extremely emotional days for Fraser, who kept pulling things out of files, materials he'd found, and giving them to me to use in the book. They were understandably difficult times for him, and with the help of his research "elves," as they call themselves—Heather McAdams, Jill De Lay, and Dorothy Caillens—he got through it. I can't thank them all enough.

Thanks to the dozens of others who participated: librarians, researchers—especially Jesse Herwitz—and so many others.

Finally, every book becomes an obsession for the author; I've written enough of them to know, and that can often be a pain to those you are closest with. I thank you all for your love and your patience, especially the women in my life. Bless them, they keep me sane when I am at my craziest and make me crazy when I'm a little too sane.

There are several people at Dey Books I wish to thank: Matthew Daddona, for his editorial partnership, guidance, and support, as well as Lynn Grady, Michael Barrs, and the publicity and marketing teams. I also wish to thank the Authors Guild, the New York Public Library for the Arts at Lincoln Center, my fellow Friars, and my friends at the Palm West, the best port in the storm, where I would go most nights after an all-day writing session for a stiff club soda (even though I'm a writer, I don't drink very much and I don't smoke. Go figure.)

Finally, to all my faithful readers who have stayed loyal through the years, I thank you all and wish you the best, until we meet again a little farther up the road.

About the Author

M arc Eliot is the *New York Times* bestselling author of more than two dozen books on popular culture, including the highly acclaimed *Cary Grant,* the award-winning *Walt Disney: Hollywood's Dark Prince, Jimmy Stewart, American Rebel: The Life of Clint Eastwood,* and *American Titan: Searching for John Wayne.* He writes regularly for a number of publications and frequently speaks about film at colleges and universities and to film groups. He appears often on radio and television and in film. He was seen most recently in Gillian Armstrong's *Women He's Undressed,* a documentary on the life of costume designer Orry-Kelly.

THE NEW LUXURY IN READING

We hope you enjoyed reading
our new, comfortable print size and found it
an experience you would like to repeat.

Well – you're in luck!

HarperLuxe offers the finest in fiction and
nonfiction books in this same larger print size and
paperback format. Light and easy to read, HarperLuxe
paperbacks are for book lovers who want to see
what they are reading without the strain.

For a full listing of titles and
new releases to come, please visit our website:

www.HarperLuxe.com